OXFORD MONOGRAPHS ON CLASSICAL ARCHAEOLOGY

Edited by
BERNARD ASHMOLE
MARTIN ROBERTSON
JOHN BOARDMAN

THE RED-FIGURED VASES OF APULIA

By

A.D. Trendall

and

Alexander Cambitoglou

Volume I

EARLY AND MIDDLE APULIAN

CLARENDON PRESS · OXFORD

Oxford University Press, Great Clarendon Street, Oxford OX2 6DP

Oxford New York

Athens Auckland Bangkok Bogota Bombay Buenos Aires
Calcutta Cape Town Dar es Salaam Delhi Florence Hong Kong Istanbul
Karachi Kuala Lumpur Madras Madrid Melbourne Mexico City
Nairobi Paris Singapore Taipei Tokyo Toronto Warsaw
and associated companies in
Berlin Ibadan

Oxford is a registered trade mark of Oxford University Press

Published in the United States
by Oxford University Press Inc., New York

© Oxford University Press 1982

Reprinted 1998

ISBN 0-19-813218-2

Printed in Great Britain
by
Ipswich Book Company, Suffolk

PREFACE

The main purpose of this book is to provide classified lists of Apulian red-figured vases, accompanied by brief explanatory comments on style and dating and by selected illustrations, which we hope will enable the reader to follow our attributions or groupings. The book is divided into three parts corresponding to the Early, Middle and Late periods of Apulian red-figure; of these the first two are dealt with in Volume I and the third in Volume II, which is planned to follow shortly and will also contain the museum, subject, and other indexes.

In the original plan for this work we were also to have had the collaboration of Andrew Oliver Jr., at that time associated with the Department of Greek and Roman Art of the Metropolitan Museum in New York. However, other commitments made it impossible for him to carry out his intentions, and we take this opportunity of acknowledging our debt to him in many regards - especially for his contribution to what is here published in the area of the Lycurgus Painter, for drawing to our attention several vases that might otherwise have escaped out notice, and for making available to us for study numerous photographs, which have been of great assistance in our work.

The two volumes follow, in general, the scheme adopted for *The Red-figured Vases of Lucania, Campania and Sicily*. Individual chapters deal with particular workshops, painters, or groups of vases closely connected in style; they include an introductory section, with the relevant bibliographical references, which deals with the stylistic characteristics of the painters concerned and their approximate dates, followed by lists of their extant vases. For named painters we have endeavoured to include all the vases known to us, but for the minor vase-groups (e.g. those listed in Chapter 11, or for the vases in Volume II which have female heads as their sole decoration) the lists do not claim to be exhaustive but aim to give a good, representative selection of typical vases, around which others may readily be grouped. Vases which we cannot at present place with any reasonable degree of accuracy have been omitted. The listed vases are numbered serially within each chapter; they are referred to within that particular chapter solely by the serial number, elsewhere by both chapter and serial number (i.e. no. 3/50 means vase no. 50 in Chapter 3).

The bulk of Apulian red-figure is very considerable; Volume I lists some 3,500 vases, and Volume II will probably include even more. We are well aware that any work dealing with such a large number of vases must inevitably contain errors and omissions and that new discoveries will undoubtedly bring about modifications to and improvements in our classifications; we are always most grateful to people who bring to our notice new or relevant material not here included.

In our choice of illustrations, which of necessity have had to be severely restricted, we have been guided by the need to provide the reader, as far as is practicable, with a satisfactory working basis on which to judge our attributions; we have tried, therefore, to illustrate representative examples of almost every painter's work, especially when these are not otherwise readily accessible. To this end we have mostly selected unpublished vases in preference to those available in *CVA, APS* and other publications, and, as far as possible, those of which we possessed photographs of reasonable quality. As the shape is often not of particular significance in Apulian ware (e.g. bell-kraters and pelikai), except in special cases we have normally confined the illustration to the pictures.

The text and lists of the present work are the result of a long collaboration between the two authors, who are most grateful to Professor Martin Robertson for making several useful suggestions for the improvement of the former. A number of variations will be noted from the attributions given in *APS* and its *Addenda*. These are mainly in the way of refinements arising from a deeper knowledge of a greater range of material, or from being able to study the original vases then known to us only from reproductions. As is pointed out in the Introduction, the products of a particular Apulian workshop are often remarkably alike in drawing, decoration and treatment of the subject, and only increasing familiarity with them enables one to draw possible distinctions between the work of master and close follower or pupil. Even then, one is not always certain one has drawn the line corrrectly; where we have felt doubts or reservations, we have not hesitated to express them. Almost all the accessible vases listed in this book have been seen and studied by at least one of the two authors, and the *Acknowledgements* give some indication of our widespread obligations to museum directors, private collectors and scholars all over the world.

ACKNOWLEDGEMENTS

During the decade or more that it has taken to put together the material for this book we have received a great deal of help from friends, scholars and museum curators in all parts of the world and especially in Italy, where a high proportion of the vases is to be found. To all of them we extend our sincerest thanks and, in particular, to the following:

Australia:	J.R. Green, A.S. Henry, R.G. Hood, Rosalinde Kearsley, M.N. Kelly, I.D. McPhee, Aedeen Madden.
Austria:	W. Oberleitner, Gerda Schwarz.
Belgium:	J. Ch. Balty, T. Hackens, F. De Ruyt, Katrien van Wonterghem-Maes.
Britain:	M.H. Ballance, Ann Birchall, B.F. Cook, R.M. Cook, P.E. Corbett, C.R. Ede, D.E.L. Haynes, R.A. Higgins, A.W. Johnston, R. Nicholls, John Prag, C.M. Robertson, B.B. Shefton, M. Vickers.
Canada:	J.W. Hayes.
Czechoslovakia:	Jan Bouzck.
Denmark:	Marie-Louise Buhl.
France:	Irène Aghion, Juliette de La Genière, P. Devambez, J. Jehasse, J.J. Jully, Lilly Kahil, A. Pasquier.
Germany:	F. Brommer, Andrea Büsing-Kolbe, A. Greifenhagen, Christiane Grunwald, R. Hampe, Margret Honroth, W. Hornbostel, N. Kunisch, H. Lohmann, D. Ohly, K. Parlasca, Elisabeth Rohde, K. Schauenburg, Erika Simon, J. Thimme, K. Virneisel.
Greece:	Barbara Philippaki, N. Yalouris.
Hungary:	J.G. Szilágyi.
Italy:	D. Adamesteanu, G. Andreassi, P.E. Arias, Mario Astarita, G. Bianco, M. Borda, Maria Reho Bumbalova, C. Carducci, V. Chini, Bruno and Gabriella D'Agostino, Gianna Dareggi, A. De Franciscis, E. De Juliis, Giovanna Delli Ponti, E. De Miro, G. Fallani, Anna Fazzari, G. Foti, E. Franciosi, S. Garofano Venosta, F. Giudice, E. Greco, G. Grimaldi, W. Johannowski, Elena Lattanzi, F.G. Lo Porto, V. Macinagrossa, G. Maetzke, P. Mingazzini, P. Moreno, V. Panebianco, Paola Pelagatti, Paola Porten Palange, A. Ragusa, L. Ricchioni, Giuliana Riccioni, F. Roncalli, Laura Ruaro Loseri, Bianca Maria Scarfì, Benita Sciarra, Gemma Sena Chiesa, Attilio Stazio, Sara Stazio Pulinas, A. Stenico, Fernanda Tinè Bertocchi, V. Tusa.
Japan:	A. Mizuta, T. Rokujo.
Netherlands:	J.M. Hemelrijk, J.H.C. Kern, J.W. Salomonson, Gisela Schneider-Herrmann, D. Yntema, Annie Zadoks-Jitta.
New Zealand:	Marion Steven.
Norway:	Axel Seeberg.

Poland:	Marie-Louise Bernhard.
Portugal:	Helena Rocha Pereira.
Spain:	A. Blanco Freijeiro, Ricardo Olmos, Luisa Vilaseca de Palleja.
Sweden:	A. Åström, C.G. Styrenius.
Switzerland:	E. Berger, H. Bloesch, H.A. Cahn, J. Chamay, Christiane Dunant, H. Jucker, J-M. Moret, K. Schefold, Margot Schmidt.
U.S.S.R.:	Lena Gatalina, Xenia Gorbunova, Nina Lossewa.
U.S.A.:	D.A. Amyx, J.K. Anderson, Louise Berge, D. von Bothmer, M. Del Chiaro, Hanita Dechter, R. Edwards, J. Frel, Betty Grossman, G.M.A. Hanfmann, Dorothy Kent Hill, Frances Follin Jones, Joan Mertens, Cornelius and Emily Vermeule, S. Weinberg.
Yugoslavia:	Valerija Damevski, Duje Rendič, Branka Vikič.

We are also deeply grateful to numerous collectors, for allowing us access to the vases in their collections and in many cases supplying us with photographs. Many of them desire to remain anonymous and we therefore have refrained from mentioning them individually and hope they will realise how deeply we appreciate their generosity and kindness.

Members of the staff of some of the larger auction-houses in Europe and America have also greatly assisted us by sending photographs or details of vases offered for sale under their auspices; we are particularly grateful in this regard to Miss Felicity Nicholson of Sotheby's and Lady Elizabeth Hastings of Christie's in London, Dick Keresey of Sotheby-Parke-Bernet in New York, to the Casa Geri in Milan, Münzen und Medaillen (= MuM) in Basel, and the Galerie Koller in Zurich. Many dealers have also been good enough to supply us regularly with details of vases that pass through their hands and we take this opportunity of expressing to them our most grateful thanks. It is not always easy to keep track of vases once they have left the market and the appearance of a vase in a *Sale Catalogue* is often its last fixed point of reference; we have therefore given these in some detail to assist in the identification of the vase should it reappear.

There are several scholars to whom we owe a great deal but who, to our profound regret, are no longer with us to receive our thanks. We should particularly like to place on record the extent of our debt to Sir John Beazley and to Noël Oakeshott, two great pioneers in the study of South Italian pottery; also to Mario Bernardini, Mario Napoli, H.R.W. Smith, Annie D. Ure and T.B.L. Webster.

The photographs from which the illustrations are taken are the work of many hands; appropriate acknowledgements are given in the List of Plates. We should like to take this opportunity of expressing our sincerest thanks to the museum authorities, gallery directors and private collectors who have supplied us with photographs and, in particular, to Dr. H. Sichtermann of the German Archaeological Institute in Rome who made available to us many photographs from its extensive archive, and also to all concerned for permission to reproduce them here. We are also extremely grateful to John Wade, of the Museum of Applied Arts and Sciences in Sydney, who, with the kind permission of the authorities concerned took photographs for us of numerous vases in the museums of South Italy. The map of Apulia (Fig. 1) and the details of drapery (Fig. 2) were drawn by Geoffrey Neil of the University of Sydney; the drafts of the text were typed by Mrs. Valda Lane and the type-setting was done by Noela Whitton in the Department of Archaeology at Sydney; to all three we are deeply indebted for the skill and care with which they have carried out their work.

We are deeply indebted to La Trobe University and the University of Sydney, which have supported our research financially and in several other ways. We would also like to express our appreciation for financial support toward the publication of our book to the Association for Classical Archaeology within the University of Sydney and the Australian Academy of the Humanities.

A.D. TRENDALL
La Trobe University

ALEXANDER CAMBITOGLOU
University of Sydney

CONTENTS

VOLUME I

EARLY AND MIDDLE APULIAN

PART 1 EARLY APULIAN

I. THE PIONEERS

II. THE DEVELOPMENT OF THE PLAIN STYLE

III. THE DEVELOPMENT OF THE ORNATE STYLE

PART 2 MIDDLE APULIAN

LIST OF PLATES

VOLUME I

Unless other acknowledgements are made, the photographs here reproduced of vases in the National Museums of Naples and Taranto come from the Gabinetto Fotografico of each museum by the courtesy of the Soprintendenti alle Antichità (Drs. A. De Franciscis and F.G. Lo Porto). Photographs of vases in the British Museum are published by courtesy of the Trustees, and of those in the Louvre and the Bibliothèque Nationale in Paris by courtesy of their Departments of Greek and Roman Antiquities. Some of the photos of vases in the Jatta Collection at Ruvo and in the Museo Domenico Ridola at Matera come from the Photographic Archive of the German Archaeological Institute in Rome and are referred to by their negative numbers preceded by the letters R.I. (= Rome Institute).

Sopr. Ant. = Soprintendenza alle Antichità
Mus. Arch. = Museo Archeologico

1 Attic Prototypes
 1–2 Bell-krater, Benevento 348 III (Kleophon Painter) Photos: Ian McPhee.
 3 Obverse of calyx-krater, Louvre G 480 (Cassel Painter)
 4 Obverse of volute-krater, Ruvo 1093 (Kadmos Painter) Photo: R.I. 64.1034.

2 Painter of the Berlin Dancing Girl
 1–2 Bell-krater, once Anagni (1/12) Photos: Arch. Inst., Zurich.
 3–4 Bell-krater, Taranto 61735 (1/1)
 5–6 Calyx-krater, Boston, Prof. J. Oddy (1/7) Photos: Wellesley College, Art Museum.

3 Painter of the Berlin Dancing Girl and associated vases
 1 Hydria, Oxford 1974.343 (1/14) Photo: Ashmolean Museum.
 2 Fragment, Paris, Cab. Méd. (1/16)
 3 Fragment, Taranto 12563 (1/17)
 4 Hydria, Taranto 134905 (1/18)

4 The Hearst Painter
 1 Fragments of bell-krater, Basel, Cahn coll. 276, 278 (1/25a) Photo: courtesy Dr. H.A. Cahn.
 2 Reverse of bell-krater, Lecce 574 (1/26) Photo: G. Guido, courtesy Mus. Prov.
 3 Obverse of calyx-krater, Agrigento R 178A (1/34) Photo: Sopr. Ant., Agrigento.

5 The Sisyphus Painter
 1 Detail of volute-krater, Ruvo 1096 (1/52) Photo: R.I. 64.1142.
 2 Details of volute-krater (frr.), Basel, private coll. (1/54) Photos: courtesy Dr. H.C. Ackermann.

6 The Sisyphus Painter
 1–2 Bell-krater, Matera 9978 (1/63) Photos: R.I. 66.1319-20.

LIST OF FIGURES

VOLUME I

The figures listed below appear on the pages following page 442

ABBREVIATIONS

The following abbreviations, based on the lists given in *AJA* 80, 1974, pp. 3–8, *LCS*, pp. xxi–xxv, and in Beazley, *ARV²*, pp. liii–lvi, are used for periodicals, serial publications, and books or articles to which frequent references are made.

 Cat. is used for the *Catalogues* of different museums, unless they have special titles; *Sale Cat*. is used with the name of the auction-house in front of it (e.g. Sotheby, Christie) and, where appropriate, that of the collection (e.g. Trau, Giudice) after it.

 GrV stands for Griechische Vasen or Greek Vases and is normally followed by the initial letter of the name of the collection referred to, which will be readily identified from the context.

1. PERIODICALS AND SERIAL PUBLICATIONS

AA	Archäologischer Anzeiger
Abhl	Abhandlungen (followed by name of academy, where appropriate)
ADelt	Archaiologikon Deltion
AdI	Annali dell'Istituto di Corrispondenza Archeologica
AJA	American Journal of Archaeology
AM	Mitteilungen des deutschen archäologischen Instituts, Athenische Abteilung
AnnBull N.G.V.	Annual Bulletin of the National Gallery of Victoria (1959–1967); thereafter Art Bulletin of Victoria (= *ArtBullVic*)
Annuario	Annuario della Scuola Archeologica di Atene
AntCl	L'Antiquité classique
AntK	Antike Kunst
AntSurv	Antiquity and Survival
AuA	Antike und Abendland
ArchCl	Archeologia Classica
ArchReps	Archaeological Reports
ArchStorPugl	Archivio Storico Pugliese
Atti....CStMG	Atti del.. Convegno di Studi sulla Magna Grecia
AttiMGrecia	Atti e Memorie della Società Magna Grecia
AttiPontAcc	Atti della Pontificia Accademia Romana di Archeologia
AZ	Archäologische Zeitung
BABesch	Bulletin van de Vereeniging tot Bevordering der Kennis van de antieke Beschaving te'S-Gravenhage
BCH	Bulletin de correspondance hellénique
BdA	Bollettino d'Arte
BICS	Bulletin of the Institute of Classical Studies, London
BJbb	Bonner Jahrbücher
BMMA	Bulletin of the Metropolitan Museum of Art, New York
BMNH	Bulletin du Musée National Hongrois des Beaux-Arts, Budapest
BMQ	British Museum Quarterly
BSA	Annual of the British School at Athens

BSR	Papers of the British School at Rome
BullNap	Bulletino archeologico Napoletano
BurlMag	Burlington Magazine
BWPr	Berliner Winckelsmannsprogramm
CRAI	Comptes-rendus de l'Académie des Inscriptions et belles Lettres
CRStP	Compte-rendu de la Commission impériale archéologique, St. Pétersbourg
CVA	Corpus Vasorum Antiquorum
DissPontAcc	Dissertazioni della Pontificia Accademia Romana di Archeologia
EAA	Enciclopedia dell'Arte Antica
EUA	Enciclopedia Universale dell'Arte
EWA	Encyclopedia of World Art
EncIt	Enciclopedia Italiana
EncPhot	Encyclopédie photographique de l'Art
FA	Fasti Archaeologici
FR	Furtwängler-Reichhold, *Griechische Vasenmalerei*
Getty MJ	The J. Paul Getty Museum Journal
HSCP	Harvard Studies in Classical Philology
ILN	Illustrated London News
ItAnt	Italia Antichissima
Jb...	Jahrbuch...
JdI	Jahrbuch des deutschen archäologischen Instituts
JbBerlMus	Jahrbuch der Berliner Museen
JHS	Journal of Hellenic Studies
MdI	Monumenti inediti pubblicati dall'Istituto di Corrispondenza Archeologica
MélRome	Mélanges d'archéologie et d'histoire de l'Ecole française de Rome
MemLinc	Memorie dell'Accademia nazionale dei Lincei
MemManch	Memoirs and Proceedings of the Manchester Literary and Philosophical Society
MemNap	Memorie dell'Accademia di Archeologia, Lettere e Belle Arti, Napoli
MetrSt	Metropolitan Museum Studies
MonAnt	Monumenti Antichi
MWPr	Marburger Winckelmannsprogramm
NSc	Notizie degli Scavi di Antichità
OMLeiden	Oudheidkundige Mededelingen uit het Rijksmuseum van Oudheiden te Leiden
RA	Revue Archéologique
RassStorSal	Rassegna Storica Salernitana
RE	Pauly-Wissowa, *Real-Encyclopädie der classischen Altertumswissenschaft*
RendLinc	Rendiconti dell'Accademia dei Lincei
RendNap	Rendiconti dell'Accademia di Archeologia, Lettere ed Arti, Napoli
RendPontAcc	Rendiconti della Pontificia Accademia Romana di Archeologia
RivIstArch	Rivista dell'Istituto di Archeologia e Storia d'Arte
RivStAnt	Rivista di Storia Antica
RM	Mitteilungen des deutschen archäologischen Instituts, Römische Abteilung
RMPh	Rheinisches Museum für Philologie
SB	Sitzungsberichte (followed by name of academy)
StEtr	Studi Etruschi
StSal	Studi Salentini

WS	Wiener Studien
WV	Wiener Vorlegeblätter
YCS	Yale Classical Studies

2. BOOKS

Ap. Grabvasen	M. Schmidt, A.D. Trendall, A. Cambitoglou, *Eine Gruppe Apulischer Grabvasen in Basel* (1976)
APS (Addenda)	A. Cambitoglou and A.D. Trendall, *Apulian Red-figure Vase-painters of the Plain Style* (1961) with *Addenda* in *AJA* 73, 1969 ff. 423–433.
Arias, *Storia*	P.E. Arias, *Storia della Ceramica di età arcaica, classica ed ellenistica* (*Enciclopedia Classica* III xi. 5; 1963).
Arias, Hirmer, Shefton	P.E. Arias and M. Hirmer, *A History of Greek Vase-painting* (English edition, tr. by B.B. Shefton; 1962)
ARV²	J.D. Beazley, *Attic Red-figure Vase-painters* (2nd ed., 1963)
Beazley Gifts	*Ashmolean Museum: Select Exhibition of Sir John and Lady Beazley's Gifts, 1912–1966* (Oxford, 1967)
Benndorf, *GSV*	O. Benndorf, *Griechische und Sicilische Vasenbilder* (1883)
Bieber, *Hist²*	M. Bieber, *History of the Greek and Roman Theater* (2nd ed., 1961)
Blavatsky	V.D. Blavatsky, *History of Ancient Painted Pottery* (1953; in Russian)
Bloesch, *AKS*	H. Bloesch, *Antike Kunst in der Schweiz* (1943)
Borda	M. Borda, *Ceramiche apule* (1966)
Brommer, *VL³*	F. Brommer, *Vasenlisten zur griechischen Heldensage* (3rd ed., 1973)
Catteruccia	L.M. Catteruccia, *Pitture vascolari italiote* (1951)
CB	Caskey and Beazley, *Attic Vase-Paintings in the Museum of Fine Arts, Boston* (1931–63)
Cl.Gr.Art	J. Charbonneaux, R. Martin, F. Villard, *Classical Greek Art* (1972)
Cook, *GPP²*	R.M. Cook, *Greek Painted Pottery* (2nd ed., 1972)
Dareggi	G. Dareggi, *Vasi apuli nella collezione Magnini a Deruta* (1976)
ÉlCér	Ch. Lenormant and J. de Witte, *Élite des monuments céramographiques* (Paris, 1837–61)
ESI	A.D. Trendall, *Early South Italian Vase-painting* (1974)
EVP	J.D. Beazley, *Etruscan Vase-painting* (1947)
FI	A.D. Trendall, *Frühitaliotische Vasen* (1938)
Gerhard, *AB*	E. Gerhard, *Antike Bildwerke* (1828)
Ghali-Kahil, *Hélène*	L. Ghali-Kahil, *Les Enlèvements et le Retour d'Hélène dans les textes et documents figurés* (1955)
Helbig-Speier	W. Helbig, *Führer durch die öffentlichen Sammlungen klassischer Altertümer in Rom* (4th ed., by H. Speier, 1963–72)
Hist.Hell.Eth.	*Historia tou Hellenikou Ethnous* (in progress). The English edition of vols. III and IV has not yet appeared.
Hoffmann, *TR*	H. Hoffmann, *Tarentine Rhyta* (1966)
Ill.Gr.Dr.	A.D. Trendall and T.B.L. Webster, *Illustrations of Greek Drama* (1971)
Inghirami, *VF*	F. Inghirami, *Pitture di vasi fittili* (1833–7)
Jacobsthal, *OGV*	P. Jacobsthal, *Ornamente griechischer Vasen* (1927)
Jucker, *Gestus*	Ines Jucker, *Der Gestus des aposkopein* (1956)
La Borde	A. de La Borde, *Collection des Vases grecs de M. le Comte de Lamberg* (1813–28)

LAF	L. Forti, *Letteratura e arte figurata nella Magna Grecia* (1966)
LCS (Suppl.)	A.D. Trendall, *The red-figured Vases of Lucania, Campania and Sicily* (Oxford, 1967), with Supplements I and II (*BICS*, Supplements nos. 26 and 31, 1970–73)
Millin	A.-L. Millin, *Peintures de vases antiques vulgairement appelés étrusques* (1808–10)
Millingen	J. Millingen, *Peintures antiques et inédites de vases grecs* (1813). (The above two works were republished in 1891 by S. Reinach as *Peintures de Vases antiques recueillies par Millin et Millingen*)
Moret, *Ilioupersis*	J.-M. Moret, *L'Ilioupersis dans la céramique italiote* (1975)
MusBorb	*Real Museo Borbonico* (15 vols., 1824–56)
NMH[2]	A.D. Trendall and J.R. Stewart, *Nicholson Museum Handbook* (2nd ed., 1948)
Neugebauer, *Führer*	K.A. Neugenbauer, *Führer durch das Antiquarium, Berlin: II. Vasen* (1932)
Overbeck, KM	J. Overbeck, *Atlas der griechischen Kunstmythologie* (1871–8)
Pagenstecher	R. Pagenstecher, *Unteritalische Grabdenkmäler* (1912)
Passeri	G.B. Passeri, *Picturae Etruscorum in Vasculis* (1767–75)
Patroni	G. Patroni, *La Ceramica antica nell'Italia meridionale* (1897)
Pfuhl, *MuZ*	E. Pfuhl, *Malerei und Zeichnung der Griechen* (1923)
Philippart, *Coll.Cér.It.*	H. Philippart, *Collections de Céramique grecque en Italie* (1932–3)
Pickard-Cambridge, *DFA*	A.W. Pickard-Cambridge, *The Dramatic Festivals of Athens* (1953)
Richter, *Furn*[2]	G.M.A. Richter, *The Furniture of the Greeks, Etruscans and Romans* (2nd ed., 1966)
Roscher, *ML*	W.H. Roscher, *Lexikon der griechischen und römischen Mythologie,* (1884–1937)
Rumpf, *MZ*	A. Rumpf, *Malerei und Zeichnung* (Handbuch der Altertumswissenschaft VI, 4.1; 1953)
RV	S. Reinach, *Répertoire des vases peints grecs et étrusques* (2nd ed., 1922–4)
Schaal	H. Schaal, *Griechische Vasen aus Frankfurter Sammlungen* (1923)
Schneider-Herrmann, *Paterae*	G. Schneider-Herrmann, *Apulian red-figured Paterae with flat or knobbed handles* (*BICS* Suppl. no. 34, 1977)
Séchan, *Études*	L. Séchan, *Études sur las tragédie grecque dan ses rapports avec la céramique* (1926)
Sichtermann	H. Sichtermann, *Griechische Vasen in Unteritalien aus der Sammlung Jatta in Ruvo* (1966)
Smith, *FS*	H.R.W. Smith, *Funerary Symbolism in Apulian Vase-painting* (1976)
Spinazzola, *Arti*	V.Spinazzola, *Le Arti decorative in Pompei* (1928)
Studiensammlung	G. Schneider-Herrmann, *Eine Niederländische Studiensammlung antiker Kunst* (1975)
Tillyard	E.M.W. Tillyard, *The Hope Vases* (1923)
Tischbein	W. Tischbein, *Collection of Engravings from Ancient Vases...now in the possession of Sir Wm. Hamilton* (1791-5)
Trendall, *PhV*[2]	A.D. Trendall, *Phlyax Vases* (2nd ed.) (*BICS* Supplement 19, 1967)
Trendall, *PP (Suppl.; Add.)*	A.D. Trendall, *Paestan Pottery* (1936), with a Revision and a *Supplement*

	and *Addenda* in *BSR* 20, 1952, pp. 1–53 and 27, 1959, pp. 1–37.
Trendall, *SIVP²*	A.D. Trendall, *South Italian Vase Painting* (British Museum, 2nd ed., 1976)
UKV	K. Schefold, *Untersuchungen zu den Kertscher Vasen* (1934)
VIE	A.D. Trendall, *Vasi antichi dipinti del Vaticano-Vasi italioti ed etruschi a figure rosse* (1953–5)
Van Hoorn, *Choes*	G. Van Hoorn, *Choes and Anthesteria* (1951)
VPol	J.D. Beazley, *Greek Vases in Poland* (1928)
Webster, *GTP*	T.B.L. Webster, *Greek Theatre Production* (1956)
Webster, *MTSP*	T.B.L. Webster, *Monuments illustrating Tragedy and Satyr-play* (1962, 2nd ed., 1967)

3. SPECIAL ARTICLES

The following special articles dealing with Apulian vases are referred to with some frequency in the text and it is therefore convenient to adopt an abbreviated form of reference to them:

Damevski *I, II, III*	V. Damevski, 'Crvenofiguralne vaze iz Apulskih radionica u Arheolškom Muzeju u Zagrebu', in *Vjesnik archeološkog Muzeja u Zagrebu, I:* 1971, pp. 75–96; *II:* 1972–3, pp. 239-252; *III:* 1974, pp. 83–118.
Lo Porto, *Penetrazione*	F.G. Lo Porto, 'Civiltà indigena e penetrazione greca nella Lucania orientale', in *MonAnt* 48, 1973, pp. 149–251
Mizuta *I, II*	A. Mizuta, 'Die griechischen Vasen in Japan, I–II', in *Balkan and Asia Minor Studies I–II* (Tokyo University, 1975–6)
Moon	Noël Moon, 'Some Early South Italian Vase-Painters', in *BSR* 11, 1929, pp. 30–49
PBD	A. Cambitoglou and A.D. Trendall, 'The Painter of the Birth of Dionysos', in *Mélanges Michalowski* (1967), pp. 675–699
Trendall, *Ceramica*	A.D. Trendall, 'La Ceramica', in *Taranto nella civiltà della Magna Grecia* (*Atti Xº CStMG*, 1970 pp. 249–265)

BIBLIOGRAPHY

The bibliography which follows is not intended to be exhaustive but to list the principal books and articles which deal with Apulian red-figure vase-painting in either general or specific terms or make substantial use of Apulian vases to illustrate different aspects of Greek culture, especially the theatre, mythology, religious cults and daily life. Those dealing with individual painters or single vases are normally given at the beginning of the relevant chapter or section within the chapter. Many other articles with incidental references to Apulian pottery will be found in the bibliographies given by A. Mau in his *Katalog des deutschen archäologischen Instituts in Rom* II, 1 (1932), pp. 697-721 and in Jean Bérard, *Bibliographie topographique de l'Italie méridionale* (Paris, 1941), with additions by T.J. Dunbabin in *BSR* 18, 1950, pp. 108–9; for other South Italian fabrics, see A.D. Trendall, *The Red-figured vases of Lucania, Campania and Sicily* (Oxford, 1967), with Supplements I and II (*BICS*, Supplements nos. 26 and 31, 1970 and 1973).

Specific Museum catalogues or guides are not here listed.

1. General

A. Furtwängler, *Meisterwerke der griechischen Plastik* (Leipzig-Berlin, 1893), pp. 149–52 (in the English translation by E. Sellers, *Masterpieces of Greek Sculpture,* pp. 108 ff.).

T. Ely, 'The Vases of Magna Graecia', in *Archaeologia* 58, 1896, pp. 113–24.

G. Patroni, 'La ceramica antica nell'Italia meridionale', in *Atti della R. Accademia di Archeologia, Lettere e Belle Arti,* Napoli, 1897 (= Patroni).

C. Watzinger, *De Vasculis Pictis Tarentinis* (Darmstadt, 1899).

H.B. Walters, *History of Ancient Pottery* (London, 1905), vol. i, pp. 467 ff.

M. Jatta, 'Vasi dipinti dell'Italia meridionale', in *MonAnt* 16, 1906, cols. 493–532.

V. Macchioro, 'Derivazioni attiche nella ceramografia italiota', in *MemLinc* 14, 1909, pp. 277–294.

V. Macchioro, 'Per la storia della ceramografia italiota', in *RM* 26, 1911, pp. 187–213; 27, 1912, pp. 21–36 and 163–188.

G. Patroni, 'Questioni vascolari', in *RendLinc* 21, 1912, pp. 549–606.

M.A. Micalella, 'Vasi italioti dei Messapi', in *Apulia* 3, 1912, pp. 3–16.

P. Ducati, *Storia della ceramica greca* (Florence, 1922) pp. 404–11 and 441 ff.

A. Della Seta, *Italia antica* (Bergamo, 1922), 140–53.

E.M.W. Tillyard, *The Hope Vases* (Cambridge, 1923), pp. 8–16.

P. Ducati, 'La ceramica della penisola italiana', in *Classification des céramiques antiques*, vol. ix, 1924.

Noël Moon (the late Mrs. Oakeshott), 'Some Early South Italian Vase-Painters', in *BSR* 11, 1929, pp. 30–49.

P. Wuilleumier, 'Questions de céramique italiote', in *RA* 1929, ii, pp. 185–210; see also his *Tarente* (1939), pp. 445–8 (here p. xliii).

M. Jatta, 'La collezione Jatta e l'ellenizzamento della Peucezia', in *Japigia* 3, 1932, pp. 241 ff.

H. Philippart, *Collections de céramique grecque en Italie* ii (Paris, 1933), pp. 13–16.

C.W. Lunsingh Scheurleer, *Grieksche ceramiek* (Rotterdam, 1936), pp. 123–31.

P. Wuilleumier, 'Vases inédits de Tarente', in *RA* 1936, ii, pp. 146-163.

A.D. Trendall, *Frühitaliotische Vasen* (Leipzig, 1938).

E. Langlotz, 'Die bildende Kunst Grossgriechenlands', in *Critica d'Arte* 7, 1942, pp. 89–106.

A.D. Trendall, *Nicholson Museum Handbook* (2nd ed., Sydney, 1948), pp. 315–36.

A.D. Trendall, *Vasi antichi dipinti del Vaticano-Vasi italioti ed etruschi a figure rosse i–ii* Città del Vaticano 1953 and 1955.

A.D. Trendall, 'South Italian red-figured pottery: a review and a reclassification', in *Atti del VII⁰ Congresso di Archeologia Classica* (Rome, 1961) ii, pp. 117–41.

A. Maiuri and others, 'The Greeks in Italy', in *Italy's Life*, vol. 26, 1961 (E.N.I.T. Official Review).

A.G. Woodhead, *The Greeks in the West* (Ancient Peoples and Places, vol. xxviii, London, 1962), pp. 146–9.

N. Degrassi, 'La documentazione archeologica in Puglia', in *Greci e Italici in Magna Crecia* (Naples, 1962), pp. 223–37.

E. Langlotz, 'Greek Art, Western', in *Encyclopedia of World Art* vii (1962) pp. 115–73, especially pp. 153–61.

E. Langlotz, 'Greco-Occidentali, centri e tradizioni', in *Enciclopedia Universale dell'Arte* vi, pp. 783–838, especially pp. 819–26.

L. Forti, 'De Ceramiek', in *Antiquity and Survival* iii. 2–3 (Magna Graecia), 1962, pp. 231–47.

P.E. Arias and M. Hirmer, *A History of Greek Vase-Painting* (English edition, London, 1963, tr. by B.B. Shefton, pp. 386 ff.

P.E. Arias, 'Storia della ceramica di età arcaica, classica ed ellenistica', *Enciclopedia Classica* III. xi. 5 (Turin, 1963), pp. 450–88.

A. Blanco Freijeiro, 'Vasos suritalicos de la Colleccion ducal de Alba' in *Zephyrus* 15, 1964, pp. 61–83.

H. Sichtermann, *Griechische Vasen in Unteritalien aus der Sammlung Jatta in Ruvo* (Tübingen, 1966).

L. Forti, *Letteratura e arte figurata nella Magna Grecia* (Fasano, 1966).

A.D. Trendall, *Phlyax Vases* (2nd ed., *BICS*, Suppl. no. 19, 1967).

O. Neeracher, *Kunst und Kultur der Westgriechen*, I. *Unteritalien* (Basel, 1971).

R.M. Cook, *Greek Painted Pottery* (2nd ed., London, 1972), pp. 190–201, with bibliography on pp. 351–2.

J. Charbonneaux, R. Martin, F. Villard, *Classical Greek Art*, (London, 1972), pp. 292 ff.

Historia tou Hellenikou Ethnous III. 2 (Athens, 1972), pp. 326–7.

M. Borda, *La ceramica italiota a figure rosse nei musei civici di Udine* (Udine, 1973).

Greek and Etruscan Arts (Exhibition Catalogue, Tokyo, 1973).

F.G. Lo Porto, 'Civiltà indigena e penetrazione greca nella Lucania orientale', in *MonAnt* 48, 1973, pp. 149–251.

A.D. Trendall, 'South Italian Vases', in G.M.A. Richter, *A Handbook of Greek Art* (7th ed., Phaidon, 1974), pp. 358–364.

B. D'Agostino, 'Pittura e Ceramografia del IV⁰ secolo a. C.', in *Popoli e Civiltà dell'Italia antica* II (Rome, 1974), pp. 243–263.

A.D. Trendall, *Notes on South Italian red-figure vase-painting* (Melbourne, 1975).

A. Mizuta, 'Die griechischen Vasen in Japan, I–II - Lukanisch und Apulisch', in *Bunmei,* special number, *Balkan and Asia Minor Studies* I (Tokyo University, 1975), pp. 48–65, II (1976), pp. 28–39.

Martin Robertson, *A History of Greek Art* (Cambridge, 1975), pp. 426 ff.

A.D. Trendall, *Vasi antichi dipinti del Vaticano-La Collezione Astarita: Parte III: Vasi italioti ed etruschi a figure rosse e di età ellenistica.* (Città del Vaticano 1976).

A.D. Trendall, *South Italian Vase Painting* (British Museum, 2nd ed., 1976).

2. Apulian red-figure

Articles dealing with specific vases or particular painters are listed at the head of the relevant chapter or section in the text.

A. Stenico, 'Àpuli, Vasi', in *EAA* i (1958), pp. 502–9 (with bibliography up to 1957).

B.M. Scarfi, 'Due pittori apuli della seconda metà del IVᵒ secolo a. C.' in *ArchCl* 11, 1959, pp. 179–188.

M. Schmidt, *Der Dareiosmaler und sein Umkreis* (Münster, 1960).

A. Cambitoglou and A.D. Trendall, *Apulian red-figure Vase-painters of the Plain Style* (Arch. Inst. of America, 1961), with *Addenda* in *AJA* 73, 1961, pp. 423–433.

G. Schneider-Herrmann, 'Zwei Studien zur Apulischen Vasenkunst', in *BABesch* 38, 1962, pp. 92-99.

E. Paribeni, *Immagini di vasi apuli* (Bari, 1964).

M. Borda, *Ceramiche apule* (Bergamo, 1966).

H. Hoffmann, *Tarentine Rhyta* (Mainz, 1966).

A. Oliver Jr., *The Reconstruction of two Apulian Tomb Groups* (*AntK,* Beiheft 5, 1968).

A.D. Trendall, 'Three Apulian Kraters in Berlin', in *JbBerMus* 12, 1970, pp. 153–190.

A.D. Trendall, 'La Ceramica', in *Taranto nella civiltà della Magna Grecia* (*Atti Xᵒ CStMG,* 1970), pp. 250–265.

P. Mingazzini, 'Su alcuni pittori vascolari tarentini', Excursus III in *Catalogo dei vasi della collezione Castellani II* (Rome, 1971), pp. 369–375.

F.P. Porten-Palange, 'Materiale archeologico conservato in collezioni private a Torino', in *Acme* 24, 1971, pp. 185–211.

V. Damevski, 'Crvenofiguralne vaze iz apulskih radionica u Arheološkom Muzeju u Zagrebu' (Red-figured Vases from Apulian workshops in the Archaeological Museum in Zagreb), in *Vjesnik Arheološkog Muzeja u Zagrebu,* 1971, pp. 75–96; 1972–3, pp. 239–251; 1974, pp. 83–118. The three articles are now published together (Zagreb, 1976).

K. Schauenburg, 'Unteritalische Alabastra', in *JdI* 87, 1972, pp. 258–298.

Selma Holo, 'Some unpublished Apulian rhyta', in *Getty MJ* 1, 1974, pp. 85–93.

G. Sena Chiesa, 'Un' oinochoe apula a figure rosse a Milano', in *Scritti in onore di Aldo Neppi Modona* (1975), pp. 421–439.

K. Schauenburg, 'Zu Apulischen Schüsseln', in *AA* 1976, pp. 72–78.

M. Schmidt, A.D. Trendall and A. Cambitoglou, *Eine Gruppe Apulischer Grabvasen in Basel* (Basel, 1976).

G. Schneider-Herrmann, *Apulian red-figured Paterae with flat or knobbed handles* (*BICS,* Suppl. no. 34, 1976).

Gianna Dareggi, *Vasi apuli nella collezione Magnini a Deruta* (*Quaderni dell'Istituto di Archeologia dell' Università di Perugia, no. 4;* Rome 1976).

3. Sites, Excavations, etc.

A full bibliography of the principal Greek sites in Apulia up to 1940 will be found in Jean Bérard, *Bibliographie Topographique* (Paris, 1941). Below are listed some of the more important books or articles published since then in which finds of r.f. vases are discussed or illustrated. Regular accounts of recent discoveries appear in *Archaeological Reports, American Journal of Archaeology, Fasti Archaeologici, Atti dei Convegni di Studi sulla Magna Grecia,* and from time to time in *Arch. Anzeiger* (1956, cols. 193–305; 1966, pp. 255–296).

(i) General
La ricerca archeologica nell'Italia meridionale (Naples, 1960).

H. von Hûlsen, *Funde in der Magna Grecia* (Berlin, 1962).

F. von Matt and U. Zanotti-Bianco, *La Magna Grecia* (Genoa, 1962).

M. Napoli, *Civiltà della Magna Grecia* (Rome, 1969).

M. Guido, *Southern Italy - an archaeological Guide* (London, 1972).

S. Moscati, *Italia Archeologica I* (Novara, 1973), pp. 22–77.

(ii) Taranto and area

P. Wuilleumier, *Tarente* (Paris, 1939; reprinted, 1968).

L. Bernabò Brea, 'Rinvenimenti nella necropoli, 1938–9', in *NSc* 1941, pp. 426–505.

B.M. Scarfî, 'Gioia del Colle', in *MonAnt* 45, 1960, cols. 145–322 and *NSc* 1962, pp. 1–288.

C. Belli, *Il tesoro di Taras* (Milano, 1970).

F. Argentina, *La città natia: Francavilla Fontana* (Fasano, 1970).

(iii) Bari and area

A.M. Chieco-Bianchi Martini, 'Scavi di Conversano', in *NSc* 1963, pp. 100–176.

Ida Baldassare, *Bari antica* (Bari, 1966).

L'antica Egnazia (Fasano, 1974).

(iv) Brindisi, Lecce and area

M. Bernardini, *I ritrovamenti archeologici di Lecce* (Lecce, 1941).

M. Bernardini, 'Gli Scavi di Rocavecchia dal 1928 al 1944', in *Atti del II° Congresso Storico Pugliese*, 1952, pp. 1–20.

M. Bernardini, *Panorama archeologico dell' estremo Salento* (Bari, 1955).

M. Bernardini, *La Rudiae Salentina* (Lecce, 1955)

M. Bernardini, 'Gli Scavi di Rocavecchia dal 1945 al 1954', in *StSal* 1, 1956, pp. 20–65.

M. Bernardini, *Lupiae* (Lecce, 1959).

B. Sciarra, *Brindisi e il suo Museo* (Florence, 1966).

(v) Canosa

M. Jatta, 'Tombe canosine del Museo Provinciale di Bari', in *RM* 29, 1914, pp. 90–126.

G. Andreassi, 'Note sull' ipogeo 'Varrese' di Canosa', in *ArchStorPugl* 25, 1972, pp. 233–259.

(vi) Ordona

J. Mertens et al., *Ordona*, vols. I–IV (Brussels, 1965–74).

(vii) Salapia - San Severo

F. and S. Tiné, 'Gli scavi 1967–8 a Salapia', in *ArchStorPugl* 26, 1973, pp. 131–158.

E. De Juliis, 'Scavi e scoperte - San Severo', in *StEtr* 42, 1974, pp. 526–7.

E. De Juliis, 'Salapia - nuovi ritrovamenti', in *NSc* 1974, pp. 485 ff.

4. Iconography

The books or articles listed below discuss some of the subjects most commony represented upon Apulian vases - which are used in them for purposes of illustration:

(i) Grave Monuments, the Underworld, religion, etc.

F. Vanacore, 'I vasi con heroön dell' Italia meridionale', in *MemNap* 24, 1905, pp. 175–196.

R. Pagenstecher, *Unteritalische Grabdenkmäler* (Strassburg, 1912).

P.L. Ciceri, 'Le figure rappresentate intorno alle tombe nella pittura vascolare italiota', in *RendLinc* 22, 1913, pp. 109–36. A further survey by the same writer, 'Il significato di alcune scene su vasi italioti', appears in *Apulia* 4, 1913, pp. 88–92.

V. Macchioro, 'Intorno al contenuto oltremondano della ceramografia italiana', in *Neapolis* 1, 1913, pp. 30–47.

G. Patroni, 'L'orfismo ed i vasi italioti', *RendLinc* 27, 1918, pp. 333–355.

C. Albizzati, 'Saggio di esegesi sperimentale sulle pitture funerarie dei vasi italo-greci', in *DissPontAcc* 14, 1920, pp. 149–220.

K. Schauenburg, 'Die Totengötter in der unteritalischen Vasenmalerei', in *JdI* 73, 1958, pp. 48–78.

R.R. Dyer, 'Evidence for Apolline purification rituals', in *JHS* 89, 1969, pp. 38–56.

H.R.W. Smith, 'Deadlocks?', in *BABesch* 45, 1970, pp. 68–85.

P. Mingazzini, 'Sulle figure nell'interno dei naiskoi sui vasi apuli', Excursus II in *Catalogo dei vasi della Collezione Castellani II* (Rome, 1971), pp. 364–368.

Eva Keuls, *The Water Carriers in Hades* (Amsterdam, 1974).

M. Schmidt, A.D. Trendall, A. Cambitoglou, *Eine Gruppe Apulischer Grabvasen in Basel* (Basel, 1976).

H.R.W. Smith, *Funerary Symbolism in Apulian Vase-painting* (Berkeley, Calif., 1976).

G. Schneider-Herrmann, 'Di alcuni simboli su vasi dell'Italia meridionale', in *Magna Grecia* 11, nos. 5–6, 1976, pp. 5–7.

(ii) Theatre, Drama, etc.

L. Séchan, *Études sur la tragédie grecque dans ses rapports avec la céramique* (Paris, 1926; reprinted 1967).

L.M. Catteruccia, *Pitture vascolari italiote di soggetto teatrale comico* (Rome, 1951).

F.G. Lo Porto, 'Nuovi vasi fliacici apuli del Museo Nazionale di Taranto', in *BdA* 49, 1964, pp. 14–20.

F.G. Lo Porto, 'Scene teatrali e soggetti caricaturali su nuovi vasi apuli di Taranto', in *BdA* 51, 1966, pp. 7–13.

P. Mingazzini, 'Pitture vascolari e frontespizi di drammi teatrali', in *RendPontAcc* 38, 1965–6, pp. 69–77.

M. Gigante, 'Teatro greco in Magna Grecia', in *Atti VI⁰ CArchCl, Taranto 1966*, pp. 83–146.

T.B.L. Webster, *Monuments Illustrating Tragedy and Satyr Play²* (*BICS*, Suppl. no. 20, 1967).

T.B.L. Webster, *Monuments Illustrating Old and Middle Comedy²* (*BICS*, Suppl. no. 23, 1969).

M. Gigante, *Rintone e il teatro in Magna Grecia* (Naples, 1971).

A.D. Trendall and T.B.L. Webster, *Illustrations of Greek Drama* (London, 1971).

Historia tou Hellenikou Ethnous III. 2, pp. 352–425 (1972).

S. Melchinger, *Das Theater der Tragödie* (Munich, 1974).

(iii) Mythology, divinities, etc.

Anna Rocco, 'Il mito di Troilo', in *ArchCl* 3, 1951, pp. 168–175.

Chr. Clairmont, *Das Parisurteil in der antiken Kunst* (Zurich, 1951).

Erika Simon, 'Die Typen der Medeadarstellungen', in *Gymnasium* 61, 1954, pp. 203–227.

Erika Simon, 'Ixion und die Schlangen', in *ÖJh* 42, 1955 pp. 5–26.

L. Ghali-Kahil, *Les enlèvements et le retour d'Hélène* (Paris, 1955).

E. Langlotz, 'Eine Apulische Amphora in Bonn', in *Anthemon (Festschrift Carlo Anti;* Florence, 1955), pp. 73–81.

K. Schauenburg, 'Bellerophon in der unteritalischen Vasenmalerei', in *JdI* 71, 1956, pp. 59–96.

K. Schauenburg, 'Neue Darstellungen aus der Bellerophonsage', in *AA* 1958, cols. 22–38.

K. Schauenburg, 'Marsyas', in *RM* 65, 1958, pp. 42–66.

K. Schauenburg, 'Phrixos', in *RMPh* 100, 1958, pp. 41–50.

K. Schauenburg, *Perseus* (Bonn, 1960).

K. Schauenburg, 'Der Gurtel der Hippolyte', in *Philologus* 104. 1960, pp. 1–13.

N. Alfieri, 'Un cratere apulo con mito di Penteo', in *Arte Antica e Moderna II*, 1960, pp. 236–247.

K. Schauenburg, 'Göttergeliebte', in *AuA* 10, 1961, pp. 77–101.

K. Schauenburg, 'Achilleus in der unteritalischen Vasenmalerei', in *BJbb* 161, 1961, pp. 216–235.

K. Schauenburg, 'Gestirnbilder in Athen und Unteritalien', in *AntK* 5, 1962, pp. 51–64.

K. Schauenburg, 'Pan in Unteritalian', in *RM* 69, 1962, pp. 27–42.

K. Schauenburg, 'Herakles unter Göttern', in *Gymnasium* 70, 1963, pp. 113–133.

G. Daltrop, *Die Kalydonische Jagd in der Antike* (Berlin, 1966).

Margot Schmidt, 'Herakliden', in *AntK*, Beiheft 4, 1967, pp. 174–185.

G. Schneider-Herrmann, 'Im Fluge mit zwei Eroten', in *BABesch* 43, 1968, pp. 59–69.

Kyle M. Phillips Jr., 'Perseus and Andromeda', in *AJA* 72, 1968, pp. 1–23.

M. Pensa, 'Problemi di iconografia della ceramica apula', in *Athenaeum* 46, 1968, pp. 236–253.

K. Schauenburg, 'Aktaion in der unteritalischen Vasenmalerei', in *JdI* 84, 1969, pp. 29–46.

K. Schauenburg, 'Ganymed in der unteritalischen Vasenmalerei', in *Opus Nobile (Festschrift Jantzen)* 1969, pp. 131–7.

G. Schneider-Herrmann, 'Spuren eines Eroskultes in der italischen Vasenmalerei', *BABesch* 45, 1970, pp. 86–117.

Margot Schmidt, 'Makaria', in *AntK* 13, 1970, pp. 71–73.

P. Mingazzini, 'Sul genio alato androgino dei vasi apuli', Excursus I in *Catalogo dei Vasi della Collezione Castellani II* (Rome, 1971) pp. 362–3.

G. Schneider-Herrmann, 'Kultstatue in Tempel auf italischen Vasenbildern', *BABesch* 47, 1972, pp. 31–42.

K. Schauenburg, 'Der besorgte Marsyas', in *RM* 79, 1972, pp. 317–322.

K. Schauenburg, 'Frauen im Fenster', in *RM* 79, 1972, pp. 1–15.

A.D. Trendall, 'The Mourning Niobe', in *RA* 1972, pp. 309–316.

Irmgard Raab, *Zu den Darstellungen des Parisurteils in der griechischen Kunst* (Frankfurt, 1972).

F. Brommer, *Vasenlisten zur griechischen Heldensage*[3] (Marburg, 1973).

K. Schauenburg, *'Frauen im Fenster*. Nachtrag', in *RM* 80, 1973, pp. 271–3.

K. Schauenburg, 'Seilenos ouron', in *RM* 81, 1974, pp. 313–6.

K. Schauenburg, 'Bendis in Unteritalien?', in *JdI* 89, 1974, pp. 137–186.

G. Schneider-Herrmann, 'Zur Grypomachie auf apulischen Vasenbildern', *BABesch* 50, 1975, pp. 271–2.

K. Schauenburg, 'Die Göttin mit dem Vogelszepter', in *RM* 82, 1975, pp. 207–216.

D. Kemp-Lindemann, *Darstellungen des Achilleus in griechischer und romischer Kunst* (Frankfurt, 1975).

J-M, Moret, *L'Ilioupersis dans la céramique italiote* (Swiss Institute, Rome, 1975).

A.D. Trendall and G. Schneider-Herrmann, 'Eros with a whipping-top on an Apulian pelike', in *BABesch* 50, 1975, pp. 267–70.

K. Schauenburg, 'Erotenspiele, 1 Teil', in *Antike Welt* 7.3, 1976, pp. 39–52.

K. Schauenburg, 'Erotenspiele, 2 Teil', in *Antike Welt* 7.4, 1976, pp. 28–35.

A.D. Trendall, 'Poseidon and Amymone on an Apulian pelike', in *Festschrift Brommer* (1977), pp. 281–7.

(iv) Various topics: Daily life, dress, music, ornament, etc.

G. Bendinelli, 'Antichi vasi pugliesi con scene nuziali', in *Ausonia* 9, 1919, pp. 185–210.

M. Láng, 'Beiträge zur altitalischen Tracht', in *ÖJh* 32, 1940, pp. 35–53.

K. Schauenburg, 'Zur Symbolik unteritalischen Rankenmotive', in *RM* 64, 1957, pp. 198–221.

G. Schneider-Herrmann, 'Der Ball bei der Westgriechen', in *BABesch* 46, 1971, pp. 123–133.

A.D. Trendall, *Gli Indigeni nella pittura italiota* (Taranto, 1971).

K. Schauenburg, 'Apulischer Krater mit Jagdszene', in *AA* 1973, pp. 221–231.

F.A.G. Beck, *Album of Greek Education* (Sydney, 1975).

G. Schneider-Herrmann, 'Das Xylophon in der Vasenmalerei Sud-Italiens', in *Festoen (Festschrift Zadoks-Jitta)* 1976, pp. 517–526.

GENERAL INTRODUCTION

The red-figured pottery of Magna Graecia has been divided into five main fabrics - Apulian, Lucanian, Campanian, Paestan and Sicilian - each corresponding broadly with the area of production and each with its own individual characteristics of style, shape and decoration. The four last fabrics have already been classified in some detail, and the present work attempts to do the same for Apulian, which in bulk is somewhat greater than all the others combined. This perhaps explains why so far scholars have been less attracted to the study of their style of drawing than to the subjects represented upon them, since these will often shed new and valuable light upon different aspects of Greek mythology and drama, as well as upon local customs, cults and beliefs. Earlier works by the present authors have provided a basis for the classification of Early Apulian, but for the sake of completeness this book includes the material already published in *APS* and *ESI*, which in many instances has been considerably expanded to include vases of recent discovery or previously inaccessible to us. Many refinements have also been made to the attributions given in those publications, since further study in greater detail has enabled better distinctions to be drawn between the work of master and pupil or between that of several painters active in the same workshop.

Volume I, broadly speaking, covers Early and Middle Apulian from the beginning of the fabric to the Lycurgus Painter and his school around the middle of the fourth century B.C.; volume II will cover later Apulian from the forerunners of the Darius Painter until the end of the fabric about 300 B.C. There is inevitably some measure of chronological overlapping between the two volumes, since it is manifestly impossible to draw an absolute date-line, and we felt it wise to deal in volume I with some of the immediate followers of painters here discussed even if, strictly speaking, their work belongs to Late Apulian. Similarly, we have left for volume II the study of a large number of vases decorated solely with female heads since, although some of these may be dated in the second quarter of the fourth century, the bulk of them belongs to the second half, and it seemed more convenient to deal with the series as a whole, rather than to split it into two sections.

The total of extant Apulian red-figured vases cannot fall far short of 10,000. We are not aiming at producing a complete corpus, especially of the host of small vases with trivial, single-figure decoration, but we have tried to include all the larger vases which can be attributed to specific painters or connected with them, and representative selections of the smaller vases, which should facilitate the classification of those not here listed. From the second quarter of the fourth century onwards the output of Apulian vases increases rapidly, and from c.350 assumes almost the proportions of mass production. One most striking feature of these vases is a technical uniformity; they show a consistency of style and treatment that makes it extremely difficult to separate them into regional groups. In this they make a notable contrast to the vases of Campania, which fall into three clearly differentiated groups (see *LCS* pp. 189 ff.), each with a well-defined style of its own, and indeed considerable variations not only in the appearance of the terra-cotta but also in the floral ornament and patternwork. No similar phenomenon has yet been observed with Apulian. There are a few pieces which look to be local imitations of the standard product (e.g. from Canosa, Ascoli Satriano and Melfi), but

on grounds of style, shape or decoration it is not possible to distinguish specific centres of manufacture at places like Ruvo, Arpi, Canosa, Ceglie del Campo, Altamura or Salapia, to name a few of the more important find-spots of Apulian red-figure, some of which, like Canosa, have often been thought of in that capacity. Several later Apulian vases of large dimensions by the Darius and Underworld Painters (e.g. Naples 3225, 3253–4; Munich 3296–7, 3300) have come from that site; so does the great series of vases from the Varrese hypogeum, now divided between the museums of Bari and Taranto (see G. Andreassi, *ArchStorPugl* 25, 1972, pp. 233 ff.; also M. Jatta, *RM* 29, 1914, pp. 90 ff. and H. Nachod, ibid, pp. 286 ff.), and a large number of minor pieces, mostly decorated with female heads in the style of the Kantharos Group, now in the local museum. It may, therefore, be that some of the later Apulian vases were in fact made there; if so, they were also widely exported, since many vases by the two painters referred to above, and particularly of the Kantharos Group, have come to light in other places.

We incline to believe that Taranto was probably the principal centre of production. It has been objected that very few vases of later date have in fact been found there, but there are in the museum several fragments of large volute-kraters by the Darius Painter and later artists, and, as the ancient necropolis is deeply buried beneath the modern city and barely capable of scientific excavation, we shall probably never be able to discover the full range of its contents. One point of interest which emerges from the material found in the larger tombs in different Apulian sites is the frequency with which such tombs contain a set of vases by a single painter or from the same workshop, a practice which may also be observed at Cumae (*LCS*, p. 447), Paestum (cf. *PPAdd*, pp. 29. ff., and the tomb in which were found the vases by the Aphrodite Painter), and Lipari (*LCS*, pp. 652 ff.), and suggests that such vases were either ordered in a set or bought all together at the same time from the potter's stock.

Whether potters travelled around or whether they had outlets for their wares in different centres must remain uncertain, but in view of the technical skill exhibited in much of later Apulian pottery and the likely cost of establishing local workshops capable of producing large vases in quantity, the idea of itinerant potters and painters seems to us, on the whole, to be improbable. The general stylistic consistency of their products, no matter where they happen to be found, implies at least that the principal workshops were in close contact and that each kept pace with any new developments another might make. This is perhaps one reason why the classification of much of Apulian is more difficult than that of say Lucanian or Campanian, where the output is comparatively restricted and a painter's individual characteristics more clearly defined. While the hand of an Apulian master-painter can usually be readily determined, the larger workshops must often have included a number of "well-drilled hacks" and it is not always easy to distinguish the work of one subordinate from that of another, especially when both are decorating vases with identical subjects treated in very much the same way. Strangely enough, it is sometimes the draped youths on the reverses of such vases which provide the key, since as Oliver has pointed out (*BMMA*, Summer 1962, p. 27), "when the painter decorates the back of a vase with a stock subject, a scene that he repeats on many vases with slight variations, he casts aside his studied, precise manner of drawing in favour of a loose, casual style where 'trademarks' appear", and in the details of the youths' himatia he often reveals himself more clearly than in the genre scenes on the front of the vase. This is also why small fragments of lower quality are frequently not easy to identify, since, unless they happen to show such a 'trademark', they can seldom be more than placed in a rather general context. We have tended to be slightly conservative in our attributions to

specific painters, preferring, in cases where we felt a certain measure of doubt, to list them as 'connected' or 'closely associated' with a painter, or to place them in a group of related vases. Further discoveries may well provide some of the connecting links at present missing and thus enable us to extend the *oeuvre* of a given painter; this is particularly so, when we have only early and late works from his hand, between which there is no obviously apparent connection, until a new find links them together (as with the Plouton and VPH Painters in Campanian, *LCS Suppl.* I, p. 45). On the very large vases it is always possible that there was collaboration between two or more painters, especially in the elaborate floral work on the necks of volute-kraters, which might well have been the work of specialists in that particular field. In Late Apulian there are many vases, especially from the Patera-Ganymede workshop, decorated with figured scenes on one side and with female heads on the other (or on the body and lid respectively); here also we may well have an instance of collaboration, since the very large numbers of vases decorated only with a female head by the same painter as the heads on the other vases, suggests that he may have concentrated on this form of decoration (e.g. the Patera and Amphorae Painters; the Ganymede and Armidale Painters; whose work will be discussed in volume II).

Apulian red-figured pottery was not widely exported and comparatively little of it is to be found far outside the confines of the province itself (see the map of the principal find-spots, Fig. 1) or the nearby Lucanian towns (e.g. Matera, Timmari, Montescaglioso). A certain amount has been found in the Lucanian hinterland (e.g. at Anzi, Armento, Roccanova) and in Calabria; much less in Campania (e.g. at S. Agata dei Goti, Montesarchio, Pontecagnano) and Sicily (e.g. at Gela Agrigento, Lipari). A few vases made their way up to Spina or over the Adriatic to Albania; others as far afield as Spain (e.g. Ampurias, Gerona, Valencia) and the south of France, and possibly even to Greece itself, since a r.f. epichysis recently found at Corinth (C.61–459) may be Apulian, although otherwise no S. Italian red figure has as yet a definite Greek provenience. However, the total number of Apulian vases found outside the province and its immediate confines would amount to only about one per cent of the extant production and that can hardly be regarded as a very significant figure. It would appear that geographical conditions, combined with political considerations, inhibited any extensive export trade outside the province itself. Here it may also be appropriate to note that between c.340 and 330 B.C. there was a definite migration of Apulian vase-painters to Campania and Paestum (see *LCS*, pp. 495 ff.) where they introduced certain Apulian patterns and elements (e.g. the naiskos and "xylophone"), not previously found in the western fabrics, as well as some characteristic Apulian stylistic features (cf. in particular, the *APZ* Painter at Cumae and the Aphrodite Painter at Paestum).

The shapes used by the pioneer vase-painters in Apulia are closely modelled upon those of contemporary Attic, especially of the school of Polygnotos and his followers. A glance at pls. 170–172 in G.M.A. Richter and L.F. Hall, *Red-Figured Athenian Vases in the Metr. Museum of Art* (New Haven, 1936) will reveal many good parallels for the different types of kraters and for hydriai; these may be readily extended, and the following examples will give a small selection of typical comparative material (references throughout are to *ARV²*, with the page numbers followed by the number of the vase concerned):

Bell-kraters – 1029, 20 (Polygnotos); 1048, 27 (Christie Painter); 1091, 51 (Painter of the Louvre Centauromachy)

Calyx-kraters – 1038, 1 (Peleus Painter); 1046, 1 (Christie Painter)

Column-kraters – 1073, 13 (Eupolis Painter); 1088, 4 (Painter of the Louvre Centauromachy); 1097, 18 (Naples Painter)

Volute-kraters – 1171, 1–2, (Polion); 1052, 25 (Polygnotan Group); 1143, 1 (Kleophon Painter)

Pelikai – 1048, 39 (Christie Painter); 1066, 5 (Barclay Painter); 1092–3, 79 and 87 (Painter of Louvre Centauromachy)

Hydriai – 1032, 58 and 65 (Polygnotos); 1033, 6 (Group of Brussels A 3096).

The above vases also provide prototypes for the meander-patterns and the decorative palmettes.

From the late fifth century B.C. Apulian red-figure follows two distinct stylistic trends, to which the designations "Plain" and "Ornate" have been given (see *APS*, p. 4, *ESI*, p. 14 and here pp. 28 ff.). In the earlier stages of the fabric the extant products of the "Plain" style workshops far exceed those of the "Ornate" (see Fig. 3); from the time of the Iliupersis Painter onwards (c.370–60 B.C.) there is a substantial increase in the production of the latter and in the second half of the century they dominate the scene, although in actual numbers they are naturally outrun by the smaller vases following the "Plain" tradition, which undergoes substantial modifications as a result of the rapid growth and obvious success of "Ornate". At first the bell-krater and the pelike are the most common shapes found in the "Plain" style; both retain their popularity throughout, but a substantial increase in the production of column-kraters, amphorae and hydriai will be noted from c.360 onwards. It is perhaps worth mentioning that the first two are not found in Campania, where the pelike is also extremely rare; nor is the volute-krater, though a couple of examples have been found at Paestum.

The table on the following page sets out the numbers of the more popular shapes from the principal "Plain" style workshops (i.e. Chapters 1, 3–6, 9–10, 12–14) down to about the middle of the fourth century B.C., without taking account of fragments from vases of indeterminate shape or of the minor vases.

The table is of some interest because it shows clearly that a few shapes (notably the column-krater and amphora of panathenaic shape - the standard type in Apulia; and, we may add, in "Ornate" the volute-krater) retained their popularity in this part of the Greek world long after they had lost it in Attica. In the vases of the Hoppin-Lecce workshop we note a big jump in the number of "other shapes"; this is largely due to the frequent appearance of the squat lekythos and chous among the minor works of the Truro Painter, and if we were to include the "opera minora" discussed in Chapter 11 there would be a still greater increase. In the same workshop we note the appearance of new shapes like the nestoris and the dish, which also figure prominently in the works of the Varrese Painter and his followers. The calyx-krater is never a popular shape in Apulian but it persists, in limited quantities, throughout; the column-krater is produced in increasing quantities from the time of the Karlsruhe B 9 and Dijon Painters onwards; the volute-krater comes into its own in Late Apulian, along with a much enlarged version of the amphora of panathenaic shape, virtually the only type of amphora to be found in Apulia (Lecce 571, no. 1/13 by the Painter of the Berlin Dancing Girl and Bonn 99, no. 13/3 by the Varrese Painter are exceptions; see also the Thyrsus Painter's vases from Paestum, nos. 19/168–171, 180). One of the most characteristic features of developed Apulian is the appearance of vases of truly monumental dimensions often a metre or more in height (e.g. the amphorae Ruvo 423 and 425, each 100 cm.; the volute-kraters Naples 3252–56, which are respectively 148, 130, 142, 142, 155 cm.). Such vases are modelled to cater for pictorial needs that are almost on the scale of wall-painting and often have an architectural quality which is emphasised by the use of dentils, Lesbian cymation and other decorative patterns taken directly from Greek buildings. About the middle of the fourth century an Apulian variant of the loutrophoros makes its appearance (e.g. Naples 3246, no. 13/22 by the Varrese Painter), sometimes without volutes (= barrel-amphora), but in either form it is pecul-

TABLE INDICATING USE OF VASE-SHAPES AMONG PAINTERS OF THE PLAIN STYLE

CHAPTERS	1 The Sisyphus Group	3 The Tarporley Group	4 Followers of the Tarporley Painter (A)	5 Followers of the Tarporley Painter (B) Hoppin—Lecce Workshop	6 Followers of the Tarporley Painter (C) Karlsruhe B 9 – Dijon Group	9 Followers of the Plain Style Tradition (A)	10 Followers of the Plain Style Tradition (B)	12 The Snub-Nose Painter and his close Associates	13 The Varrese Painter and his close Associates	14 Followers of the Snub-Nose and Varrese Painters
Bell-kraters	49	46	175	128	121	108	32	67	42	96
Calyx-kraters	12	4	4	13	2	3	2	1	3	4
Column-kraters	10	8	24	–	29	67	7	23	16	57
Volute-kraters	5	1	1	–	–	–	–	–	3	3
Amphorae	5	3	8	3	4	16	8	24	16	23
Pelikai	4	36	31	48	38	41	16	7	50	61
Hydriai	9	18	14	10	19	19	2	3	28	11
Skyphoi	4	1	4	27	3	1	–	–	–	–
Other shapes	4	4	9	64	10	19	8	9	36	10
TOTAL	102	121	270	293	226	274	75	134	194	265

NOTE: This table does not include the vases of the TARDOL Group in Chapter 3, nor those in the Group of the London Pelikai (Chapter 10), since we now regard them as Lucanian. The minor vases (Chapter 11), as well as those by the Thyrsus and Lampas Painters (Chapter 10, 5 –6) are also omitted.

iar to Apulia. Other essentially Apulian shapes which come into more general use in the second half of the fourth century are the dish, with flat or knobbed handles (cf. nos. 8/50–66 by the Iliupersis Painter; see also Schnewider-Herrmann, *Paterae*), later also to assume monumental dimensions (e.g. Lecce 855, with a diameter of 69 cm.; Naples 2541, 74 cm. and 2646, 75 cm.), the rhyton, the askos, the tall oenochoe (shape 1), and the kantharos (especially in the last third of the century). The only other shape that merits particular comment is the so-called nestoris (*trozzella*), which is an adaptation of a local Messapian shape; although it is represented on Early Apulian vases (e.g. B.M. F 174, no. 1/55 by the Sisyphus Painter), it does not itself appear until towards the middle of the fourth century (e.g. nos. 5/84 and 88 from the workshop of the Hoppin Painter), and is never in common use. Nestorides were probably made to cater for the tastes of the native Italian inhabitants of Apulia rather than of the Greek colonists; Apulian vase-painters, unlike their colleagues in Lucania, seem to have avoided decorating them as long as possible, and never use the uglier form (type 2) frequently found there; the column-krater may have served as a substitute, since representations of youths or warriors in Oscan costume are confined to vases of that shape until c.360 B.C.

The subjects represented upon Apulian vases cover a wide range and are often of considerable interest and importance. As might be expected, Dionysiac themes predominate, for Dionysos is god not only of wine, but also of drama — myth performed in his honour — and of the mysteries which promise their initiates a better life in the hereafter. Any aspect, therefore, of his triple godhead is an appropriate subject for a vase which might be used in his service at the symposium or be placed in the tomb as an offering to the dead. The late Professor H.R.W. Smith has dealt in great detail with various aspects of Dionysiac eschatology in his recent book *"Funerary Symbolism in Apulian Vase-painting"*; if, at times, he seems to press this interpretation rather far, none the less the all-pervading presence of the god himself, his symbols (thyrsus, grapes, etc.) or his followers (satyrs and maenads) suggests that his cult exercised a very strong influence. Scenes inspired by Greek drama are also reasonably frequent, especially by the plays of Euripides, which clearly enjoyed a considerable vogue in South Italy in the fourth century.

The local type of farce known as the phlyax play is often depicted, sometimes with the actual stage upon which it was performed — it looks to be a simple, impromptu type of structure which could be readily erected out of doors as required (cf. no. 15/28) and is supported on posts or columns, sometimes with a piece of drapery hanging between them (e.g. nos. 4/33, 45–46, 244–5, 250). On the earliest Apulian phlyax vase (no. 3/7 by the Tarporley Painter) there are metrical inscriptions, perhaps actual lines from the play itself, and since these are in Attic and not, as might be expected in Tarentum, in Doric, the vase may represent an Attic comedy rather than a local farce. The phlyax vases cease in Apulia soon after the middle of the century, although scenes inspired by tragedy persist until red-figure vase-painting comes to an end.

One of the more interesting aspects of Apulian vases is the way in which they represent rare myths, some of which are not illustrated elsewhere (e.g. Callisto on nos. 7/10 and 12, the return of Alcestis on no. 16/68, or her farewell to her children on the Basel loutrophoros, *Ap. Grabvasen*, pl. 21) and others still not satisfactorily explained (e.g. no. 2/1). Such vases are of great value for the light they may shed upon Greek mythology or the help they may afford in reconstructing a lost Greek drama.

As most of the surviving Apulian vases come from tombs, it is not surprising that a large number of them depict various forms of funerary monument. Most common are *naiskoi* and

stelai, for each of which several hundred are represented, providing good evidence for the reconstruction of the actual monuments, which have not come down to us intact. The *naiskos* vases, often found in large chamber-tombs, must have been meant as a sort of substitute for the real thing, since the figures within the *naiskos* are usually in added white to simulate the effect of the marble or stuccoed limestone of the original. A few vases (e.g. nos. 2/3, 8/10 and 12) show a statue of the deceased, usually on a plinth, and sometimes in a floral setting. Other vases give us representations of the Underworld (e.g. nos. 16/79—80), with the palace of Pluto and Persephone in the centre, surrounded by well-known denizens of Hades (Sisyphus, Tantalos, Cerberus, etc.), and often with Orpheus, perhaps in quest of Eurydice, but also in the company of initiates, whom he is bringing to the world below. Orphism seems to have had a considerable vogue in Tarentum during the fourth century, perhaps under the influence of Archytas, and various episodes in the history of Orpheus (playing music to Thracian warriors; his death at the hands of the Thracian women; his descent to the Underworld) are figured upon many Apulian vases, just as his head, with a Phrygian cap upon it, often appears as a subsidiary decoration on the necks of volute-kraters.

Scenes from daily life also occupy a prominent place, though one cannot always be certain that they do not also have some cult or religious significance. Athletics in various forms - palaestra scenes, crowning of victors, races on foot with torches or on horseback or in chariots - may be studied on many vases; also scenes of battle, e.g. Greeks against Oscans (as distinct from their mythological prototypes with Amazons, or Trojans). The more tranquil aspect of human life, especially as it concerns women, will be seen on those vases which show them busy with their daily tasks - spinning wool, playing with, or even punishing, the children, getting ready for the toilet, preparing for a wedding ceremony - or indulging in pastimes, listening to music, practising the dance, bouncing a ball. In all, Apulian red-figured vases give a good panorama of colonial Greek life in the fourth century, with an occasional youth or warrior in Oscan costume to remind us that the Greeks were not the only inhabitants of the land.

Eros also plays a large part - the force of love was no less potent then than now. With the progress of time he tends to become more effeminate in appearance and on some of the later vases looks androgynous, since his body becomes more like that of a young woman. He frequently appears in attendance upon Aphrodite, often in company with other Erotes, who in that context normally have the aspect of small children.

Passing reference may perhaps be made to the female heads which appear on so many later Apulian vases. At first such heads are used largely as a subsidiary motif on the necks of volute-kraters (e.g. on no. 8/11 by the Iliupersis Painter), then as the sole decoration on minor vases like skyphoi, pelikai, plates, lekanis lids, etc., and, in the last third of the century, on a much larger scale on the reverses of volute-kraters and on amphorae and loutrophoroi. However, they still continue to appear in their original decorative position, in a floral setting which becomes progressively more elaborate. Exactly how to interpret them is still an open question; one on the neck of B.M. F 277 (no. 8/5) is inscribed Aura, some probably represent Aphrodite or Hera Eileithyia, or may be associated with *anodos* scenes, as on Attic vases (cf. Bérard, *Anodoi*, pls. 6—7, figs. 23—29), others, bracketed between wings, should stand for Nike; the majority of those on the smaller vases may well have no particular mythological or religious significance. Male heads in this context are rare, and most commonly depict Orpheus (or Attis ?), Pan or a satyr.

The frequency with which elaborate mythological scenes appear on Apulian vases gives rise to a more extensive use of descriptive inscriptions than is found on fourth century Attic vases.

Several vases (e.g. nos. 8/6, 16/54—55, 80; Boston 03.804; Naples 3253, 3255) are very fully inscribed; others name only the principal characters (e.g. nos. 1/12, 2/6, 8/3, 8/149, 16/6). Such inscriptions are generally incised, although on some vases they are painted in added white, which has often largely worn off in the course of time and can be very difficult to decipher. Signatures on Attic vases had almost died out by the end of the fifth century - Aristophanes, Mikion, Phintias and Xenophantos are among the last, although a few persist on the b.f. panathenaics of the fourth century, e.g. Kittos c.370 B.C. - and there are as yet no authentic ones from Apulia, that of Lasimos on Louvre K 66 being regarded as a modern addition; the same applies to ΚΑΛΟΣ inscriptions; those on Bonn 1758 (no. 5/99) and Berlin F 3289 (no. 6/161) are not ancient. Several vases have pillars upon them, bearing inscriptions in black glaze: sometimes they are clearly associated with sport, like ΝΙΚΑ on nos. 4/83—84, or ΤΕΡΜΩΝ on nos. 6/215 and 217, at others with a god or hero, like Aphrodite on no. 6/216 or Herakles on no. 4/85. A couple of vases have inscriptions on small tablets on the reverse - ΔΙΩΝΙ on Sèvres 9 (no. 14/192) or ΧΑΙΡΕ on Lecce 635 (no. 14/160). The use of an inscription to give a title, as it were, to the scene on a vase as a whole is extremely rare - ΠΕΡΣΑΙ on the Darius Painter's name vase in Naples (3253) is the best example, perhaps the ΠΑΤΡΟΚΛΟΥ ΤΑΦΟΣ and ΚΡΕΟΥΣΑ on two of his other vases (Naples 3254 and a loutrophoros in Taranto from Altamura) may be intended for a similar purpose.

For the chronology of Apulian red-figure we are largely dependent upon internal and stylistic evidence, and the lack of proper reports on the early excavations is a serious loss, since many of the finds have been dispersed and it is no longer possible to reconstruct the original tomb-groups (cf. Oliver, *The Reconstruction Of Two Apulian Tomb Groups, AntK* Beiheft 5, 1968). The discovery of Attic vases at several sites (e.g. Taranto, Gravina, Rutigliano) along with those by the pioneers of Apulian red-figure has provided evidence, on comparative stylistic grounds with some allowance for a short time-lag, for the dating of the latter within the last quarter of the fifth century. The knowledge that certain Attic vases like the Pronomos krater from Ruvo, now in Naples, or the Marsyas krater by the Kadmos Painter in Ruvo (1093; *ARV²* 1184, 1) or the Talos krater had been exported to Apulia, where they had probably been seen by the local vase-painters, is also significant, since the Pronomos krater seems to have had a measure of influence on the Tarporley Painter (cf. no. 3/15), and the Kadmos Painter's volute-krater (Pl. 1, 4) on the Painter of the Birth of Dionysos (cf. with no. 2/6); we might therefore expect these two painters to be slightly later in date than their Attic models, i.e. at the very beginning of the fourth century B.C. With the use of similar stylistic criteria and of parallels with vases in other South Italian fabrics for which there is a better established chronology (e.g. Sicilian), it is possible to work out a succession of dates for the various Apulian schools; possible confirmation for such a scheme may be had in a bell-krater, now in Liverpool, which figures on the reverse the helmeted head of a Greek warrior with the graffito ΑΡΧ, almost certainly an allusion to Archidamos of Sparta, who was invited over by the Tarentines to help them in a war against the Lucanians and was killed in 338 B.C. in a battle at Manduria (see Richter, *Portraits of the Greeks : Supplement*, p. 6, fig. 889a), since on the evidence of style the vase had been dated from the figure of a running woman on its obverse to c.340 B.C. There seems little doubt that red-figured pottery comes to an end in Apulia, save for a few possible local stragglers, by c.300 B.C.; the Gnathia style continues for some time thereafter, but probably not for very long after the Roman conquest in 273.

In conclusion, we may point out that we have found the detailed study of vase-painting in Apulia to be highly rewarding. Some Apulian vases attain a remarkable level of both technical and artistic competence (e.g. nos. 1/51; 2/6 and 10; the Alcestis loutrophoros in Basel:

Ap. Grabvasen pls. 19–22 and colour pl. p. 78), which will easily bear comparison with contemporary Attic, and in a few particular cases (e.g. nos. 1/8; 7/8–9; B.M. F 272: Trendall, *SIVP2*, pl. A; Basel BS 468) are outstanding for the sensitivity of their drawing. Even when mass-production has caused some deterioration in the quality of the design, the interest of the subject-matter is maintained and right to the end Apulian vases are an unfailing source of information on Greek drama, religion, mythology and the cult of the dead. They also enable us, at least to a limited extent, to fill in some of the gaps left by the virtually complete disappearance of local literature and of the actual grave monuments. Finally, we hope that the classification of an uninterrupted sequence of vases covering some five generations will be of service to students in the fields of history, archaeology and art. A table, setting out the stylistic and chronological relations between the principal painters (or workshops) of Early and Middle Apulian, is given in Figure 3 at the end of the volume.

* * * * *

In the lists which follow, vases illustrated on the Plates are designated by an asterisk (*) before their serial number; a Plate reference preceded by (b) indicates that only the *reverse* of that particular vase is illustrated, otherwise the reference is either to the main design or, where applicable, to both sides.

For the designation of the various shapes under which the vases are listed the reader is referred to Beazley, *ARV*2, pp. xlix–li and to Fig. 2 in Trendall, *SIVP*.

The bibliography given for each vase in not intended to be exhaustive, but to list the more significant publications and the best illustrations. When vases are already published in *CVA*, *APS* or *ESI*, the bibliography continues from that point.

References to museums and collections follow the practice adopted in *LCS*. When a museum uses more than one system of numbering (e.g. the numbers in a specific vase-catalogue, in conjunction with those of a general inventory, as in Madrid, Naples, Leningrad, the Vatican, etc.) reference is made to both, in order to assist in the identification of the relevant vases. The numbers in more common use (in most cases of the inventory, with the exception of the British Museum, Naples and the Vatican) are given first, followed by the others in brackets. For the vases formerly in the Fienga Collection at Nocera and at present housed in the Soprintendenza at Salerno, the first number is that of the catalogue by Karl Lehmann, the second that of the inventory prepared by Dr. A. De Franciscis.

* * * * *

While the printing of this book was in progress a number of new vases, some of considerable interest and importance, have come to light, especially from the recently excavated necropolis at Rutigliano. Where possible, such vases have been inserted in the lists with *a* numbers, but those attributed to painters discussed in the first eight chapters, especially the Painter of the Berlin Dancing Girl, are discussed in the Addenda at the end of this volume.

PART ONE

EARLY APULIAN

I THE PIONEERS

CHAPTER 1

THE SISYPHUS GROUP

1. The Painter of the Berlin Dancing Girl
2. The Hearst Painter
3. The Sisyphus Painter
4. The Parasol Painter
5. The Ariadne Painter

Bibliography

Noël Moon, 'Some Early South Italian Vase-painters', in *BSR* 11, 1929, pp. 30–49 (= Moon).

M. Jatta, 'La collezione Jatta e l'ellenizzamento della Peucezia', in *Japigia* 3, 1932, pp. 241 ff.

A.D. Trendall, *VIE* I, pp. 1–8; *FI*, pp. 20–25 and *ESI*, pp. 14–18.

A. Cambitoglou and A.D. Trendall, *APS*, pp. 3–18.

M. Borda, *Ceramiche apule*, pp. 29–38.

Introduction

There is little need to go in any great detail into the beginnings of the Apulian red-figured style since its early course has already been well charted, and recent discoveries, while extending the lists of attributed vases, have added but little to our knowledge of the pioneers, as the circle of painters around the Sisyphus Painter may well be called.

Furtwängler (*Meisterwerke*, p. 150 = *Masterpieces*, p. 108) plausibly connected the earliest South Italian red-figured vases with the founding of Thurii in 443 B.C. The first of the local products - the work of the Pisticci Painter, who draws very closely upon Attic models of c.450 and just after - are more properly regarded as the forerunners of Lucanian, but it now seems clear that this fabric and Early Apulian ran along parallel lines during the first stages of their development, with a substantial measure of cross-relationship between them. Early in the fourth century (c.380 B.C.) the vase-painters of the former school, who are known to have had a workshop at that time in Metaponto (*ESI*, p. 23) and whose vases are commonly found in that area (e.g. at Policoro = the ancient Herakleia, Pisticci, Ginosa), seem to have moved away into the Lucanian hinterland, perhaps as a result of increasing competition from the rather superior products of the other school. Thenceforth the distinction between the two fabrics becomes much more clearly defined, and it is significant that Lucanian vases cease almost completely to be found in Apulian sites. The name "Early South Italian" is often used to refer to the combined products of the two schools during the fifth century B.C.

Where the second, or Apulian, school actually began is still an open question, and the discovery of a single fragmentary vase by the Hearst Painter (no. 29 below) during the recent excavations at Sybaris does little to resolve it. There cannot be much doubt that at a very early stage the main centre of production was located at Taranto, the largest city in Apulia, with convenient access to extensive beds of clay, which are still in use. It would be an obvious place in which to develop a potttery industry, especially as it must have had wide trade connexions with neighbouring Greek towns and native settlements, the inhabitants of which could have bartered local produce (wool, grain, wine, etc.) for Tarentine luxury goods, among which pottery would find a place. It is unfortunate that very few of the earliest Apulian vases have an established provenience, but it is clear that while many of them were found in the

nearby area (e.g. Ruvo, Ceglie, Ugento, Rugge, etc.), still more come from Taranto itself (e.g. nos. 6, 17, 25, 33, 37, 38), very often in fragmentary form, since conditions of excavation in that city are not conducive to the recovery of complete vases, nor is it likely that the ancient necropolis can ever be fully opened up.

From the analogies with Attic vases, some details of which are given in the introductory sections below, it is probable that the first Apulian vases should be dated early in the last third of the fifth century B.C. (c.430—420). Close parallels in shape, pattern-work, figure-drawing and the rendering of drapery will be found on vases of the Polygnotan school (e.g. by the Peleus, Lykaon and Christie Painters), and by the Painter of the Louvre Centauromachy and, a little later, by the Kleophon and Dinos Painters. The painters who form the Sisyphus Group must have worked in very close co-operation, presumably in the same workshop, since their vases are linked together by many common elements in both the drawing and the decorative patterns, as well as in the subjects represented upon them. Their earliest work is still faithful to Attic models, but a measure of individuality quickly develops and, in the absence of a long-existing tradition, such as obtained in Athens, personal mannerisms tend to play a more significant part and are copied with minor variations by one painter from another, and from one generation to the next.

In the work of the Sisyphus Painter we may note the beginnings of what are to be the two principal styles of vase-decoration in Apulia, at least down to the middle of the fourth century B.C. He paints a large number of what may be called ordinary vases of standard size and shape (e.g. bell-kraters, pelikai, hydriai) decorated with straightforward two- or three-figure compositions based on themes associated with Dionysos or with everyday life, and a few larger volute-kraters decorated with more elaborate mythological scenes (nos. 51—53), disposed at different levels over the surface of the vase. From the former there develops the so-called "Plain" style of Apulian, from the latter the "Ornate"; in the first half of the fourth century there is a far greater output of "Plain" style vases than "Ornate", as the Table in Figure 3 indicates, but in the second half the position is reversed and the "Ornate" style dominates.

We should also not overlook the fact that several of the monumental Attic vases of the later fifth century were found in Apulia: e.g. at Ruvo — Ruvo 1093, by the Kadmos Painter (Pl. 1, 4); Naples 3240, by the Pronomos Painter; Naples 2883, near to the latter; Ruvo 1501, by the Talos Painter; Ruvo 1498, by the Meleager Painter, and at Taranto — frr. in Taranto (ARV^2 1337, 4) and in Würzburg (4781; ARV^2 1338), near or akin to the Pronomos Painter. Such vases may well have served as models for the local vase-painters and clearly exercised a profound influence on the development of the early "Ornate" style.

1. THE PAINTER OF THE BERLIN DANCING GIRL

The Painter of the Berlin Dancing Girl, who was first identified by the late Mrs. Oakeshott (née Noël Moon) and named by her after his calyx-krater in Berlin (no. 8), is the earliest of the Apulian red-figure vase-painters and, as might be expected, his work reflects very clearly Attic influences, especially those of painters of the Polygnotan Group and their contemporaries who must have been active in the thirties of the fifth century. These influences may be seen in his choice of shapes and subject-matter, in certain elements of his drawing and in his use of inscriptions. Of particular interest for their shapes are the neck-amphora in Lecce (no. 13) and the Leningrad bell-krater (no. 5) with lugs instead of the usual handles. The neck-amphora is an exceptionally rare shape in Apulian and is found either at this early stage or, considerably later,

among the Paestanising vases associated with the Thyrsus Painter (e.g. nos. 10/168–171), although it is common in Campania and at Paestum. The Lecce vase recalls neck-amphorae of the Polygnotan Group (e.g. ARV^2 1058, 111 ff.) and is particularly close in regard to both shape and subject-matter to New York 06.1021.116 by the Lykaon Painter (ARV^2 1044, 1). The use of lugs on bell-kraters is rare in Early South Italian, though a few examples will be found among the works of the Pisticci Painter (e.g. LCS, pp. 14 ff., nos. 1, 15 and 33). Lugs appear however more frequently in Attic, again on bell-kraters of the Polygnotan Group (e.g. ARV^2 1029, 28 by Polygnotos; 1045, 6 by the Lykaon Painter; 1055, 72–75) and their contemporaries (e.g. ARV^2 1083, 6 by the Cassel Painter), on whose vases Amazonomachies are often represented (e.g. ARV^2 1051, 10–14; 1053, 50–51; 1058, 115–6; 1059, 132; 1084, 15 and 1085, 20 by the Cassel Painter), sometimes with striking similarity to those by the Painter of the Berlin Dancing Girl.

Another interesting comparison for shape and subject may be made between his name vase (no. 8) and the calyx-krater Louvre G 480 by the Cassel Painter (Pl. 1, 3; ARV^2 1084, 12 = CVA 5, III Id, pl. 31, 7–8), the Pyrrhic dancer on which also finds a parallel on Taranto 61735 (no. 1). The youth to right on the reverse of Naples 2861 (no. 4) adopts a pose, common on Attic vases, with one shoulder bare, leaning upon a stick held in his left hand and with his right hand resting on his hip. There are numerous examples of this pose on Attic vases of the second half of the fifth century, especially among the Polygnotans (e.g. Louvre G 491, ARV^2 1029, 26 by Polygnotos; Louvre G 421 ARV^2 1037, 1 near the Hector and Peleus Painters; Vienna 3733, ARV^2 1067, 1 = CVA 3, pl. 114, 2, by the Barclay Painter; Vienna 786, ARV^2 1083, 4 = CVA 3, pl. 116, 4, by the Cassel Painter; Benevento 348 III by the Kleophon Painter = Pl. 1, 2). It is also found on a vase by the Hearst Painter (Lecce 574, no. 26 below = Pl. 4, 2) which is very close to the Benevento krater, but thereafter dies out almost immediately, as indeed it does also in Athens, where it is seldom found after the time of the Dinos Painter.

We may also note on the reverses of some of the kraters by the Painter of the Berlin Dancing Girl the presence of a column, usually Doric, on either side of which stands a draped figure (e.g. nos. 7–9, 13), a device also adopted by the Hearst and Sisyphus Painters (e.g. nos. 27, 33, 65–66 below) and later by the Lecce Painter. Similar columns will be found on a few Attic vases of the Polygnotan period, and a close parallel may be seen on the reverse of Naples 2297 by the Nikias Painter (ARV^2 1333, 4 = BdA 45, 1960, p. 209, fig. 7), who flourished towards the end of the fifth century B.C. Reference may also be made to our painter's use of inscriptions to identify the characters upon some of his vases (e.g. nos. 10, 12, 13, 15, 16). Such inscriptions, which are very rare in Early South Italian, must look back to Attic prototypes; later they are to become more common but mostly on the larger and more elaborate works with mythological or theatrical representations. ΚΑΛΟΣ inscriptions are not found in Apulian, but by the last quarter of the fifth century they had become exceedingly rare in Attic, though a couple occur in Early Lucanian (LCS, p. 9).

The Attic parallels mentioned above or in the Introduction suggest that the Painter of the Berlin Dancing Girl probably began his career in the thirties of the fifth century B.C. As his output is comparatively limited, his main activity may be placed in the last decade but one of the century.

As particularly characteristic of his work we may note:

(i) the solemn appearance of his figures, which sometimes have an almost statuesque look (see the reverses of nos. 9, 12, 13, and no. 14);

(ii) the frequent presence of a bearded man wearing a himation draped over one shoulder and across the

waist in a series of parallel fold-lines (e.g. nos. 3, 4, 8, 9, 11, 12, 13, 15);

(iii) the youth draped similarly to the bearded man (e.g. nos. 1, 3, 7);

(iv) the drawing of the eyes, the pupil of which is regularly shown as a round black dot; the indication of the eyelashes on the upper lid only (e.g. nos. 15–17), and the careful rendering of the ear (e.g. nos. 3, 9, 13, 15, 16, 17);

(v) the comparative angularity of the facial features, in contrast to those of the Sisyphus Painter [e.g. nos. 1, 3, 4, 5, 7, 11; the Melbourne pelike (no.15) is an exception and perhaps reflects the influence of the Hearst and Sisyphus Painters];

(vi) the treatment of the fold-lines on the women's drapery, which tend to fall in very straight, vertical lines (e.g. nos. 4, 10, 13, 14);

(vii) the very individual meander pattern with thick lines, accompanied by uncrossed squares with a large black dot rather carelessly placed near the middle of each side [as a variant upon this the artist sometimes uses a chequered square (e.g. nos. 10, 12), probably of Attic inspiration; the pattern below the picture on the Oxford hydria (no. 14) is unique];

(viii) the laurel leaves which always have a black line down the centre (e.g. nos. 3–9, 12–14), as often upon Attic kraters of the Polygnotan group.

It is instructive to trace the progress in the painter's rendering of the human figure and of drapery from the rather tentative approach of his earliest vases (e.g. nos. 1–3 and 7), through the neat, if somewhat angular, precision of the succeeding phase (nos. 4–6, 8, 10–11), to the fuller and more rounded features, and the rather more massive style, of his later work (nos. 12–17), on which we may perhaps see the influence of the Sisyphus Painter.

(i) EARLY WORK (see also p. 433)

Bell-kraters

* 1 Taranto 61735, from Ceglie del Campo. PLATE 2, 3–4.
 APS, p. 6, no. 1; *ESI*, p. 46, no. B1.
 (a) Youth dancing in armour (Pyrrhic), while youth plays the flute, (b) two draped youths.
 The characteristic dotted, but uncrossed, squares accompany the meanders; note also the row of parallel fold-lines on the himation across the body of the l. youth on the reverse. The drawing should be compared with that on an oenochoe in Ferrara (V.T. 512) by the Shuvalov Painter (ARV^2 1206, 4).

2 Gela 9241, from Vassallaggi.
 APS, p. 6, no. 2; *ESI*, p. 46, no. B2.
 (a) Bearded man and youth with lyre, (b) draped youth standing beside column.

3 Vienna 883.
 APS, p. 6, no. 3, pl. 2, figs. 5–6; *ESI*, p. 46, no. B3.
 (a) Youth holding hydria between two draped women, (b) draped youth (as to l. on no. 1) between draped youth and bearded man.

4 Naples 2861, (inv. 81571), from S. Agata dei Goti.
 APS, p. 6, no. 7; *ESI*, p. 46, no. B4, pl. 17 b–c; Forti, *AntSurv* 3, 1962, p. 236, fig. 7.
 (a) Herakles struggling with the Nemean lion between Athena and a woman (Nemea ?), (b) bearded man between two draped youths.

5 Leningrad inv. 1656 = St. 1316 (with lugs).
 APS, p. 7, no. 8; *AnnBull N.G.V.*, 8, 1966–7, p. 3, fig. 4; *ESI*, p. 46, no B5, pl. 18a.
 (a) Young Greek warrior fighting mounted Amazon, (b) bearded man between two draped youths.

6 Taranto 12569, from Taranto (frr.).
 APS, p. 7, no. 9; *ESI*, p. 46, no. B6; Paribeni, *Immagini*, colour-plate 5.
 (a) Amazonomachy with Herakles, (b) draped youth and woman.

Calyx-kraters

* 7 Boston, Prof. John Oddy (on loan to Wellesley College). PLATE 2, 5—6.

 APS, p. 6, no. 5; *ESI*, p. 46, no. B8.

 (a) Bearded warrior fighting mounted Amazon, (b) two draped youths beside a Doric column (cf. with nos. 2 and 8).

 8 Berlin F 2400.

 APS, p. 6, no. 4; *ESI*, p. 46, no B9; Zweierlein-Diehl, *Helena und Xenophon,* 8; Beck, *Album,* pl. 78, fig. 383; *Kultbild und Porträt* (*Antike Welt,* Sondernummer 1977), p. 57, fig. 73.

 (a) Girl dancing in front of seated woman playing the flute, (b) bearded man and draped youth beside a Doric column.

 9 Providence 22.215 (ex Hope 208), from Capua.

 APS, p. 6, no. 6; *ESI*, p. 46, no. B10; *Classical Vases,* no. 58, pls. 110—111.

 (a) Herakles fighting two centaurs, (b) draped youth and bearded man beside a Doric column.

Hydria

 10 Leningrad inv. 1842 = St. 1143. Recomposed from frr.

 APS, p. 7, no. 11; *ESI*, p. 47, no. B15; Schauenburg, *JdI* 73, 1958, p. 59, fig. 7.

 Shoulder: Amazonomachy with Theseus (inscribed).

 Body: Woman and youth seated on couch, with women and Erotes around.

 The vase has been extensively restored and repainted, but what remains of the original leaves no doubt that it was by the Painter of the Berlin Dancing Girl; note in particular the drawing of the eyes and the rendering of the ear. Of the scene on the shoulder the following details are genuine: part of the warrior with a shield, part of Theseus, most of the three figures in the chariot and part of the horses; of the frieze round the body: the head of the draped woman to l., parts of the woman and youth on the couch, the lower part of the woman beside it, the wings of Eros.

 In style and drawing it is to be closely associated with Naples 2861 (no. 4) and 3140 (no. 11).

Skyphos

 11 Naples 3140 (inv. 81345), From Nola.

 APS, p. 7, no. 12; *ESI*, p. 46, no. B12, pl. 17a.

 (a) Danae and Perseus in the chest, (b) draped youth and bearded man.

 For the interpretation of the obverse see Cook, *Zeus* iii, p. 458, n. 2; Clairmont, *AJA* 57, 1953, p. 93, no. 6; Schauenburg, *Perseus,* p. 9.

(ii) DEVELOPED STYLE (see also p. 434)

Bell-krater

* 12 Zurich Market, Arete, ex Anagni, Museo del Duomo. PLATE 2, 1—2.

 APS, p. 7, no. 10; *ESI*, p. 46, no. 7; (a) Schauenburg, *RM* 65, 1958, pl. 38, 2; Hoffmann, *Jb. Hamburger Kunstsammlungen*, 14—15, 1970, p. 42, fig. 11. Photos: R.I. 58.1975—7.

 (a) Orpheus (inscribed), seated on a rock, with a Thracian wearing a black tunic and standing beside his horse, (b) draped woman between draped youth and bearded man.

 The treatment of the horse is in the Penthesilean tradition (cf. with the cup Ferrara T. 18 = ARV^2 882, 35; also with B.M. E 280 by Polygnotos = ARV^2 1030, 35 and especially with Ferrara T. 203 by the Eupolis Painter = ARV^2 1073, 7).

 The Thracian's black tunic may be compared with the black cuirass of the charioteer on Ruvo 1088 (no. 2/23 below), Attic parallels to which will be found on Ferrara T. 579 and Bologna 289 (ARV^2 612, 1 and p. 891).

Neck-amphora

 13 Lecce 571, from Rugge.

 APS, p. 7, no. 15; *ESI*, p. 46, no. B14; Borda, p. 31, fig. 21.

(a) Warrior between woman and bearded man, (b) bearded man and woman with fillet beside a Doric Column.

Neck: (a) and (b) Lion.

The inscriptions on the obverse are thought by Bernardini (*StSal* 8, 1959, pp. 7 ff.) to be modern additions.

Hydria

* 14 Oxford 1974.343. PLATE 3, 1.

Sotheby, *Sale Cat.*, 29 April 1974, no. 319, pl. 42; Vickers, *BurlMag.* 97, June 1975, p. 390, fig. 89.

Two women beside a table on which is a lekythos, l. winding wool, r. holding a skein above a kalathos.

In style and drawing this vase goes closely with the reverse of no. 12 and with Lecce 571 (no. 13).

Pelike

15 Melbourne 1391/5.

APS Addenda, p. 424, no. 17; *AnnBull N.G.V.*, 8, 1966–7, pp. 1–4, figs. 1–3; *GrV in the Felton coll.*, p. 25, pl. 11; *ESI*, p. 47, no. B15; Trendall, *Ceramica*, pl. 16.

(a) Amazonomachy – Telamon attacking Andromache (both inscribed), while another Amazon flees to r., (b) bearded man between two youths.

Fragments

* 16 Paris, Cab. Méd. (ex Froehner coll.). From a skyphos. PLATE 3, 2.

APS, p. 7, no. 13; *ESI*, p. 46, no. B13.

Fragment showing the upper part of a man with the inscription ΤΕΡΕΥΣ, in applied red. To r. the tips of the feathers of a wing (or the fingers of a hand ?).

The bearded head is very close to that of the bearded man on the obverse of Lecce 571 (no. 13).

* 17 Taranto 12563, from Taranto. PLATE 3, 3.

APS. p. 7, no. 16; *ESI*, p. 46, no. B11.

Head of draped youth.

(iii) VASES CLOSELY ASSOCIATED WITH THE PAINTER

Hydria

* 18 Taranto 134905, from Ugento. PLATE 3, 4.

Lo Porto, *AttiMGrecia*, n.s. 11–12, 1970–1, p. 131, no. 18, pls. 54–56, and *Atti X° CStMG*, 1970, pl. 103b; *ESI*. p. 47, no. B17.

Bearded man with staff (his body going beneath the l. handle), youth with spear, wearing short tunic with dot-cluster pattern, veiled woman whose l. arm is grasped by a nude youth wearing a chlamys and holding a spear, silen seated upon a rock which goes down beneath the r. handle.

Lo Porto interpreted the subject as a bridal scene by analogy with the Marriage of Sisyphus on Munich 3268 (no. 51), but it may well represent Antigone brought before Kreon by two guards (cf. B.M. F 175 = *LCS*, p. 103, no. 539), in which case the silen to r. is probably meant to indicate an outdoor setting.

In style the vase stands very close to the Painter of the Berlin Dancing Girl and may well be by his own hand. Compare (i) the head of the bearded man with those on the reverse of Lecce 571 and the Tereus fragment (nos. 13 and 16), (ii) the head of the silen with those of the centaurs on the Providence krater (no. 9), (iii) the nude youth with Achilles on Lecce 571 (no. 13).

The bearded man is also close to those on Bonn 80 and the Cahn fragment 213 (nos. 49–50 below).

Dot-cluster patterns are Sisyphean (cf. Ruvo 1096, Matera 9978; nos. 52 and 63), and the composition as a whole resembles that of the hydria Bari 4394 (no. 71), though there the figures do not go beneath the handles. The crossed squares accompanying the meanders are more in the manner of the

Sisyphus or Hearst Painters, and are not like those of the Painter of the Berlin Dancing Girl. The silen has a faintly Amykan or PKP look (cf. *LCS*, nos. 109, 110, 267), and this vase provides further evidence for the connexion between the two principal Early South Italian workshops in the later fifth century B.C.

Fragment

19 New York, Dr. D. von Bothmer.
 Upper part of bearded man leaning upon stick.

2. THE HEARST PAINTER

Bibliography

A. Stenico, 'Hearst, Pittore di', in *EAA* iii, p. 1124.
A. Stenico, 'Un' anfora panatenaica del Pittore di Hearst', in *Boll. Soc. Pavese di Storia Patria* 60, n.s. 12, 1960, pp. 21–27.
A. Stenico, 'Un frammento di cratere a campana del Pittore di Hearst', in *op. cit.* 63, n.s. 15, 1963, pp. 41–44.
A.D. Trendall and Alexander Cambitoglou, 'A fragmentary calyx-krater by the Hearst Painter', in *AntK* 13, 1970, pp. 101–2.
K.F. Felten, *Thanatos und Kleophonmaler* (1971), pp. 58 ff.
A. Bedini in *Sibari* (III Supplement to *NSc* 95, 1970), pp. 140 ff.

The Hearst Painter, who takes his name from the vase formerly in the Hearst collection at San Simeon (no. 20) is a close colleague of both the Painter of the Berlin Dancing Girl and the Sisyphus Painter, but is perhaps nearer to the former in style and spirit, as may be seen from his treatment of bearded heads (vid. nos. 21, 22, 24, 28), and the appearance of Doric columns on his reverses (vid. nos. 27, 33). We may also note the occasional presence (vid. nos. 26 and 31) of a youth to right on the reverse, leaning slightly forward to left on his stick, with the upper part of his body left bare and his right arm resting on the hip. A very close parallel to that youth on the reverse of Lecce 574 (no. 27) will be found on the reverse of a bell-krater from Montesarchio, now in Benevento (348 III; Pl. 1, 2), and of another, formerly on the Basel market (MuM, *Auktion* 51, 14–15 March 1975, no. 165), both attributed to the Kleophon Painter, with several of whose other works the Hearst Painter has much in common – cf. the Nike on the fragmentary hydria in Syracuse (24135 = ARV^2 1147, 65; Gualandi, *Arte antica e moderna* 20, 1962, pl. 114a) or the athletes on the bell-krater Oxford 1922.8 (ARV^2 1145, 34; Gualandi, *op. cit.* pl. 114d). Felten (*op. cit.*, p. 58) has drawn some interesting parallels between various heads by the Hearst Painter (illustrated on p. 116 = pl. 32) and those by the Lupoli Painter (ARV^2 745), but, although two of the latter's vases were found at Taranto (ARV^2 745, 1–2) and might even have been seen by the Hearst Painter, it is with the work of the Kleophon Painter and his colleagues that the closest stylistic parallels are to be found. This would suggest that the main period of the Hearst Painter's activity falls into the last quarter of the fifth century; the discovery at Sybaris of a fragmentary bell-krater (no. 29) by him lends support to a slightly earlier dating than that originally proposed in *APS*, but his latest vases (e.g. nos. 32, 37), which are comparable with the later work of the Sisyphus Painter and that of the Parasol Painter, may well go down into the first decade of the fourth century.

On the whole the Hearst Painter is not an artist of high quality; his male figures are often clumsily drawn (vid. no. 20), and sometimes the pupils of the eyes are greatly exaggerated in size. His ears are drawn with less care than those by the Painter of the Berlin Dancing Girl and often consist of little more than a small reserved area in the mass of black hair which covers

the head and which sometimes has a row of dots on top, to represent tight curls (e.g. on nos. 24, 27), or actual curls (e.g. on nos. 22, 28, 32). He never quite succeeds in mastering the art of drawing the face in three-quarter or fully frontal view, as is very clear from that of Orestes on no. 32. His treatment of drapery is weak, and the fold-lines on his garments frequently appear to bear little relation to the bodies they cover; this is especially true of many of his draped youths on the reverses (e.g. of nos. 28, 32, 36, 46). A noteworthy characteristic of the painter is his habit of omitting the top horizontal side of saltire squares, and using the upper border-line of the meander pattern to provide it (see nos. 20, 21, 27, 28, 34, 35; cf. meander patterns on vases by the Kleophon Painter).

The artist's best work is to be seen on the Palermo calyx-krater (no. 22), where the woman pouring a libation is particularly well drawn, and comparable with some of the best Sisyphean female figures; on the Basel fragments, one (no. 24) with the rare subject of Odysseus slaying the suitors, the other (no. 25a) with an *anodos* scene, and on the Heidelberg fragment (no. 25) with Thetis on a dolphin. As he progresses his style seems to coarsen and his figures become heavier and less lifelike; the Berlin krater (no. 32) and the Mississippi amphora (no. 46) afford excellent examples of this. His range of subjects is comparatively extensive; in addition to mythological themes (nos. 21, 24—5, 25a, 40, 44), one vase may have been inspired by Aeschylean drama (no. 32), three show Nike about to crown a rider (no. 26) or an athlete (nos. 30, 34), the former comparable with vases by both the Sisyphus and the Tarporley Painters (nos. 59 and 3/27 below — Trendall, *Ceramica*, pls. 17—18), and the bearded herm on no. 34 recalling those which figure frequently on vases by the Pisticci and Amykos Painters (e.g. *LCS*, p. 24, nos. 73—76; p. 34, nos. 114—118). Other vases show scenes from everyday life — the palaestra, the symposium, the komos, or offerings to the departed, as no. 46, which is also of interest for the two b.f. amphorae of similar shape to the vase itself depicted upon it. It may be noted that the leaves of his laurel-wreaths, like those of the Painter of the Berlin Dancing Girl, have a central black rib.

The Hearst Painter is one of the first Apulian artists to decorate amphorae of panathenaic shape (nos. 46—47), a type of vase which by the end of the fifth century had virtually disappeared in Attica [two late Athenian examples, one found in Ruvo, belong to the Group of Naples 3235 in the circle of the Meidias Painter (*ARV²*, 1316, 1—2)]. The shape appears in early Lucanian (*LCS*, nos. 57, 184, 218—223, 246—250) and is to have a long history in Apulian, where it becomes taller and more elaborately decorated, until it ultimately reaches monumental dimensions. It is not found in the western fabrics, where the neck-amphora (or its variant the bail-amphora) is in general use, possibly as a result of the extensive import of attic vases of that shape. The designation amphora in the lists which follow always refers to amphorae of panathenaic shape.

(i) EARLY WORK

Bell-kraters

20 Once San Simeon 2369, later New York Market (Parke-Bernet, *Sale Cat.*, 5 April 1963, no. 83).
 APS, p. 14, no. 1; *ESI*, p. 47, no. B19, pl. 21b.
 (a) Komos — two youths revelling with a small boy between them, playing the flute, (b) two draped youths at a stele.

21 Lecce 628.
 CVA, 1, IV Dr, pl. 5, 1—2; *APS*, p. 14, no. 8; *ESI*, p. 47, no. B18; *LAF*, no. 27 (ill.); Moret, *Ilioupersis*, pl. 102, 3; Schauenburg, *ÖJh* 51, 1976—7, p. 38, fig. 30. Photo: R.I. 62.1221.

(a) Deianeira, Herakles and Nessos, (b) two draped youths.

The reverse is very close to that of no. 20.

Calyx-kraters

22 Palermo 2179 (old no. 155), from Terranova.

APS, p. 14, no. 11; *ESI*, p. 47, no. B27, pl. 22 b–c.

(a) Nude youth, woman pouring libation to seated bearded warrior with spear and sword, (b) nude youth between two draped youths.

23 Leningrad inv. 309 = St. 876.

(a) Woman holding out phiale in l. hand, with drapery over her arms and behind her back (cf. Palermo 2179), standing nude youth with pilos in r. hand and stick in l., (b) two draped youths, l. with stick and r. arm akimbo, r. with strigil.

24 Basel, Cahn coll. 272 (frr.). On loan to the Antikenmuseum.

APS Addenda, p. 425, no. 11 bis, pl. 115, fig. 4; *AntK* 13, 1970, pp. 101–2, pl. 48, 1–3; *ESI*, p. 47, no. B28.

(a) Odysseus and the suitors, (b) missing.

Fragments (from bell-kraters)

25 Heidelberg 26.89, from Taranto.

APS, p. 15, no. 22; *CVA*, pl. 72, 3; *ESI*, p. 48, no. B34.

(a) Thetis on dolphin, holding sceptre in l. hand.

* 25a Basel, Cahn coll. 276 and 278. PLATE 4, 1.

(i) Symposium — heads of two men facing r.; part of two banqueters on a couch beside a bearded man with cithara; two banqueters (one bearded, holding a kylix in his l. hand) on a couch beside a table, watching a dancer.

(ii) Above – komos; below – *anodos* scene.

The Cahn pieces (no. 25a) are bell-krater fragments, but it has not yet been determined whether from a single vase (obverse and reverse) or from two distinct ones. Bell-kraters with two rows of figures, here separated by a band of egg-pattern with a reserved stripe above and below it, are a great rarity in South Italian. In view of the similar pattern above the head of Thetis on no. 25, it is probable that this piece too comes from such a vase.

The fragment with the two banqueters and the dancer should be compared with Yale 324 (no. 31), of which it is the forerunner; the head of the bearded banqueter with the kylix is very close to that of Herakles on no. 21 or of the seated man on no. 22. The scene on the lower register of the other fragments, representing an *anodos*, is of particular interest, since as well as three silens, one with a hammer, it includes another figure, also holding a hammer above his head, who, since he is draped and does not have pointed ears, could be Hephaestus. The scene, therefore, might represent the *anodos* of Pandora and owe its inspiration to the satyr-play *Sphyrokopoi* of Sophocles. It has some parallels on Attic vases of the third quarter of the fifth century B.C. (notably the volute-krater Ferrara T. 579, *ARV²* 612, 1, the bell-krater Stockholm 6, *ARV²* 1053, 40, and the volute-krater Oxford G 275 (V 525), *ARV²* 1562, 4, where the man with the hammer is inscribed Epimetheus), as well as on an Early Lucanian bell-krater by the Pisticci Painter (Matera 9975 = *LCS*, p. 14, no. 1, pl. 1, 1). For a full discussion of the subject see Claude Bérard, *Anodoi* (with bibliographies on pp. 173–4); for Pandora see also: M. Guarducci, 'Pandora o i martellatori' in *MonAnt* 33, 1929, pp. 5–38; Buschor, *Feldmäuse*, pp. 22–28; Brommer, *Satyrspiele²*, p. 72; *Ill. Gr. Dr.*, pp. 33 ff; I.D. McPhee, *ArtBullVic* 1976, pp. 39 ff.

(ii) DEVELOPED STYLE

Bell-kraters

* 26 Lecce 574. (b) PLATE 4, 2.

CVA 1, IV Dr, pl. 4, 1–3; *APS*, p. 14, no. 3; Borda, p. 33, fig. 23; Trendall, *Ceramica*, pl. 18, 1; *ESI*, p. 47, no. B20. Photo: R.I. 62.1220.

Bell-kraters (continued)

(a) Nike with fillet standing in front of rider, (b) two draped youths, r. with bare torso, leaning forward on stick.

27 Agrigento R 178 (ex Giudice 137).
 APS, p. 14, no. 2; *ESI*, p. 47, no. B21.
 (a) Eros with mirror, woman with tambourine, and Hermes with caduceus, (b) two draped youths beside a Doric column.

28 Geneva 14984.
 APS, p. 14, no. 4; *ESI*, p. 47, no. B22. Photo: R.I. 34.738.
 (a) Bearded man holding up crown in front of young rider, whose l. arm is bound with a fillet, (b) three draped youths, r. with strigil.

29 Sybaris 12850—3 (fragments), from Sibari.
 Bedini, *NSc* III Supplement to vol. 95, 1970, figs. 136—9 and 143.
 (a) Three youths (warriors), l. and centre with shields beside them, (b) three draped youths.

30 Catania MB 4209 (L. 702). Rim broken.
 Libertini, *Cat.*, pl. 76; *ESI*, p. 47, no. B23.
 (a) Nike with fillet, youth with spear, and youth with petasos running up, (b) draped youth with r. shoulder bare, nude youth with drapery over r. arm; pilos above suspended between them.

31 New Haven, Yale University 324.
 APS, p. 14, no. 7; *ESI*, p. 47, no. B24.
 (a) Symposium — flute-girl with two reclining banqueters, (b) half-draped youth and draped youth with l. arm akimbo.

32 Berlin, inv. 4565.
 APS, p. 14, no. 8; Dyer, *JHS* 79, 1969, pl. 5, fig. 8; *ESI*, p. 47, no. B25; Moret, *Ilioupersis,* pl. 91, 1. Photo: R.I. 35.201.
 (a) Orestes in Athens, (b) draped woman with fillet between two nude youths with spears.
 Late work in a rather heavier style; cf. the Martini amphora (no. 47). The three-quarter face of Orestes should be compared with those by the Parasol Painter.

Calyx-kraters

33 Taranto 4626, from the Arsenal (frr.).
 APS, p. 14, no. 10; *ESI*, p. 47, no. B29.
 (a) Woman between two youths, all running to l., (b) two draped youths, l. with r. shoulder bare, beside a Doric column.

* 34 Agrigento R 178A. PLATE 4, 3.
 APS, p. 15, no. 12; *ESI*, p. 47, no. B30; Griffo and Zirretta, *Il Museo Civico di A.,* ill. on p. 112; detail of (a): Felten, *op. cit.,* pl. 32, 5 (= p. 116). Photo: R.I. 55.731.
 (a) Nike with fillet, and athlete with crown, at bearded herm, (b) three draped youths, l. with r. shoulder bare.

35 Naples 2284 (inv. 81866), from Bari.
 APS, pl. 15, no. 13; *ESI*, p. 47, no. B31.
 (a) Woman with phiale and oenochoe between two warriors, (b) two draped youths, l. with r. shoulder bare (as on nos. 33—4), holding stick.

36 Lecce 629.
 CVA 1, IV Dr, pl. 2, 1 and pl. 3, 1—2; *APS*, p. 15, no. 14; *ESI*, p. 47, no. B32. Photo: R.I. 62.1212.
 (a) Woman at laver between Hermes and a silen, (b) three draped youths.

37 Taranto 4651, from Taranto (Contrada S. Lucia).
 APS, p. 15, no. 15; *ESI*, p. 47, no. B33.
 (a) Silen with lyre, Dionysos holding kantharos and thyrsus, three-quarter faced maenad with flute, one reed in each hand, (b) three draped youths, l. with r. shoulder bare (cf. nos. 33—35).
 The style is comparable to that of Berlin 4565 (no. 32).

Krater fragments

The following fragments are mostly small and come from kraters.

38 Taranto, from Taranto
 APS, p. 15, no. 18; *ESI*, p. 48, no. B35.
 (a) Upper part of heads of a woman and of a warrior wearing a petasos, (b) missing.
39 Oxford 1966. 1038.
 APS, p. 15, no. 19; *Beazley Gifts*, no. 498, pl. 66; detail: Felten, *op. cit.*, pl. 32, 4; *ESI*, p. 48, no. B36.
 Leg and tail of satyr, boy with torch, Dionysos with kantharos.
40 Once Basel Market, MuM.
 APS, p. 15, no. 20; *ESI*, p. 48, no. B37.
 (a) Bellerophon on Pegasus, Athena seated to r.
41 Pavia, Stenico coll.
 APS Addenda, p. 425, no. 20 ter; Stenico, *Bull. Soc. Pavese di Storia Patria*, n.s. 15, 1963, pl. 2; *ESI*, p. 48, no. B38.
 Dionysos with thyrsus and phiale following woman playing the flute.
42 Zurich Market, Arete.
 ESI, p. 48, no. B39.
 Youth driving chariot.
43 Oria, private coll.
 APS, p. 425, no. 20 bis; *ESI*, p. 48, no. B40.
 Part of the rim of a krater with head of youth.
44 Amsterdam 2534.
 APS, p. 15, no. 21, fig. 12; Felten, *op. cit.*, pl. 32, 3; *ESI*, p. 48, no. B41.
 (a) Phineus and Boread.
45 Amsterdam 4630.
 ESI, p. 48, no. B42.
 (b) Part of nude youth and head of draped youth.

Amphorae

46 Mississippi, University (ex Robinson coll.).
 APS, p. 15, no. 16; *ESI*, p. 48, no. B43.
 (a) Woman with short hair, carrying a tray of offerings on her head, between two nude youths holding fillets, two b.f. amphorae between them, (b) three youths (two draped, one nude).
47 Turin (Pessione), Martini Museum.
 APS, p. 15, no. 17; *ESI*, p. 48, no. B44; Stenico, *Bull. Soc. Pavese di Storia Patria*, n.s. 12, 1960, pls. 1–2; *Martini Museum*, pl. 17.
 (a) Seated youth, standing youth and woman holding two wreaths. (b) three draped youths.

(iii)

The following vase, which has been extensively repainted, looks also to be by the Hearst Painter.

Bell-krater

48 Berlin F 3181.
 APS, p. 15, no. (i); *ESI*, p. 47, no. B26.
 (a) Eros pursuing youth, (b) two draped youths.
 The wave-pattern below the pictures is unusual for this painter.

(iv) VASES ASSOCIATED WITH THE PAINTER

The bell-krater Bonn 80 was associated in *APS* (p. 14, no. 9) with the Hearst Painter, and it will be noted that the saltire squares are drawn in his characteristic manner. On the other hand there are also stylistic affinities with the work of the Painter of the Berlin Dancing Girl (cf. the youths on the reverse with those on Vienna 883; no. 3), and there are some Sisyphean elements as well (cf. the poses of the reverse youths with those on his krater in the Victoria and Albert Museum, no. 57 below). The Bonn vase is clearly a product of this workshop, but it seems to be by another painter with whose work may also be associated the Cahn fragment (no. 50), in view of the striking similarity between the bearded heads; the treatment of the eye is also connected with the work of the Sisyphus Painter.

Bell-krater

49 Bonn 80.
 APS, p. 14, no. 9; *Antiken aus dem Akad. Kunstmuseum,* no. 218, fig. 101; Moret, *AntK* 15, 1972, pl. 29, 3; *ESI,* p. 48, no. B45.
 (a) Bellerophon with Pegasus, delivering the letter to Iobates (or according to Moret, *op. cit.,* p. 103, receiving it from Proitos), (b) three draped youths.

Hydria (fr.)

50 Basel, H.A. Cahn coll. 213.
 ESI, p. 48, no. B46.
 Shoulder and arm of woman, shoulder and head of bearded king with sceptre.

3. THE SISYPHUS PAINTER

Bibliography

A. Furtwängler, FR ii, pp. 201 ff. (text to pls. 98–99).
J.D. Beazley, *Greek Vases in Poland,* pp. 72 ff.
Noël Moon, pp. 32 ff.
A. Stenico, 'Sisiphos, Pittore di', in *EAA* vii, pp. 355–6.

The Sisyphus Painter was first identified by Beazley (*VPol,* pp. 72 ff.) who named him after the main subject on his volute-krater in Munich (no. 51). Mrs. Oakeshott made pertinent additions to the comments on his style which accompanied Furtwängler's publication of the vase in FR (pls. 98–99) and emphasised the close relation in which he stands to the Painter of the Berlin Dancing Girl. New material has raised the total of his vases to 38 and we are now able to trace the development of his style in some detail. He is the principal painter in the pioneer Apulian workshop and of great importance in the history of that fabric, since in his vases we see the origins of both the "Plain" and the "Ornate" styles.

The figures on his monumental vases have a certain statuesque quality, perhaps a reflection of contemporary trends in sculpture (cf. with the Parthenon and Phigaleia friezes), transmitted through the work of Attic vase-painters like the Kleophon Painter and his colleagues. The division of the body of the Sisyphus krater into two distinct registers, separated by a band of egg-pattern, is of interest; it may be derived from the similar practice in Attica for two-row calyx-kraters, but is unusual for volute-kraters, although we have already noted it on a fragmentary bell-krater by the Hearst Painter (no. 25a, Pl. 4, 1). On Ruvo 1096 (no. 52) the division is also apparent, but less formal, and is heightened in the Amazonomachy on the reverse by the use of ground-lines between the two levels; on the Warsaw krater (no. 53) the more usual "all-over" design is used, as is regularly the practice in Athens on vases of this shape. From what remains

of the fragmentary krater in Basel (no. 54) the composition of the obverse seems similar to that of Ruvo 1096.

The quality of the Sisyphus Painter's work shows considerable variation. Beazley referred to "the peculiar penmanship of his lines" and of "the beauty of the large grave ox-eyed three-quarter heads", and at his best the Sisyphus Painter can certainly draw beautiful figures, but on the whole his compositions tend to lack internal unity and strength and often consist of little more than a series of rather coldly arranged groups, which perhaps explains why his style is seen to particular advantage on fragments.

Characteristic of the painter is his treatment of women's drapery, with his fondness for long overfalls on their peploi – perhaps a reflection of a fashion popular in Taranto, since they reappear on the vases of several of his colleagues and successors, notably the Tarporley Painter and the artists of the Long Overfalls Group. He also makes an extensive use of stars and dot-clusters as a decorative pattern on the drapery (see nos. 52, 54, 63, 66). Of particular interest are the two column-kraters nos. 55–6, as being the first Apulian vases to show youths wearing "native" or Oscan costume. On the former a woman pours a libation to the departing horseman from a vase of local shape, generally referred to as a *nestoris* or *trozzella* (see Trendall, *Gli Indigeni*, pp. 7 ff.; Yntema, 'Messapian painted pottery', in *BABesch* 49, 1974, pp. 5 ff.; Schauenburg, *JdI* 89, 1974, pp. 137 ff.). Although vases of this shape regularly appear in Lucanian from the time of the Amykos Painter onwards (*LCS*, pp. 29–30, and p. 44, nos. 215–7; *Suppl.* II, p. 156, no. 137b, pl. 30, 1), it is not until the second quarter of the fourth century that they are actually made in Apulia (e.g. Naples 2326 from the Hoppin workshop) and they were never popular there'. It is perhaps significant that until about the middle of that century the only shape upon which Oscan costumes or nestorides appear is the column-krater, which may have had a particular appeal for the native inhabitants, since it seems likely that vases with such scenes upon them were manufactured for export rather than for Greek customers in Taranto.

Among the draped youths on his reverses we may note the following types as particularly characteristic, setting a fashion copied, with slight modifications, by his successors:

(i) the youth with one arm (normally the l.) akimbo, and the himation draped over that arm and shoulder, and across the waist, so as to leave part of the chest and the right shoulder bare (e.g. nos 55, 57, 60, 62); – a variant of this will be found on nos. 55, 56, 58, 59, 63, where the himation is so draped as to leave only the shoulder and not the chest bare. The head may be turned either to l. (nos. 56, 67) or to r. (nos. 59, 64).

(ii) the completely draped youth, with the l. arm slightly extended to produce a slight forward bulge from which the himation falls down with vertical folds (as on nos. 56, 57, 59, 60, 62, 64, 67);

(iii) the completely draped youth, with the himation drawn fairly tightly round the neck and falling down behind one arm (as on nos. 55, 58, 60, 63, 64, 66); sometimes this arm is fully akimbo with consequent modifications to the folds (e.g. nos. 59, 67).

The Sisyphus Painter uses both crossed and saltire squares with his meanders, which are usually confined to a band below the picture. On the earlier bell-kraters in (i) there is no pattern-work below the handles; the laurel leaves are not veined, unlike those of the Painter of the Berlin Dancing Girl and the Hearst Painter.

Beazley (*VPol*, p. 74) pointed out the analogy between the earlier style of the Sisyphus Painter and that of the Dwarf and Codrus Painters in Athens, and parallels may also be observed with the volute-kraters of Polion (*ARV²* 1171, 1–2). It seems likely, therefore, that the Sisyphus Painter's main works fall into the last two decades of the fifth century, though his latest are probably to be placed in the early years of the fourth.

(i) EARLY VASES

Volute-kraters

51 Munich 3268.

 APS, p. 9, no. 1; *Addenda*, p. 424 (for subsequent bibliography); Paribeni, *Immagini*, no. 6, ills. on p. 10 and p. 12; Brilliant, *Art of the Ancient Greeks*, p. 246, fig. 7.33; *ESI*, p. 48, no. B47, pls. 19–20; details of (b): Zinserling, *Die Frau*, pl. 51b; Beck, *Album* pl. 82, fig. 396; *Kultbild und Porträt* (*Antike Welt*, Sondernummer 1977), p. 67, fig. 81.

 (a) Neck: two Erotes, Eros crowning Aphrodite, two Erotes playing morra.

 Body: (i) the wedding of Sisyphus, (ii) Jason attacking the dragon, supported by Medea, in the presence of the Argonauts.

 (b) Neck: horse-race.

 Body: (i) the nine Muses, (ii) Centauromachy.

 Note the simplicity of the floral patterns below the handles as compared with those on vases by the Painter of the Birth of Dionysos (e.g. Taranto 8264 and Brussels A 1018; no. 2/6 and 9 below).

* 52 Ruvo 1096, from Ruvo. PLATE 5, 1.

 APS, p. 9, no. 3; *ESI*, p. 48, no. B48, pl. 18b; Sichtermann, K 39, pls. 60–61.

 (a) The Rape of the Leucippidae, (b) Amazonomachy with Herakles.

53 Warsaw 142296 (ex Goluchow 57), from Ruvo.

 APS, p. 9, no. 2; *ESI*, p. 48, no. B49, pl. 21a.

 (a) Peleus and Thetis, (b) komos.

* 54 Basel, private coll. (frr.). PLATE 5, 2.

 ESI, p. 48, no. B50.

 (a) Dionysiac scene: to l. maenad with tambourine, satyr-boy, maenad with krotala, woman beside thymiaterion with box of incense, Dionysos seated beneath a vine holding kantharos and thyrsus, in three-quarter view to r., maenad in three-quarter view. Below: woman grasping the hand of youth, (b) missing.

 Most of the upper part of (a) remains. The female figures have the characteristic long overfalls to their drapery, which is often decorated with dot-clusters.

Column-kraters

55 B.M. F 174.

 APS, p. 9, no. 4; *ESI*, p. 48, no. B51; *SIVP*, pl. 5; *Gli Indigeni*, fig. 12.

 (a) Woman pouring libation from nestoris to departing Oscan warrior, standing beside his horse; to l. another warrior with spear and shield, (b) four draped youths.

 Note the animal leg suspended between the two youths to l.; it reappears on Matera 9978 (no. 63).

56 Boulogne 653.

 APS, p. 9, no. 5; *ESI*, p. 48, no. B52.

 (a) Woman pouring libation to seated Oscan warrior, Oscan warrior with shield and spear beside his horse, (b) four draped youths.

 There is a striking resemblance between this vase and B.M. F 174, especially in the treatment of the youth beside his horse and the draped woman.

Bell-kraters

57 London, Victoria and Albert Museum 4803.1901, from Ruvo.

 APS, p. 9, no. 6; *ESI*, p. 48, no. B53.

 (a) Two kalathiskos-dancers with a bearded flute-player between them, (b) three draped youths.

58 Zurich, Wolfensperger coll. (ex Ruesch 14).

 APS, p. 9, no. 7; *ESI*, p. 48, no. B54.

 (a) Three kalathiskos-dancers, (b) three draped youths.

59 Louvre G 493.

 APS, p. 9, no. 8; Trendall, *Ceramica*, pl. 17; *ESI*, p. 48, no. B55.

Nike crowning rider, (b) three draped youths.

60 Milan, "H.A." coll. 408.
 APS, p. 10, no. 14; *ESI,* p. 48, no. B56; *CVA* 2, IV D, pl. 6, 3–4.
 (a) Dionysos, silen dancing on a table, and maenad playing the flute, (b) three draped youths.

61 Ruvo 1291, from Ruvo. Repainted.
 APS, p. 9, no. 10; *ESI,* p. 49, no. B57.
 (a) Maenad adjusting kottabos-stand between two silens, (b) three draped youths.

62 Vatican U 9 (inv. 17957).
 APS, p. 10, no. 15; *ESI,* p. 49, no. B58.
 (a) Nude youth, seated youth being crowned by draped woman holding phiale filled with eggs, (b) three draped youths (the head of the central youth is missing).

* 63 Matera 9978, from Pisticci. PLATE 6, 1–2.
 APS, p. 9, no. 13; *ESI,* p. 49, no. B59; Lo Porto, *Penetrazione,* pl. 30, 1–2.
 (a) Woman seated between nude youth leaning on stick and draped woman holding kalathos, (b) three draped youths.

64 Stockholm 3.
 APS, p. 9, no. 12; *ESI,* p. 49, no. B60.
 (a) Woman holding torch, and two youths, (b) three draped youths.

65 Leningrad inv. 1668 = St. 1780.
 APS, p. 9, no. 9; *ESI,* p. 49, no. B61.
 (a) Maenad playing the flute, and silen dancing, beside a kottabos-stand, (b) two draped youths, with a Doric column between them.

66 Vatican U 7 (inv. 17955).
 APS, p. 9, no. 11; *ESI,* p. 49, no. B62.
 (a) Draped woman with phiale, and nude youth with stick, beside a Doric column, (b) two draped youths, with a column between them (partly restored; the head of the l. youth is modern).

67 Turin, private (R.S.) coll.
 Porten-Palange, *Acme* 24, 1971, pp. 186–192, pl. 1; *ESI,* p. 49, no. B63.
 (a) Woman running to l., playing the double-flute, followed by nude youth about to crown her, (b) two draped youths.

Fragments of kraters

68 Basel, Cahn coll. 236.
 ESI, p. 49, no. B64.
 Seated veiled woman with short, fringed white hair; to r. part of sanctuary or altar, and feet of another woman.

69 Kiel, private coll.
 ESI, p. 49, no. B65; Schauenburg, *RM* 82, 1975, pl. 57, 1.
 Head of goddess (Hera ?) with crown and veil, holding bird-sceptre.

70 Taranto, from Taranto.
 APS, p. 10, no. 17; *ESI,* p. 49, no. B66.
 Woman playing the double-flute.

Hydriai

71 Bari 4394, from Ceglie del Campo.
 APS, p. 10, no. 18; *ESI,* p. 49, no. B67. Photo: R.I. 62.1160.
 Helen and Paris between seated woman and seated youth.
 Cf. with the hydria Taranto 134905, closely associated above with the Painter of the Berlin Dancing Girl (no. 18).

Hydriai (continued)

72 Taranto, from Gravina (frr.).
 Standing youth, draped woman holding cista, woman seated on *klismos* spindling wool, woman.
 Beneath handles: goose.

Lekythos

73 Oxford 1932.1233.
 APS, p. 10, no. 20; *ESI*, p. 49, no. B68.
 Eros pursuing woman.

Skyphos (of Corinthian shape)

74 Cambridge G 239.
 APS, p. 10, no. 19; *ESI*, p. 49, no. B69.
 (a) Eros with arms outstretched towards (b) woman running to r.

Skyphos (restored as an oenochoe, shape 2)

* 75 Louvre G 570. PLATE 6, 3.
 Tischbein V 73; *ESI*, p. 49, no. B70.
 Herakles (or Theseus ?) attacking a centaur.
 The above fragment, originally from a skyphos (cf. the foot with that of the preceding vase, especi-
ally the band of ray-pattern), but incorrectly restored as an oenochoe, was attributed in *APS* (p. 7, no. 14) to
the Painter of the Berlin Dancing Girl (cf. with the Providence krater, no. 9 above); but a fuller study, after
the cleaning of the vase, suggests that it is closer in style to the work of the Sisyphus Painter. The left side of
the hero and part of the centaur's body have been repainted. Whether he is Herakles or Theseus is not easy to
determine; Brommer (*VL³*, p. 89) favours the former, in which case the centaur may well be Eurytion (cf.
Brussels A 264 = *CVA* 2, IV Db, pl. 4, 1).
 The face of Herakles is very Sisyphean and may be compared with that of Jason on Munich 3268
(no. 51) or with those of some of the Lapiths on the centauromachy on the same vase [cf. also with the rider
on Louvre G 493 (no. 59) and with Eros on the Cambridge skyphos (no. 74)].

(ii) LATER STYLE

 The vases in this division (see *APS*, p. 9) belong to the later phase of the Sisyphus Painter's
activity. That they are by his own hand seems clear from the extremely close connexion be-
tween the reverses of Matera 9978 (no. 63; Pl. 6, 2) and Jena 424 or Naples 2228 (nos. 76–7),
which in turn are linked with the other vases by a number of repeated figures, common to all
of them. Note in particular:

 (a) the nude youth, especially with three-quarter frontal chest and profile head (nos. 77–8, 83);
 (b) the standing woman wearing a peplos (once, on Bari 5260, with a short overfall), with a reserved
 head-band and a chignon at the back (nos. 76–7, 83);
 (c) the youths on the reverses: at first (nos. 76–7) they are close to those on the kraters in (i), but later
 they are often characterised by a reserved band worn around their head (nos. 78, 80), as also on the
 obverses of Naples Stg. 295 and Bari 6312 (there is often a black stripe just above the hem-line of
 their himatia, e.g. on nos. 77–80, as also on nos. 60, 63, 64 and on nos. 87–88).

The features are somewhat more rounded, and in profile the eyebrows tend to come almost
to the bridge of the nose.
 The vases in this division are closely connected in style with those of both the Tarporley and
the Creusa Painters; their influence on the latter (especially in the treatment of the draped
youths on the reverses) in his earlier phase again emphasises the relationship between the two
main schools of Early South Italian vase-painting at the end of the fifth and the beginning of

the fourth century B.C.

(a)

Bell-kraters

76 Jena 424.

APS, p. 10, no. 21, pl. 1, figs. 1—2; *ESI*, p. 49, no. B71.

(a) Woman seated between nude youth offering her a wreath, and draped woman holding mirror, (b) three draped youths.

Cf. the obverse with that of Matera 9978 (no. 63); the reverse is almost identical with that of Naples 2228 (no. 77).

77 Naples 2228 (inv. 82549).

APS, p. 10, no. 22, pl. 1, figs. 3—4; *ESI*, p. 49, no. B72.

(a) Two nude warriors and a draped woman with a wreath, (b) three draped youths.

The second warrior is a replica of the central athlete on no. 78.

78 Vatican U 8 (inv. 17956).

APS, p. 10, no. 16; *ESI*, p. 49, no. B73.

(a) Three nude athletes, (b) three draped youths.

79 Naples Stg. 295. Badly preserved.

APS, p. 10, no. 24; *ESI*, p. 49, no. B74.

(a) Woman with oenochoe between two youths with spears, (b) three draped youths.

80 Bari 5260, from Gioia del Colle.

APS, p. 10, no. 23; *ESI*, p. 49, no. B75: Möbius, *Die Reliefs der Portlandvase*, pl. 4b. Photo: R.I. 51.72.

(a) Youth with sheathed sword and warrior being crowned by draped woman, (b) three draped youths.

The three-quarter view of the central youth on the obverse recalls the work of the Parasol Painter.

Hydriai

81 Bonn 95.

APS, p. 10, no. 26; *ESI*, p. 49, no. B76.

Nude youth with strigil, seated nude youth being crowned by draped woman.

82 Boulogne 176.

APS, p. 10, no. 27; *ESI*, p. 49, no. B77.

Youth and woman.

83 Bari 6312 (Polese 127).

APS, p. 10, no. 25; *ESI*, p. 49, no. B78.

Woman holding mirror, and two nude athletes.

The woman is very close to those on nos. 76 and 77 above; with the heads of the athletes cf. those of the l. and r. youths on no. 80.

Squat lekythos

* 84 Once Zurich Market, Arete. PLATE 6, 4.

Liste 9 (1972), ill. on p. 11; *ESI*, p. 49, no. B79.

Standing woman with mirror and sash, nude youth with bird on string, seated draped woman.

(b)

The vases in this sub-division are slightly cruder in style, but seem to be the work of the same painter, as they follow closely on from those in (a). They are very late.

Bell-kraters

85 Altamura 4.

ESI, p. 49. no. B80.

Bell-kraters (continued)

(a) Nude youth holding pilos, nude youth with shield and two spears, (b) two draped youths.

86 Trieste 1797, from Taranto.

ESI, p. 49, no. B81.

(a) Nude youth with stick, and woman with fillet, (b) two draped youths (as on no. 85, except that the poses are reversed).

Note the treatment of the borders of the drapery, as on Naples Stg. 295 (no. 79) and Bari 5260 (no. 80).

Pelikai

87 Vienna 854.

ESI, p. 50, no. B82.

(a) Draped woman with wreath, and nude youth with strigil beside a pillar, (b) two draped youths.

Note the pose of the nude youth, with the l. arm akimbo (cf. no. 65); this is to become a very popular pose with later painters and also in the Intermediate Group of Lucanian (*LCS* pp. 62 ff.).

* 88 London, University College 525. PLATE 6, 5–6.

APS, p. 10, no. (i); *ESI*, p. 50, no. B83.

(a) Nude youth with stick, and woman holding phiale and oenochoe, standing beside a pillar, (b) two draped youths.

Very close in style to Altamura 4 (no. 85); cf. also the youth to l. on the reverse with the corresponding one on Vatican U 8 (no. 78). Note the broken double stripe down the woman's drapery.

(iii) CLOSELY ASSOCIATED WORKS

(a)

The vases in this sub-division stand very close to the painter himself.

Pelike

* 89 Ruvo 654 PLATE 7, 1–2.

APS Addenda, p. 424, no. (iiib); Sichtermann, K34, pl. 50. Photo: R.I. 64.1241.

(a) Draped woman with alabastron, two nude women in front of a laver, one combing and the other binding her hair, young satyr kneeling behind tree, (b) three nude youths, l. with strigil, r. with aryballos.

The treatment of the nude youths, especially the drawing of the head and the hair, finds a close parallel on the three athletes on the reverse of Louvre CA 3291 (no. 101), which in style is perhaps rather nearer the Parasol Painter.

The two nude women are the only examples of female nudes so far known in the workshop of the Sisyphus Painter, and from the drawing of the one combing her hair it is clear that the artist is not much at home with his subject. Hair-combing is not a common theme in either Attic or South Italian vase-painting (for an Attic parallel see Milan, "H.A." coll. 316 = *CVA* 2, III I, pl. 2, 1; for an Apulian, Heidelberg 25.05 = *CVA* 2, pl. 89, 2).

Note also the presence of two b.f. squat lekythoi, which are a rare shape in Early Apulian (cf. the lekythos once on the Zurich market, no. 84, by the Sisyphus Painter), and do not become at all common until the time of the Iliupersis Painter.

In addition to the pebbles beneath the kneeling woman, the ground is indicated by incised circles, as, on the name vase of the Painter of the Birth of Dionysos (no. 2/6 below).

Volute-krater

90 B.M. F 158.

APS Addenda, p. 424, no. (iiia).

(a) Departure of warrior: queen and seated king with sceptre clasping hand of youth standing beside

his horse, (b) Amazonomachy.

Note the use of the dot-stripe down the woman's drapery and as a border on the cloak over the king's knees.

(b)

Bell-krater

* 91 Leningrad inv. 295 = St. 855; W.1117. (b) PLATE 7, 3.

APS Addenda, p. 424, no. (vi), pl. 115, figs. 1—2; Richter, *Furn.*[2], fig. 300.

(a) Dionysos and Ariadne, seated on a couch, riding on a mule, led by a silen playing the flute, (b) nude youth with spear, and two nude youths with strigils and short cloaks.

(c)

Fragments

92 Oxford 1922.208, from a skyphos.

APS, p. 11, no. (ii).

Icarus.

93 Amsterdam 2557.

Part of winged figure; frontal head and shoulders of woman, with both hands on top of head.

The treatment of the three-quarter face is very like that of Icarus.

The three following fragments are somewhat more individual in style (cf. the treatment of the hair with fringe, and the use of squiggly relief lines which find a parallel in the work of the Black Fury Painter) but seem also to belong to the circle of the Sisyphus Painter.

94 B.M. E 509.

B.M.Cat. iii, p. 308, fig. 14; Moret, *Ilioupersis,* pl. 7, 3.

Thracian nursemaid, holding, and probably suckling, an infant; a piece of her drapery is caught between her teeth.

Cf. also with the fragment Cahn 236 (no. 68, by the Sisyphus Painter).

95 Basel, Cahn coll. 224, from a calyx-krater.

Schauenburg, *RM,* 79, 1972, pl. 24, 1.

Woman looking out of window, and head of woman below.

95a Amsterdam 2498, from Taranto.

Gids, no. 1489, pl. 76, 1; *Gods and Men in the A.P.M.,* pl. 35.

Head of woman looking out of window; to l. pediment and top of head.

Cf. with the three-quarter heads on nos. 51—54, 68, 69, and 95.

(iv) CONNECTED VASES

The two following amphorae of panathenaic shape, both found at Gravina in 1974 and by a single painter, are connected in style with the Sisyphus Painter, although they also show some influence from the school of the Amykos Painter and the PKP Group of Early Lucanian. The dot-clusters on the drapery are very Sisyphean, is also in the treatment of the drapery and the drawing of the heads. The tucking in of the chlamys beneath the girdle (no. 97) finds a parallel on a column-krater in Basel (no. 4/243).

The amphorae of panathenaic shape, though not uncommon in Early Lucanian, is comparatively rare in Apulian at this stage; two such amphorae were attributed to the Hearst Painter (nos. 46—7). Note on the Gravina vases the use of two registers divided by a reserved band; this follows the practice of the Amykos Painter (cf. *LCS,* p. 45, nos. 218, 218a and p. 48, no. 246, pl. 20, 1).

Amphorae

96 Taranto, from Gravina.

 (a) Three youths beside an Ionic column on a plinth, (b) above: seated woman between to. l. woman and Eros, to r. two youths; below: woman, youth, woman bouncing ball, nude youth leaning on stick, woman holding fillet.

97 Taranto, from Gravina.

 (a) Above: Orestes and Electra at the tomb of Agamemnon; to l., Pylades, to r. woman with cista; below: woman with wreath and cista, youth, woman pursued by youth, (b) above: nude youth, two women, youth with strigil; below: nude youth, woman with wreath, Nike holding out wreath to nude youth.

4. THE PARASOL PAINTER

Bibliography

A. Stenico, 'Parasole, Pittore del', in *EAA* v, p. 948.

The close stylistic connexion between the later work of the Sisyphus Painter and the vases attributed to the Parasol Painter, who takes his name from the parasol held by the maid on the Heidelberg krater (no. 98) suggests that their careers must have overlapped at least for a period, although the latter is inferior as a painter. Sisyphean influence may be seen in his treatment of drapery and particularly in his drawing of the three-quarter head of the warrior on the obverse of no. 98, which looks back to the Sisyphus of the Munich krater (no. 51) and, more immediately, to the youth on Bari 5260 (no. 80), and of the standing woman to left, with her right arm resting on her hip, who appears regularly on later vases by the Sisyphus Painter. The head of Apollo on the Sydney fragment is almost a replica of that of the warrior on the Heidelberg krater, just as the youth's head on the second fragment duplicates the head (note especially the drawing of the ear) on the reverse of that vase, although facing to left instead of to right. Little remains of the Telegonos fragment in Budapest (no. 100), but the drawing of the youth's eye, nose and mouth shows that it belongs here; it is the subject of a detailed study by J.G. Szilágyi in *Acta Ant Acad Hung* 1, 1951, pp. 113–119.

Bell-kraters

98 Heidelberg 26.85.

 APS, p. 11, no. 1, pl. 2, figs. 7–8; *CVA*, pl. 71 and pl. 72, 1.

 (a) Standing woman, nude youth with two spears, woman seated on cushion with maid holding parasol over her, and youth (b) nude youth, draped woman and nude youth (mostly missing).

99 Sydney 51.37 and 53.08 (two frr.).

 APS, p. 11, no. 2, pl. 3, figs. 9–10.

 (a) Apollo with lyre, (b) nude youth.

 The Apollo fragment almost certainly comes from the obverse of the vase, which may have represented the contest with Marsyas (Clairmont, *YCS* 15, 1957, p. 168, no. 31; Schauenburg, *RM* 65, 1958, p. 52); the other probably from the reverse, but here one cannot be certain.

Fragment

100 Budapest 50.101.

 APS Addenda, p. 424, no. 3.

 Telegonus and Circe (both inscribed).

The following vases are connected in style with the above:

Skyphos

101 Louvre CA 3291.

 APS, p. 12, no. (ii).

 (a) Maenad dancing between Dionysos and silen with wine-skin, (b) three nude athletes, l. with strigil, centre with aryballos, and r. with stick.

 Compare the head of the maenad with that of the seated woman on no. 98, and the athletes on the reverse with the youths on the reverse of the same vase and also of Ruvo 654 (no. 89).

Fragment

102 Basel, Cahn coll. 204.

 Head of silen (Marsyas ?).

The following fragment recalls the work of the Parasol Painter, but the drawing is much cruder; note the incised outline of the youth's hair.

Hydria (fr.)

103 Basel, private coll.

 APS Addenda, p. 425, no. (iii), pl. 115, fig. 3.

 Nike crowning athlete.

5. THE ARIADNE PAINTER

Bibliography

A. Stenico, 'Arianna, Pittore di', in *EAA* i, p. 633.

The connexion between the Ariadne Painter and the Sisyphus workshop was mentioned in *APS* (p. 16) and two other artists (the Adolphseck Painter and the Painter of Boston 00.348) were there associated with him; these are of somewhat later date and are discussed below in Chapters 4, 3 and 10, 2. The Ariadne Painter, who takes his name from the well-known stamnos in Boston (no. 104) showing the desertion of Ariadne, is a late contemporary and follower of the Sisyphus Painter, and most of his work should be dated to the first two decades of the fourth century; the influence of the Tarporley Painter, who must have begun work at the beginning of that century, is also to be seen in the treatment of some of the draped youths on his reverses (e.g. nos. 109–112), while others are more clearly based on Sisyphean models (e.g. nos. 105, 107).

The Ariadne Painter is fond of mythological subjects, which he treats in the grand manner with monumental compositions. Here again we may see Sisyphean influence and perhaps also that of early "Ornate" painters like the Painter of the Birth of Dionysos. Athena appears on six of his vases (nos. 104–8, 112), Herakles on three (nos. 105–6, 108) and Bellerophon on two (104, 107). Dionysiac themes are less common (nos. 111, 114), and a single vase (no. 110) shows us a scene with warriors in native costume together with two women wearing the typical peploi with long overfalls, one of whom holds a nestoris in her hand, recalling the column-krater by the Sisyphus Painter (no. 55).

Characteristic of his work are the male figures, often nude, with heads in three-quarter view (e.g. on nos. 104, 105, 107, 108); note also his fondness for black borders, sometimes dotted as well, on his drapery (e.g. nos. 104–5, 107–8, 110, 112, 115). A passing reference may be made to his use of the stamnos, a shape very rare in South Italian, of which only three other Apulian examples are so far known (nos. 8/19a, 16/71 and Taranto 8876).

(i) EARLY WORK

Stamnos

104 Boston 00.349.

 APS, p. 17, no. 1; *Greek Gods and Heroes* (Boston, MFA), p. 83, fig. 70; *ESI*, p. 50, no. B84, pl. 23; Philostratus, *Imagines* (Loeb edn.), fig. 6, opp. p. 63; *Ill.Gr.Dr.* III.3, 45 and 51; Moret, *AntK* 15, 1972, pl. 28, 2; Brommer, *Die Wahl des Augenblicks*, pl. 34; *Cl.Gr.Art*; fig. 349.

 (a) Theseus deserting Ariadne, (b) departure of Bellerophon.

 Note the bird sceptre carried by Proitos on (b); cf. with the Kiel fragment by the Sisyphus Painter (no. 69) and especially with B.M. F 158 (no. 90). Compare also the head of Athena on (a) with that of Ariadne on Leningrad 295 (no. 91), and note the egg-and-dot pattern round the handle-joins.

Bell-kraters

105 Ruvo 545.

 APS, p. 17, no. 2; *ESI*, p. 50, no. B85. Photos: R.I. 66.1712–3.

 (a) Nike crowning youthful Herakles in the presence of Athena, (b) four draped youths.

106 Berlin F 3187.

 APS, p. 17, no. 3; *ESI*, p. 50, no. B86.

 (a) Hermes bringing a pig for sacrifice to Herakles in the presence of Athena, (b) youth and woman at altar.

 This vase was destroyed in World War II and it has therefore not been possible to check this attribution.

(ii) STANDARD STYLE

The vases in this section may be regarded as typical of the standard work of the Ariadne Painter, and a link with his earlier work is provided by the seated Athena on Ruvo 1091 (no. 107), who is very close to her counterpart on Ruvo 545 (no. 105). It is particularly at this stage that we note the influence of the Tarporley Painter on the treatment of the draped youths on the reverses (especially on Bari 6253, no. 109) where the strongly-marked vertical fold-lines on the overhang of the himatia are typical. Note also the thick wavy black line across the folds of the himation immediately below the neck (nos. 108–112, 115), and the wavy border of the overhang of the himation on the youth on the extreme left (nos. 107, 109–115), which is very characteristic of these vases. Another common feature of the draped youths is the way in which the outlines of one leg are often clearly to be seen beneath the drapery (vid. the second youth on nos. 108–110).

The Ariadne Painter sometimes combines crossed and saltire squares with his meanders, as on Ruvo 545 (no. 105) and, in this section, on nos. 107 and 111, and it may be noted that the berries accompanying the ivy leaves on the necks of his column-kraters consist of a large cluster of black dots not always arranged in a pure rosette form (nos. 107–109). The Ruvo Perseus krater, attributed to this painter in *FI*, p. 40, no. B54 was transferred in *APS* (p. 60) to the area of the Bendis Painter. This arose through confusion with another Ruvo vase, and it has now been restored to its rightful place; its reverse is very like those of the other bell-kraters in this section. B.M. F 161 (no. 114), which in *APS* (p. 36) was placed near the Tarporley Painter, is also seen from its reverse to belong here; its obverse should be compared with that of Naples 2149 (no. 111).

Column-kraters

107 Ruvo 1091.

 APS, p. 17, no. 5, pl. 4, fig. 15; *ESI*, p. 50, no. B90; Sichtermann, K 46, pl. 78; Borda, p. 33, fig. 24.

Photos: R.I. 62.1336 and 64.1173.

(a) Bellerophon on Pegasus attacking the Chimaera in the presence of Athena and Poseidon, (b) four draped youths.

The representation on the obverse finds a close parallel on a vase, formerly in the Hamilton collection (Tischbein I, 1 = *AntK* 15, 1972, p. 101, fig. 1), of which small fragments have recently been recovered from the wreck of the *Colossus*, and which may well also be by the Ariadne Painter.

108 Naples 2408 (inv. 81872).

APS, p. 17, no. 6, pl. 4, fig. 16; *ESI*, p. 50, no. B91; Forti, *AntSurv* 3, 1962, p. 237, fig. 8.

(a) Youthful Herakles with cornucopia and club seated between Zeus to l., and Athena and Hermes to r., (b) four draped youths.

109 Bari 6253.

APS Addenda, p. 425, no. 7, pl. 116, fig. 6; *ESI*, p. 50, no. B92; Moret, *Ilioupersis*, pl. 64, 2.

(a) Amazonomachy, (b) four draped youths.

The bead-chain running down the chest of the rider from the clasp of his chlamys is unusual.

110 Once Vienna, Matsch coll.; later Lucerne Market.

CVA, Matsch coll., pls. 12–13; Lucerne, Galerie Fischer, *Sale Cat.* 21 June 1955, no. 108, ill. on pl. 2; *ESI*, p. 50, no. B93.

(a) Two young warriors and two women, (b) four draped youths.

Rim of (a): b.f. animals.

Bell-kraters

The first three of the following bell-kraters stand very close together in style and have very similar reverses.

*111 Naples 2149 (inv. 81423). (b) PLATE 7, 4.

APS, p. 17, no. 4; *ESI*, p. 50, no. B87.

(a) Maenad, silen and Dionysos running to r., (b) three draped youths.

112 Ruvo n.i. 20.

APS, p. 60, no. (v), where it was in error confused with another vase in Ruvo and associated with the Bendis Painter; *ESI*, p. 50, no. B88.

(a) Perseus leaning on pillar and reflecting the gorgoneion in the shield of Athena who stands beside it to l.; to r. seated Hermes with caduceus, (b) three draped youths.

113 Naples Stg. 302.

ESI, p. 50, no. B89.

(a) Eros adjusting kottabos-stand, nude youth holding cup and resting arm on stick, (b) two draped youths (as to l. and r. on the Ruvo krater).

114 B.M. F 161.

APS, p. 36, no. (iii), pl. 14, fig. 61.

(a) Silen playing the flute, maenad with kottabos-stand and situla, Dionysos with phiale, all running to l., (b) two draped youths.

In *APS* this vase was associated with the Tarporley Painter, but the treatment of the drapery of the youths on the reverse shows it to belong here; cf. also the obverse with that of no. 111.

Amphora

115 Bassano del Grappa, Chini coll. 67.

ESI, p. 50, no. B94.

(a) Woman dancing between standing nude youth with strigil and stick in l. hand, and seated woman juggling balls, (b) three draped youths.

The l. youth on the reverse is very like the corresponding ones on nos. 111–2 above.

The two following column-kraters, which are by the same hand, stand very close to the later phase of both the Sisyphus and the Ariadne Painters, especially in their treatment of the

draped youths on the reverses. The three-row ivy-leaf pattern on the neck of the Hillsborough krater (no. 116) finds a parallel on B.M. F 174 (no. 55) by the Sisyphus Painter and on Ruvo 1091 (no. 107) by the Ariadne Painter, and the rendering of the berries is very much in the manner of the latter; the reverse of no. 116 is also very close to that of the Matsch krater (no. 110), and it is not impossible that these two vases are by the painter himself.

We should also note:

(a) that the animals of the frieze round the rim of the obverses are black-figure (cf. no. 110 and no. 118 below);

(b) that the neck of the reverses is left black;

(c) that there is no meander pattern below the pictures, but only a narrow reserved band;

All these characteristics will also be found on several column-kraters by the Amykos Painter (e.g. *LCS,* nos. 177a, 178–182) and serve to emphasise the stylistic connexions between the two schools of Early South Italian vase-painting.

Column-kraters

116 Hillsborough (Calif.), Mrs. R.A. Hearst (ex San Simeon 5612).
 I.K. Raubitschek, *The Hearst Hillsborough Vases,* pp. 93–97, no. 27; Moret, *AntK* 15, 1972, pl. 29, 2; *ESI,* p. 50, no. B95.
 (a) Bellerophon on Pegasus approaching Iobates, (b) four draped youths.

117 Milan, "H.A." coll. 345.
 CVA 2, IV D, pl. 3, 1 and pl. 4, 1 and 3; *ESI,* p. 50, no. B96.
 (a) Amazonomachy: Greek with spear and Greek with shield and spear attacking mounted Amazon, (b) four draped youths.

To these two vases may now be added a third, a column-krater recently acquired by the Museum of Fine Arts in Boston, which has around the rim of its obverse a row of boars and lions which almost duplicates that on no. 117. The four youths on its reverse are also very similar to those on that krater, especially in the treatment of the fold-lines and the lower borders of their himatia. The subsidiary decorative patterns on the Boston krater, however, are more in the canonical tradition, with the standard "rosette" type of ivy-berries on the neck and a band of meanders and saltires below the pictures. The obverse depicts a boar-hunt and it is of interest to note that two of the participants wear native costume, one with the very common swastika designs on his tunic. We may therefore assume that the representation is not intended to have any specific mythological significance. The general setting, with a rocky landscape, recalls that of the Amazonomachy on the Milan krater, and somewhat similar pebbles appear also on Ruvo 654 (no. 89). The three-quarter face of the youth in the centre of the obverse recalls some of those on the krater no. 51 by the Sisyphus Painter himself, with whose work this vase is closely linked, as it is also with that of the Gravina Painter on whose volute-krater (no. 2/1 below) a spirited rendering of a more famous boar-hunt is represented, that of Meleager. (See also Addenda pp. 435–436.)

Column-krater

118 Boston 1970.236.
 Gli Indigeni, fig. 35; Vermeule, *BurlMag,* Feb. 1973, p. 118, fig. 69.
 (a) Boar-hunt, (b) four draped youths.
 Rim of (a): two pairs of b.f. lions and boars.

The following vases should be compared with the work of the Ariadne Painter:

(a)

Calyx-krater

119 Taranto, from Taranto (frr.).
 APS, p. 18, no. (i); detail of Athena: *ÖJh*, 1913, p. 173, fig. 89; *ESI*, p. 50, no. B97.
 (a) Theseus fighting the bull in the presence of Zeus and Athena, (b) Dionysiac scene (very fragmentary).

(b)

The following column-krater, also in bad condition, is similar in its decoration to nos. 116–7 above:

Column-krater

120 Syracuse 43981.
 (a) Long-haired youth with spear, woman wearing peplos with overfall and double stripe, Oscan youth with foot raised on rock, holding fur pilos upside down, Oscan youth wearing swastika-patterned loin-cloth with shield and spear, (b) four draped youths.
 Rim of (a): b.f. animals.

(c)

The drawing of the youths on the reverse of the vase no. 121 connects it with the work of the Ariadne Painter (cf. Ruvo 545, no. 105); the pattern-work (especially the leaves with serrated edges), and the drapery of the figures on the obverse are perhaps closer to the work of the Tarporley Painter.

Bell-krater

121 Newcastle, Laing Museum 19.1524 (ex Hope 209).
 Tillyard, *Hope Vases*, pl. 30, no. 209; *APS*, p. 36, no. (ii), Gloag, *Social History of Furniture Design*, p. 67 (ill.).
 (a) Maid with fan, and seated woman, between two nude youths, (b) three draped youths.

(d)

Connected with the work of the Ariadne Painter and also with that of the Sisyphus Painter is the following:

Bell-krater

122 Louvre K 7.
 APS, p. 11, no. (v), where it is said to be by an imitator of the Sisyphus Painter.
 (a) Papposilen and two maenads, one holding up tambourine, the other playing the flute, (b) nude youth between two draped youths, r. holding up strigil.
 Cf. the maenad playing the flute with the women on nos. 64 and 67.

CHAPTER 2

THE BEGINNINGS OF THE ORNATE STYLE

1. The Gravina Painter
2. The Painter of the Birth of Dionysos
3. The Argonaut fragments and other vases from Taranto
4. Vases connected with the Painter of the Birth of Dionysos

Introduction

Reference has already been made to the importance of the Sisyphus Painter among the pioneers of Apulian red-figure as being the first of them to decorate volute-kraters with mythological scenes in the grand manner (nos. 1/51–53) and thus to lay the foundations for the development of the "Ornate" style. For about half a century the "Plain" and "Ornate" styles run on parallel lines. The latter was obviously much better adapted for the representation of large-scale compositions illustrating mythological or dramatic subjects in which the principal characters wear richly-decorated costumes and are disposed on several different levels, sometimes around a temple, palace or other building. As we approach the middle of the fourth century, the "Plain" style is seen to fall increasingly under the influence of "Ornate", and we note a growing tendency towards a greater use of added white and yellow colour for details, of more varied adjuncts in the field, and of elaborate pattern-work. However, despite the rapid and extensive increase in the production of vases in the "Ornate" style during the second half of the fourth century, the "Plain" tradition of simple two- or three-figure compositions on vases of small or moderate dimensions never quite dies out, and such vases are still being made when the red-figure comes to an end about 300 B.C.

The painters in the "Ornate" style were clearly influenced by the many changes and developments that tool place in monumental painting at the end of the fifth century B.C. and the beginning of the fourth. The literary evidence suggests that painters such as Apollodoros, Agatharchos, Parrhasios and Zeuxis made innovations of the highest significance for painting, notably in the development of chiaroscuro and perspective, as well as in the rendering of character and emotion (see Robertson, *History of Greek Art,* pp. 411 ff.; and on *skiagraphia,* Eva Keuls in *AJA* 79, 1975, pp. 1–16, with comment by Elizabeth G. Pemberton in *AJA* 80, 1976, pp. 82–84), and all these features are reflected in the "Ornate" vase-paintings of the fourth century. In general, the "Ornate" style is characterised by the richness and elaboration of its decoration and by an increasing use of added colours, at first largely confined to white, yellow and red, but later extending to a wider range. The former element is seen not only on the costumes of many of the principal characters in the various scenes depicted on the vases – where it may, at least to some extent, be due to theatrical inspiration – but also in the floral ornaments, which from simple but elegant beginnings in the form of palmettes, move to elaborate designs which may justly be called "baroque" (cf. nos. 15/36–37 and 16/72, 77–79) and which may riot all over the surface of a vase, though they are more usually

confined to the areas below the handles, the necks of volute-kraters and the shoulders of amphorae and loutrophoroi. Such decoration is one of the hall-marks of later Apulian and is not found to anything like the same extent in the other South Italian fabrics, except at Paestum in the work of the Aphrodite Painter, who may well have been a migrant from Apulia (see Introduction to Chapter 8).

On the volute-kraters of the Sisyphus Painter very sparing use is made of added white, and then either in a natural context (e.g. for the white hair of the aged Laertes on no. 1/51) or to highlight a decorative pattern (e.g. the vine-leaves on the neck of no. 1/52). Adjuncts rarely appear in the field (no. 1/56), which is normally left plain black, although an occasional pair of *halteres* or some similar athletic symbol may be represented on the reverses (e.g. nos. 1/60 and 62), usually not out of context. The same is in general true of the work of the Gravina Painter and the earlier work of the Painter of the Birth of Dionysos, but on the volute-kraters in Naples and Brussels (nos. 8 and 9 below) there is a notable increase in the use of added white for details and for a wide variety of different objects; henceforth it will appear to an ever greater extent. By the time we come to the Felton Painter (Chapter 7, section 5) we may note its use for different adjuncts in the field above the pictures — ivy-leaves, dots, bunches of grapes, branches, etc. — and this practice is followed also by the contemporary painters of the "Plain" style (e.g. the Hoppin and Lecce Painters) and carried still further in the next generation by the followers of the Snub-Nose Painter.

The more ambitious subjects which the "Ornate" painters are able to employ to decorate the greater area now at their disposal on the surface of their larger vases lend themselves not only to the use of more elaborate costumes, appropriate to the great figures of mythology or drama, but also to experiments in the use of perspective and the rendering of spatial depth. At first the treatment is rather tentative (cf. nos. 10, 23, 24 below) and the pictures often look flat; but by the middle of the century, with the Lycurgus Painter, a reasonably satisfactory solution to the problem of creating an illusion of depth has been found, as may be seen from his Boreas and Oreithyia krater in the British Museum (no. 16/10 below), and the frequent representations of naiskoi on vases from the time of the Iliupersis Painter onward give scope for the study of the foreshortening of buildings (cf. B.M. F 283, no. 8/7 by the Iliupersis Painter, with B.M. F 352, no. 16/20, by the Lycurgus Painter).

Another noteworthy feature of "Ornate" Apulian is its fondness for the representation of rare, and sometimes inexplicable, mythological scenes. In this chapter nos. 2 (death of Stheneboia), 5 (rape of Thalia), 6 (birth of Dionysos), 11 (Alcmena), 23 (Herakles and Kyknos) fall into the first category, nos. 1 and 25 as yet in the second. This tradition persists throughout the life of the fabric and explains perhaps the popularity of such vases in the nineteenth century, when more attention was paid to subject-matter than to artistic merit.

It is unfortunate that so much of the work of the Early "Ornate" painters has come down to us only in the form of fragments and that, in consequence, it is not easy to draw a very clear picture of this phase in its development. Some of these fragments come from bell- or calyx-kraters of most impressive dimensions (e.g. no. 19), of which no complete specimens have survived. There are, therefore, considerable gaps in our knowledge and, although recent finds (e.g. at Policoro in 1963 and Gravina in 1974) have gone a little way towards filling them, the impossibility of a proper excavation of the ancient necropolis at Taranto, now buried beneath the modern city, makes it unlikely that we shall ever know the full story. The same restriction applies to the immediate followers of the Painter of the Birth of Dionysos like the Sarpedon and Black Fury Painters, whose work is discussed in Chapter 7, and it is not until these large

vases begin to be exported in quantity, or possibly manufactured in centres other than Taranto, that many complete examples become available for study in detail. Any conclusions that may be made about "Ornate" before the second quarter of the fourth century must therefore be regarded as somewhat tentative, especially as a comparatively small fragment may often give a rather misleading impression of the quality of the vase as a whole.

1. THE GRAVINA PAINTER

A tomb discovered at Gravina in 1974 contained, in addition to the two amphorae discussed above (nos. 1/96–7), a number of other vases among which are three of considerable importance, all the work of a single artist, to whom the name of the Gravina Painter may conveniently be given. These vases, which were found in a very fragmentary condition, are at the time of writing in process of reconstruction and restoration in the Taranto Museum and we are deeply grateful to Professor Lo Porto for making them available for study and for providing us with working photographs. The Gravina Painter is a new artist of considerable importance who stands stylistically in very close connexion with the Sisyphus Painter and whose work provides a link between him and the Painter of the Birth of Dionysos; he may thus be regarded as one of the pioneers of the "Ornate" style.

The three vases from Gravina (nos. 1, 2 and 3) stand close together in style and treatment. We may note in particular the drawing of the three-quarter faces, the rendering of the hair, the treatment of the women's drapery and of the nude male body; in all these, particularly in the first two, Sisyphean influence is extremely clear. The decorative patterns, the use of saltires and of crossed squares with the meanders, also follow his practice and that of the Ariadne Painter. The swan-heads at the handle-joins of the volute-krater, and the open-work volutes are, however, not Sisyphean and are more like those of the kraters by the Painter of the Birth of Dionysos; likewise, the elaborate palmette decoration below the handles is also very much in the latter's manner (cf. with that on nos. 6–9). The palmettes and scrolls are admirably drawn, and the two sphinxes which flank the lowest fan-palmette just above the meanders add a novel feature; they may be compared with the sphinxes beneath the handles on Oxford G 1002 (no. 20). It should be noted that added white is used only very sparingly.

The volute-krater (no. 1) is a remarkable vase; like the Sisyphus krater itself (no. 1/51), it gives us four unconnected mythological scenes, here, however, in two large-scale compositions on each main side, and two in smaller scale on the neck. On the obverse is an elaborate picture of the Calydonian boar-hunt with Meleager and his companions attacking the boar with a variety of weapons while, below, a youth endeavours to succour a wounded friend, a hound lying dead beside them. The landscape is indicated by clusters of rocks, trees, plants and reserved wavy lines to represent rising ground, from behind which to right a bearded silen looks on in wonder. The picture invites comparison with the simpler version of a boar-hunt on the Boston column-krater associated with the Ariadne Painter (no. 1/118); the resemblance between the poses and, in particular, the heads of the two principal figures is striking. The landscape elements are also very similar and may be compared as well with those on nos. 1/109, 117 and 119.

For the interpretation of the main scene on the reverse, there are as yet no parallels to guide us. It is divided vertically on the left by a tall Ionic pillar on which is a statue of Eros in white, and horizontally across the middle by a band of egg-pattern supported on two Ionic columns painted in added pink, giving the effect of two separate levels, almost as on the Sisyphus krater (no. 1/51) where the registers are actually so divided. Behind the pillar is a staircase leading to the upper level, down which a girl is carrying a stool and beside which stands a

youth with another stool. On the upper level to the right of the pillar is a draped woman, draw-ing a veil up over her head as she moves away from the other figures — a youth with a strigil talking to another who wears a pilos, a seated bearded figure with his hand on his head, look-ing puzzled, beside whom, on a couch, is seated an elaborately dressed person, holding a sceptre, with a short cloak drawn on to the head with the effect of a veil [the sex of this figure is not obvious; the veil and costume suggest that it may be a woman (cf. with the woman to right by the incense burner), though the possibility of its being male cannot be altogether ruled out]. Beside this person is a nude youth reclining on the couch; his left hand touches the other's wrist and his right is stretched out in front of the right thigh of a youth standing nearby adjust-ing his petasos; next to him is a nude youth holding his horse by the bridle. These two might well be the Dioskouroi, in which case the youth on the couch might be drawing attention to the scar on Castor's thigh, the result of a wound he received while fighting Aphidnos for the rescue of his sister Helen (Schol. *Iliad* iii, 242). On the lower level, below the dividing band of egg-pattern, a woman on a couch is being embraced by a youth, while an Eros, perched on a cushion behind them, bends forward over his raised right leg to hold a wreath above their heads. To the right a woman puts incense on a thymiaterion. In the centre a seated Aphrodite watches the proceedings with interest. Another Eros flies by her with a fillet in his hands, and from the left a draped woman comes up with a ball or a cake in her hands.

No convincing explanation has yet been made, but the scene may be associated with the story of Helen of Troy, showing in the upper level Paris in Sparta, with Helen and Menelaus, who has handed his sceptre over to her as he is about to set out for Crete. According to legend, when Paris and Helen departed for Troy they took some of the household furniture with them, and the taking away of the stools by the two servants may be a reference to this. In the lower level we may see the next stage in the story, with Paris embracing Helen in the approving pre-sence of Aphrodite, who has now fulfilled her promise made at the time of his famous judge-ment.

Another possible interpretation, recently suggested to us by Dr. Margot Schmidt, is that the scene may represent the arrival of Jason and the Argonauts at Lemnos; in that case the figure with the sceptre would be Hypsipyle and her appearance and dress give the impression of an "emancipated" woman, which would be very appropriate. The bearded man might be one of the seers who accompanied the Argonauts on their expedition. The scene below might represent the aftermath of the visit with Jason making love to Hypsipyle. Neither version seems completely convincing and we may well have here an illustration of a legend with which we are not otherwise familiar.

The scene on the neck of the obverse shows the death of Actaeon, on whose head the stag's horns are clearly visible and who is attacked by two of his hounds, maddened by Lyssa on the right and urged on by Artemis on the left, in the presence of a youth (? Pan) with a syrinx and a bearded silen with hands upraised in a gesture of surprise. Behind some rising ground appears the head of a fawn. On the other side is an Amazonomachy, recalling those on some of the Sisyphean kraters (e.g. nos. 1/52 and 90; cf. also the reverse of nos. 6 and 9 below, by the Painter of the Birth of Dionysos).

The two amphorae (nos. 2 and 3), which in shape are close to the other pair from the same tomb (nos. 1/96—7) and to the one attributed to the Ariadne Painter (no. 1/115), also have subjects of some interest on their obverses. The first (no. 2) shows the death of Stheneboia. According to the version of the legend used by Euripides in his play *Stheneboia* (T.B.L. Webster, *Tragedies of Euripides*, p. 81), when Bellerophon returned after slaying the chimaera he induced

Stheneboia to mount Pegasos and then threw her off into the sea near Melos. This is the main scene on the amphora. Bellerophon on Pegasos occupies the middle of the composition; he looks down without pity at Stheneboia plunging headlong into the sea, represented symbolically by a couple of dolphins, some fish and a squid, with Poseidon and Triton on the right, and Aphrodite and Eros to the left. Only one other representation of this event is known to us, on a polychrome vase in Leningrad, which has been thought to be modern (see Brommer, *VL³*, p. 298).

The other amphora (no. 3) shows the statue of a young warrior holding helmet and shield; it stands upon a square plinth, in front of which is a black amphora and on the base a row of offerings. A draped woman to right is about to crown the statue, and around it are two more women and two youths, with wreaths or other offerings in their hands. It is the prototype of the sort of scene which is to become common in Apulian vase-painting, especially with the school of the Iliupersis Painter and his followers (for the black eggs and vases cf. nos. 8/1 (b), 26, 103, 110 and for the statue no. 8/12). The youth to right, who leans against a pillar, with his left leg crossed in front of the right, has a somewhat sculptural look and his pose anticipates that later made popular by Praxiteles and repeated on many vases around the middle of the century.

The reverses of both amphorae, which are preserved only in part, show two pairs of figures, each consisting of a nude youth with a seated woman, and a nude youth with a standing woman. The poses and drawing of these figures may be compared with those on some of the vases by the Dinos Painter (e.g. Syracuse 30747 = *ARV²* 1153, 17); they also strongly recall those on the reverses of vases in the Policoro Group (*LCS*, pp. 55 ff., nos. 283, 287–9, pls. 25, 4; 27, 6; 28, 2) and, in particular, on the obverse of Munich 3275 by the Amykos Painter (*LCS*, p. 49, no. 250, pl. 20, 2); such close parallels provide a convenient check for the dating. The nude youths may also be compared with several of those on vases by or associated with the Sisyphus Painter (e.g. nos. 1/78, 89 and 91) or on no. 1/115 by the Ariadne Painter.

All three vases have a number of stylistic features in common – in particular, the drawing of the three-quarter face, the rendering of the drapery, often (especially on nos. 2–3) with a double black stripe running down it (cf. with the Parasol Painter and, in Attic, with the Dinos Painter; also with Munich 3275), and the elaborate pattern-work.

The influence of the Sisyphus and the Ariadne Painters is very clear, both on the drawing and in the composition: compare the two seated women on no. 3 with similar figures by the former (especially on no. 1/52) and Bellerophon on no. 2 with his counterpart on Ruvo 1091 (no. 1/107), whom he very closely resembles.

Together with the three Gravina vases were found some fragmentary Attic pieces, including two which have been attributed to the Eretria Painter. His main activity may be placed between c.430 and 410 B.C. and thus their presence provides welcome external evidence for the likely dating of the Gravina Painter's work which, on stylistic evidence and by comparison with the work of the Dinos Painter, the Policoro vases and the Amykos Painter's Munich amphora, must be placed at the very end of the fifth century B.C.

Volute-krater

* 1 Taranto, from Gravina. PLATE 8, 1–2.
 (a) Calydonian boar-hunt, (b) uncertain mythological scene.
 Neck: (a) death of Actaeon, (b) Amazonomachy.

Amphorae

* 2 Taranto, from Gravina. PLATE 8, 3.

(a) Death of Stheneboia: Bellerophon on Pegasus, with Stheneboia plunging into the sea; to l. Aphrodite and Eros, to r. Poseidon and Triton, (b) two nude youths and two women.

* 3 Taranto, from Gravina. PLATE 8, 4.

(a) Three women and two youths beside the statue of a young warrior, (b) nude youth and seated woman, nude youth and standing woman.

Another vase, formerly in Nostell Priory and sold in 1975 on the London Market, may be attributed to this painter:

Bell-krater

4 Once London Market, Christie's, *Sale Cat.*, 30 April 1975, no. 21, pl. 6, 3–4 (ex Nostell Priory).

(a) Silen with torch and situla, Dionysos with thyrsus, and maenad with tambourine, (b) three draped youths.

The similarities in style of drawing with nos. 1, 2 and 3 are quite striking, especially the three-quarter face of Dionysos, the ecstatic maenad with her fluttering scarf and filmy drapery with double stripe, and the bearded silen. Although the draped youths on the reverse cannot be compared with any of the figures on the other vases by the Gravina Painter, they show a distinct influence of the Sisyphus Painter (cf. the youth to r. with those on nos. 1/58, 60, 63–6) and the Ariadne Painter (cf. with no. 1/107 and 115, also 117 and 118).

The following vase, particularly on account of the rendering of Thalia who, with her double-striped drapery, and slightly protruding breast, strongly resembles a horizontal version of the falling Stheneboia on no. 2, is probably also to be attributed to this painter:

Hydria

5 Trieste S 437.

CVA 1, IV D, pl. 1, 1–2; Schauenburg, *AuA* 10, 1961, pl. 14, fig. 27.

Rape of Thalia.

2. THE PAINTER OF THE BIRTH OF DIONYSOS

Bibliography

C. Watzinger in FR iii, pp. 340–350 (on Amsterdam 2579 and Naples 2411), with lists of related vases on pp. 348–9 (= W.).
Noël Oakeshott, 'The Dionysiac Painter', in *JHS* 55, 1935, pp. 230–232.
A.D. Trendall, *FI,* pp. 28ff. and 42; *VIE* i, p. 70; *ESI,* pp. 21–22 and 53–54.
A. Stenico, 'Dionisiaco, Pittore', in *EAA* iii, p. 111.
A.D. Trendall and Alexander Cambitoglou, 'The Painter of the Birth of Dionysos' in *Mélanges Michalowski* (1967) pp. 675–699 (= *PBD*). (This is a full discussion of the painter; the numbers of the vases in the list are here given in brackets immediately after the serial numbers).

The Painter of the Birth of Dionysos was originally named the Dionysiac Painter by Mrs. Oakeshott, who included among the vases attributed to his hand the calyx-krater B.M. F 275 which has a Dionysiac theme. Since this vase, however, has now been transferred to the Painter of Athens 1714 (no. 8/151) and the old name has caused some confusion (especially in translation), we felt it wise to rename the artist after the principal subject of his volute-krater in Taranto (no. 6; Pl. 9, 1), which is of considerable rarity in South Italian vase-painting.

The centre of this scene is occupied by the seated figure of Zeus, from whose thigh the infant Dionysos emerges with hands outstretched towards Hera Eileithyia. The importance of the central group is emphasised by inscriptions to identify Zeus and Dionysos. Grouped around at a slightly higher level are Eros and Aphrodite, Pan, Apollo and Artemis, and on a lower level three women, perhaps Moirai, Hermes and a silen, who seems to be starting backwards with a

gesture of astonishment. The composition should be compared with that on the obverse of the Kadmos Painter's volute-krater in Ruvo (1093; Sichtermann, K 10, pl. 12; here Pl. 1, 4), where a remarkable similarity will be noted in the poses and arrangement of the figures. On the reverse is an Amazonomachy, which should be compared with those on the reverses of Ruvo 1096 (no. 1/52 by the Sisyphus Painter) and of B.M. F 158 (no. 1/90), since all three are linked by repeated figures or groups (e.g. the duel group below on the Ruvo and Taranto kraters, the dead Amazon on B.M. F 158 and no. 6, the mounted Amazon on all three), which perhaps indicates a common source of inspiration, perhaps a lost great painting. On the neck of the obverse is a centauromachy, one of the two groups of which shows a centaur biting into a Lapith's neck a traditional motif in such representations (cf. especially the Phigaleia frieze, B.M. 527 — Kenner, *Der Fries,* pl. 8; Hofkes-Brukker and Mallwitz, *Der Bassai-Fries,* p. 50 — dated to c.415 B.C.), which is repeated on nos. 8 and 12. On the reverse a youthful Herakles, feasting after his labours, is served by three young satyrs (cf. the reverse of no. 10), a subject perhaps of theatrical inspiration.

The Taranto krater is one of the most impressive pieces of the early "Ornate" style. Among its characteristic stylistic features we may note the treatment of the drapery folds, which should be compared with those on vases by late-fifth and early-fourth century Attic painters, especially of the Meidian school, the pearl-like quality of the eyes (e.g. of Aphrodite and Apollo), the disposition of the figures, which seldom overlap and are less formal than those of the Sisyphus Painter, the soft bodies, the solemn, placid faces and the statuesque poses. We should also note his use of dot-clusters on the drapery, derived from the Sisyphus Painter. The painter's taste for ornament may well be seen in the rich floral pattern below the handles, which consists of a central cross of palmettes rising from an acanthus and surrounded by small palmettes, tendrils and rosettes. Comparatively little use is yet made of added white, except for minor details.

Closest in style to no. 6 are the two fragmentary calyx-kraters (nos. 10 and 11), both of which show the same refinement of drawing (cf. the three-quarter faces of Apollo and Alcmena) and have inscriptions to designate the principal figures. The Amsterdam krater (no. 10; Pl. 9, 2) is of particular interest for its representation of the statue of Apollo inside a temple, beside which the god himself is seated. The treatment of the statue, seen through the foreshortened open doors, is noteworthy, since the artist has covered the figure with white, gold and brown paint, with a masterly use of shading and high-lights, in an attempt to reproduce the appearance of a bronze sculpture. Also of interest is his essay in perspective in the drawing of the temple itself, where he shows us one side, with five Doric columns, although he has failed to relate the recession of their capitals to the architrave above (see Robertson, *History of Greek Art,* p. 430 and Richter, *Perspective,* p. 47). Apollo should be compared with his counterpart on no. 6, whom he strongly resembles; the maenad in the Dionysiac scene on the reverse reproduces in her head and face the female figure below Aphrodite on that vase. Very little remains of the reverse of no. 11, but the double black stripe down the drapery of the woman with the tambourine recalls the work of the Gravina Painter; Alcmena on the obverse is like Aphrodite on no. 6.

The Ruvo krater (no. 7) is unusual in both shape and decoration. The shape is more squat than that of no. 6 and nearer to Sisyphean kraters (e.g. no. 1/52); it recalls Attic prototypes (e.g. New York 24.97.25 = Richter and Hall, pl. 171, 128) and the ribbing on the upper part of the body gives it a metallic look. The figure decoration consists of four chariots running in a continuous frieze round the lower part of the vase, and giving the impression of a procession

rather than a race. The horses should be compared with those on the reverse of no. 6, and the face of the charioteer beside the rearing horse on the reverse is very typical of the painter's work. The subsidiary scenes on the neck show Orestes at Delphi and a woman running between two youths.

The two remaining volute-kraters (nos. 8–9) are both slightly later and show an increased use of added white and yellow paint; there are, however, many connecting links between them and the other vases, in the drawing of the drapery, the rendering of the faces and in the pattern-work. The flute-player on the neck of the reverse of no. 9 reminds us of the one on Louvre K 7 (no. 1/122), but the silen (cf. no. 6) and the figures of Dionysos and Ariadne on the obverse are very characteristic of the painter's work. We should note a new element of harshness in the drawing of the three-quarter faces, which now begin to assume the tormented look which we find on those drawn by the Iliupersis Painter and, even more, by his successor, the Lycurgus Painter. We can appreciate this new feature better by comparing the face of the central Greek in the lower register of the Amazonomachy on no. 9 with the figures of Theseus or Achilles on nos. 8/2 and 9 by the Iliupersis Painter.

Comparisons with Attic vases in regard to shape, drapery (e.g. Arezzo 1460, ARV^2 1157, 25, manner of the Dinos Painter), and the drawing of the face and eyes (e.g. Berlin F 2471, ARV^2 1247, 1, by the Eretria Painter), as well as with the work of the Sisyphus Painter, from whom the Painter of the Birth of Dionysos obviously drew a substantial measure of inspiration, suggest a date between the end of the fifth century B.C. and c.385 for the greater part of the latter's work. He had a very considerable influence not only on his contemporaries and followers, whose work has unfortunately come down to us only in very fragmentary form, but on the whole subsequent development of the "Ornate" style of Apulian; significant, too, is the fact that the strong links which we see between his work and contemporary Attic grow progressively weaker as "Ornate" Apulian begins to move after him along its own particular path.

Volute-kraters

* 6 (1) Taranto I.G. 8264, from Ceglie del Campo. PLATE 9, 1.
 JHS 54, 1934, pls. 8–9; *FI*, pl. 31 = *ESI*, no. B166; *CVA* 2, IV Dr, pls. 19–26; Cook, *Zeus* iii, pl. 13, 1–2; Rumpf, *MZ*, pl. 38, 5; *EAA* iii, p. 111, fig. 141; Herbig, *Pan*, pl. 26; Séchan, *Les grandes divinités*, pl. 24; Trendall, *Ceramica,* pl. 20; Belli, *Tesoro di Taras,* ills. on pp. 164–7; details: *PBD*, figs. 1–3; Borda, p. 34, fig. 25; Richter, *Furn.²*, fig. 344; Lipsius, *Alexander the Great*, p. 83.
 (a) Birth of Dionysos, (b) Amazonomachy.
 Neck: (a) Centauromachy, (b) Herakles served by satyrs.

 7 (3) Ruvo 1494, from Ruvo.
 Japigia 3, 1932, p. 265, fig. 46; Sichtermann, K 38, pls. 56–59; *PBD*, figs. 6–8; *ESI*, no. B168.
 Photos: R.I. 62.1339–41; 64.1182–6.
 Body: below, all around – chariot race.
 Neck: (a) Orestes at Delphi, (b) woman running between two youths.

 8 (2) Naples 2411 (inv. 82922), from Ruvo.
 FR, pls. 175–6; Bieber, *JdI* 32, 1917, p. 43, fig. 16; Pfuhl, *MuZ*, fig. 801; Spinazzola, *Arti*, pl. 206; Matz, *Dionysiake Telete*, p. 35; *PhV²*, no. (xxiii); Bieber, *Hist.²*, p. 27, fig. 95; *PBD*, fig. 5; *FI*, no. 92 = *ESI*, no. B167.
 (a) Sacrifice to Dionysos, (b) Centauromachy.
 Neck: (a) chariot scene, (b) four youths.

* 9 (4) Brussels A 1018, from Bari. PLATE 10.
 Millingen-Reinach, pls. 36–38; *CVA* 1, IV Db, pl. 1; W., p. 348, no. 1; *FI*, no. 93 = *ESI*, no. B169;

Volute-kraters (continued)

> *PBD,* figs. 9–10 and 17; Moret, *Ilioupersis,* pl. 63, 1.
> (a) Apotheosis of Herakles, (b) Amazonomachy.
> Neck: (a) Komos, (b) libation to warrior.
> The scene on the neck carries on the Sisyphean tradition.

Calyx-kraters (fragmentary)

* 10 (5) Amsterdam 2579 (*Gids* 1486), from Taranto.　　　　　　　　　　　　PLATE 9, 2.
> FR iii, pp. 340 ff., figs. 160–1, pl. 174 and p. 348, no. 6; *FI,* no. B97, pl. 32 = *ESI,* no. B170;
> *Gids,* pl. 77, 2; Rumpf, *MZ,* pl. 38, 8; Reuterswärd, *Polychromie,* p. 125, fig. 20; *PBD,* figs. 11-13;
> Borda, p. 35, fig. 26; *Cl.Gr.Art,* fig. 361 (colour); Richter, *Perspective,* p. 47, fig. 198; Gjödesen,
> *Medd. Ny Carlsberg Glypt.,* 27, 1970, p. 53, fig. 59; Schneider-Herrmann, *BABesch* 47, 1972, p. 32,
> fig. 1; Robertson, *History of Greek Art,* p. 430, pl. 133b.
> (a) Apollo and Artemis beside a temple in which is a statue of Apollo, (b) thiasos: Dionysos
> with narthex, maenad with tambourine, silen with kantharos.

11 (6) Taranto I.G. 4600, from Taranto.
> *Arch Reps,* 1955, pl. 5c; Schauenburg, *AuA* 10, 1961, pl. 13, fig. 25; Dörig, *JdI* 80, 1965, p. 157,
> fig. 10; Paribeni, *Immagini,* pl. 14 (colour), no. 12; *LAF,* no. 140 (ill.); Degrassi, *BdA* 50, 1965, fig.
> 54; Webster, *MTSP*2, no. TV 42, pl. 8a; *PBD,* figs. 14–16; *Ill.Gr.Dr.* III.3, 6; Belli, *Tesoro di Taras,*
> pp. 162–3; *ESI,* no. B171.
> (a) Alcmena on the pyre, with Amphitryon (inscribed) beside it and Eros above, between Zeus
> seated to l. and Hermes to r., (b) youthful Herakles, with maenad to l.

Lekanis lid

12 (7) Bari 1616.
> Watzinger, *ÖJh* 16, 1913, pp. 158–9, figs. 81a–b; FR iii, p. 348, no. 13; *PBD,* figs. 18–21; *ESI,*
> no. B172.
> Centauromachy (four pairs of Lapiths and centaurs in combat).

Fragments

13 (8) Once Rome, L. Curtius.
> *PBD,* fig. 4; *ESI,* no. B173. Photos: R.I. 37.445–6.
> Head of goddess.
> The drawing of the eye on this fragment is very close to that of Hermes and of one of the seated
> Moirai on the obverse of no. 6 — the eyebrow is not a continuous curving line, but consists of two
> almost straight lines meeting at an obtuse angle.

The same treatment of the eyebrow will be noted on the following fragment which, if not
by the painter himself, is very close to him in style:

Fragment (from a krater)

14　Heidelberg 26.87a.
> Schauenburg, *AntK* 5, 1962, pl. 19, 3; *APS,* p. 11, no. (iii); *CVA,* pl. 74, 1.
> Helios.

3. THE ARGONAUT FRAGMENTS AND OTHER VASES FROM TARANTO

(a) THE ARGONAUT FRAGMENTS

The following fragments in Taranto are of unusually high quality, comparable with the
finest work by the Painter of the Birth of Dionysos. Particularly noteworthy is their stylistic
connexion with the later work of the Dinos Painter and of his followers like the Pronomos and
Talos Painters (whose name vases were both found at Ruvo), clearly visible in the drawing of

the heads and the rendering of the drapery; one should compare, for example, the profile head of Apollo on no. 15 or the three-quarter head of Hera on no. 17 with the heads on the calyx-krater Villa Giulia 2382 (near to the Talos Painter; ARV^2 1339, 4 = Hahland, *Vasen um Meidias,* pl. 13) or on the fragments of a volute-krater in Leningrad (KAB 33a; ARV^2 1408, 1 = Hahland, pl. 17a) by the Painter of the New York Centauromachy. The Argonauts are also represented on a large unpublished bell-krater in Gela, which is a later work of the Dinos Painter; this and the other Attic vases mentioned above fall into the period between c.410 and 390 B.C. and thus confirm the date we have suggested for the Painter of the Birth of Dionysos and his contemporaries.

It is possible that all three fragments formed part of the same calyx-krater; the last two (nos. 16–17) certainly come from the same vase. On the former we have the lower part of Aphrodite's body with the leg of Eros beside it; on the latter we see the top of her head and the tip of one of his wings. The drapery is richly decorated; over the breasts of Hera on no.17 it has a multitude of fine, dense fold-lines. Parallels to both will be found in Attic on the Talos krater in Ruvo (Sichtermann, K 14, pls. 27–29), on which the Argonauts' ship is also depicted; for the fine fold-lines we might also compare Aphrodite on the Birth of Dionysos krater. The palmette decoration on the rim finds a parallel in the lower band on the Gravina krater (no. 1); similar palmettes will be found on the neck of the Cadmus Painter's volute-krater in Ruvo (Sichtermann, K 10, pls. 12–13; ARV^2 1184, 1; here Pl. 1, 4). We have already noted that a number of Attic vases of the end of the fifth century had found their way to Ruvo and other Apulian cities, and these may well have provided the models for the early "Ornate" artists not only in shape and decoration, but also in the rendering of drapery, the posing of the figures, and the composition.

Fragments (of calyx-kraters)

* 15 Taranto 12570, from Taranto. PLATE 11, 1.
 Paribeni, *Immagini,* no. 7, ill. on p. 5; Trendall, *Ceramica,* pl. 21, 1–2.
 Herakles, Apollo, Hermes and two youths with petasoi (? Dioskouroi); woman with palm-branch.
 16 Taranto 54946, from Taranto.
 Trendall, *Ceramica,* pl. 21, 3.
 Forepart of animal (? deer), back hair of female figure; Argonaut, youth seated by prow of ship with *aphlaston,* seated female figure beside whom is the leg of a boy (= Aphrodite and Eros on no. 17); below: head of man wearing pilos beside a laurel-tree.
 17 Taranto 54943, from Taranto.
 Wing of Eros, top of Aphrodite's head, Hera with sceptre, winged figure (? Nike).

(b) TWO FRAGMENTARY CALYX-KRATERS

The two following vases, preserved only in part, are connected in style with the above and with the Painter of the Birth of Dionysos. Both have round the rim palmette decoration similar to that on no. 17. The first (Pl. 11, 2) shows Perseus terrifying silens with the gorgoneion in the presence of Athena (cf. the Karneia krater, *LCS,* p. 55, no. 280, pl. 24, 1–2), perhaps a reflection of a contemporary satyr play. The three-quarter face of Perseus, the drapery with wave borders, star-patterns and very fine fold-lines is comparable to that on the fragments above, but the drawing of the faces is less refined. Very little of the reverse remains, but it must have represented a Dionysiac scene, and the face of the maenad should be compared with that of the woman shading her eyes on the fragment Taranto 12566 (no. 21).

The other calyx-krater, of which only a fragment of the obverse remains, has unfortunately

suffered greatly at the hands of the restorer, who has redrawn the heads or faces of nearly all the figures, thus making a precise attribution almost impossible. However, the rendering of the drapery with its wave borders and star-patterns, and, in particular, the meander borders on the veil of the woman to the left, which look back to those on the Ruvo volute-krater by the Sisyphus Painter (no. 1/52), certainly give the vase a place in the present context. The scene shows Oedipus in front of the Sphinx, originally of singular beauty, with pearl-like eyes and soft, wavy hair. Behind him is a man in regal garb, perhaps Creon, and in the background a bearded man wearing a pilos, a richly draped woman, and a figure with white hair (very heavily restored); a couple of trees at different levels beside the rock on which the Sphinx is perched give a landscape setting to the scene. The vase is of considerable size, as were many of the other vases of this period that have survived only in fragments.

Calyx-kraters (frr.)

* 18 Taranto 124007, from Taranto. PLATE 11, 2.
 Arch Reps 1967, p. 42, fig. 12; *Ill.Gr.Dr.* II, 14.
 (a) Perseus terrifying silens with the gorgoneion in the presence of Athena, (b) missing, except
 for part of a satyr holding a situla, a maenad with a tambourine, and the shoulder and arm of a
 nude male figure.
 19 Taranto 106581, from Taranto.
 Paribeni, *Immagini,* no. 9, pl. 9.
 (a) Oedipus and the Sphinx, (b) missing.
 For the double dot-stripe running down the drapery of the woman to l., cf. B.M. F 158 (no.
 1/90), and Oxford G 1002 (no. 20).

4. VASES CONNECTED WITH THE PAINTER OF THE BIRTH OF DIONYSOS

With the exception of the volute-krater Ruvo 1088 (no. 23), all the vases in this section have come down to us only in a sadly mutilated or fragmentary state. Their connexion with the Painter of the Birth of Dionysos is clear from the treatment of the drapery and the drawing of the faces, but beyond that it does not seem at the moment feasible to go.

(i) CLOSELY CONNECTED WORKS

Hydria

 20 (9) Oxford G 1002. Recomposed from fragments, with much missing.
 PBD, fig. 22—24.
 Seated Dionysos surrounded by maenads and silens.

Fragments

 21 (14) Taranto 12566, from Taranto (from a hydria).
 Paribeni, *Immagini,* no. 8, pl. 8; *PBD,* fig. 30.
 Woman with sword (? Agave), Dionysos in stag-drawn chariot, woman shading her eyes.
 22 (15) Amsterdam 2555 + 3525 B—C (*Gids* 1491—2), from Taranto (probably from an amphora).
 PBD, figs. 28—29.
 Amazonomachy.

The Oxford hydria (no. 20) is connected with the Painter of the Birth of Dionysos by the treatment of the three-quarter face of the seated Dionysos and by the maenad standing to the right. The two sphinxes beneath the handles recall those on the Gravina krater (no. 1). On the Taranto fragment (no. 21) is a robust woman holding up a sword in her l. hand; the scene probably represents the death of Pentheus, and, if so, she may well have been holding his

in her missing right hand. Behind her is Dionysos in a stag-drawn chariot, which again reminds us of the Phigaleia frieze (B.M. 523; Kenner, pl. 4; Hofkes-Brukker and Mallwitz, pp. 60–62). Below is the upper part of a maenad shading her eyes with her right hand and holding what looks like the leg of an animal in her left. The fragments in Amsterdam, which seem to have come from an amphora rather than a hydria, depict an Amazonomachy of the sort with which we are already familiar in the work of the Sisyphus Painter and the Painter of the Birth of Dionysos. We have again the dead Amazon (cf. no. 1/90 and no. 6 above), here with her breasts shaded to emphasise their roundness, and with very prominent nipples (as on no. 21). The three-quarter faces of the two Greek warriors, both of whom wear piloi, are very like that of Agave on no. 21 and may also be compared with those on the reverse of Brussels A 1018 (no. 9).

(ii) LARGER VASES CONNECTED WITH THE PAINTER

This division contains the larger vases connected with the Painter of the Birth of Dionysos, which have survived intact or to a reasonable extent.

Volute-krater

23 (10) Ruvo 1088, from Ruvo.
 Bull.Nap. 1, pl. 6; W., p. 348, no. 5; *Japigia* 3, 1932, p. 263, fig. 44; *FI*, no. B94 = *ESI*, no. B174; Sichtermann, K 42, pls. 69–71; *PBD*, figs. 25–27; *Cl.Gr.Art*, figs. 357–8; *Popoli e Civiltà dell' Italia antica* ii, pl. 111. Photos: R.I. 62.1362, 64.1174–6.
 (a) Herakles and Kyknos, (b) thiasos: seated maenad and silen with situla, woman pouring libation to Dionysos, seated Silen.

Calyx-kraters (fragmentary)

* 24 Taranto 52265, from Taranto. PLATE 12, 1.
 Arias, *RivIstArch* 1955, p. 113, fig. 22; Schneider-Herrmann, *BABesch* 32, 1957, p. 39, fig. 9 (detail); Schauenburg, *AntK* 5, 1962, pl. 18, 2; *BJbb* 161, 1961, p. 42, 1; *EAA* vi, p. 235, fig. 251; Paribeni, *Immagini*, no. 10, pls. 10–11; *LAF*, no. 15, (ill.); Moret, *Ilioupersis*, pls. 2–3 and 60, 1.
 (a) Gigantomachy, (b) Rape of Cassandra.

* 25 Taranto 52230, from Via Giovine (Aug. 1952). PLATE 12, 2.
 Arch Reps 1955, pl. 5a–b; *AA* 1956, 223, figs. 17–21; Paribeni, *Immagini*, no. 11, pls. 12–13; (b) Simon, *Portlandvase*, p. 11, pl. 9, 1.
 (a) Thersites, Menelaos, Odysseus, Leda, Helen and the egg of Nemesis; Aphrodite and Eros, a Dioskouros beside a palace in which are three figures, one standing and two seated, (b) Dionysos and the deserted Ariadne, with Theseus departing to r. towards his ship.

The Ruvo krater (no. 23) differs somewhat in shape from the other volute-kraters discussed in this chapter, in that the body is more squat (cf. Ruvo 1494, no. 7), and the neck curves in more sharply (cf. with the Sisyphean kraters, nos. 1/51–53) and is left undecorated. The subject of the obverse, for which several interpretations have been put forward, probably represents the moment before the combat between Herakles and Kyknos. The latter used to prey on passing travellers, especially pilgrims to Delphi, and thus incurred the wrath of Apollo, who aroused Herakles against him (Hesiod, *Shield,* 68 ff.). The two met in single combat and Kyknos was slain; Ares intervened to avenge his son's death, but Athena changed the course of his spear and it failed to harm Herakles, who indeed managed to wound him in the thigh so that he had to return to Olympus. On the Ruvo krater the two combatants occupy the centre, with Apollo standing between them at a slightly higher level. Both wear helmets and greaves and carry shields; the normal accoutrements of Herakles (bow, lion-skin and quiver) lie at his

feet. Behind him is Athena, who holds his spear as well as her own, and above a Fury is seated. To right is a frontal chariot, its driver (who may well be Ares himself) wearing a black cuirass (cf. no. 4/140), like the Thracian's tunic on no. 1/12, with a helmet and a flapping cloak, and in the corner is a Scythian trumpeter, to give the signal for the start of the combat. Above the head of Kyknos is an eagle with a snake in its claws — an omen of disaster for him (cf. *Iliad* xii, 200 ff.).

In style the vase seems very near to the later work of the Painter of the Birth of Dionysos; it lacks the austere elegance of his name vase, and stands closest to Brussels A 1018 (no. 9).

Noteworthy is the disposition of the figures on the obverse, with their mannered poses, somewhat after the Meidian fashion, and the attempt at foreshortening, as seen in the horses of the chariot (cf. Pliny *NH* 35, 126 on Pausias, who 'devised an innovation ... wishing to display an ox's length of body, he painted a front and not a side view of the animal and yet contrived to show its size'). We see here the beginning of a pictorial trend which is destined to develop steadily during the coming decades. The reverse figures a Dionysiac scene, a forerunner of what is to become a standard type on many of the volute-kraters by the Iliupersis and Lycurgus Painters and their followers.

The gigantomachy on the Taranto krater (no. 24; Pl. 12, 1) also invites comparison with Brussels A 1018 (no. 9; Pl. 10, 1), the composition following very similar lines with the quadriga dominating the centre, though here it is facing in the opposite direction, and below we have a scene of conflict instead of peace. Again we note the richly patterned drapery, with its multiple fine fold-lines (e.g. on Nike), the drawing of the faces in three-quarter view; the shield of the figure below Zeus in the chariot should be compared with that of Herakles on no. 23, both have the same black interior, with a laurel pattern. On the reverse is a spirited version of the rape of Cassandra, with Ajax dragging her violently from the sanctuary of the altar, to the horror of the white-haired priestess who runs off to left with the temple-key. Above to right Athena looks down on the defilement of her shrine with a somewhat petulant look, and below a female attendant raises her hand in a gesture of dismay. The drawing of the temple is of interest for comparison with that on no. 10; here we see three columns on either side, the facade has a triglyph-metope frieze and the ceiling-beams are shown, although the painter is far from having mastered the principles of perspective. Both subjects will prove to be popular with later Apulian vase-painters. Round the rim are opposed palmette-fans similar to those on nos. 17—19.

The other calyx-krater (no. 25; Pl. 12, 2), is unfortunately even less well preserved and much of the central portion of the obverse is missing, making the full interpretation of the picture extremely difficult, despite the inscriptions which identify the surviving figures on the left as Thersites and Menelaos above, and Leda, Helen and Odysseus below. In the centre is a building resting on a base of squared blocks; it has a pediment with acroteria, of which scanty traces remain. Within it stands a nude youth, next to whom is a richly-draped figure seated upon a folding-stool and holding a sceptre (or staff); he is, therefore, presumably a king and he faces a woman dressed in a black robe and seated on a couch. To the right of the building was a nude youth beside his horse, and above, Aphrodite with Eros. The scene is certainly closely concerned with the legend of Helen, who appears as a young girl seated upon her mother's lap and holding in her hand the black egg of Nemesis. We may well have here a representation of Helen restored to her home and parents in Sparta by the Dioskouroi after her abduction by Theseus. In that case the two youths, one inside the building and the other standing beside it with his horse, could be Castor and Pollux, the seated figure Tyndareus, and the woman in

black Aithra, the mother of Theseus, whom the Dioskouroi brought back with them. Menelaos and Odysseus were among the subsequent suitors of Helen, the former winning her hand, the latter advising Tyndareus how to deal with the difficult situation that had arisen owing to their great numbers. The presence of Thersites is less easy to explain; he certainly shows none of the deformities with which Homer credits him, as he rests one arm on top of a pillar, while his right hand holds what looks like a stylus, as if he were intending to take notes of the proceedings, which might later serve his spiteful purposes. His pose has a very statuesque look and is a forerunner of the youth with crossed legs leaning against a pillar, who becomes almost a cliché by the middle of the fourth century.

The scene on the reverse represents the desertion of the sleeping Ariadne by Theseus on the island of Naxos. He rushes off with drawn sword towards his ship, of which the prow is visible to right; Dionysos comes up and fondles the breast of the sleeping maiden, while above a maenad and a satyr run past, followed by a small Eros. The picture corresponds closely with the description given by Pausanias of a painting in the sanctuary of Dionysos Eleutherios at Athens (i, 20, 3) depicting 'Ariadne asleep, and Theseus putting to sea, and Dionysos come to carry Ariadne off' (cf. also Philostratus, *Imag.* i, 15 and Robertson, *History of Greek Art*, p. 441, n. 213), and it takes the story one step further than the scene on the Boston stamnos (no. 1/104).

The following fragment, also from a calyx-krater, is closely connected in style with the above:

Fragment

26 Taranto 54959, from Taranto.
 Figure seated inside a palace; to r. above, seated Artemis with hound; below, Orpheus with lyre.

In the centre of the scene was a palace with Ionic columns, a frieze with painted metopes, a pediment (cf. no. 24) and a coffered ceiling. The column in front has a sphinx resting on the capital as a support for the architrave, as in the palace of Pluto on the volute-krater Karlsruhe B 4 (no. 16/81); it is therefore reasonable to conclude that our fragment also represents his palace, especially as one of the figures in it was holding a bird-crowned sceptre, and is probably to be identified as Pluto. The presence of Orpheus on the right would be very appropriate for an Underworld scene, and, if this is the case, we have here the earliest of a series of vases showing Orpheus in the Underworld beside Pluto's palace. It is rare for a vase-painter to show sculptural decoration on palaces or naiskoi; painted metopes recur on the base of a naiskos on a volute-krater in the B.M. (F 276; Carter, *AJA* 74, 1970, pl. 31, fig. 16 and *Sculpture of Taras*, p. 15, n. 6, where it is referred to as an amphora) and no doubt reflect such decoration on the actual monuments in Taranto.

(iii) SMALL FRAGMENTS

The following small fragments have figures upon them associated in style with the vases in the preceding sections:

Fragments

(a)

27 Sydney 51.47.
 Warrior with shield in front of a building.
28 (13) Heidelberg 25.04 (from a closed vase).
 CVA, pl. 72, 2.

Fragments (continued)

Artemis with bow in front of a temple, inside which is a statue.

Cf. also with the Oxford Icarus fragment (no. 1/92).

29 Basel, Cahn coll. 219.

APS Addenda, p. 424, no. (iia).

Head and shoulders of woman.

30 Basel, Prof. K. Schefold.

Schefold, *Meisterwerke,* p. 234, no. 291, ill. on p. 236, and *Die Griechen und ihre Nachbarn,* pl. 232a.

Eros and woman.

Cf. head of woman with Hera on Taranto 54943 (no. 17); also with Heidelberg 25.04 (no. 28).

31 Munich 8713 (ex Curtius) from a calyx-krater.

AA 1957, cols. 389—90, no. 11, fig. 14. Photo: R.I. 1938.2066.

Apollo and Muse.

The palmettes on the rim should be compared with those on nos. 17—19; the drawing of the breasts on this fragment and on no. 30 is very characteristic (cf. nos. 17, 24, 25).

32 Amsterdam 2587 (*Gids* 1497).

Ausonia 7, 1912, p. 109, fig. 1; *ESI,* no. B164; Jehasse, *Corse Historique* 11, 1963, p. 10, fig. 8.

Underworld scene, with three sleeping Thracians at top l.

33 Hamburg, private coll.

Seated figure in Oriental costume (? Orpheus) resting head on hand, between two standing women.

34 Würzburg H 4705, from Taranto.

Bielefeld, *Von gr. Malerei,* pl. 15, fig. 21; Froning, *AA* 86, 1971, p. 35, fig. 2; *ESI,* no. B165; *Führer,* p. 302.

Sleeping Thracian.

Note the treatment of the eyelashes and drapery (especially the dot-patterns), as well as the subject.

35 Basel, Cahn coll. 226 (from a hydria).

White-haired woman seated in dejection, wearing veil.

Cf. with the priestess on the reverse of no. 24; for the drawing of the eye cf. the fragment no. 1/69 by the Sisyphus Painter.

36 (11) Amsterdam 2491 (*Gids* 1504), from Taranto.

Bieber, *JdI* 32, 1917, p. 52, fig. 24; Trendall, *PP,* p. 54, fig. 39; Bieber, *Hist.²,* p. 14, fig. 44; *Gods and Men in the A.P.M.,* pl. 43.

Papposilen and two seated women.

37 (12) Amsterdam 2580, from Taranto.

PBD, fig. 31.

Part of seated male figure, with head of woman below.

38 Once Zurich Market.

Head of bearded man, inclined to r.

(b)

The following look slightly more developed in style and nearer to the vases discussed in Chapter 7.

39 Amsterdam 2588 (*Gids* 1495), from Taranto.

CVA, Scheurleer 2, IV Db, pl. 3, 1.

Hades and Kore; charioteer to l., fleeing woman to r.

Note the use of added white for the figure of Kore, her filmy drapery and red cloak; cf. the charioteer with the youth on the fr. 3525 (no. 22 above). For the flapping cloak of the charioteer

cf. that of Ajax on the Sydney fragment showing the rape of Cassandra (Moret, *Ilioupersis,* pl. 6, 1), which is probably also to be placed in this area.

40 Kiel, private coll.

Woman emerging from the door of a blazing building; to r. a missing figure held a large hydria from which water is pouring down.

For the building, which has ceiling-beams and a triglyph-metope frieze, cf. nos. 24 and 26.

II THE DEVELOPMENT OF THE PLAIN STYLE

CHAPTER 3

THE TARPORLEY GROUP

1. The Tarporley Painter
2. The Klejman Painter
3. The Group of Lecce 686
4. The Chaplet Group
5. The Imitators of the Tarporley Painter
6. The Group of Vatican V5

Bibliography

Nöel Moon, 'Some Early South Italian Vase-Painters', *BSR* 11, 1929, p. 41.
A. Cambitoglou and A.D. Trendall, *APS*, pp. 31 ff.
A.D. Trendall, *ESI*, pp. 50–53.

Introduction

The vases listed in this chapter are so closely connected by the style of the drawing of the figures and the subsidiary decoration that it is barely possible to regard them as other than the products of a single workshop, in which the chief master was the Tarporley Painter. This artist exercised a very profound influence over "Plain" style Apulian in the first half of the fourth century, as may be seen from a study of the vases discussed in Chapters 4 to 6.

The influence the Tarporley Painter exerted upon his immediate associates is nowhere better seen than in the way they copy certain of his mannerisms in the drawing of the fold-lines or borders of the himatia worn by the youths on the reverses of his vases. Three very clear examples of such copying will suffice:

(i) the youth on the l., especially in the later phases of the Tarporley Painter's work, often has two thick parallel black lines running down the left side of his himation, below the border of the overhang, which is normally shown as an oblique straight line (Fig. 2b; see nos. 27, 29, 30, 34, 35, 39, 41, 60, 61, 63); this characteristic feature is directly copied by the Painter of Lecce 686 and his group (see nos. 69, 70, 74–5, 77) and by later followers like the Schiller Painter and the Painter of Karlsruhe B 9 (see nos. 4/6–8, 10; 6/1–5, 8–10).

(ii) on the himatia of some youths there is a long wavy line which splits up just above the lower hem into two even more wavy branches, giving an effect not unlike an inverted squiggly Y (Fig. 2a; see nos. 4, 8, 11, 27, 33, 36, 51, 60, 61); this feature is particularly favoured by the Painter of Lecce 686 and his group (see nos. 67–68);

(iii) youths facing to l. often have their l. arm bent at the elbow to give a "sleeve"-like effect to that part of the himation which covers it; this has a thick wavy black line for its border, beneath which descend to the lower hem two parallel black lines, giving an effect rather like an elongated Π (see nos. 11, 27, 35–38, 44); this mannerism recurs on vases by the Klejman and Rainone Painters (e.g. on nos. 64–5 and nos. 4/224–6) and with slight modifications on other by the Schiller Painter (e.g. on nos. 4/15, 17 and 19) and the Painter of Karlsruhe B 9 (e.g. on no. 6/3).

Noteworthy also is the close stylistic connexion between certain of the later vases of the Tarporley Painter and a number of vases attributed to the Dolon Painter; these are listed and discussed in some detail below on p. 53 in division (v).

1. THE TARPORLEY PAINTER

Bibliography

E. Paribeni, 'Tarporley, Pittore di', in *EAA* vii, p. 633.

The Tarporley Painter, who takes his name from no. 10, formerly in the collection of the Hon. Marshall Brooks at Tarporley, was first identified by Mrs. Oakeshott (Moon, p. 41) who pertinently commented of his style that "you feel at once that this painter had the Sisyphus Painter behind him". The connexion is clearly seen on one of the Tarporley Painter's earliest vases, the skyphos B.M. F 126 (no. 1), where the woman on the obverse is very Sisyphean in both stance and drapery; somewhat similar female figures reappear on nos. 3, 10–14. We may also note on his earlier vases (e.g. nos. 2, 3, 5, 6, 8, 9) the presence on the reverses of a youth draped in the Sisyphean manner with a himation across his body and over one shoulder, leaving the other bare; other similar comparisons may also be made, for instance between the draped youth to left on the reverse of Boulogne 671 (no. 9) and the corresponding one on U.C. 525 (no. 1/88).

As the style of the Tarporley Painter develops, it becomes somewhat more personal, if slightly inferior, and we have endeavoured below to divide his vases into a series of sub-groups to illustrate this development. From the start he is fond of Dionysiac themes (e.g. nos. 2, 6, 10, 13), and subjects associated with athletics (e.g. nos. 5, 14, 27), or the theatre (e.g. nos. 2, 7, 12, 15) and to him must be given the credit for painting one of the first Apulian phlyax vases (no. 7), on which he apparently gives us actual quotations from the play, since the inscriptions upon it are metrical (*APS,* p. 32; Beazley, *AJA* 56, 1952, p. 193). Accompanying Dionysos on several of the vases is a youthful figure with small horns who may well be Pan (*APS,* p. 33), but who, by analogy with the satyr on no. 10, where a small tail is evident, or with the bearded figure on Marburg 789 (no. 29), who has a flourishing tail, may also be regarded as a horned satyr, and this would certainly not be inappropriate in such a context (cf. nos. 2, 10–12).

More than sixty vases may now be ascribed to the hand of the Tarporley Painter, whose main activity must cover the first quarter of the fourth century, although his very earliest vases may perhaps be placed in the closing years of the fifth.

(i) EARLIEST WORK

In this phase of the Tarporley Painter's work Sisyphean influence is particularly strong (cf. the drapery of the female figures and the youths with bare chest on the reverses), and we may note the following features as typical:

(a) some youths wear a "chaplet" shown as a reserved band in the hair, with a short spike in front (nos. 1–3, 5);

(b) nude youths often rest their weight on the l. leg while keeping the right slightly flexed, and generally hold out some object in their extended l. hand, e.g. a bird, for which this painter has an obvious liking (vid. nos. 1–3);

(c) heads tend to be fairly small and are often inclined slightly downward (vid. nos. 1–5); the mouth is small, the facial features neatly drawn;

(d) there is generally a black border to the drapery, which on the obverse is sometimes further decorated with dots (e.g. on no. 3);

(e) most of the scenes consist of two-figure compositions (nos. 6–7 are exceptions);

(f) on most kraters there is no decoration below the handles; the meander pattern runs only beneath the pictures (no. 6 is again an exception), and, except on no. 4, is accompanied by saltire squares;

(g) the laurel pattern round the rim of kraters and on the neck of nos. 8 and 9 invariably runs to r., and the leaves, like those of the Sisyphus Painter, have no central vein.

Skyphos

1 B.M. F 126.

APS, p. 36, no. 45, pl. 11, figs 49—50; *ESI*, p. 50, no. B98; Schneider-Herrmann, *BABesch* 45, 1970, pp. 98—9, figs. 15, 16.

(a) Eros with half-open cista, and woman with mirror, (b) youth with cat perched on shoulder, and bird on his r. hand, holding strigil in l., draped woman, playing with ball.

Note the use of leaves with serrated edges on the side-scrolls of the fan-palmettes below the handles and of rows of fine dots across the drapery of the women; also the saccos worn by the woman on (a), which later provides a model for those of the Dolon Painter.

Bell-kraters

* 2 New York L. 63.21.5 (ex San Simeon 3985 and Ruesch 28; on loan from Mr. Jan Mitchell). PLATE 13.

APS, p. 33, no. 5; *ESI*, p. 51, no. B99, pl. 27a; Parke-Bernet, *Sale Cat.*, 5 April 1963, no. 79; *PhV²*, p. 93, no. (xiii).

(a) Dionysos with thyrsus and mask, satyr dipping oenochoe into b.f. bell-krater, (b) two draped youths, r. holding up aryballos.

3 Brunswick (Maine), Bowdoin College 1915.47.

APS, p. 33, no. 3, pl. 11, figs. 51—2; *ESI*, p. 51, no. B100; Herbert, *Ancient Art in Bowdoin College*, pl. 27, no. 213.

(a) Dionysos with branch in r. hand and bird perched on l., maenad with phiale, (b) two draped youths.

Note the animal-leg suspended between the two youths on the reverse; cf. with B.M. F 174 and Matera 9978 by the Sisyphus Painter (nos. 1/55 and 63 above).

4 Oxford 1917.65 (ex Hope 213).

APS, p. 34, no. 16; *ESI*, p. 51, no. B101.

(a) Orestes pursued by a Fury, (b) two draped youths.

5 Once Lucerne Market, Ars Antiqua.

APS, p. 34, no. 17; *ESI*, p. 51, no. B102.

(a) Youth with targe beside herm (cf. no. 11), Nike with fillet and crown, (b) two draped youths.

6 Madrid 11079 (L. 324).

APS, p. 34, no. 11; *ESI*, p. 51, no. B103.

(a) Dionysos between maenad with tambourine and satyr with situla and kottabos-stand, (b) three draped youths.

Calyx-krater

7 New York 24.97.104.

APS, p. 34, no. 20; *ESI*, p. 51, no. B122, pl. 28b; Borda, p. 42, fig. 30; *LAF*, no. 174 (ill.); Pickard-Cambridge, *Festivals²*, fig. 105, *PhV²*, p. 53, no. 84; *Ill. Gr. Dr.* IV, 13.

(a) Phlyax scene: the punishment of a thief, (b) three draped youths.

For the inscriptions see also Whatmough, *HSCP* 39, 1928, pp. 1—6, and *CP* 47, 1952, p. 26; Webster, *CQ* 42, 1948, p. 25 and *Festschrift Schweitzer*, p. 260; Beazley, *AJA* 56, 1952, p. 193.

Amphora

8 Philadelphia 31.36.17.

APS, p. 34, no. 19; *ESI*, p. 52, no. B134.

(a) Woman with hydria, and youth with sash, (b) two draped youths.

Pelike

9 Boulogne 671.

APS, p. 35, no. 35; *ESI*, p. 52, no. B136.

(a) Youth with bird between two women, (b) three draped youths.

The youth to r. on the reverse has his r. hand thrust inside his himation; this device recurs on several later vases by the painter (e.g. on nos. 11, 27, 38, 63) and on a number of those by his followers (e.g. nos. 70, 75, 88 and 4/2, 21, 51 and 195).

(ii) EARLY VASES

The vases in this division are still closely connected with those in (i), as may be seen from a comparison between the obverses of no. 2 and no. 10, and the frequency with which a small bird continues to appear perched on the hand of one of the figures (e.g. on nos. 10–13). The style of drawing, however, in general is beginning to move further away from Sisyphean prototypes, with consequent developments in the treatment of the face, the drapery and the youths on the reverses. The overfall on women's peploi is still extensively used, but now with a thicker wavy border (contrast nos. 3 and 11); the heads assume a slightly more oval shape (e.g. nos. 10–14) and those of the reverse youths are somewhat bigger; the "chaplet" appears far less frequently (e.g. on no. 21), and women begin to lose their statuesque quality, as may be seen from a comparison with that on no. 1. Three-figure compositions increase in popularity (nos. 10–16) and youths in native dress make their first appearance (no. 22), with large swastikas on their tunics, as on the column-krater once presented to Hitler (no. 42).

Characteristic of the drapery of the youths on the reverses in this phase are:

(a) the squiggly black line across the fold-lines at the top of the himation (e.g. on nos. 11–16);
(b) the inverted squiggly Y in one of the lower corners of the himation, which continues from the vases in division (i) and becomes increasingly emphasised on nos. 10, 12, 13, 14 and 18;
(c) the occasional appearance of two vertical parallel black lines on the l. edge of the himation of the l. youth (e.g. nos. 10, 11, 18; and p. 49);
(d) the broader effect of the himation of the central youth caused by the projection of the bent elbow of one of the two arms (e.g. nos. 11, 12, 14, 18, 22).

Note also on the obverses the practice of having a piece of drapery looped over one arm and held in the hand of the other (e.g. on nos. 10, 12), a device which will reappear frequently on the vases of his followers (e.g. the Schiller Painter) and which looks back to the Sisyphus Painter (cf. Stockholm 3, no. 1/64, and Bari 6312, no. 1/83).

Bell-kraters

10 Los Angeles 50.8.29 (ex Hope 211).
 APS, p. 33, no. 1; *ESI*, p. 51, no. B104; *CVA*, pl. 40.
 (a) Dionysos crowned by maenad, and satyr with bird perched on r. hand, and thyrsus in l., (b) three draped youths.
11 Newcastle-upon-Tyne, Laing Museum 19.1525 (ex Hope 212).
 APS, p. 34, no. 10; *ESI*, p. 51, no. B105.
 (a) Youth and Nike with fillet beside herm (cf. no. 5) and to r. satyr with bird on r. hand (cf. no. 10), (b) three draped youths.
12 B.M. F 163.
 APS, p. 33, no. 4; *ESI*, p. 51, no. B106; *SIVP*, pl. 6b; *PhV²*, p. 91, no. (vii); Borda, p. 42, fig. 32.
 (a) Nike about to crown youth holding mask (cf. no. 2), satyr with bird perched on r. hand (cf. nos. 10–11), (b) two draped youths and a woman.
* 13 Sydney 54.04. PLATE 14, 1–2.
 APS, p. 33, no. 2; *ESI*, p. 51, no. B107.
 (a) Young satyr with oenochoe and phiale beside b.f. calyx-krater, Dionysos, and maenad with bird perched on r. hand, (b) three draped youths. (continued next page)

Bell-kraters (continued)

Note the Dolonesque quality of the youth on the obverse.

* 14 Cambridge (Mass.), Fogg Art Museum 1960.359 (ex Robinson). PLATE 14, 3—4.

APS, p. 34, no. 6; *ESI*, p. 51, no. B108.

(a) Nike holding fillet in front of nude youth with targe (cf. no. 5), draped woman with chaplet, (b) three draped youths.

15 Sydney 47.05 (ex Hope 210).

APS, p. 34, no. 15; *ESI*, p. 51, no. B109; *PhV²*, p. 98, no. (xxii); *Ill.Gr.Dr.* II, 2; *Hist.Hell.Eth.* III, 2, ill. on p. 358.

(a) Three actors preparing for a satyr-play, (b) three draped youths.

16 Boston 1970.237.

APS Addenda, p. 426, no. 3 bis; *ESI*, p. 51, no. B110; Vermeule, *BurlMag*, Feb. 1973, p. 117, figs. 70 and 74.

(a) Perseus, Athena reflecting the gorgoneion in her shield, Hermes leaning against a tree-trunk, (b) nude youth with strigil between two draped youths.

17 Bassano del Grappa, Chini coll. 66.

ESI, p. 51, no. B111.

(a) Youth with b.f. oenochoe, woman with panther-skin over her arm playing the flute and youth with part of kottabos-stand, (b) three draped youths.

The reverse is very close to that of Sydney 47.05 (no. 15); the central youth on both vases holds a strigil in his r. hand.

18 Taranto 127609, from Ginosa, T. 30.

APS Addenda, p. 426, no. 18 ter; *ESI*, p. 51, no. B112.

(a) Eros with oenochoe and phiale, seated woman with mirror; between them, a plant, (b) two draped youths.

19 Taranto. In bad condition.

(a) Nude youth with stick, woman with mirror, youth with stick, (b) three draped youths.

20 Bonn 2675 (fr.).

APS Addenda, p. 426, no. 18 bis; *ESI*, p. 51, no. B113.

(a) Silen, youth and maenad running to l.

Calyx-krater

21 Naples 1901 (inv. 81470).

ESI, p. 52, no. B124.

(a) Youthful Herakles with lion-skin, club and laurel branch, and Hermes with mug at an Ionic stele, (b) two draped youths.

Column-krater

22 Once London Market, Christie's, *Sale Cat.*, 30 April 1975, p. 19, no. 20, pl. 7 (ex Nostell Priory).

ESI, p. 52, no. B126.

(a) Woman offering libation to seated Oscan warrior holding phiale in outstretched r. hand and two spears in l.; Oscan warrior with foot raised on rock, holding spear, (b) three draped youths.

Hydriai

23 Milan, "H.A." coll. 362.

ESI, p. 52, no. B146.

Standing woman with dish of offerings, nude youth seated on rock with stick; fillet above.

Cf. the woman's drapery with that of Nike on no. 27.

24 Leningrad inv. 1707 = St. 1686.

APS Addenda, p. 426, no. 34 bis; *ESI*, p. 52, no. B147.

Woman holding phiale, and plucking at the drapery on her r. shoulder; nude youth with stick.

25 Leningrad 1196 = St. 1398.
 APS, p. 35, no. 31; *ESI*, p. 52, no. B148.
 Youth with stick and helmet in l. hand, woman with spear, shield and sheathed sword.

Pelike

26 Once Roman Market.
 APS, p. 35, no. 40; *ESI*, p. 52, no. B137.
 (a) Youth and woman with phiale, (b) two draped youths.

(iii) MATURE STYLE

The vases in this division illustrate a further development in the work of the Tarporley Painter and represent his mature style which is probably to be dated c.380–70 B.C. It is at this period that the close connexion with the work of the Dolon Painter (see below) is particularly apparent.

The drawing is now rather more fluid, but less careful and precise. This is certainly true of the treatment of the drapery, especially that of the youths on the reverses. The faces look rather coarser by comparison with the neater ones in (i) and (ii). Note particularly the very wavy hem-lines on women's peploi (e.g. those on nos. 27, 28, 32, 35), the increasing popularity of tendrils between the figures on the obverse (e.g. of nos. 27–8) and the use of multi-leafed plants (e.g. on no. 28).

On the reverses the two parallel lines in the left corner of the himation of the left youth become even more pronounced (see nos. 27, 28, 30, 35, 39, 41), and sometimes a black dot appears just above them (see nos. 27–8, 30, 39, 41). The reversed squiggly Y in the right-hand corner of the himation of some youths mostly facing left is also given greater emphasis (e.g. on nos. 27–8, 33, 35). On some vases there is a "sleeve" drape over the bent arm of youths with parallel black lines descending from it and occasionally a small black dot above them (see nos. 35–38, 44). The tendency on these vases for drapery to billow should also be noted.

Black-figured kraters now appear in represented scenes with increasing frequency (e.g. on nos. 29, 32, 33, 36, 37; cf. also nos. 2 and 13 above); so do rocky eminences on which figures sit or place one foot (e.g. on nos. 30, 33, 35, 39). The meander pattern on bell-kraters tends increasingly to encircle the vase, and beneath the handles there is often a fan-palmette with scrolls or tendrils on either side (e.g. on nos. 30–31, 33, 35–38).

Bell-kraters

(a)

27 Once New York Market (ex Durham; later San Simeon 5604).
 APS, p. 34, no. 13; Parke-Bernet, *Sale Cat.*, 5 April 1963, no. 94; *ESI*, p. 51, no. B114; Trendall, *Ceramica*, pl. 18.
 (a) Nike with crown and fillet approaching rider holding targe, (b) three draped youths.
28 Copenhagen, Ny Carlsberg H 154.
 APS, p. 34, no. 7; *ESI*, p. 51, no. B115. *Bildertafeln*, pl. 53, 2.
 (a) Dionysos, satyr and maenad, (b) three draped youths.
29 Marburg 786.
 APS, p. 57, no. 1, pl. 33, figs. 157–8; *ESI*, p. 51, no. B116; Schauenburg, *RM* 69, 1962, pl. 12, 2.
 (a) Maenad with thyrsus dipping situla into b.f. calyx-krater, and capering silen, (b) two draped youths.
 In *APS* this vase was attributed to "the Marburg Painter", but a fuller study, especially of its reverse,

Bell-kraters (continued)

shows that it should be attributed to the Tarporley Painter. Note in particular the parallel fold-lines on the himation of the youth to l., the squiggly lines on that of the one to r., and the animal-leg suspended between them (cf. no. 3).

* 30 Taranto, Ragusa coll. 277. PLATE 15, 1–2.
 ESI, p. 51, no. B117.
 (a) Silen with foot raised on rock, holding thyrsus in r. hand and woman with phiale and situla, (b) two draped youths.
 This vase clearly stands close to the Marburg krater, especially in the treatment of the draped youths. It should, however, also be compared with Vatican V 1, Trieste S 412, and other vases by the Painter of Karlsruhe B 9 (see Chapter 6 below).

 31 Deruta (Perugia), Magnini coll. 10.
 Dareggi, no. 1, pl. 1.
 (a) Silen with torch and oenochoe, Dionysos with kantharos and thyrsus and woman playing the flute, (b) two draped youths beside an altar.

 32 Vienna 646.
 APS, p. 34, no. 18, pl. 12, fig. 54; *ESI*, p. 51, no. B118.
 (a) Dionysos and maenad, with a b.f. calyx-krater (cf. no. 13) between them, (b) two draped youths.
 With this vase cf. Vatican U 11, (no. 70) in the Group of Lecce 686.

(b)

The vases in this sub-division are closely connected by the treatment of the youths on their reverses, especially by the drawing of the parallel fold-lines on the himation of the left youth and the squiggly ones on the himation of right youth (cf. also the reverse of no. 27).

In *APS*, Würzburg 824 was separated from the work of the Tarporley Painter, though placed very near to him. In the light of our present knowledge we could scarcely regard the reverse of this vase as by a hand other than his own.

* 33 Once New York, Eisenberg (ex London, Sotheby). PLATE 15, 3–4.
 Sotheby, *Sale Cat.*, 1 Dec. 1969, no. 115, ill.; *ESI*, p. 51, no. B121.
 (a) Seated silen with thyrsus, nude youth with kantharos and thyrsus leaning on pillar; between them a b.f. bell-krater, (b) two draped youths.

 34 Zurich 3585 (formerly Ros coll. 81; ex Signorelli coll. 228).
 APS, p. 34, no. 14; *ESI*, p. 51, no. B119.
 (a) Maenad with dagger and part of torn animal between Dionysos and satyr with torch and situla, (b) three draped youths.

 35 Wurzburg 824.
 APS, p. 40, no. (i); *ESI*, p. 51, no. B120.
 (a) Seated woman with parasol, Eros with duck seated on rock, standing woman with fillet (b) three draped youths.
 The youth to r. on the reverse resembles closely the corresponding one on no. 33.

 36 Gotha 74.
 CVA, pl. 80.
 (a) Maenad with tambourine, Dionysos with thyrsus, silen with bell-krater, (b) three draped youths.

 37 Once London Market, Sotheby, *Sale Cat.*, 24 Feb. 1975, no. 203 (ill.); 19 May 1975, no. 212, pl. 15, 3; 15 May 1976, no. 365, pl. 16.
 (a) Dionysos, maenad and satyr, (b) three draped youths.
 Nos. 36 and 37 stand very close to each other.

 38 Madrid 11090 (L. 329).
 APS, p. 67, no. 2.

(a) Dionysos, holding duck and thyrsus, between seated maenad with tambourine and silen seated on amphora, (b) three draped youths.

Calyx-krater

39 Gotha 72.

APS, p. 34, no. 21; ESI, p. 52, no. B125, pl. 28a; CVA 2, pl. 79.

(a) Athena reflecting the gorgoneion in a pool for Perseus, (b) two draped youths.

40 Ruvo 1495.

APS Addenda, p. 427, no. (iiib); ESI, p. 51, no. B123; Sichtermann, K 52, pl. 85.

(a) Youth with thyrsus, and bearded man playing kottabos on couch between seated woman with tambourine and boy with oenochoe, (b) thiasos – Dionysos, silen with situla and torch, maenads with tambourines.

Column-kraters

41 Copenhagen 3633.

APS, p. 35, no. 22; ESI, p. 52, no. B127, pl. 27b.

(a) Maenad with dagger and hare, silen drinking from wine-skin, seated woman (? nymph), (b) three draped youths.

42 Once Berlin, Adolf Hitler.

APS, p. 35, no. 23, pl. 12, figs. 55–6; ESI, p. 52, no. B128.

(a) Woman fluting, and Oscan youth with nestoris, woman with nestoris and youth with lyre, (b) four draped youths.

Volute-krater

43 Geneva 15036.

APS, p. 35, no. 25, pl. 12, fig. 53; ESI, p. 52, no. B133; EAA vii, p. 619, fig. 738. Photos: R.I. 33.1512 and 34.740–744.

(a) Amazonomachy, (b) maenad with torch and thyrsus, silen with tambourine, Dionysos with thyrsus and bell, maenad with dagger and thyrsus.

This is the only volute-krater known to us that can be attributed to the Tarporley Painter; in shape and subsidiary decoration it closely follows Sisyphean models (cf. the volutes with those of Munich 3268 and Ruvo 1096), and the Amazonomachy on the obverse is also derived from similar scenes on his vases. The reverse is more in the regular manner of the Tarporley Painter in this phase (cf. the silen and maenads with those on nos. 31, 34, 36, 41).

Pelikai

44 Taranto, private coll.

APS, p. 35, no. 39, pl. 13, figs. 57–60; ESI, p. 52, no. B138; Arias, Storia, pl. 156; Moreno, Riv IstArch 13–14, 1964–5, p. 35, fig. 5.

(a) Perseus, Athena reflecting the gorgoneion in a shield, and Hermes, (b) three draped youths.

Note the appearance of the youth leaning on a stele with his drapery around it (cf. no. 45).

45 Naples 2355 (inv. 81725).

APS, p. 35, no. 37; ESI, p. 52, no. B139.

(a) Youth leaning on stele, and woman with fillet and phiale, (b) two draped youths.

46 Liverpool M 10690.

APS, p. 35, no. 36; ESI, p. 52, no. B140.

(a) Woman with chaplet and phiale running to l. followed by nude youth, (b) two draped youths.

47 Florence, private coll.

(a) Standing woman with mirror and nude youth with stick seated on rock, (b) two draped youths.

Nos. 46 and 47 stand very close to each other.

48 Ruvo 1243.

ESI, p. 52, no. B141.

Pelikai (continued)

> (a) Draped woman with alabastron and cista beside a laver and nude woman with drapery on column beside her, (b) two draped youths.

49 Ruvo 1247.
> *APS*, p. 35, no. 43; *ESI*, p. 52, no. B144.
> (a) Youth with targe about to be crowned by Nike, (b) two draped youths.

50 Taranto 54958.
> *ESI*, p. 52, no. B145.
> (a) Nude youth with strigil and draped youth with fillet, (b) two draped youths.
> The reverse, like that of Ruvo 1243 (no. 48), leads up to those on the vases of the TARDOL Group (see below).

Amphora

51 Matera 11999.
> *ESI*, p. 52, no. B135; Lo Porto, *Penetrazione*, pl. 16, 3–4.
> (a) Nude youth with stick, and draped woman with mirror, (b) two draped youths.
> This vase should also be compared with those by the Painter of Lecce 686.

Hydriai

52 Florence 4040.
> *APS*, p. 35, no. 30; *ESI*, p. 52, no. B149.
> Woman holding mirror, and youth.

53 Milan, Biblioteca Ambrosiana.
> *APS*, p. 35, no. 29; *ESI*, p. 52, no. B150.
> Seated woman offering wreath to standing youth.

54 B.M. F 95.
> *APS*, p. 35, no. 26; *ESI*, p. 52, no. B151; Harris, *Sport in Greece and Rome*, fig. 48.
> Two women at a stele, l. with mirror, r. bouncing ball (*aporrhexis*); mirror top r., bird flying between.

55 Bari 2328.
> *APS*, p. 35, no. 32; *ESI*, p. 52, no. B152.
> Two women, l. with phiale, r. with chaplet; altar and plant between them.

56 Liverpool M 10772.
> *ESI*, p. 52, no. B153.
> Woman with situla running to l., followed by nude youth.

57 Bari 6314 (P. 124).
> *APS*, p. 35, no. 34; *ESI*, p. 52, no. B156.
> Two nude youths with sticks; r. with foot raised on rock.

58 B.M. F 94.
> *APS*, p. 35, no. 28; *ESI*, p. 52, no. B155.
> Woman with half-open box seated between nude youth leaning on drapery-covered pillar and maid holding up parasol.
> For the parasol cf. Würzburg 824 (no. 35).

The following vase should be closely associated by its obverse with those in division (iii), although the reverse shows a very different manner of drawing.

Column-krater

59 Syracuse 22912, from Camarina.
> *MonAnt* 14, 879–80, fig. 83 and pl. 54; *APS*, p. 36, no. (i).
> (a) Silen, Dionysos and maenad running to r., (b) three draped youths.
> The subsidiary decoration of the obverse (b.f. animals and ivy-leaves and berries) as well as the

plain black neck on the reverse and the absence of a meander band below the figure-work are features which connect this vase with the Hillsborough and "H.A." column-kraters associated with the Ariadne Painter (see above nos. 1/116—7) and the Amykos Painter (see *LCS* pl. 15, 1—2 and 3—4).

(iv) THE LATEST PHASE

The vases in this division represent the latest phase of the work of the Tarporley Painter and also stand very close to those in the TARDOL group (see below). They are very closely connected in style with those in division (iii), especially by the treatment of the draped youths. One should note again the presence of the black dot in the corner of the overhang of the himation (vid. nos. 60, 61, 63), as on Gotha 72 (no. 39) and other vases, and also the double squiggly fold, as on Würzburg 824 (no. 35). The drawing is somewhat coarser, especially of the face. One may also note the presence of swastikas upon the apron-like garments worn by the Oscan youths on no. 61, as well as the b.f. nestorides on the same vase and no. 62.

Column-kraters

* 60 Geneva 15042. PLATE 16, 1—2.
 APS, p. 35, no. 24; *ESI*, p. 52, no. B129.
 (a) Two warriors and two women, (b) four draped youths.
* 61 New York 17.120.241. PLATE 16, 3—4.
 APS, p. 35, no. 23 bis; *ESI*, p. 52, no. B130; *Gli Indigeni*, fig. 13; (b) Trendall, *Ceramica*, pl. 19a.
 (a) Woman with oenochoe and nestoris, and Oscan youth with shield and spear; woman with oeno-
 choe and Oscan youth with nestoris, shield and spear, (b) four draped youths.
 62 Copenhagen 1682 (fr.).
 Tischbein V, 67; *ESI*, p. 52, no. B131; *Gli Indigeni*, fig. 16.
 (a) Woman holding out b.f. nestoris to warrior (of whom only the hands, with part of his spear and
 shield, remain).
 The head, with its large ear-ring, goes very closely with those on the New York krater (no. 61).
 63 Vatican T 9 (inv. 17948).
 VIE, pl. 22 c—d; *ESI*, p. 52, no. B132.
 (a) Two women and two warriors, (b) four draped youths.

(v) THE TARDOL GROUP

Bibliography

APS, pp. 37—8; *LCS*, p. 98 and *Suppl.* II, pp. 167—8; *ESI*, p. 13 and p. 44; also N.R. Oakeshott, *JHS* 95, 1975, p. 297.

In this division a small group of vases is listed and discussed which provide a close connecting link between the work of the Dolon Painter (Early Lucanian) and that of the Tarporley and Klejman Painters, and to which the designation TARDOL has been given. Vases A to E below were attributed to the Dolon Painter in *LCS* and F to G to the Tarporley Painter in *APS;* a fuller study, however, especially of their reverses, shows that these seven vases form a reasonably compact group and should therefore be the work of a single artist, who, in the light of the material from the Dolon and Creusa Painter's kiln discovered in 1973 at Metaponto (see below), would seem to be that of the Dolon Painter himself.

(a)

Vases attributed in *LCS* to the Dolon Painter:

Bell-kraters

 A Warsaw 198190.
 APS, p. 37, no. (i); *LCS*, p. 100, no. 518, pl. 50, 3 and pl. 51, 3; *CVA*, Poland 7, IV Dr, pl. 4; *ESI*,

Bell-kraters (continued)

p. 44, no. 485.

(a) Eros seated, with open box, woman and youth, (b) three draped youths.

B Once Rome and later New York Market.

LCS, p. 101, no. 521, pl. 50, 5 and pl. 51, 5; *ESI*, pl. 44, no. 486.

(a) Woman with bird on finger between two nude youths, (b) two draped youths and a woman.

C Naples Stg. 373.

LCS, p. 100, no. 519; *ESI*, p. 44, no. 487.

(a) Nude youth and draped woman, (b) three draped youths.

Column-krater

D Bari 6264 (Polese 70).

APS, p. 37, no. (iii); *LCS*, p. 102, no. 535, pl. 53, 1 and pl. 51, 8; *ESI*, p. 44, no. 488.

(a) Two youths and two women, (b) four draped youths.

Amphora

E Bari 6254 (Polese 60).

APS, p. 37, no. (ii); *LCS*, p. 103. no. 536, pl. 53, 2 and pl. 51, 9; *ESI*, p. 44, no. 489; *Ill.Gr.Dr.* III.6, 4; *La Collezione Polese*, no. 31, pl. 10, 2.

(a) Woman and boy on (?) altar, between youth with spear and woman with axe, (b) three draped youths.

(b)

Vases attributed in *APS* to the Tarporley Painter:

Pelikai

F Bari 6282 (Polese 88).

APS, p. 35, no. 38; *ESI*, p. 44, no. 490; *La Collezione Polese*, pl. 13, no. 44.

(a) Nude youth with strigil, and nude youth resting l. arm on pillar and holding leash of dog in r., (b) two draped youths.

G Ruvo 926.

APS, p. 35, no. 44; *ESI*, p. 44, no. 491; Sichtermann, K 32, pl. 49, 1. Photo: R.I. 64.1204.

(a) Standing woman offering phiale to seated nude youth; to r. woman bouncing ball, (b) three draped youths.

If we look at the reverses of A to G, we shall find it almost impossible not to regard them as the work of a single painter, since most of the types of draped youth are repeated from vase to vase:

(i) the youth facing to r., with l. arm bent at the elbow, r. bent sharply upward with a "sling" drapery effect; with a moderate overhang of the himation on one shoulder, a pronounced recess of the outline at the belly, a long thigh and a short leg (A, C, D, F, G) [this figure is derived from similar ones by the Tarporley Painter (e.g. on nos. 45, 60–61) and is particularly close to those on the two vases attributed to the Klejman Painter (nos. 64–5 below); a similar figure will be found on the vases *LCS* pp. 101–2, no. 520, 527 and 534 by the Dolon Painter];

(ii) the youth facing to r., as on B and D, with no overhang and the r. arm not bent upwards, but the left hand slightly extended beneath the drapery to form a slight bulge [this pose finds parallels on several vases by the Dolon Painter (type H in *LCS;* notably p. 101, nos. 522–3), is very popular with the Creusa Painter, and is derived from such Tarporley vases as nos. 46–7 above];

(iii) the youth facing to l., with l. arm bent outwards at the elbow, to give a broader effect to the figure as a whole, sometimes with a "sleeve"-like drape over that arm (B, E, G), and sometimes without (A, D, F) [prototypes occur on nos. 60–61 by the Tarporley Painter and also on no. 64 by the Klejman Painter;

this youth is also favoured by the Dolon Painter (particularly good examples may be seen on the vases *LCS* p. 101, nos. 527–8, which must go extremely closely with A, D and F)];

(iv) the youth facing to l., but without the bent arm, and in consequence looking somewhat thinner, completely enveloped in his cloak, with an almost collar-like effect at the neck (D and G) [a variant on A and E gives a slight bend to the l. arm and a "sleeve" drape over it (with this compare nos. 41, 51 by the Tarporley Painter, and nos. 63–4 by the Klejman Painter; parallels by the Dolon Painter will be found on the vases *LCS* p. 101, nos. 522, 524a, 528, 533a)];

(v) the youth to r. on B, with the drapery bunched up over the l. shoulder who finds an exact parallel on the vase *LCS* p. 101, no. 527 by the Dolon Painter, which must be by the same hand.

The obverses provide similar connecting links. The draped woman on B, the reverse of which we have just noted as inseparable from that of the vase *LCS* p. 101, no. 527 by the Dolon Painter, recurs on A. The draped woman on D, with the double stripe down her drapery, appears also on E and G, and again is remarkably close to the one on no. 63 by the Klejman Painter and should also be compared with those on nos. 32, 47, 51, 55, 56, 60 by the Tarporley Painter. Similar parallels are to be found between the nude youths who appear on most of the vases listed above.

Also, the recent discovery at Metaponto of a kiln actually used by the Dolan and Creusa Painters, together with numerous fragments from discarded vases by both of them, enables us to widen the long series of parallels between the figures on the TARDOL vases and those undoubtedly by the Dolon Painter himself. On the large Amazonomachy hydria inv. 29057, in the lower frieze, is a splendid example of a draped youth with a hand-bulge resembling those on B and D above and of a woman draped exactly like the figure to right on the reverse of B. There are also numerous examples of a female figure with a double-stripe running down her drapery and on the fragmentary amphora inv. 29059 of a woman wearing a saccos exactly like those worn on A and B.

However, although the reverse youths on the TARDOL vases are so like some of those by the Tarporley and Klejman Painters in general appearance, a close look at their faces will show that the treatment of their mouth is quite different and much more like that of the mouth of youths by the Dolon Painter.

In the light of all this evidence, it seems impossible to divorce these vases from the Dolon Painter. Furthermore, now that we know that this artist actually worked at Metaponto, which is so close to Taranto, there is no good reason for not supposing that he spent some time in the Tarporley Painter's workshop where he picked up some of his mannerisms and adapted them to his own use. It is increasingly clear that in the first fifty years or so of vase-production in the South-East part of Italy (Lucania and Apulia) there was a good deal of interchange of painters between the Schools, both of which sold their products over much the same area, and that the TARDOL Group is an excellent illustration of this phenomenon.

Since the TARDOL vases must be contemporary with the advanced stages of the Tarporley Painter's career they should be dated in the last ten years of the first quarter of the 4th century B.C. (see above p. 49).

2. THE KLEJMAN PAINTER

The two vases attributed to the Klejman Painter are very close to those in divisions (iii) and (iv) of the Tarporley Painter, but the hips and buttocks of his youths are somewhat heavier, their thighs longer, and their heads more massive, though retaining the ovoid shape favoured by the latter. The "sling" drape of the youth to left on his reverses is now more pronounced,

with the right arm bent upward at a very sharp angle (cf. with nos. 15, 29, 34, 36, 45 by the Tarporley Painter), and there is a small bunch of radiating fold-lines beside the bent knee of the two women on the obverses, which is not characteristic of the Tarporley Painter. These two figures are remarkably alike and look back to those on such vases as nos. 30, 32, 55 above. The close connexion between his women and draped youths and those on the TARDOL vases has already been stressed; it is interesting to note that the head-band worn by the woman on the Syracuse pelike (no. 65) is of a type much used by the Dolon Painter (cf. *LCS* pp. 101–103, nos. 524, 529, 530, 533a, 538).

Bell-krater

64 New York, Klejman coll. (ex Vienna 956).
 APS, p. 37, no. 1, pl. 15, figs. 67–8; *ESI*, p. 52, no. B157.
 (a) Woman with mirror between two nude athletes, (b) three draped youths.
 The reverse should be compared with that of New York 17.120.241 (no. 61 above), and also with those of Warsaw 198109 and Bari 6264 in the TARDOL Group (p. 53 and p. 54).

Pelike

* 65 Syracuse 33713, from Palazzolo. PLATE 17, 1–2.
 APS, p. 37, no. 2; *ESI*, p. 53, no. B158; *CVA* 1, III I, pl. 6, 1.
 (a) Woman with mirror between two youths. (b) three draped youths.

 The following vase looks to be associated with the Klejman Painter, especially in the drawing of the woman's drapery and in the pose of the youth:

Pelike

66 Taranto 102574, from the Via Giovine (22/12/1955).
 APS Addenda, p. 427, no. (iv).
 (a) Woman with wreath and box, nude youth with staff, (b) two draped youths.

3. THE GROUP OF LECCE 686

(i) THE PAINTER OF LECCE 686

The Painter of Lecce 686, like the Klejman Painter, descends directly from the later work of the Tarporley Painter, especially such vases as Vienna 646, Matera 11999, Geneva 15042 and New York 17.120.241 (nos. 32, 51, 60–61), but his drawing is less careful, especially of the draped youths, who often look very scrappy, although their heads are very reminiscent of those by the Tarporley Painter. Youths and women are repeatedly represented with one hand on their hip; the drawing of the knee-caps is very characteristic (e.g. nos. 69–72); the fold-lines of the women's peploi generally fall in pairs. Reference has already been made (p. 44) to the way in which this painter copies from the Tarporley Painter his mannerism of drawing two parallel black lines on the himation below the overhang (cf. nos. 68–9) and of the inverted wavy Y on the drapery of the youth to right (e.g. nos. 67–8); the zig-zag line across the folds at the top of the himation becomes more strongly pronounced.

 The Painter of Lecce 686 seems to have been active in the eighties and early seventies of the fourth century B.C.

Pelike

67 Lecce 686.
 APS, p. 38, no. 1.
 (a) Youth and woman, (b) two draped youths.

Compare the two figures on (a) with those to l. on the obverse of Syracuse 33713 by the Klejman Painter (no. 65).

Amphora

68 Copenhagen 20 (B–S. 218).
 APS, p. 38, no. 3; *CVA*, pl. 238, 2.
 (a) Woman with phiale, and nude youth, (b) two draped youths.

Bell-kraters

* 69 Erbach 33. PLATE 17, 3–4.
 (a) Dionysos with stemless cup and thyrsus, and maenad playing the flute, (b) two draped youths.
70 Vatican U 11 (inv. 17959).
 APS, p. 38, no. 2.
 (a) Dionysos with thyrsus, and woman, (b) two draped youths.
 Cf. especially with Vienna 646 (no. 32); for the pose of the youth to r. on the reverse cf. no. 9 above, by the Tarporley Painter.
71 Milan, "H.A." coll. 399.
 CVA 2, IV D, pl. 7, 3–4.
 (a) Eros with stick, and woman with bird and mirror, (b) two draped youths.
72 Taranto 128018, from Gravina.
 APS Addenda, p. 427, no. (iiia).
 (a) Nude youth with strigil, and nude youth at laver, above which is a lion-spout, (b) two draped youths.
73 Monopoli, Meo-Evoli coll. 955.
 (a) Nude youth with thyrsus and satyr with dish of offerings and situla, (b) two draped youths.
 Close to Vatican U 11 (no. 70).
74 Once New York Market (ex Preyss coll.).
 APS, p. 34, no. 9.
 (a) Nude youth and woman with phiale, (b) two draped youths.

The following vases look to be connected in style with this painter:

Bell-kraters

75 Once New York, then Swiss Market, Parke-Bernet, *Sale Cat.,* 24 April 1970, no. 263 (ill.); Galerie am Neumarkt, *Sale Cat.,* 16 April 1971, no. 83 (ill.).
 (a) Silen with situla and thyrsus following maenad with torch, (b) two draped youths (cf. with no. 70 above).
76 Naples 982 (inv. 82581).
 (a) Silen with thyrsus and woman with mirror, (b) two draped youths.
 The head of the silen has been repainted.

(ii)

The following vases form a compact group closely associated in style with the above and connected also with the Klejman Painter:

Bell-kraters

* 77 Once New York Market, R.J. Myers (ex Zurich Market, Arete). PLATE 17, 5–6.
 R.J. Myers, *Sale Cat.,* 10 Oct. 1974, no. 122 (ill.).
 (a) Draped woman with oenochoe and phiale and nude youth with drapery over l. shoulder; beside him is a dog, (b) two draped youths.
78 Santa Barbara, Avery Brundage coll. (damaged by fire in 1964).
 (a) Two nude youths, r. leaning on pillar, with bird perched on r. hand, (b) two draped youths.

Bell-kraters (continued)

79 Matera 9577.
 (a) Nude youth seated by kottabos-stand, silen pouring wine into a bell-krater from an amphora,
 (b) two draped youths.
 The youths on the reverse are very close to those on the Brundage krater.
* 80 Taranto, Ragusa coll. 103. PLATE 18, 1—2.
 Photos: R.I. 68.4728—30.
 (a) Silen with thyrsus and drinking-horn, Dionysos with thyrsus, (b) two draped youths.
* 81 Bari, Macinagrossa coll. 19. PLATE 18, 3—4.
 (a) Nude youth with stick, draped woman with phiale, (b) two draped youths.

(iii)

The three following vases, which are cruder in style, seem to be connected with one another
and with those in division (ii):

Pelikai

82 Milan, "H.A." coll. 432.
 (a) Nude youth with stick, and draped woman, (b) two draped youths.
83 Bari 6285.
 (a) Seated nude youth with wreath, woman bouncing ball, (b) two draped youths, l. with stick.
84 Boulogne 122.
 (a) Seated woman with tambourine, nude youth with stick, (b) two draped youths.

(iv) THE LA ROSIAZ PAINTER

With the La Rosiaz Painter we come to the end of this line. The reverses of nos. 85—87
should be compared with those by the Painter of Lecce 686, from whom he clearly draws his
inspiration, but the drawing has become much scrappier and more slovenly. Typical are the
thick wavy black lines which mark the border of the overhang on the himation of the youths
to left on his reverses, and the sketchy drawing of his faces and particularly the eyes. His
meanders are drawn with thick, uneven lines, and are unconnected. Two of his vases have amus-
ing subjects – the Perrone krater (no. 87) which shows a young satyr lifting up the drapery of
a woman, who expresses her contempt for him by holding out a female mask with a protruding
tongue, and the Marburg pelike (no. 88) on which a woman fills a b.f. hydria with water from
a spout while Pan sheds light on the proceedings from his torch.

Bell-kraters

* 85 La Rosiaz, Mme. Ernst. PLATE 18, 5—6.
 (a) Standing woman with sash and phiale, seated Dionysos with thyrsus, (b) two draped youths.
* 86 Naples 2191 (inv. 81429). PLATE 19, 1—2.
 (a) Seated woman grasping thyrsus, and nude youth, (b) two draped youths.
* 87 Bari, Perrone coll. 1. PLATE 19, 3—4.
 (a) Satyr with thyrsus, lifting up the drapery of a woman who holds in her r. hand a white-fleshed
 female mask, (b) two draped youths.

Pelikai

* 88 Marburg 34. PLATE 19, 5—6.
 (a) Pan holding thyrsus and torch and woman running up with hydria to collect water from a
 fountain-spout above a pool, (b) two draped youths.
89 Ruvo 941.
 (a) Nude youth with drapery over l. arm, and woman with phiale, (b) two draped youths.

(v) THE BAISI PAINTER

The three vases in this division are the work of a single painter whose style has something in common with that of the La Rosiaz Painter, especially in his drawing of the mouth (cf.those of the seated woman on no. 90 and the running woman on no. 88).

Pelikai

* 90 Policoro 33373. PLATE 20, 1—2.
 (a) Eros standing before seated woman holding mirror, (b) two draped youths, r. holding up wreath.
 91 Turin 4494.
 CVA 1, IV D, pl. 3, 5—6.
 (a) Nude youth and woman with fillet and cista beside an altar, (b) two draped youths, l. with wreath, r. with stick.
* 92 Taranto, Baisi coll. 42 (T 21). PLATE 20, 3—4.
 (a) Satyr with fillet and phiale, woman with torch and tambourine, moving to r., (b) two draped youths by altar.

4. THE CHAPLET GROUP

This Group takes its name from the chaplet which appears on several of the vases in it, either held in somebody's hand or suspended above (vid. nos. 93, 99—100). The two principal painters are very closely connected with each other.

(i) THE "R.S." PAINTER

The Turin bell-krater in the R.S. collection (no. 93) was formerly ascribed to the Tarporley Painter himself (*APS Addenda*, p. 426, no. 17 bis; Porten Palange, *Acme* 24, 1971, pp. 192—7, pl. 2), but closer study shows that, although it stands near to him (cf. with his no. 5), it is not by his own hand. The treatment of the Nike's drapery and of that of the youths on the reverse is different, although the enclosed fan-palmettes beneath the handles resemble those on no. 31. Characteristic of the "R.S." Painter is the way in which he draws the fold-lines above the girdle round the waist and on the overfall of his female figures. Noteworthy also is the way in which the bent leg beneath the drapery is kept free of fold-lines, though there may be a vertical stripe running down or beside it. All his vases are closely linked by the repetition of figures from one to another and by the use of unconnected meanders.

Bell-krater

 93 Turin, private (R.S.) coll.
 APS Addenda, p. 426, no. 17 bis; *Acme* 24, 1971, pp. 192—7, pl. 2.
 (a) Nude youth with staff, and Nike with chaplet, beside a Doric column, (b) two draped youths.

Hydriai

* 94 Naples 742 (inv. 82726). PLATE 21, 1.
 Nude youth with stick, woman with balls beside pillar.
* 95 Louvre K 22. PLATE 21, 2.
 Pagenstecher, pl. 7a.
 Two women beside a statue of a nude youth with spear standing on a three-stepped base.
 96 Avignon.
 Nude youth and standing woman holding tendril.

The following vases are connected in style with the above, as may be seen from the treatment of the women's drapery:

Hydria

97 Ruvo 873.
 Woman with ball pursued by Eros with wreath.

Oenochoe (shape 3)

98 Once London Market, Christie's, *Sale Cat.*, 2 Dec. 1970, no. 69.
 Nude youth with strigil, and draped woman.

(ii) THE PAINTER OF BOLOGNA 498

The connexion between the Painter of Bologna 498 and the "R.S." Painter is close, as may be seen from a comparison between the draped women on nos. 99—101 and those on nos. 93—94. The treatment of the youths on the reverses, however, differs considerably from that on the Turin krater (no. 93) and a characteristic feature of their himatia is the way in which the far corner splits up into two parts, with something of the effect of "tails", down each of which runs a wavy black line (nos. 100—102); a similar effect may be seen on the piece of drapery which envelops the left arm of the youths on nos. 99 and 101.

In *APS* (p. 39), Bologna 498 was attributed to the Painter of Bologna 497, but we now see that it stands apart from that vase, which will be discussed in Chapter 4 in relation to the Painter of Karlsruhe B 9.

(a)

Hydria

99 Milan, "H.A." coll. 420.
 Woman with chaplet, and nude youth with stick.

Pelikai

100 Bologna 498.
 APS, p. 39, no. 2.
 (a) Eros with chaplet, and woman bouncing ball, (b) two draped youths.

*101 Taranto 110035, from Taranto. PLATE 21, 3—4.
 APS, p. 35, no. 41; *ESI*, p. 52, no. B142, (where erroneously attributed to the Tarporley Painter).
 (a) Woman with mirror, and nude youth, (b) two draped youths.

102 Milan, "H.A." coll. 421.
 (a) Nude youth with drapery over l. arm, and woman with chaplet beside Ionic column, (b) two draped youths.

(b)

The following vases show a rather cruder style, especially in the drawing of the face, but have the same characteristic treatment of the drapery.

Pelikai

103 Taranto 101641, from Piazza Sardegna (10/8/55).
 (a) Eros with chaplet, and woman bouncing ball above tendril, (b) two draped youths.
104 Trieste S434.
 APS, p. 39, no. 3, pl. 15, figs. 69—70.
 (a) Nude youth with strigil, and woman bouncing ball, (b) two draped youths.
105 Zurich Market, Arete.
 (a) Nike with phiale, (b) nude youth with stick.

Squat lekythos

106 Zurich Market, Arete.
 Woman with mirror, and woman bouncing ball, both moving to l.

Oenochoe (shape 3)

107 Vienna 1017.
 APS, p. 72, no. (xlvii).
 Woman running to l., with mirror in r. hand.

(iii) THE GROUP OF SYDNEY 71

The three following vases look to be by a close follower of the R.S. Painter and the Painter of Bologna 498.

Hydriai

*108 Sydney 71. PLATE 21, 5.
 Woman holding up a tambourine, nude youth with stick and wreath.
109 Minnesota 73.10.5 (ex New York Market).
 Parke-Bernet, *Sale Cat.,* 26 Sept. 1973, no. 273 (ill.).
 Draped woman beside tendril; looped fillet to l.

Oenochoe (shape 3)

*110 Rome, private coll. PLATE 21, 6.
 Woman with wreath, and nude youth with wreath and stick beside an altar.

(iv) CONNECTED VASES

The following three vases, of which the first two are by a single hand, are connected in style with those in the preceding divisions. Bari 6283 (no. 113) should also be compared with the work of the La Rosiaz Painter.

Pelikai

111 Stockholm 29.
 APS Addenda, p. 427, no. (iv a).
 (a) Eros and nude woman at a laver, (b) two draped youths, with sash suspended between them.
112 Taranto 52516.
 (a) Standing woman with phiale, nude youth with drapery over l. arm; between them, an altar,
 (b) two draped youths.
113 Bari 6283.
 (a) Nude youth with drapery behind back and woman seated on cista, (b) two draped youths.
 The youths should be compared with those on Bologna 498, especially in the drawing of the face.

5. IMITATORS OF THE TARPORLEY PAINTER

Of the following two pelikai no. 114 was attributed in *APS* to the Tarporley Painter himself, while no. 115 was connected with "The Painter of Bologna 497" (see Chapter 6, p. 136). In *APS Addenda,* no. 115 was associated with the Tarporley Painter. These vases now seem to be the work of imitators of this artist. The woman on Louvre K 29 (no. 114) looks back to similar figures on such vases as the the pelike in Florence (no. 47 above) and should also be compared with the female figures on the vases of the Chaplet Group (e.g. nos. 94, 100–102).

Pelikai

114 Louvre K 29.
 APS, p. 35, no. 42; *ESI,* p. 52, no. B143, (Tarporley Painter).
 (a) Nude youth and draped woman holding chaplet and mirror, (b) two draped youths.
115 Vatican U 10 (inv. 17958).

Pelikai (continued)

> *APS,* p. 39, no. (i) and *Addenda,* p. 427, no. (iv b); Schneider-Herrmann, *BABesch* 46, 1971, p. 127, fig. 5.
> (a) Two women, one bouncing ball, (b) two draped youths.

6. THE GROUP OF VATICAN V 5

In *APS,* p. 53, a "Painter of Vatican V 5" is mentioned as a companion to the "Painter of Copenhagen 335" (on this painter see the introductory comments on the Painter of Athens 1714; Chapter 8, section 3) to whom the pelike Vatican V 5 and two bell-kraters, one in Lecce, the other in the Errera Collection in Brussels were assigned. Of these pieces the two bell-kraters are now attributed to the Adolphseck Painter (see Chapter 4, nos. 56–57) and the pelike Vatican V 5 is used as the name vase of the following group which represents a slightly later development from the vases of the Chaplet Group.

<div align="center">(i)</div>

Pelikai

116 Vatican V 5 (inv. 18032).
 APS, p. 53, no. 1.
 (a) Woman with bunch of grapes and cista pursued by nude satyr with wreath, (b) two draped youths.
117 Grottaglie, private coll.
 (a) Seated half-draped woman with cista, and satyr holding wreath and bunch of grapes, (b) two draped youths at stele.
118 Louvre K 30.
 (a) Draped woman with phiale, and nude youth with stick in r. hand and drapery over l. arm, beside a stele, (b) two draped youths.

The following vase should be compared with nos. 116–118.

119 Madrid, Palacio de Liria CE 11.
 Blanco Freijeiro, *Zephyrus* 15, 1964, p. 73, no. 9, pls. 10, 2; 11 and 12, 1.
 (a) Two women at a laver, (b) two draped youths.

<div align="center">(ii)</div>

Pelike

120 Toulouse 26.316 (378).
 (a) Nude woman holding mirror, and woman with cista at a laver with a hydria on a stand beside it, (b) two youths, l. holding fillet, r. with bare torso and r. arm partly extended beneath the himation.

Hydria

121 Crotone CR 128.
 Photo: R.I. 68.4004.
 Seated woman with open box, and half-draped woman holding fillet.

CHAPTER 4

FOLLOWERS OF THE TARPORLEY PAINTER (A)

1. The Schiller Painter
2. The Reckoning Painter
3. The Adolphseck Painter
4. The Prisoner Painter
5. The Eton-Nika Painter
6. The Long Overfalls Group
7. The York Group
8. The Rainone Painter
9. The Eumenides Group

Bibliography

A. Cambitoglou and A.D. Trendall, *APS,* pp. 19—20 (Adolphseck Painter), pp. 21—24 (Eumenides Group), pp. 27—28 (Dioskouroi Painter), pp. 42—47 (Eton-Nika Painter, York Group, Long Overfalls Group and Painter of Bonn 1364), pp. 59—60 (Bendis Painter) and *Addenda,* pp. 425 ff.
A. Stenico, 'Eton, Pittore di', *EAA* iii, p. 466.
A. Stenico, 'Eumenidi, Pittore delle', *EAA* iii, p. 527.
A. Stenico, 'Lunghe Falde, Pittore delle', *EAA* iv, p. 731.
A. Stenico, 'York, Pittore di,' *EAA* vii, p. 1240.
Gianna Dareggi, *Vasi apuli nella collezione Magnini a Deruta, passim.*

Introduction.

The Tarporley Painter had a profound influence upon the "Plain" style painters of the first half of the fourth century and this and the two following chapters survey their work. As far as feasible, the different artists have been put together in related groups to illustrate the stylistic connexions between them, and it is clear that they are remarkably close, suggesting a limited number of workshops, probably in close proximity to one another. We have made several modifications to the groupings originally given in *APS,* since a wealth of new material has enabled us to define more precisely the various workshops and their mutual influences.

The "Plain" style painters, in general, continue the traditions established by the pioneers and, with few exceptions, decorate only vases of smaller dimensions, for the most part with Dionysiac or genre subjects, and on the reverses with the inevitable draped youths. These often reflect a certain measure of individuality on the part of the painter and serve to distinguish the work of one artist from another. Several vases (mostly column-kraters) depict scenes with Oscan warriors, either in battle or in a domestic setting, and scenes from phlyax plays, often with a representation of the actual stage, become more frequent. The influence of the vase-painters of the "Ornate" style becomes increasingly apparent, especially in the greater use of added white and yellow paint, and also in the appearance on the obverses of larger-scale compositions inspired by mythology and the drama, often with characters wearing richly decorated costumes (e.g. nos. 51, 127, 183—4, 186). The appearance of a volute-krater (Leningrad 585; no. 140) decorated in the "Plain" style is another example of the interaction of the two trends.

1. THE SCHILLER PAINTER AND RELATED VASES

The Schiller Painter is named after Baurat Schiller, the former owner of a bell-krater now in the British Museum (no. 21), and his early work is closely connected in style with that of the Tarporley Painter.

(i) EARLY WORK

The Schiller Painter's dependence upon the Tarporley Painter is well illustrated by a number of vases in this division. We may note, in particular, the following characteristic features:

(a) the treatment of the drapery of the woman on the Karlsruhe and Laon kraters (nos. 1–2), which is very much in the Tarporley Painter's manner;
(b) the two parallel vertical fold-lines in the bottom l. corner below the overhang on the himatia of the youths facing r. (nos. 1, 6, 7);
(c) the tendrils on the Karlsruhe and Laon vases (nos. 1–2);
(d) the drapery and poses of the youths on the reverses (similar to those on nos. 30 and 33 by the Tarporley Painter, especially the latter), on which there is also a stele between them (as on nos. 1 and 6);
(e) The drapery and pose of the youth to r. on no. 2 which should be compared with those on nos. 3/9, 11, 27 and 38 by the Tarporley Painter.

Our artist carries still further the Tarporley Painter's practice (which, in turn, looks back to the Sisyphus Painter; cf. nos. 1/60, 64) of giving his nude male figures a piece of drapery either looped over both arms and hanging behind their back, or looped over one arm and held by the hand of the other (nos. 1, 2, 5, 6, 7, 8, 10, 11, 13, etc.). Such figures appear on many of his vases.

We may also note his fondness for putting a wavy line across the top of the himation of his reverse youths, and another, which soon assumes the characteristic zig-zag form of a "lightning-flash" (Fig. 2c) in the bottom corner of the cloak of youths facing to l. (nos. 1 and 3, where it is still wavy; nos. 6, 7, where it has the regular zig-zag form). A similar line also appears later on the cloaks of youths facing to r., when their bodies are frontal (as on nos. 13–18). The black-figure decoration on the rims of bell-kraters nos. 1–2, 10 and 18, and the egg-patterns below the pictures on nos. 1 and 4a are unusual.

Bell-kraters
1 Karlsruhe B 127.
 CVA, pls. 58, 2 and 55, 5; *APS*, p. 57, no. 2.
 (a) Dionysos with filleted thyrsus, and maenad with phiale and oenochoe, (b) two draped youths.
2 Laon 37.1042.
 APS, p. 57, no. 3, pl. 33, figs. 159–160.
 (a) Dionysos with thyrsus and phiale, maenad with wreath and tambourine beside a herm, (b) two draped youths.
 For the herm cf. nos. 3/5 and 11 by the Tarporley Painter.
* 3 Once London Market, Sotheby. PLATE 22, 1–2.
 Sotheby, *Sale Cat.,* 9 July 1973, no. 112, pl 35.
 (a) Dionysos with filleted thyrsus moving to l., preceded by a Maltese dog and followed by a silen with a wine-skin on his shoulder, (b) two draped youths, r. holding fillet.
 The youths on the reverse well illustrate the connexion with the Tarporley Painter (cf. his nos. 30 and 33), and are very close to those on no. 1 above.
4 Bari, Lagioia coll.

(a) Young satyr with raised l. foot pouring wine into a phiale held by seated Dionysos, with thyrsus in l. hand, (b) two draped youths (cf. with Naples 1862, no. 7 below).

Note the curious "bent" pillar between the two youths.

4a Würzburg H 5697.

(a) Phlyax scene: woman with skyphos approaching an altar on which is a man kneeling with a drawn sword in his r. hand and a wine-skin in his l., (b) nude youth with strigil and stick and seated nude youth.

The subject of the obverse is an amusing parody of the story of Telephos and Orestes, in the standard representations of which (Brommer, *VL³*, pp. 471–2; Bauchhenss-Thüriedl, *Der Mythos von Telephos*, pp. 87–89) Telephos is shown on the altar with a drawn sword in one hand and the infant Orestes in the other. Here a skin of wine is substituted for Orestes (cf. with Naples RC 141 = *LCS*, pl. 133, 4) and the priestess comes up with a large skyphos to collect the wine when Telephos stabs the skin (cf. Aristophanes, *Thesm.*, 733 ff.). For the egg-pattern below the pictures cf. no. 1; for the nude youths to l. on the reverse cf. the obverses of nos. 1, 2, 5, 6 and for the seated youth cf. no. 4.

5 Ruvo 1716.

APS, p. 36, no. (viii), where numbered 1714 in error.

(a) Woman with phiale, and youth with thyrsus, (b) two draped youths.

6 Taranto 6954, from Pisticci.

(b) Trendall, *Ceramica,* pl. 19, 2.

(a) Satyr with situla and torch, Dionysos with phiale and thyrsus, (b) two draped youths.

Krater

* 7 Naples 1862 (inv. 82792). PLATE 22, 3–4.

Photos: R.I. 72.1911–2.

(a) Silen with wreath and torch, Dionysos with situala and thyrsus, (b) two draped youths.

The shape is most unusual, with double handles on each side, and looks to be a modern improvement on the remains of an ancient bell-krater; the foot is also an addition. The youths on the reverse have white head-bands (as on Naples 2101, no. 19), but the treatment of the fold- and border-lines on their himatia is typical.

Pelikai

8 Taranto 6242, from Crispiano.

NSc 1913, p. 421, fig. 2.

(a) Nude youth with cista, and seated woman, (b) two draped youths.

9 Milan, "H.A." coll. 429.

(a) Youth with strigil, and draped woman with fillet and mirror, (b) two draped youths.

(ii) MATURE STYLE

In *APS* (pp. 57–8) three of the vases (nos. 17–19) in this division were attributed to the Valletta Painter and placed in the Hoppin Group. Thanks to all the additional material now available, we see that they are in fact the work of the Schiller Painter in a more mature phase of his career.

In style these vases represent a logical development from his earlier work. We see the continuation of many of the characteristics that had been previously noted, as well as a number of new features among which the following are mentioned as typical:

(a) the figure holding a situla in one hand (nos. 10–12, 14–15, 17–19), or a tambourine, often decorated in the centre with a rosette pattern (nos. 10, 11, 13, 14);

(b) the draped woman running in one direction but turning her head in the other, with her peplos billowing out around one foot (nos. 13, 15, 17, 18);

(c) the standing nude youth with a piece of drapery behind his back, to whom reference was made in (i) (nos. 10, 11, 13, 17 19); the bottom corners of the drapery are often marked with a series of sideways U's or wavy black lines;

(d) the youth on the reverses who sometimes holds up a strigil (e.g. nos. 10—11) and has his l. arm often bent with a "sleeve" drape terminating in a straight oblique line, in the corner of which is a loop to represent a small weight (nos. 13, 15, 17—19, 21, 26);

(e) the youth facing to r. with one corner of his himation often sticking out slightly behind his back (e.g. nos. 13, 14, 16—19);

(f) figures combining a profile head with a frontal body on both sides of vases.

The two-figure compositions favoured by the Schiller Painter in his early work continue for a while (nos. 10—17), but are then replaced with three-figure ones (nos. 19—22). On the smaller vases the meanders are confined to the areas just below the pictures; on the larger ones, they encircle the vessel and are combined with fan-palmettes and side-scrolls beneath the handles (nos. 19—21). One should also note the appearance of windows as a decorative adjunct (nos. 13, 16, 20), as well as the usual *halteres* and hanging sashes, to which the painter is very partial.

His subjects are rather monotonous; two standing or running figures, either male and female or both male, are the standard theme, with slight variations for the larger compositions, which often include a seated figure. His name vase represents a departure from the norm and looks back to earlier prototypes (cf. vases by the Sisyphus, Hearst and Tarporley Painters); the two amphorae both show offerings at a stele, but otherwise illustrate the painter's individual style.

Bell-kraters

10 Paris, Cab. Méd. 931.

 (a) Dionysos with thyrsus and tambourine, maenad with drinking-horn and situla, (b) two draped youths.

11 Zagreb 22.

 APS, p. 41, no. (iii); Damevski I, p. 91, no. 21, pls. 11, 1 and 14, 2.

 (a) Nude youth with tambourine, and young satyr seated on rock, holding kantharos and situla, (b) two draped youths.

12 Pontecagnano 3762, from T 784. In bad condition.

 (a) Satyr with torch and phiale and woman with situla running to r., (b) two draped youths.

 The youths on the reverse differ slightly from the normal type, and the vase might be by a close imitator rather than the painter himself.

* 13 Once London Market, Sotheby. PLATE 22, 5—6.

 Sotheby, *Sale Cat.,* 6 May 1968, no. 185.

 (a) Dionysos and woman with tambourine and sash, (b) two draped youths.

14 Castlecoole 1.

 (a) Dionysos with thyrsus and tambourine, satyr with torch and situla, (b) two draped youths.

15 Nocera, Fienga coll. 544 (De F. 583).

 (a) Dionysos with thyrsus and woman with situla and torch, both running to r. and looking back to l., (b) two draped youths.

16 Madrid 11032 (L. 356).

 APS, p. 47, no. 4.

 (a) Maenad with thyrsus and tambourine followed by Dionysos with phiale and thyrsus, (b) two draped youths.

17 Karlsruhe B 96.

 CVA 2, pls. 58, 1 and 55, 4; *APS,* p. 58, no. 2.

(a) Dionysos with thyrsus and phiale and woman running to r. with situla and tambourine, (b) two draped youths.

18 Altenburg 305.

CVA, pl. 111, 7–8; APS, p. 58, no. 5.

(a) Dionysos and woman running to r. and looking back to l., (b) two draped youths.

19 Naples 2101 (inv. 81424).

APS, p. 58, no. 4, pl. 34, figs. 167–8.

(a) Dionysos, seated maenad and silen with torch and thyrsus, (b) three draped youths.

For the white dots on the ground, cf. Zagreb 22 (no. 11).

20 Bari, Lagioia coll.

(a) Satyr with situla and thyrsus, seated Dionysos with thyrsus and maenad with torch, (b) three draped youths.

* 21 B.M. 1929.5–13.2 (ex Baurat Schiller coll., no. 410). (b) PLATE 23, 1.

APS, p. 41, no. (ii), where it is associated with Würzburg 824, now attributed to the Tarporley Painter (no. 3/35).

(a) Nike with fillet, youth with branch and targe and boy on horseback, (b) three draped youths.

For the youth to r. on (b) cf. no. 2.

Column-krater

22 Once London Marker (ex Warwick Castle).

Christie's, Sale Cat., 11 June 1968, no. 89.

(a) Youth with shield and kantharos, woman with sash and oenochoe and youth with wreath, (b) three draped youths.

Hydriai

* 23 Bassano del Grappa, Chini coll. 71. PLATE 23, 2.

Nude youth with stick and open box, seated woman with bird on r. hand and seated woman with sash and mirror; above: Eros with outstretched hands.

24 Francavilla al Mare, Ceci Macrini coll. 381.

Standing youth with cista, and seated woman with outstretched hands.

25 Toronto 419 (inv. 963.168.11).

Cat., pl. 80.

Woman with cista and mirror and youth with phiale at grave monument.

Cf. with Naples 1964 (no. 31).

Pelikai

26 Bari, Merlin coll. 37.

(a) Running woman bouncing ball, and Eros moving to r., with oenochoe and phiale, (b) two draped youths.

27 Bari 6276.

(a) Running woman with mirror, and youth with ball and staff moving to r. and looking back to l., (b) two draped youths.

Note the rounder youth to r. on the reverse. Both pelikai are close in style to the bell-kraters nos. 15 and 17.

28 Turin, private (R.S.) coll.

(a) Seated nude youth with phiale and woman with wreath, (b) two draped youths.

29 Berlin F 3160.

Nude youth with sash, woman with wreath and ball by stele, (b) two draped youths.

Amphorae

30 Potenza, private coll.

(a) Seated woman with fan, seated youth with phiale, warrior and nude youth at stele, on top of which is a kantharos, (b) four draped youths.

Amphorae (continued)

31 Naples 1964 (inv. 81744).
> (a) Woman with b.f. lekythos and dish of offerings, and nude youth with wreath at grave monument, beside the base of which is a b.f. amphora, (b) two draped youths.
> Note the half-shield suspended above.

The following amphora, which is in a poor state of preservation, is very close in style to the above and probably by the painter's hand:

31a Palermo, old inv. 957.
> (a) Youth and woman with alabastron and sash at stele, on the top of which is a hydria and on the base black vases, (b) two draped youths, l. with stick and r. with strigil.

The following bell-krater, which has been very heavily repainted and of which the foot is a modern addition, looks as if, in its original state, it might have been a work of the Schiller Painter:

Bell-krater

32 Chicago, Natural History Museum 27679.
> *PhV²*, p. 90, no. (iii), pl. 14a.
> (a) Silen with torch, seated Dionysos holding kantharos and thyrsus and maenad putting incense on thymiaterion; above Dionysos, a frontal female mask, (b) three draped youths, centre and r. with stirgils.

(iii) ASSOCIATED VASES

The following vases are very closely connected in style with the work of the Schiller Painter and may even be by his own hand:

(a)

Bell-krater

33 Los Angeles Market, Summa Galleries, inv. 90, ex Basel Market, MuM, *Sale Cat.* 51, 14 March 1975, no. 176.
> (a) Three phlyakes, one seated with inscription ΣΘΕ on mask, (b) two youths, one draped, holding up strigil, the other with drapery behind his back.
> The nature of the scene on the obverse makes a definite attribution difficult, but the nude youth to r. on the reverse is very much in the manner of the Schiller Painter, especially in the treatment of the piece of drapery looped over both arms and hanging behind his back and in the drawing of the limp l. hand (cf. with nos. 10, 14, 17, 19, 25, 27).

(b)

The following characteristics on nos. 34–38 should be noted:

(i) the treatment of the drapery of the seated women (cf. Copenhagen 374, no. 34, with Naples 2101, no. 19);
(ii) the presence of tendrils between the figures (e.g. Copenhagen 374 – cf. with nos. 1–2);
(iii) the representation of youths with a piece of drapery looped over their arms and hanging behind their back;
(iv) the representation of youths with legs crossed leaning against a pillar (nos. 34, 38) on top of which is a piece of drapery (cf. no. 3/44 by the Tarporley Painter).

Hydriai

34 Copenhagen 374 (B–S. 202).
> *CVA*, pl. 237, 1; *APS*, p. 36, no. (vi).

Nude youth resting r. arm on drapery-covered pillar and holding rabbit in l. hand, woman seated on altar.

35 Bari 6315.
 APS Addenda, p. 427, no. (vi b).
 Nude youth with drapery over l. arm and stick in r. hand, seated woman holding kalathos.
36 Nocera, Fienga coll. 550 (De F. 684).
 Nude youth with wreath, and seated woman with ball on lap and sash in l. hand.
37 Bari, Macinagrossa coll. 25.
 Nude youth between two draped women.

Lebes gamikos

38 Cork, University College J. 1269.
 APS, p. 36, no. (vii), pl. 14, figs. 65–66.
 (a) Seated Eros with bird perched on l. hand and standing woman with phiale, (b) woman with mirror and nude youth with fillet resting l. arm on drapery-covered pillar.
 Cf. with Ruvo 1716 (no. 5) and note the egg pattern below the pictures, as on nos. 1 and 4a.

(c)

From the treatment of the draped youths, and of the running woman on no. 40, the two following vases should find a place here:

Bell-kraters

39 Vatican V 12 (inv. 18045).
 VIE, pl. 29a and pl. 31a.
 (a) Maenad with tambourine and thyrsus, seated Dionysos with phiale and thyrsus, (b) two draped youths with sticks.
* 40 Hildesheim (ex Berlin F 3299). PLATE 23, 3–4.
 (a) Silen pursuing maenad with situla, (b) two draped youths at stele.
 Note the way in which the hand of the youth to r. on (b) projects slightly out of the himation and cf. the vases in Chapter 5, 2 (vi) by the Hoppin Painter.

(iv) RELATED VASES

The two following vases look to be related to the work of the Schiller Painter, but are less close to him than those in (iii):

Bell-krater

41 Liverpool 50.60.63.
 (a) Dionysos seated on Ionic capital, maenad with torch and thyrsus, (b) two draped youths, l. with strigil, r. with stick.

Pelike

42 Naples Stg. 675.
 (a) Nude youth with spear, l. foot raised on rock, beside a tree; woman running up from r., (b) two draped youths.

2. THE RECKONING PAINTER

This painter, who is named after the phlyax scene on the obverse of Leningrad 1661 (no. 45), looks back, especially in the treatment of the himatia of the draped youths on his reverses, to the Painter of Bologna 498. The youths have a rather vapid look, but the phlyax scenes show the painter at his best; both are taking place on a very similar simple form of stage supported

by plain posts. One gives us the day of reckoning, when the old countryman, with his travel-pack behind him, comes to settle an account that is obviously not working out too well; the other (no. 46) shows two phlyakes with drawn swords grasping a woman who has fallen on her knees, perhaps Odysseus and Elpenor threatening Circe (though not very probably, since the latter had not been turned back into a human being by then) or Odysseus and Diomede with Theano, but more likely a scene from everyday life showing two men coming to blows over a woman, as each tries to grab her for himself.

Bell-kraters

* 43 Bari 5595. PLATE 23, 5–6.
 (a) Nike with fillet, nude athlete with strigil and stick, woman with wreath, (b) three draped youths.
* 44 Nocera, Fienga coll. 547 (De F. 689). PLATE 24, 1–2.
 (a) Eros with phiale, Dionysos seated on klismos, maenad with thyrsus and situla, (b) three draped youths.
 Note the T-square between the two youths to r.
 45 Leningrad inv. 1661 = St. 1779; W. 1120.
 PhV², p. 33, no. 33 (where bibliography).
 (a) Phlyax scene: "The Reckoning", (b) two draped youths.
* 46 Ruvo 901, from Ruvo. PLATE 24, 3–4.
 PhV², p. 43, no. 57 (where bibliography). Photo: R.I. 66.1715.
 (a) Phlyax scene: two men attacking a woman, (b) two draped youths, l. with stick, r. with strigil.

3. THE ADOLPHSECK PAINTER AND RELATED VASES

In *APS* (pp. 19–20) the Adolphseck Painter, who takes his name from the bell-krater in Schloss Fasanerie (no. 51) and to whom three vases were then attributed, was seen as a follower of the Ariadne Painter. Thanks to a considerable amount of new material, it is now possible to trace his career in somewhat more detail and, while his mature work certainly reflects a measure of influence from the Ariadne Painter, his earlier work is closer to that of the associates of the Tarporley Painter and the Schiller Painter, and runs closely parallel to that of the Painter of Karlsruhe B 9 (cf. with Trieste S 412, Bari 2250, Erlangen K 86, Wellington V.U. 1959.1; nos. 6/10, 14, 16 and 19 below). Most of his vases represent Dionysiac scenes, but occasionally he ventures into mythology (e.g. nos. 50–52) and his name vase (no. 51) depicts a very rare subject, which was rightly identified by Möbius (*Antiken in deutschem Privatbesitz*, p. 42, no. 181; Shefton, *AJA* 60, 1956, p. 162, n. 25; Brommer, *CVA* 2, Text, p. 40 and *VL³*, p. 259, D1) as the recognition of Theseus by Aigeus (cf. with no 183 below).

(i) EARLY WORK

The four following vases, all bell-kraters, may be assigned to the painter's early phase; they are closely connected by the treatment of the draped youths on the reverses.

We should note, in particular, the following recurring elements in the drawing of the youth's himatia:

(a) the l. youth has an overhang over the l. shoulder and down his back, with an S-shaped black border (those on nos. 48–50 are almost identical); his r. arm is bent and may be completely enveloped in the himation (nos. 47 and 49), or allow the hand to project (no. 48) or the arm to be extended (no. 50); the lower border of his cloak is flat and has a curving wavy line in the corner;

(b) the r. youth has his l. arm bent at the elbow with a "sleeve" drape; the lower edge of the sleeve is marked by a C-shaped black line, with two straight lines descending from it, one touching the lower hem-line, the

other terminating beside it in a double curve (Fig. 2d); this characteristic feature appears on all four vases, and is particularly clear on nos. 47–8; across the top of the himation, always draped so as to leave the r. shoulder bare, there is normally a wavy line (nos. 47–48), between the curves of which there are sometimes small hook-shaped lines [these are especially typical of later vases (e.g. nos. 54, 56–7 below)].

Other noteworthy characteristics are his way of drawing the collar-bone with broken lines (nos. 47–9), and his rendering of the eye, especially in three-quarter faces (as on no. 49), where the dot indicating the iris is painted between the two eyelids, either without touching them at all or else barely touching the upper. The meanders may be accompanied by saltires or by squares with upright crosses (nos. 47, 49), for which he shows a preference in his later work.

The pillar inscribed with a series of seemingly meaningless letters on the Copenhagen krater (no. 50) is of interest; such pillars are not uncommon in South Italian and we shall see more of them on the vases of the Graz Painter (nos. 6/215–7), sometimes with the inscription TEPMΩN, which suggests a setting in the palaestra (cf. also nos. 83–4 below, with the inscription NIKA).

Bell-kraters

47 Bari 6330.
 (a) Satyr and Dionysos, each with thyrsus, running to l., (b) two draped youths.
* 48 Zagreb 5. PLATE 24, 5–6.
 Damevski I, p. 93, no. 28, pl. 7, 3 and pl. 13, 2.
 (a) Satyr with torch and situla moving l., followed by Dionysos with torch and thyrsus, (b) two draped youths.
49 Marseilles 2933.
 APS, p. 20, no. 2, pl. 4, figs. 17–18.
 (a) Dionysos, maenad with thyrsus and torch, and satyr drawing wine from a krater, (b) three draped youths.
50 Copenhagen 333 (B–S. 214).
 CVA, pl. 234, 2.
 (a) Herakles with club by altar, Nike with wreath and fillet, nude youth, (b) three draped youths by inscribed pillar.

(ii) MATURE WORK

The transition from the earlier to the more mature style of the Adolphseck Painter is well illustrated by nos. 51 and 53 below and also by comparing nos. 54 and 56 with his name vase (no. 51). The drawing of the three-quarter face of the maenad on the Marseilles krater (no. 49) strongly resembles that of the three-quarter faces of Medea and Theseus on the Adolphseck vase; we may note also a remarkable similarity in the pattern-work, and on both there is an upright cross in the squares accompanying the meanders. The reverse, however, of the Adolphseck vase, is nearer to that of the Copenhagen krater (no. 50), especially in the treatment of the youth on the left, although there is now a more wavy border to the overhang, replacing the earlier S-shaped one. The central youth now looks to the right and leans slightly across in that direction, thus clearly linking this vase with Naples Stg. 1 (no. 54) in which the youth reappears in just the same pose. On the Adolphseck krater, as on no. 53, the upper borders of the himatia are mostly shown as plain black lines; on the other kraters (nos. 54–59) the artist reverts to the wavy line, with small hook-like folds on either side of it, of which the prototype may be seen on Zagreb 5 (no. 48).

On the Nocera krater (no. 53) we may note that the black upper borders of the himatia

follow the lines of those on the Marseilles vase (no. 49); the rendering of the hem-line at their bottom exactly follows that of the himatia on the Naples, Lecce and Errera kraters (nos. 54, 56–7). The faces of the two youths are closer to those on the Adolphseck krater (no. 51) and the drapery of the maenad should be compared with that of the woman on Zagreb 1073 (no. 60), on the reverse of which the left youth has the S-shaped border to his overhang, as on the vases in division (i).

We should also note on the Naples krater (no. 54) the way in which the peplos billows out behind the leg of the running maenad, with the hem-line assuming the form on an enlarged omega; the same phenomenon will be observed on nos. 56–60. From now on figures in rapid motion in either direction appear regularly upon this artist's vases, and he is particularly fond of showing a woman with her head thrown back and one hand upraised to hold a tambourine or some other object (nos. 54, 57, 59). In the drawing of the face the mouth has a flat look, with a very slight downward curve; in the eyes the iris appears as a fine dot between the lids, and the fingers of the hands are stubby. *Halteres* are often used as decorative adjuncts on the reverses, and a five-leafed plant, sometimes in flower, appears on several of the vases (nos. 56, 58, 59), together with small heaps of pebbles.

The connecting links between the vases in this division are, in fact, extremely clear and there can be little doubt as to the validity of the attributions. In *APS* (p. 53), however, the Lecce and Errera kraters (nos. 56–7) were attributed to the Painter of Vatican V 5. The superficial resemblance between them and the pelike Vatican V 5 serves but to emphasise the uniformity of style among the various vase-decorators associated with the Tarporley Painter.

Little remains of the fragmentary krater in Boston (no. 52), but its attribution to the artist is based on the strong resemblance between the three-quarter head of Apollo and those on the Adolphseck krater. Most of the vases in this section should be dated to the seventies of the fourth century, and they lead on to the work of the Judgement Painter (see Chapter 10).

Bell-kraters

(a)

51 Adolphseck 179.
Möbius, *Die Reliefs der Portlandvase*, pl. 5a; *CVA* 2, pl. 80, 1–2: *APS*, p. 20, no. 1; *Ill.Gr.Dr.*, III.3,3.
(a) Medea, Theseus and Aigeus, (b) three draped youths.

52 Boston 61.112 (fr.).
APS, p. 20, no. 3; Vermeule, *BurlMag*, Feb 1973, p. 118, fig. 77.
(a) Apollo with cithara; part of Zeus (l. shoulder, arm and sceptre), and of Nike (wing and fillet), above.
For the bird-sceptre see Schauenburg, *RM* 82, 1975, pp. 207 ff.

(b)

* 53 Nocera, Fienga coll. 521 (De F. 691). PLATE 25, 1–2.
(a) Maenad with kid in l. hand and unsheathed sword in r., followed by silen with torch, (b) two draped youths.
This vase serves as a good connecting link between those in (a) and (b).

* 54 Naples Stg. 1. PLATE 25, 3–4.
(a) Dionysos with thyrsus, maenad with tambourine, satyr with torch, all running to r., (b) three draped youths.

55 Louvre CA 3198. Badly preserved.
(a) Maenad with tambourine running to l., followed by silen with torch and situla and Dionysos with thyrsus, (b) three draped youths, l. with wreath.

56 Lecce 626.
 CVA 2, IV Dr, pl. 18, 4 and 5; *APS*, p. 53, no. 2.
 (a) Komos: Dionysos with thyrsus and bell, satyr with torch, and maenad with tambourine, all
running to r., (b) three draped youths.
57 Brussels, Errera coll.
 APS, p. 53, no. 3, pl. 31, figs. 149—50.
 (a) Maenad between two satyrs, all running to l., (b) three draped youths.
58 Leningrad inv. 296 = St. 802.
 APS, p. 47, no. 6, pl. 27, fig. 125.
 (a) Dionysos, satyr and maenad, all running to l., (b) three draped youths.

Calyx-krater

59 Louvre N 2785.
 (a) Silen with thyrsus and situla, maenad with thyrsus and torch, and satyr with tambourine, all
running to r., (b) nude youth with strigil between two draped youths.

Pelike

60 Zagreb 1073.
 Damevski II, p. 247, no. 47, pl. 24, 3.
 (a) Woman with cista running to l., followed by youth with sash, (b) two draped youths.

(iii) VASES RELATED IN STYLE

The following vases stand close in style to the Adolphseck Painter.

Bell-kraters

61 Ruvo n.i. 19.
 (a) Silen with torch and wine-skin, maenad with oenochoe and dish, (b) two draped youths, l.
with ball, r. with stick, at stele.
 This vase is particularly close to the painter in its rendering of the maenad on the obverse and the
draped youths on the reverse and might well be a comparatively early work by the painter himself.
Note also the presence of the five-leafed plant beside a heap of pebbles (cf. nos. 56, 58—9) and compare
the silen with those on nos. 55 and 59 above.
61a Kiel, Kunsthalle B 537.
 (a) Herakles shooting an arrow at one of the Stymphalian birds in the presence of a seated Athena,
(b) two draped youths beside a stele.
 The reverse is particularly close to that of no. 61; the scene on the obverse is unique in Apulian and
the semi-human face of the bird quite remarkable.

Pelike

62 Ruvo 647.
 (a) Seated nude youth with thyrsus approached by woman with kantharos and oenochoe, (b) two
draped youths at stele.
 The drawing of the woman's drapery, especially the way in which her peplos billows out behind her
leg, is very much in the manner of the Adolphseck Painter; the rendering of the faces is, however, less
skilled, and the draped youths differ somewhat from the canonical type. It is possible that the vase is
by the painter himself on an off day.

4. THE PRISONER PAINTER

The Prisoner Painter, who takes his name from the battle-scenes on the two column-kraters
Ruvo 1709 and B.M. F 173 (nos. 71 and 73), on each of which is depicted a prisoner with his
hands bound together at the wrists, is an artist of some interest, whose work may be divided

into an earlier and a later group, the former influenced by the Schiller Painter and the Painter of Karlsruhe B 9 (see Chapter 6). His work is fairly consistent in style, especially in the treatment of the draped youths on his reverses, of which we may note the following features as characteristic:

(i) the himation of the l. or middle youth looking to r. is regularly draped over the l. shoulder with a fairly long overhang, arranged in a series of parallel folds, slightly bunched up (nos. 63, 67, 69, 75, 76); down its l. bottom corner runs a long wavy line (nos. 63, 65 and 75) (Fig. 2e);

(ii) the himation of the youth to r. sometimes has a "sleeve" around the l. arm with a wavy line at the edge and two lines descending from it to the hem (nos. 63—4, 66); when there is no sleeve, the lines are straighter than in (i);

(iii) youths often hold a strigil in their extended r. hand (nos. 63, 66, 70, 74—5).

Also noteworthy is the painter's fondness for giving white head-bands to the youths on the obverses (nos. 63—5, 67—70), but not on the reverses.

The meanders, which are often rather carelessly drawn, are invariably accompanied by saltire squares.

(i) EARLY WORK

It is in this phase that the influence of the Schiller Painter and the Painter of Karlsruhe B 9 is most apparent. One should compare, for example, the himatia of the youths to right on B.M. F 44 and De Blasi 12 (nos. 65 and 67) with those of corresponding figures on vases by the former, and the himatia of youths on Bologna 591 and Bochum S 504 (nos. 63—4) with those of corresponding figures on vases by the latter.

At this stage the painter is fond of two-figure Dionysiac compositions, with either moving or static groups. His characteristic treatment of the overhang of the himation, worn by the left youth on the reverses, with its parallel fold-lines ending in a wavy or a zig-zag line, is apparent from the start (nos. 63—66), and on several vases (nos. 63, 69, 70) there is a pillar between the two youths.

The first four vases (nos. 63—66) are closely inter-linked; the obverses of Bologna 591 (no. 63) and B.M. F 44 (no. 65) are very similar, and so are the reverses of the former and of Bochum S 504 (no. 64). The reverse of B.M. F 44 (no. 65) is connected with that of the De Blasi krater (no. 67), which, in turn, leads on to the reverses of the Copenhagen and Macinagrossa vases (nos. 69—70).

Bell-kraters

63 Bologna 591.
 CVA 3, IV Dr, pl. 24, 5—6.
 (a) Satyr with thyrsus and drinking-horn following nude youth with phiale, (b) two draped youths, r. with strigil.

64 Bochum S 504.
 Kunisch, *Cat.,* no. 121, ill. on pp. 142—3.
 (a) Young satyr with raised foot, holding wine-skin in l. hand and Dionysos with phiale and thyrsus, (b) two draped youths.

65 B.M. F 44.
 (a) Nude youth with drinking-horn and satyr with torch and thyrsus, (b) two draped youths.

66 Naples 1797 (inv. 81647).
 (a) Seated Dionysos with thyrsus and young satyr with phiale, (b) two draped youths, l. with stirgil. Rather more careless drawing than usual.

* 67 Bari, De Blasi coll. 12. PLATE 25, 5–6.
 (a) Seated Dionysos with thyrsus and torch and silen with raised foot holding wreath and phiale,
 (b) two draped youths.
 68 Monopoli, Palmieri-Piangevino coll. 56.
 (a) Woman with thyrsus, and nude youth with drapery over l. arm, (b) two draped youths.
 69 Copenhagen 292 (B–S. 216 A).
 CVA, pl. 253, 2; *APS*, p. 50, no. 3 (Painter of Bologna 571).
 (a) Woman with phiale and wreath and seated nude youth with wreath, (b) two draped youths.
* 70 Bari, Macinagrossa coll. 17. PLATE 26, 1–2.
 (a) Satyr with phiale of offerings, and woman with torch and tambourine beside a banded situla on
 a stand, (b) two draped youths.
70a Taranto, from Rutigliano T. 3.
 (a) Dionysos holding thyrsus in his l. hand seated between woman with situla and oenochoe, from
 which she pours wine into a phiale held by him, and satyr with drinking horn, (b) three draped youths.

(ii) LATER VASES

 The later phase of the painter's work is characterised by a rather more sure touch and by
compositions of a somewhat more ambitious nature. The four column-kraters with battle-
scenes are of particular interest: all show one warrior attacking another, who has usually been
transfixed by a spear (nos. 71–73) and may stretch out his hands in a plea for mercy (nos. 71,
73). On three of these column-kraters (nos. 71, 73–4) the scene of combat is flanked on the
left by a prisoner with his hands bound by thongs which are tied to a nearby tree. The duel has
been interpreted as Achilles slaying Lycaon (*Iliad* xxi, 1–118), but in view of the native
costume worn by the warriors it probably represents little more than an episode from a local
conflict. The column-krater published in Passeri (pl. 256) is not identical with B.M. F 173, as
Walters suggested in the British Museum Catalogue (iv, p. 86), since the scenes on the obverses
of the two vases differ at many points and the former has three draped youths on the reverse,
the latter four. The S-pattern with dots on the rims of nos. 71 and 72 is unusual; otherwise the
four make a very coherent group.
 On the reverse of B.M. F 173 are four draped youths. The two in the centre hold up a strigil
in their right hand, like the two to left on no. 74; they are more or less duplicated in the first
two youths on the reverse of Bari 2249. The typical treatment of the overhang may also be
noted, together with the wavy line down the left side of the himatia of the youths facing to
right (Fig. 2e). The obverse of Bari 2249 provides a good link with some of the vases in division
(i). The Turin krater (no. 76) has an interesting representation on its obverse, which associates
Dionysos with the theatre, as there is a female mask with long hair suspended beside him; he
holds a narthex, as he does on several of the vases in the Long Overfalls Group, which are
decorated with theatrical subjects (nos. 144, 165 below). The reverse of the Turin vase is very
close to that of Bari 2249, except that the youths do not hold strigils.
 The Prisoner Painter should be contemporary with the Adolphseck Painter, with his *floruit*
in the 70s of the fourth century B.C.

Column-kraters

 71 Ruvo 1709.
 Heydemann, *JdI* 4, 1889, ill. on p. 263; Sichtermann, K 63, pl. 104; *Gli Indigeni*, fig. 38. Photo:
 R.I. 64.1171–2.
 (a) Warrior about to slay speared warrior; to l., captive warrior bound to tree, (b) three draped
 youths, l. and r. holding strigil.

Column-kraters (continued)

72 Once New York Market (ex H. de Morgan, *Sale Cat.* 1901, 386), Anderson Galleries, *Sale Cat.* 29 Oct. 1932, no. 573, ill. on p. 81.

(a) Warrior with spear approaching tree, beside which a kneeling warrior with a shield is speared by another warrior, (b) three draped youths holding strigils.

* 73 B.M. F 173. PLATE 26, 3—4.

Schauenburg, *BJbb* 161, 1961, pl. 49, 3; *Gli Indigeni*, fig. 37.

(a) Warrior about to slay kneeling warrior; to l., captive warrior bound to tree, (b) four draped youths, the two central ones holding strigils.

74 Once Bologna, Marchese Bentivoli.

Passeri, pl. 256.

(a) Speared warrior bound to tree, to r. of which one warrior is about to slay another, (b) three draped youths, the two to l. holding strigils.

Bell-kraters

* 75 Bari 2249. PLATE 26, 5—6.

(a) Maenad with tambourine, satyr with torch and situla, Dionysos with thyrsus and kantharos, (b) three draped youths, the two to l. with strigils.

76 Turin, private coll.

APS Addenda, p. 429, no. 3 bis; Porten-Palange, *Acme* 24, 1971, pp. 201—8, pls. 4 and 6, figs. 7—8, 11—12.

(a) Satyr pouring wine into b.f. bell-krater, Dionysos with kantharos and narthex, maenad; above: female mask, (b) three draped youths.

In the *APS Addenda* (p. 429) this vase is attributed to the Painter of Munich 3269, to whom it stands very close in style (cf. especially the maenad to r. with the one on the reverse of the Munich krater), but the treatment of the youths on the reverse shows it to belong here.

The following two vases are comparable with the work of the Prisoner Painter:

Calyx-krater

77 Monopoli, Meo-Evoli coll. 947.

(a) Nude youth with thyrsus running to l., followed by woman holding up tambourine in both hands, (b) two draped youths.

Cf. the reverse with that of B.M. F 166 by the Eumenides Painter (no. 232 below).

Bell-krater

78 Naples 1990 (inv. 81413).

(a) Nike with situla and wreath, seated Herakles with phiale and club, Hermes, (b) three draped youths, centre one with strigil, held downwards.

Also comparable with the work of the painter is the calyx-krater Munich 3269, which in *APS* (p. 67 and *Addenda,* p. 429) was attributed to the painter of that name, but which seems better placed in the present context in view of its resemblance to the obverse of the Turin krater (no. 76 above).

Calyx-krater

79 Munich 3269.

APS, p. 67, no. 1.

(a) Silen with drinking-horn, youth with thyrsus receiving a female mask from Dionysos, who holds a narthex and is seated on a chair; to r. balding silen seated on amphora, and, above, maenad with flute, (b) Dionysos between satyr and maenad.

The balding silen may be compared with that on a fragment in the collection of Professor Langlotz

(*APS*, p. 67, no. 4).

5. THE ETON-NIKA PAINTER AND RELATED VASES

The painter is named after his vase in Eton (no. 80) and from the pillars inscribed NIKA on the reverses of nos. 83 (Pl. 27, 1) and 84 (cf. also HEPAKΛEΣ on no. 85, and the inscribed pillar on no. 50 above).

As characteristic of the work of the Eton-Nika Painter we may note the following:

 (i) women normally wear a peplos, fastened on each shoulder; it sometimes has a short overfall with a wavy border below the girdle (cf. nos. 80—1);
 (ii) on the faces of the figures the eyebrow is convex; between it and the upper eyelid there is often a curving line, which sometimes touches the former (see Dionysos on no. 80 or the draped youth to l. on no. 81); the pupil is shown as a black dot or a line;
(iii) on the reverses. the l. youth normally faces in profile to r., but turns his shoulder into a three-quarter or nearly frontal position (no. 80); his l. arm is akimbo and wrapped in the himation, with a slight "sleeve" effect; the r. youth is in profile, with a slight frontal turn of the body, the r. foot brought forward and the knee bent; his l. arm is akimbo, wrapped in the himation, with a more pronounced "sleeve" effect; on the edge of the sleeve there is normally a short horizontal black line (sometimes slightly concave), beneath which two vertical black lines descend to the hem, which has a wavy border with a pronounced curve above the ankle of the left foot; across the fold-lines at the top of the himation there is a thick, slightly wavy, black line (nos. 81—85);
 (iv) a five-leafed plant (cf. nos. 56, 58—9, 61 above) appears on several vases (e.g. nos. 80, 83—4), also a ten-dril with bud (nos. 81, 83, 87, 89); a chaplet appears occasionally in the field above the pictures (cf. nos. 81, 84, 86);
 (v) below the scenes on (a) and (b) is a band of meanders, which does not run right around the vase, accompanied by either crossed squares (usually with small strokes in each corner, as on no. 80) or chequers (as on no. 81); there are not normally palmettes beneath the handles.

In style the Eton-Nika Painter is fairly close to the Painter of Karlsruhe B 9 (Chapter 6), whose influence is very evident on B.M. F 53 and F 67 (nos. 81 and 85), and with whom he must be contemporary. The Eton-Nika Painter decorated mainly bell-kraters.

(i) VASES ATTRIBUTED TO THE PAINTER HIMSELF

Bell-kraters

 80 Windsor, Eton College (ex Hope 230).
 APS, p. 43, no. 1, pl. 19, figs. 91—2.
 (a) Maenad with thyrsus and situla and seated Dionysos playing kottabos, (b) two draped youths.
 81 B.M. F 53.
 APS, p. 43, no. 2, pl. 19, figs. 93—4 and pl. 20, fig. 95.
 (a) Woman with spear and rabbit and seated youth with branch, (b) two draped youths at stele (very close to those on no. 80).
 For the palmette rising from acanthus cf. B.M. F 163 by the Tarporley Painter (no. 3/12 above).
 82 Bari 3909, from Gioia del Colle.
 APS, p. 43, no. 3; *PhV²*, p. 90, no. (ii).
 (a) Maenad with situla and kantharos and Dionysos seated on altar, holding female mask and thyrsus, (b) two draped youths.
 * 83 Bonn 79. (b) PLATE 27, 1.
 APS, p. 43, no. 4, pl. 20, fig. 96.
 (a) Perseus holding up the gorgoneion, and silen covering his eyes; to r. owl flying with wreath, (b) two draped youths at pillar inscribed NIKA.

Bell-kraters (continued)

84 Madrid 11081 (L. 325).

> *APS*, p. 43, no. 5, pl. 20, figs. 97–8.
>
> (a) Youth with shield on l. arm and fillet tied round r., standing in front of Nike, seated on an altar and holding a phiale, (b) two draped youths at pillar inscribed NIKA.

85 B.M. F 67. The upper part of the obverse is missing.

> *APS Addenda*, p. 428, no. 5 ter.
>
> (a) Maenad with tambourine, and seated Dionysos, holding phiale and thyrsus, (b) two draped youths at pillar inscribed ΗΕΡΑΚΛΕΣ.
>
> For the drawing of the toes of the youth to r. cf. B.M. F 53 (no. 81).

86 Cremona, Dordoni coll. (once Ginosa, private coll.).

> *APS*, p. 43, no. 9, pl. 21, figs. 99–100.
>
> (a) Maenad with oenochoe and situla and seated Dionysos playing kottabos, (b) two draped youths.
>
> The obverse is very close to that of no. 80.

87 Altenburg 272.

> *CVA* 2, pl. 85; *APS*, p. 43, no. 12.
>
> (a) Standing woman with basket, and nude youth seated on altar, (b) two draped youths beside a tall pillar.

88 B.M. E 505.

> *APS*, p. 43, no. 6; detail of (a): Woodford, *AJA* 80, 1976, p. 294, pl. 55, fig. 5; (b) Schauenburg, *RM* 80, 1973, pl. 83, 1.
>
> (a) Woman, with oenochoe and dish of offerings, and silen at a statue of Herakles on top of an Ionic column, rising from a black plinth on a stepped base; to r. a tree, from which hangs a wine-skin, and at the foot of which is a b.f. bell-krater, (b) two draped youths, with a door between them.
>
> Susan Woodford (*op. cit.*) suggests that the statue might be the Herakles Alexikakos of Hageladas.

89 Madrid 11085 (L. 357).

> *APS*, p. 43, no. 11, pl. 21, figs. 101–2.
>
> (a) Woman with foot raised holding oenochoe in l. hand, and bending forward to offer wreath in r. to seated nude youth with phiale and branch, (b) two draped youths (much of l. youth is missing).

90 Syracuse 22662, from Scoglitti.

> *CVA* 1, III I, pl. 22, 3; *APS*, p. 43, no. 8.
>
> (a) Nude youth holding spear and aryballos, athlete with strigil seated on rock-pile by tree, woman with phiale, (b) three draped youths.

91 Matera 9977.

> *APS Addenda*, p. 428, no. 5 bis, pl. 117, figs. 12–13; Lo Porto, *Penetrazione*, pl. 32, 1–2. Photos: R.I. 66.1323–4.
>
> (a) Youth with spear and shield, draped woman with fillet, beside an altar, (b) two draped youths.

(ii) VASES RELATED TO THE ETON-NIKA PAINTER

(a)

Bell-kraters

* 92 Berlin F 3045. (b) PLATE 27, 2.

> *PhV*[2], p. 29, no. 21; Schneider-Herrmann, *BABesch* 48, 1973, p. 183, fig. 2.
>
> (a) Phlyax scene: death of Priam, (b) two draped youths.
>
> The patterns round the rim (Lesbian cymation) and below the obverse (zig-zag with triangles) are very unusual, but the reverse is very close to those of vases by the painter himself.

93 Ruvo 1120.

> Sichtermann, K 51, pl. 84. Photo: R.I. 64.1219.
>
> (a) Silen with thyrsus and wine-skin and reclining Dionysos with kantharos and thyrsus, (b) two draped youths.

With the reverse of Ruvo 1120, that of the following vase may also be compared:

Bell-krater

94 Brussels A 725.
 CVA 3, IV E, pl. 2, 1.
 (a) Eros with dish of offerings and a fillet flying towards a herm, in front of which is an altar, (b) two draped youths.

(b)

To judge from the draped youths on its reverse the following phlyax vase should also probably find a place in this context:

Bell-krater

95 Naples 3370 (inv. 81377), from S. Agata.
 PhV², p. 40, no. 49, pl. 4b.
 (a) Apollo at Delphi, (b) two draped youths.

(c) THE GROUP OF RUVO 730

The Syracuse krater (no. 96) was associated in *APS* (p. 44) with the Eton-Nika Painter on the strength of the figures on its obverse. Its reverse connects it with that of Ruvo 730, since the third youths on both vases correspond very closely in stance and drapery, and the second youths in the treatment of their himatia.

Bell-kraters

* 96 Syracuse 22663, from Scoglitti. (b) PLATE 27, 5.
 CVA, III I, pl. 22, 2; *APS*, p. 44, no. (iii).
 (a) Woman with cista running off to l. followed by flying Eros with wreath, seated nude youth and woman with wreath, (b) four draped youths.
* 97 Ruvo 730. PLATE 27, 3—4.
 (a) Satyr with horn and situla, maenad with thyrsus and tambourine, reclining Dionysos with thyrsus, maenad with thyrsus, (b) four draped youths.

Pelike

98 Bari 6284.
 (a) Youth with phiale following draped woman, running to r., (b) two draped youths.

With the above compare the following:

Bell-krater

* 99 Dijon 1198. (b) PLATE 27, 6.
 APS, p. 44, no. (vii), pl. 23, fig. 110.
 (a) Nude woman adjusting kottabos-stand, seated Dionysos with cup and thyrsus, satyr with pan-pipes, (b) three draped youths.

 The style is rather more coarse, but the treatment of the youths' himatia, and especially the pose of the youth to r. is close to that on no. 97.

6. THE LONG OVERFALLS GROUP

The Group takes its name from the frequent appearance on the vases assigned to it of a woman wearing a peplos with an unusually long overfall (nos. 100–1, 140–1), who serves as one of the several elements which provide links between the various sub-divisions. Another may be seen in the draped youth facing to right with his body turned to an almost frontal position and his left arm akimbo (cf. with the similar youth on the reverses of the vases by the Eton-Nika

Painter). The principal artist in the Group is the Painter of the Long Overfalls, but he has several colleagues whose work resembles his own very closely, so that it is not always very easy to distinguish one from the other. Several of the vases have unusually interesting subjects, (e.g. nos. 119, 127, 140), a few with theatrical associations (e.g. nos. 144, 165), and the increasing use of added white for adjuncts and details illustrates the growing influence of the "Ornate" style, as does the appearance of a volute-krater (Leningrad inv. 585, no. 140) clearly decorated by a "Plain"-style painter. Most of the vases in this group should be dated between c.380 and 365 B.C.

(i) THE PAINTER OF THE LONG OVERFALLS

This artist is very close in style to the Eton-Nika Painter, especially in his two-figure compositions and his treatment of the draped youth to left on the reverses, but the faces are more rounded and less angular.

As particularly characteristic of his work we may note the following:

(a) women often have a long overfall to their peploi (nos. 100–101); their breasts are small, and one tends to protrude (nos. 100, 103, 105, 107, 108); their hair is usually bound with a sash or a sphendone, with a small bunch sticking out at the back; youths on the obverses often wear a white head-band;

(b) in comparison with the Eton-Nika Painter the chin of his figures is slightly smaller and more rounded, and more emphasis is given to their lower lip;

(c) the draped youth to l. on the reverse (cf. the Eton-Nika Painter) is normally drawn with the head in profile to r. and the body frontal, slightly inclining to the right; the l. arm is akimbo and enveloped in the drapery, with a rounder appearance than on the Eton-Nika Painter's vases; his r. shoulder is bare, and his r. hand usually grasps a stick; the other youth, facing l., is similarly draped, but his body is not frontal; the right foot is slightly advanced and the knee bent; the leg appears very short by comparison with the length of the thigh; the l. arm is akimbo, with a rounded "sleeve" drape; the two vertical black hem-lines form the shape of an elongated Π with a slightly curved line across the top; this joins the left-hand hem-line with a curve beneath which is a small semi-circle (nos. 106–110), a peculiarity repeated on most of his earlier vases (Fig. 2f); the lower hem-line on the himatia of both youths is fairly straight until it comes to the r. hand corner, when it tends to assume the shape of a wavy U (nos. 100 and 151, Fig. 2g), though the line may break at the bottom of it, and invariably does so on the vases in the Calvet sub-group; the youths have a slightly squatter appearance than those of the Eton-Nika Painter;

(d) the meanders below the pictures, which are often rather carelessly drawn, normally run in groups of three; when they do not run right round the vase they are often cut short on the right (nos. 105–7); they are accompanied by saltire squares, and are normally continuous, but may at times not be joined at the centre (no. 100).

(a) EARLIER VASES

Pelikai

100 Bologna 537.
 CVA 3, IV Dr, pl. 9, 3 and 4; *APS,* p. 45, no. 6.
 (a) Woman with tambourine and seated youth with phiale, (b) two draped youths.
101 Brussels A 140.
 CVA 2, IV Db, pl. 6, 5; *APS,* p. 45, no. 5.
 (a) Woman with oenochoe, and seated youth with phiale, (b) two draped youths.
102 Deruta (Perugia), Magnini coll. 7.
 Dareggi, no. 3, pl. 2.
 (a) Woman with tambourine running to l. followed by nude youth with drapery over l. hand, (b) two draped youths.
 Cf. with Bari 6333 (no. 108).

103 Ruvo 470.
 (a) Nude youth with stick and wreath, and woman with fan, both moving to r., (b) two draped
youths at stele.
104 Catania L. 785.
 Libertini, *Cat.,* pl. 91.
 (a) Seated woman with mirror in outstretched r. hand, (b) nude youth with stick, l. arm enveloped
in cloak.
 Very close to Turin 4130 (no. 111).

Bell-kraters

105 Bari 20281, from Gioia del Colle.
 APS Addenda, p. 428, no. 4 bis; Scarfi, *MonAnt* 45, 1960, 317 ff., figs. 143–5.
 (a) Woman with tambourine followed by youth with phiale, (b) two draped youths.
106 Verona 171,
 CVA, IV D, pl. 3, 1.
 (a) Seated woman with mirror and standing nude youth holding duck, (b) two draped youths.
*107 Sydney 67. PLATE 28, 1–2.
 APS, p. 45, no. 2.
 (a) Woman with cista and fillet, nude athlete bending forward over raised foot and holding strigil
in r. hand, (b) two draped youths.
108 Bari 6333.
 (a) Standing woman with tambourine and seated nude Dionysos with phiale and thyrsus.
109 Taranto 6981 (old inv. 6793), from Pomarico.
 (a) Woman with tambourine and situla and youth with phiale and thyrsus, both running to l., (b) two
draped youths.
109a Policoro 42615, from Guardia Perticara. Badly damaged.
 (a) Missing, (b) two draped youths.
*110 Vienna 734. PLATE 28, 3–4.
 (a) Nude woman with situla and torch standing beside Dionysos resting on couch and holding phiale
and thyrsus, (b) two draped youths.
111 Turin 4130.
 CVA, IV D, pl. 7, 4–5.
 (a) Dionysos reclining with phiale and thyrsus, (b) running woman with tambourine.
 The Dionysos is almost a replica of the one on the Vienna krater (no. 110); for the woman com-
pare Bari 6333 (no. 108). Note the black S-pattern round the rim; compare the squat lekythos no.
136 below.
112 Taranto 8087.
 (a) Woman running to l. with thyrsus and tambourine, (b) nude youth.
113 Bologna 428.
 CVA 3, IV Er, pl. 3, 1–2; *APS,* p. 45, no. 1.
 (a) Woman with situla and tambourine, seated Dionysos with phiale and thyrsus, (b) two draped
youths.
114 Taranto 127917 (ex Arnò coll. 72).
 Arnò Sale Cat., 23 May 1966, p. 18, no. 72, ill. on pl. 2.
 (a) Maenad dancing in front of seated Dionysos holding narthex, to r. satyr with cup and situla,
(b) three draped youths.
 This vase has an elaborate design on the obverse which links it with those in sub-section (c) below;
the drawing of the draped youths on the reverse, however, connects it very closely with the vases
above. Note the appearance of the narthex, which recurs on several of the vases below (e.g. nos. 115,
142, 143, 146).

(b) THE CALVET SUB-GROUP

The following vases, which are still early, are remarkably close to one another and form a compact group which may be named after the Musée Calvet in Avignon. The treatment of the draped youths differs slightly from that of the youths of the vases in the preceding sub-division in that their heads are more rectangular and their features less rounded. The fold-line running across the top of their himatia is more pronounced and more wavy. The youth to left, who normally holds a stick in his right hand, leans a little towards the right; the other youth has his left arm bent at the elbow to form the characteristic "sleeve" drape, with a horizontal line at the edge, and two vertical lines descending from it, but without the little semi-circle on the earlier vases. The influence of the Eton-Nika Painter is still strong on these vases.

Bell-kraters

115 Avignon, Musée Calvet.
 APS, p. 45, no. 3.
 (a) Standing woman with situla and tambourine and seated Dionysos with kantharos and narthex, (b) two draped youths.
 For the draped woman cf. no. 113 and for the narthex, no. 114.

116 Once London Market, Ohly.
 (a) Standing woman with thyrsus and seated nude youth with thyrsus, (b) two draped youths.

*117 Once Basel Market, MuM. PLATE 28, 5—6.
 (a) Silen playing the flute and nude youth with spear seated on drapery, (b) two draped youths (as on no. 116, except that the one to l. holds a strigil).

118 Taranto.
 (a) Standing woman with thyrsus and tambourine and seated Dionysos with thyrsus, (b) two draped youths.

119 Agrigento R 179.
 Schauenburg, *Perseus*, pl. 32, 3. Photo: R.I. 55.732.
 (a) Standing woman with wreath and phiale and youth wearing Phrygian cap seated upon altar, holding spear in l. hand, (b) two draped youths.

119a Freiburg Market, Günter Puhze.
 Libresso, *Bibliographie*, no. 13 (1976—7), fig. 5.
 (a) Woman with tambourine, and young satyr with situla and torch, both running to r., (b) two draped youths.

120 Bari 6331.
 APS, p. 45, no. (iii), near the York Painter; *La Collezione Polese*, pl. 13, no. 46.
 (a) Maenad with tambourine, and youth with kottabos-stand over his shoulder, (b) two draped youths.

120a Once Agrigento, Giudice coll. 622.
 (a) Satyr with situla and torch running to l., followed by maenad with tambourine, (b) two draped youths.
 The maenad is very similar to the one on no. 120.

121 Vatican T 1 (inv. 17940).
 VIE, pl. 23f and pl. 24f.
 (a) Maenad playing the flute, and youth with dish of offerings and torch, (b) two draped youths.

*122 Naples 2040 (inv. 81439). PLATE 29, 1—2.
 (a) Silen with raised foot, seated nude youth playing the flute and standing woman with phiale, (b) two draped youths.
 Cf. with Cab. Méd. 428 by the Bendis Painter (no. 176 below).

123 B.M. F 45.

 APS Addenda, p. 428, no. (i a).

 (a) Youth with spear and shield, woman with chaplet and phiale, (b) two draped youths.

Pelike

124 Louvre G 542.

 (a) Seated woman with phiale, standing woman with chaplet, (b) two draped youths.

(c)

The vases of this sub-division are very close in style to those in the preceding two, but with a somewhat freer treatment of the draped youths (cf. B.M. F 171, no. 126). The wavy line across the top of the himation is given still more emphasis than before, and the himation of the youth to right gives the appearance of being wrapped around his bent left arm to produce a "sleeve" effect somewhat different from that of the vases previously listed.

Bell-kraters

125 B.M. F 56.

 (a) Seated Dionysos with thyrsus holding out kantharos to silen with oenochoe in r. hand and tambourine in l., (b) two draped youths.

 Cf. the reverse with that of Ruvo 820 (no. 142).

126 B.M. F 171. Repaired, with a few pieces missing.

 APS Addenda, p. 428, no. (i), pl. 120, fig. 22.

 (a) Dancing silen holding tambourine, Dionysos seated with Ariadne, Nike flying above, (b) three draped youths.

127 Leningrad inv. 298 = St. 1734; W. 978.

 Dyer, *JHS* 89, 1969, pl. 4, 1.

 (a) Purification of Orestes, (b) three draped youths (as on no. 126).

128 Once Gravina, Museo Pomarici Santomasi.

 (a) Satyr with tambourine and seated Dionysos with kantharos and thyrsus, (b) two draped youths.

129 St. Gallen 399/1.44 (ex Züblin coll.).

 (a) Two nude women at a laver in front of which crouches a young satyr, (b) two draped youths.

130 Hamm 1546.

 AA 1948—9, cols. 145—6, figs. 17—18; *APS,* p. 45, no. 4.

 (a) Seated Dionysos with phiale and thyrsus, (b) maenad running to l., holding tambourine and torch.

Column-krater

131 Bitonto, private coll.

 (a) Woman with cista, Oscan youth and Oscan warrior with spear and pilos, (b) three draped youths.

Pelikai

132 Vatican Z 1 (inv. 18040).

 APS, p. 46, no. 7.

 (a) Woman with fillet and nude youth with strigil resting l. arm on pillar, (b) two draped youths.

133 Hanover 774.

 (a) Nude youth and woman with phiale and situla, (b) two draped youths.

 Beside the fan-palmette beneath the handles is a single free-standing leaf (cf. also no. 132).

Hydriai

134 Bologna 560.

 APS, p. 46, no. 9.

Hydriai (continued)

Woman with torch and tambourine followed by nude youth with stick.
135 Altenburg 321.
CVA 3, pl. 101, 1.
Youth with stick and phiale, woman with kalathos, running to r.
The meander pattern is very like that on no. 134.

Squat lekythos

136 The Hague, Schneider-Herrmann coll. 195, ex London Market.
Christie's, *Sale Cat.,* 6 Dec. 1972, no. 263, pl. 11 b; *Studiensammlung,* no. 114, pl. 46.
Woman holding box by handle, nude athlete holding strigil in r. hand, having l. hand enveloped in drapery.
Note the S-pattern below the picture, as on no. 111.

Skyphoi

137 Rome, Conservatori 103.
APS Addenda, p. 428, no. 11; *CVA* 2, IV D, pl. 36.
(a) Running woman with tambourine and torch, (b) nude youth with phiale and thyrsus.
138 Deruta (Perugia), Magnini coll. 199.
Dareggi, no. 4, pl. 3.
(a) Running woman with cista and mirror, (b) nude youth with fillet in r. hand and drapery over l. arm.

Skyphos (of Corinthian shape)

139 Bologna 513 (much repainted).
APS, p. 46, no. 10.
(a) Running woman with tambourine, (b) nude youth with phiale and thyrsus.

(d) MATURE STYLE: THE SUB-GROUP OF RUVO 820

In this phase of the painter's work we see more of the influence of the "Ornate" style, of which the Leningrad volute-krater (Pl. 29, 3–4; no. 140) affords an excellent example, since vases of this shape are seldom decorated by "Plain" style painters. The black cuirass worn by the mounted Greek warrior finds a parallel on Ruvo 1088 (no. 2/23) connected with the Painter of the Birth of Dionysos; on the Leningrad vase, however, the comparative absence of added white paint will be noted. The reverse is in the painter's typical style, especially the drapery of the maenads, for which parallels can be found on several of his earlier vases, (e.g. nos. 100, 105, 134) and particularly on the column-krater Louvre K 522 (Pl. 29, 5–6; no. 141). The reverse of that vase shows the characteristic treatment of draped youths: we note again the wavy-sided U in the bottom corners of the himatia (cf. Fig. 2g), the very wavy line across the top and the enveloped arm. On several of the vases at this period the central youth holds a stick in his extended right hand, turns his head to right but keeps much of his body frontal (nos. 142, 144). Dionysiac scenes are especially popular, with the god sometimes holding a narthex (nos. 142, 143; cf. also nos. 114–5) or associated with the theatre by the presence of a mask suspended above (no. 144). The fans held by the women on the Luscombe Castle pelike (no. 151) and the San Simeon hydria (no. 152) provide the connecting link with the lebes gamikos in the Cabinet des Médailles (no. 154). Noteworthy at this period is an increasing fondness for faces in three-quarter view, which were rare in the painter's earlier works. The face of the woman to left on Louvre K 522 (no. 141) should be compared with those of the seated women on the obverse of nos. 154 and 155, and many other connecting links will readily be observed.

Volute-krater

*140 Leningrad inv. 585 = St. 854. PLATE 29, 3—4.
 (a) Combat between Greeks and Oscans, (b) thiasos: two maenads, two silens and Dionysos, all moving to r.
 Note the tendril running sideways on the reverse.

Column-krater

*141 Louvre K 522. PLATE 29, 5—6.
 APS, p. 46, no. (i).
 (a) Komos: two women and two youths, (b) three draped youths.

Bell-kraters

*142 Ruvo 820. (b) PLATE 30, 1.
 Sichtermann, K 43, pls. 72—3.
 (a) Maenad with situla and torch, old silen warming himself by brasier, Dionysos with narthex, (b) three draped youths.

143 Bari 5596.
 APS, p. 43, no. (iii).
 (a) Dionysos with narthex seated between maenad with tambourine and oenochoe, and satyr with situla, (b) three draped youths (as on Ruvo 820).

144 Naples 1866 (inv. 81425).
 APS, p. 46, no. 2, pl. 25, figs. 117—8, and pl. 26, figs. 121—2; *PhV²*, p. 92, no. (ix).
 (a) Silen, maenad playing the flute to reclining Dionysos, maenad with situla and tambourine; female mask suspended above, (b) three draped youths, l. holding chaplet.

145 Naples 2128 (inv. 81940).
 (a) Warrior with spear and shield, seated warrior being crowned by Nike, (b) three draped youths, l. with strigil.

146 Leningrad inv. 297 = St. 846.
 APS, p. 43, no. (ii), pl. 23, fig. 109.
 (a) Naked woman with torch and tambourine, seated Dionysos with cup and narthex, silen with wreath, (b) three draped youths.

147 Zurich Market, Arete (frr.).
 (a) Nude youth with strigil, woman crowning athlete holding aryballos, nude youth with shield, (b) two draped youths (r. as on Naples 1866).

148 Naples 2067 (inv. 81471). The obverse is much repainted.
 (a) Silen, reclining youth with phiale and thyrsus, kneeling satyr, and woman with tambourine and situla, (b) three draped youths.

149 Taranto 134231.
 (a) Woman with tympanum, nude youth with oenochoe and thyrsus, silen, (b) two draped youths.

Calyx-krater (fr.)

150 Cambridge, Mus. Class Arch. UP 133a.
 APS Addenda, p. 428, no. 2 bis.
 Warrior and Athena.

Pelike

151 Luscombe Castle (Devon), Sir Peter Hoare.
 APS, p. 47, no. 3, pl. 26, figs. 119—120, and pl. 25, fig. 116.
 (a) Woman with fan seated between nude youth and draped woman, (b) two draped youths.

Hydriai

152 San Simeon 5441 (SSW 10082). (continued next page)

Hydriai (continued)

APS, p. 47, no. 4.
Woman seated between nude youth and draped woman.

152a Once Lucerne Market, ex Ros coll.
Sale Cat., Galerie Fischer, 5 Dec. 1963, no. 413, pl. 9a.
Nude youth, holding cista (cf. no. 136) in l. hand and resting r. arm on drapery-covered pillar, seated draped woman (cf. nos. 151–2).

Plate

*153 B.M. F 131. PLATE 30, 2.
Youthful Herakles seated on rock with club and bow-case.
Cf. the head of Herakles with that of the striding warrior on Leningrad 585 (no. 140).

Lebetes gamikoi

*154 Paris, Cab. Méd. 953. PLATE 30, 3.
(a) Youth and woman seated on chair between draped woman with mirror and Eros flying towards them with wreath, (b) woman seated between woman holding box and fan and nude youth with strigil.

155 Berlin F 3195.
Neugebauer, *Führer*, pl. 78, 1; Schauenburg, *RM* 79, 1972, pl. 15, 1.
(a) Eros crowning woman, who has a kalathos on her lap, seated between standing woman and youth holding duck, (b) seated youth and woman with phiale; between them, a kalathos.
Lid: (a) Eros, (b) head of youth.

156 Once Zurich Market, Arete.
(a) Seated woman holding mirror, (b) Eros with dish and fillet.

(ii) VASES CONNECTED IN STYLE WITH THE PAINTER OF THE LONG OVERFALLS

Bell-krater

157 New York Market, A.G. Molloy (ex Philadelphia and Basel Markets).
Hesperia Art Bull. XLIX, no. 16, ill. on p. 9; Molloy, *Cat.* 1975, no. 42, ill. on cover.
(a) Silen approaching sleeping maenad, (b) two draped youths.

Hydria

158 Once London Market, Sotheby, *Sale Cat.* 10 June 1958, no. 35.
APS Addenda, p. 427, no. (vi a).
Nude youth with stick, and draped woman bouncing ball.

The following vases are connected with nos. 154–6 above, but are in a very poor state of preservation; nos. 160–1 have been extensively repainted.

Lebetes gamikoi

159 Bari, Macinagrossa coll. 37.
(a) Woman holding fillet with both hands, (b) nude youth with stick in r. hand and drapery over l. arm.

160 Bari, Macinagrossa coll. 32.
(a) Eros with fillet flying towards seated woman, (b) seated woman with mirror approached by Eros.

161 Once London Market, Sotheby, *Sale Cat.* 29 March 1971, no. 94.
(a) Draped woman with mirror, (b) Eros with wreath seated on hollow rock.

(iii) THE PAINTER OF WASHINGTON 378475

This is a minor artist, close in style to the Painter of the Long Overfalls, to whose hand the Turin pelike (no. 164) was attributed in *APS* (p. 46). His treatment of the draped youths on the reverses is characteristic: the one to left has his head in profile to right. His body is frontal and his left arm is akimbo with a "sleeve" drape over it and Π-like fold-lines below it along the

edge of the himation. His bent leg is very clearly outlined beneath his drapery. The hand and arm of the right youth are enveloped in the himation, with a somewhat similar treatment of the folds to that on the left youth.

Bell-kraters

162 Washington 378475.
> *APS,* p. 57, no. 4, pl. 33, figs. 161–2 (where attributed to the Marburg Painter).
> (a) Warrior with spear and shield, woman with phiale and helmet at stele, (b) two draped youths.

163 Milan, "H.A." coll. 327.
> *CVA* 2, IV D, pl. 8, 1–2.
> (a) Standing woman with thyrsus and situla, seated nude youth with phiale and thyrsus, (b) two draped youths (as on the preceding vase).
> Note the "chaplet" in the field to l. on the reverse.

Pelike

164 Turin 4502.
> *CVA* 1, IV D, pl. 4, 5–6; *APS,* p. 46, no. 8.
> (a) Seated woman with mirror, and youth with stick, (b) two draped youths (as on the two preceding bell-kraters).

(iv) THE PAINTER OF BARI 1364

The Painter of Bari 1364 stands exceedingly close to the Painter of the Long Overfalls. In *APS* three of the latter's vases (nos. 144, 151–2) were attributed to this painter, but his treatment of the youths on the reverses is slightly different; they have a slighter aspect and smaller heads. The connexion of the vases of this artist with those of division (v) is also very close and it is clear that all must be products of a single workshop.

Bell-kraters

165 Bari 1364.
> *APS,* p. 46, no. 1, pl. 25, fig. 115; *PhV²*, p. 90, no. (i).
> (a) Seated maenad, silen resting his arm on the shoulder of standing maenad with situla and Dionysos seated holding white female mask in r. hand and narthex in l., (b) three draped youths.

166 Brussels, Errera coll. D 9.
> (a) Silen with raised foot holding tambourine and situla, dancing woman and Dionysos reclining on couch with kylix and thyrsus; female mask above, (b) three draped youths.

167 Naples 1895 (inv. 81663).
> *APS Addenda,* p. 429, no. 4 bis.
> (a) Athena, Hermes, Herakles seated on altar, and Bendis, (b) three draped youths.

(v) THE BENDIS PAINTER AND RELATED VASES

The Bendis Painter was first identified in *APS* (p. 59), where he was associated with the Hoppin Painter. It is now clear, especially from his treatment of the draped youths on his reverses, that he must have been a member of the same workshop as the Adolphseck Painter and the Painter of the Long Overfalls. His fondness for representing Bendis, who appears on his vases in Thracian costume, is noteworthy; her cult in South Italy has recently been made the subject of an intensive study by Konrad Schauenburg (*JdI* 89, 1974, pp. 137 ff.).

The work of the Bendis Painter falls into two main groups. The earlier vases are particularly close to the work of the Adolphseck Painter, the later to that of the Painter of the Long Overfalls, with a progressive decline in the quality of the drawing.

(a)

The vases in this sub-division reflect the influence of the Adolphseck Painter, as may be seen from a comparison of the reverses of the Boston bell-krater or Ruvo 879 (nos. 168 and 172) with those of vases like Adolphseck 179 or Naples Stg. 1 (nos. 51 and 54 above), where the close correspondence in the treatment of the drapery is particularly noteworthy. The influence of such vases as Agrigento R 179, Bari 6331, B.M. F 171 (nos. 119, 120, 126) by the Painter of the Long Overfalls is also noticeable, especially in the use of a wavy line across the upper part of the himation. The Bendis Painter at this stage frequently draws a wavy lower hem-line to his himatia, with a pair of sideways U's (double-curve) beside it, but distinct from it (nos. 168–177; Fig. 2h). When there are three youths on the reverse of his vases, the one in the centre normally turns his head to right, keeping his body frontal and his left arm bent at the elbow beneath the himation to produce a "sleeve" effect, the bottom edge being shown as a slightly curved, thick horizontal black line (nos. 168, 171, 172, 173).

The necks of his column-kraters are decorated with widely-spaced, rounded ivy leaves, with clusters of berries in the form of dot rosettes. The meanders are invariably accompanied by saltires, and are usually not continuous, but separated by a single upright line (nos. 169, 171–2, 174). Windows are drawn with a thick square-bracket-shaped line in a reserved oblong (nos. 169, 171).

Bell-kraters

168 Boston, Dr. C.C. Vermeule.
 APS, p. 59, no. 3, pl. 35, figs. 169–170.
 (a) Artemis Bendis, seated Apollo with rabbit and branch, Hermes, (b) draped youth with strigil, draped youth crowning draped youth.
169 Vatican V 3 (inv. 18030).
 APS, p. 40, no. 3.
 (a) Youth with wreath and phiale, woman with branch and sash, at an altar, (b) two draped youths, r. with strigil.
170 Naples Stg. 436.
 (a) Satyr with situla, and seated youth with phiale, (b) two draped youths.
*171 Potenza, Soprintendenza (sequestro). PLATE 30, 4–5.
 (a) Youth with stick, nude youth seated on rocky ground with his hands bound behind his back and youth with raised foot (interrogation of prisoner ?), (b) three draped youths.
 The connexion between the reverse and that of Ruvo 879 is very close; the youth to l. on the obverse well illustrates the influence of the Tarporley Painter.

Column-kraters

172 Ruvo 879.
 Sichtermann, K 66, pl. 105. Photo: R.I. 64.1170.
 (a) Woman holding column-krater, seated Oscan warrior, nude Oscan warrior with spear, (b) three draped youths.
173 Once Milan Market, Casa Geri.
 Sale Cat. Nov. 1963, no. 266 (ill.).
 (a) Seated king with white hair between Oscan youth with shield and spear, and queen with phiale and oenochoe, (b) three draped youths.

Amphora

174 Cortona 395.
 (a) Woman with oenochoe and warrior pouring libation from phiale, (b) two draped youths.
 The reverse is very close to that of the Potenza bell-krater (no. 171).

Pelike

175 E. Berlin 32700.

(a) Draped woman taking sash from cista, nude woman disrobing beside kalathos; to r. a pillar, (b) two draped youths, l. with chaplet, r. with stick (as on Ruvo 879).

(b)

The drawing of the youths on the vases of this sub-division tends to be less precise. We may note the beginning of the decline on the reverse of Louvre G 515 (no. 177); this becomes increasingly apparent upon the subsequent vases, leading on to those of the Dechter Group (Chapter 10). The bearded king who figures on the Geri krater (no. 173) is repeated on two of the later vases (nos. 183—4), one of which shows the recognition of Theseus by Aigeus, perhaps inspired by the Adolphseck krater (no. 51 above).

Bell-kraters

*176 Paris, Cab. Méd. 428. (b) PLATE 30, 6.

APS, p. 59, no. 2.

(a) Artemis Bendis, Apollo and Hermes, (b) two draped youths.

177 Louvre G 515.

APS, p. 59, no. 1; Schauenburg, op. cit., p. 182, fig. 46.

(a) Artemis Bendis, Apollo seated on altar, Hermes, and youth with spear, (b) three draped youths.

178 Madrid 11047 (L. 328).

APS, p. 59, no. 4; Schauenburg, op. cit., p. 182, figs. 48—9.

(a) Youth wearing petasos, with shield and spear, seated woman with Phrygian cap holding cista (Artemis Bendis ?), and nude youth, (b) two draped youths.

179 Once Swiss Market.

APS Addenda, p. 428, no. (i c), pl. 118, figs. 14—15.

(a) Hermes, Herakles seated on rock and Athena with shield and spear, (b) two draped youths.

180 Leningrad inv. 550 = St. 1726.

(a) Woman with fillet, woman and youth with thyrsus seated on couch, youth with phiale and thyrsus, (b) three draped youths (cf. with the reverse of no. 179).

181 Naples 1971 (inv. 81443).

(a) Maenad, satyr, Dionysos and maenad, (b) three draped youths.

182 Naples 1972 (inv. 81385).

(a) Hermes, Athena, and Herakles seated on black-spotted rock, (b) two draped youths.

(c)

The three following vases go closely together and provide a connecting link with the Dioskouroi Painter:

Bell-kraters

183 Leningrad inv. 2075.

APS, p. 27, no. (v), pl. 8, figs. 37—8 (where associated with the Rehearsal Painter); *Addenda*, p. 428, no. (i b).

(a) Recognition of Theseus, (b) three draped youths.

183a Basel Market, MuM (frr.).

(a) Herakles with cornucopia and club reclining on lion-skin between Hermes and Athena, (b) three draped youths.

For the subject of (a) cf. no. 179; the youths on the reverse are close to those on nos. 183—4 (cf. also with nos. 187—8).

Column-krater

184 Naples Stg. 3. Much repainted.
> Schauenburg, *AA* 1962, 771–2, fig. 17.
> (a) Seated half-draped youth, woman with fan stnading in front of seated white haired king (as on the Geri krater) holding phiale, woman with torch and situla, warrior with phiale, targe and two spears, (b) four draped youths.

(d)

The following vase is associated with the Bendis Painter in the treatment of the representation on the obverse (cf. no. 179 above), although the reverse stands apart from those of the vases attributed to him.

Bell-krater

185 Madrid 32658 (P. 146).
> *APS*, p. 59, no. (i), pl. 35, figs. 171–2.
> (a) Herakles seated between Hermes and Athena, (b) three half-draped youths.

(vi) THE DIOSKOUROI PAINTER

The white-haired king who is represented on nos. 183 and 184 above provides a link between B.M. F 172 and the Bendis Painter, but the treatment of the youths on its reverse is somewhat different. We should note, in particular, the strong, clearly-defined fold-lines, the slight twist of the upper part of the body and the series of parallel lines across the top of the himation where it passes over the chest and the shoulder. The bent leg beneath the cloak is very clearly indicated (cf. Naples 2128, no. 145) and looks forward to the similar treatment on some of the vases by the Dechter Painter (see Chapter 10). The Dioskouroi Painter seems to have a liking for Ionic columns, with clearly marked flutings (reverse of B.M. F 172 and Sydney 66). On the Sydney and Ruvo kraters (nos. 187–8) the drawing is less precise but the general treatment of the figures is very similar.

Column-krater

186 B.M. F 172.
> *APS*, p. 27, no. 1, pl. 9, figs. 39–40.
> (a) White-haired king with sceptre seated on klismos and queen with phiale and oenochoe between two youths holding spears (the Dioskouroi with Tyndareus and Leda ?), (b) three draped youths, beside an Ionic column to l.

Bell-kraters

*187 Sydney 66. PLATE 31, 1–2.
> (a) Eros leading couple towards door, (b) three draped youths.
*188 Ruvo 908. PLATE 31, 3–4.
> (a) Woman seated on couch playing the flute, youth on couch with thyrsus, standing half-draped youth with thyrsus, (b) two draped youths.

The following vases should be compared with the work of the Dioskouroi Painter:

Bell-kraters

(a)

189 B.M. F 50.
> *APS*, p. 28, no. 2, pl. 9, figs. 41–2.
> (a) Woman with kottabos-stand and torch, youth with kantharos and thyrsus, running to l., (b) youth

holding dish on his shoulder containing body of an animal, half-draped youth holding up a purse. Compare the treatment of the drapery with that on B.M. F 172.

<div align="center">(b)</div>

190 Vatican T 5 (inv. 17944).
 VIE, pl. 22 a and b.
 (a) Artemis pouring a libation into a phiale held by seated Apollo, holding laurel branch in l. hand; to r. satyr with syrinx and lagobolon, (b) half-draped youth between two draped youths.

<div align="center">(c)</div>

The following vase is too heavily repainted to allow of any certainty but, from the treatment of the drapery, seems to belong to this area:

191 Brussels, Errera coll.
 (a) Nude youth and woman, nude youth and woman with cista beside a stool, (b) four draped youths.

7. THE YORK GROUP

The work of the several painters included in the York Group is fairly uniform and connected in style with that of the Eton-Nika Painter and the Long Overfalls Group, especially in the treatment of the draped youths.

An increasing use of added white will be observed on many of the vases for adjuncts like head-bands, thyrsi, etc. and for objects such as phialai, shields and helmets (cf. the later vases by the Painter of the Long Overfalls and the vases by the Bendis Painter), marking the growing influence of the "Ornate" on the "Plain" style.

(i) THE PAINTER OF SYDNEY 46.48

In *APS* (p. 67) the Painter of Sydney 46.48 was associated with the Lecce Painter. Here, however, he is seen to belong to the York Group and to provide a link between it and the Long Overfalls Group, especially with the Dioskouroi Painter. In the treatment of the faces the drawing of the mouth, with a slightly protruding lip (nos. 192–5), is very typical; so are his nude male figures with a piece of drapery behind their backs (cf. the Schiller Painter), sometimes held in one hand (as on nos. 192, 194, 198). The borders of drapery are often indicated by a thick black line. The three-quarter faces (nos. 196–7) are not altogether successful and tend to give the figures a rather unhappy look.

Bell-kraters

*192 Sydney 46.48. PLATE 31, 5–6.
 APS, p. 67, no. 1.
 (a) Seated woman, nude youth with cista, and Eros, (b) three draped youths.
193 Lecce 678.
 CVA 2, IV Dr, pl. 16, 3 and pl. 15, 2; *APS,* p. 67, no. 2.
 (a) Silen with wine-skin, Dionysos with thyrsus and phiale, maenad with oenochoe in r. hand, resting l. arm on pillar, (b) nude youth, with drapery over l. arm, between two draped youths.
194 Once London Market, Charles Ede. *Cat.* 104 (Aug. 1976), no. 3 (ill.).
 (a) Two nude athletes, (b) two draped youths.

Column-kraters

195 Bologna 500.
 APS, p. 68, no. 3; *CVA* 3, IV Gr, pl. 2, 1–3.

Column-kraters (continued)

> (a) Two women and two nude warriors, (b) four draped youths.
>
> Note in particular the treatment of the overfall and of the fold-lines around the breasts. For the pose of the youth to r. on the reverse cf. no. 3/9 by the Tarporley Painter.

196 Milan, "H.A." coll. 359.

> *CVA* 2, IV D, pl. 3, 2 and pl. 4, 2 and 4.
>
> (a) White-haired man holding helmet, youthful warrior holding shield and spear, warrior wearing pilos and holding spear seated on altar, woman with phiale and oenochoe, (b) four draped youths.
>
> For the old man cf. the Geri krater and Naples Stg. 3 (nos. 173 and 184 above).

197 Karlsruhe B 8.

> *CVA* 2, pl. 57, 1 and pl. 55, 1; *APS*, p. 68, no. 1.
>
> (a) Seated warrior between woman with oenochoe and phiale and nude youth with raised foot, (b) three draped youths.

Pelike

198 Woburn Abbey.

> *APS*, p. 39, no. (iii), pl. 16, figs. 73–4.
>
> (a) Youth with cista and woman seated on cista, (b) two draped youths.

(ii) THE PAINTER OF BOLOGNA 425

This painter was first identified by Trendall in his joint publication with Mrs. Schneider-Herrmann (*BABesch* 50, 1975, pp. 267–70) of the Matera pelike (no. 204); in *APS* some of his vases were associated with the Tarporley and Dioskouroi Painters, but he is now seen to emerge as an artist in his own right, with a characteristic style that owes a good deal to his contemporaries like the Adolphseck Painter and the Painter of the Long Overfalls.

His four bell-kraters are linked by their Dionysiac themes, the first two showing a nude woman adjusting a kottabos-stand in the presence of Dionysos, while a bearded silen looks on. The same silen reappears on the Madrid krater (no. 201), and the maenad with the fawn-skin draped across her body on that vase is repeated on the Leningrad krater, where she pours wine into a large black-figure calyx-krater like the one on Bologna 425. The reclining Dionysos on the Trieste krater recalls his counterpart on Vienna 734 (no. 110) by the Painter of the Long Overfalls and the narthex and suspended female mask on Leningrad 1662 are comparable to those on Naples 1866 by the same painter (no. 144). All these points of resemblance emphasise the close connexion between the various painters of the post-Tarporley school.

The reverse youths owe much to those of the Eton-Nika Painter and the Long Overfalls Group, especially the central one on nos. 199 and 201; one should note the omega-shaped curve on the hem-line above the ankle.

The other vases show similar characteristics to the bell-kraters, and it is interesting to observe that on them, as on Leningrad 1662, a square with an upright cross accompanies the meanders (cf. the Adolphseck and Eton-Nika Painters). The subject of the Matera pelike, Eros with a whipping-top, is unique in South Italian vase-painting (for a similar top cf. the volute-krater, Brussels A 730, *CVA* 2, IV Db, pl. 3, 1a); the bird, probably a dove, perched in the window above is also a rarity in that particular context.

Bell-kraters

199 Bologna 425.

> *CVA* 3, IV Er, pl. 3, 5–6; *APS*, p. 44, no. (vi).
>
> (a) Silen with thyrsus and torch, nude woman adjusting kottabos-stand for Dionysus, (b) three draped youths.

200 Trieste S 407.
 CVA 1, III I, pl. 4, 4–6; *APS*, p. 30, no. (i), pl. 10, figs. 47–48 (where wrongly numbered 2126).
 (a) Silen, maenad adjusting kottabos-stand, reclining Dionysos with kylix, (b) three draped youths.
*201 Madrid 11078 (L. 326). PLATE 32, 1–2.
 APS, p. 34, no. 12, where attributed to the Tarporley Painter.
 (a) Seated silen, maenad with phiale, and Dionysos holding lyre, (b) three draped youths.
202 Leningrad inv. 1662 = St. 1728; W. 1119.
 APS, p. 67, no. 3; *PhV*2, p. 91, no. (vi).
 (a) Seated Dionysos, maenad with narthex pouring libation into calyx-krater, seated papposilen; female mask suspended above, (b) three draped youths.

Amphora

203 Ruvo 1197.
 (a) Standing woman with fillet and cista, seated woman with parasol, nude youth with drapery behind his back, holding duck, (b) three draped youths.

Pelike

204 Matera, from Montescaglioso (sequestro 1974).
 BABesch 50, 1975, pp. 267–270, figs. 8–11; Schauenburg, *AntikeWelt* 7.3, 1976, p. 52, fig. 24; *Il Museo Nazionale Ridola di Matera*, pl. 46, 3.
 (a) Seated woman, Eros about to whip a top, woman with ball, (b) three draped youths.
 Very close to Ruvo 1197; the treatment of the central youth on the reverse is unusual.

The two following pelikai, which are closely connected in style, should be compared with the work of the Eton-Nika Painter (cf. the youth to left on the reverse of no. 205 and the youth to right on the reverse of no. 206 with those on the reverses of nos. 81, 84 and 85), with that of the Painter of the Long Overfalls (cf. no. 103), and the work of the painters in the two preceding divisions (nos. 192–204). The youths on the reverses should also be compared with those of the York Painter (e.g. those on no. 108). The pelikai stand perhaps nearest to the Eton-Nika Painter, but several details of the drawing (e.g. the outstretched arms, the stele, etc.) show the close relationship they bear to nos. 192–204. All these points of resemblance underline the influence that the various artists in this workshop must have exercised upon one another's painting.

Pelikai

205 Milan, "H.A." coll. 424.
 (a) Nude youth pursuing woman with cista, running to r., (b) two draped youths.
206 Brussels, Mignot coll. 28.
 De Ruyt and Hackens, *Cat.* pp. 115 ff., no. 28, figs. 58–60.
 (a) Seated youth with strigil, woman with phiale, (b) two draped youths.

(iii) THE YORK PAINTER

The early work of the York Painter (e.g. Naples 2358, 2068) is very close to that of the Eton-Nika Painter; in his more developed style, however, (Ruvo 724 and York 19) we see parallels also with the vases of the Long Overfalls Group and the Painter of Bologna 425. He is fond of representing a half-shield (or possibly a tambourine) above his pictures, especially on the reverses (nos. 208–211).

Bell-kraters

207 Naples 2358 (inv. 81377). (Continued next page)

Bell-kraters (continued)

 (a) Woman with phiale and spear, seated youth with bird, (b) two draped youths beside a stele, l. with wreath, r. with strigil.

208 Naples, 2068 (inv. 81370).
 APS, p. 44, no. 2, pl. 24, figs. 111–3.
 (a) Seated woman holding sash, and nude youth with foot raised, holding phiale beside a tree, (b) two draped youths beside a stele.

*209 Ruvo 724. PLATE 32, 3–4.
 (a) The Dioskouroi, one resting foot on the rocky border of a spring and holding pilos and spear, the other seated, holding spear and wearing petasos, beside a tree, and a draped woman with an oenochoe and a phiale, (b) three draped youths beside a stele.

210 York 19 (ex Hope 261).
 APS, p. 44, no. 1, pls. 22–3, figs. 103–8, and pl. 24, fig. 114.
 (a) Maenad with tambourine, Dionysos with lyre, and silen with torch and situla, all running to r., (b) three draped youths.

211 Stuttgart 4.248 (old no. 153).
 APS, p. 43, no. 7 (attributed to the Eton-Nika Painter, corrected in *Addenda*, p. 428); *CVA*, pl. 47, 1-2.
 (a) Nude youth with oenochoe and torch, and youth with kottabos-stand running to r. towards pillar on top of which is a bucrane, (b) two draped youth at stele.

212 Turin 4544. Badly damaged.
 (a) Maenad with thyrsus and tambourine, Dionysos seated with thyrsus, satyr with kottabos-stand, fillet and situla, (b) three draped youths.
 The vase is in very bad condition, but the reverse youths are very like those on the previous vase, especially the one to r.

Pelikai

*213 Naples Stg. 465. (b) PLATE 32, 5.
 APS, p. 36, no. (iv), pl. 14, fig. 62.
 (a) Standing youth with duck in l. hand, seated woman holding mirror, (b) two draped youths beside a stele.
 The reverse is very close to that of the Stuttgart krater (no. 211).

214 Deruta (Perugia), Magnini coll. 8.
 Dareggi, no. 5, pl. 4.
 (a) Nude youth with bird on outstretched l. hand and drapery over r. arm, seated woman with small dish containing cake, (b) two draped youths.

Column-kraters

*215 Oxford 1947.266. (b) PLATE 32, 6.
 Schauenburg, *Gymnasium* 70, 1963, pl. 8, 1.
 (a) Symposium: woman with tambourine, two reclining banqueters (Herakles and Dionysos ?), and satyr with situla, (b) four draped youths.
 The figures on the neck of (a) are a modern addition; the draped youth to l. on (b) looks back to the one on Vatican U 10 (no. 3/115).

216 Bari 874.
 (a) Combat scene, (b) four draped youths.

217 Ruvo 412.
 Heydemann, *JdI* 4, 1889, ill. on p. 260; Sichtermann, K 60, pls. 97 and 99. Photos: R.I. 64.1205–6.
 (a) Oscan warrior, seated woman with child on lap touching helmet held by warrior, (b) three draped youths.

The two following vases should be connected in style with the work of the York Painter:

Bell-kraters

218 Naples 2042 (inv. 81384).
 APS, p. 45, no. (ii).
 (a) Youth playing kottabos, with draped woman adjusting the stand, (b) two draped youths.
219 Trieste S 410.
 APS, p. 45, no. (i); *CVA*, IV D, pl. 4, 1–3.
 (a) Silen carrying tripod followed by Herakles with club and bow, (b) two draped youths, with half-shield above.

(iv) THE PAINTER OF WARSAW 198120

This is a painter with a highly individual style, seen especially in his drawing of faces and his rendering of drapery. The obverses of his vases look back to those of the Tarporley Painter, but the draped youths on his reverses are closely linked with those by the Painter of Bologna 425 and the York Painter. Particularly characteristic are the strong fold-lines and the row of parallel folds across the waists of the draped youths.

It is interesting to note that the amphora no. 221 was found at Gravina in the same tomb as the vases by the Gravina Painter, whose influence may perhaps also be seen in the treatment of the women's drapery.

Pelike

220 Warsaw 198120.
 APS, p. 36, no. (v), pl. 14, figs. 63–4; *CVA*, Poland 7, pl. 35.
 (a) Woman with necklace seated between nude youth with ball and draped woman resting l. arm on pillar, (b) two draped youths beside a stele.

Amphora

*221 Taranto, from Gravina. PLATE 33, 1–2.
 (a) Nude youth, woman with mirror and seated woman with cista on lap in front of young warrior with spear and shield, (b) woman with tendril and phiale between two draped youths, each with r. shoulder bare.

Bell-krater

222 Once Paris Market (Platt).
 APS Addenda, p. 427, no. (v a).
 (a) Dionysos with narthex, silen with torch and situla, maenad with tambourine, (b) three draped youths beside an open door.

Hydria

223 London, University College 527.
 Nude youth, nude youth with strigil seated on Ionic capital and draped woman with l. arm akimbo.
 Cf. with Warsaw 198120 (no. 220) for the meanders and saltire squares.

8. THE RAINONE PAINTER

The Rainone Painter, who takes his name from the well-known phlyax krater (no. 224) in the former Rainone collection at S. Agata dei Goti, has close affinites with the Tarporley Painter, especially in his treatment of the drapery of the youths on the reverses (cf. also with those by the Painter of the Long Overfalls) and the ovoid shape of their heads. He is also associated in style with the Dijon Painter (Chapter 6), with whom he must be contemporary.

The phlyax scene on the S. Agata dei Goti krater is particularly amusing as a parody of the Antigone. The actor playing that role holds in his left hand the hydria to be used for carrying

out the burial rites of Polynices, but as Antigone is dragged off by the guard to Creon she takes off her mask to reveal the balding and hoary head of an old man to the evident consternation of Creon, whose raised eyebrows and open mouth testify his surprise at the unexpected outcome of the story.

Bell-kraters

*224 S. Agata dei Goti, former Rainone coll. 1. (b) PLATE 33, 5.
 PhV², p. 44, no. 59; *Ill.Gr.Dr.* IV, 33.
 (a) Phlyax scene: Antigone with guard before Creon, (b) three draped youths.
 224a Vidigulfo, Castello dei Landriani 261.
 (a) Phlyax scene, on simple stage with portico and door to l.: white-haired phlyax with cista, small white-haired phlyax behind box, his l. arm grasped by another white-haired phlyax who holds a stick in his l. hand, (b) three draped youths.
*225 Florence 4050. PLATE 33, 3–4.
 (a) Maenad dancing with tambourine over her head, seated Dionysos with wreath and narthex, capering satyr with drinking-horn; beside Dionysos, a seated fawn, (b) three draped youths.
*226 Bari, Loconte coll. 2. (b) PLATE 33, 6.
 (a) Youth driving biga, (b) three draped youths.

Amphora

 227 Ruvo 612.
 (a) Youth with shield (snake emblem) beside Ionic column to l., holding up drapery behind his back and woman with phiale, with drapery flapping behind her, (b) two draped youths.

Associated in style with this painter, especially in the treatment of the draped youths on its reverse (cf. the rendering of the drapery and the drawing of the mouth) is the following vase:

Bell-krater

 228 Venice (Calif.), High School.
 (a) Nude youth with torch running to l., followed by woman with phiale, (b) two draped youths.

9. THE EUMENIDES GROUP

The Eumenides Group, named after its principal artist, includes a few other painters of some significance, one of whom decorated some notable phlyax vases (nos. 244—5). In style their work harks back to the Sisyphus and Ariadne Painters, but a substantial measure of influence from the painters of the Tarporley workshop is also apparent. The minor vases, especially in their treatment of the draped youths on their reverses, stand especially close to those of the Eton-Nika Painter; the larger ones, often with subjects of some interest, combine elements of the "Ornate" and the "Plain" styles. An increasing use of added white and yellow paint is also to be noted in this group.

(i) THE EUMENIDES PAINTER

Named after the Louvre and Finarte kraters, which show the purification of Orestes at Delphi (see Dyer, *JHS* 89, 1969, pp. 38—56, esp. pp. 51 ff.), the Eumenides Painter has a neat and precise style of drawing, as may be seen from the profile of Apollo's head on the Louvre krater and on B.M. F 166 (nos. 229 and 232). The drapery of the woman to left on the reverse of the former vase is also very characteristic and may be compared with that of the maenad on the reverse of the Finarte krater (no. 230) or of Nike on B.M. F 47 (no. 231); noteworthy is the slight curve at the end of the black stripe which runs down the side of the peplos.

The obverse of B.M. F 47 clearly looks back to the Tarporley Painter; the reverse however is much nearer to those of the Eton-Nika Painter and the Painter of the Long Overfalls, especially in the treatment of the youth to left, with the typical profile head, frontal body and left arm bent at the elbow beneath the himation. The same type of youth recurs, with but slight variation on the reverse of B.M. F 166, which is in much better state, and here we may note the wavy line across the top of the himation, the triple curved line in the bottom corner, and the omega-shaped curve on the hem-line just above the foot, for all of which parallels will be found on the reverses of the Eton-Nika Painter's vases (B.M F 53, Madrid 11081; nos. 81 and 84). The column on B.M. F 166 reminds us of some of those on some of the "pioneer" vases (cf. nos. 1/7–9, 27, 65) and should be compared with the columns on the earlier vases of the Lecce Painter.

The work of the Eumenides Painter bridges the first and second quarters of the fourth century.

Bell-kraters

229 Louvre K 710.
 APS, p. 22, no. 1; *LAF*, no. 108 (ill.); Dyer, loc. cit., pl. 2, 1; Schneider-Herrmann, *AntK* 15, 1970, p. 59, pl. 30, 1; Vickers, *Towards Greek Tragedy*, pl. 7; *Cl.Gr.Art*, fig. 350; Pinsent, *Gr. Myth.*, p. 132.
 (a) Purification of Orestes at Delphi, (b) two youths and two women.

230 Once Milan Market, Finarte, *Cat.* 5, no. 85, pls. 42–3.
 APS Addenda, pp. 425–6, no. 4, pl. 116, fig. 8; Dyer, loc. cit., pl. 2, 2.
 (a) Purification of Orestes, (b) satyr with oenochoe and amphora, Dionysos with thyrsus and torch, maenad with tambourine.
 Note the unusual uncrossed squares with solid black centres accompanying the meanders; the reverse is comparable with the work of the Iliupersis Painter and the Painter of Athens 1714 (Chapter 8).

*231 B.M. F 47. The reverse is in very poor condition. PLATE 34, 1.
 APS, p. 22, no. 3; Schauenburg, *Gymnasium* 70, 1963, pl. 6, 1.
 (a) Herakles and Nike, (b) two draped youths, r. holding fillet.

*232 B.M. F 166. (b) PLATE 34, 2.
 APS, p. 22, no. 2, pl. 5, figs. 19–20; Dyer, loc, cit., pl. 3, 3; Pinsent, op. cit., p. 131.
 (a) Apollo purifying Orestes, (b) two draped youths beside a Doric column.

*233 Rome, Villa Giulia 43995, from Vignanello. PLATE 34, 3.
 CVA 1, IV Dr, pl. 2, 4–5.
 (a) Seated silen holding thyrsus and wine-skin looking r. at maenad with kantharos and tambourine, nude youth (Dionysos?) with bell and thyrsus, (b) silen with thyrsus and wreath moving to l. followed by maenad with thyrsus.
 Compare the head of the maenad on the obverse with those of Nike and Apollo on nos. 231–2. Note also the connection with the Tarporley Painter, e.g. with nos. 3/14 and 29.

(ii) THE PAINTER OF BOLOGNA 501

The Painter of Bologna 501 is very close to the Eumenides Painter, as may be seen from a comparison of his draped youths with those on B.M. F 166. The youth to left on the reverse of Bologna 501 is very characteristic, with the left arm akimbo beneath the cloak and a long wavy line running down the right side as also on the cloak of the central youth (no. 234, Fig. 2i). The hair tends to be slightly straggly around the ears, which are sometimes represented as a reserved indent (nos. 234 and 239). The omega-like curve in the hem-line just above the left foot is apparent on these vases, as on those by the Eumenides Painter. One should also compare the treatment of the draped female figures by these two painters.

Column-kraters

234 Bologna 501.
> *CVA* 3, IV Gr, pl. 2, 1–3.
> (a) Woman with nestoris and dish, seated warrior in three-quarter face, warrior adjusting his pilos,
> (b) three draped youths, r. with strigil.

235 Zagreb 1030.
> Damevski I, pl. 3, 1 and pl. 5, 1.
> (a) Warrior with spear and shield fighting mounted Amazon, (b) two draped youths with sticks.
> For the youth to l. cf. Bologna 501.

Bell-krater

236 Leningrad inv. 1663 = St. 1774.
> *CRStP* 1869, pl. 6, 1–2; *APS Addenda,* p. 426, no. 3.
> (a) Maenad with thyrsus and kottabos-stand, Dionysos with lyre, and silen holding b.f. calyx-krater,
> (b) Nike with wreath, seated warrior between two standing warriors.

Amphora

237 Bologna 494.
> *CVA* 3, IV Gr, pl. 1, 7–8.
> (a) Woman pouring libation to youth seated on base of grave monument between nude youth and
> draped woman, (b) three draped youths, r. with strigil.

The two following vases are very close in style to the work of the Painter of Bologna 501 and are possibly minor works by his own hand, although on no. 239 the drawing is less careful:

Bell-kraters

238 Taranto 52976.
> (a) Silen with thyrsus and drinking-horn, and draped woman beside a stele, (b) two draped youths
> beside an Ionic column.

239 Matera 12399.
> Lo Porto, *Penetrazione,* pl. 58, 3–4.
> (a) Dionysos with thyrsus and kantharos running to r. after maenad with torch and situla, (b) two
> draped youths.

(iii) VASES RELATED TO THE EUMENIDES PAINTER AND THE PAINTER OF BOLOGNA 501

(a)

Column-kraters

*240 Ruvo 1090. PLATE 34, 4.
> Photo: R.I. 62.1335.
> (a) Warrior holding helmet and spear seated between, to l., young warrior and woman with dish of
> fruit, to r., woman with phiale and oenochoe, and youth with shield and spear, (b) four draped youths.

*241 Taranto, A.I. 174, from Ruvo. PLATE 34, 5.
> (a) Woman with nestoris and phiale between two nude warriors, l. seated, holding conical hat and
> spear, (b) three draped youths, centre with strigil.

(b)

The column-kraters nos. 242 and 243, which seem to be the work of a single painter, are connected with the vases in the previous sections, and, like some of them, look back to the work of the Sisyphus and Tarporley Painters. No. 243 is discussed in some detail in *Ap. Grab-vasen,* pp. 109 ff.

Column-kraters

242 Trieste S 394.
 CVA, IV D, pl. 6, 1–2.
 (a) Two women with two Oscan warriors, (b) nude satyr with thyrsus and wine-skin between two draped women, l. with drinking-horn, r. with wreath.
243 Basel, Antikenmuseum, S 28.
 Ap. Grabvasen, pls. 25–26; *Gli Indigeni*, fig. 19.
 (a) Athena driving Herakles in a quadriga, (b) two Oscan youths and two women.
 For the owl with a wreath in its mouth cf. Brussels A 1018 by the Painter of the Birth of Dionysos (no. 2/9).

(iv) THE McDANIEL PAINTER

The painter takes his name from the phlyax vase no. 244 in the McDaniel collection in the Department of Classics at Harvard, which is an excellent example of his work and extremely close in style to the Würzburg phlyax krater no. 245 (cf. the two white-haired phlyakes and the youths on the reverses). Characteristic of this painter are the thin laurel leaves round the rim and the comparative smallness of the meanders (cf. also no. 246). The phlyax mask suspended above the two figures on the obverse of no. 244 reminds us of the similar mask on the "Thief" krater by the Tarporley Painter (no. 3/7 above). The stage is of the simplest type (see *PhV²*, p. 13), without the supports which appear on no. 245. At first sight the Naples krater looks somewhat different in style, but the drawing of the faces, especially the eyes, mouth and nose, of the maenad and Dionysos on its obverse finds a close parallel on the two draped youths on the reverse of the Harvard krater. The Philadelphia column-krater is connected by the figures on its reverse, which are very close to those on the other three vases. They should date around 370 B.C.

Bell-kraters

244 Cambridge (Mass.), Harvard University – McDaniel coll. (once Hirsch 703).
 Bromberg, *HSCP* 64, 1959, pp. 237 ff., pls. 1–2; *APS*, p. 24, no. (v), pl. 7, fig. 30; *PhV²*, p. 30, no. 24; *Ill.Gr.Dr.* IV, 16.
 (a) Phlyax scene: old man and woman, (b) two draped youths.
*245 Würzburg H 4689. (b) PLATE 34, 6.
 APS, p. 24, no. (vi), pl. 7, fig. 31; *PhV²*, p. 47, no. 67; *Führer*, p. 202.
 (a) Phlyax scene: old man offering spear to seated warrior, (b) two draped youths.
246 Naples Stg. 279.
 (a) Maenad with tambourine and seated Dionysos with thyrsus, (b) draped woman with wreath and draped youth.

Column-krater

247 Philadelphia 40.34.1.
 Edith Hall Dohan, *AJA* 47, 1943, pp. 171–3.
 (a) Warrior feeding horse, nude youth with spear moving off to r., (b) four draped youths.

The following vase seems to be connected in style with the McDaniel Painter, but is perhaps a little closer to the Sisyphean tradition and might be a slightly earlier work:

Bell-krater

248 Poughkeepsie (N.Y.), Vassar College 48.97.
 (a) Maenad with tambourine and satyr capering beside tree, (b) two draped youths.

The following two vases should be compared with the above:

Bell-kraters

249 Bari, De Blasi coll. 13.
 (a) Nude youth pursuing woman, (b) two draped youths.
250 Catania MB 4232 (L. 735).
 Libertini, *Cat.*, pl. 83; *PhV²*, p. 31, no. 25.
 (a) Phlyax scene: Herakles bringing the Cercopes to Eurystheus, (b) two draped youths.

The following two vases should also find a place in this general context:

Bell-kraters

251 Boston 69.951.
 Vermeule, *BurlMag* 112, 1970, pp. 628–9, figs. 103–4.
 (a) Phlyax scene: athlete by herm, old man pouring oil onto his hand; to r. shopping basket with
 two kids and a goose, (b) youth with oenoche following nude youth with stick, running to r.
252 B.M. F 151.
 APS, p. 24, no. (vii), pl. 7, fig. 32; *PhV²*, p. 35, no. 37; *Ill.Gr.Dr.* IV, 35.
 (a) Chiron's cure, (b) nude youth seated between two draped youths.

(v)

The two following vases should be compared with the above and with those in (vi) below:

Pelikai

253 Karlsruhe B 126.
 CVA, pl. 80, 2.
 (a) Draped woman offering phiale to seated nude youth, (b) two draped youths.
254 Zurich 2502. Badly preserved, with much missing.
 CVA 1, pl. 24, 5–6.
 (a) Seated woman and youth bending forward with sash, (b) two draped youths.
 The association of the Zurich pelike (no. 254) is less certain, in view of its bad condition; it was
published in the *CVA* as Attic, but it is surely Early Apulian, and the similarity of the pattern-work on
it and on no. 253, as well as the treatment of the youths on the reverse, suggests that it should be placed
here.

(vi) THE PAINTER OF REGGIO 7001

The subject of the Reggio krater associates it with the Painter of Bologna 425, but the
style seems closer to that of the vases in the Eumenides Group. The nude youths on the two
reverses are very similar.

Bell-kraters

255 Reggio Cal. 7001.
 APS, p. 49, no. (vii); Foti, *Il Museo di R.C.*, pl. 52.
 (a) Silen holding oenochoe seated beside b.f. bell-krater, nude woman adjusting kottabos-stand,
 Dionysos with thyrsus reclining on couch, (b) nude youth, with drapery over arms and behind back
 and draped woman holding out wreath; pillar between them.
256 Naples 2041 (inv. 81463).
 (a) Nude youth carrying kottabos-stand in l. hand and handled cista in r., Dionysos and Ariadne,
 each grasping one handle of a kantharos, beneath a grape-vine, and silen running up with pointed
 amphora on r. shoulder, (b) nude youth to r. between draped woman with strigil beside a Doric
 column and draped youth.

The following pelike should be compared with nos. 255 and 256, especially for the draw-
ing of the face of Artemis and the treatment of the youths on the reverse:

Pelike

257 Leningrad inv. 350 = St. 873.

 Schauenburg, *JdI* 73, 1958, p. 55, fig. 4.

 (a) Seated youthful Herakles, Artemis with crown and two spears, Pan with syrinx leaning on pillar, (b) nude athlete with aryballos seated between nude youth and draped youth (cf. also with the reverse of no. 252).

(vii) THE PAINTER OF PERSEUS AND ATHENA

The painter takes his name from the situla in the British Museum (no. 258), on which the figure of Perseus closely resembles the male figure on the Tübingen fragment. One should especially note the drawing of the mouth, which is shown as tightly closed, with a slight downward turn. The woman on the reverse of the British Museum situla should be compared with that on the reverse of Reggio Cal. 7001 (no. 255).

Situla

258 B.M. F 83.

 APS, p. 23, no. 1, pl. 6, figs. 23–4; Schauenburg, *Perseus,* pl. 3, 1.

 (a) Athena holding out the *harpe* to Perseus, (b) satyr with tambourine, and draped woman.

Hydria (fr.)

259 Tübingen F 20 (inv. 1668).

 APS, p. 23, no. 2; Ghali-Kahil, *Hélène,* pl. 28, 4.

 Paris and female figure (from a scene with Paris and Helen or the Judgement of Paris).

 The interpretation as Paris and Helen is perhaps more plausible that the other suggestion made in *APS* p. 23.

The following vases are connected in style:

Skyphos

260 Taranto 22488.

 APS, p. 23, no. (iv); *CVA* 2, IV Dr, pl. 31.

 (a) Paris and Helen, (b) Eros and woman.

Bell-krater

261 Louvre S 4051.

 Schauenburg, *Perseus,* pl. 42.

 (a) Perseus and Athena, (b) two draped youths.

 Note the two lines of dots across the himation of the r. youth on the reverse, which find a parallel on that of the youth on the reverse of the fragmentary phlyax bell-krater Taranto 121613 (*PhV*2, p. 45, no. 61).

The following vase should perhaps be mentioned in the context of the Eumenides Group:

Bell-krater

262 Naples 2413 (inv. 81415).

 APS, p. 23, no. (i), pl. 6, figs. 25–6.

 (a) Jason wrestling with the bull in the presence of Nike and Medea, (b) woman with ball seated between nude youth with duck and standing woman.

CHAPTER 5

FOLLOWERS OF THE TARPORLEY PAINTER (B)

THE HOPPIN-LECCE WORKSHOP

Bibliography

A. Cambitoglou and A.D. Trendall, *APS*, pp. 55–57 (The Hoppin Painter), p. 58 (The Painter of Lecce 614), pp. 62–65 (The Lecce Painter) and 68–74 (The Truro Painter); also *Addenda* pp. 429–430.

A. Cambitoglou, 'Two vases by the Truro Painter in the Nicholson Museum' in *Festschrift Brommer,* pp. 67–76, pls. 21–22.

A. Stenico, 'Hoppin, Pittore di', *EAA* iv, p. 56.

A. Stenico, 'Truro, Pittore di', *EAA* vii, p. 1025.

A. Stenico, 'Lecce, Pittore di', *EAA* iv, pp. 523–4.

Introduction

The Hoppin-Lecce workshop is responsible for some of the more interesting Early Apulian vases, many of which are listed and discussed in *APS,* with additions and refinements in *Addenda.* The Hoppin Painter is an artist of considerable importance, whose work had a wide influence, especially upon that of the Truro and Lecce Painters. He should also be studied in connexion with the Felton Painter (Chapter 7, 5), and the Painter of Athens 1680 (Chapter 9, 7).

1. THE PAINTER OF LECCE 614

In *APS* (p. 58) two bell-kraters in Lecce (612 and 614) were attributed to this painter, whose style was noted as akin to that of the Hoppin Painter. Also clear is its close connexion with that of the Tarporley Painter, especially now that we have transferred from him to the Painter of Lecce 614 the bell-krater in Mississippi (no. 1). The youths on its reverse are remarkably like those on the name vase of our artist and the compositions of the two obverses also correspond closely, as does the treatment of the seated women holding a tambourine. The relationship between the Mississippi krater (no. 1) and the early work of the Tarporley Painter is very clear.

Particularly characteristic of the Painter of Lecce 614 is the draped youth on the reverse of his vases with one arm akimbo and the himation drawn fairly tightly round the neck, who is derived from a somewhat similar youth on such vases as Madrid 11079, B.M. F 163 and Sydney 47.05 (nos. 3/6, 12, 15).

Also typical is the rendering of the meanders, each of which is drawn independently, separated from its neighbours by a vertical line, and consisting itself of an unbroken line ending at the centre (unlike those of the Tarporley Painter).

There is also some connexion between the work of this painter and that of the Painter of Karlsruhe B 9, with whom he must be contemporary in the latter part of the first quarter of the fourth century B.C.

Bell-kraters

* 1 University of Mississippi (ex Robinson and Trau colls.) PLATE 35, 1—2.
 APS, p. 34, no. 8.
 (a) Seated woman with tambourine between Dionysos with thyrsus and satyr, (b) three draped youths.
 2 Lecce 614.
 CVA 2, IV Dr, pls. 14, 4 and 16, 7; *APS*, p. 58, no. 2.
 (a) Seated woman with tambourine between Dionysos and a stayr, (b) two draped youths.
 3 Lecce 612.
 CVA 2, IV Dr, pls. 14, 5 and 15, 3; *APS*, p. 58, no. 1.
 (a) Seated draped woman, and nude woman with sash leaning on laver, goose between them, (b) two draped youths.

Calyx-krater

 4 Lecce 736.
 CVA 1, IV Dr, pl. 3, 3—4; *APS*, p. 49, no. (vi).
 (a) Athlete with strigil, and draped woman with sash, (b) two draped youths.

2. THE HOPPIN PAINTER

The style of the Hoppin Painter draws its inspiration from the work of the Tarporley Painter and the Painter of Lecce 614; their influence is very clear on his earlier vases (e.g. Naples 2094, Zagreb 7), especially in the treatment of the youths' heads, the use of tendrils or birds in people's hands, and in the drawing of youths shown in three-quarter view. There is also a stylistic connexion between the Hoppin Painter and the Painter of the Long Overfalls, and in his later vases parallels will be found as well with the work of the Iliupersis school, especially the Painter of Athens 1714.

The vases of the Hoppin Painter may be sub-divided into different phases of his stylistic development. His rendering of drapery is very characteristic, especially his use of small, broken fold-lines at the waist of female figures, which produce a rather fussy look. Women's hair is generally done up in a *sphendone,* with a bun sticking up at the back. On some of his earlier vases the youths on the reverse do not wear white head-bands, but later this practice is generally adopted, and is also taken up by his associates and followers. These white head-bands often appear on obverse figures as well, usually with a slight twist (nos. 23, 49). Dionysiac scenes are popular with the Hoppin Painter.

It may be noted that on his bell-kraters the meander-band seldom runs right round the vase; on his earlier works it is usually confined to the area immediately below the pictures (nos. 5—6, 8—9). When there are fan-palmettes with side scrolls beneath the handles, these come down to the bottom level of the band, which stops at that point (nos. 16—19, 23—24). On some of the later vases (nos. 34, 36, 38) the saltire squares have a hollow triangle in each of the four quarters.

(i)

In this phase the artist is very closely connected with the Tarporley Painter and the Painter of Lecce 614. There is normally a band of meander pattern immediately below the pictures of

his vases, with a saltire square at the left end, and sometimes at the right end as well. There are generally small tendrils on either side of the picture. Noteworthy is the swastika on the cloak of the youth on Naples 2094 (no. 5), a device which is favoured by the Hoppin Painter (cf. nos. 19, 20, 23, 34). The draped youths do not wear white head-bands; the left youth usually has his right arm extended to hold a stick, with a long overhang over the left shoulder; the right youth holds a stick or strigil in his right hand, and has a simple "sleeve" draped over the left arm.

Bell-kraters

* 5 Naples 2094 (inv. 81378). PLATE 35, 3—4.
 (a) Woman with wreath and box moving to l., followed by nude youth with wreath and drapery over l. arm, (b) two draped youths.
 6 Monopoli, Meo-Evoli. 956.
 (a) Youth with drapery over l. arm moving to l., followed by woman holding cista, (b) two draped youths.
 7 Bochum S 446.
 Kunisch, *Cat.*, no. 120, ill. on pp. 140—1.
 (a) Youth with drapery over l. arm moving to l., followed by woman with cista, (b) two draped youths.
 8 Zurich Market, Koller, *Cat.* 33 (May-June 1975), no. 4192, ill. on pl. 100.
 (a) Woman with wreath and phiale, Eros with tendril and phiale bending forward over raised r. foot, (b) two draped youths.
 9 Zagreb 7.
 Damevski I, p. 89, no. 15, pls. 7, 2 and 14, 4.
 (a) Woman with phiale, and youth with drapery over l. arm, beside an altar, (b) two draped youths.
 10 Taranto 6341, from Vaste.
 (a) Woman with cista, and nude youth with strigil by altar, (b) two draped youths.
 11 Philadelphia L. 64.244.
 APS, p. 56, no. 9.
 (a) Woman with cista, and youth with stick and drapery, (b) two draped youths.
 12 Monopoli, Meo-Evoli coll. 1.
 (a) Woman with thyrsus and phiale running to l., followed by youth with wreath and thyrsus, (b) two draped youths, r. with wreath.
 The crossed squares of this meander should be compared with those on Philadelphia MS 4007 (no. 54 below).

Pelike

 12a Bari, De Blasi Cirillo coll. 9. Surface worn.
 (a) Woman with fillet and tambourine, nude youth with drapery over l. arm leaning on stick, (b) two draped youths, l. with stick, r. with strigil, with an altar between them.
 For the draped youth to r. cf. no. 5.

The following vase, if not by the Hoppin Painter himself, is by a very close imitator. One should compare the obverse with those of nos. 5 and 6, and the reverse with those of nos. 6, 7 and 8.

Bell-krater

 12b Taranto 6588.
 (a) Woman with wreath and phiale moving to l. followed by satyr with outstretched arms, (b) two draped youths at stele.

(ii)

(a) VASES WITH REVERSE YOUTHS NOT WEARING WHITE HEAD-BANDS

These vases follow on closely from those in division (i) above. The running women however are slightly more animated, and the fold-lines of their drapery are beginning to break up, especially in the area of the breasts and waist. The reverse youths are very close to those by the Painter of Lecce 614; one should note on the youth to left the way in which one hand may be extended slightly forward beneath the drapery with a bulge-like effect as on nos. 13—14, also the swastikas on the himatia of the youths on nos. 19, 20, 23 (cf. no. 5).

Bell-kraters

13 Lecce 620.
 CVA 2, IV Dr, pl. 12, 7—8; Bernardini, *Il Museo di Lecce,* 43, 3; *StSal.* 9, 1960, p. 19, fig 13; *EAA* iv, p. 56, fig. 73; *APS,* p. 56, no. 3; Smith, *FS,* pl. 8b. Photo: R.I. 62.1216.
 (a) Woman washing her hair between two youths, (b) three draped youths.

* 14 Geneva Market, Galerie Faustus (ex London Market, Sotheby and Christie). PLATE 35, 5—6.
 Sotheby's, *Sale Cat.* 9 Dec. 1974, no. 125 (ill.); Christie's, *Sale Cat.* 27 April 1976, no. 204, pl. 16, 1; Galerie Faustus, *Antiquités* (Oct. 1976), no. 54 (ill.).
 (a) Youth with tendril and phiale, maenad with tambourine and thyrsus, satyr with torch, (b) three draped youths.

15 Baltimore, Museum of Art, L 59.80 (on loan from Johns Hopkins University).
 CVA, Robinson coll. 3, pl. 19, 1; *APS,* p. 56, no. 2.
 (a) Silen with torch and situla, maenad with tambourine, and Dionysos with oenochoe and thyrsus, all running to l., (b) three draped youths.

16 Valletta 4.
 Caruana, *Ancient Pottery in Malta* (1899), p. 31, pl. 12, 4; *APS,* p. 58, no. 1, pl. 34, figs. 163—4 (where attributed to the Valletta Painter).
 (a) Maenad and silen, each with tambourine, (b) two draped youths, running to l.

(b) VASES WITH REVERSE YOUTHS WEARING WHITE HEAD-BANDS

17 Cambridge (Mass.), Fogg Art Museum 1925.30.48.
 CVA, Hoppin coll., pl. 18, 3—4; *APS,* p. 56, no. 1.
 (a) Woman with tendril seated on rock between nude youth with strigil and woman with wreath, (b) three draped youths.
 For the squares in the meander pattern with solid black centres cf. the bell-krater by the Eumenides Painter formerly on the Milan Market (no. 4/230).

18 Taranto 54027, from Taranto, Palazzo I.N.A., T. 37.
 APS, p. 56, no. 4, pl. 32, figs. 153—4; Trendall, *Ceramica,* pl. 25.
 (a) Maenad between nude youth and satyr, all running to l., (b) three draped youths.

19 Bari 4311.
 APS, p. 56, no. 7.
 (a) Youth with strigil, woman, and silen with wine-skin and phiale, (b) three draped youths.

20 Taranto, from Manduria (7.2.72).
 (a) Dionysos with thyrsus and phiale, seated woman with branch, woman resting r. arm on pillar, (b) three draped youths.

21 Lecce 737. Recomposed from frr., and badly preserved.
 APS, p. 56, no. 8.
 (a) Woman seated on rock between two youths, (b) three draped youths.

22 Havana, Lagunillas coll.
 APS, p. 56, no. 5.

Bell-kraters (continued)

 (a) Woman with wreath and cista, and youth with tendril, running to l., (b) two draped youths.

23 Gotha 77.

 CVA, pl. 81; *APS*, p. 56, no. 6.

 (a) Nude youth and woman holding thyrsus and tambourine, (b) two draped youths.

24 Orvieto, Museo Faina 2631.

 (a) Youth with wreath and cista, and woman with tambourine, both running to l., (b) two draped youths.

Fragments

25 The Hague, Gemeentemuseum O.C. 71–34 (ex Arndt coll. 8428 and Scheurleer 4656).

 (a) Nude youth with drapery over l. arm, black strigil in l. hand, r. upraised holding wreath (?); tendril to r. The rest of the vase is missing.

26 Once Rome Market.

 Upper part of woman.

Pelike

27 Havana, Lagunillas coll.

 APS, p. 56, no. 11, pl. 32, figs. 150–1.

 (a) Woman holding parasol seated between woman with phiale and youth holding bird, (b) woman with wreath and phiale, and youth with sash and wreath beside a stele.

 For the drapery of the woman on the reverse cf. no. 23.

Hydria

28 New York Market (E.V. Thaw).

 Standing woman with thyrsus and cista, seated woman with mirror, seated Eros above; nude youth with palm branch and drapery over l. arm.

(iii)

On the vases in this division we may note the appearance of rows or piles of stones. The youths normally wear white head-bands and follow closely on from those on Bari 4311 (no. 19). A more conscious use of added white is made on the obverses, where more elaborate decorative adjuncts and ornaments (e.g. rows of white dots and/or ivy leaves above the pictures as on nos. 31 and 33, with or without a band of wave-pattern) now appear, probably under the influence of early "Ornate" vase-painters like the Felton Painter, who, it may be noted, uses triangulated saltire squares like those on nos. 34 and 36. The compositions are rather more elaborate, with figures disposed at different levels. Eyebrows on the faces of figures tend to be high and arched. The meanders under the pictures are still normally terminated by the palmettes beneath the handles.

Bell-kraters

(a)

29 Deruta (Perugia), Magnini coll. 195.

 Dareggi, no. 7, pl. 5.

 (a) Maenad with tambourine running to l., followed by silen with fillet, (b) two draped youths.

30 Deruta (Perugia), Magnini coll. 197.

 Darreggi, no. 8 pl. 6.

 (a) Satyr dancing, maenad with tambourine, Dionysos with thyrsus, (b) three draped youths.

31 Lecce 636.

 CVA 2, IV Dr, pl. 18, 6 and pl. 19, 2; *APS*, p. 56, no. (i).

 (a) Maenad between Dionysos and satyr, (b) three draped youths.

32 Taranto 124871, from Manduria.
 (a) Dionysos, maenad with thyrsus and tambourine, silen, (b) three draped youths.
33 Santa Barbara, Avery Brundage coll. 3/206 (ex Merlo 166).
 Del Chiaro, *Greek Art in private colls. of S. California*[2], no. 60 (ill.).
 (a) Woman with oenochoe and kantharos beside seated Dionysos, woman pouring libation to silen
 holding palm branch, (b) woman and satyr running to l.
 Subsequently destroyed by fire.
* 34 Princeton, Prof. Chr. Clairmont. (Broken and fragmentary). PLATE 36, 1–2.
 (a) Mythological scene, probably connected with the myth of Ixion: lower part of male figure
 with two spears, draped figure by altar on which is a wheel (?), elaborately draped male figure with
 sceptre, woman facing to r., with downcast head; above to r.: feet of figure seated beside the wheel,
 drapery of another figure, (b) woman between two youths running to l., woman facing r., nude youth
 facing l.
35 Nocera, Fienga coll. 545. (Broken and fragmentary).
 (a) Maenad between two youths, (b) three draped youths.
 For the reverse cf. Bari 4311 (no. 19).

(b)

The vases in this sub-division are a little later than those in (a) and approach the manner of
the Lecce and Truro Painters in the breaking up of the fold-lines of the drapery, especially on
the chest.

* 36 Geneva 15020. (b) PLATE 36, 3.
 APS, p. 63, no. 11, where attributed to the Lecce Painter.
 (a) Veiled woman between standing youth and seated youth with phiale, (b) three draped youths.
37 Florence, La Pagliaiuola 117.
 (a) Woman with wreath, youthful Herakles with club and bow being crowned by Athena, (b) three
 draped youths.
38 Taranto 116138, from Poggiardo. Surface rather corroded.
 (a) Nude youth with thyrsus and tambourine, seated woman, satyr with torch and situla, (b) three
 draped youths.
39 Once New York Market, Parke-Bernet, *Sale Cat.* 31 Jan.–1 Feb. 1946, no. 214, ill. on p. 21.
 (a) Youth with palm branch, woman with mirror and wreath, youth with stick; between the youth
 and the woman to l., a plant, (b) three draped youths.

Calyx-krater

40 Riederau an Ammersee, Professor E. Boehringer.
 Greifswalder Antiken, no. 400, pls. 49–50; *APS*, p. 56, no. 10.
 (a) Youth seated in building, surrounded by two women, a youth, and a dog, (b) Dionysos, maenad
 and satyr.

Fragments of kraters

41 Greenwich (Conn.), Bareiss coll. 191 (formerly on loan to Metropolitan Museum, L. 69.11.53; *Exhib-
 ition Cat.* no. 109).
 (a) Woman with box (mostly missing), woman dressing, with both hands raised, Dionysos reclining
 beneath an ivy trail, (b) missing.
42 Basel, Cahn coll. 237.
 Das Tier in der Antike, fig. 261.
 Above: silen, maenad with thyrsus; below: fore-parts of four horses rearing at the sight of a bull
 (? death of Hippolytos).

Fragments of kraters (continued)

43 Basel, Cahn coll. 235.

Youth bending forward to embrace woman with mirror resting l. arm on white pillar; above: frontal female mask hanging from ivy-trail; to l. part of another youth (Dionysos ?).

44 Los Angeles, Dr. N. Neuerburg.

Maenad with tambourine in l. hand, plucking at her drapery with the r.

45 Once Zurich Market, Arete.

Hand resting on shoulder of seated bearded man, of whom only the upper half is preserved.

Squat lekythos (frr.)

46 Munich, Bareiss coll. 166.

Five women in a cyclic dance in front of altar, holding hands.

Pelike

46a Munich Market.

(a) Amymone with hydria and Poseidon with trident at the fountain house; to l. Pan and silen; below the fountain, a seated woman, (b) Dionysos with thyrsus running to l., satyr with torch and situla, woman with fillet and tambourine moving to r.

(iv)

The vases in this and the following divisions are now seen to be the work of the painter himself rather than of a close imitator, as was suggested in *APS Addenda*, pp. 429—30, A 1—2, B 3—5, C 7 and D 8—9. They carry on from those in division (iii) above as one can see from the continued appearance of the piles of stones, ornamental adjuncts, etc. On the reverses the draped youth to left often has two parallel wavy lines on the lower part of the overhang (nos. 49—52) and there is a tendency for some of the fold-lines of the himation to break up into a row of dots (nos. 51, 53, 54). The meanders are accompanied by saltire squares, sometimes with strokes, at others with dots, at the centre of the sides. The treatment of the horses on nos. 50 and 53 is very similar; the scroll pattern on the latter unusual, but copied by some of the painter's followers. One should note, in particular, the drawing of the peplos worn by the woman on the reverse of Bari 4400 (no. 53) and the obverse of Philadelphia MS 4007 (no. 54), which links these two vases.

Bell-kraters

47 Lecce 632.

CVA 2, IV Dr, pl. 27, 10.

(a) Nude youth with wreath, seated nude youth with palm branch, standing woman with mirror, (b) two draped youths, r. with wreath.

48 Lecce 738.

CVA 2, IV Dr, pl. 24, 7.

(a) Woman with oenochoe and cista standing in front of seated Dionysos with thyrsus, (b) two draped youths.

49 Lecce 4147, from Lecce.

NSc 1932, pp. 525—6, figs. 5—6; Bernardini, *Lupiae*, p. 61, figs. 31—32; Schauenburg, *JdI* 78, 1963, p. 307, fig. 13; *APS*, p. 60, no. 4, and *Addenda*, p. 429, B 4. Photo: R.I. 62.1227.

(a) Maenad seated between youth and silen, (b) three draped youths.

* 50 Basel Market, Palladion. (b) PLATE 36, 4.

Katalog (1976), no. 43 (ill.).

(a) Youth with whip on horseback, attacked by warrior holding spear and shield (Troilos and Achilles ?), (b) three draped youths (very close to no. 49).

For the subject of the obverse cf. Lecce 766 (no. 57).

51 Lecce 673.
 CVA 2, IV Dr, pl. 19, 3; Bernardini, *La Rudiae Salentina*, fig. 24; *APS*, p. 60, no. 3.
 (a) Youth with tambourine and maenad with fillet, running to r., (b) two draped youths.
 Cf. with the Brundage krater (no. 33).

52 Brindisi 1461, from Torchiarolo.
 (a) Standing woman with cista, seated nude youth with wreath, (b) two draped youths.

* 52a Taranto 61261. PLATE 36, 5–6.
 (a) Youth with torch following woman with situla and tambourine, (b) two draped youths, l. with strigil, r. with palm-branch.
 Very close in style to the above; it should be compared in particular with nos. 48 and 51, and for the youths on the reverse also with no. 37.

Calyx-krater

* 53 Bari 4400, from Ceglie. PLATE 37, 1–2.
 Gervasio, *Japigia* 3, 1932, p. 262; *APS Addenda*, p. 430, D 9.
 (a) Mounted Amazon and warrior with shield and spear, (b) nude youth and draped woman, with mirror and wreath.

Pelikai

The reverses of these three pelikai are extremely similar, the pose of the draped youth to right being almost identical on all of them.

* 54 Philadelphia MS 4007. PLATE 37, 3.
 APS, p. 58, no. (ii).
 (a) Woman with wreath and nude youth with situla, (b) two draped youths.

55 Petworth House.
 AJA 60, 1956, p. 340, pl. 116, figs. 48–49; *APS Addenda*, p. 429, A 1.
 (a) Woman and youth, (b) two draped youths.

56 Pavia, private coll.
 APS, p. 61, no. 8, pl. 36, figs. 177–8 and *Addenda*, p. 429, A 2; Stenico, *Boll. Soc. Pavese* 15, 1963, pl. 3.
 (a) Woman with phiale, and youth at stele, (b) two draped youths.

(v)

The vases in this division, which are very close in style and treatment to those in (iv), are characterised by the use of a diamond-shaped flower in the ornaments beneath the handles. The saltire squares of the meander bands have black dots at the centre of each side. The reverse of Lecce 766 (Pl. 37, 4) is extremely close to those of the vases in (iv); the youths on the other vases have slightly more rounded features, but the treatment of their himatia is very similar, especially the curling hem-lines in the lower corners.

Bell-kraters

* 57 Lecce 766. (b) PLATE 37, 4.
 Romanelli and Bernardini, *Il Museo di L.*, p. 59; *La Rudiae Salentina*, fig. 29; *APS Addenda*, p. 429, B 3. Photo: R.I. 62.1224.
 (a) Greek (Theseus ?) fighting mounted Amazon, (b) three draped youths.

58 Monopoli, Meo-Evoli coll. 12.
 (a) Woman with mirror and kalathos, and silen with wine-skin and thyrsus, standing beside altar, (b) two draped youths.

59 Louvre K 18.
 PhV², p. 41, no. 52 (where bibliography); *APS*, p. 51, no. (ii), and *Addenda*, p. 429, C 7.
 (a) Two phlyakes on a stage, l. holding a basket, (b) two draped youths.

Bell-kraters (continued)

60 Naples 1889 (inv. 81650).
 (a) Youth with wreath, half-draped woman seated on rock, (b) two draped youths.

Calyx-krater

61 Lecce 675.
 CVA 2, IV Dr, pl. 28, 4 and 6; *APS Addenda,* p. 430, D 8.
 (a) Eros with mirror seated between woman with wreath and tendril, and nude youth with chaplet,
 (b) two draped youths.

Skyphos

62 Seattle Cs 20.17.
 APS, p. 75, no. (ii), pl. 39, fig. 197.
 (a) Running woman with cista, (b) nude youth with stick running to l.

(vi)

With the vases in this division we move into the final phase of the Hoppin Painter's career. The Adolphseck krater (no. 63) provides a link with the vases in division (iv) above, since its reverse is very close to those of nos. 49–51 and 54. On the reverse of the Adolphseck vase, however, we may note the curious manner in which the right hand of one of the youths projects slightly forwards from his himation, a mannerism repeated on both Geneva 15022 and Taranto 6413 (nos. 64 and 66).

The Geneva bell-krater was associated in *APS* (p. 60, no. 5) with the Bucrane Painter and in *APS Addenda* (p. 429, no. 3 ter) with the Painter of Munich 3269. The use of egg pattern with white ivy leaves or dots above the picture, coupled with the treatment of the draped youths on the reverse, suggests, however, that it would be better placed here. One should note particularly on the himatia of the youths the double curving lines across the centre of the body, forming a sort of ellipse. Triangulated saltire squares, as on nos. 64 and 66, are regularly used in the meander-pattern.

Bell-kraters

63 Adolphseck 182.
 CVA, p. 82; *APS,* p. 50, no. (i) and *Addenda,* p. 429, B 5.
 (a) Maenad, Dionysos and satyr, (b) three draped youths.
* 64 Geneva 15022. PLATE 37, 5–6.
 APS, p. 60, no. 5 and *Addenda,* p. 429, no. 3 ter. Photo: R.I. 34.739.
 (a) Capering balding silen, seated Dionysos, and woman playing the flute, (b) three draped youths.
65 Brindisi 589.
 (a) Woman with wreath and phiale, followed by nude youth with drapery over l. arm, (b) two
 draped youths.

Calyx-kraters

66 Taranto 6413.
 (a) Woman with thyrsus and fillet, nude youth seated with strigil, (b) two draped youths, l. with stick.
67 New York, Iris Love coll. S.I.9 (frr.).
 Woman holding up drapery with r. hand.

The following fragments are near in style to the above:

Hydria (frr.)

68 Policoro.
 RM, Ergänzungsheft 11, 1967, pl. 20, 3–4.

Woman with tambourine, and woman playing flute.
Fragment

69 Basel, Cahn coll. 246.
 Upper part of woman, tip of wing.

3. VASES ASSOCIATED WITH THE HOPPIN PAINTER

Associated with the Hoppin Painter are several artists who closely imitate his style and whose vases are not always easy to distinguish from his own. We may observe the similarities in the pattern-work, in the treatment of the draped youths on the reverses, in the rendering of women's drapery and in the use of white head-bands for youths and satyrs, as well as in several minor details like the presence of a row of white ivy leaves above the pictures, the dotted ground-lines, etc. The vases of these artists may be classified as follows:

(i) THE PAINTER OF LECCE 681

The two following bell-kraters are by a single hand. One should note the treatment of the women's drapery with the fine dot-stripe along the hem, also the drawing of the three-quarter face, and the use of upright crosses in the squares between the meanders. The draped youths on the reverses are also extremely alike, the central one on each grasping a strigil in his extended right hand.

Bell-kraters

70 Lecce 681.
 Bernardini, *La Rudiae Salentina*, fig. 22; *APS*, p. 56, no. (ii); Moret, *Ilioupersis*, pl. 1. Photo: R.I. 62.1226.
 (a) Youth with shield and spear, Cassandra clutching the Palladion, woman moving off to r., (b) three draped youths.
71 Budapest 57.4 A (Letet 134).
 APS, p. 56, no. (iii), pl. 32, figs. 155–6.
 (a) Warrior beside his horse between standing woman with fillet and seated woman with phiale, (b) three draped youths.

(ii) THE BUCRANE GROUP

In *APS* (p. 60) several vases were assigned to the Bucrane Painter, of which three (Lecce 4147, 673 and Geneva 15022) have now been given to the Hoppin Painter (nos. 49, 51 and 64). The bucrania on Lecce 782 (no. 72) find a counterpart on Lecce 681 (no. 70) in the previous division; a simpler form appears on Lecce 677 (no. 77).

(a)

The vases in this sub-division are very close indeed to the Hoppin Painter. One should note the treatment of the drapery over the arm of the draped youths on nos. 73–4 and of the standing women on nos. 72, 75 and 76. The meanders are accompanied by saltire squares with black dots.

Bell-krater

72 Lecce 782.
 CVA 2, IV Dr, pl. 23, 5 and pl. 22, 4.
 (a) Nude youth with wreath and phiale, draped woman with oenochoe and wreath beside altar, young satyr with thyrsus and wine-skin standing on table, (b) draped youth, draped youth with wreath, draped youth with bare torso holding phiale.

Hydriai

 73 Nocera, Fienga coll. 551 (De F. 682).
 APS, p. 64, no. 24.
 Seated woman with tendril, and nude youth with drapery wrapped around his l. arm.
* 74 B.M. F 362. PLATE 38, 1.
 Woman with filleted thyrsus and phiale, nude youth with stick.

Oenochoe (shape 3)

* 75 Zurich Market, Arete. PLATE 38, 2–3.
 Seated nude youth and woman with sash and cista; standing nude youth with wreath and stick, and woman bending forward over raised foot holding sash.

With the above oenochoe, one should compare the following, which has a similar scroll pattern on the neck (cf. also Bari 4400, no. 53 above).

Oenochoe (shape 3)

 76 Taranto, Ragusa coll. 126.
 Two small Pans stealing the weapons of Herakles while he is asleep.

<p align="center">(b)</p>

The following vases are very close to those in divisions (iv) and (v) of the Hoppin Painter's work, especially in the treatment of the himatia of the draped youths on the reverses (cf. with nos. 51 and 57), although here the youth to right has his right shoulder bare. Women wear stephanai with radiate spikes, and their hair normally ends in a chignon at the back of the head.

Bell-kraters

 77 Lecce 677.
 CVA 2, IV Dr, pl. 22, 2; *APS*, p. 60, no. 1. Photo: R.I. 62.1217.
 (a) Dionysos and maenad playing the flute, (b) two draped youths.
 For the quartered disk between the two youths cf. the reverse of Lecce 675 (no. 61).
 78 Lecce 765.
 CVA 2, IV Dr, pl. 25, 5 and pl. 26, 4; *PhV*2, p. 91, no. (v); *APS*, p. 60, no. 2.
 (a) Dionysos holding white female mask, and seated maenad with phiale and thyrsus, (b) two draped youths.
 79 Cortona.
 (a) Woman with cista and nude youth with sash, (b) two draped youths with sticks.

<p align="center">(c)</p>

The vases in this sub-division are comparable with those above:

<p align="center">(a)</p>

Bell-kraters

 80 New York, Cooper-Hewitt Museum 1957–23–2.
 APS, p. 50, no. 3, figs. 135–6, and *Addenda*, p. 429, C 6.
 (a) Maenad and satyr, (b) two draped youths.
 81 Hamburg 1917.1068.
 APS, p. 61, no. 7, pl. 36, figs. 175–6.
 (a) Woman with phiale and tendril, nude youth with staff, (b) two draped youths.

<p align="center">(β)</p>

Bell-krater

 82 Taranto 6327, from Patù.
 (a) Nude youth with phiale of offerings, and woman bending forward over raised foot with wreath; top

r., facade of building, (b) two draped youths, l. with wreath, r. with strigil.

Pelike

* 83 Chapel Hill (N.C.), Packard coll. (ex New York market, Parke-Bernet). PLATE 38, 4–5.
 Parke-Bernet, *Sale Cat.* no. 3404, 26–28 Sept. 1972, no. 284 (ill.).
 (a) Seated woman on rock-pile and nude youth holding out wreath above kalathos, (b) two draped youths by altar.
 Cf. Lecce 765, no. 78.

<div align="center">(γ)</div>

Nestoris (type 1)

84 Naples 2315 (inv. 81829). The foot is modern.
 Spinazzola, *Arti,* pl. 212 b; Schauenburg, *JdI* 89, 1974, p. 158, fig. 27.
 (a) Nude youth and draped woman with palm branch, (b) two draped youths.

Pelike

85 Leningrad 2525.
 (a) Standing woman with wreath and tendril, nude youth with thyrsus and strigil, seated on altar, (b) two draped youths.
 Note the white head-bands of the youths on the reverse and their straggly hair.

<div align="center">(iii) THE GROUP OF STOCKHOLM 1999</div>

<div align="center">(a) THE PAINTER OF STOCKHOLM 1999</div>

The vases by this painter should also be compared with those in the Choes Group (Chapter 11, 5), to which two were attributed in *APS* (nos. 88 and 90). One should note the treatment of the border of the overfall on the women's peploi on nos. 86 and 90 and the use of a double vertical stripe running down from the waist of some women across their bent leg (nos. 86, 88). The drawing of the draped youths on the reverses is very characteristic; the right youth may have his right arm extended (nos. 86–7) or else enveloped in the himation (nos. 88–9), but the left is bent at the elbow to produce a "sleeve" effect, with a long wavy line running down the side of the himation below the "sleeve" towards the lower hem, which has a pronounced upward curve just above the left foot (nos. 86, 88–9, 92). The influence of the Hoppin Painter is particularly evident on the nestoris Naples 2326 (no. 88). It is interesting to note that vases of this peculiarly local shape (see in particular: *Gli Indigeni*, pp. 8 ff.; K. Schauenburg, *JdI* 89, 1974, pp. 151 ff.; D. Yntema, *BABesch* 49, 1974, pp. 7 ff., with illustrations of the different varieties of this shape on p. 8) now make their appearance in Apulian red-figure for the first time (cf. Naples 2315, no. 84 above and no. 6/148 below), although they had been represented as in use in scenes upon vases of other shapes considerably earlier (e.g. on the column-krater B.M. F 174, by the Sisyphus Painter).

Pelikai

86 Stockholm 1999.
 (a) Nude youth with stick in l. hand and drapery over l. arm, woman holding out beaded wreath towards him, (b) two draped youths.
87 Bari, Sette Labellarte coll. 32.
 (a) Woman running to l. with wreath and cista, followed by nude youth with bird and strigil, (b) nude youth and draped youth.

Nestoris (type 1)

* 88 Naples 2326 (inv. 81826). (b) PLATE 38, 6.
 APS, p. 74, no. 6 (where attributed to the Choes Painter).

Nestoris (type 1) (*continued*)

(a) Youth with sceptre, and woman with fillet, (b) two draped youths.

Amphora

89 Ruvo 1148.
 Photos: R.I. 72.62–63.
 (a) Seated woman with wreath and mirror, nude youth wearing petasos and holding spear beside an Ionic column on top of which is an oenochoe; to r. woman with raised foot, holding parasol, nude youth with strigil, (b) draped woman with mirror between two draped youths.

Oenochoai (shape 3)

90 Copenhagen 75 (B–S. 250).
 CVA, pl. 264, 1; *APS*, p. 74, no. 1 (where attributed to the Choes Painter).
 Youth with strigil and stick, draped woman with wreath.

91 Graz, Landesmuseum.
 APS, p. 48, no. (iv).
 Woman with tambourine moving to l., followed by youth with chous.

(b)

The vases in this sub-division are very close to those in (a), especially in the treatment of the draped youths on the reverses, one of whom holds either a strigil or a wreath.

Amphora

92 Milan, "H.A." coll. 423.
 CVA 1, IV D, pl. 23.
 (a) Woman and nude youth with spear at grave monument, (b) two draped youths.
 The obverse should be compared with the work of the Painter of Karlsruhe B 9.

Pelike

93 Buncrana, Swan coll. 689.
 (a) Draped woman with wreath, towards whom Eros is flying, with a sash held in both hands, (b) two draped youths.

Bell-krater

94 Taranto 20930, (old. no. 10865), from Rudiae.
 APS, p. 60, no. (iv), pl. 35, figs. 173–4.
 (a) Woman seated on rock holding tendril, nude youth with thyrsus, (b) two draped youths.

With the Taranto bell-krater (no. 94) one should compare the following:

Bell-krater

95 Louvre K 10 (N 2617; ED 120).
 APS, p. 43, no. (v).
 (a) Youth seated on altar between youth holding phiale and woman with branch and sash, (b) two draped youths.

95a Louvre K 6 (N 2767).
 Ghali-Kahil, *Hélène*, p. 179, no. 143, pl. 30, 1. Photo Giraudon 15163.
 (a) Woman seated on rock opening box, youth in oriental costume holding spear (Helen and Paris ?).
 (b) two draped youths.
 Cf. also with no. 87.

(c)

With the above, and with the vases in (ii), one should compare the following:

Pelike

96 Agrigento R 186.
 (a) Nude youth with strigil and mirror, draped woman with ball and fan, (b) two draped youths, l. with stick and r. with strigil.

3. THE TRURO PAINTER

The style of the Truro Painter (*APS*, pp. 69 ff., *Addenda* p. 430; A. Cambitoglou, in *Festschrift Brommer*, pp. 67–76, pls. 21–22), who takes his name from the pelike in Truro (no. 103), is clearly greatly influenced by that of the Hoppin Painter, whose close colleague he must have been. A comparison between the draped youths on the reverses of Bonn 1758, Naples 1947, or Vienna 894 (nos. 99–100 and 125) with those on several of the bell-kraters in divisions (iii) to (vi) of the Hoppin Painter will clearly demonstrate the connexions, and we may note that on the reverse of the Naples pelike (no. 100) the youths are disposed at different levels, as on the reverse of the Hoppin Painter's late bell-krater Geneva 15022 (no. 64). The relation is further strengthened by the presence of a small swastika on the drapery of the youths on the Truro pelike (no. 103) and the Magnini oenochoe (no. 135), (cf. with nos. 5, 19, 20, 23, 34).

The Truro Painter decorates mainly smaller vases, especially pelikai, usually with youths or women, who tend to wear fussy drapery, especially at the waist, with a multitude of small broken or curved lines to mark the folds which sometimes give the effect of "pointillisme". The anatomy of the nude youths is shown in some detail and their hair is generally straggly and almost invariably decorated with a rather thick head-band. Palm branches are frequently held by people or else appear as decorative adjuncts. Above the pictures there is sometimes a row of white ivy leaves, dots, or strokes. The meanders are generally accompanied by saltire squares with dots.

Mythological scenes, like that on Lecce 770, are the exception, but the recent addition of a phlyax vase (no. 141) to the list of the painter's works suggests a greater versatility than he had originally been thought to possess. A number of small choes decorated with phlyax masks may also be associated with the Truro Painter.

In *APS* (pp. 70–74) a large number of smaller vases was associated with the artist. These are listed and discussed in Chapter 11, since it now seems likely that most of them are better grouped together with, or near to, the minor vases of the Iliupersis workshop.

Pelikai (shape 1, larger, with two- or three-figure compositions)

97 Taranto, from Taranto.
 APS, p. 69, no. 12.
 (a) Youth and woman with thyrsus, (b) two draped youths.
98 Hamm 1558 (ex Treben, von Leesen).
 Sale Cat., pl. 3, no. 58; L. Budde, *AA* 1948–9, 147–8, figs. 12–20; *APS*, p. 68, no. 7.
 (a) Nude youth and woman holding palm branch, (b) two draped youths.

Pelikai (shape 2, larger, with two- or three-figure compositions)

99 Bonn 1758.
 APS, p. 69, no. 13.
 (a) Woman with sash seated between two nude youths, r. with palm branch, (b) three draped youths.
 The inscriptions are modern.
*100 Naples 1947 (inv. 81746). PLATE 39, 1–2.
 APS, p. 69, no. 15.
 (a) Woman with sash seated on altar betweem two nude youths, (b) three draped youths.

Pelikai (shape 2, larger, with two- or three-figure compositions) (*continued*)

 The youths on the reverse are clearly connected with those on the reverses of vases in division (iii) of the Hoppin Painter's work.

101 Göttingen.
 APS, p. 69, no. 16.
 (a) Woman between two youths, r. seated on laver, (b) youth and woman.
102 Mainz, RGZM O. 12952 (fr.).
 APS Addenda, p. 430, no. 16 bis.
 Youth with another figure to r.

Pelikai (shape 1, smaller, with a single figure on each side)

*103 Truro, Cornwall County Museum. PLATE 39, 3.
 APS, p. 68, no. 1, pl. 37, fig. 183.
 (a) Nude youth with palm-frond in r. hand and drapery over l. arm, (b) draped woman with wreath by altar.
 Note the swastika on the youth's drapery (cf. no. 135 and also nos. 5, 20, 23, 36 by the Hoppin Painter).
104 Vatican Y 16 (inv. 18122).
 VIE, pl. 48 i; *APS*, p. 68, no. 2.
 (a) Nude youth, (b) draped woman with phiale.
105 Lecce 691.
 CVA 2, IV Dr, pl. 36, 10; *APS*, p. 68, no. 3.
 (a) Seated woman with phiale, (b) seated youth.
106 Once Arnò coll., later Rome Market. Arnò coll. *Sale Cat.*, no. 82 (ill.).
 APS Addenda, p. 430, no. 2 bis.
 (a) Seated woman, (b) standing nude youth.
107 Oxford V 431.
 APS, p. 68, no. 4.
 (a) Woman with wreath and phiale, (b) nude youth.
108 Norwich, Castle Museum.
 APS, p. 68, no. 5, pl. 37, fig. 184.
 (a) Draped woman with wreath and cista, (b) nude youth.
109 Lecce 704.
 CVA 2, IV Dr, pl. 39, 1 and pl. 38, 11; *APS*, p. 68, no. 6.
 (a) Draped woman with sash, (b) nude youth.
110 Cambridge GR 11/1963.
 (a) Draped woman with wreath, (b) nude youth with wreath, drapery over l. arm, moving to r.
111 E. Berlin 32110.
 (a) Draped woman with situla, (b) nude youth with wreath running to r.
112 Limoges 78–98.
 CVA, pl. 26, 3–4; *APS*, p. 69, no. 9.
 (a) Woman with sash and wreath, (b) nude youth with sash and wreath.
113 Philadelphia MS 4010.
 APS, p. 69, no. 10.
 (a) Woman with wreath, (b) youth with wreath and drapery.
114 Hamm 1559.
 L. Budde, *AA* 1948–9, col. 148, fig. 21; *APS*, p. 70, no 5.
 (a) Woman, (b) youth.
115 Gallipoli 53.
 (a) Maenad with thyrsus, (b) Eros.

116 Taranto, from Taranto.
 APS, p. 69, no. 11.
 (a) Woman by laver, (b) youth with thyrsus and wreath.
117 Once London Market, Sotheby, *Sale Cat.*, 14 Nov. 1960, no. 99, and 12 Dec. 1960, no. 122.
 APS, p. 69, no. 12 bis.
 (a) Woman seated on stool, (b) nude youth with sash.
118 Once London Market, Charles Ede, *Cat.* 88, (Oct. 1972) no. 6 (ill.), ex Christie's.
 Christie's, *Sale Cat.*, 16 May 1972, no. 187.
 (a) Woman seated on rocks, (b) nude youth with fillet, and drapery over l. arm.
119 Milan.
 (a) Draped woman with fillet, (b) nude youth holding crown above kalathos.
120 Philadelphia 47.2.2.
 APS, p. 69, no. 14.
 (a) Woman with sash and phiale, (b) youth with wreath and drapery.

Pelikai (shape 1, small, decorated with female heads)

121 Lecce 956.
 CVA 2, IV Dr, pl. 40, 12; *APS*, p. 69, no. 8.
 (a) and (b) Female head.
122 Bari 6298.
 (a) and (b) Female head.
123 Monopoli, Palmieri-Piangevino coll. 31.
 (a) and (b) Female head.
124 Monopoli, Brigida coll.
 (a) and (b) Female head.

Bell-kraters

*125 Vienna 894. (b) PLATE 39, 4.
 APS, p. 69, no. 17; A. Cambitoglou, *Festschrift Brommer*, p. 71, pl. 21, 3–4.
 (a) Youth with thyrsus and phiale, seated woman with deer, (b) two draped youths.
126 Compiègne 1059.
 CVA, pl. 27, 4 and 6; *APS*, p. 69, no. 18.
 (a) Maenad between Dionysos and silen, (b) youth and woman with palm branch.
127 Taranto, from Gioia del Colle.
 APS, p. 69, no. 19.
 (a) Woman with tambourine and youth with sash, (b) two draped youths.
128 Monopoli, Meo-Evoli coll. 953.
 (a) Nude youth with strigil, and drapery over l. arm, and draped woman, (b) two draped youths,
 r. with strigil.
129 Moscow 1138.
 APS Addenda, p. 430, no. 21 bis.
 (a) Maenad with mirror and phiale, silen with tambourine, (b) woman with phiale and branch run-
 ning to r.
130 Sydney 53.11 (frr.).
 APS, p. 70, no. 45 (where thought to be from a skyphos); A. Cambitoglou, *Festschrift Brommer*,
 pp. 67 ff., pl. 21, 1–2.
 (a) Seated woman and youth, (b) woman crowning youth.
131 Trieste 1850.
 APS, p. 69, no. 20.
 (a) Woman running, (b) seated youth.

Calyx-krater

132 Lecce 770.
 CVA 1, IV Gr, pl. 2, 1, 2 and 4; *APS,* p. 69, no. 22; Moret, *Ilioupersis,* pl. 51, 2. Photo: R.I. 62.1213.
 (a) Orestes at Delphi, (b) woman seated between two youths.

Krater fragments

133 Taranto.
 APS, p. 69, no. 21.
 Lower part of youth and seated woman.
134 Amsterdam 2556.
 APS Addenda, p. 430, no. 22 bis.
 Youth, woman, and arm and leg of youth.

Oenochoai (shape 3, larger choes)

135 Deruta (Perugia), Magnini coll. 207.
 Dareggi, no. 12, pl. 10, 2.
 Woman between two youths.
 For the swastikas on the drapery cf. the Truro pelike (no. 103).
136 Taranto 100777.
 APS Addenda, p. 430, no. 27 bis, pl. 120, fig. 25; Richter, *Perspective,* fig. 164.
 Aphrodite in chariot drawn by Nike and Eros.
137 Taranto 101422.
 APS, p. 69, no. 23.
 Youth with phiale, standing woman with phiale, seated nude youth with palm branch, standing
 woman with dish, and standing nude youth with branch.
138 Rome, Rotondo coll. 46.
 APS Addenda, p. 430, no. 27 ter.
 Seated woman with phiale, dancing woman, silen with thyrsus.
139 Bari, Ricchioni coll. 14.
 Nude youth holds out kantharos to seated woman, who stretches out her hands to take it.
140 Geneva MF 243.
 APS, p. 69, no. 26.
 Youth with stick and fillet, and woman with palm branch.
*141 Sydney 75.02 (ex Basel Market, MuM). PLATE 39, 5.
 MuM, *Sale Cat.,* no. 51, 14 March 1975, no. 177 (ill.); A. Cambitoglou, *Festschrift Brommer,*
 p. 69, pl. 22.
 Phlyax scene: man and woman on low platform.
 With the Sydney phlyax oenochoe may be associated six small choes decorated with phlyax masks
 similar to that worn by the bearded man (Type B, Trendall, *PhV²,* nos. 154, 158–160, 162 and 167,
 Pl. 10 e–j) and one at present on the London market (Charles Ede, *Greek Pottery from S. Italy* IV,
 1975, no. 19, ill., ex Sotheby, *Sale Cat.,* 30 July 1973, no. 303, 1).

Oenochoai (shape 3, smaller choes)

142 Lecce 692.
 CVA 2, IV Dr, pl. 40, 7; *APS,* p. 69, no. 24.
 Woman running towards kalathos.
143 Lecce 698.
 CVA 2, IV Dr, pl. 40, 8; *APS,* p. 69, no. 25.
 Woman with situla.

Oenochoai (shape 3, smaller choes) (*continued*)

144 Once Amsterdam Market, J. Schulman, List 870, pl. 3, no. 12.
 Woman with wreath running to l.
145 Taranto, from Palagiano, T 1.
 Woman running with fillet and wreath.
146 Hoensbroek, Rodolf coll.
 Woman running to l.
146a Taranto Market.
 Photos: R.I. 68.4672–3.
 Silen holding thyrsus and fillet.
147 Taranto 52513, from Taranto.
 APS, p. 69, no. 27.
 Youth with sash and drapery.
148 Taranto 109940.
 APS, p. 79, no. (ii).
 Youth with wreath and thyrsus moving to r.
149 Once Amsterdam Market, J. Schulman, List 870, pl. 3, no. 11.
 Nude youth with sash, drapery over l. arm.
150 Once London Market, Charles Ede.
 Nude youth with wreath and situla.
151 Taranto, Baisi coll. 66.
 Nude youth with stick.
152 Limoges 80–32.
 CVA, pl. 26, 1 and pl. 27, 4.
 Seated youth beside thyrsus.
153 Udine 1606.
 Borda, *Ceramica italiota*, no. 9 (ill.).
 Seated youth holding egg, palm branch to r.
154 Heemstede, Hoogewerff coll.
 Klassieke Kunst uit particulier Bezit (Exhibition Catalogue, Leiden, May-July 1975), no. 578, fig. 244.
 Eros running to l.

Oenochoe (shape 5A – Olpe)

155 Once London Market, Folio Fine Art, *A Collection of Greek Pottery*, no. 91 (ill.) (ex Sotheby's).
 Sotheby, *Sale Cat.* 1 April 1969, no. 191; *APS Addenda*, p. 430, no. 27 quater.
 Running Eros bouncing ball.

Squat lekythoi

156 Bari 1512.
 Youth, duck and seated woman.
157 Lecce 748.
 CVA 2, IV Dr, pl. 50, 2; *APS*, p. 69, no. 29.
 Youth with bird, and woman at altar.
158 Deruta (Perugia), Magnini coll. 181.
 Dareggi, no. 13, pl. 11.
 Satyr and woman.
159 Brindisi 698 (ex Taranto 52840).
 Benita Sciarra, *Musei d' Italia* 9. Brindisi, *Mus. Arch. Prov.* p. 35, fig. 224.
 Eros with wreath.

Squat lekythoi (continued)

160 Dunedin E 48.333.
 APS, p. 69, no. 28.
 Youth with bird and drapery.

161 London Market, Charles Ede.
 Seated nude youth holding tendril.

162 Taranto.
 CVA 2, IV Dr, pl. 38, 6.
 Running youth with wreath.

163 Taranto 117509 (with flat body).
 APS Addenda, p. 430, no. 30 bis; Carter, *Sculpture of Taras*, pl. 72 e.
 Running woman (cf. with no. 176).

164 Leiden K 1894/9.25.
 APS Addenda, p. 430, no. 30.
 Head of youth (as on Lecce 871, no. 177).

Squat lekythos (with round body)

165 Moscow 1232.
 Female head to l.

Skyphos (Corinthian shape)

166 Geneva I 735.
 APS, p. 70, no. 31.
 (a) Woman, with cista in l. hand, (b) nude youth, moving to r., with wreath in r. hand and drapery
over l. arm.

Skyphoi

167 Lecce 754.
 CVA 2, IV Dr, pl. 31, 7 and 9; *APS*, p. 70, no 32.
 (a) Woman and youth, (b) youth and woman.

168 Lecce 778.
 CVA 2, IV Dr, pl. 31, 2 and 6; *APS*, p. 70, no. 33.
 (a) Woman and youth seated on altar, (b) youth and woman at altar.

169 Taranto. Recomposed from fragments.
 APS, p. 70, no. 34.
 (a) Youth with phiale, and seated woman holding tendril, (b) standing woman with box, and seated
youth with stick.

170 Lecce 761.
 CVA 2, IV Dr, pl. 31, 8 and pl. 30, 4; *APS*, p. 70, no. 35.
 (a) Maenad, (b) youth.

171 Taranto 54414, from Valesio.
 APS, p. 70, no. 36.
 (a) Maenad with thyrsus and phiale, (b) youth with thyrsus and drapery.

172 Leningrad 4557.
 APS, p. 70, no. 37.
 (a) Maenad with thyrsus and cista, (b) nude youth with thyrsus.

173 Leningrad 4558.
 APS, p. 70, no. 38.
 (a) Woman with fillet and cista, (b) nude youth with palm branch.

174 Bari, Sette Labellarte coll. 40.
 (a) Woman with egg and wreath running to l., (b) nude youth with wreath, drapery over l. arm.

175 Zagreb 44.
 Damevski III, p. 96, no. 74, pl. 35, 1–2.
 (a) Woman with mirror, (b) nude youth with wreath.
176 Taranto 117507.
 APS Addenda, p. 430, no. 31 bis; Carter, *Sculpture of Taras,* pl. 72 b.
 (a) Running woman with ball, (b) youth.
 Cf. the obverse with no. 163.
177 Lecce 871.
 CVA 2, IV Dr. pl. 56, 9 and pl. 55, 8; *APS,* p. 70, no. 39.
 (a) Head of youth, (b) bird.

Skyphos fragments

178 Taranto.
 APS, p. 70, no. 40.
 Draped woman.
179 Taranto.
 APS, p. 70, no. 41.
 Youth with drapery and phiale.
180 Zurich Market, Arete.
 (i) Upper part of body of youth holding stick, (ii) leg of youth, (iii) torso of youth.
181 Deruta (Perugia), Magnini coll. 125.
 Woman with wreath.
182 Deruta (Perugia), Magnini coll. 96.
 Head of woman.

Cup skyphoi

183 Once London Market, Charles Ede, *Cat.* 84, (Jan. 1972), no. 5 (ill.) (ex Sotheby's).
 Sotheby, *Sale Cat.* 29 March 1971, no. 144.
 (a) Draped woman with cista, (b) Eros with wreath.
183a Taranto 117505.
 Carter, *Sculpture of Taras,* pl. 72 f.
 (a) and (b) Female head.

Dish (with flat handles)

184 Bari 8256.
 Schneider-Herrmann, *Paterae,* no. F 13.
 (a) Woman with sash, youth by tree and woman with wreath, (b) woman, youth and woman.
 A good deal of the vase is missing.

Dishes (with knob handles)

*185 Bari 21995, from Bitonto, T. 1 (1961). PLATE 39, 6.
 Schneider-Herrmann, *Paterae,* p. 121, no. 209.
 (a) Draped youth with strigil and phiale followed by nude youth with wreath and stick, (b) draped
woman with fillet.
186 Padua, Casuccio coll. 25.
 Schneider-Herrmann, *Paterae,* no. 213.
 (a) Woman with phiale, youth, seated woman with tendril, (b) seated woman with tendril, youth
with palm branch, seated woman with fan.
187 Bari 2781a.
 APS, p. 70, no. 42.
 I. Seated woman with phiale.

Hydria

188 Lecce 800.
 CVA 2, IV Dr, pl. 42, 2 and 7; *APS*, p. 70, no. 43.
 Youth seated between two women.
 Beneath handles: owl.

Amphora

189 Brussels, Errera coll.
 APS, p. 70, no. 44.
 (a) and (b) Youth with drapery.

Askos

190 Bari 6441 (Polese 93).
 (a) Woman with fillet, (b) Eros with wreath.

The following vases are closely connected in style with the work of the Truro Painter. One should note on nos. 192 and 193a the presence of a palm-wreath similar to that on the Truro pelike (no. 103).

Oenochoe (shape 3)

191 Naples, private coll. 36.
 Nude youth with branch, draped woman with wreath and thyrsus.

Hydriai

192 Once Vienna, Matsch coll.
 CVA, pl. 14, 2 and 3; *APS*, p. 70, no. (i).
 Youth with strigil and woman with palm-wreath.
193 Lecce 724.
 CVA 2, IV Dr, pl. 41, 11; *APS*, p. 70, no. (ii).
 Youth and woman.
193a Ruvo 670.
 Sichtermann, K 29, pl. 47, 2. Photo: R.I. 64.1259.
 Nude youth with wreath and thyrsus standing before woman seated on altar, with a cista on her lap.

5. THE LECCE PAINTER

The Lecce Painter is a prolific artist whose style runs closely parallel to that of the Hoppin Painter, but shows a more rapid deterioration. The quality of the drawing on the vases of some of his followers becomes extremely scrappy, and on those by the Thyrsus Painter approaches near-barbarism.

The early work of this artist is very near to that of the Hoppin Painter (cf. nos. 194–6), but even on these vases he differs from him by the use of hook-folds on the himatia of the draped youths (cf. in particular no. 196). Noteworthy is the Doric column appearing between the two youths on the reverses of the Geneva and Fienga kraters, looking back to those on the vases of the Painter of the Berlin Dancing Girl and the Hearst Painter (1/7–8, 27 and 33).

As his style develops, the figures of the Lecce Painter tend to become more squat than those of the Hoppin Painter, while their heads become larger in proportion to the body, and are often given a downward inclination (nos. 197–8, 200–2, 206). The eyes, frequently indicated by strongly curving lines, are very characteristic. The drapery, as with the Hoppin Painter, tends to be rather fussy, with a multitude of fine fold-lines, especially round the breasts and sometimes over the bent leg. On the himatia of the youths on the reverses there is often a

thick black border, with squiggly lines at the corners or on the overhang. There is sometimes a fringe of small curls just above the ears of his youths (nos. 201–2, 205–6).

Characteristic also is a small palmette tendril on one or on both sides of the vase. The meanders are scrappily drawn, generally with saltire squares. On most of his vases the band is confined to the area below the pictures, although on some (e.g. Lecce 633; no. 200) it runs right round the vase, and is occasionally interrupted by the handle-palmettes, as with the Hoppin Painter (nos. 201–202). Above the obverse designs on bell- and calyx-kraters there is sometimes a thin band of wave-pattern (nos. 204–5, 207–8, 212–3).

(i) EARLY WORK

As has already been mentioned, the earliest vases of the Lecce Painter are particularly close to those of the Hoppin Painter; this can be seen by comparing the obverses of the three vases below with those of nos. 5, 7 and 9 by that artist, and it would seem that both must have worked in the same establishment.

The Geneva krater (no. 196) provides a convenient link with the Lecce Painter's more mature vases in (ii).

Bell-kraters

194 Lecce 618.
 CVA 2, IV Dr, pl. 11, 5–6.
 (a) Nude youth with strigil, and woman with thyrsus, (b) two draped youths.
195 Nocera, Fienga coll. 542 (De F. 690).
 (a) Nude youth with drapery over l. arm running to l. followed by draped woman holding ball, (b) two draped youths beside a Doric column.
*196 Geneva 13188. PLATE 40, 1–2.
 (a) Woman with box moving l., followed by nude youth with l. shoulder and arm enveloped in drapery, (b) two draped youths beside a Doric column.

(ii) DEVELOPED STYLE

This division includes the typical vases of the Lecce Painter's developed style. Vatican U 13 (no. 197) is very close to the Geneva krater (no. 196), especially in the treatment of the reverse; but the youth on its obverse has a somewhat heavier head and in the treatment of the drapery of the figures there is a tendency for the fold-lines to start breaking up. The Lecce Painter is very fond of running figures (nos. 198–201), and of figures holding up a tambourine in one hand (nos. 200–1, 208, 212, 215). Noteworthy also is his frequent use of a white head-band tied in a double loop round the head (nos. 202, 205, 208, 212–3). The Utrecht vase (no. 209) has an unusual subject; its reverse connects it closely with the Rodin and British Museum kraters nos. 207–8.

Bell-kraters

197 Vatican U 13 (inv. 17961).
 VIE, pl. 23 a and pl. 24 a; *EAA* iv, p. 524, fig. 616; *APS*, p. 63, no. 9.
 (a) Youth and woman at altar, (b) two draped youths beside a Doric column.
*198 Oxford 1879.200 (V 433). PLATE 40, 3–4.
 APS, p. 63, no. 5.
 (a) Satyr with torch, woman with sash and situla, and nude youth, all moving to l., (b) three draped youths.
199 Taranto 52408, from Via Battisti (28/5/51).
 (a) Woman with cista running to l., looking back at nude youth with stick and drapery over l. arm,

Bell-kraters (continued)

(b) two draped youths (heads mostly missing).
200 Lecce 633.
 CVA 2, IV Dr, pl. 15, 5 and 8; *APS*, p. 63, no. 3.
 (a) Woman with tambourine between two youths, (b) two draped youths.
201 Lecce 641.
 CVA 2, IV Dr, pl. 14, 1 and pl. 15, 1; *APS*, p. 63, no. 4.
 (a) Maenad between silen and youth, (b) two draped youths.
202 Oxford 1879.211 (V 434).
 APS, p. 63, no. 6.
 (a) Woman with thyrsus between two youths, (b) two draped youths.
203 Taranto 127898, from Mesagne.
 (a) Woman with tambourine, and nude youth with wreath, (b) two draped youths.
204 Lecce 623.
 CVA 2, IV Dr, pl. 12, 4 and pl. 13, 6; *APS*, p. 63, no. 2; Smith, *FS*, pl. 8a.
 (a) Woman with mirror seated on rock between two nude youths, (b) three draped youths.
205 Lecce 617.
 CVA 2, IV Dr, pl. 15, 4 and 7; *APS*, p. 63, no. 1.
 (a) Woman between youth and satyr, (b) three draped youths.
206 B.M. F 55.
 APS, p. 63, no. 7.
 (a) Woman with mirror between two nude youths, (b) three draped youths.
207 Paris, Rodin 968.
 CVA, pl. 38, 3–4 and pl. 40, 4–5; *APS*, p. 65, C (ix).
 (a) Maenad between silen and satyr, all moving to r. over rocky ground, (b) three draped youths.
*208 B.M. F 168. **PLATE 40, 5.**
 (a) Woman with tambourine, between youth with oenochoe and youth with stick, (b) three draped youths.
*209 Utrecht 39. **PLATE 40, 6.**
 APS, p. 58, no. (i).
 (a) Youthful Dionysos between maenad drinking from askos and young satyr beside laver, (b) three draped youths.

Fragments

210 Reading 22. iii. 22.
 CVA, pl. 32, 2.
 (a) Missing, (b) two draped youths (only part of the r. youth survives).
211 Basel, Cahn coll. 240–1.
 Two heads of women with long, curly hair.

Calyx-kraters

212 Taranto 107936.
 ArchReps 1957, p. 42; *AA* 81, 1966, p. 287, figs. 37–8; *APS*, p. 63, no. 16.
 (a) Aphrodite in chariot drawn by two Erotes, with two Erotes flying behind; below: two satyrs with thyrsi, (b) woman with thyrsus between two nude youths.
213 Taranto 20935, from Rudiae.
 APS, p. 63, no. 14.
 (a) Maenad with fillet and thyrsus, and Dionysos with thyrsus, (b) two draped youths.
214 Once Rome Market.
 APS, p. 63, no. 15.
 (a) Youth with tambourine and seated woman holding branch, (b) two draped youths.

215 Leningrad inv. 304 = St. 1314. Foot modern.
 (a) Dionysos with thyrsus and maenad with tambourine, (b) two draped youths.

Hydria (fr.)

216 Basel, Cahn coll. 209.
 Woman pushing another woman in a swing.
 Cf. with no. 233 and New York 13.232.3 for the subject.

Pelikai

217 Bonn 2658, ex Treben, von Leesen coll.
 Schulze, *Cat.*, pl. 1; *Sale Cat.*, pl. 1, no. 53; *APS*, p. 63, no. 17; Langlotz, "Eine Apulische Amphora
 in Bonn", in *Anthemon*, pp. 73–81, pl. 4, 1–2.
 (a) Eros, woman and youth, (b) three draped youths.
218 York 29.
 APS, p. 63, no. 18.
 (a) Woman seated between two youths, (b) three draped youths.
219 Swiss Market.
 (a) Nude youth with phiale, woman and Eros; seated woman with hand on thigh and panther-cub
 on knee, small nude boy above to r.; Dionysos with narthex, Ariadne and satyr-boy with tambourine;
 below, beside a laver, reclining white-haired silen with drinking-horn, (b) nude youth with thyrsus,
 woman seated on rock, seated woman with phiale and palm-leaves, nude youth running to r. and look-
 ing back l.
 Cf. with Vatican U 13, no. 197.

Lebes gamikos

220 Lecce 720.
 CVA 2, IV Dr, pl. 46, 4–5; *APS*, p. 63, no. 20.
 (a) Youth and woman, (b) seated woman.
 Cf. with the Bonn pelike (no. 217); also very close in style to the Hoppin Painter.

Skyphoi

221 Taranto.
 APS, p. 64, no. 26.
 (a) Woman with cista, and seated woman, (b) standing woman and seated woman.
222 Zurich Market, Arete (fr.).
 (a) Woman with cista, youth, and silen, moving to l., (b) missing.
222a Taranto 52406.
 (a) Woman with branch running to r., (b) woman running to r.

Lekythoi

223 Berlin F 3209. Much repainted.
 APS, p. 64, no. 21.
 Woman seated between youth with tambourine and nude youth.
224 Portland 26.286.
 APS Addenda, p. 430, no. 21 bis.
 Nude youth with mirror, draped woman with fillet and mirror, nude youth leaning against drapery-
 covered pillar.

Squat lekythoi

225 Philadelphia L. 64.224.
 APS, p. 64, no. 22, pl. 36, fig. 179; Trendall, *Ceramica*, pl. 26.
 Woman seated on an altar between a woman and a youth on each side.
226 Boston 76.59. (continued next page)

Squat lekythoi (continued)

APS, p. 64, no. 23, pl. 36, fig. 180.
Woman with bird on lap seated between woman with phiale and youth leaning on stick.
Round the mouth: thiasos.

*227 North German private coll. PLATE 41, 1–2.
Woman with mirror and phiale beside a tree, with a fawn nibbling one of its leaves, nude youth by laver, against which Eros is leaning, woman with mirror.
Acanthus leaf decoration in applied white on mouth.

Oenochoai (shape 3: choes)

228 Bassano del Grappa, Chini coll. 92.
Athlete with strigil standing beside white tree, Aphrodite with mirror, holding white Eros in l. arm, white hound, Pan with lagobolon, tree with skin hanging from branch, papposilen with flute, white hound, athlete with flute, strigil and aryballos, leaning against tree.
For the fan-palmettes with sprung leaves on each side of the central leaf cf. Philadelphia L. 64.224 (no. 225), with which this vase is closely connected.

229 Once New York Market (Carlebach Gallery).
APS Addenda, p. 430, no. 25 bis.
Standing draped woman with bird, seated woman with bird, and standing nude youth.
Close to Boston 76.59 (no. 226).

(iii) LATER VASES

The style of these vases is somewhat coarser:

Oenochoai (shape 3: choes)

230 Kiel B 509.
Maenad with dagger and fawn, Dionysos seated on rocks, holding wreath and thyrsus, silen bending forward with thyrsus.

*231 Zurich Market, Arete. PLATE 41, 3.
Nude youth with phiale seated on rock between two standing draped women.
Cf. the rock with that on no. 204 above.

Oenochoe (shape 8)

232 Naples 2123 (inv. 82281).
APS, p. 64, no. (i).
Nike with incense-burner, satyr with kottabos-stand and torch, Dionysos with narthex seated on panther, maenad with thyrsus, crouching silen and maenad with tambourine and thyrsus.

Skyphos

233 B.M. F 123.
Schauenburg, *AntikeWelt* 7.3, 1976, p. 46, fig. 15.
(a) Woman with mirror and Eros pushing woman in swing (cf. no. 216), (b) two nude youths with sticks, seated draped woman with mirror.

Calyx-krater

234 Naples 2885 (inv. 81865).
APS, p. 65, no. (xi).
(a) Two Hesperids (inscribed ΕΛΤΗ and ΑΡΕΤΤΟΣΑ) feeding a serpent coiled round an apple-tree, beside which is an illegible inscription, (b) two draped youths.

The following vase, though not attributable to the Lecce Painter himself, has certain characteristics of drawing (cf. especially the treatment of the eyes, nose and mouth) which associate it with the vases in division (iii), particularly with the two oenochoai nos. 230–1.

Oenochoe (shape 3: choes)

235 Melbourne University V 34.
 Once Geneva Market, Galerie Motte, *Sale Cat.*, 31 Oct. 1970, no. 93, ill. on p. 49; then London Market, Sotheby, *Sale Cat.*, 6 Dec. 1971, no. 98.
 Pan seated frontally with ball (?) in r. hand and lagobolon in l.

6. ASSOCIATES AND FOLLOWERS OF THE LECCE PAINTER

Around the Lecce Painter may be grouped a number of vases by several different painters who closely imitate his style and copy his mannerisms. Some of them are extremely like the painter's own work, but the drawing is generally scrappier; the latest vases descend to near barbarism.

(i) THE ROHAN PAINTER

The Rohan Painter is named after the museum in Strasbourg, which houses one of his most typical vases, and is very close in style to the developed work of the Lecce Painter. The eyes of his figures are very characteristic with a small dot for the pupil and an arching eyebrow. This artist uses the same diadems and head-bands as the Lecce Painter, but his rendering of the hair is particularly scrappy.

Bell-kraters

236 Strasbourg, Musée Rohan.
 APS Addenda, p. 430, no. (v a), pl. 120, figs. 23—4.
 (a) Nude youth seated between woman with phiale and nude youth with staff, (b) three draped youths.
237 Lecce 742.
 CVA 2, IV Dr, pl. 17, 6 and pl. 18, 3; *APS*, p. 64, no. (v).
 (a) Youth with phiale, and maenad with tambourine, (b) two draped youths.
 Very close to the Strasbourg krater; cf. also with Lecce 634 by the Thyrsus Painter.
238 Lecce 747.
 CVA 2, IV Dr, pl. 19, 1; *APS*, p. 64, no. (iv).
 (a) Satyr and maenad, (b) two draped youths.
239 Taranto 100528, from Manduria.
 AA 1956, 278, fig. 58; *APS* Addenda, p. 430, no. 13 bis.
 (a) Youth with thyrsus, and woman with fillet, (b) two draped youths.

Fragments

240 Heidelberg U 29 (from a skyphos).
 CVA, pl. 81, 2.
 Woman with phiale.
241 Mainz, RGZM O. 12971 (rim of bell-krater).
 (a) Woman and Eros, holding up tambourine.
242 Mainz, RGZM O. 12972 (from the rim of a krater).
 Schauenburg, *RM* 82, 1975, pl. 60, 2.
 Head of woman, head of bearded man with bird-sceptre.

(ii)

The two following vases, which are by one hand, are closely connected in style with the work of the Rohan Painter, but the drawing is of rather better quality.

Pelike

243 Rome, private coll. (Continued next page)

Pelike (continued)

(a) Youth with thyrsus seated on laver, Eros holding parasol above seated woman, standing woman with cista, (b) woman between nude youth with strigil and draped youth.

Calyx-krater

244 Genoa 1142.
 CVA, IV Dr, pl. 5; *Hellas and Rome*[2], 183.
 (a) Nude youth leaning on pillar and watching female acrobat beside a kottabos-stand, (b) two draped youths.

(iii) THE IRIS PAINTER AND ASSOCIATED VASES

This division includes the work of the Iris Painter, named after the bell-krater in the Vatican (U 14; no. 262), and a good number of related vases, which closely imitate the later style of the Lecce Painter. Pieces such as the Valletta and Lagioia kraters (nos. 272–3) descend into something approaching barbarism.

Characteristic is the thick black stripe across the top of the himatia of the reverse youths. Noteworthy also is the drawing of the thyrsi and the way in which the youths hold their sticks, looking almost as if they are dangling down from their hands.

(a)

The two vases in this sub-division are still very close to the Lecce Painter, and no. 245 might almost be by his hand, as it has many elements characteristic of his work (the thyrsi, the tambourine, the fringe of curls on the youths' heads, etc.). The drapery of the reverse youths, however, is treated in a rather different manner; the rows of parallel fold-lines across the top of their himatia are characteristic of the vases by the Iris Painter and his associates.

Bell-kraters

*245 Florence, La Paglaiuola 108. PLATE 41, 5–6.
 (a) Dionysos, naked maenad with thyrsus and tambourine, capering satyr, (b) three draped youths.
*246 Bari, Macinagrossa coll. 16. PLATE 41, 4.
 (a) Two women at a laver, (b) two draped youths.

(b)

The Geneva krater (no. 247) provides a connecting link between the vases mentioned above and those listed in this sub-division and those in (a). The drawing of the eyes of the figures recalls that of the eyes of figures by the Rohan Painter, but the beards are rather different.

Bell-kraters

247 Geneva 15002.
 APS, p. 63, no. 12; Schauenburg, *Antike Welt* 7.4, 1976, p. 34, fig. 33.
 (a) Eros pursuing woman with tambourine, (b) two draped youths.
248 Brooklyn 60.129.3.
 APS, p. 63, no. 13.
 (a) Maenad and satyr, (b) two draped youths.
249 Montevideo (frr.).
 APS Addenda, p. 430, no. 13 ter.
 (a) Two draped women, with a portion of the drapery of a third.

Pelike

250 Taranto 4607.
 CVA 2, IV Dr, pl. 36, 3–4; *APS*, p. 63, no. 19.

(a) Youth with phiale and woman with thyrsus, (b) two draped youths.

Skyphoi

251 Bari, Abruzzese coll. 1.
 (a) Maenad with tambourine, (b) capering satyr with tambourine.
 Very close to the Brooklyn krater (no. 248).
251a Taranto, from Rutigliano T. 20.
 (a) Maenad with tambourine, (b) satyr with tambourine.
 Very close to no. 251.
252 Copenhagen 85 (B–S. 254).
 CVA 6, pl. 241, 3.
 (a) Woman with phiale and thyrsus, (b) satyr with phiale moving to r.
253 Mainz, RGZM O. 12987 (fr.)
 Maenad with thyrsus.
253a Mainz, RGZM O. 12993 (fr.).
 Head and upper part of woman.

Oenochoai (shape 3: choes)

254 Naples 2256 (inv. 81702).
 APS, p. 64, no. 25.
 Youth with thyrsus, and woman with tambourine.
255 Taranto 52409.
 Youth on horse approaching Doric column.
*256 Once London Market, Christie's. PLATE 42, 1.
 Christie's, *Sale Cat.,* 2 Dec. 1970, no. 66.
 Nude youth.

(c)

This sub-division contains the works which may be attributed to the Iris Painter himself. He is an artist of some originality and a painter of phlyax scenes. The first two vases in the Vatican (nos. 257–8) are still very near to the Lecce Painter, but the youths on their reverses are different from his and characteristic of this artist. Noteworthy is the thick black stripe across the top of the himatia of the reverse figures on nos. 259–264.

Bell-kraters

257 Vatican T 3 (inv. 17942).
 VIE, pl. 25 f and pl. 24 l; *APS,* p. 64, no. (iii).
 (a) Eros and woman with thyrsus, (b) two draped youths.
258 Vatican U 12 (inv. 17960).
 VIE, pl. 26 a and d; *APS,* p. 64, no. (vii).
 (a) Nude youth with thyrsus, and woman with tambourine, (b) two draped youths.
*259 London, V. and A. 1776–1919 (ex Hope 220). (b) PLATE 42, 2.
 *PhV*², no. 41, (where bibliography); *Ill.Gr.Dr.* IV, 25.
 (a) Phlyax scene: Herakles feasting between two old phlyakes, (b) two draped youths.
260 Leningrad inv. 299 = St. 1775; W. 1121.
 *PhV*², no. 31 (where bibliography).
 (a) Phlyax scene: Herakles at the temple of Olympian Zeus, (b) two draped youths.
*261 Vienna 849. PLATE 42, 3–4.
 (a) Satyr with raised foot holding tambourine in l. hand, maenad with torch and tambourine, (b) two draped youths.

Bell-kraters (continued)

262 Vatican U 14 (inv. 17962).
 VIE, pl. 23 g and pl. 24 g; *APS*, p. 65, no. (xii).
 (a) Iris attacking a satyr, (b) two draped youths.
263 Vatican T 4 (inv. 17943).
 VIE, pl. 25 a and 24 k; *APS*, p. 66, no. (ii).
 (a) Athlete with strigil, and Nike at pillar, (b) two draped youths.
264 Lecce 676, from Vaste.
 CVA 2, IV Dr, pl. 17, 4; *APS*, p. 64. no. (vi).
 (a) Woman and youth, (b) two draped youths.
265 Pavia.
 Séchan, *Études*, p. 381, fig. 110; Macchioro, *ÖJh* 12, 1909, pp. 318 ff., fig. 158; Löwy, *JdI* 44, 1929, p. 63, fig. 12; Cambitoglou, *AntK* 18, 1975, pl. 25, 3.
 (a) Orestes brought by guard before Iphigenia, (b) three draped youths.

Pelike

266 Naples 2318 (inv. 81715).
 APS, p. 65, no. (x).
 (a) Two nude women at a laver, (b) two draped youths.

The following vase seems to be connected in style with the above, especially in the treatment of the hair and the profile faces:

Lebes gamikos

267 Taranto 8268.
 Schauenburg, *RM* 82, 1975, pl. 58.
 (a) Eros beside a seated draped woman, (b) seated nude woman with polos and nude woman.

(d)

The vases in this sub-division continue the style of the Iris Painter but are later and crude.

Bell-kraters

268 Hamburg 1917.1119.
 APS, p. 65, no. (xiv).
 (a) Dancing maenad and capering satyr, (b) two draped youths.
*269 Munich 2395. PLATE 42, 5–6.
 (a) Maenad with tambourine and satyr moving to l., (b) two draped youths.
270 Taranto, from Oria (June 1973), T. 2.
 (a) Nude youth and draped woman at altar, (b) two draped youths.
271 Naples 2066 (inv. 81431).
 (a) Woman with stick and tambourine, Eros touching Doric column, (b) two draped youths.
 Cf. the reverse with that of no. 269.
272 Valletta 5.
 APS, p. 65, no. (xiii).
 (a) Maenad with tambourine followed by capering satyr, (b) two draped youths.
273 Bari, Lagioia coll.
 (a) Nude youth and woman with thyrsus, (b) two draped youths by column.
274 Lecce 739.
 CVA 2, IV Dr, pl. 28, 2 and 5.
 (a) Woman seated between woman with phiale and nude youth with thyrsus, (b) draped youth and draped woman, with fillet between them and Ionic column. to r.

(iv) THE PAINTER OF SYDNEY 64

The Columbia krater (no. 275) is still close to the work of the Lecce Painter and the column between the draped youths on the reverse recalls those on nos. 195–6 above. The quality of the drawing has, however, deteriorated considerably. Particularly characteristic of this painter is the S-shaped border to the overhang of the himation worn by the draped youth to the left on the reverses. One should also note the use of a double black stripe down the drapery of the women and the carelessly drawn looped squiggles in the bottom corners of the youths' himatia.

Bell-kraters

275 Columbia, University of Missouri 70.159.
 (a) Woman with phiale running to l., followed by silen with wreath and thyrsus, (b) two draped youths beside a Doric column.
276 Lecce 637.
 CVA 2, IV Dr, pl. 14, 2 and pl. 13, 7; *APS*, p. 64, no. (ii).
 (a) Silen with tambourine capering between two maenads, (b) three draped youths.
277 Brussels, Mignot coll. 29.
 De Ruyt and Hackens, *Collection Abbé Mignot*, pp. 122 ff. figs. 61–63.
 (a) Youth and Eros, (b) two draped youths.
278 Sydney 64.
 APS, p. 66, no. (i), pl. 37, figs. 181–2.
 (a) Eros and woman, (b) two draped youths.
*279 Dresden 376. PLATE 43, 1–2.
 (a) Nude youth by altar, Nike holding crown, balding silen with thyrsus, (b) three draped youths.
 Cf. with Lecce 637, no. 276.
280 Lecce 674.
 CVA 2, IV Dr, pl. 12, 2 and 6.
 (a) Nike with fillet between two nude youths, (b) three draped youths.
 The reverse is very similar to those of nos. 276 and 279.
281 Once Milan Market, Finarte.
 Sale Cat. 5, pl. 38, no. 79.
 (a) Woman with wreath and phiale, Eros with tendril, woman with thyrsus, (b) three draped youths.

Pelike

282 Lecce 710.
 CVA 2, IV Dr, pl. 38, 12 and pl. 39, 2.
 (a) Woman, (b) youth.

The following two vases are closely connected with the Painter of Sydney 64.

Bell-kraters

283 Louvre K 11 (N 2993). Greatly repainted.
 (a) Nude youth with stick, draped woman with phiale, youth in three-quarter view resting l. arm on pillar, (b) three draped youths.
284 Lecce 732. In bad condition.
 CVA 2, IV Dr, pl. 18, 1.
 (a) Maenad with ball and thyrsus running l., pursued by stayr with outstretched arms, (b) two draped youths.

(v) THE PAINTER OF THE LARGE EGG PATTERNS

This is a very poor artist whose style is almost barbarised. He takes his name from the large egg patterns beneath the pictures on the obverses and reverses.

An interesting stylistic comparison may be made in regard to the youths on the reverses, and the large egg patterns, between the vases listed below and some vases and fragments from Olympia and Elis, now in the Olympia Museum (cf. the reverses of two calyx-kraters, Photos: A.I. 5955 and 6345), which appear to be a local variety of red-figure.

Bell-kraters

285 Lecce 643, from Rugge.
 CVA 2, IV Dr, pl. 13, 1; *APS*, p. 66, no. 1.
 (a) Three women, one holding torch, the others wreaths, (b) three draped youths.

286 Lecce 740, from Rugge.
 CVA 2, IV Dr, pl. 13, 2 and 5; *APS*, p. 66, no. 2.
 (a) Draped youth with two women, one holding branch and torch, the other a branch, (b) three draped youths.

287 Lecce 744, from Rugge.
 CVA 2, IV Dr, pl. 13, 3.
 (a) Satyr between two maenads, l. with thyrsus, r. with branch, (b) three draped youths.

(vi) THE LEESEN PAINTER

The Leesen Painter is a very poor artist and close in style to the Painter of Sydney 64. On two of his bell-kraters a nude male figure is shown as dancing with both feet off the ground. In the treatment of this figure one should note the characteristic way in which the calves are separated from the shins by a clearly-marked line. Like the Painter of Sydney 64 the Leesen Painter uses a double black stripe down women's drapery.

Bell-kraters

288 Copenhagen, Ny Carlsberg H 45 (inv. 2246), ex Treben, von Leesen, *Sale Cat.,* pl. 3, no. 29; *APS,* p. 66, no. 1.
 (a) Eros and Nike, (b) two draped youths.

289 Lecce 642.
 CVA 2, IV Dr, pl. 13, 4 and pl. 15, 6; *APS,* p. 66, no. 2.
 (a) Woman with cista, and youth with torch by kalathos, (b) two draped youths, with large flowering plant between them.

290 Karlsruhe B 774.
 CVA, pl. 80, 3–4.
 (a) Frontal woman standing, and youth with spear seated by herm beside tree, (b) three draped youths.
 Cf. the youths on the reverse, especially the one to l., with those on Lecce 642.

Hydria

291 Geneva 13189.
 APS, p. 66, no. (iii).
 Two women running to l., l. with fillet and mirror, r. with stick and wreath.
 Cf. the drapery of the women with that of the woman on the obverse of no. 290.

7. ARTISTS RELATED TO THE LECCE PAINTER

In this section we look at the work of three painters, whose work is broadly connected with that of the Lecce Painter and his associates, but who display a substantial measure of individuality in both the drawing and the subject-matter.

(1) THE PAINTER OF NAPLES 2865

The name vase of this painter (no. 292) is one of considerable interest for its treatment of three-quarter faces on the obverse, and for its reverse which shows a draped youth with a small

goatee beard (unique in Apulian) crowning a nude athlete in the presence of another youth, who finds an almost exact counterpart on the reverse of B.M. F 52 (no. 293).

Bell-kraters

*292 Naples 2865 (inv. 81410). (b) PLATE 43, 5.
 Moret, *Ilioupersis*, pl. 76, 1.
 (a) Herakles slaying the bull, crowned by Nike, between Iolaos with shield and spear and Athena,
 (b) draped youth crowning nude youth, and draped youth.
 293 B.M. F 52.
 (a) Maenad with thyrsus seated to left between young satyr, with fillet and situla, and maenad with
 basket of fruit and thyrsus, (b) two draped youths.

(ii) THE JASON PAINTER

This is an artist of considerable interest for the subjects depicted on the obverses of the two vases listed below, which their reverses show to be by the same hand, since both depict a draped youth holding out a chaplet, above an altar, to another draped youth. The borders of the himatia of these youths are marked by thick wavy black lines. There is a C-shaped line at the end of the "sleeve" of the youth to right, from which descend two parallel black lines in a manner which recalls the style of the York Group (Chapter 4). The subject of no. 294 is rare in South Italian, although we have already seen a rather different version of it on the Sisyphus Painter's name vase. The phlyax scene on the Copenhagen krater is entertaining and gives us a good representation of the stage, with a central Ionic column, presumably to mark the building from which a slave is carrying off a chest to the baffled amazement of his colleague. The subject has been discussed in some detail by Miss H.S. Roberts in the *Nationalmuseets Arbejdsmark* 1970, pp. 132 ff.

Bell-kraters

*294 Turin, private coll. PLATE 43, 3—4.
 (a) Jason and Medea beside a tree round which is coiled a serpent and on one branch of which is the
 golden fleece, (b) draped youth offering "chaplet" to another draped youth; large altar between them.
*295 Copenhagen 15032. (b) PLATE 43, 6.
 Roberts, figs. 3—4.
 (a) Phlyax scene on stage, (b) two draped youths.

(iii) THE PAINTER OF NAPLES 2307

The two following vases which are by the same hand have affinities with the Lecce Painter and his associates. The rather scrappy style of drawing of the obverse figures is akin to that on some of the vases in this section, for example no. 292, and the draped youths on the reverses are close in treatment to those on Naples 2318 (no. 266). The nestoris no. 296, however, should also be compared in shape with nos. 84 and 88 in section 3, although it will be noted that it has marks in added white colour on the upper disks of the handles and marks in relief at the lower handle-joins. The flat meanders below the figure-work recall those on nos. 52a, 70 and 71 of sections 2 and 3.

Nestoris (type 1)

 296 Naples 2307 (inv. 81832). Masks on the rotelle, and at the handle-joins.
 (a) Eros standing in between two women, l. seated with mirror, r. with foot rasied, (b) two draped
 youths, l. with strigil, r. with stick.

Pelike

 297 Naples 2345 (inv. 81728).
 (a) Woman with box moving to l. and looking back at satyr with wreath, (b) two draped youths, as
 on previous vase.

CHAPTER 6

FOLLOWERS OF THE TARPORLEY PAINTER (C)

THE KARLSRUHE B9 – DIJON GROUP

1. The Painter of Karlsruhe B 9
2. The Fat Duck Group
3. Vases associated with the Painter of Karlsruhe B 9 and the Fat Duck Group
4. The Dijon Painter
5. Close associates of the Dijon Painter
6. The Graz Painter and connected vases

Bibliography

A. Cambitoglou and A.D. Trendall, *APS* pp. 40–42 (The Painter of Karlsruhe B 9 and the Fat Duck Painter), p. 49 (The Graz Painter), p. 51 (The Dijon Painter), pp. 53–54 (The Rodin Painter); also *Addenda* pp. 427–428.

Introduction

The two principal artists in this chapter are the Painter of Karlsruhe B 9 and the Dijon Painter, the latter an artist of some importance because of his connexions with the Iliupersis Painter and the Painter of Athens 1714 (see Chapter 8), which illustrate the gradual fusion of the "Plain" and "Ornate" styles. Both stem out from the later phase of the Tarporley Painter, and their earlier vases should be compared also with those in the Chaplet Group (Chapter 3, nos. 93 ff.). Their work should also be looked at beside that of the Schiller, Adolphseck and Prisoner Painters and the Painter of the Long Overfalls (see Chapter 4) with which it has a good deal in common.

Most of the vases in this chapter belong to the two decades between c.380 and 360 B.C. and are perhaps best considered as Early Apulian. Although the latest vases overlap chronologically those of the Iliupersis Painter and probably approach the middle of the century, they can hardly be separated from the others.

1. THE PAINTER OF KARLSRUHE B 9

Since the publication of *APS* a great deal of new material has come to light which now enables us not only to attribute many more pieces to this painter and to trace better the development of his comparatively long career, but also to define more precisely the stylistic relations between his vases and those, on the one hand, of the Tarporley Painter, from whom his style is in the first instance derived, and, on the other, of the Dijon Painter, whose work was greatly influenced by him. The Painter of Karlsruhe B 9 must, therefore, now rank as one of the most significant of the immediate followers of the Tarporley Painter.

As general characteristics of his style we may note in particular the following:

(a) male and female figures tend to have soft faces with small noses, neatly drawn (nos. 4–8);
(b) women's drapery tends to be fussy at the waist; the garments have no overfalls; down their bent leg runs a thick black vertical line, generally following its contour; down their stiff leg the folds fall in a series of parallel vertical lines; the lower border of their garment spreads out to some extent beyond the supporting foot (nos. 4, 5, 8);
(c) the nipples of nude male figures are generally indicated by a circle (nos. 3–8, 16–18); the genitals are

small, with an upturned penis (no. 4); youths or Eros often sit with one leg crossed behind the other (nos. 4, 13, 18, 25, 27); running male figures usually have one leg bent at the knee (nos. 3, 10), standing ones one leg slightly flexed (nos. 5, 6, 8, 9); their hair may be long, falling down on to the shoulders (nos. 3, 8, 10, 31), or short, with curls around the ear and at the back (reverse of 8, 9); youths often have a piece of drapery over one arm, held by the hand of the other (nos. 5, 8, 9 — cf. the Schiller Painter) or else over both arms (nos. 8, 10);

(d) on all but the earliest vases the meander frieze runs right round the vase and is intercepted by saltire squares which at first have strokes in the centre of each side (nos. 5–10); later the strokes are normally replaced by dots in the four intersections (nos. 13, 15–16, 18–21).

The subjects are, in general, uninspired; the painter shows a marked preference for simple two-figure compositions, often with a Dionysiac theme or with Eros. Occasionally he depicts warriors in native costume (nos. 45, 52) and stele scenes (nos. 24 and 35; cf. also the reverse of 25). Ruvo 417 (no. 25) is perhaps his most ambitious piece, showing two youths beside a small naiskos, in which hangs a shield, with a kantharos between two pomegranates below it, and a row of offerings along the base, together with a black-figure amphora standing beside it. This artist is also fond of people holding birds in their hands, especially in his later work (nos. 9, 15, 27, 33, 35, 46, 51).

The Painter of Karlsruhe B 9 is on the whole conventional in his use of shapes. His rhyton no. 31, however, is one of the earliest examples extant in Apulian red-figure and his dish no. 44 may well mark the first appearance of this shape, since those by the Truro Painter (nos. 5/184–186) are probably slightly later. The rhyton becomes popular with the Iliupersis Painter and especially in later Apulian in the workshop of the Patera and Ganymede Painters; the dish becomes also a very popular shape from the time of the Iliupersis Painter onward (see Schneider-Herrmann, *Apulian Red-Figured Paterae, BICS* Suppl. no. 34, 1977).

(i) EARLIEST WORK

The early vases of the Painter of Karlsruhe B 9 are very closely connected in style with those of the Tarporley Painter's division (iii) and with the work of the Painter of Lecce 686 and the Schiller Painter. A comparison between most of the vases listed below and nos. 29–36 by the Tarporley Painter will leave little doubt that the latter provided the models from which the Painter of Karlsruhe B 9 took his inspiration. We may note in particular the two parallel lines running down below the overhang of the himation on the draped youth to left on the reverses of nos. 1–4 (cf. with nos. 29-34 by the Tarporley Painter), also the capital-omega-shaped line at the border of the overhang on nos. 5, 9, 10 (cf. with nos. 33 and 36 by the Tarporley Painter) and, in particular, the wavy, almost corkscrew-like, line in the far corner of the himation of the youth to right on nos. 1 and 6–10 (Fig. 2 j), which finds an exact parallel on the Ragusa krater no. 30 by the Tarporley Painter, the obverse of which is also very close to those on nos. 1 and 3 in the treatment of the woman on the former and the silen on the latter. We may also compare the Dionysiac scenes on nos. 3 and 10 with that on Gotha 74 (no. 3/36). Further comparisons with the work of the Painter of Lecce 686 (e.g. 3/66–69) and the Schiller Painter (e.g. 4/1–3 and 10–13) make it clear that the Painter of Karlsruhe B 9 must have begun his career along with these two artists under the aegis of the Tarporley Painter, probably in the eighties of the fourth century B.C.

Characteristic of his early work is the treatment of the draped youths on the reverses. As has already been mentioned the himation of the left youth has a fairly long overhang behind the left shoulder, below which two parallel black lines run down to the hem; the right youth

has a wavy line down the far border of his cloak (Fig. 2 j), and a wavy lower hem-line, which ends by running parallel to the former, each on a separate piece of the garment, giving somewhat the effect of two "tails" (nos. 1 and 4—10). Below the handles of his bell-kraters there is often a fan-palmette with characteristic side-scrolls extending from it (nos. 6—10).

In *APS* (p. 39) a "Painter of Bologna 497" was identified and placed among the followers of the Tarporley Painter, in close association with the Painter of Lecce 686. In addition to the name vase two other pelikai (Bologna 498 and Trieste 434) were attributed to that painter, which have now been detached and given to the Painter of Bologna 498 (3/100 and 104). The name vase itself seems better placed in the present context; it provides an excellent link between the Tarporley Painter (especially his no. 30) and the Painter of Karlsruhe B 9, but is closer to the latter's work (cf. the reverse with those of nos. 2, 3, 6, 9 and 10).

Many of the characteristics of the painter's more developed style find their beginnings in this early phase (cf. the women on nos. 4 and 5 with those on nos. 13 and 18 and the running figures on no. 10 with those on nos. 14 and 16; cf. also the treatment of the himation of the youth to left on nos. 9 and 10 with that of the himation of the corresponding youths on nos. 13—16).

Pelike

1 Bologna 497.
 CVA 3, IV Gr, pl. 1, 11—12; *APS*, p. 39, no. 1.
 (a) Eros resting l. arm on pillar, and woman with basket, (b) two draped youths.

Bell-kraters

* 2 Naples 2186 (inv. 81446). PLATE 44, 1—2.
 (a) Satyr with phiale and torch, woman with tambourine, running to r., (b) two draped youths.
 Note the b.f. ivy on the rim and the egg-pattern below the pictures.

3 Erbach 34.
 (a) Dionysos with thyrsus moving to l. and looking back at silen with tambourine in upraised l. hand, (b) two draped youths.
 Note the way in which the saltire square is joined to the meander; cf. no. 4/210 by the York Painter.

4 Bari 6366.
 (a) Standing woman with phiale and seated nude youth, (b) two draped youths.

5 Bari 6266.
 (a) Nude youth with thyrsus, standing woman with situla, (b) two draped youths.

6 Vatican V 1 (inv. 18028).
 VIE, pl. 23 d and pl. 24 d.
 (a) Satyr with situla and phiale, Dionysos with thyrsus by stele, (b) two draped youths.
 The l. youth on the reverse has been incorrectly restored as seated.

7 Taranto, Moretti coll. 19.
 (a) Standing woman with cista, seated Eros with bird in r. hand, (b) two draped youths.

8 Karlsruhe B 9.
 CVA, pls. 57, 2 and 55, 3; *APS*, p. 40, no. 1.
 (a) Nike with phiale in l. hand holding out wreath to nude youth with thyrsus (Dionysos ?), (b) two draped youths.

* 9 Agrigento C 1540. PLATE 44, 3—4.
 (a) Nude youth with feline on r. arm, seated woman with dish, (b) two draped youths.

10 Trieste S 412.
 CVA, IV D, pl. 3, 3—4.
 (a) Satyr with torch and situla following Dionysos who holds phiale and thyrsus, (b) two draped youths.

The obverse provides a close link with Bari 2250 (no. 14) in the next division.

Hydriai

11 Ruvo 500.
 Eros with mirror and standing woman holding sash in both hands.
12 Karlsruhe B 93.
 Seated nude youth and woman with wreath and cista.

(ii) EARLY VASES

Karlsruhe B 9 and Trieste S 412 (nos. 8 and 10) provide excellent connecting links between divisions (i) and (ii) (cf. with nos. 13–14). The treatment of the draped youths on the reverses now becomes somewhat freer; on the left youth the omega-shaped line at the lower border of the overhang is more pronounced (e.g. on nos. 13–16 and 27) and the "sling" drape (i.e. the drapery effect, comparable to that of a sling, produced by one arm bent outwards at the elbow beneath the himation) becomes increasingly popular (e.g. on nos. 14–16 and 18; cf. with nos. 4, 5 and 9 in the preceding division), especially for the youth to left. The youth on the right may have a "sleeve" drape over the bent left arm (as on no. 13), usually with a sweeping curve, which becomes progressively rounder (e.g. on nos. 18–19), and the wavy line in the bottom right hand corner may now break down into what looks like a series of U's on their sides (e.g. on nos. 13–16 and 27; Fig. 2 k). The fold-lines of the drapery are clearly defined and on women's peploi they often run up from the girdle on to the breasts in a series of short parallel lines (e.g. on nos. 17–20), sometimes with a horizontal row of dots across the top (e.g. on nos. 15, 24, 27 and 30). The black stripe down the side of women's garments continues in use, even when the woman is seated (cf. no. 17).

On the vases of this division we also note the appearance of rocks, sometimes spotted as on nos. 15 and 18, sometimes decorated with lines (no. 13), on which people are seated; also an increasing use of birds (e.g. on nos. 15, 25, 27, 32–3). The scrolls beside the handle-palmettes are now detached; the saltires of the meander-patterns always have dots in the intersections. As adjuncts in the field we find diptychs, dotted phialai, *halteres* and windows.

Parallels with the work of the Schiller Painter will be observed in the drapery of Dionysos on no. 14 and in the situla held by the woman on no. 13.

Bell-kraters

13 B.M. F 165.
 APS, p. 40, no. 2, pl. 17, figs. 79–84; Schneider-Herrmann, *BABesch* 45, 1970, p. 86, fig. 1.
 (a) Eros with phiale seated on rock, woman with wreath and situla, (b) two draped youths.
14 Bari 2250.
 (a) Satyr with situla following Dionysos with kantharos and thyrsus, (b) two draped youths.
15 Barcelona 339.
 (a) Seated woman with phiale, Eros with duck and bunch of grapes, (b) two draped youths.
* 16 Erlangen K 86. PLATE 44, 5–6.
 (a) Dionysos with kantharos and thyrsus moving to r., following young satyr with torch and situla,
 (b) two draped youths.
17 Zurich Market, Koller, *Sale Cat.*, no. 33 (22 May–10 June 1975), no. 4191.
 Antike Kunst aus Privatbesitz Bern-Biel-Solothurn, no. 165, pl. 24.
 (a) Seated woman with bunch of grapes and thyrsus, satyr with phiale and situla, (b) two draped
 youths.
* 18 Once Rome Market. PLATE 45, 1–2.
 (a) Nude youth with thyrsus seated on spotted rock, and standing woman with phiale, (b) two

Bell-kraters (continued)

draped youths.

The curve of the "sleeve" on the youth to r. on the reverse assumes a more sweeping form than on B.M. F 165 (no. 13).

19 Wellington (N.Z.), Victoria University 1959.1 (ex Sotheby, *Sale Cat.* 18 March 1957, no. 91).
APS Addenda, p. 427, no. 5.
(a) Satyr with situla and torch following maenad holding up tambourine, (b) two draped youths. (Cf. with the krater formerly on the Rome Market, no. 18).

20 Monopoli, Meo-Evoli coll. 8.
(a) Woman with phiale pursued by satyr with torch, (b) two draped youths.

21 Frankfurt Market, De Robertis, *Lagerliste* II, no. 55.
(a) Woman with torch and situla running to r., followed by nude youth with thyrsus, (b) two draped youths.

22 Monopoli, Meo-Evoli coll. 949.
(a) Standing woman with phiale, seated satyr with thyrsus, (b) two draped youths.

23 Matera 13067, from Ginosa.
(a) Seated satyr with thyrsus and phiale, standing woman with mirror and situla, (b) two draped youths.

Amphorae

24 Milan, "H.A." coll. 315.
CVA 1, IV Dr, pl. 25.
(a) Woman with bunch of grapes and phiale, nude youth with fillet, at stele, (b) two draped youths.

25 Ruvo 417.
Photo: R.I. 72.48.
(a) Two nude youths, l. seated with phiale, r. standing with duck at shrine in which is a shield and kantharos, (b) two draped youths at stele.

26 Bari 1279.
(a) Woman with phiale, and seated nude youth with strigil, (b) two draped youths.

Pelikai

* 27 Karlsruhe B 770. PLATE 45, 3–4.
CVA, pl. 80, 1; *APS,* p. 41, no. 1 (where attributed to the Fat Duck Painter).
(a) Woman and seated youth holding duck, (b) two draped youths.

27a Catania MB 4358.
(a) Seated woman with phiale, and nude youth with wreath, (b) two draped youths, with white head-bands.

28 Leningrad 528 = St. 1104.
(a) Seated woman with mirror and nude youth with stick, (b) two draped youths.

29 Verona 169.
CVA, IV D, pl. 8, 1.
(a) Seated nude youth and woman with wreath, (b) two draped youths.

29a Vidigulfo, Castello dei Landriani 498.
(a) Seated woman with phiale, standing woman with sash; above: seated Eros with mirror, (b) standing woman with stemless cup and nude youth with spear.
The reverse has been somewhat repainted.

Squat lekythos

30 Baranello 204.
Draped woman holding duck beside altar.
Note the row of dots across the drapery as on Milan "H.A." 315 and Karlsruhe B 770 (nos. 24 and 27).

Rhyton (goat-head)

31 Bari 6257.

 APS, p. 40, no. 4, pl. 18, fig. 85; Hoffmann, *TR*, p. 27, no. 128, pl. 14, 1–2; *La Collezione Polese*, no. 47, pl. 15. Photo: R.I. 62.1165.

 Seated woman with tendril and branch; Eros seated on cista.

 This is one of the earliest Apulian r.f. rhyta (see above p. 135).

Hydriai

32 Reading 140.51 RM.

 Nude youth and woman with cista beside a laver, in which is a duck.

33 Milan, "H.A." coll. 419.

 Woman with wreath and phiale at altar, to r. of which is seated a nude youth with a bird perched on his r. hand.

 Below l. handle: swan.

34 Bari, Sette Labellarte coll. 33.

 Eros with phiale seated on dotted rock.

(iii) LATER VASES

The vases in this division are close to those of the preceding one, as may be seen from a comparison between the hydriai in each, but the drawing tends to become more fluid, and at times more flamboyant, as shown by the increasing waviness of the borders on the drapery. The black stripe on the side of women's drapery becomes thicker (nos. 35–37).

Many of the characteristics in division (ii) persist, and it is interesting to compare the Eros on no. 51 with that on no. 1, whom he closely resembles; on the latter vase the cista on which the woman is seated should also be compared with that on no. 31. Slightly different rocks now make their appearance: they consist of two or more rounded stones on top of one another, sometimes decorated with black dots, sometimes with a solid black core relieved by a white line or a row of white dots, as on the hydria Milan, "H.A." 439 (no. 36), which is a good transitional piece, since the draped woman on it is characteristic of the painter's earlier style. This kind of rock reappears on no. 46, and is very common on the latest vases [division (iv)].

Hydriai

35 Naples 2347 (inv. 81800).

 Photos: R.I. 60.595–7.

 Woman seated on cista in front of Ionic monument; to l. Eros bending forward with wreath, to r. draped woman with phiale.

 Below handles: owls.

36 Milan, "H.A." coll. 439.

 Eros with wreath seated on rock, standing woman with bunch of grapes and bird flying between them.

37 B.M. F 358.

 Woman with phiale seated on altar, standing woman with wreath.

38 Bologna 499.

 CVA 3, IV Gr, pl. 3, 1.

 Eros with wreath and phiale, woman with mirror seated on cista.

39 Warsaw 147821.

 APS Addenda, p. 428, no. 7; *CVA* 7, pl. 30 and pl. 28, 3–4.

 Woman with phiale seated on cista and standing woman with fan beside a stele.

40 Budapest 75. 43A, from Rionero.

 Seated woman and standing woman with mirror and wreath.

Hydriai (continued)

For the wavy lower hem-line of the women's drapery cf. Vatican V 3 (no. 4/169 by the Bendis Painter) and the hydria Trieste S 436 (no. 10/30 by the Judgement Painter).

41 Bologna 554.

CVA 3, IV Dr, pl. 31, 2.

Seated woman with mirror and standing woman with wreath and phiale beside a white Ionic stele.

42 Once Zurich Market (ex London, Sotheby; then Munich, Brienner Gallery).

Sotheby, *Sale Cat.* 4 May 1970, no. 114; Galerie am Neumarkt, *Auktion XXII,* 16 April 1971, pl. 6, no. 80.

Woman with fan seated on cista, standing woman with phiale beside an altar.

43 Gravina, from Botromagno T. 5 (1972).

Standing woman with wreath and cista, youth with wreath seated on rock.

Dish

44 Berlin F 3344. Repainted.

(a) Standing woman with bunch of grapes and phiale, seated Eros with duck in r. hand; woman moving to r. and looking back l., holding fan and open box, seated woman with mirror, (b) Eros with fillet and torch, Dionysos running to r., with drapery behind back and over l. arm and thyrsus in l. hand, maenad with tambourine.

For the shape see above p. 135.

Column-kraters

45 Manchester Aa 46 (on loan to the University).

Herford, *Handbook of Greek Vase-Painting,* pl. 11 b.

(a) Woman with oenochoe and dish, seated Oscan youth with two spears, standing Oscan youth with kantharos, shield and two spears, (b) three draped youths.

46 Milan, ex Riquier coll.

(a) Seated nude youth with phiale of fruit, draped woman with thyrsus and tambourine, (b) two draped youths (largely missing).

47 Verona 174.

CVA, IV D, pl. 1, 2.

(a) Eros seated with wreath and dish of offerings, standing woman with bird and situla, (b) two draped youths.

Bell-krater

48 Naples 947 (inv. 82584).

(a) Eros and seated woman with bunch of grapes, (b) two draped youths.

Cf. with Verona 174.

Lebes gamikos

49 Naples 2322 (inv. 81904).

(a) Seated woman with mirror, standing woman with phiale and spray, Eros seated above bird, (b) Eros with rabbit seated on rock, woman with wreath and spray.

Pelike (shape 1)

50 Catania MC 4390.

(a) Standing draped woman with ball and phiale, nude youth seated on drapery, (b) two draped youths.

Pelike (shape 2)

* 51 Benevento 378 (old no. 1517). (b) PLATE 45, 5.

(a) Eros with bird in r. hand leaning against pillar, and seated woman with phiale, (b) two draped youths.

(iv) THE LATEST PHASE

The latest vases of this painter continue directly from those in the preceding division, with a similar treatment of rocks and other adjuncts. Double fold-lines are more popular on the drapery of women (nos. 52, 53, 56, 62) and the wavy line across the top of the youths' himatia, or in the bottom corner, becomes more pronounced. One should note the drawing of the window on the reverse of no. 53 where it looks like a square bracket in a reserved rectangle (cf. with no. 54 and with nos. 17 and 37 above). The meanders are sometimes thicker and usually well drawn. It is important to note on Bari 6265 and the Cooper-Hewitt krater (nos. 53 and 57) the appearance of a new type of crossed square with the meanders which is divided by a horizontal and a vertical line into four smaller squares, in the centres of which is a black dot. This is one of the most common types of crossed square in Apulian during the second half of the 4th century, and it will in future be referred to as a "quartered" square.

Column-kraters

52 Verona 173.
> *CVA,* IV D, pl. 1, 1.
> (a) Oscan youth seated on rock holding spear, standing draped woman with phiale and bunch of grapes, (b) two draped youths.
> Cf. the youths and the diptych on the reverse with those on the reverse of Barcelona 339 (no. 15).

* 53 Bari 6265. PLATE 45, 6.
> (a) Seated Eros with wreath and phiale, standing woman with mirror and cista, (b) two draped youths, r. holding fillet.
> For the window on the obverse cf. no. 51.

Bell-kraters

54 Once Agrigento, Giudice coll. 212 (*Sale Cat.* 421).
> *APS,* p. 50, no. (i), pl. 29, fig. 138.
> (a) Satyr with thyrsus and phiale seated on rock, woman with mirror and situla, (b) two draped youths.

55 Bitonto, private coll.
> (a) Satyr with torch and Dionysos with thyrsus, both moving to r., (b) two draped youths.
> Nos. 54—5 are closely connected with Verona 173 (no. 52).

56 Minervino Murge 1, from T. 1 (1956).
> (a) Eros seated on rock with phiale, draped woman with wreath and bunch of grapes, (b) two draped youths.

57 New York, Cooper-Hewitt Museum 1957.23.1.
> (a) Satyr with situla and phiale approaching seated Dionysos, (b) two draped youths.
> Cf. the youths and the quartered squares with those on Bari 6265 (no. 53).

58 Naples 1828 (inv. 81445).
> (a) Woman with thyrsus, seated youth with cista, (b) two draped youths.

59 Padua, Casuccio coll. 14.
> (a) Satyr with phiale and seated nude youth with thyrsus by stele, (b) two draped youths.
> The reverse is very close to that of the Debrecen vase (no. 62), and the head of the youth on (a) resembles that of Eros on the Bari rhyton (no. 31).

60 Liverpool 50.60.62.
> (a) Young satyr with l. foot raised on rock, holding calyx-krater, (b) two draped youths.

61 Port Sunlight X 2150 (ex Hope 249).
> (a) Dionysos with thyrsus and phiale, satyr holding calyx-krater, (b) two draped youths.

62 Debrecen, Déri Museum G. II. 4.
> Szilágyi, *Acta Class. Univ. Debrecen* 5, 1969, pp. 45 ff., pls. 6—8.

Bell-kraters (continued)

(a) Woman with phiale, satyr with thyrsus seated on rock, (b) two draped youths.

(v) IMITATIONS OF THE STYLE OF THIS PAINTER

The two following vases, which are by a single artist, seem to be the work of a very inferior imitator of the Painter of Karlsruhe B 9, who copies his mannerisms, without completely understanding them. Both subjects and compositions are directly derived from his work (cf. no. 63 with nos. 14 and 16), and we note on no. 64 the appearance of his characteristic bird, curious window and crossed diptych (cf. nos. 36, 37, 52); the quality of the drawing, however, has sadly deteriorated. Characteristic are the heavy meanders, accompanied by saltire squares in which the angles between the diagonals are filled with smaller matching angles or with T's (obverse of 64).

Bell-kraters

63 Verona 172.
 CVA, IV D, pl. 3, 2.
 (a) Nude youth with phiale moving to r. behind satyr with torch and situla, (b) two draped youths.
64 Palermo 2195 (old inv. 2660).
 (a) Nude youth, holding in l. hand a phiale on which a duck is seated, moving to r. behind maenad with spray and thyrsus, (b) two draped youths.

With these two vases should be compared a highly remarkable bell-krater in Bari, which also looks like a distant, or even provincial, imitation of the painter's work. The treatment of the himatia .of the reverse youths seems to have been inspired by that of the painter's later vases (e.g. nos. 61−2), and we may also note the use of saltire squares with dots in the intersections.

Bell-krater

65 Bari 6324.
 (a) Dionysos with narthex and young satyr with branch and torch running to r., (b) two draped youths at an altar on top of which is a plant.

2. THE FAT DUCK GROUP

The Fat Duck Painter was identified in *APS* (p. 41) as a follower of the Painter of Karlsruhe B 9, with whose work his own has much in common, although in quality it is decidedly inferior. A number of other vases may how be grouped around him by reason of the similarlity of the female figures and the draped youths on the reverses.

(i) THE FAT DUCK PAINTER

In *APS* (p. 41, no. 1) the pelike Karlsruhe B 770 was attributed to the Fat Duck Painter. We now see, however, that this vase is, in fact, by the Painter of Karlsruhe B 9 himself (no. 27 above) and that it probably provided the model on which the Fat Duck Painter based his slightly watered-down version of it on Sydney 88 (no. 66). The two standing women are quite alike in treatment, though the version by the Fat Duck Painter is somewhat less elegant and the drawing less precise.

The two seated youths with the duck are also very similar, except that the one on no. 66 sits on a large spotted rock (cf. nos. 15, 18). The reverses of the two vases are further apart, though again the one is clearly derived from the other. The typical "omega" border of the over-

hang on the left youth has now degenerated into a Z, and there is a similar break-down of the wavy hem-lines. The youths' faces have assumed a vacant look distinct from the more intent impression characteristic of the Painter of Karlsruhe B 9.

The draped woman, who finds typical counterparts on nos. 5, 8, 13, 47 and 52 above, wearing a chiton, down the side of which runs a black stripe following the line of the leg (nos. 66–68), and which tends to splay out over her feet, is very popular with the Fat Duck Painter and his circle. Her hair is normally done up in a chignon at the back which tends to droop slightly downwards. The feet are carelessly drawn, and on some vases they tend to merge together.

Pelikai

66 Sydney 88.
 APS, p. 41, no. 2, pl. 18, fig. 89.
 (a) Woman and seated youth holding duck, (b) two draped youths.
 The border of white dots around the rock recalls the work of the Schiller Painter.
67 Bari 1169.
 APS, p. 42, no. 3.
 (a) Eros seated on rock, holding duck, and standing woman, (b) two draped youths.
68 Milan, "H.A." coll. 427.
 (a) Standing draped woman holding wreath in r. hand and cista in l., seated nude youth, (b) two draped youths.
69 Matera 9982.
 APS Addenda, p. 427, no. (iii a), pl. 117, fig. 11; Lo Porto, *Penetrazione,* pl. 32, 3–4. Photos: R.I. 66.1330–1.
 (a) Seated woman with wreath and phiale, nude youth with duck, (b) two draped youths.

Skyphos (Corinthian shape)

70 Halle 516.
 APS, p. 42, no. 5, pl. 18, fig. 90.
 (a) Seated nude youth holding duck, (b) woman.

(ii) VASES CONNECTED WITH THE FAT DUCK PAINTER

(a)

The three following vases, of which the first two were associated in *APS* (p. 39) with Bologna 497, seem to be the work of a single hand. They are very close indeed to the Fat Duck Painter, as may be seen from a comparison of their reverses with his and of the obverses of nos. 71 and 69, which are remarkably alike.

Pelikai

71 Prague, Museum of Applied Art 639.
 APS, p. 39, no. (iv), pl. 16, figs. 75–6.
 (a) Seated woman and nude youth with wreath in r. hand, and drapery behind his back, (b) two draped youths.
72 Naples 2281 (inv. 81724).
 APS, p. 39, no. (v), pl. 16, figs. 77–8.
 (a) Draped woman with fillet and wreath, seated nude youth with phiale and branch, (b) two draped youths.
73 Bari, Lagioia coll.
 (a) Nude youth with staff and strigil, seated draped woman with phiale and wreath, (b) two draped youths.

(b)

The two following vases, by a single painter, are also closely connected (cf. the reverse of no. 74 with that of no. 69).

Pelikai

74 Louvre K 31 (N 2467).
 (a) Woman with sash, bouncing ball, and Eros with mirror seated on rock, (b) two draped youths, l. with stick, r. with strigil.
75 Taranto 6243, from Crispiano.
 (a) Woman seated, holding tendril, nude youth with strigil bending forward over raised foot, (b) two draped youths, l. with strigil, r. with stick.
 Cf. also with the work of the Painter of the Long Overfalls.

(c)

The two following minor vases should also find a place here, from the treatment of the draped women upon them.

Skyphoi

76 Karlsruhe B 775.
 CVA, pl. 81, 4–5; *APS,* p. 42, no. (i).
 (a) Draped woman with wreath, (b) nude youth with stick and chaplet.
77 Vatican Y 12 (inv. 18118).
 APS, p. 42, no. (ii).
 (a) and (b) Draped woman.

3. VASES ASSOCIATED WITH THE PAINTER OF KARLSRUHE B 9 AND THE FAT DUCK GROUP

In addition to the vases in the Fat Duck Group there are some others which have a close stylistic affinity with the work of the Painter of Karlsruhe B 9, manifest especially by the presence of a standing draped woman, with a black stripe down the side of her garment derived from the female figures on such vases as nos. 8, 12–13, 18, 27, 35–6, 46 and 50. We should also note the treatment of the himatia of the reverse youths (e.g. on nos. 78–82) recalling the somewhat similar treatment of those on vases by the Painter of Karlsruhe B 9. The influence of the Schiller Painter is also visible in the posing of some of the figures (e.g. on Zagreb 4, no. 85), especially the drooping arms.

(i) THE PAINTER OF PALERMO 2177

(a)

The two following vases form a closely-connected pair, with very similar reverses and pattern-work. We should note the narrow reserved band round the handle-joins.

Bell-kraters

78 Palermo 2177 (old no. V 794).
 APS Addenda, p. 431, pl. 119, figs. 20–21.
 (a) Seated youth with wreath, draped woman with oenochoe, (b) two draped youths.
79 Bari 6323.
 (a) Satyr with outstretched arms pursuing woman, (b) two draped youths.

(b)

The two following vases, both by the same hand, are very close to nos. 78—9 and may well be the work of the same painter.

Bell-kraters

80 Berkeley 8/3816.
 (a) Woman with phiale, and nude youth, by stele, (b) two draped youths.
81 Rome, Dr. G. Castelli.
 (a) Nude youth with drapery over l. arm, followed by woman holding cista, both moving to l.,
 (b) two draped youths.

The following bell-krater should be compared with Bari 6323 (no. 79).

82 Naples 1837 (inv. 81428).
 (a) Woman with situla moving to l., followed by satyr with outstretched hands, (b) two draped youths.

(ii) VASES COMPARABLE TO THOSE BY THE PAINTER OF KARLSRUHE B 9 AND THE FAT DUCK PAINTER

Bell-kraters

83 Brindisi 329.
 Benita Sciarra, *Brindisi e il suo Museo*, pl. 15; Benita Sciarra, *Musei d'Italia* 9. *Brindisi, Mus. Arch. Prov.* p. 13, fig. 71.
 (a) Standing woman with phiale, seated nude youth, (b) two draped youths.
84 Bari 6335.
 (a) Nude youth with drapery over l. arm, draped woman with wreath, (b) two draped youths.
85 Zagreb 4. Repainted.
 APS, p. 48, no. (i), pl. 38, figs. 127—8; Damevski I, pl. 7, 1.
 (a) Nude youth with phiale, draped woman with fruit by stele, (b) two draped youths.

Pelike

86 Turin, private coll.
 (a) Nude youth with strigil, draped woman with ball by altar, (b) two draped youths.

(iii) VASES PROBABLY CONNECTED WITH THE PAINTER OF KARLSRUHE B 9 AND THE FAT DUCK GROUP

The following vase, known to us only from inferior illustrations, should perhaps find a place in this context.

Hydria

87 Gerona 790.
 Trias, *Ceramicas griegas*, pl. 14, 4.
 Nude youth and standing woman with duck between them.
 Below handles: owl.

The following vase seems to be connected with those listed above by the treatment of the draped woman on its obverse (see *APS*, p. 41); however, the youths on its reverse differ considerably from those on any of them.

Bell-krater

88 Vienna 777.
 APS, p. 41, no. (vii), pl. 18, figs. 87—8.
 (a) Draped woman with cista, and seated nude youth with bird, (b) two draped youths.

With Vienna 777 compare, especially in regard to the draped youth to r. on the reverse, the following vase, the obverse of which seems to be associated with those of nos. 84—5 above.

Bell-krater

89 Bari 5598.

(a) Dionysos with thyrsus, and seated satyr with bird and thyrsus, (b) two draped youths.

4. THE DIJON PAINTER

In *APS* (p. 51) the Dijon Painter was treated as a comparatively insignificant artist to whom only three vases were attributed. He has now blossomed out into one of the most important vase-painters of the "Plain" style in the second quarter of the fourth century, to whom over eighty vases can be assigned, including a few previously distributed among his colleagues (e.g. nos. 160, 168) or given to the Painter of Copenhagen 335 (nos. 162—3).

With the work of the Dijon Painter the "Plain" style begins more rapidly to approach the "Ornate" as the connexion between vases attributed to him, like Adolphseck 180 and Naples 2065 (nos. 154—5) and vases by the Iliupersis Painter like Louvre K 3 and B.M. F 66 (nos. 8/17—18), clearly indicates. The link is further reinforced by the parallels between many of his column-kraters and the column-kraters by the Painter of Athens 1714, especially those grouped around Copenhagen 335 (no. 8/220). The relationship is, in fact, so close that one is almost led to think of the Dijon Painter as being an associate of these two artists.

In general style and individual treatment of his figures the Dijon Painter in his early stages stands very close to the Painter of Karlsruhe B 9, (cf. especially the drapery and poses of his female figures and his reverse youths). Like his colleagues, he is very fond of Dionysiac themes (nos. 90, 94, 98, 102, 104, 106), but his range of subjects is much wider and includes a little mythology (e.g. no. 92), some drama (nos. 95—97), and a great many representations of Oscan warriors, always, in accordance with the regular practice at this time, represented upon column-kraters (nos. 99, 117, 146—7, 162—5, 167—8, 171).

The vases listed below have been divided on the basis of style and subject-matter. Although there is inevitably some measure of overlapping between these divisions they illustrate, broadly speaking, the development of the painter's style and the increasing influence on it of the Iliupersis Painter and his associates.

The work of the Dijon Painter mostly falls between c.380 and 360 B.C., with a few of the later vases going further down, towards the middle of the century.

(i) EARLIEST WORK

As has already been mentioned the earliest vases are very close to those by the Painter of Karlsruhe B 9. The connexion is brought out by a comparison of the women with the black stripe down the side of their garments on nos. 90, 91 and 95 with those on nos. 5, 8, 13 and 18 above (and one should also compare the face and the diadem on the woman on no. 90 with those of the woman on no. 18). The influence of the Tarporley Painter, especially in his later period (nos. 3/36—8, 61) is also to be observed, though perhaps more through the work of his immediate followers.

The vases in this division are linked together by the presence of a draped female figure, who is represented standing or running (nos. 90, 93) and, in particular, by the treatment of the draped youths on their reverses, whose hair is usually shown as a solid black mass with a narrow reserved contour and a small indent for the visible ear (as on nos. 90—91). The youths fall

mostly into the following stock types which should be compared with those on the vases of the Snub-Nose Painter and his associates (see pp. 314 ff. and Plate 97).

(i) Youth facing to right:

(a) with a "sling" drape, a pronounced upward bend of the covered arm, an overhang with a wavy border, and a flat black hem-line above the feet ending in a wavy line at the corner of the himation (as on nos. 90 – 91 and 94; cf. with Pl. 97, 1–2.)

(b) with the himation so draped as to leave the r. shoulder and arm bare; with the hand of the bare arm brought forward to hold a stick or strigil (as on no. 92) and the l. arm bent at the elbow;

(c) with the head in profile to r. but the body turned round until it is almost frontal; with the l. arm akimbo and a "sleeve"-like effect in the drapery; with the r. shoulder and arm exposed; with a flat hem-line of the himation above the feet forming a wave at the corner (as on no. 93, 95–7).

(ii) Youth facing to left:

(a) with the cononical draping consisting of the himation over the l. shoulder to leave the r. bare; with one hand extended to hold a strigil or stick, and the l. arm bent beneath the himation to produce a "sleeve"-like drape; with the edge of the sleeve marked by an omega-shaped line, beneath which two or more vertical lines run down to the bottom corner of the himation meeting the wavy part of the hem-line to the r. of the feet where there is generally an omega-like loop; with the black line across the top of the himation curling round the neck in a very characteristic manner (nos. 90, 93), but generally running straight down the chest;

(b) with pose corresponding to that of the type (i) (c) above, but with head facing l. instead of r. (as on the central youth on no. 94; cf. with Pl. 97, 6).

The meanders invariably start from the bottom and are usually accompanied by saltire squares at intervals of three. When they run right round the vase, there are two superposed fan-palmettes below the handles, with small scrolls on either side (nos. 94–97). *Halteres* regularly appear above the draped youths on the reverses and there is sometimes a hanging chaplet in the field (no. 90, reverse of 94), or a large square window, shown in perspective, with a black centre (nos. 95–6, reverse of 97).

The influence of the Tarporley Painter or the Painter of the Long Overfalls may perhaps be seen in the subject of no. 95 which shows a reclining actor served by a satyr and crowned by a woman holding a tympanon, with a female mask suspended above, and in the two phlyax vases (96–7), the first of which gives an amusing parody of the birth of Helen, the other a comic version of a scene from everyday life, with two men off to a barbecue, accompanied by a flute-girl. Both scenes are shown as taking place upon a simple stage, supported by posts, between which curtains have been hung; but for the reverses, which are very typical, it might have been difficult to identify the painter, although the swirling drapery of the flute-girl finds parallels on others of his vases (e.g. nos. 93–4). The column-krater no. 99 with the Oscan rider seems best placed here, since the reverse is very close to those of nos. 95–7.

Bell-kraters

* 90 Taranto 61059, from Gioia del Colle (T. 5; 1953). PLATE 46, 1–2.

(a) Dionysos with thrysus and torch, woman with phiale and wreath at altar, (b) two draped youths at pillar.

 91 Naples 2109 (inv. 82240).

(a) Standing woman with oenochoe and phiale, seated nude youth with branch, (b) two draped youths. Very close to Taranto 61059.

 92 Bari, Malaguzzi-Valeri coll. 53.

(a) Herakles with club and bow beside altar, Athena with crown and spear, (b) two draped youths, l. with strigil, r. with stick, at a pillar.

Bell-kraters (continued)

* 93 Sydney 46.03. PLATE 46, 3–4.

 APS, p. 43, no. 10 (where grouped with the Eton-Nika Painter).

 (a) Maenad with two torches followed by satyr with situla and thyrsus, (b) two draped youths.

 94 Trieste S 395.

 Simon, *JdI* 76, 1961, p. 171, fig. 37; *CVA*, IV D, pl. 5, 1 and 3–5; detail: Bérard, *Bull. de l'Ass. Pro Aventino*, 22, 1974, p. 9, pl. 2, 3.

 (a) Dionysos, silen carrying liknon on head, maenad with torch, (b) three draped youths.

 95 Vatican T 7 (inv. 17946).

 APS, p. 52, no. 9 (where attributed to the Painter of Copenhagen 335).

 (a) Dionysos reclining on a couch between satyr with oenochoe and situla and maenad with wreath and tambourine; female mask above, (b) three draped youths, r. with strigil.

 96 Bari 3899.

 PhV², p. 27, no. 18 (where bibliography). Photo: R.I. 62.1161.

 (a) Phlyax scene: Birth of Helen, (b) three draped youths.

 97 Leningrad inv. 2074 = W. 1122.

 PhV², p. 34, no. 34.

 (a) Phlyax scene: Off to the feast, (b) three draped youths.

Calyx-krater

 98 Madrid 32651 (P. 116).

 (a) Maenad with tympanum and narthex, satyr bringing a goat to sacrifice at an altar, Dionysos with narthex, (b) nude athlete with strigil between two draped youths.

 Cf. the maenad with the the the one on Trieste 395 (no. 94) and the draped youth to l. on the reverse with the corresponding one on Vatican T 7 (no. 95). Note the use of the narthex which occurs also in the Long Overfalls Group.

Column-krater

 99 Naples Stg. 29.

 (a) Oscan warrior on horseback woman with phiale, and woman holding a nestoris, with a dish of offerings on her head, (b) three draped youths.

 Cf. the reverse with that of Bari 21994 (no. 116).

Pelike

100 Nocera, Fienga coll. 556 (De F. 749).

 (a) Eros with wreath and phiale between nude youth and woman seated by cista, holding mirror, (b) two draped youths by altar.

(ii) COMPARATIVELY EARLY VASES

On the vases in this division the draped youths closely follow the canons established in (i); the "sling" however tends to be more horizontal (cf. nos. 101, 106, 119 with no. 90) and is less frequent, since the youth to left normally is of type (b) with the right shoulder bare and the arm extended (nos. 102–4, 107–110). The youth to right almost invariably has the typical "sleeve" drape for the bent left arm, with a curved line, shaped rather like a bracket, round the border of the "sleeve" (Fig. 2 l). At the bottom right corner of his himation, the wavy line tends to break up into what look like large U's or V's on their sides, as on nos. 106–7 (Fig. 2 l) and 119, which becomes a regular feature on the later vases. The draped youth with profile head and frontal body continues on nos. 111, 113, 116 and 118. The influence of the Iliupersis Painter is apparent on the figures on the pelikai nos. 125–6, especially in the women's drapery and the nude youths. The designs of the obverses of the bell-kraters are still very similar to those in (i), with running and static figures about equally divided. A different type of thyrsus

now puts in an appearance, with a long head, decorated with white dots, as on nos. 101, 103, 107 and 109. The painter still has a predilection for figures holding up some object in one hand, for example a tambourine (101, 102, 107), a box (103), a cista (113), or a dish with a key-pattern (109, 120). The neat woman wearing a stephane is almost a stock figure (nos. 107–111).

Bell-kraters

(a)

101 Zagreb 8.
 Damevski I, p. 94, no. 29, pl. 7, 4 and pl. 13, 3.
 (a) Satyr with thyrsus and kantharos running to l. and looking back at running maenad with tambourine, (b) two draped youths.
102 Hamburg 1917.1120.
 APS, p. 47, no. 5.
 (a) Maenad and satyr running to left, (b) two draped youths.
*103 Los Angeles 62.27.3. PLATE 46, 5–6.
 CVA, pl. 41, 3–4.
 (a) Woman with cista running to l., followed by nude youth with wreath and thyrsus, (b) two draped youths.
104 Berkeley 8/3815.
 CVA, pl. 56, 3.
 (a) Dionysos and maenad running to left, (b) two draped youths.
105 Mississippi, University — Robinson coll.
 Ex Trau coll., *Sale Cat.* 14 June 1954, no. 260, pl. 5; Robinson, *AJA* 60, 1956, p. 24, pl. 19, figs. 82–3.
 (a) Nude youth with wreath and phiale standing in front of seated woman holding out kantharos and resting l. hand on tambourine, (b) two draped youths.
106 Frankfurt X 2628.
 (a) Maenad with thyrsus and phiale, satyr with wreath and situla, beside an altar, (b) two draped youths.
*107 Matera 9690, from Montescaglioso. PLATE 47, 1–2.
 NSc 1947, p. 133, fig. 2.
 (a) Woman holding up tambourine, and seated Dionysos with phiale and thyrsus, (b) two draped youths.
108 Monopoli, Meo-Evoli coll. 951.
 (a) Standing woman with thyrsus and phiale, seated nude youth with strigil and branch, (b) two draped youths, with white head-bands.
109 Stockholm 16.
 (a) Maenad with cista, Dionysos holding thyrsus in r. hand and bending forward over r. leg, (b) two draped youths.
109a Bari, private coll.
 (a) Woman holding cista, bending forward over raised l. foot, satyr with kantharos and torch beside altar, (b) two draped youths.
 The obverse is very close to nos. 107–9; the reverse looks forward to the style of the Verona Painter.
110 Once Paris Market — Hôtel Drouot, *Sale Cat.,* 10 June 1973, no. 45 (ill.).
 (a) Woman bending over raised foot, with tambourine in l. hand, satyr with situla and thyrsus, (b) two draped youths.
111 Bari 6367.
 (a) Maenad with open cista, satyr with kantharos and situla, (b) two draped youths.

Bell-kraters (continued)

112 Naples 2145 (inv. 81427).
 (a) Eros seated between woman with wreath and cista and nude youth with bird, (b) three draped youths.

(b)

The four following vases form a compact group, all with very similar reverses.

113 Glasgow, private coll.
 APS Addenda, p. 429, no. 2 bis, pl. 119, figs. 18–19 (where attributed to the Valletta Painter).
 (a) Woman with thyrsus and cista, and young satyr with torch and situla, (b) two draped youths.
114 Berlin F 3298.
 (a) Young satyr with situla and sash, seated Dionysos with kantharos and thyrsus, (b) two draped youths.
115 Taranto 134232.
 (a) Nike with phiale, nude youth with raised foot, (b) two draped youths.
116 Bari 21994.
 (a) Dionysos with thyrsus, maenad with torch and tambourine, satyr with phiale and thyrsus, all moving to l., (b) three draped youths.

Column-krater

117 U.S. Market, Mr. Samia.
 (a) Oscan warrior with shield and spear, woman with kantharos and dish of cakes; in field above, pilos and bunch of grapes, (b) two draped youths beside an altar.

Pelikai

*118 Bari 6280. PLATE 47, 3–4.
 (a) Woman with wreath and mirror, and youth with wreath at stele, (b) two draped youths.
*119 Dresden 527. PLATE 47, 5–6.
 (a) Woman with wreath and phiale, nude youth with staff at stele, (b) two draped youths.
119a Once London Market, Sotheby, *Sale Cat.* 13 July 1976, no. 489, ill. on p. 195.
 (a) Draped woman with cista, nude youth holding up wreath in r. hand, and resting l. arm on pillar, (b) two draped youths.
 This vase is close to nos. 118 and 119.
120 Lecce 715.
 CVA 2, IV Dr, pl. 36, 4 and 6.
 (a) Woman with cista, and youth with fillet and branch, (b) two draped youths.
121 Naples Stg. 400.
 (a) Woman seated on rock with bird, nude youth with phiale, (b) two draped youths.
122 Agrigento R 183.
 (a) Draped woman with wreath, and nude youth with bird in r. hand and strigil in l., beside an altar, (b) two draped youths, r. bouncing ball by stele.
123 Trieste 2115 (Obl. 39).
 (a) Standing woman with mirror, nude youth seated on drapery, holding stick, (b) two draped youths.
124 Catania MB 4379 (L. 783).
 Libertini, *Cat.*, pl. 91.
 (a) Woman with raised foot, holding wreath and mirror, and youth seated on rock, (b) two draped youths.
 Close in style to Trieste 2115.
125 Ruvo 660.
 Photo: R.I. 64.1237.

(a) Youth with bird, and woman with wreath, (b) two draped youths.

*126 B.M. F 316. PLATE 48, 1.
 (a) Seated woman with mirror, nude youth with raised foot, holding wreath, (b) two draped youths.

Hydriai

127 New Haven, Yale University 1909, 10.
 Woman with cista running l., nude youth with wreath.
 Cf. with no. 113.
128 Cambridge, Corpus Christi College.
 Woman with cista, and nude youth with wreath beside laver.

Oenochoe (shape 3)

129 Deruta (Perugia), Magnini coll. 208.
 Dareggi, no. 2, pl. 10, 1.
 Woman running to l., followed by nude youth with stick.

Amphora

130 Leningrad inv. 504.
 (a) Woman with branch and cista, and woman with mirror, (b) two draped youths at stele.

(iii) DEVELOPED STYLE

On the vases of this division we may note the absence of the "sleeve" drape, which was so characteristic of the youths facing left on the reverses of the vases in divisions (i) and (ii). Instead we regularly find that the youth to right is draped in a himation covering his left shoulder, but leaving the right one bare, with the corresponding arm extended, often to grasp a stick. The left arm is bent slightly at the elbow, with a series of radiating fold-lines across the himation; in the bottom corner of the himation are the sideways U's, of which we saw the beginnings in the previous division (nos. 131–8). We may also note that the black line of the top of the himation, which used to curl around the neck (as on nos. 90 and 93–4) has now completely disappeared. It is interesting to compare the subject of no. 132 with that of the bell-krater in New York by the Tarporley Painter (no. 3/2); the resemblance between the two black figure bell-kraters is striking and must represent the continuation of a tradition established by the older master and followed by many of his successors.

(a)

Bell-kraters

131 Dijon 1199.
 APS, p. 51, no. 1, pl. 30, figs. 139–40.
 (a) Satyr with tambourine, and maenad with thyrsus and wreath, moving to l., (b) two draped youths.
132 Copenhagen 78 (B–S. 215), from Bari.
 CVA 6, pl. 234, 1; *APS*, p. 51, no. 2.
 (a) Maenad and satyr beside altar on which is a bell-krater, (b) two draped youths.
*133 Matera 12475, from Ferrandina. PLATE 48, 2–3.
 NSc 1935, pp. 384–5, figs. 1–2.
 (a) Maenad and satyr, (b) two draped youths, l. with strigil.
134 Deruta (Perugia), Magnini coll. 5.
 Dareggi, no. 6, pl. 7.
 (a) Satyr with torch and woman with situla moving to r., (b) two draped youths.
135 Nocera, Fienga coll. 543 (De F. 579).
 (a) Woman with phiale and torch, followed by satyr with situla and thyrsus, both running to l.,

Bell-kraters (continued)

 (b) two draped youths.
 136 Zagreb 18.
 Damevski I, p. 88, no. 14, pl. 12, 2.
 (a) Eros with wreath and phiale, draped woman with bunch of grapes and mirror, (b) two draped youths.
 137 Leningrad inv. 543 = St. 1090.
 (a) Youth with stick and phiale, and woman with fillet leaning on pillar, (b) two draped youths.
 138 Moscow, Historical Museum.
 (a) Young satyr with thyrsus and situla, woman with wreath and phiale standing beside altar on which a fire is burning, (b) two draped youths.
*139 Naples Stg. 339. PLATE 48, 4—5.
 (a) Satyr with thyrsus and torch followed by maenad with phiale and tambourine, (b) two draped youths by altar, r. with strigil.
 Cf. the reverse with that of Matera 12475 (no. 133), and the plant on the obverse with that on Adolphseck 180 (no. 154).
 140 Taranto, from Oria (6.6.73), Tomb 7.
 (a) Satyr playing the flute, Dionysos with thyrsus and phiale, maenad with wreath and tambourine, (b) three draped youths.
 For the maenad cf. Naples Stg. 339 (no. 139).
 141 Paris, Institut d'Art et d' Archéologie (ex Louvre N 2986 = ED 113).
 (a) Maenad with thyrsus and kantharos, seated youth with phiale and thyrsus at bloodstained altar, (b) two draped youths at altar.
 Cf. the reverse with that of Naples Stg. 339 (no. 139).
 142 Milan, "H.A." coll.
 (a) Nude youth with situla and phiale, satyr with situla and thyrsus, (b) two draped youths.
 143 Naples 2020 (inv. 81448).
 (a) Running woman with thyrsus and phiale, satyr with situla and thyrsus, (b) two draped youths.

Pelike

 144 Vatican Z 2 (inv. 18041).
 VIE, pl. 27 d and h.
 (a) Seated woman with tambourine, and Eros with wreath, (b) two draped youths.

Oenochoe (shape 3)

 145 Milan 252.
 CVA 1, IV D, pl. 15, 1.
 Satyr with wreath running to l., followed by draped woman holding up tambourine.

(b)

The four vases in this sub-division are all characterised by the appearance of white head-bands on the youth on their reverses; otherwise they are very similar to those in (a). It is interesting at this period (c.370—60) to note the appearance of an actual red-figure nestoris (no. 148; cf. with nos. 5/84 and 88 above).

Column-kraters

 146 Trieste S 388.
 CVA, IV D, pl. 7, 3—4.
 (a) Bearded Oscan holding two spears, seated woman with nestoris on her head, Oscan warrior holding kantharos, (b) three draped youths.

147 Naples 1981 (inv. 82339).

 (a) Woman with basket on her head, woman holding situla in l. hand and pouring libation from oenochoe in her r. hand into phiale held by seated Oscan warrior with two spears and shield, Oscan warrior holding pilos in r. hand and two spears and shield in l., (b) four draped youths.

Nestoris (type 2)

148 Naples 2321 (inv. 81827).

 (a) Woman with phiale, seated youth, (b) two draped youths.

Pelike

149 Once Gravina.

 (a) ?, (b) draped youth, and woman with mirror, at altar.

 The youth on the reverse is very close to those on Naples 1981 (no. 147).

(iv) THE LATEST PHASE

The vases in this division represent the culmination of the Dijon Painter's work and show it drawing closer to that of the Iliupersis Painter. This is visible in the drawing of the saltire squares (e.g. on no. 158), which resemble his, but even more in the compositions, (nos. 154—5) which now favour three figures, and in the reverses (cf. with those of Louvre K 3 and B.M. F 66, nos. 8/17—18). The reverse draped youths follow the types already established, with a few minor variations; for example, the youth to left sometimes has his himation closely wrapped around him, with his left fist slightly extended to produce a small "bulge" (nos. 155, 159). We may also note on the reverses of the column-kraters a particular fondness for the "sleeve" drape, with a sweeping curve around the bent arm, and a bracket-like line on the border of the "sleeve" (nos. 162—4, 167—9), obviously a continuation of the type so popular in division (ii) above. The "sling" drape of the youth to left tends to descend a little (no. 162), and it is interesting to compare this type with the upward type on nos. 90—91 and 94, and the more horizontal one on nos. 101 and 106.

Oscan warriors regularly appear on the column-kraters and we should note the woman on Altenburg 343 (no. 163) with a panier of cakes on her head and a black-figure nestoris in her hand (cf. no. 99). Paniers of cakes (either the round flat *plakountes* or the *pyramides*) seem to be a common offering to Oscans (nos. 164—5, 168, 170). We note again the deep-set windows (nos. 154, 159, 160, 161, 173—4) and also the use of mesomphalic phialai as adjuncts on the reverses (nos. 150, 164, 167—8, 171), in addition to the standard *halteres* and balls.

Bell-kraters

150 Zagreb 23.

 APS, p. 51, no. 3, pl. 30, figs. 141—2; Damevski I, p. 87, no. 10, pl. 8, 3 and pl. 13, 1.

 (a) Woman resting left arm on pillar between two nude youths, (b) three draped youths.

151 Kyoto, H.K. coll. 96/91.

 Mizuta I, no. 2, pls. 2—4.

 (a) Woman with tambourine, seated Dionysos, satyr with situla, (b) three draped youths.

152 Altenburg 342.

 CVA, pl. 101, 2—3 and 5.

 (a) Woman with wreath and thyrsus, seated Eros with mirror and woman with fan, (b) three draped youths.

153 Catania MC 4324.

 (a) Seated woman with thyrsus and tambourine, Dionysos with thyrsus, and wreath; between them, a fawn, (b) two draped youths.

 Cf. with Nocera 555, no. 173.

Bell-kraters (continued)

154 Adolphseck 180.
 CVA 2, pls. 81, 1 and 80, 3.
 (a) Young satyr between seated maenad and Dionysos, (b) three draped youths.
*155 Naples 2065 (inv. 81664). PLATE 49, 1–2.
 (a) Maenad, satyr and Dionysos, (b) three draped youths.
156 Matera. Broken and repaired.
 (a) Satyr with thyrsus and phiale, seated Dionysos with kantharos and thyrsus, (b) two draped
 youths, with altar to l.
157 Once Paris Market (C. Platt).
 (a) Maenad with tambourine, and satyr with situla and thyrsus, moving to r., (b) two draped youths.

Fragment of bell-krater

158 Once Rome, Dr. Hermine Speier.
 APS, p. 51, no. (i), pl. 30, fig. 143. Photo: R.I. 31.630.
 Upper part of woman and face of bearded silen.

Column-kraters

*159 Gardiner (Maine), Mr. Robert H. Gardiner. PLATE 49, 3–4.
 (a) Woman with phiale of offerings, youth with spear seated on altar, woman with cista, (b) three
 draped youths.
 Cf. the youth to l. on the reverse with his counterpart on Naples 2065 (no. 155).
160 Vatican V 40 (inv. 18073).
 VIE, pl. 32 d and pl. 33 d; *APS*, p. 52, no. (i).
 (a) Woman offering libation to seated warrior, standing youth to r. wearing pilos, (b) three draped
 youths.
*161 Berlin F 3289. The foot and the handles are modern. (b) PLATE 48, 6.
 Lessing, *Voyages of Ulysses,* colour-pl. 11 (detail).
 (a) Telemachus and Nestor (inscribed), with draped woman holding dish of cakes, (b) three draped
 youths.
 The inscriptions seem to be a modern addition (especially the improbable ΚΑΛΟΣ), made at the
 time of the vase's incorrect restoration.
162 Vienna 851.
 APS, p. 52, no. 7 (where attributed to the Painter of Copenhagen 335).
 (a) Oscan warrior pouring libation between two women, (b) three draped youths.
163 Altenburg 343.
 APS, p. 52, no. 8; *CVA* 3, pls. 108, 4; 109; 110, 5; detail: *Gli Indigeni,* fig. 15.
 (a) Woman with basket on her head, holding oenochoe and nestoris, Oscan warrior on horseback
 (b) three draped youths.
164 Parma C 106.
 CVA 2, IV D, pl. 1.
 (a) Oscan warrior with two spears, between woman with oenochoe and dish of offerings and woman
 with cista, (b) three draped youths.
165 Ruvo 620.
 Sichtermann, K 58, pls. 93–4; *Gli Indigeni,* fig. 22. Photos: R.I. 64.1212–3.
 (a) Woman with situla, youth in Oscan costume with kantharos in r. hand and shield and two spears
 in l., woman with dish of offerings, (b) three draped youths.
166 Ruvo 700.
 Sichtermann, K 61, pl. 100. Photo: R.I. 64.1207.
 (a) Woman pouring libation to warrior, woman with cista to r., (b) three draped youths.
 For the warrior cf. Naples 2417 (no. 8/28), by the Iliupersis Painter.

Column-kraters (continued)

*167 Ruvo 981. PLATE 49, 5—6.
 (a) Woman with cista between two Oscan warriors, (b) three draped youths.
 168 Copenhagen 31 (B—S. 212).
 CVA 6, pl. 251, 2; *APS*, p. 54, no. 2.
 (a) Seated Oscan warrior, woman with dish of offerings and bunch of grapes, woman with fan,
 (b) three draped youths.
 169 Copenhagen, Ny Carlsberg 2666.
 Poulsen, *Vases grecs*, no. 24, figs. 46—7.
 (a) Youth with phiale and thyrsus seated between woman with wreath and woman with tympanon,
 (b) three draped youths.
 170 Taranto 9872.
 (a) Woman with wreath and dish of cake, woman with bunch of grapes and cista, Oscan youth with
 sash, shield and two spears, (b) three draped youths.
 171 Göttingen J 47.
 Jacobsthal, *Gött. V.* pl. 17, fig. 50.
 (a) Boar hunt with three youths, (b) four draped youths.

Pelikai

 172 Naples 2117 (inv. 81770).
 (a) Three women at a laver, (b) three draped youths.
 The reverse is very close to that of Adolphseck 180 (no. 154).
 173 Nocera, Fienga coll. 555 (De F. 688).
 (a) Woman with mirror, seated Eros with cista, woman with cista, (b) three draped youths.
*174 Venice (Calif.), High School. PLATE 50, 1—2.
 (a) Nude youth with wreath and strigil, seated woman with mirror, standing woman with fan,
 (b) three draped youths.

Hydria

 175 Ruvo 584.
 Woman with wreath, woman with sash and cista, Eros seated on rock.
 Cf. also with the work of the Iliupersis Painter.

Oenochoe (shape 3)

175a Policoro 41465, from S. Chirico Raparo.
 Woman with tambourine, seated Dionysos with kantharos and thyrsus, satyr with raised foot.

5. CLOSE ASSOCIATES OF THE DIJON PAINTER

A number of vases, some attributable to individual artists, may be grouped around the Dijon
Painter since they are very close in style to his own work. They should be distinguished from
the vases painted by his followers, which are discussed in Chapter 9.

(i) THE PAINTER OF VIENNA 549

The following two bell-kraters may be attributed with certainty to one hand. That they are
closely connected is clear from the almost identical appearance of the draped youths to right on
their reverses. The treatment of their head and hair recalls that of corresponding figures on the
earlier vases by the Dijon Painter (nos. 90—93) and the pose of the left youth on no. 176 recalls
that of the corresponding youths on nos. 155 and 159, on which we may note the same hand-
bulge beneath the himation. The obverse of the Zagreb krater (no. 177) is ill-preserved, but the
standing woman should be compared with those on nos. 90 and 107—9 by the Dijon Painter.

Bell-kraters

*176 Vienna 549. PLATE 50, 3–4.
 (a) Nude youth standing in front of seated woman holding phiale in r. hand and parasol in l., (b) two draped youths.

177 Zagreb 307.
 Damevski I, p. 88, no. 13, pls. 11, 3 and 16, 2.
 (a) Nude youth with thyrsus and draped woman standing by altar, (b) two draped youths.

With the two above vases compare the following for the treatment of the draped youths upon its reverse and for the nude youth on the obverse, who resembles the one on no. 176.

Bell-krater

178 Naples 2131 (inv. 81369).
 (a) Draped woman with thyrsus and situla, nude youth with staff, (b) two draped youths, l. with stick and r. with strigil.

(ii) THE PAINTER OF ALTAMURA 3

The three bell-kraters which may be attributed to this painter are exceedingly close in style to the Dijon Painter (especially no. 180), but differ slightly in the treatment of the overhang of the draped youths to left on their reverses.

The pattern-work on nos. 179–80 is very similar, and it should be noted that the meanders are stopped, that they begin at the top and that for the most part they do not meet at the centre.

Bell-kraters

*179 Altamura 3. PLATE 50, 5–6.
 (a) Satyr with thyrsus and cista followed by draped woman with wreath and tambourine, (b) two draped youths.

180 B.M. old cat. 1311.
 (a) Maenad with thyrsus and phiale, followed by Dionysos with thyrsus, (b) two draped youths.
 Very close to the preceding vase.

181 Potenza, Mus. Prov., from Banzi.
 (a) Woman with thyrsus and dish of cake, nude youth with torch and thyrsus, (b) two draped youths, with white head-bands.

With the above vases compare the following, which is also very close in style to the Dijon Painter himself.

Pelike

182 Potenza, Soprintendenza (sequestro).
 (a) Youth leaning on stick and seated woman with phiale, (b) two draped youths.
 For the plant with diamond-shaped florals between the two figures on the obverse cf. Naples Stg. 339 (no. 139) and Adolphseck 180 (no. 154).

(iii) THE GROUP OF RUVO 892

The vases in this group, which may well be by one hand, continue on directly from those in division (ii) and are also very closely comparable with the work of the Dijon Painter.

(a)

On the column-kraters in this sub-division (nos. 183–6) we should note the wide spacing of the ivy leaves and berries on the neck (three or at most four in the panel) as against the five or six more commonly found on the vases of the Dijon Painter himself. In this regard the vases

of this sub-division are comparable with some by the Painter of Athens 1714, especially those grouped around Copenhagen 335 (cf. nos. 8/220–1 and 223–5), on which we may also note the presence of wavy lines across the top of the himatia of the reverse youths, as on no. 183.

The column-kraters all figure youths in Oscan dress (cf. nos. 162–5, 167–8 by the Dijon Painter), usually with a standing draped woman (nos. 183–5) holding a situla or oenochoe (cf. nos. 160, 165–6). We should also note the treatment of the overhang on the draped youth to left on the reverse of no. 184, on which the wavy border joins the line making the outer edge (cf. no. 179) in contrast to the normal practice of the Dijon Painter. A recurring feature is the youth facing to left with a "sleeve" drape in which the edge of the "sleeve" is marked by an inclined bracket-shaped line at an angle as on no. 183 (cf. nos. 103 and 107 by the Dijon Painter on which, however, the bracket-shaped line is horizontal). Such vases lead up to those in the Montpellier Group (see Chapter 9), and to works by other followers of the Dijon Painter, who use the same device. The meanders start at the top and are normally stopped, as on the vases in the previous divisions; they are usually unaccompanied by crossed squares. The meander on no. 184, however, has a crossed square of special type.

Column-kraters

*183 Bonn 98. (b) PLATE 51, 1.
 APS, p. 50, no. 2, pl. 29, fig. 137 (where assigned to the Painter of Bologna 571, now incorporated into the Painter of Athens 1714); *Gli Indigeni*, fig. 33.
 (a) Woman with situla and phiale standing beside couch, on which reclines a banqueter, holding a kantharos; to r., Oscan youth with lyre, (b) three draped youths.
*184 Ruvo 892. (b) PLATE 51, 2.
 Sichtermann, K 63, pl. 102; *Gli Indigeni*, fig. 20. Photo: R.I. 64.1292.
 (a) Long-haired youth in Oscan dress with wreath and dish of offerings, woman offering libation to seated Oscan warrior wearing conical hat, (b) three draped youths.
 185 Trieste 7586.
 (a) Woman with fillet, and two Oscan warriors, one with phiale and two spears, the other with spear and shield, (b) three draped youths.
 186 San Simeon 5553 (SSW 10029).
 (a) Woman with wreath and cista seated between two Oscan warriors, each holding two spears, (b) three draped youths.

With the above vases, especially no. 183, compare the following:

Column-krater

 187 Once Rome Market.
 (a) Satyr with situla and torch, seated maenad with tambourine and thyrsus, Dionysos with kantharos and thyrsus, (b) three draped youths.

(b)

The treatment of the draped women on the obverses, and of the youths on the reverses of the vases in this sub-division suggests that they are the work of a single artist who should be viewed in the present context. Nos. 188 and 189 are not in a good state of preservation.

Bell-kraters

 188 Plymouth 157.16.
 (a) Draped woman with wreath and cista, seated nude youth with stick, (b) two draped youths.
188a Vatican T 8 (inv. 17947).
 APS, p. 22, no. (i).
 (a) Seated Dionysos with thyrsus and drinking-horn, maenad with phiale and thyrsus, young satyr

Bell-kraters (continued)

bending forward over raised foot and holding situla and kantharos, (b) two draped youths, with palmette between them.

Cf. also with the work of the Eumenides Painter.

Pelikai

189 Portland 26.314.
 APS Addenda, p. 428, no. 8.
 (a) Youth and woman, (b) two draped youths.
190 Turin, private (R.S.) coll.
 Acme 24, 1971, pp. 197–201, pl. 3, figs. 5–6.
 (a) Youth bending forward over raised foot to offer wreath to standing woman with phiale, (b) two draped youths, l. with strigil, r. with stick.

(c)

The following vase, with an unusually interesting subject, seems to be connected in style with the above.

Bell-krater

191 Bari 3719.
 Schauenburg, *Mon. Chiloniense (Festschrift Burck),* pl. 7, fig. 14.
 (a) Woman with drawn sword pursuing fleeing youth (Agave and Pentheus ?), (b) two draped youths.

(iv) THE RODIN PAINTER

The Rodin Painter is very close both to the vases of division (iii) sub-division (a) and to the Dijon Painter. His meanders, however, are continuous and generally accompanied by saltire squares with strokes in the middle of each side.

The close resemblance between the reverses of the Rodin and New York kraters (nos. 192–3) is obvious; an unusual element on the former is the part of an animal held by the youth to left. The youth to right invariably has a long "sleeve" drape with the typical "bracket" border to the "sleeve", and a single line ending in a double curl as the lower border. The standing draped female figure to left on nos. 193–5 should be compared with the one on Bonn 98 (no. 183), but her face is a shade more angular. The side-scrolls framing the pictures on the bell-kraters are like those on nos. 179–180, but here the separate leaf points downwards more definitely.

Column-kraters

192 Paris, Rodin 970.
 CVA, pl. 36, 1–2; *APS,* p. 54, no. 1.
 (a) Woman between two youths in Oscan costume, (b) three draped youths.
193 New York 06.1021.216.
 Hôtel Drouot, *Sale Cat.* 11–14 May 1903, pl. 53, no. 149; Sambon, *Coll. Canessa* (1904), pl. 9, no. 126.
 (a) Woman with wreath and phiale, seated Oscan warrior with spear and shield, standing Oscan holding conical hat and spear, (b) three draped youths.
 Cf. also with Ruvo 700 (no. 166).

Bell-kraters

*194 Milan, "H.A." coll. 375. PLATE 51, 3–4.
 (a) Maenad with egg and thyrsus, satyr with drinking-horn and situla, (b) two draped youths.
195 Once Milan Market, Casa Geri, *Sale Cat.,* 1–3 March 1967, no. 1279.

(a) Maenad with thyrsus and tambourine, seated nude Dionysos with thyrsus, (b) two draped youths, by stele.

196 B.M. F 60.

(a) Standing woman (head missing), with tambourine, and Eros seated on rock, (b) two draped youths.

Cf. the reverse with that of no. 187.

(v) VASES COMPARABLE WITH THOSE BY THE DIJON PAINTER

(a) THE PAINTER OF BARI 1523

The two following vases have very similar reverses and seem to be related to the Dijon Painter, as well as the Painter of Karlsruhe B 9.

Bell-kraters

*197 Bari 1523. PLATE 51, 5–6.

APS, p. 42, no. 4.

(a) Woman with phiale, and nude youth seated on rock, (b) two draped youths.

198 Milan 226.

CVA, IV D, pl. 2.

(a) Nude youth with wreath and phiale standing before seated woman with mirror, (b) two draped youths.

(b)

Calyx-krater

199 Bari 2795, from Valenzano.

PhV², p. 49, no. 74, pl. 6a; *Puglia*, p. 167, fig. 156.

(a) Phlyax scene : Master and servant, (b) two draped youths.

Compare the treatment of the draped youth to r. on the reverse with the corresponding youth of Stockholm 16 or Bari 6367 (no. 111) and the phlyakes with those on no. 97.

(c) MINOR VASES

The following minor vases, mostly bell-kraters, seem to be connected with the Dijon Painter, especially in the treatment of running women and nude youths.

Bell-kraters

200 Karlsruhe B 129.

CVA, pl. 80, 5–6.

(a) Woman with ball and tambourine, (b) nude youth with wreath and phiale.

For the pattern cf. Minnesota 73.10.5 (3/109 above).

201 Madrid, Palacio de Liria 12 (CE. 54).

Zephyrus 15, 1964, p. 75, no. 12, pl. 14; *APS*, p. 73, no. lvi a.

(a) Running woman with phiale, (b) nude youth.

202 Paris, Cab. Méd. 933.

(a) Nude youth with thyrsus running to r., (b) woman with cista and torch running to r.

203 Brindisi 5718.

Benita Sciarra, *Musei d'Italia* 9 – Brindisi, *Mus. Arch. Prov.* p. 60, figs. 508–9.

(a) Running woman with outspread arms, (b) running youth with drapery over l. arm.

Hydria

204 Louvre CA 3190.

Woman running to l. with cista and oenochoe, nude youth with bird on r. hand and drapery over l. arm.

Pelike

205 Delft, Rust coll.
 (a) Woman with wreath and sash moving to r. and looking back l., (b) youth.

6. THE GRAZ PAINTER AND CONNECTED VASES

In *APS* (p. 49) the Graz Painter was noted as a collaborator of the Painter of Athens 1714. There is a considerable similarity of style between the two painters, but the obverse of such a vase as Philadelphia L 64.231 (no. 207) suggests an even closer affinity with the Dijon Painter (cf. with nos. 101–3, 113, 133), especially in the treatment of the running woman.

(i) THE GRAZ PAINTER

The most noteworthy novelty in the work of the Graz Painter is his preference for nude instead of draped youths on his reverses. The reverses of nos. 206–211 all depict a nude youth with a piece of drapery over his extended left arm, running to left and looking back to right at another nude youth, who holds out a strigil in his right hand. The pictures on the reverses of nos. 212 and 213 follow the same pattern but the first youth on no. 212 holds a wine-skin in his left hand instead of a piece of drapery and the second youth on no. 213 holds a stick instead of a strigil. All reverse youths have spindly legs, and flat or carelessly drawn feet.

(a) EARLIER WORK

Bell-kraters

206 Graz, Landesmuseum 4611.
 APS, p. 49, no. 1, pl. 28, figs. 129–30.
 (a) Seated woman with thyrsus and phiale, youth with wreath and thyrsus, (b) two nude youths running to left.
207 Philadelphia L 64.231.
 APS, p. 49, no. 2, pl. 28, figs. 131–2.
 (a) Satyr with torch, maenad with tambourine, and youth with wreath all moving to l., (b) two nude youths running to l.
208 Taranto 6989 (old. no. 4742), from Ferrandina.
 NSc 1935, pp. 387–8, figs. 4–5; *APS*, p. 49, no. 3.
 (a) Youth with torch and situla, woman with tambourine, approaching altar, (b) two nude youths running to l.
209 Cremona 596.
 Pontiroli, *Cat.*, no. 53, pl. 43.
 (a) Maenad with tambourine between young satyr with wine-skin and seated Dionysos, (b) two nude youths, l. with stick, r. with strigil.
210 Bologna 427.
 CVA 3, IV Er, pl. 3, 3–4.
 (a) Maenad seated in altar between youth and satyr, (b) two nude youths running to l.
211 Naples 1820 (inv. 81426).
 (a) Dionysos with thyrsus seated between woman and satyr with wine-skin and thyrsus, (b) two nude youths.
*212 Bari 6325. PLATE 52, 1–2.
 La Collezione Polese, pl. 19, no. 60.
 (a) Maenad with thyrsus offering wreath to Dionysos reclining on a couch and holding skyphos and thyrsus, (b) two nude youths, l. with wine-skin, r. with strigil, running to l.

213 Liverpool 50.60.64.
 (a) Woman catching ball in r. hand and holding open cista in l. running to l., satyr with phiale run-
 ing r. toward altar but looking back l., (b) two nude youths, l. with drapery over l. arm, r. with stick.

Squat lekythos

214 Edinburgh 1881.44.17.
 Woman running to stele, holding tambourine in l. hand.
 Very close to the Dijon Painter.

(b) LATER VASES

The two following vases seem to represent a slightly later phase of the painter's work and
are linked together by the presence on each of an inscribed pillar and the unusual meander and
crossed square pattern on the obverse of no. 215 and the reverse of no. 216. The nude youths
on both reverses are very much in the painter's manner.

Bell-kraters

*215 B.M. F 62. PLATE 52, 3.
 (a) Woman seated on rock holding phiale, nude youth resting l. arm on pillar inscribed TEPMΩN,
 (b) two nude youths.
 For a discussion of τέρματα on Greek vases see H.M. Lee, *JHS* 96, 1976, pp. 70–79.
 216 Cleveland 24.534.
 Schneider-Herrmann, *BABesch* 45, 1970, p. 90, fig. 5; *CVA*, pl. 43; Hiller, *AntK* 19, 1976, p. 33,
 pl. 7, 4; Smith, *FS*, pl. 19. Photo: R.I. 32.1491.
 (a) Aphrodite seated on cista by pillar inscribed AΦPOΔITH, Eros holding fillet, (b) two nude
 youths, one moving to l., the other to r.

(c)

The following vase is linked to no. 215 by the presence on the reverse of a tall pillar in-
scribed TEPMΩN. It is stylistically connected with the rest of the artist's work by the treat-
ment of the nude male figures on the obverse. Its reverse, however, depicts two draped (instead
of the more typical nude) youths, who show the influence of the Dijon Painter in their stance
and draping, (cf. nos. 93, 95, 113 above), and should also be compared with those by the Bendis
Painter in the Long Overfalls Group (nos. 4/168 ff.).

Bell-krater

*217 Naples Stg. 657. (b) PLATE 52, 4.
 Campo, *Drammi satireschi*, p. 210, pl. 11, fig. 31.
 (a) Hermes with caduceus following Herakles, who holds club in r. hand and supports a table of cakes
 on his l. shoulder, (b) two draped youths with a large pillar, inscribed TEPMΩN, between them.

(ii) VASES CONNECTED WITH THE GRAZ PAINTER

The two following vases are connected in style with the work of the Graz Painter, especially
in the treatment of their reverses.

Bell-kraters

218 Leipzig T 83.
 APS, p. 59, no. (ii); Cook, *Zeus* iii, pl. 62; Brommer, *Die Wahl des Augenblicks*. pl. 39.
 (a) Athena reflecting the gorgoneion in a well for Perseus, between Hermes to l. and a satyr to r.,
 who turns his head away, (b) three nude youths running to l.
*219 Naples 2409 (inv. 81510). PLATE 52, 5–6.
 (a) Amazonomachy: Amazon shooting arrow from bow, dead Amazon on back of horse, Greek
 warrior with shield, (b) three nude youths.

The following vases are connected by the key-pattern to Graz 4611 (no. 206).

Oenochoe (shape 3)

220 Leningrad inv. 346 = St. 1246; W. 1067.
 Young satyr with banded situla, bending forward over raised l. foot.

Bell-krater

221 Dresden 377.
 Schauenburg, *JdI* 89, 1974, p. 182, fig. 47.
 (a) Artemis Bendis and nude youth with spear, (b) two draped youths, l. with strigil.

III THE DEVELOPMENT OF THE ORNATE STYLE

CHAPTER 7

EARLY ORNATE VASES

1. The Sarpedon Painter
2. The Black Fury Group
3. The Painter of the Moscow Pelike and associated vases
4. The Painter of Ruvo 1364
5. The Felton Painter
6. Followers of the Felton Painter

Introduction

This chapter deals with those vases of the "Ornate" style which lie between the Painter of the Birth of Dionysos (Chapter 2) and the Iliupersis Painter (Chapter 8). The earlier vases are briefly discussed in *FI*, pp. 27–8 and *ESI*, pp. 20–21, and it will be noted that they have come down to us mostly in very fragmentary form. They must have been made at Taranto and, as yet, exported only in comparatively limited quantities. The ancient necropolis of Taranto lies buried beneath the modern city and proper excavation is a virtual impossibility. From time to time rebuilding operations bring to light tombs containing badly-damaged vases (e.g. no. 28), and sporadic excavations have yielded a harvest of fragments, which were often acquired by passing collectors and are now widely dispersed. The Museum at Taranto houses numerous such fragments, but, with the exception of those of exceptional quality, they are often inaccessible, and the time has not yet come when it is possible to make a full and detailed study of the early stages of the "Ornate" style. From the beginning of the second quarter of the fourth century onwards the picture becomes somewhat more clear, as many of the larger vases are found at other sites (e.g. Ceglie, Gioia del Colle, Altamura, Ruvo, Canosa, etc.) in a much better state of preservation, though even then many suffered greatly at the hands of nineteenth century restorers and are in some cases too repainted to be of great value for stylistic study.

1. THE SARPEDON PAINTER

Bibliography

A. Stenico, *EAA* vii, pp. 55–6.

The Sarpedon Painter (see *FI*, pp. 27–8 and 41; *ESI*, pp. 20–21 and 53) is an admirable draughtsman who specialises in unusual mythological subjects, which are elaborately treated with a wealth of decorative detail. He takes his name from the New York krater (no. 1) with the return of Sarpedon, which is unfortunately in a bad state of preservation. As characteristic of his work we may note the elaborately patterned and embroidered drapery, with berried laurel pattern on the sleeves (nos. 2, 3, 5) and embattled borders (nos. 1, 5), the use of relief-lines for the hair, the drawing of the head in three-quarter view and the presence of elaborate furnishings (e.g. nos. 1, 3).

In style he is clearly influenced by the pioneers like the Sisyphus Painter (cf. the drapery on nos. 3–4 with the long overfalls) and the Painter of the Birth of Dionysos, but he is an artist of considerable originality both in his choice of subjects and in his treatment of them, and it is interesting to compare his handling of both the Sarpedon and Pelops-Hippodamia themes with that of his Early Lucanian contemporary the Policoro Painter (Policoro 35294

and 35000; *LCS*, p. 57, nos. 285 and 284; Degrassi, *BdA* 1965, nos. 1–2, figs. 1–2, 5, 7 = *RM Erghft*, 11, 1967, pp. 197–204, pls. 50;58, 1;59, 1). The fact that two different painters should choose identical, and uncommon, subjects for their vases at the same time suggests an external source of inspiration, which might well have been dramatic performances.

His meanders are not continuous and are sometimes divided by uprights (nos. 1, 3); he is very fond of egg pattern with dots between, sometimes with touches of white (nos. 1–2). Note also the use of white and yellow and of shading, especially on the vases in (ii), where added white is also used for the visible flesh of women.

(i)

The two vases in this division go very closely together in the treatment of faces and drapery.

Bell-krater

* 1 New York 16.140. (b) PLATE 53, 1.
 BMMA 1916, p. 257, figs. 6–7; Messerschmidt, *RM* 47, 1932, p. 138, figs. 5–7; Richter, *Metr. Mus.Hdbk.*[7], p. 116, pl. 96c; *FI*, no. B 88 = *ESI*, no. B 159; Bieber, *Hist.*[2], p. 77, fig. 283; Pickard-Cambridge, *Theatre*, p. 100, figs. 30–31; *Ill.Gk.Dr.* III.1, 17; Melchinger, *Das Theater der Tragödie*, fig. 26.
 (a) Sleep and Death bringing back the body of Sarpedon to Europa, (b) Europa discusses with Zeus and Hera the fate of Sarpedon in the presence of Hypnos and Pasithea.
 For the interpretation of (b) see Picard, *CRAI* 1953, pp. 103–130.

Hydria

2 Taranto 4604, from the Arsenal.
 Degrassi, *BdA* 50, 1965, fig. 52; *FI*, no. B 89 = *ESI*, no. B 160.
 Pelops and Hippodamia.
 Connected by the drapery of Pelops with the Taranto krater, and with the New York krater by the decoration of Hippodamia's drapery (dotted rosettes), and by the profile of Hippodamia and Aphrodite. For the subject, see Lacroix, *BCH* 100, 1976, pp. 337 ff.

(ii)

The two vases in this division show an almost identical treatment of the drapery.

Bell-krater

3 Taranto 4605, from the Arsenal.
 RA 1936 ii, p. 157, fig. 5; *FI*, no. B 86, pl. 30a = *ESI*, no. B 161; Wuilleumier, *Tarente*, pl. 47, 4; Reuterswärd, *Polychromie*, p. 124, fig. 19; Paribeni, *Immagini*, pl. 17 (colour), no. 15; *LAF*, no. 104 (ill.). Photos: R.I. 72.36–7.
 (a) Meeting of Electra and Orestes at the tomb of Agamemnon, (b) draped woman to r.; rest missing, except for part of the hand of the woman to l.

Hydriai (frr.)

4 Sydney 51.39 + Leiden, Univ. Arch. Inst. 35 (CWLS 252).
 BABesch 13, 1938, p. 17, fig. 3; van de Wiel, *Verzameling Ceramiek en Terracottas*, p. 24, no. 35, pl. 2; *BABesch* 46, 1971, pp. 134 ff., figs. 1–2; *ESI*, no. B 162.
 The Danaids.
 These two fragments, both from Taranto, although they do not join, are certainly from the same vase and enable us to identify the women with hydriai (one with a carrying-pad on her head) as Danaids, in which case the wing is probably that of a Fury.
 For the Danaids, see Eva Keuls, *The Water Carriers in Hades* (1974), where reference is made to these fragments on p. 172.

(iii)

Bell-krater (frr.)

5 Heidelberg 26.87 (frr.).
 FI, no. B 85, pl. 29 = *ESI*, no. B 163; Rumpf, *MZ*, pl. 42. 5; *Die Welt der Griechen*, fig. 27; *CVA*,
 pl. 73; *LAF*, no. 8 (ill.); Borda, p. 42, fig. 31; Robertson, *History of Greek Art*, pl. 134a.
 (a) Embassy to Achilles, (b) missing.
 Note the laurel pattern on the sleeve, and the combination of the wave and embattled patterns.
 The drawing is particularly fine, especially of the faces and hands.

 With the above compare:

Fragment

* 6 Amsterdam 2493, from Taranto. PLATE 53, 2.
 Gods and Men in the A.P.M., pl. 31; *Gr. Etr. en Romeinse Kunst*, p. 48, fig. 45.
 Youth feeding horse from phiale.

2. THE BLACK FURY GROUP

(i) THE BLACK FURY PAINTER

The following fragments, which appear to be by a single hand, are related in style to the work
of the Sarpedon Painter but are of superior quality.

 Of particular importance and interest is the Boston fragment (no. 10) which for many
years was thought to represent a centauress. In the light of the Malibu oenochoe (no. 12,
Pl. 54, 6) the woman can now be identified with certainty as Callisto in the process of being
transformed into a bear. The story of Callisto has come down to us in several variant forms
(see, in particular, A.B. Cook, *Zeus* ii, pp. 228–9, notes 4–7; Kerenyi, *Gods of the Greeks*,
p. 146; Trendall, *AntK* 20, 1977, pp. 99–101 and the relevant articles in *ML* ii.1, 931 ff. and
RE x, 1726 ff.; for the ancient sources see Grimal, *Dictionnaire*, p. 76), but all agree on her
being turned into a bear and subsequently becoming the constellation we know as the Great
Bear. Callisto was one of the virgin nymphs in the retinue of Artemis, one of whose by-names
was Kalliste, presumably the source of Callisto's own name. Zeus fell in love with her and
seduced her; when her pregnancy was discovered while she was bathing in a spring, Artemis, in
wrath at the violation of her pledge of maidenhood, turned her into a she-bear. Such was
the oldest form of the myth (Hesiod, fr. 137), but in a later version (Callimachus, fr. 335;
Ovid, *Metam.* 2, 409 ff.) it was Hera who was responsible for the transformation, and in a
third version it was Zeus himself who brought about the change in order that the affair might
escape the notice of Hera who, however, being all too well aware of what had happened,
persuaded Artemis to shoot Callisto with her arrows as a wild beast. This scene is shown on a
bronze coin of Orchomenos in Arcadia (c.370 B.C.; Cook, op. cit., p. 229, fig. 158; Head,
*Historia Numorum*2, p. 451), and a silver coin of Pheneus of about the same date shows
Hermes carrying the infant Arcas (Head, *B.M. Coin Guide*, pl. 24, 49; Seltman, *Greek Coins*,
pl. 35, 12). The Malibu oenochoe (no. 12, Pl. 54, 6) gives us one of only two complete ren-
derings of the story extant in vase-painting; the other appears on a calyx-krater of slightly later
date in the Dordoni collection in the Museo Civico at Cremona (see below no. 10/27a), on
which the principal figures are all inscribed and include, as well as Artemis and Apollo, the
figure of Lyssa, which suggests a different source of inspiration, perhaps of dramatic origin,
since Lyssa appears in scenes depicting the madness of Lycurgus (e.g. B.M. F 271, no. 16/5
below, Pl. 147) which probably have theatrical associations (see *Ill.Gr.Dr.* III.1, 15--16).

In the centre of the Malibu oenochoe is Callisto, seated upon a rocky eminence, with her right leg bent beneath the thigh, an appropriate posture for child-birth; her head is bent slightly downward as she gazes with pain and horror at her upraised left hand, which is slowly turning into a paw, as the fingers become claws, and fur begins to sprout all along her arms. Her ear has become pointed like that of a bear, and her transformation is obviously in progress. Beside the rock, which is flanked by two leafy trees, are her two spears; on top of the rock is the skin of a wild animal, and other plants and shrubs grow around or on it. This is perhaps a symbolic allusion to Callisto's grave, which according to Pausanias (viii. 35, 8) was a lofty mound covered with trees, on the summit of which was a sanctuary to Artemis Kalliste. To left is the figure of a huntsman, with his left arm wrapped up in his cloak as a protection against possible attacks by wild beasts; to right is Hermes, who stretches out his hand to pick up the infant Arcas, fruit of Callisto's labour, to take him to his mother Maia on Mt. Kyllene in Arcadia, so that in due time he may become the eponymous hero of the Arcadians. Thanks to this vase we can now recognise the figure on the Boston fragment (no. 10) as Callisto in the process of her transformation — the pointed ears, the fingers becoming claws, correspond exactly, and once again we note the tree beside her, together with a small portion of another figure, perhaps the huntsman. The scene is repeated on another fragment (no. 25), which also shows the infant Arcas, who in this version must have been beside his mother, and, above, the lower part of a draped female figure, perhaps Artemis. The two last (nos. 12 and 25) are slightly later than the Boston fragment, but it is interesting to find three representations of this rare theme only a few years apart, and not far from contemporary with the Arcadian coins on which it also appears.

The treatment of the hair on all the fragments in this division is very similar and it is rendered with a mass of fine curls in relief; the New York fragments (no. 8) are amongst the finest examples of Apulian vase-painting that have come down to us and the look of pathos on the face of Priam is very moving.

Fragments

*	7	Amsterdam 3525 A (*Gids* 1487).	PLATE 53, 3.
		CVA, Scheurleer 2, IV Db, pl. 3, 3.	
		Head of Fury with black face.	
*	8	New York 20.195—20.196.	PLATE 53, 4.
		FI, pl. 30b and c; *Cl.Gr.Art*, figs. 355—6; *Ill.Gk.Dr.* III.1, 21.	
		(a) Hermes with the suppliant Priam, (b) Apollo with lyre.	
		Probably both from the same calyx-krater.	
*	9	Princeton, Fine Arts Museum, 59.114.	PLATE 54, 1.
		Head of Zeus (or Hades).	
		Cf. profile with that of Artemis on Naples 3249 (no. 13).	
		To right is an inscription, perhaps HPA or AΔH.	
		Attributed to the Sarpedon Painter in *FI*, no. B 90.	
*	10	Boston 13.206.	PLATE 54, 2.
		FR ii, p. 264, fig. 94b; *Bull.Comm.* 58, 1930, p. 59, fig. 1; Trendall, *AntK* 20, 1977, pl. 22, 5.	
		Callisto.	
	11	Bonn, Professor Langlotz.	
		(1) Two women, with small aedicula to r., (ii) male (?) figure with flying hair and drapery.	
		Note the connexion with Orestes and Artemis on Naples 3249 (no. 13).	

(ii) CLOSELY CONNECTED VASES

Oenochoe (shape 3)

* 12 Malibu, J. Paul Getty Museum 72 AE 128. PLATE 54, 6.
 Trendall, *AntK* 20, 1977, pl. 22, 1–3.
 Callisto being transformed into a bear, while Hermes to r. rescues the infant Arcas.

Volute-krater

 13 Naples 3249 (inv. 82270).
 Pernice, *Hell. Kunst in Pompeji* iv, p. 8, fig. 8; FR, pl. 179 and pp. 362 ff., figs. 172–3; *Birth of
 W. Civilisation*, p. 113, fig. 10; colour plate in *EAA* v, opp. p. 742; Borda, p. 41, fig. 29; Moreno,
 RivIstArch 13–14, 1965–6, p. 37, fig. 7 and p. 41, fig. 13 (lid); Mingazzini, *Ceramica greca*, p. 140,
 fig. 63 (colour); *Cl.Gr.Art*, figs. 362–3 (colour); *Hist.Hell.Eth.* III, 2, p. 373 (colour).
 (a) Orestes in Delphi, (b) Dionysos seated between woman, Eros and papposilen.
 On the lid, which may not belong: (a) papposilen with stick and narthex, (b) seated Muse.
 Compare the profile of Artemis on the obverse with that of the Princeton head. Note also the
 connexion with later vases like Oxford G 269 (no. 15/22).

Fragments

* 14 Maplewood (N.J.) J.V. Noble coll. PLATE 54, 3.
 Telephos (inscribed) brandishing sword.
* 15 Toronto 959.17.176. PLATE 54, 4.
 Photo: R.I. 37.56.
 Clasped hands in front of Hermes.
 16 Basel, Cahn coll. 212.
 To l. column; head of youth wearing pilos, with chlamys fastened by a brooch. (? Orestes at tomb
 of Agamemnon).

(iii) CONNECTED VASES

(a)

Fragments

* 17 Cambridge (Mass.), Fogg Art Museum 1952.33. PLATE 54, 5.
 Curtius, *Scritti Nogara*, pls. 13, 1 and 14; Manni, *Sicilia Pagana*, pl. 34.
 Thalia.
 Cf. calyx-krater, Taranto 52265 (no. 2/24).
 18 Greenwich (Conn.), Bareiss coll. 171 (formerly on loan to the Metropolitan Museum, L. 69.11.100;
 Exhibition Cat. no. 115).
 Part of a youth (? Dioskouros) standing beside a horse, and to r. a woman wearing elaborate drapery
 and holding a phiale.
 Perhaps from a Talos scene, in which case the woman would be Medea. Very close in style to the
 Priam fragment (no. 8).
 19 Basel, Cahn coll. 205.
 Herakles wrestling with the lion, crowned by Nike (?).

Skyphos (fr.)

 20 Heidelberg 26.90, and 26.76.
 CB ii, p. 75, Suppl. pl. 11, fig. 6; *APS*, p. 23, pl. 6, fig. 28 (where associated also with the Painter
 of Perseus and Athena); *CVA*, pl. 74, 3–4.
 Death of Orpheus.
 Note the ray-pattern on the drapery of Orpheus and compare it with that of the Thracian woman
 on Amsterdam 2581. For the subject cf. Taranto 52407 by the Painter of Athens 1714 (no. 8/150).

Pyxis

21 Louvre CA 960.
 Frontal male head (? Helios).

<div align="center">(b)</div>

Calyx-krater (frr.)

22 Amsterdam 2581 (*Gids* 1494), from Taranto.
 FR, pl. 178; *Gids,* pl. 77, 1.
 (a) Dealth of Orpheus, (b) mostly missing.

It is interesting to compare this vase with a fragment in the Cahn collection in Basel, near in style to the Talos Painter (ARV^2 1430, 8), which shows part of a woman with upturned head beside the neck of a horse, with the tips of two spears behind (horseman carrying off a woman ?). The treatment of the hair and drapery is remarkably similar and provides a useful confirmation for the dating of the Amsterdam vase early in the fourth century B.C.

The following small fragment looks to be connected with the above krater by reason of the similarity of subject, the patterned drapery and the drawing of the face.

Fragment (of calyx-krater)

23 Florence PD 462.
 CB ii, p. 75, Suppl. pl. 11, fig. 7.
 Orpheus and Thracians.

<div align="center">(c)</div>

Fragments

24 Once Roman Market (ex Curtius).
 Hellas and Rome[2], p. 257. Photo: R.I. 1935, 225.
 Maenad with tambourine between two maenads.
25 American private coll.
 Trendall, *AntK* 20, 1977, pl. 22, 4.
 Callisto, with the infant Arcas beside her (cf. nos. 10 and 12).

<div align="center">(d)</div>

The following fragments, although too individual in style to be attributed to the Black Fury Painter himself, are probably best placed in this group by reason of the treatment of the hair and drapery, and the drawing of the face. It is possible that the Bareiss fragments come from the same vase as the fragmentary calyx-krater in the Cahn collection; both have similar subjects, perhaps the struggle between Peleus and Thetis.

Bell-krater (frr.)

26 Greenwich (Conn.), Bareiss coll. 205 (on loan to Metropolitan Museum, L. 69.11.49).
 Scylla with trident, dolphin below; above − lower part of draped figure beside unidentified object.
 To r. of Scylla, leg and hoof of animal (? bull).

Calyx-krater (frr.)

27 Basel, Cahn coll. 234.
 Das Tier in der Antike, pl. 44, no. 260.
 To l. leg and foot and part of spear (or sceptre), diving dolphin with squid, octopus and perch, Scylla with upraised arms, two legs of youthful figure.

Fragment

28 Berne (on loan from Prof. C. Clairmont).
 Winged bearded man (Thanatos ?) holding dead boy in his hands.

(e)

The following badly damaged volute-krater should find a place in this context, as still close in style to the early followers of the Painter of the Birth of Dionysos and leading on to the vases in section 3.

Volute-krater

29 Taranto, from Taranto. Recomposed from fragments; much missing.
 Forti, *BdA* 52, 1967, pp. 61., figs, 1—4 and 6—13; Moret, *Ilioupersis*, pls. 36—7 and 64, 1.
 (a) Theft of the Palladion, (b) Amazonomachy.
 Neck: (a) Oinomaos in pursuit of Pelops and Hippodamia, (b) Amazonomachy.

3. THE GROUP OF THE MOSCOW PELIKE AND ASSOCIATED VASES

The vases in this group are still under the influence of the Painter of the Birth of Dionysos, especially in the rendering of the three-quarter head, but the figures on the reverses look forward to the work of the Iliupersis Painter.

(i) THE PAINTER OF THE MOSCOW PELIKE

Note on the two vases specifically attributed to this painter:

(a) the frequent appearance of plants (especially cinquefoils), of large palmette leaves with scalloped edges (cf. the Felton Painter; nos. 54—7), and of stones.

(b) the drawing of the three-quarter face (Athena and Aphrodite on no. 30; Amymone on no. 31).

(c) the profile female head which is finely drawn, with small mouth, and hair in a chignon at the back.

(d) the treatment of the drapery, with straight fold-lines for standing women, and fine folds on seated women.

Pelikai

* 30 Moscow 733. PLATE 55, 1—2.
 (a) Judgement of Paris, (b) seated woman between youth and woman, with Eros above.

* 31 Zurich Univ. 2656 (old no. 2291), from Piedimonte d'Alife. PLATE 55, 3—4.
 CVA, pls. 35—6 and 38 and p. 54, where full bibliography; van de Wiel, *BABesch* 46, 1971, p. 137, fig. 3.
 (a) Poseidon and Amymone with Erotes, youths and women, (b) three women, youth and Eros.

(ii) ASSOCIATED VASES

(a)

Volute-krater

32 Berlin F 3257, from Ceglie.
 FR, pl. 149; details: Jacobsthal, *OGV*, pl. 117 d; Arias, *RivIstArch* n.s. 4, 1955, p. 136, fig. 120.
 (a) Marriage of Herakles and Hebe, (b) mostly missing — the scene seems to have included Poseidon, Artemis and satyrs.
 In the medallions in the centre of the handle-palmettes: Eros drawing his bow.

Of this vase a large portion of the obverse, but almost nothing of the reverse, is preserved. It is associated in style with the two pelikai above (nos. 30—31), in the treatment of the drapery, and of the frontal and profile women's heads (compare those in the upper register with those on Zurich 2656) and is also close to the work of the Iliupersis Painter.

Volute-krater

33 Ruvo 1499.
 Sichtermann K 41, pls. 66—68 (bibliography on p. 37). Photos: R.I. 1360—2.
 (a) Departure of Bellerophon, (b) thiasos — maenad, Dionysos and two silens.
 Neck: (a) three riders, (b) Orestes at Delphi.

The reverse of this vase is near the work of the Iliupersis Painter.

(b)

Hydriai

34 Berlin F 3164.
 Neugebauer, pl. 75; *APS*, p. 27, no. (iv); Moret, *Ilioupersis*, pl. 91, 2.
 Io seated at the base of a statue of Artemis, with Hera and Argos to l., and Zeus and Aphrodite to
 r., and Eros above.
 Beneath the handles: female heads (cf. with Naples 1962 = no. 68; also Adolphseck 185 = no. 9/161,
 by the Schlaepfer Painter).
35 Hanover 775.
 Ghali-Kahil, *Hélène*, pl. 29, 1; *APS*, p. 27, no. (iii).
 The arrival of Paris in Sparta.

(c) THE SKIRON GROUP

 The three vases in this sub-division are again connected by the treatment of the faces and
the drapery.

Skyphos

36 Warsaw 142473 (ex Goluchow 124).
 CVA 1, pl. 47, 5.
 (a) Theseus and Skiron, (b) Eros crowning seated woman, youth to right.

Lebes gamikos

37 Paris, Petit Palais 332.
 CVA, pl. 37, 1–3.
 (a) Seated woman with Eros standing on her lap, and two standing women, (b) woman with mirror,
 youth with cista, and seated woman.

Squat lekythos

38 The Hague, Schneider-Herrmann coll. 16.
 Studiensammlung, p. 44, no. 113, pl. 45.
 Eros and woman seated on klismos, with cat in r. hand and bird perched on l.
 Cf. also with the work of the Iliupersis Painter (e.g. the Newcastle lebes gamikos; no. 8/34).

(d)

Phiale

39 Havana, Lagunillas coll.
 Seated woman with mirror; seated silen with tambourine; seated Eros.

Lekanis

40 Prague, University 58/d.
 Seated woman, kneeling Eros with phiale, nude youth seated on drapery.

4. THE PAINTER OF RUVO 1364 AND RELATED VASES

(i) THE PAINTER OF RUVO 1364

The three situlae (nos. 41–43) form a very compact group, similar in shape and decoration, all
with bead and reel ornament around the rim. The figures have a statuesque quality: the heads
tend to be rather heavy, the pupils of the eyes are large, women's breasts are rounded and
clearly visible beneath the drapery. The drapery itself is fine with simple black borders and
tends to cling to the body. The meanders are accompanied either by saltires with dots or
hollow triangles, or, on the obverse of no. 43, by quartered squares with smaller dotted squares

within the quarters, the first appearance of this particular motive in Apulian vase-painting. The work of this painter provides a convenient link between the vases in the Moscow Pelike Group and the Felton Painter.

Situlae (type 2)

* 41 Ruvo 1364. (b) PLATE 56, 3.
 Japigia 3, 1932, p. 271, fig. 52; Sichtermann K 76, pl. 143; M.-L. Säflund, *E. Pdmt. Olympia*, p. 103, fig. 66. Photo: 64.1229.
 (a) Apollo and Marsyas, (b) silen with wine-skin on his shoulder, Dionysos with thyrsus, and woman with wreath and bunch of grapes, all running to r.

* 42 Swiss Market — Ascona, Galleria Casa Serodine. PLATE 56, 1–2.
 (a) Nike driving a quadriga; Ionic column to r., (b) frontal youth with hound standing between seated nude youth and woman with foot raised, holding wreath.

 43 Bari 1525.
 Magi, *RendPontAcc* 11, 1935, p. 136, fig. 7. Photos: R.I. 6284–5.
 (a) Loving couple served by satyr-boy and woman, with small Eros seated above, (b) Dionysos seated between satyr and maenad, with raised foot, holding wreath.

<div align="center">(ii)</div>

The following vase is very close in style to the above and may also be the work of the same painter.

Pelike

 44 B.M. F 311.
 El.Cér, ii, pl. 49; Richter, *Furn.* 2, fig. 649, and *Perspective*, fig. 170.
 (a) Eros above couch on which is youth, to l. nude woman kneeling in front of basin, and woman lifting up drapery, to r. woman taking off her shoes, (b) woman with fan, and two nude youths, one seated and one standing.

<div align="center">(iii) RELATED VASES</div>

Volute-krater

* 45 Edinburgh 1873.21.1 (once Jerome Bonaparte — Froehner, *Cat. d'un coll. d'antiquités*, 23–26 March 1868, no. 89). PLATE 56, 4.
 (a) Dionysos on couch playing at kottabos, with to l. youth and woman, to r. satyr with torch and situla, (b) woman seated on box between two nude youths, l. with bird, r. with dish of offerings.
 Neck: (a) Female bust amid florals and palmettes.
 For the pattern work on the neck of the reverse cf. Milan "H.A." 239 and Leningrad 586.

Pelike

 46 Glasgow 05.159.
 (a) Satyr with tambourine and thyrsus, Eros above couple embracing on couch, (b) three draped youths, l. and r. with bare torsos.
 The reverse is reminiscent of some of those in the Hoppin Group.

Dish

 47 Ruvo 1629.
 Schneider-Herrmann, *Paterae,* no. 184.
 I. Thetis on a sea-dragon with helmet and spear (arms of Achilles). A. Nude youth holding fillet and open cista beside woman seated on box; Eros with alabastron and wreath, seated nude youth. B. Dionysos with thyrsus, maenad with tambourine, and young satyr with torch and thyrsus, all running to r.

Acorn lekythos

48 Berlin, Dr. Greifenhagen.
 Youth standing beside tree, of which a branch is grasped by Eros; seated woman with phiale.

5. THE FELTON PAINTER

The Felton Painter, whose name vase in the Felton collection in the Melbourne National Gallery, is the subject of an article by Trendall in *Essays and Studies in honour of Sir Daryl Lindsay* (1964), pp. 45–52 (= *FP*), is an artist of considerable originality, as may be seen from his treatment of well-known themes (e.g. nos. 49, 61–3) with a rich vein of rustic humour, manifest in his comic dwarfs and in other figures on his phlyax vases. In style he must be broadly associated with the Hoppin Painter (cf. his use of triangulated saltires and his drawing of the eye and mouth), and he had some influence upon the work of the Painter of Athens 1680, notably in his rendering of the face and in the representation of running figures. Particularly characteristic of the Felton Painter's work is the treatment of the hair and the face — he is fond of curly hair, often with long ringlets falling down to the shoulders (e.g. nos. 50, 54); the mouth has a pronounced downward curve, there is a small hook or dot to mark the nostril, the eyebrow is arched, the upper eyelid tends to turn upwards at an obtuse angle, sometimes intersecting the brow, the pupil is a fine dot. The fold-lines of the drapery are clearly defined, a few hook-folds appear (cf. the Painter of Athens 1714) and the lower border is usually very wavy (e.g. nos. 50, 54, 57); sometimes there is a dot-stripe border. His range of subjects is wide; some have obvious theatrical connexions (e.g. nos. 50, 62–3, 67, 68, 70) and, even those which are mythological may have a suggestion of dramatic inspiration.

(i)

The vases in this division form a compact group, linked by similarity of subject and uniformity in style. In addition to the standard characteristics of the painter's work referred to above, we should note in particular his treatment of the full face (e.g. nos. 49–50, 61–3), his fondness for wrapping up one or both hands in the drapery (nos. 49–52, 54) and for filmy garments which reveal the body beneath very clearly (nos. 50, 51, 54, 61). Above the pictures there are white dots and ivy leaves, sometimes also sprays or bunches of grapes; his palmette leaves may be outlined in white, often with scalloped edges (nos. 54–7; cf. also nos. 30–31). The meander frieze, when not continuous, either begins or ends with a crossed square, beside which a small space is reserved; the meanders begin at the top and are normally not continuous; they are accompanied by saltires of various types. For the dwarfs on nos. 49–50, see *FP*, pp. 46 ff.; they are a most remarkable feature of the painter's work (cf. no. 54) and recur on some of the minor vases (nos. 89–93) associated with him.

Oenochoai (shape 3)

49 Melbourne, National Gallery 90/5.
 FA 14, 1959, pl. 1, figs. 1–2; *FP*, fig. 27; *PhV*2, no. 195, pl. 13a; Schauenburg, *RM* 79, 1972, pls. 130 and 131, 1.
 Marsyas and Apollo with Olympos (?) between two comic dwarfs.
50 Toledo, Art Museum 67.136.
 MuM, *Sale Cat.* 34 (6 May 1967), p. 96, no. 183, pl. 63; *PhV*2, no. 193, pl. 13b; *Greek Vases in Toledo*, ill. on p. 21; Hoffmann, *Collecting Greek Antiquities*, fig. 112 a–c; *Museum News* 15.3, 1972, p. 75, fig. 19; Schauenburg, *RM* 79, 1972, pls. 131, 2 and 132.
 Dwarf, woman pouring wine for Dionysos reclining on a skin-covered couch, young satyr and dancing woman. White female mask suspended above the head of Dionysos.

50a Basel Market, Palladion.

 Katalog (1976), no. 49 (ill.), where attributed to the CA Painter.

 Youth, with cloak draped round his body, urinating.

 For the subject cf. no. 8/130 associated with the Iliupersis Painter.

51 Taranto 4661, from Taranto (Contrada Vaccarella).

 CVA 1; IV Dr, pl. 15, 1; von Matt and Zanotti-Bianco, *La Magna Grecia*, fig. 219; *FP*, fig. 29.

 Dancing maenad with tambourine between youth and silen playing the flute.

52 Taranto 52555, from Taranto (Via Dante).

 AA 1956, cols. 219–20, fig. 15.

 Torso of woman, wearing veil with stephane, draped in a cloak across the front of the body, which envelops her arms (cf. nos. 49–50).

53 Taranto 20406.

 Von Matt and Zanotti Bianco, *La Magna Grecia*, fig. 220.

 Mime dancer – woman enveloped in cloak, with only her eyes visible.

 Cf. the Baker bronze dancer – Bieber, *Hellenistic Sculpture*, figs. 378–9; D.B. Thompson, *AJA* 54, 1950, pp. 371 ff., figs. 1–3, 11 and 14; and terracotta statuettes, *La Magna Grecia*, figs. 222–6. A similar dancer is depicted on Naples 3242 (below no. 15/45).

Pelikai

54 Taranto, Ragusa coll. 127.

 Schauenburg, *RM* 79, 1972, pl. 133, 2.

 (a) Comic dwarf, woman seated on end of couch lifting up her tunic in the presence of a reclining youth and a woman leaning on the head of the couch; Eros seated above, (b) maenad with tambourine, and young satyr moving to l.

55 Ruvo 1549.

 (a) Love scene, (b) maenad with tambourine moving l., followed by satyr with outstretched arms.

 The reverse is a near replica of that on the Ragusa pelike.

56 Bari, Malaguzzi-Valeri coll. 55.

 (a) Youth bending forwards towards seated woman with cista on her lap; to r. standing woman, above l., female bust, (b) woman with cista, and nude youth by kalathos.

57 Bari 1162.

 (a) Seated woman playing the harp, and youth playing the double-flute, (b) woman with phiale and eggs moving to l. and looking back to r.

Squat lekythoi

58 Bari 6272.

 Woman standing in front of seated woman with phiale and bunch of grapes, satyr, and another figure.

58a Hamburg, private coll.

 Youth bending forward, l. arm enveloped in drapery, Eros flying towards the outstretched arms of a seated woman (Aphrodite ?), maid with parasol.

Hydriai

59 Naples Stg. 664.

 Seated woman with cista and standing nude youth, with drapery over l. arm.

60 Sydney, private coll. (frr.).

 Woman with fan, seated woman wearing polos and holding mirror, standing woman.

(ii)

 The vases in this division represent the painter's best work and include several pieces of unusual interest, notably the three oenochoai in Taranto (nos. 61–63), the Ruvo phlyax askos

(no. 68) and the Würzburg Andromeda pelike (no. 70). The Orestes oenochoe (no. 62) gives us a highly original version of the story, with Athena in full panoply dominating the picture as she flies in on a winged griffin surrounded by a nimbus in added red; this must refer to the role she is later to play in the *Eumenides* as advocate of Orestes. To right are two winged Furies, one with drawn sword; to left Orestes holds up his left arm, enveloped in his cloak, as a shield against their attack; above him sits a long-haired Apollo with laurel branch. The nimbus is repeated on the Actaeon oenochoe (no. 63), this time encircling Artemis as she rides in on a panther to witness the rending apart of Actaeon by his hounds; to left a small Pan with lago-bolon makes a gesture of surprise, to right is a papposilen and above him Apollo on a swan. On the Bellerophon oenochoe (no. 61) we also have Pan and the papposilen, the former bearded, the latter much like the dwarfs on nos. 49—50, with his cloak draped round him, as on the woman on no. 52. The spotted deer below is repeated on the reverse of the Andromeda pelike. All three oenochoai have a stopped meander frieze accompanied by enclosed saltires.

It is a pity that so little remains of the Taranto krater with the Dioskouroi beside a building (no. 64); their horses find a parallel on the Oxford fragment (no. 65). The winged figure seated beside a building has been interpreted as Dike; she is not commonly represented on South Italian vases (see Jane Harrison, *Themis,* pp. 520 ff., Beazley, *EVP,* p. 144), nor is she normally shown as winged, so it is possible that this figure might represent a Fury (cf. no. 62). In either case we might expect the building in the background to be the palace of Pluto in the Under-world.

The two phlyax vases show the painter at his best. The bell-krater represents a hag (who should be compared with the negroid hag on the Ruvo askos, no. 68) rushing after a parasite, who runs off with a pointed amphora; he has partly devoured a cake and is shown in frontal face, with a balding head reminiscent of the dwarfs on nos. 49—50 and a singularly vacuous stare. The askos depicts a thiasos in which a phlyax, also shown frontally, is taking part; once more we have the veiled dancer with her arms wrapped up in her cloak (cf. no. 52). The drawing of the faces of the maenads with tambourines is very typical of the Felton Painter, as is their filmy drapery, with the legs clearly visible beneath. The maenad beside the torch-bearing silen provides the link with the Oxford squat lekythos (no. 69); note also the wavy, dotted border of her cloak which recurs on the Andromeda pelike (no. 70). The seated Eros provides another link with that vase, especially with the two youths on the reverse, both of whom resemble him closely, and have the same curly hair and white head-bands. The battered obverse shows us Andromeda bound onto a rock; this looks like a stage prop, and should be compared with the one to which Prometheus is bound on Berlin 1969.9 (see Trendall, *JbBerlMus* 12, 1970, pp. 168 ff., figs. 10—11; *Ill.Gr.Dr.* III.1, 27; *Hist.Hell.Eth.* III.2, p. 375; Melchinger, *Das Theater der Tragödie,* figs. 19—20; Moret, *Ilioupersis,* pl. 95, 2). It reinforces the theatrical influence already observed in several of the painter's other vases.

The phlyax vase in the Ragusa collection in Taranto (*PhV*[2], no. 115, pl. 8 b), showing Oedipus, Kreon and the Sphinx, looks also to be associated with the Felton Painter, but in the absence of any specific connecting link we would hesitate to make a positive attribution.

(a)

Oenochoai (shape 3)

61 Taranto 52363, from Taranto.
 JdI 71, 1956, pp. 59 ff., figs. 1—3; von Matt, op.cit., fig. 227; *FP,* fig. 28; *LAF,* no. 154 (ill.); colour ill. in Mobil Calender, July 1976.
 Bellerophon on Pegasus, slaying the Chimaera.

* 62 Taranto, from Taranto. PLATE 57, 1.
 Lo Porto, *Atti X° CStMG,* pl. 106; Trendall, *ArchReps* 1973, p. 39, fig. 10a; Schauenburg, *Festschrift Brommer,* p. 251, pl. 70, 1–3.
 Orestes at Delphi — seated Apollo with laurel branch, Orestes with drawn sword, Athena on griffin surrounded by nimbus, two Furies.
* 63 Taranto, from Taranto. PLATE 57, 2.
 Lo Porto, loc. cit., pl. 105; Trendall, loc. cit., p. 40, fig. 10d.
 Death of Actaeon — Pan with lagobolon, Artemis on panther surrounded by nimbus, Actaeon attacked by three hounds, Apollo with laurel branch riding on white swan, papposilen and hound.

Calyx-krater (frr.)

64 Taranto, from Contrada Corti Vecchie 9/8/29.
 Schauenburg, *Mélanges Mansel,* p. 112, pl. 60 b–c.
 (a) Building flanked by the Dioskouroi with their horses, (b) mostly missing, except for the head of a silen.
 Cf. the Dioskouroi with Bellerophon on Taranto 52363 (no. 61).

Fragments of kraters

65 Oxford 1966.1040 (from two bell-kraters).
 Beazley Gifts, no. 502, pl. 68.
 (i) Dike seated beside building, with legs of youth above, (ii) torso of the youth and top of the building, (iii) head of horse, (iv) draped man talking to nude man seated on a traveller's pack; below: youth with drawn sword standing beside a horse.
66 Zurich Market, Arete.
 Head of man with curling hair, wearing helmet.

(b)

Bell-krater

67 Berlin F 3047, from Ruvo.
 Trendall, *PhV²,* p. 30, no. 23 (where bibliography).
 (a) Pursuit of parasite, (b) two draped youths.

Askos

68 Ruvo 1402.
 Sichtermann K 90, pls. 144–6; *PhV²,* no. 135, pl. 6c.
 Thiasos — maenad with tambourine, dancing silen with torch; draped woman, dancing phlyax; satyr with torch and tambourine, capering hag, running maenad with tambourine, silen and torch.

Squat lekythos

* 69 Oxford 1919.24. PLATE 58, 1.
 Woman standing in front of Eros seated on altar.

Pelike

* 70 Würzburg 855 (H. 4606), from Taranto. (b) PLATE 58, 2.
 Langlotz, *Cat.,* pl. 242; Phillips, *AJA* 72, 1968, p. 11, pl. 2, fig. 32; Jobst, *Die Höhle,* p. 128, fig. 24; *Führer,* p. 208.
 (a) Andromeda, (b) thiasos.

(iii)

The vases in this division carry on from those in (ii), but the drawing is less precise, and the heads tend to be rather heavier.

Pelikai

* 71 Minneapolis, University of Minnesota, 73.10.14. PLATE 58, 3.
 Ex Henri de Morgan coll.; Parke-Bernet, *Sale Cat.* no. 3404, 26 Sept. 1972, no. 277 (ill.); *Gazette des Beaux-Arts,* Feb. 1974, Suppl., p. 99, no. 328 (ill.).
 (a) Two nude women at a laver, above which is Eros, (b) draped woman with wreath and cista, nude youth with drapery over l. arm standing beside an altar.
 72 Catania MB 4392 (L. 778).
 Libertini, *Cat.,* pl. 91.
 (a) Woman with tambourine and satyr with wreath and situla running to l.; above: head of woman in window, (b) seated woman and nude youth.
 Compare with the reverses of nos. 54 and 55.

Hydriai

 73 Naples 1962 (inv. 82297).
 Shoulder: Seated woman with phiale, bust of woman.
 Body: Nude youth with crossed legs, woman with mirror seated on plinth, on to which a maid with a fan steps up.
 Below handles: female heads.
* 74 Naples Stg. 454. PLATE 58, 4.
 Woman with cista and standing woman with fan at a large stele on top of which is a dish of eggs and on the base of which is a seated woman.
 75 Nuremberg 3517.
 Woman with bunch of grapes and cista, and Eros with branch at a laver.

Fragment

 76 Basel, H.A. Cahn coll. 206.
 Upper part of woman to r.
 Goes very closely with Naples Stg. 454 (no. 74).

Squat lekythoi

 77 Prague, University E 9.
 Eros leaning forward over l. foot raised on rock and holding phiale in r. hand and bunch of grapes in l. in front of woman seated on rock, with egg in r. hand.
 78 Lecce 833.
 CVA 2, IV Dr, pl. 49, 3.
 Eros flying to seated woman.
 79 Basel Market, MuM.
 Woman disrobing.
 Cf. with Lecce 848 (no. 80).

Oenochoai (shape 3)

 80 Lecce 848.
 CVA 2, IV Dr, pl. 38, 5.
 Woman disrobing in front of nude youth with bunch of grapes and mirror, resting r. foot on stone.
 81 Once New York Market, Sotheby-Parke-Bernet, *Sale Cat.* 8 May 1976, no. 346 (ill.).
 Woman with bunch of grapes and phiale, nude youth with wreath and phiale beside an altar.

(iv) SMALLER VASES

The following vases, mostly of rather smaller dimensions and decorated with one or two figures, are close in style to the work of the Felton Painter, if not by his own hand, as may

well be the case with those in (b), on several of which is depicted an achondroplasiac dwarf similar to those on nos. 49—50, 54.

(a)

Nos. 83—4 form a matching pair, with which no. 85 is closely connected; it is by the same hand as nos. 86—88.

Squat lekythoi

82 Taranto 4667.
 Woman with cista, seated woman with mirror looking up at nude youth bending forward to speak to her.
83 Taranto 101423.
 Seated Eros holding phiale.
84 Taranto 101424.
 Seated woman holding phiale and wreath.

Oenochoai (shape 3)

85 Taranto 20391, from Contrada Vaccarella (25 Oct. 1929).
 Silen with thyrsus and wreath moving to l., followed by draped woman.
86 Taranto 20356, from Via Leonida.
 CVA 2, IV Dr, pl. 35, 1.
 Woman running to l. holding phiale, and satyr bending forward to catch bird.
87 Taranto I.G. 4631 (old inv. 3938).
 Woman with bunch of grapes and phiale, Eros holding wreath.
88 Taranto 4746.
 Woman with kalathos running to r., Eros with wreath and thyrsus.

(b)

Oenochoai (shape 3)

89 Taranto 52571, from Taranto.
 Japigia 7, 1936, fig. 2; *PhV*2, no. 198 (where bibliography); *FP*, fig. 31.
 Running comic.
90 Once Milan Market (ex Oria, private coll.).
 Sale Cat. Finarte 5 (14 March 1963), no. 95, pl. 53; *PhV*2, no. 196, pl. 12d.
 Two running comics with a sapling between them.
91 Turin, private coll. (Mario Bruno).
 Ex Zurich Market, Koller, *Sale Cat.* 32, Oct.–Nov. 1974, no. 3771, pl. 62, 1.
 Phlyax with sword and shield running to l., followed by warrior wearing pilos and holding shield.
92 Taranto, Ragusa coll. 120.
 Dwarf running to l.; drapery top r.
93 Taranto, Ragusa coll. 7.
 *PhV*2, no. 197, pl. 12c.
 Comic dwarf running to left.
94 B.M. F 366.
 *PhV*2, no. 194 (where bibliography); Schauenburg, *BJbb* 161, 1961, pl. 41, 3; Scherer, *Legends of Troy*, p. 107, fig. 86; *FP*, fig. 30; *LAF*, no. 180 (ill.); Moret, *Ilioupersis*, pl. 41, 1.
 Odysseus and Diomede with the Palladion.
 Close in style to Taranto 52571 (no. 89).

(c)

The following vases depict male or silen heads and, from the drawing of the mouth and eye, look also to be the work of the Felton Painter, or else very closely connected with him.

Oenochoai (shape 3)

95 Taranto, Ragusa coll. 125.
 Head of bearded man to l.
96 Taranto, Baisi coll. 80.
 Head of silen to l.
96a Freiburg Market, Günter Puhze.
 Libresso, *Bibliographie,* no. 13 (1976–7), fig. 6, 3; *Kunst der Antike* (*Cat.* 1977), no. 135.
 Head of silen to l., as on no. 96.
96b Malibu, J. Paul Getty Museum 74AE50.
 Head of silen to l., as on 96a.
96c Taranto, Ragusa coll. 62.
 Head of silen to l.
96d Rome, Rotondo coll. 63.
 Head of silen to l. with hand as on 96c.
97 Baltimore, Johns Hopkins University.
 Head of young satyr to l.

With the above compare:

Pelike

98 Once London Market, Sotheby, *Sale Cat.* 25 Oct. 1971, no. 136.
 (a) Head of youth, (b) head of satyr.

(v) VASES CONNECTED IN STYLE

The following vases should be compared with the work of the Felton Painter for the treatment of the faces and the drapery.

Hydria

99 Reggio Cal. 7034, from S. Arcangelo.
 APS, p. 52, no. 4, pl. 31, figs. 146 and 148.
 Woman seated on rock, holding fan, and nude youth with wreath.
 Below handles: birds.

Squat lekythos

100 Melbourne, La Trobe University, private coll.
 Seated woman holding ball.

Oenochoai (shape 3)

101 Taranto, Ragusa coll. 174.
 Seated half-draped woman with phiale of offerings.
102 Ravenna, Prof. Bendandi.
 Seated woman with phiale opposite satyr bending forward over raised foot.
103 Turin, private coll. (Mario Bruno).
 Bearded man enveloped in cloak, holding mirror in r. hand.
 Cf. with nos. 92 and 95.

Skyphos

104 Taranto, Baisi coll. 61.
 (a) Draped woman with cista and wreath, (b) nude youth with wreath moving to r.

Pelike

104a Freiburg Market, Günter Puhze (handles modern). *Cat.* (1977), no. 157.
 (a) Seated woman with box, (b) Eros with mirror running to l.

6. FOLLOWERS OF THE FELTON PAINTER

The vases discussed in this section are clearly under a very strong influence from the work of the Felton Painter; chronologically they should probably belong to Middle Apulian (after c.360 B.C.), but in view of their close stylistic connexion with this artist, it seems not inappropriate to look at them at this point.

(i) THE GROUP OF THE ST. LOUIS PELIKE

(a)

The two pelikai in this division are closely connected in style and drawing. One (no. 105) depicts a woman seated on a klismos on a low platform between a youth and a woman, with an Eros seated above, a scene which looks back to those on nos. 56 and 73 by the Felton Painter, just as the reverse is related to that of his Minnesota pelike (no. 71). The drawing of the faces is also near to his manner, especially on the vases in (iii) above, and on no. 106 we note the visible leg beneath the woman's drapery as on nos. 50–51 and 54. The heads now become rather heavy.

Pelikai

105 St. Louis, City Art Museum 41.21.
 Mus. Bull. 7, 1922, p. 5, fig. 5.
 (a) Woman seated on klismos between nude youth and woman with cista; Eros above, (b) woman with kalathos, and nude youth holding wreath, with drapery behind his back.
*106 Milan, "H.A." coll. 241. PLATE 59, 1.
 (a) Woman with cista and sash standing beside seated nude youth with phiale, (b) two draped youths.

(b)

The meander and crossed squares on no. 106 provide a connecting link with the three vases in this division, which also form a compact sub-group. We note the same type of window in the field as on no. 106 and the same emphasis upon the rather heavy jaw. The drapery of the youth to right on the reverse of no. 107 should be compared with that on some of the vases by the Schlaepfer Painter (nos. 9/165–8 below), with which these must be contemporary.

Bell-krater

*107 York 21. PLATE 59, 2.
 (a) Nude youth with drapery over l. arm holding out wreath to draped woman with spray and situla, (b) two draped youths.

Hydria

*108 Geneva MF 242. PLATE 59, 3.
 Robinson, *AJA* 60, 1956, pl. 19, figs. 84–87.
 Seated woman with alabastron and phiale, and standing woman with wreath and phiale at an Ionic grave monument.

Amphora

*109 Naples 2253 (inv. 81734). PLATE 59, 4.
 Patroni, p. 139, fig. 94.
 (a) Two nude youths at a grave monument on top of which is a b.f. volute-krater, (b) two draped youths.

(c)

With the above compare, especially for the treatment of the faces: ·

Pelike

110 Bari 1368.
 (a) Standing woman with fillet, woman seated on klismos, nude youth with wreath, (b) woman seated on klismos holding branch between woman with raised foot and nude youth with wreath.

(ii) THE KYMINNON GROUP

The Group takes its name from the inscription on the Pentheus krater in Ferrara (Alfieri, *Arte antica e moderna* 11, 1960, p. 243, pl. 68 c), one of the very few Apulian vases to have been found at Spina. In both style and subject, the vases, especially 2239, no. 114, owe much to the Felton Painter, but the quality of the drawing has deteriorated, particularly on the later pieces. The bridal scenes which now begin to make their appearance on vases (e.g. nos. 112–3) are destined to become very popular, and considerably more elaborate, in Middle and Late Apulian.

(a)

Calyx-krater

*111 Ferrara from Spina, T. 476 B. PLATE 59, 5.
 Alfieri, op. cit., pp. 236–247, pls. 67–70.
 (a) Pentheus attacked by two maenads between young satyr to l. with situla and torch and, to r., seated Dionysos with thyrsus, (b) young satyr with torch and situla between, to l., two maenads, to r., maenad with phiale and white-haired man with thyrsus.

Hydria

*112 Taranto, Baisi coll. 41. Much of the central portion is missing PLATE 59, 6.
 Bridal scene — woman beside a couch on which is a seated youth; above to l., woman with cista; to r., Eros and Aphrodite.
 Beneath the handles: a bird.

Lebes gamikos

113 Bari 8251 (in bad condition).
 (a) Eros flying to crown youth, woman with branch, seated woman bouncing ball, (b) missing.

(b)

The following represents a later development of this style:

Lebes gamikos

114 Bari 2239.
 (a) Eros above youth with phiale and seated woman; to r. woman with fan, (b) youth seated between two standing women.

(c)

With the above compare:

Oenochoe (shape 5)

115 Meer (Belgium), private coll.
 Aphrodite and Eros, seated nude youth, woman with raised foot holding bunch of grapes with mirror.

PART TWO

MIDDLE APULIAN

MIDDLE APULIAN

Introduction

The term Middle Apulian may conveniently be applied to the vases produced during the years immediately before and after the middle of the fourth century B.C., i.e. between c.370–360 and 340–330. These take us, in the "Plain" Style, from the followers of the Dijon Painter to those of the Varrese Painter, and, in the "Ornate", from the Iliupersis Painter to the immediate forerunners of the Darius Painter, with whom Late Apulian may be said to begin. During this period we note the rise of a more elaborately decorative style to which the term "Baroque" may justly be applied (see Chapter 15) and which is to flourish in later Apulian, from the Darius Painter onward. He is an artist of immense significance for the development of the later Apulian style, since it was he who established the canons for the decoration of the truly monumental vases (volute-kraters and amphorae sometimes exceed a metre in height) which appear in increasing numbers in the last third of the fourth century, decorated with mythological, dramatic, bridal or funerary scenes, in which the figures are disposed in two or three registers.

After c.360 there is a steady and substantial increase in the output of Apulian red-figured vases, reaching between c.340 and 320 almost the level of mass production. As in Early Apulian, the vases fall into two broad categories, one of which continues and develops the "Plain" Style tradition, the other the "Ornate". The distinction between the two, however, is not nearly so clear as formerly, especially as an extensive use of added white and yellow is now found on small vases as well as large, but in general it is still applicable, especially in regard to subjects, composition and decoration, though several painters (e.g. the Painter of Athens 1714 and the Varrese Painter) decorate vases in both styles, and the connexion between them becomes increasingly close.

In this period we may also see the beginning of many of the characteristic features of later Apulian vase-painting, notably:

(i) the increasing use of added colours – various shades of red and brown are now added to the yellow and white

(ii) the elaboration of the subsidiary decoration, especially on the necks of volute-kraters or the necks and shoulders of amphorae, where female heads, either in frontal or profile view, in a floral setting become increasingly popular – the floral decoration may also be extended to the body of the vase (cf. nos. 15/6, 11, 36, 37)

(iii) the greater frequency of female heads – the female head (or, far less commonly, the male) begins to make a regular appearance as the sole decoration on smaller vases; in Late Apulian it also appears quite often as the reverse design on larger vases, which usually have a naiskos or similar scene on the obverse

(iv) the greater fluidity of the drawing and the attention paid to foreshortening and perspective, as may be seen from a study of the treatment of the naiskoi (cf. Richter, *Perspective*, pp. 45 ff.), and to the representation of objects in the distance.

The other group, which continues the "Plain" style, consists mainly of vases of smaller dimensions, especially bell- and column-kraters, pelikai, hydriai and, later, various types of oenochoe (notably types 1 and 8). They are mostly decorated with simple genre scenes, often involving Dionysos or Eros, which may be associated with the cults of these divinities or with the life after death (see the recent studies on this theme by H.R.W. Smith and Mrs. Schneider-Herrmann in *BABesch* 45, 1970, pp. 68–117, and the former's book *Funerary Symbolism*;

and also Marina Pensa, *Le rappresentazioni dell' oltretomba nella ceramica apula.*

Apart from the immediate followers of the Dijon and Hoppin Painters (see Chapters 9–11), the two principal artists of the "Plain" style are the Snub-Nose and Varrese Painters, the latter well illustrating the tendency at this period for the two styles to merge, since he himself decorated a large number of vases in both. These two painters had a very extensive following, and the works of their associates and successors show such a remarkable uniformity that they are often extremely difficult to attribute to individual painters and are perhaps best grouped together as workshop products. The reverses of their kraters and pelikai are regularly decorated with two or three draped youths, and these are worth a fuller study than is generally accorded them, since when a painter decorates the back of a vase with a stock subject like this, repeated on numerous other vases with only trifling variations, he abandons the more studied and precise manner of drawing he is likely to have employed for the more important picture on the obverse, in favour of a less considered, more casual style in which certain individual "trademarks" may appear. This phenomenon is very clear in the drawing of the himatia of the youths by the two painters referred to, and it often serves as the best way of distinguishing between the several painters in a given workshop, whose styles maintain a remarkable degree of uniformity, but who tend to have little individual idiosyncrasies in the draping of their reverse youths. A discussion of the "stock types" will be given in the Introduction to the Snub-Nose Painter (Chapter 12) and they are illustrated on Plate 97.

Most of the vases listed in Part Two cover the period c.370–340 but a few of the later vases from the Varrese workshop must belong to the succeeding decade, and are closely connected in style with the smaller vases from the workshop of the Darius Painter and his followers, especially the Underworld Painter, whose minor works look like their direct successors. The influence of the Schulman Group is also to be seen in the vases of the Patera Painter and his school (cf. especially the Trieste Owl Group).

It is still too early to provide precise locations for the various schools of Middle and Late Apulian. Several of the Darius and Underworld Painters' vases come from Canosa and Altamura, and a tomb recently found at Arpi (*StEtr* 42, 1974, pp. 520–1) yielded a number of large vases from the workshop of the Baltimore Painter. The possibility is not to be excluded that some of these vases may actually have been produced in these towns, since their size would have made their transport a difficult, though not insoluble, problem. On the other hand, the remarkable uniformity in style, shape, decoration and subjects of Apulian red-figure in the second half of the fourth century shows that the several schools of vase-painters must have worked in fairly close collaboration and argues in favour of at least a central source of inspiration, which almost certainly would have been the school of Taranto.

CHAPTER 8

THE ILIUPERSIS PAINTER, THE PAINTER OF ATHENS 1714 AND THEIR ASSOCIATES

Introduction

The school of the Iliupersis Painter produced some of the most important Apulian vases of the second quarter of the fourth century and he introduced into vase-decoration a number of new elements which had a profound influence upon all subsequent painters. It is during this period that we see the "Plain" style beginning to merge with the "Ornate", with a gradual increase in the use of added white and yellow for adjuncts and details and a growing tendency towards more elaborate ornamental decoration and composition on a grander scale. The two chief painters in the school are the Iliupersis Painter and the Painter of Athens 1714; both paint many large vases in the "Ornate" manner, the latter rather more in the "Plain" tradition, using figures and themes taken from the reverses of his major works. Associated with these two painters, who must have worked in close collaboration, are several lesser artists who produce not only standard "Plain" style vases, but numerous small pieces decorated with single figures, which will be discussed in detail by themselves in Chapter 11.

1. THE ILIUPERSIS PAINTER

Bibliography

Noël Moon, *BSR* 11, 1929, pp. 45 ff. (= Moon).
E. Buschor, FR iii, pp. 164—9 (on Naples 3223; no. 3 below).
C. Watzinger, FR iii, pp. 349—350 (= W).
A. Stenico, *EAA* iv, p. 107.
A.D. Trendall, *SIVP*2, pp. 19 ff.
Gemma Sena Chiesa, "Vasi apuli di stile ornato", in *Acme* 21, 1968, pp. 327—379 (= Sena Chiesa).
The theme of the painter's name vase is dealt with exhaustively by J-M. Moret in *L'Ilioupersis dans la céramique italiote* (Institut Suisse de Rome, 1975).

The Iliupersis Painter is a figure of paramount importance in the history of Apulian vase-painting since it was he who established the lines along which the "Ornate" style was to develop and who introduced a number of new features in both the ornamental and figured decoration on the larger vases, which were to become almost canonical in later "Ornate" Apulian. He is primarily a painter in the "Ornate" style and continues the tradition established by the Painter of the Birth of Dionysos, although on his minor works and on the subsidiary scenes on the necks of his larger vases we may observe close parallels with the work of the followers of the Tarporley Painter, especially the Schiller Group (Chapter 4, 1) and the Painter of Karlsruhe B 9 (Chapter 6, 1), and some of his reverses depicting nude or draped youths (e.g. nos. 11, 17, 18)

should be compared with the work of the Dijon Painter. The main period of the Iliupersis Painter's activity falls into the second quarter of the fourth century, his latest work going down perhaps as far as c.350 B.C.

Most noteworthy are his innovations in the decoration of volute-kraters, since these were to exert a very powerful influence on all subsequent painters of such vases, the production of which increases greatly in the second half of the century. Up to his time volute-kraters had been comparatively rare — they begin with the pioneer pieces by the Painter of the Berlin Dancing Girl (no. 1/12a in Addenda) and the Sisyphus Painter (nos. 1/51—54), and continue with those of the Painter of the Birth of Dionysos and his associates (Chapter 2) and followers (Chapter 7), who made slight modifications to the shape and had a preference for the use of swan-heads at the handle-joins on the shoulder. From the second quarter of the fourth century onwards the volute-krater is to become one of the most popular shapes in "Ornate" Apulian, with a steady increase both in size and in the elaboration of the ornamental decoration until we come to the monumental vases of the Darius and the Underworld Painters (c.330—20 B.C.) which sometimes reach a height of over 140 cm. and may have as many as twenty or more figures in the main scene. There can be little doubt that its later popularity owes much to the Iliupersis Painter, to whose hand some 14 such vases may be ascribed, illustrating a wide range of subjects and a considerable development in the decoration. Up to the end of the first quarter of the fourth century the subjects represented upon volute-kraters had been largely mythological and Dionysiac (especially on the reverses); such themes are also extensively used by the Iliupersis Painter (e.g. nos. 2, 5, 6, 8, 9), together with others having a strong theatrical association as well (e.g. Orestes in Tauris, Neoptolemos at Delphi — nos. 3 and 4 — both connected with plays by Euripides), but his great innovation lies in the introduction of a specifically funerary theme in the form of either a naiskos, with a figured representation of the deceased, to which mourners bring different kinds of offerings, or a stele, normally tied with black fillets and rising from a base upon which various offerings (eggs, vases etc.) have been placed. Many fragments both of the actual naiskoi and of their sculptural and architectural decoration have been found at Taranto (see, in particular, J.C. Carter, "Relief Sculptures from the Necropolis at Taranto", in *AJA* 74, 1970, pp. 125 ff. and *The Sculpture of Taras;* H. Klumbach, *Tarentiner Grabkunst* (Reutlingen, 1937) and L. Bernabò Brea, "I rilievi tarantini in pietra tenera", in *RivIstArch* n.s. 1, 1952, pp. 1 ff.) and the vases must surely be meant to serve as reproductions of the original monuments, thus providing a somewhat less expensive substitute for burial within the tomb. That the naiskoi on the vases are intended to simulate the marble or stuccoed stone of the actual monuments seems clear from the way in which both they and the figures inside them are almost invariably represented in added white. At first we find only single figures (e.g. nos. 1 and 7); later two- and three-figure compositions (cf. nos. 29—30) become common, and very close parallels to them can be drawn from the long series of Attic gravestones from the Kerameikos and other cemeteries. A list of naiskos vases is given by Francesca Vanacore in "I vasi con heroön dell' Italia meridionale", in *Atti Acc Arch Napoli* 24, 1905, pp. 175 ff., and a fuller study of them is promised in two doctoral dissertations at present in progress, one by Hans Lohmann of Würzburg, the other by John Wade of Sydney, in which much new material is added to the original list, bringing the total of such representations to over 600.

Two volute-kraters by the Iliupersis Painter (Leningrad 577 and B.M. F 283 = nos. 1 and 7; Pls. 60, 1—2 and 61, 1—2) give us the archetype of the typical "Ornate" Apulian funerary vase with a naiskos scene on the obverse and a stele scene on the other side. On both these

vases we see on the obverse a simple naiskos, with Ionic columns and an architrave supporting a pediment with acroteria, resting upon a basis, in one case stepped (no. 1) with rows of black eggs on the steps, in the other (no. 7) decorated with a triglyph-metope frieze. On this vase the ceiling-beams are also clearly indicated. Within the naiskos on each is a nude youth beside a laver, both shown in added white, to simulate, as has already been noted, the marble or stuccoed stone of the actual monument. The laver, in which on B.M. F 283, the youth is about to dip his hand, plays of course a vital part in the lustral ceremonies associated with death (see R. Ginouvès, *Balaneutike*, esp. chaps. 4 and 5; Kurtz and Boardman, *Greek Burial Customs*, p. 151; cf. also Denise Callipolitis Feytmans, *Les louteria attiques*, pp. 40 ff.). On both vases the naiskos is surrounded by youths and women; they generally hold in their hands some kind of offering, which they may be about to place on the tomb; these usually have some funerary significance, often associated with the after-life (see Eva Keuls, *The Water Carriers in Hades*, pp. 97 ff, and H.R.W. Smith's article "Deadlocks?" in *BABesch* 45, 1970, pp. 68 ff., and his recent book *Funerary Symbolism*, in the index to which on pp. 292–4 references are made to many such items under the heading "Chattel-symbolism"). Here the numbers are uneven (three women and two youths on one, two women and three youths on the other) and the figures are arranged in a variety of different poses; later there is a strong tendency towards a balanced and chiastic arrangement, as on the stele scenes on the two reverses, on which we have on the Leningrad vase (no. 1) seated youth and standing woman to left, standing youth and seated woman to right, and on B.M. F 283 (no. 7) seated youth and standing woman to left, standing woman and seated youth to right. Such rigidly balanced groupings, which are the rule on most of the later funerary vases, tend to become extremely monotonous, the permitted variations being mainly in the different objects held by the mourners. Naiskos and stele scenes will regularly appear from now onwards on amphorae and hydriai (cf. nos. 27–30, 32, 39–43); later, also on loutrophoroi, pelikai, oenochoai, calyx-kraters and a few other shapes, though so far never on a bell- or column-krater. It should be noted that naiskos vases are essentially Apulian; a few naiskoi will be found on Lucanian vases, especially by the Primato Painter (e.g. *LCS*, p. 165, nos. 920, 923), in imitation of Apulian; none have yet been found in Paestan or Sicilian, and in Campanian mainly in the Apulianizing phase at Cumae (see *LCS*, pp. 454 and 501, *Suppl.* I, pp. 92–3; note also *LCS*, p. 386, no. 187 and p. 409, no. 327, both in the AV Group, with naiskoi and vases like those on nos. 29–31) when they were no doubt introduced by the migrant artists from Apulia.

It is important to distinguish these naiskoi from the temples or palace-buildings which also appear with some frequency upon Apulian vases. Excellent representations of temples will be found upon the Amsterdam krater by the Painter of the Birth of Dionysos (no. 2/10), nos. 3 and 4 by the Iliupersis Painter, and on Ruvo 1097 (no. 16/16) by the Lycurgus Painter, and they may normally be identified without difficulty; palace and other buildings may lead to more confusion, but are generally drawn in a quite different manner from naiskoi, with free-standing columns and without the use of added white for the figures inside them (cf. Heidelberg 26.87 by the Sarpedon Painter = no. 7/5; Karlsruhe B 4, Naples 3222, for the palace of Pluto; Leningrad 2085 = no. 103 below, for the fountain-house). On some later Apulian vases, especially by the Baltimore Painter, the youth or woman within the naiskos may appear in red-figure, but this is exceptional.

Naiskoi may also contain, instead of the effigy of the deceased (as on nos. 1, 7, 27, 39–40) or a funerary group (nos. 29–30), some symbol of the departed (cf. the shield on Ruvo 417 by the Painter of Karlsruhe B 9 = no. 6/25) or a vase (e.g. reverses of nos. 29–31, no. 42),

just a hanging fillet (no. 41) or a mirror (no. 43), all of which are to be associated with the cult of the dead (see Pagenstecher, *Unteritalische Grabdenkmäler,* pp. 91 ff.; Keuls, *The Water Carriers in Hades,* pp. 97 ff.; Smith, *FS,* loc. cit.) and will appear subsequently on numerous other vases. The stelai in their simplest form consist of a tall shaft rising from a stepped base upon which various offerings (eggs, pomegranates, etc.) together with vases (usually shown in black silhouette) are frequently placed, as on the reverse of no. 1. The shaft may assume the form of an Ionic or Doric column, and may be crowned by a vase (reverse of no. 7; no. 44); sometimes it stands upon an altar (no. 44), but these are no more than variations on a fairly standard theme. The floral which stands on top of the altar on no. 38 is the forerunner of many such plant-forms, which more commonly appear inside the actual naiskoi (see Schauenburg, *RM* 64, 1957, pp. 198 ff. and Margot Schmidt in *Ap. Grabvasen,* p. 31, pls. 12–13). On the reverse of Naples 2147 (no. 26) is a grave-mound with a b.f. amphora on top (Pagenstecher, p. 27, pl. 13a), a theme repeated on two vases by a follower of the Iliupersis Painter (nos. 116–7 below). Less common is a statue of the deceased, as on no. 10, where it appears on a low base beside an Ionic column, or on no. 12, where it is set between two large florals with spiralling tendrils, like those which frame the female heads on the necks of volute-kraters (nos. 5 and 11; cf. also no. 14).

The innovations made by the Iliupersis Painter in the ornamental decoration of the volute-krater are no less significant for the subsequent history of Apulian vase-painting than his introduction of the naiskos/stele representations. Up to his time (c.380–370 B.C.) the handles of volute-kraters had regularly taken the form of volutes decorated with ivy pattern or with partly open-work relief (e.g. nos. 1–5 below; cf. with 1/51–3, 2/7–9), and it seems to have been the Iliupersis Painter who first adopted the practice of applying round medallions, decorated in added paint or with painted reliefs (nos. 6–7), often taking the form of masks (nos. 8–12), over the volutes, thus creating the "mascaroon" volute-krater, which is one of the most typical products of the Apulian potter, although not found in Campanian or Sicilian. Attic prototypes in pottery are rare (see Schauenburg, *JdI* 89, 1974, pp. 163 ff.); there is a curious column-krater in Naples (2205; Baldassare *Bari Antica,* fig. 24; Schauenburg, *AA* 1977, p. 195, figs. 1–2) with mascaroon handles, which Beazley (*ARV²* 1118, 20) attributes to the Duomo Painter, expressing some reservations as to whether the handles are original, and this vase finds a parallel in two Apulian column-kraters also in Naples (2349 and 1982), of which the latter has undergone considerable restoration, and the handles of the former are not entirely above suspicion, so it may be that all three (significantly all in the same collection) are the results of an imaginative restoration of the nineteenth century. As the volute-krater dies out in Attic pottery about 380 B.C., it is more likely that we should find the Attic models in the metal vases of the later fifth and early fourth centuries of which very few specimens have survived; the well-known krater from Dherveni, now in the museum of Thessaloniki (see, in particular, Makaronas in *ADelt* 18 B, 1963; *BCH* 87, 1963, pls. 16–20; Webster, *Hellenistic Art,* pp. 20 ff., pl. 1; *The Greek Museums,* 275, 278–9; Robertson, *History of Greek Art,* pp. 482–3, pl. 141 b), which is probably to be dated c.330 B.C. and may well be based upon earlier examples, has mascaroon handles in the form of bearded male heads, which are not identical, as is often the case with the masks on the Apulian kraters, although this identity is sometimes slightly obscured when the masks on the obverse are painted and those on the reverse are not (cf. nos. 9–10).

An early stage in the development of the medallion type of handle-decoration may be seen on the Neoptolemos krater in Milan (no. 4), where on the obverse we have the normal ivy

decoration in applied colour, but on the reverse a medallion has been attached, decorated with a radiate star-pattern in added white. On Leningrad 586 (no. 6) there is a figured scene on the obverse medallion, showing an Amazon on horseback, with the more normal mask on the reverse; on B.M. F 283 (no. 7) is a dancing satyr playing the flute in front of a seated maenad. Figured scenes on medallions are rare (for other examples cf. the reverses of Leningrad 1718 and B.M. 1933.6–13.7, both showing Athena fighting a giant; Schauenburg, *JdI* 89, 1974, p. 164 and fig. 38); instead there is normally a mask, often painted, which may represent a gorgoneion, occasionally also with ram's horns (Wuilleumier, *Tarente,* p. 499; Schauenburg, *Perseus,* pp. 99 ff. and *RM* 80, 1973, pp. 195 f., n. 27), female heads with cow's horns, probably Io (see Schauenburg, *AuA* 10, 1961, p. 90, n. 146), female heads (mostly frontal; those in profile, as on Naples Stg. 31, no. 103 below, are an exception) and, less commonly, Amazons and male heads (including silens).

The earlier painters of volute-kraters often placed a figured scene on the neck of the obverse immediately below a band of ornamental pattern (cf. nos. 1/51, 2/1, 6–9) and this practice is followed by the Iliupersis Painter on nos. 6, 8, 9, 14, but on the whole he prefers an animal frieze, with two lions or griffins confronted (nos. 1, 7), sometimes with a plant (no. 2) or another animal (nos. 3, 4, 10) between them; and on no. 13 with a head of Pan. Characteristic of his lions are their spoon-shaped tongues, which often loll from their open mouths (e.g. nos. 2–4, 7, 10, 13; cf. also the lion on no. 16). Two kraters (nos. 5 and 11) show an important new development in the decoration of the neck, in the form of a female head surrounded by flowers and tendrils, and provide the prototypes for what is to be perhaps the most characteristic decorative element in later Apulian – a head, usually in added colour, in a very elaborate floral setting, which is rightly regarded as one of the "hall-marks of developed Apulian" and which does not find an exact counterpart on any other of the South Italian fabrics, although some of the Apulianizing vases from Paestum (e.g. those by the Aphrodite and Floral Painters) strongly reflect the influence of Apulian floral pattern-work (see Greco, *Il Pittore di Afrodite,* pp. 16 ff., pls. 1 and 4). On the Boston krater (no. 11) we see in r.f. the head of a girl in three-quarter view, slightly inclined to the right, rising from two acanthus leaves and framed between the stems of a plant with spiralling tendrils and bell-like flowers. Such floral compositions may be associated with the Sicyonian painter Pausias, who flourished in the second quarter of the fourth century B.C., and who developed the art of flower-painting (Pliny, *NH* 35, 123–5; Robertson, *History of Greek Art,* pp. 486 ff.). Pebble-mosaics from Sicyon (Robertson, *JHS* 87, 1967, pp. 133–4, pl. 24; see also Williams, *Hesperia* 45, 1976, p. 114, n. 13) show plants with bell-like flowers and curling stems, as do those from Vergina-Palatitsa (Vanderpool, *AJA* 61, 1957, pl. 86, fig. 14); scroll-like leaves are found on the Olynthus mosaics (see Robertson, *JHS* 85, 1965, p. 78, pl. 18, 2 and Robinson, *Olynthus* V), and the border of the somewhat later stag-hunt mosaic from Pella (Robertson, loc. cit., pl. 20, 2; id., *History of Greek Art,* p. 488, pl. 153a; Petsas in *La mosaique greco-romaine,* pp. 41 ff., with bibliography, and fig. 7; *The Greek Museums*: Pella, pp. 255 ff., figs. 2–5), signed by Gnosis, gives a very close parallel to the decoration on the necks of volute-kraters by the Ganymede and Baltimore Painters in the last third of the century. Even closer is a mosaic floor from Epidamnus (Dyrrhachium) in Albania, which shows a female head surrounded by florals, almost exactly as on Apulian vases (Rumpf, *MZ,* p. 139, fig. 16; *Shqiperia Arkeologjike,* pl. 99; *Archéologia,* no. 78, Jan. 1975, ill. in colour on p. 33; Robertson, *History,* p. 487, pl. 152 c, and n. 107). As Robertson (op. cit., p. 486) points out, it is improbable that Greek mosaics and Apulian vase-painting would have had any direct influence on each other, and it is more likely that both "reflect an important

new development in contemporary painting", of which Pausias was the chief exponent. Nor should the possible influence of architectural decoration be overlooked, as somewhat similar motives appear on the ceiling-coffers of the Tholos at Epidaurus (after 370 B.C., see Lyttleton, *Baroque architecture in classical antiquity,* p. 32, pl. 34; Papadakis, *Epidauros,* pls. 29 and 33; cf. also the fragments from Lecce and Taranto illustrated in figs. 55–58 of Bernabò Brea "I relievi tarantini in pietra tenera", in *RivIstArch* n.s. 1, 1952, pp. 85 ff.); an acanthus base is used for the palmette acroteria of the Parthenon (Jacobsthal, *OGV,* pl. 134 a and c; Gropengiesser, *Die pflanzlichen Akrotere,* pls. 6, 10, 33–34) and the Argive Heraeum (Gropengiesser, pls. 14 and 21; also at Tegea, pl. 29), and it also appears below the palmette decoration on several Attic vases of the later fifth century (e.g. *OGV,* pl. 129). However, it is quite clear that, once introduced as an ornamental element into Apulian vase-painting, floral patterns soon become very popular and increasingly elaborate, and they must be regarded as a particular specialty of that fabric and one of its more significant contributions to vase decoration (see Jucker, *Das Bildnis in Blätterkelch,* pp. 195 ff., figs. 125–8).

The flowers themselves are not always easy to identify, since they are drawn in a highly stylised manner, but among them we may note the convolvulus (campanula), dianthus, lily and rock-rose, together with thistles, acorns, spiralling tendrils and buds of different sorts. Acanthus leaves often serve as a basis, and from them springs a garland of assorted floral forms which, while modelled on nature, are artificially combined to heighten the decorative effect.

On the neck of B.M. F 227 (no. 5) the head, which is crowned by a polos, is shown in full-face between stems with flowers and thin spiralling tendrils; above is the incised inscription ΑΥΡΑ (Webster, *Hellenistic Art,* pl. 2 and p. 25; Jucker, op. cit., fig. 127), which at least identifies this particular head and calls to mind the αὔρα φέρουσα ἀπὸ χρηστῶν τόπων ὑγίειαν (Plato, *Rep.* 410 c), though perhaps Aura is not altogether to be dissociated from the scene below, Pluto carrying off Persephone. This seems to be a particular instance, and it is unlikely that the general run of female heads is meant to represent Aura – sometimes it is certainly Aphrodite, since she is attended by Erotes (e.g. Moscow 747; B.M. F 278; New York 17.120.240), at others perhaps Nike, since it is enclosed by wings (e.g. Bochum S 993). The Triptolemos on the neck of no. 14 is the forerunner of many other mythological scenes, like Ganymede with the swan, or Phrixos on the ram, represented in a similar floral setting, which becomes somewhat incongruous in these circumstances; a particularly good example of this may be seen on a calyx-krater in a private collection in Naples by the Lycurgus Painter (no. 16/7, Pl. 148, 4; Schneider-Herrmann, *BABesch* 50, 1975, pp. 271 ff., fig. 15), which depicts an Arimaspian fighting a griffin, a scene transferred, as it were, from the smaller scale of the neck-picture to become the main decoration of the obverse, which emphasises the incongruity of the elaborate floral setting (cf. also the Bellerophon dish from Altamura from the workshop of the Baltimore Painter). The corresponding decoration on the reverse is usually much simpler and consists of some form of palmette, normally a central fan with side-scrolls (as on nos. 1, 4, 6, 7, 8, 10), sometimes with an acanthus base (nos. 2, 9); later the reverses have more elaborate designs, including female heads when there is a figured scene on the obverse (e.g. Leningrad 1711; Moscow 747; Basel BS 464).

The decorative patterns regularly used by the Iliupersis Painter on his volute-kraters are:
rim — egg pattern.
neck — wave, ivy, berried laurel; sometimes with a narrow dividing stripe decorated with strokes (nos. 2, 9) or bead and reel (no. 1).

shoulder — tongues, sometimes with a narrow band of egg pattern below (e.g. nos. 1, 4–7 with egg pattern; 2–3, 8–9 without).

below the pictures — meanders, commonly in groups of three, interspersed with saltire squares, with lines at the middle of each side, *not* dots.

His meander and saltire squares are remarkably uniform; the latter are sometimes left open at the top (e.g. nos. 7, 13, 17, 43–44), in which case the side strokes tend to be rather larger; the quartered square (see nos. 6/53 and 57) is still very rare (e.g. no. 38). A palmette and lotus pattern appears on the rim of no. 14 and on the necks of the pelikai nos. 20–23, and also, in added white, on the plinths of the naiskoi on nos. 28–30. He is also fond of a wide variety of adjuncts —shields, with various different emblems; decorated cistae and boxes; laurel trees and plants; sashes with a zig-zag pattern down the centre and fringed ends; windows and phialai.

Ground-lines are shown by rows of dots; sometimes there are small heaps of stones, interspersed with white pebbles (e.g. nos. 9, 13, 16). A new feature is the presence of the "reflecting pool" into which Europa looks on Louvre K 3 (no. 17; Pl. 62, 1), and beside which a woman is seated on Boston 1970.235 (no. 11; Pl. 61, 3). This looks not unlike a rock, since the painter has not fully mastered the problems of perspective, but it is in reality a small pool, with plants growing around the edges, and it is destined to play a part of increasing importance on later Apulian vases; on both the vases here referred to, a woman with a hydria stands beside it, suggesting that she has come to collect water from the pool or from the spring which feeds it. Another attempt at perspective drawing, also not entirely successful, may be seen on the two Ruvo vases depicting the temple at Delphi (nos. 3–4; see Richter, *Perspective,* p. 46 and figs. 176 and 197).

In his drawing of the three-quarter face, the Iliupersis Painter stands between the Painter of the Birth of Dionysos and the Lycurgus Painter; his faces have not yet acquired the tormented look so characteristic of the latter's, but on some of his vases (e.g. nos. 2, 8, 9, 16) they clearly show the effects of strain or concentrated effort. Women's hair is often drawn with long curls down the back or at the sides (e.g. nos. 1, 3, 7, 8, 25, 27, 42, 44, 50, 67). Their favourite garment is a peplos with a narrow black girdle tied with a loop around the waist and a couple of small dots at each end (e.g. reverses of nos. 1, 4, 6, 7, 8), when they are running, it billows out behind their legs with a very wavy border. Sometimes the peplos has an overfall (e.g. nos. 1, 8, 26), and at others there is a short cloak draped across the body (e.g. nos. 2, 3, 6, 10, 11). The peploi are not elaborately decorated; Iphigenia's on no. 3 has an inset black stripe with a white pattern running down the centre, but this may be to emphasise her role as a priestess or perhaps under the influence of stage costume (see, however, Cambitoglou in *AntK* 18, 1975, p. 65 and cf. the woman to right on no. 33). One noteworthy feature is the way in which the painter regularly leaves a bare triangular space immediately below the shoulder, when the arm is extended (cf. the woman by the naiskos on no. 1, reverse of no. 6, the woman with the kalathos on no. 7, the maenad on the reverse of no. 16, and the woman to left of the apple tree on no. 33). Women often pluck at the drapery above their shoulder (e.g. nos. 2, 6, reverses of 7 and 8, 11, 16) and sometimes draw a short cloak over their heads with a veil-like effect (e.g. nos. 2, 5, 11, 13, 17, 25). A radiate stephane, frequently with three spikes, is the normal headdress.

The heads of both women and youths are neatly drawn; the nose is small, there is a fine line between the upper eyelid and the brow, and the dotted pupil is often wedge-shaped. Arms tend to be less well drawn and often have a rather rubber-like appearance. Women's breasts

are well-developed, and the projecting nipple is often clearly seen beneath the drapery (cf. nos. 3, 5, 11, 13, 21, 25); on nude youths, the nipples appear as small circles, when in profile projecting out from the body (cf. the reverses of nos. 7, 11, 13, 18, 25, 30), and often placed too far to one side. The painter is fond of standing his figures on tiptoe to express movement, especially on the bent leg (e.g. nos. 1, reverse of 6, 8, reverses of 9, 17); there are two curving lines at the knee and a drop-line for the ankle.

The Iliupersis Painter was a productive artist and over sixty vases may be attributed to his own hand. He decorated a wide range of shapes, including several dishes and rhyta (nos. 50–66; 88 ff.), which up to now have appeared only rarely in Apulian (cf. the dishes by the Truro Painter, nos. 5/184–6 and Berlin F 3344 by the Painter of Karlsruhe B 9, no. 6/44, which must be almost contemporary, and the rhyton Bari 6257, no. 6/31 also by that painter). Some dishes have flat handles with painted figures (e.g. nos. 50–54), on others the handles are raised and decorated with knobs (nos. 57–64; see G. Schneider-Herrmann, *Apulian red-figured Paterae = BICS,* Suppl. no. 34, 1977, and Schauenburg, *AA* 1976, pp. 72–78); the shape, at least in r.f., is confined to Apulian and in the later stages of the fabric assumes quite remarkable dimensions, sometimes exceeding 70 cms. in diameter.

Although the vases of the Iliupersis Painter cover a wide range of subjects – mythological, Dionysiac, dramatic, funerary and genre – they are characterised by the constant repetition of a number of stock figures, which provide convenient links between one vase and another, almost irrespective of their themes, and of various adjuncts like lavers, boxes, sashes, kalathoi, balls, etc. Another feature to which reference should be made is his use of inscriptions to identify some of the characters who are represented upon his vases. Such inscriptions, of course, have virtually no place on vases of the "Plain" style on which mythological subjects are comparatively rare, but on the larger "Ornate" vases which lend themselves to mythological compositions on a larger scale they become more common at this period and later, although they never come into widespread general use in South Italian, the signed vases of Asteas and Python at Paestum being notable exceptions. A comparison between the letters used by the Iliupersis Painter in his inscriptions on nos. 3–6 and 52 will show a considerable measure of uniformity, especially in regard to E,M,Σ, and leaves little doubt that they are all the work of the same hand.

The Iliupersis Painter, as might be expected, had a considerable influence not only on the work of his colleague, the Painter of Athens 1714, and his other associates, but also on the followers of the Dijon Painter, who are dealt with in Chapter 9. It is not always easy to tell their work apart, especially when it survives only in small fragments. A number of such, almost all of Tarentine provenience, has been ascribed to the Iliupersis Painter himself (nos. 73–79); there are many other similar pieces, but they have not been included here, unless their attribution is reasonably certain.

(i)

Volute-kraters

(a) WITHOUT MASCAROON HANDLES

* 1 Leningrad inv. 577 = St. 352. Recomposed from large fragments, with some repainting. PLATE 60, 1–2.
 (a) Nude youth in naiskos with bird in r. hand, leaning against a laver; to l., two women and a youth with offerings; to r., nude youth, and woman looking at b.f. amphora, (b) two youths and two women with offerings at a stele.
 Neck: (a) confronted griffins, (b) palmette.

2 Milan, "H.A." coll. 377.

Cat. Caputi, pl. 7; W., p. 349, no. 3; Ghali-Kahil, *Hélène,* pl. 41, 2; Sena Chiesa, pp. 343 ff., no. 3, pl. 3, figs. 5—6; *CVA* 1, pls. 5—6; Moret, *Ilioupersis,* pl. 73.

(a) Theseus and the Marathonian bull, (b) Dionysos with three maenads.

Neck: (a) confronted lions with plant between them, (b) palmettes.

3 Naples 3223 (inv. 82113).

W., p. 349, no. 10; FR iii, pl. 148, p. 165, fig. 79; White, *Perspective,* pl. 6a; Richter, *Furn.*2, fig. 654 and *Perspective,* fig. 197; *LAF,* no. 129 (ill.); *Ill.Gr.Dr.* III.3, 28; *Hist.Hell.Eth.* III.2, p. 395 (colour); detail: Schneider-Herrmann, *BABesch* 48, 1973, p. 182, fig. 1.

(a) Orestes in Tauris, (b) two youths and two women.

Neck: (a) spotted deer between two lions.

Found together with the loutrophoros Naples 3242. The names of Pylades, Orestes and Iphigenia inscribed in added white beside them.

* 4 Milan, "H.A." coll. 239. PLATE 60, 3.

W., p. 349, no. 11; *Ill.Gr.Dr.* III.3, 9; Sena Chiesa, pp. 328 ff., no. 1, pl. 1, 1—2; *CVA* 1, pls. 1—2; Moret, *Ilioupersis,* pl. 51, 1; *Hist.Hell.Eth.* III.2, p. 391 (colour).

(a) Neoptolemos at Delphi, (b) thiasos — Dionysos, two maenads, papposilen and Pan.

Neck: (a) fawn between two lions, (b) palmettes.

The names of Neoptolemos, Orestes and Apollo are inscribed in white letters above their heads.

* 5 B.M. F 277. In bad condition, with most of the reverse missing. PLATE 60, 4.

W., p. 349, no. 4; Schauenburg, *JdI* 73, 1958, p. 58, fig. 5; details of reverse — Watzinger, *ÖJh* 16, 1913, p. 161, fig. 82 (before cleaning); Moret, *Ilioupersis,* pl. 62, 2; Schauenburg, *ÖJh* 51, 1976—7, p. 39, fig. 31.

(a) Pluto carrying off Persephone, (b) centauromachy.

Neck: (a) Aura (inscribed) in floral surround (Jucker, *Blätterkelch,* fig. 127; Webster, *Hellenistic Art,* pl. 2).

(b) WITH MEDALLION OR MASCAROON HANDLES

6 Leningrad inv. 586 = St. 350; W. 1137.

W., p. 349, no. 9; Cook, *Zeus* i, pl. 19.

(a) Triptolemos in snake-drawn chariot, (b) Dionysos with two maenads and two satyrs.

Neck: (a) three riders, (b) palmette.

Handle medallions: (a) mounted Amazons, (b) female masks with ram's horns.

The names of Neilos (the river in the foreground), Triptolemos, Horai, Demeter, Aphrodite and Peitho are inscribed in white letters above them.

For the subject of the obverse see Delatte, *Bull. Acad. royale Belge* 38, 1952, pp. 194—208.

* 7 B.M. F 283. PLATE 61, 1—2.

W., p. 349, no. 12; Moon, fig. 10; Trendall, *Ceramica,* pl. 22; detail — Richter, *Perspective,* fig. 194.

(a) Youth beside laver in naiskos; to l. seated youth and woman, youth with wreath; to r., seated youth and woman coming up with kalathos, (b) two women and two youths at a stele.

Neck: (a) confronted lions, (b) palmettes.

Handle medallions: satyr playing the flute and seated maenad. For similar medallions cf. Leningrad 1718 (no. 16/55).

8 B.M. F 160.

W., p. 349, no. 14; Moon, p. 46, fig. 9; Arias, *RivIstArch* n.s. 4, 1955, p. 112, fig. 20; Davreux, *Cassandre,* fig. 50; *EAA* iv, p. 108, fig. 137; *SIVP,* pl. 7; Pinsent, *Gr. Mythology,* ill. on p. 112; Galinsky, *Aeneas, Sicily and Rome,* fig. 42; Moret, *Ilioupersis,* p. 11, no. 2, pls. 8, 9, and 10, 1; B.F. Cook, *Greek and Roman Art in the B.M.,* p. 124, fig. 98.

(a) Iliupersis, (b) three warriors between two women.

Neck: (a) Dionysos with two maenads, all running to r., (b) palmettes.

Handle medallions: female heads with ram's-horns and white flesh.

Volute-kraters (continued)

9 Naples 3228 (inv. 82921). Broken and repaired.

W., p. 349, no. 2; Schauenburg, *BJbb* 161, 1961, pl. 45, 1.

(a) Achilles dragging Hector's body round the tomb of Patroclus, (b) Dionysos, two maenads and a satyr, running to r.,

Neck: (a) Amazonomachy, (b) palmette with side-scrolls.

Handle medallions: female masks, with white flesh.

Moon (p. 45) associates this vase with B.M. F 283 (no. 7).

10 Milan, "H.A." coll. 285.

Cat. Caputi, pl. 3; W., p. 349, no. 8; Sena Chiesa, pp. 338 ff., no. 2, pl. 2, figs. 3–4; *CVA* 1, pls. 3–4.

(a) Six figures (two youths, three women and an old man) grouped around the statue of an athlete on a plinth beside an Ionic column, (b) three young warriors and a woman.

Neck: (a) crane between two lions, (b) palmette.

Handle medallions: (a) female masks with white flesh, (b) female masks.

* 11 Boston 1970.235. PLATE 61, 3–4.

Vermeule, *BurlMag*, Feb. 1973, p. 118, fig. 75.

(a) Youth standing in front of woman seated by pool, looking into mirror, with seated woman and youth above, Eros and woman with hydria below, (b) woman between two nude youths.

Neck: (a) female head in three-quarter view to r., rising from acanthus with side-scrolls and bell-flowers, (b) palmettes.

Handle medallions: female heads in white.

12 Leningrad inv. 567 = St. 878.

(a) Statue of youth on plinth between acanthus florals, with a seated woman above to l. and to r., (b) two youths and two women at a stele.

Neck: (a) acanthus with side-scrolls, (b) palmette.

Handle medallions: gorgon masks, with white flesh.

13 Vatican AA 2 (inv. 18255).

VIE, pp. 192–5 (where bibliography), pl. 52 a–c; Pickard-Cambridge, *DFA*, fig. 36; detail – Rallo, *Lasa*, pl. 15, 1.

(a) Unexplained tragic scene (from the *Second Thyestes* or *Oedipus at Colonus* ?; see Séchan, *Études*, p. 209), (b) Dionysos, two maenads, a satyr and Eros.

Neck: (a) head of Pan flanked by lions, (b) palmettes.

Handle medallions: missing.

For the subject of (a) cf. the loutrophoros in a private collection in Naples, attributed to the Darius Painter.

Neck of a volute-krater

14 Matera 150121.

Il Museo Nazionale di M., pl. 32.

(a) Triptolemos in snake-drawn chariot, (b) thiasos – satyr with cista and torch, maenad with thyrsus and tambourine, fluting silen, maenad with phiale and thyrsus, all running to r.

Cf. with B.M. F 461 (no. 60 below).

Calyx-kraters (fragmentary)

15 Taranto 7104 (frr. of rim).

(a) Heads of slain suitors of Hippodamia suspended beside half-shield and chariot-wheels beside the palace of Oinomaos, (b) head of woman and head of satyr (from a thiasos ?).

For the subject of (a) cf. B.M. F 331 (no. 13/5) and an amphora in the Cirillo De Blasi coll. at Bari.

16 Munich 8714.

Lullies, *AA* 1957, col. 390, no. 12, fig. 15; de Haan-van de Wiel, *BABesch* 45, 1970, p. 120, fig. 4; Moret, *Ilioupersis*, cat. no. 81, pl. 71, 2.

(a) Herakles wrestling with the Nemean lion, (b) missing.

Bell-kraters

* 17 Louvre K 3. PLATE 62, 1–2.
 Overbeck, *KM,* pl. 6, 12; Cook, *Zeus* iii, p. 623, fig. 422; *EncPhot* iii, 34A and 35C. Photo: Giraudon
 15161.
 (a) Europa and the bull, (b) satyr, maenad and Dionysos, all running to r.,
* 18 B.M. F 66. (b) PLATE 62, 3.
 W., p. 350, no. 25; Richter, *Perspective,* fig. 177.
 (a) Herakles about to sacrifice a bull beside an altar, in the presence of Nike and a woman, (b) half-
 draped youth, athlete with strigil, and woman with wreath.
 Cf. also with Adolphseck 180 by the Dijon Painter (no. 6/154 above).
 19 Mainz, Univ. Arch. Inst. 28.
 Hampe and Simon, *Gr. Leben,* no. 9; *APS,* p. 47, no. 9.
 (a) Maenad with thyrsus and tambourine, (b) silen with situla and torch.
 A smaller vase, but from the quality of the drawing on the obverse almost certainly by the painter
 himself, rather than by the Painter of Athens 1714.

Pelikai

 20 Catania MB 4402 (L. 768).
 Libertini, *Cat.,* pl. 90.
 (a) The Garden of the Hesperides, (b) four women beside a laver, with Eros above.
 21 Taranto 14007, from Monticelli.
 (a) Eros and woman, two women seated beside a laver; to r., Ionic column surmounted by tripod,
 to r. of which are a standing woman and a youth, (b) seated youth and three women.
 For the tripod-column cf. B.M. F 271 (no. 16/5) by the Lycurgus Painter.
 22 Once London Market, Ohly.
 (a) Above: seated woman with fan and wreath, Eros with phiale; below: woman bending forward,
 nude youth holding out wreath to seated woman with lyre, standing woman, (b) standing woman,
 seated nude youth with phiale crowned by woman holding fillet, Eros above.
 23 San Simeon 5429 (SSW 10442).
 (a) Standing woman with fan, standing woman with box, leaning against seated woman opening
 box, youth with fillet leaning on staff, (b) standing nude youth with staff and strigil, standing woman,
 draped youth with staff.
 White wreath on shoulder of obverse.
 24 Naples 2384 (inv. 81754).
 (a) Seated woman with cista, standing woman with mirror and ball, (b) draped youth and draped
 woman, with wreath above altar.
* 25 B.M. F 324. PLATE 62, 4.
 (a) Woman with mirror seated on pedestal beneath a tree between two women, l. with wreath and r.
 with fan, (b) nude youth with strigil between two draped youths.

Amphorae

 26 Naples 2147 (inv. 82138), from Ruvo.
 Neapolis 1, 1913, p. 35, fig. 5b; detail of (b) – Pagenstecher, pl. 13a.
 (a) Three youths and a woman at a stele on a stepped base, decorated with black fillets, (b) woman
 between two youths at a grave-mound on which is a b.f. amphora (cf. nos. 116–7).
 27 Leiden GNV 154. Broken and repaired, with much repainting.
 (a) Woman in naiskos with woman and youth on either side, (b) seated woman and two standing
 women.

Amphorae (continued)

28 Naples 2417 (inv. 82309).

(a) Warrior with shield and two spears in naiskos with woman and youth on either side, (b) two women above and two youths below at a grave monument (cf. obverse of no. 26).

29 Madrid 11223 (L. 346).

Ossorio, pl. 41; Leroux, pl. 42; Pickard-Cambridge, *Theatre*, p. 100, fig. 32; *Guia del Mus. Arq. Nacional*, pl. 26; Paris, *Musée Arch.*, pl. 44, 1; Trendall, *PhV²*, p. 96, no. (xxv); *Ill.Gr.Dr.* IV, 7 b; Engemann, *Architekturdarstellungen*, pl. 61, 4; Olmos, *Cerámica griega*, figs. 36—7; Schauenburg, *JdI* 68, 1953, p. 62, fig. 17; detail of (a) — Robsjohn-Gibbings and Pullin, *Furniture of Classical Greece*, ill. on p. 118.

(a) Youth with lyre and man in naiskos, with mask suspended above, and a calyx-krater on each side of it; woman and youth with offering on either side, (b) two women and two seated youths at a naiskos in which is a sash and a kantharos, with black fillets, eggs and a black kantharos on the base.

For the white palmette decoration on the base of the niaskos on (a) cf. Naples 2417 and Vatican AA 4; for the naiskos on (b) cf. nos. 30—31, and also those on nos. 41—43.

30 Vatican AA 4 (inv. 18256). Foot modern.

VIE, pp. 207—9 (where bibliography) and pl. 55 a—e; detail of (b) — Ginouvès, *Balaneutike*, pl. 46, fig. 145.

(a) Mistress and maid in naiskos with four women around, (b) two youths and two women at a naiskos in which is a large vase and on the base of which are black fillets, eggs and a hydria.

31 Rome Market. A large part of the obverse is missing.

(a) Achilles and Troilos (?) at the fountain-house, with warriors and women around, (b) three youths and two women at a naiskos in which is a large vase; in front of the base, a black kantharos.

The subject of the obverse is doubtful; the building is not a naiskos, since it has four free-standing columns and the figures are not in added white. The youth by the laver may be Troilos, with Achilles, who holds two spears in his l. hand, grasping his horse by the bridle. Some of the surrounding figures are warriors, others hold offerings and would be more in place at a naiskos scene; it is unfortunate that so much of the central portion is missing or in a poor state of preservation. For the naiskos on the reverse cf. nos. 29—30.

The following amphora, which is in a poor state of preservation, looks also to be the work of the Iliupersis Painter (if not of a very close imitator):

32 Leningrad inv. 1702 = St. 810.

Schauenburg, *ÖJh* 51, 1976—7, pp. 31—32, figs. 21—22.

(a) Youth and seated man in naiskos, on each side of which is a seated and a standing nude youth, (b) four nude youths (two seated above, two standing below) with offerings at a stele.

Compare the reverse with that of no. 1 for the treatment of the stele and the nude youths.

Pelike

32a Once Market.

(a) Eros fastening the shoe of a half-draped woman (Aphrodite ?) in three-quarter view between a standing woman with an open box and a nude youth leaning on a stick; above — seated woman looking in mirror held out in l. hand and plucking with r. at drapery above her shoulder, (b) ?.

Lebetes gamikoi

33 Bari 6271.

(a) Woman seated beneath fruit tree, with youth standing beside her. On either side is a standing woman with a phiale and in the branches of the tree Eros, who places a fruit into the phiale held by the woman to l., (b) embracing couple on couch with Eros above and four women around.

34 Newcastle-upon-Tyne, University — Greek Museum.
 (a) Seated woman, Eros and youth, (b) Eros above laver between two women.
 Lid: (a) running youth, (b) seated woman.
 Cf. with Petit Palais 332 (no. 7/37).

Hydriai

35 Ravenna, Prof. Bendandi.
 Eros kneeling by laver, with two youths and two women around.
36 Ruvo 1069.
 Woman with open box, running woman with wreath beside an altar.
37 Ruvo 489.
 Seated woman holding box, standing woman with fan, woman holding sash, standing beside pillar.
 Below handles: ducks; above handle to l., kalathos.
38 Bologna 550.
 CVA 3, IV Dr, pl. 31, 3.
 Two women, l. with cista and wreath, r. with sash and mirror at grave monument with floral on top.
39 Karlsruhe B 6.
 CVA, pl. 81, 1.
 Girl with branch and cista in naiskos; to l. standing woman with open box and fillet, to r., woman
 moving away with wreath and open box.
40 Bari 6095.
 Woman with cista and sash in a naiskos, with standing woman to l., and seated woman to r. above a
 kalathos.
* 41 Naples 2390 (inv. 82299). PLATE 63, 1.
 Woman with open box seated on altar in front of naiskos, between two standing women, l. with
 sash, r. with wreath.
42 Munich 3294.
 Woman with wreath and cista seated on the base of a naiskos, with a seated woman above to l., and
 to r., a standing woman holding a sash (cf. Naples 2390).
* 43 Once London Market, Sotheby. (Ex Frankfurt Market, De Robertis). PLATE 63, 2.
 Sotheby, *Sale Cat.* 13 July 1976, no. 485, ill. on p. 194; De Robertis, *Lagerliste* I, ill. on p. 26.
 Woman with fan and cista, woman with fillet and phiale beside a shrine in which is a mirror and in
 front of which, beside a laver, sits a nude youth with a stick in his r. hand and a phiale in his l., and
 a piece of drapery over his legs.
44 Naples 3422 (inv. 82295).
 Three women, one standing and one seated to l., one with wreath standing to r., at a stele on top
 of which is a hydria, and on the base of which is a black hydria.
45 Naples 2217 (inv. 81838).
 Two women to l., and a youth and woman to r., beside an Ionic grave monument, with black
 fillets, and a black hydria in front of the base.
46 Leningrad inv. 1708 = St. 858.
 Seated woman in naiskos, with two women on either side; below — two women with offerings
 on either side of an Ionic column.

The following hydria is very close in style to the work of the Iliupersis Painter and is
probably also by his hand:

47 Naples 2106 (inv. 82372).
 Woman with fan and open box in naiskos with two seated and two standing women around.
 For the woman in the naiskos cf. no. 40 and for the woman running up below to r. nos. 30, 53,
 60; for the b.f. fan-palmette on the neck cf. nos. 39–40, 67.

Lekanides

48 Naples 2302 (inv. 82198).
 Photos: R.I. 76.1217–8.
 Dionysos seated between two standing maenads and satyrs; satyr between two maenads, all running.
49 Leningrad inv. 1651 = St. 1776.
 Woman with two flutes and Dionysos with kantharos and thyrsus on a couch, beside which is a calyx-krater and a dish of eggs; silen approaching with pointed amphora, maenad with thyrsus dancing (cf. no. 48), young satyr with two torches, woman with dish of cakes approaching altar, capering silen with flapping fawn-skin, dancing meanad with tambourine, seated silen with stick beside whom is a doe, woman putting incense on thymiaterion.

Dishes (with flat handles)

(a)

50 Brussels R 383.
 CVA 2, IV Db, pl. 4, 4a–c; Schneider-Herrmann, *Paterae,* no. F 5, pl. 5, 3.
 A. Woman with phiale, woman leaning on pillar, woman bouncing ball, standing woman. B. Two women carrying a chest between a standing woman with fan and cista, and a seated woman with a mirror.
 On handles: (a) running horse, (b) griffin.
 Closely related in style to the Ruvo dinos, Munich 3294 and Naples 2217 (nos. 67, 42, and 45).
51 B.M. F 132.
 Schauenburg, *AA* 1976, pp. 73 ff., figs. 1–2; Schneider-Herrmann, op. cit., no. F 1, pl. 5, 1.
 A. Two seated women approached by Eros, seated woman with mirror and phiale. B. Two pairs of seated women, woman coming up with cista.
 On handles: (a) panthers, (b) boar (in white).
52 Naples 2562 (inv. 82039).
 Moret, *Ilioupersis,* pl. 59.
 A. Perseus (inscribed) reflecting the gorgoneion for Athena. B. Death of Pentheus (inscribed).

(b)

* 53 Naples 2839 (inv. 82076). PLATE 63, 3.
 Schauenburg, *AA* 1976, p. 75, figs. 3–4; Schneider-Herrmann, op. cit., no. F 3. Photos: R.I. 71. 341–4.
 I. White vine-wreath. A. Maenad with tambourine and thyrsus, woman offering wreath and oenochoe to seated Dionysos, youth leaning on staff. B. Maenad, Dionysos and satyr, with torch and situla.
 On handles: hounds (in white).
54 Leningrad inv. 390 = St. 769.
 Schauenburg, *AA* 1976, p. 77, figs. 6–7.
 A. Youth with cista and palm branch resting l. arm on pillar, seated woman with mirror, Eros with fillet and wreath, woman bouncing ball. B. Draped woman with ball, seated nude youth approached by Nike with wreath, woman coming up with mirror and basket.
 On handles: hound, hare.
55 Taranto 8097, from Montescaglioso.
 Schneider-Herrmann, op. cit., no. F 2.
 A. Seated youth with stick, seated woman with cista, running woman with ball. B. Running woman with mirror, nude youth with chaplet and stick.
56 Bari 2234.
 Schneider-Herrmann, op. cit., no. F 6.
 A. Woman, Eros and two women at laver, B. Woman and Eros, standing woman and seated youth, woman with dish of offerings.

Dishes (later, with looped handles and knobs)

* 57 Ruvo 727. PLATE 63, 4.
 Schneider-Herrmann, op. cit., no. 204.
 A. Three youths between two women. B. Woman and seated youth, woman with phiale and youth with strigil.
 Cf. with Naples 2839 (no. 53).

 58 B.M. F 464.
 Schneider-Herrmann, op. cit., no. 205.
 A. Woman with sash and open box, seated woman with fan, nude youth with bird. B. Nude youth between two women, all running to r.

 59 Leningrad inv. 388 = St. 823.
 Schneider-Herrmann, op. cit., no. 201 A.
 I. White wreath. A. Youth holding branch, with foot raised on rock, woman running right with dish of cake and kantharos, standing woman with cista, seated youth with phiale and two spears. B. Seated youth with laurel branch, holding a cista opened by a woman standing in front of him; Eros offering wreath to woman with fan.

* 60 B.M. F 461. Detail of I: PLATE 64, 1.
 Gow, *Theocritus,* pl. III; Schneider-Herrmann, op. cit., no. 198, pl. 20, 1.
 I. (a) Seated woman between woman and youth, (b) seated youth between two women. In the centre: a white star. A. Komos – youth with thyrsus and torch between two running women. B. Nude youth seated between woman with fan and woman with wreath and cista.

* 61 Once Zurich, Bank Leu. B: PLATE 64, 2.
 Schneider-Herrmann, op. cit., no. 108.
 I. Female head in white to r., surrounded by laurel-wreath. A. Standing woman with fan and mirror, seated half-draped youth with phiale and branch, standing woman leaning on Ionic column, standing woman. B. Youth leaning on stick, seated half-draped woman with cista, Eros, woman with fan.
 Goes very closely with no. 60.

 62 Taranto 4437/102.
 Schneider-Herrmann, op. cit., no. 188 A.
 I. Nude youth and woman with cista by altar. A. Youth with situla and torch, woman with dish of cake and thyrsus approaching altar. B. Satyr with thyrsus and torch, maenad with bell and thyrsus.

 63 Milan, "H.A." 312.
 Schneider-Herrmann, op. cit., no. 214.
 A. Seated woman with mirror between woman with wreath and phiale and seated woman in front of whom is a small Eros. B. Woman seated between two women.

 64 Naples 2574 (inv. 82038).
 Schneider-Herrmann, op. cit., no. 206, pl. 13, 3a; Schauenburg, *Antike Welt* 7.3, 1976, p. 45, fig. 10.
 A. Satyr with situla and torch, Dionysos and maenad, each with thyrsus. B. Standing woman with wreath and fan, woman seated on cista, holding counting-stick for morra with seated youth; above them, Eros with wreath.

The two following dishes, which have been too heavily repainted to permit of a certain attribution, look close in style to the above and to Naples 2839 and, if not actually by the Iliupersis Painter, are surely a product of his workshop.

 65 Naples 2840 (inv. 82078). Much repainted.
 Pernice, *Hell. Kunst in Pompeji* iv, p. 13, fig. 16; Schneider-Herrmann, op. cit., no. F 4.
 I. White laurel-wreath, with central palmette. A. Woman with mirror, seated woman with open box, Eros, seated youth, standing woman with fillet and cista. B. Seated woman with mirror, Eros, youth, seated woman by laver, woman with open box.

Dishes (later, with looped handles and knobs) *continued*

66 Berlin F 3348.
 Schneider-Herrmann, op. cit., no. 199.
 I. White vine. A. Eros with branch and phiale, woman with cista and fan moving to r. B. Woman with fan and phiale running to l., followed by nude youth with situla, his drapery billowing out behind his back.

Dinos with twisted handle (on stand)

* 67 Ruvo. (The stand is 1618, but the vase itself seems to have no number). PLATE 64, 3.
 Sichtermann, K 78, pls. 136–7; Schneider-Herrmann, *Paterae,* pl. 3, 2a–b. Photos: R.I. 64.1232–5.
 Woman with open cista by Ionic column, woman with long hair holding dish above box beside which is seated a woman holding a b.f. aryballos, running woman with ball and cista.
 B.f palmettes and lotus buds on shoulder; four r.f. fan-palmettes within the spokes of a wheel on the base.

Oenochoe (shape 3)

68 Bari 2416, from Ruvo.
 Nude youth with drapery behind his back, and draped woman with mirror beside an altar.

Squat lekythoi

69 Bochum S 573.
 Kunisch, *Jb. Ruhr-Universität Bochum* 1974, pp. 142 ff., figs. 8–13; *Wallraf-Richartz-Jb.* 37, 1975, p. 304, fig. 17.
 Nude youth with cista, seated woman on cista catching ball, Aphrodite with mirror in r. hand, clasping Eros in l.

70 Wassenaar, Noorden-Lochard coll.
 Woman with cista looking to r.

71 Mainz, University 181.
 Woman with bird perched on right hand.

With the above (especially nos. 57, 60, 63), and with the women on some of the fragments and plastic vases which follow, the seated woman on the following vase should be compared.

Pelike

* 72 Taranto, Baisi coll. 38. PLATE 64, 4–5.
 (a) Seated woman with bunch of grapes and phiale, (b) lozenge pattern.
 The pattern on (b) will reappear on a number of later Apulian vases (e.g. by the Darius and Underworld Painters) with slight variations; it is perhaps derived from the decoration on some Apulian vases imitating the St. Valentin class (see *EVP,* pp. 219 ff. – the Xenon Group).
 The seated woman should also be compared with the one on the squat lekythos on the Zurich market (no. 131 below).

With the seated woman on no. 72, the one on the following vase should be closely compared:

Stemless cup

72a Basel Market, Palladion.
 Katalog (1976), p. 46, no. 45 (ill.).
 Seated woman holding wreath and spray.
 Note the characteristic V-shaped gap beneath the outstretched right arm.

Fragments (mostly from amphorae or kraters)

73 Sydney 51.48 and 53.12.
 (a) Lower part of seated youth holding shield; head and shoulders of woman holding up wreath; arm and shoulder of another woman.

(b) Upper part of nude youth; part of a large shield to r.

These two fragments seem to come from the same amphora.

74 Amsterdam 4646, from Taranto.
Maenad holding up tambourine in l. hand.

75 Reading 22.3.30.
Woman holding cista.

76 Amsterdam 2509.
Upper part of woman holding dish of eggs; hand and arm of another woman.

77 Zurich Market, Arete.
Head of woman (cf. with Amsterdam 2509).

78 Taranto 54944, from Taranto.
Schauenburg, *RM* 79, 1972, pl. 25, 1.
Woman seated beside open window.

79 Policoro.
(i) Upper part of maenad with thyrsus, (ii) foot, lower part of woman, two feet.

Fragments of the upper part of the obverse of a krater in Policoro (35551; Photo: R.I. 69.2970), representing a white-haired man holding an oar (Charon ?) beside a column sur-mounted by a sea-horse, to right of which is the head of a woman and part of an Eros flying to right, look to be associated in style with the work of the Iliupersis Painter and might possibly by by his own hand.

Lost vase (amphora ?)

The following vase, now lost to sight, looks as if it were by the Iliupersis Painter from the treatment of the subject and the drawing of the seated youth and the running woman.

80 Raoul-Rochette, pl. 30.
(a) Vase in naiskos on the base of which are two black vases; to l., seated woman and youth with spear and helmet, to r., seated youth with shield, and woman with cista moving off to r.

The stepped pyramid on top of the naiskos finds a close parallel on the following fragment, which should also probably be placed here (cf. the hanging fillet with zig-zag pattern and fringe).

Fragment

81 Los Angeles, Neuerburg coll.
Neuerburg, *Archaeology* 22, 1969, p. 111.
Upper part of naiskos, with stepped pyramid on top.
Cf. Karlsruhe B 5 and Taranto 8922 (no. 13/1).

(ii) PLASTIC VASES

Some, at least, of the following plastic vases look to be by the Iliupersis Painter himself (e.g. nos. 83, 87—91); the others are very close in style and are probably products of his workshop (cf. also with the Painter of Athens 1714).

(a) TWO-HANDLED (KANTHAROID) VASES

Io head

82 Los Angeles 50.8.25 (ex Marshall Brooks).
Sotheby, *Sale Cat.* 14 May 1946, no. 63; Clement, *Hesperia* 24, 1955, p. 23; *CVA*, pl. 43.
(a) Seated Eros with phiale, swan to l., and fawn to r., (b) woman playing harp. Below — frieze of lions.

Janiform – silen/woman

83 Copenhagen 13790.
 (a) Woman with wreath and phiale running towards altar, (b) young satyr bending over raised foot, holding wreath and phiale.
84 San Simeon 5666 (SSW 9812).
 Smith, *AJA* 49, 1945, pp. 473 ff., fig. 7, 4a–c and 8, 5.
 (a) Reclining satyr playing the pipes, (b) woman bending down to pick up bird.
85 Ruvo 1514.
 Sichtermann, K 125, pls. 164–5, 1.
 (a) Silen with situla and torch, (b) Nike flying r. with fillet.
86 Ruvo 1510.
 Sichtermann, K 126, pls. 164–5, 2.
 (a) Youth with phiale reclining on couch, (b) seated woman with wreath.

Bull's head

87 Canberra, A.N.U. 65.33.
 (a) Running woman with tambourine, (b) running woman with thyrsus and phiale (head missing).

(b) RHYTA

88 Ruvo 1361 (bull-head).
 Hoffmann, *TR*, no. 58, pl. 7, 1 and 3. Photos: R.I. 64.1092–3.
 Nude youth with phiale and drapery over l. arm.
89 B.M. F 422 (bull-head).
 Hoffmann, *TR*, no. 57, pl. 7, 2 and 4.
 Satyr playing the flute.
90 Malibu 71 AE 196 (bull-head).
 Holo, *GettyMJ* 1, 1974, p. 87, figs. 6–8 and p. 90, fig. 12.
 Woman with tambourine.
91 Ruvo 1405 (bull-head).
 Hoffmann, *TR*, no. 42, pl. 8, 1–2. Photos: R.I. 64.1110–1.
 (a) Seated Zeus with thunderbolt and sceptre, (b) woman bending down over swan.
92 B.M. F 425 (ram-head).
 Hoffmann, *TR*, p. 30, no. 142, pl. 16, 1–3; Holo, loc. cit., p. 86, figs. 4–5.
 Silen in front of Dionysos seated by kottabos-stand.
93 Malibu 71 AE 195 (ram-head).
 Holo, loc. cit., p. 86, figs. 1–3 and p. 90, fig. 11.
 Seated half-draped youth with strigil.
94 Ascona, Galleria Case Serodine (ram-head).
 Woman with wreath and kantharos, seated nude youth with wreath and strigil.
95 B.M. F 433 (griffin-head).
 Hoffmann, *TR*, p. 74, no. 440, pl. 44, 2 and 4.
 Seated youth with phiale.
96 Trieste S 496 (griffin-head).
 Hoffmann, *TR*, p. 74, no. 442, pl. 44, 1 and 3; *CVA*, IV D, pl. 29, 3–4.
 Seated youth with phiale of offerings.
97 Bari 20172, from Gioia del Colle (deer-head).
 Van Buren, *AJA* 63, 1959, pl. 97, fig. 12; Scarfi, *MonAnt* 45, 1961, pp. 277 ff., figs. 108, 114–5; Hoffmann, *TR*, p. 59, no. 356, pl. 39, 1–3.
 Nude youth with spear; satyr holding up torch.
 The deer-head is bridled and the horns are painted on to the bowl.

(c) DRINKING HORNS

98 Ruvo 1127.

 Sichtermann, K 137, pl. 175, 2; Hoffmann, *TR,* p. 84, no. 505, pl. 48, 1b and pl. 49, 3. Photos: R.I. 64.1119–20.

 Young satyr with calyx-krater in front of seated maenad with torch and thyrsus.

99 Ruvo 1325.

 Sichtermann, K 138, pl. 175, 3; Hoffmann, *TR,* p. 84, no. 504, pl. 48, 1a and pl. 49, 2. Photos: R.I. 64.1119–20.

 Thiasos — satyr with torch and situla, maenad, Dionysos with thyrsus, satyr with torch and wreath, maenad with tambourine.

2. VASES ASSOCIATED WITH THE ILIUPERSIS PAINTER

This section lists a number of vases which in style are to be closely associated with the Iliupersis Painter and are almost certainly products of his workshop. In a few cases the hands of specific painters can be recognised, but for the most part the vases fall into related groups, connected by similarities in subject, drawing and pattern-work.

(i) LARGER VASES

Volute-kraters

100 Naples Stg. 31.

 Jacobsthal, *Aktaions Tod,* p. 11, fig. 13; Schauenburg, *JdI* 84, 1969, p. 44, fig. 11, and 89, 1974, p. 165, fig. 35.

 (a) Actaeon slaying stag in presence of Pan, Hermes, Artemis and satyr, (b) nude youth with drapery over l. arm, nude youth with strigil, half-draped youth, nude youth with stick.

 Neck: (a) boar and lion, (b) palmette.

 Handle medallions: Amazon (?) heads in added white, wearing Phrygian caps.

 This vase is extremely close to the work of the painter himself, especially the reverse, which should be compared with those of nos. 18 and 25. For the lion on the neck of the obverse cf. nos. 2–4, and for the foreground no. 5; note the presence of the spring with two waterspouts, in contrast to the reflecting pool on nos. 11 and 17.

*101 Bari 1394, from Ceglie. In very bad condition. Detail of (a): PLATE 65, 1.

 Mayer, *Apulien,* p. 72, note 2; Pagenstecher, p. 50, detail on pl. 14d.

 (a) Offerings at a stele, on the base of which are a shield and a r.f. panathenaic amphora, (b) mostly missing — Ionic column, woman, youth with two spears.

 Neck: (a) frontal female head in floral surround.

 The obverse has been very badly damaged but enough of the figures remains to suggest a close stylistic connexion with the Iliupersis Painter, both in the grave monument (cf. no. 26) and, more particularly, in the treatment of the woman to r. holding up a wreath (cf. the reverses of 10, 11, and 17) and in the drawing of the faces in three-quarter view (cf. nos. 2, 4, 9). The head on the neck should be compared with that on no. 11, and also with that on the reverse of Ruvo 1372 by the Painter of the Dublin Situlae (see Chapter 15, 2).

102 Ruvo 1722A = XIX (*Cat.* p. 992). Some repainting on the restored reverse.

 Sichtermann, K 53, pls. 86–88. Photos: R.I. 64.1197–9.

 (a) Nike sacrificing a ram in the presence of two warriors (Dioskouroi ?), Athena, a woman and to l. an attendant bearing armour, (b) thiasos — satyr, Dionysos and two maenads.

 Neck: (a) confronting griffins.

 For the griffins on the neck cf. no. 1; the drawing of the hair of Athena and Nike should be compared with that of the Painter of Athens 1714 (e.g. nos. 146–7 and 149–50), but the treatment of

Volute-kraters (continued)

the drapery, especially of the running figures on the reverse is closer to the manner of the Iliupersis Painter (cf. the thiasoi on the reverses of nos. 4, 6, 9 and 21, and on the exterior of no. 60).

103 Leningrad inv. 2085; W. 987. In bad condition and much repainted.

W., p. 349, no. 13; *AA* 1958, 33—4, fig. 6; Jacobsthal, *OGV*, pl. 108a; (b) Schauenburg, *Monumentum Chiloniense (Festschrift Burck)*, pl. 8, fig. 15.

(a) Achilles and Troilos, (b) death of Pentheus.

Neck: (a) floral, (b) palmettes.

The vase is too repainted to admit of any certainty, but the figures on the reverse, especially the standing and running maenads, are closely connected in style with those of the Iliupersis Painter. For the subject of the obverse cf. no. 31, particularly in regard to the fountain-house and to the horse of Troilos.

104 B.M. F 159.

W., p. 349, no. 20; FR iii, p. 165, fig. 80; Pinsent, *Gr. Mythology,* ill. on p. 119.

(a) Sacrifice of Iphigenia, (b) two youths and two women.

Neck: (a) two griffins with palmette between (cf. nos. 1 and 102).

This vase reflects the influence of both the Iliupersis Painter and the Painter of Athens 1714; the reverse should be compared with that of Leningrad 586 (no. 6), and also with the vases in the sub-group of Copenhagen 335.

Hydria

105 Munich 3267 (J. 807).

Philippart, *Iconographie des Bacchantes,* p. 54, no. 137 (where bibliography), pl. 7a.

Shoulder: Peleus and Thetis between, to l., centaur, Aphrodite and Eros; to r. Nereus and Nereid on dolphins. (Birgitt Schiffler, *Typologie des Kentauren,* no. G 21, pl. 10, 2.)

Below: (a) Pentheus attacked by maenads, (b) battle scene.

No visible trace remains of the two pairs of confronted lions in the band between the Peleus and Pentheus scenes.

This vase is in very bad condition and comparatively little of the original is now left. The Pentheus scene finds parallels in the work of the Iliupersis Painter, but in its present state it is difficult to make a more precise attribution of the vase.

Calyx-krater (frr.)

106 Taranto 133741, from Taranto.

(a) Battle between Greeks and Persians, (b) satyr with three women.

(ii) VASES WITH STELE OR FUNERARY SCENES

We have already noted on several vases by the Iliupersis Painter the presence of a stele rising from a stepped base on which various offerings, including vases shown in black silhouette, are placed (e.g. nos. 26, 44—45, reverses of nos. 1 and 7) and this practice is adopted by several of his associates, who decorate vases with similar funerary scenes. The vases listed below, which are not the work of a single painter, are linked together by the presence of a grave monument surrounded by mourners with offerings.

Amphora

107 Liverpool 51.10.2.

Inghirami, *VF,* pl. 155.

(a) Two youths beside a grave monument tied with fillets, on the base of which are two kylikes and a kantharos, (b) two draped youths, with a pillar between them.

107a Ruvo 416.
 Photo: **R.I.** 72.47.
 (a) Four youths standing (above) or seated (below) around a shrine in which are a shield and a pilos and which stands on a stepped plinth in front of which is a black amphora, (b) nude youth with spear and drapery behind his back, holding phiale in r. hand, between two draped youths.

Hydriai

(a)

108 Berlin F 3168.
 Youth with spear and sword, woman with phiale and oenochoe, youth wearing pilos at Ionic grave monument (Orestes, Electra and Pylades ?).
109 Palermo 2248 (old no. 838).
 Seated nude youth with cista, and standing woman with wreath at white stele, on top of which is a phiale outlined with dots.

(b)

110 Berlin F 3170.
 Youth with spear, woman seated on base of stele which is decorated with a black kylix and a squat lekythos, standing woman with fan.
 Below handles: owl and laurel branch.
 The treatment of the drapery is very much in the manner of the Iliupersis Painter.

(c)

111 London, Wellcome Museum R 481/1936.
 APS, p. 35, no. 27 (where attributed to the Tarporley Painter).
 Standing woman with cista and seated woman with ball and alabastron at grave stele, decorated with black fillets and with a black hydria in front of the base.
112 Paris, Cab. Méd. 978.
 Two women, one seated with fillet, the other standing with dish of offerings at an Ionic stele, on top of which is a hydria.
113 Once Zurich Market.
 Standing woman with phiale, seated woman with fan beside a kalathos on a cista decorated with a fillet.
 Below handles: owl and laurel branch (cf. no. 110).

(d)

*114 New York 56.171.65 (ex Ruesch and Hearst colls.). PLATE 65, 2.
 Ruesch Sale Cat., pl. 17, no. 32.
 Three women decking a grave stele, to the base of which are attached two black kylikes.

By the same hand as no. 114 are two fragments of a bell-krater:

Fragments

115 Sydney 51.49 and 51.50.
 Head of woman, with wing to left: Nike.

(iii) THE MOUND PAINTER

The reverse of the amphora Naples 2147 (no. 26) showed a grave-mound decorated with black fillets and wreaths, with a b.f. amphora on top of it, and a similar mound reappears on two hydriai, clearly the work of a single painter. His treatment of women's drapery is close to

that of the Iliupersis Painter and we may note his fondness for a double stripe down the peplos and for a wavy hem-line. On both the hydriai (nos. 116—7) an Ionic grave-column stands in front of the mound; the women beside it hold various offerings, including (on no. 117) a bird, which recalls some of those on vases by the Dijon Painter. The Mainz lekythos (no. 118) is closely linked by the draped woman to right who is the counterpart of the one on no. 116; the nude youth provides a connexion between the vases by this painter and those in (iv). The Ruvo volute-krater (no. 110), on the obverse of which there is a good deal of repainting, is added because of the close resemblance between the women on its reverse and those on nos. 116—8, especially in regard to the treatment of the hair and the drapery.

<div align="center">(a)</div>

Hydriai

*116 Vienna 532. PLATE 66, 1.
 Two women with offerings at an Ionic stele in front of a mound decorated with black fillets.
 117 B.M. F 19.
 Standing woman with chaplet and bird, woman with phiale seated on cista, at an Ionic stele in front of a mound.

Squat lekythos

 118 Mainz, University 180.
 Hampe and Simon, *Gr. Leben im Spiegel der Kunst,* no. 30.
 Youth with stick, woman carrying box, woman with mirror, woman with mirror, woman by stele.

Volute-krater (with mascaroons)

 119 Ruvo 413.
 Sichtermann, K 35, pl. 51. Photos: R.I. 62.1376 and 64.1349.
 (a) Woman, old silen, seated youth and Nike, (b) woman with torch, followed by youth and woman.
 Neck: (a) hound pursuing hare.

<div align="center">(b)</div>

The following should be compared with the work of the Mound Painter, especially for the treatment of the drapery of the woman with the torch (cf. with nos. 116 and 118); note also the use of enclosed saltire squares as on no. 118.

Oenochoe (shape 3)

 120 Louvre K 36.
 Schauenburg, *BJbb* 161, 1961, pl. 41, 3; Moret, *Ilioupersis,* pls. 38—9. Photos: Giraudon 15159—60.
 Athena with Odysseus and Diomede, who are carrying off the Palladion, Hecate (?) with torch.

With the above compare, in particular for the draped woman to left:

Skyphos

 121 Naples 2924 (inv. 81990).
 (a) Embracing couple on couch between two small Erotes, standing woman to l., (b) Eros, woman and youth.
 The figures to r. should also be compared with those on vases by the Painter of Boston 00.348 and the Berkeley Painter (Chapter 10, sections 2 and 3, especially nos. 52 and 53).

<div align="center">(iv) THE GROUP OF VIENNA 4013</div>

The figures on both sides of the pelike Vienna 4013 (no. 122) are extremely Iliupersic, and many parallels to them (particularly to the youth and draped woman on the reverse) will be

found on the reverses of that painter's vases (e.g. for the youth cf. nos. 7, 8, 10, 11, 17, 23; for the woman, nos. 10, 22, 23) and on the outside of his dishes (e.g. 53, 56—7. 63). The palm branches remind us of those on vases of the Hoppin Painter and his group, with which the vases below should also be compared, and we may note on the reverse of no. 120 the hollow triangles in the saltire square, so typical of that painter (cf. also with the Felton Painter). The composition, the treatment of the drapery, the posing of the figures, however, all suggest a much stronger influence from the Iliupersis Painter.

(a)

Pelike

*122 Vienna 4013. PLATE 65, 3—4.
 (a) Seated woman with palm branch, Eros leaning on tree watching woman feeding deer, nude youth with palm branch, resling l. arm on pillar. (b) nude youth with stick, and woman with mirror and palm branch.

(b)

 The two following vases, very close in style to no. 122, are by one hand, as may be seen from a comparison between the draped youths on their reverses, the two on no. 123 corresponding very closely with the first two on no. 124, especially in regard to the overhang and the "sleeve".

Pelike

123 Ruvo 748.
 (a) Eros with phiale seated below tree, standing woman with mirror, (b) two draped youths, with large fillet above.

Calyx-krater

124 Lecce 613.
 CVA 2, pl. 19, 4 and pl. 20, 4; *APS*, p. 60, no. 6. Photo: R.I. 62.1211.
 (a) Dionysos, seated maenad, and silen pouring wine out of a wine-skin, (b) three draped youths.

(c)

 The following vases are connected with the above:

Squat lekythoi

125 Edinburgh 1887.219.
 Youth, seated woman, woman with fan and fillet, youth resting l. arm on pillar.
126 B.M. F 109.
 Cook, *Zeus* iii, pl. 11; Bielefeld, *Von gr. Malerei*, pls. 8—9.
 Judgement of Paris, with Hera enthroned.

Oenochoe (shape 3)

127 B.M. F 102.
 Mingazzini, *MemLinc* 1925, pl. 2, fig. 2.
 Herakles conducted by Nike to Olympus in a biga, preceded by Eros.

Hydria

128 Bari 1369.
 Woman, youth leaning against base of monument on top of which is a laver; and youth with pilos, sword, and spear.

(v)

(a)

Oenochoai (shape 3)

*129 Athens Market, Martinos (ex London Market, Sotheby). PLATE 66,2.
 Sotheby's, *Sale Cat.* 9 Dec. 1974, no. 207, ill. on p. 121.
 Standing youth, seated woman by kalathos, and youth playing morra.

130 North Germany, private coll.
 Schauenburg, *RM* 81, 1974, pl. 175 and *Kunst der Antike – Schätze aus norddeutschem Privat-*
 besitz (1977), no. 304, ill. on pp. 355–6.
 Silen urinating, Dionysos on couch, maenad with kantharos.
 The pose of the maenad, with her raised r. foot resting upon the egg pattern border, as if it were
 on a platform, is most unusual. For the subject cf. the oenochoe by the Felton Painter, no. 7/50a
 above.

Squat lekythoi

*131 Zurich Market. PLATE 66, 4.
 Nude youth with palm branch, and seated woman with mirror and bunch of grapes.
 For the palm branch cf. Vienna 4013 (no. 122) and for the woman, the Baisi pelike no. 72 above.

*132 Basel 1921.386. PLATE 66, 5.
 Youth with sash, seated woman with bird perched on outstretched r. hand and small white Eros
 on her foot.
 The pattern below the picture, rows of dots interspersed with stars, and crosses with dots, is unique.

133 Once London Market, Sotheby's, *Sale Cat.* 29 March 1971, no. 81, ill. opp. p. 22.
 Two nude women at a laver, to r. draped woman.

Krater (fr.)

134 Amsterdam inv. 2564.
 CVA, Scheurleer 2, IV Db, pl. 4, 4.
 Woman holding mirror and youth holding flute; tree between.

 With the above compare:

Dinos (frr.)

135 New York 14.130.13 (frr.).
 Symposium – youth in three-quarter view, reclining on couch, holding kantharos, youth coming
 up with phiale; banqueter; two banqueters on a couch, youth pouring wine from a pointed amphora
 into a dinos on a stand, lower part of a draped woman.

(b)

 The following are slightly coarser in style:

Skyphos

136 Providence 25.089.
 CVA, pl. 28, 2; *Classical Vases*, no. 59, pl. 112.
 (a) Eros playing "flying angel" on a woman's back, (b) nude youth with strigil, seated woman
 with bird.

Oenochoe (special shape)

137 Tarnato I.G. 8104, from Montescaglioso.
 Schauenburg, *Gymnasium* 70, 1963, pl. 10.

Nike crowning youthful Herakles between to l., youth holding two spears and, to r., seated woman with wreath and palm branch, standing woman with fillet, and seated youth with two spears and petasos.

Cf. with the figures on the outside of the dishes by the Iliupersis Painter.

Oenochoai (shape 3)

*138 Sydney 73.02. PLATE 66, 3.
 Pentheus, with two spears and sword, assailed by two maenads, l. with branch and r. with sword.
 139 Once Zurich Market, Arete.
 Oedipus and the sphinx.
 140 Once Zurich Market, Arete.
 Youth with bird followed by dwarf attendant, with stick in r. hand and cithara in l.

These three oenochoai have subjects of unusual interest for smaller vases; the theme of Oedipus and the sphinx, though not uncommon on Attic vases of the fifth century, is rare in Apulian. For the paidagogos-dwarf on no. 140 cf. the dwarfs on the vases of the Felton Painter. In style these vases are connected with the oenochoe in Taranto (no. 137), especially by the drawing of the face and the mouth; cf. also some of the minor vases associated in style with the Iliupersis Painter (e.g. nos. 11/80–82).

<div align="center">(c)</div>

The two following vases are both by the same painter, who stands close to the Iliupersis Painter, and especially to his less pretentious work (e.g. the figures on the neck of B.M. F 160, no. 8, or on nos. 70–71). They should also be compared with nos. 136–140.

Calyx-krater

 141 Taranto 52412 (ex Rocca coll.).
 (a) Satyr wearing panther-skin, followed by Dionysos with narthex and maenad playing the double flute, (b) woman with phiale, and Eros with tendril.

Oenochoe (shape 3)

 142 Taranto 4659.
 Woman with thyrsus and fillet.

<div align="center">(d)</div>

The figures on the following vase, especially its reverse, suggest that it might be placed here; the connexion with the Iliupersis Painter (cf. no. 13) is clear, and again we may note the palm-branch held by the woman to left on the reverse.

Volute-krater

 143 Dresden 521.
 (a) Youth and woman on couch in arbour attended by two Erotes; bottom l., satyr feeding goat, (b) above – seated woman with tambourine and standing woman with tendril and tambourine; below – woman with palm-branch, nude youth with strigil.
 Neck: (a) lions devouring deer, (b) the like.

<div align="center">(vi) TWO VOLUTE-KRATERS</div>

The two volute-kraters listed below are both in extremely poor condition and have been so heavily repainted that definite attribution is not possible. They are connected by the frieze of dentils on the neck below the berried-laurel pattern, as well as by the treatment of

the drapery and the drawing of the faces. Below the main picture on Bari 3648 (no. 144) is a frieze of animals, including a "spoon"-tongued lion, so characteristic of the Iliupersis Painter; the drawing of the temple in the top right-hand corner of the obverse is also highly reminiscent of those on nos. 3–4, and the piles of stones are also in the painter's manner. The scene on the neck is almost entirely overpainted, but it must come from an otherwise lost tragedy. The Berlin krater should be compared with F 3257 (no. 7/32), especially for the palmette-decoration with figured medallions (Jacobstahl, *OGV,* pl. 117, c and d), but it looks to be somewhat later and much closer to the work of the Iliupersis Painter (cf. the running figure to right on the neck).

Volute-kraters

144 Bari 3648, from Ceglie del Campo.
 Roscher, *ML* iv, 1538 (ill.); *NSc* 1900, p. 507; Pickard-Cambridge, *Festivals,* fig. 171; Schmidt, *AntK* 13, 1970, pp. 71 ff., pls. 33–34; *Ill.Gr.Dr.* III.5, 5 (neck).
 (a) Battle scene — with Nike in quadriga above to l., and below, two warriors supporting a dead woman, with fighting warrior and dead warrior to r.; above, to r. temple with half-open door, (b) temple with half-open door, through which a woman is looking; to l. above, youth and seated woman, youth and woman touching one of the columns of the temple; to r. seated youth, woman with hydria on her head, woman running up with fan.
 Neck: (a) Clymene, Merops, Melanippos and Stornyx, who is seated upon an altar; to r., fleeing priestess, (b) missing except for one figure on the extreme r.
145 Berlin F 3256, from Ceglie.
 Jacobsthal, *OGV,* pl. 117 c; *LAF,* no. 109 (ill. of neck).
 (a) Nike sacrificing a ram in the presence of Herakles and others, (b) boar-hunt (much restored).
 Neck: (a) Orestes at Delphi, (b) thiasos.
 In a medallion in the centre of the handle-palmettes: gorgoneion.

3. THE PAINTER OF ATHENS 1714

In *APS* (p. 47) the Painter of Athens 1714 was included among the painters of the "Plain" style, although the close connexion between his work and that of the Iliupersis Painter was duly noted. With the attribution of a number of major works to his hand, it is now clear that he should take his place beside the Iliupersis Painter (see *APS Addenda,* p. 423) as one of the "Ornate" painters, who, however, also decorated a large number of vases in the "Plain" tradition, thus affording an excellent illustration of the merging of the two styles in the second quarter of the fourth century. About one hundred vases may now be assigned to his hand, of which a quarter must rank as major works. With all the new evidence now available, some of the vases assigned in *APS* to his associates like the Painters of Bologna 571 (p. 50) and of Copenhagen 335 (p. 52) are now, in fact, seen to be his own work and to illustrate different phases in the development of his style.

In the treatment of his youths and draped women the Painter of Athens 1714 stands particularly close to the Iliupersis Painter, and it is not always easy to distinguish between them. Two noteworthy points of difference emerge:

(a) the drawing of the hair, which is often designated by small curls in relief (nos. 146, 149, 150), or by rows of curls around the top of the head and behind the ears (e.g. nos. 146, 151–6), or by a series of loops (reverse of no. 157, 161). These characteristics are repeated again and again on the figures on the bell- and column-kraters in (ii) and (iii).

(b) the treatment of women's drapery. Women normally wear peploi, sometimes with overfalls (as on nos. 152–3, which may be regarded as typical), more often without (e.g.

on the reverses of nos. 155–6, and on 158, 161–2); characteristic is the frequent use of hook-folds and small, semi-elliptical lines (drop-folds), on the garments, as well as a much fussier bunching of folds at the waist above the girdle, in comparison with the much simpler rendering of the Iliupersis Painter — compare, for example, the women's drapery on nos. 151–3, 155–6, and 161–2 with that of the corresponding figures on nos. 2, 7, 8, 11 and 18, and the difference is immediately apparent.

Characteristic of the male figures are bent knees with rather pointed knee-caps (e.g. nos. 146–7, 149, 151–6); on the obverses, his youths are generally nude, with a piece of drapery in their hands, over one arm, or behind their backs, and this is also true of the reverses of his major vases (e.g. nos. 151–5). The youths often wear white head-bands and women a radiate stephane (as on nos. 152–4).

Ground-lines are indicated by white dots, sometimes with plants as well (nos. 151, 154, 161); the meanders are normally accompanied by saltire squares, with longish strokes at the centre of each side, like those of the Iliupersis Painter, but more carelessly drawn.

The work of the Painter of Athens 1714 falls into two main divisions, one consisting of his larger and more elaborately-decorated vases in the "Ornate" style, the other of his less pretentious pieces, in which those related to Copenhagen 335 form a clearly defined sub-group.

(i) MAJOR WORKS

As might be expected, the vases in this division cover a wider range of subjects — mythological (nos. 146–150), theatrical (151–3), Dionysiac (154–8), funerary (reverse of 146, 169–172), and genre (159–168) — and there is a greater use of patterned drapery (nos. 146–149, 152–4). The three kraters with theatrical themes (151–3) are among the painter's best work, the drawing on nos. 151–2 being extremely neat and careful, and it is interesting to compare them with Naples 1866 in the Long Overfalls Group (no. 4/144), which has a similar subject. The boxing match between the two satyrs on no. 156 is an amusing and original subject, and the four satyrs carrying a large, ivy-bedecked skin of wine into the house of Dionysos makes a lively picture, but, in general, the Painter of Athens 1714 has a preference for static scenes. The naiskos on no. 169 (Pl. 68, 1) should be compared with those on nos. 30–31 by the Iliupersis Painter, and the stele on no. 170 with that on the reverse of no. 1, or on no. 26.

Volute-kraters

146 Louvre CA 227.
 W., p. 349, no. 15; Moon, p. 47, pls. 15–16; Eva Keuls, *The Water Carriers in Hades*, pls. 4–5. Photos: Giraudon 15169, 27121–2.
 (a) Suppliant before seated king, (b) three women and two youths with offering at a naiskos, in which is a hydria and a round shield.
 Neck: (a) Dionysos with two maenads and a satyr, (b) maenad between two satyrs.
 Probably the chief work of the painter. The same subject appears on a fragment in Amsterdam (4670; *Neapolis* 1, 1913, p. 138). Its interpretation is open to question — Noël Moon suggested Chryses begging Agamemnon for the release of Chryseis, and, more recently, Eva Keuls has proposed Danaus requesting King Pelasgus for asylum in Athens (op. cit., pp. 75 ff.; see note 38 for other explanations), associating the scene with the Aeschylean trilogy on the Danaides, and noting a possible (if rather dubious) connexion between them and the hydria in the naiskos on the reverse.

147 Naples 1978 (inv. 82347).
 Schauenburg, *JdI* 89, 1974, p. 175, fig. 44; *Wandlungen*, pl. 36 b.
 (a) Orpheus and the Thracians, (b) Dionysos seated between woman and satyr.
 Neck: (a) griffin and lion.

Volute-kraters (continued)

148 Bari 12013. Very fragmentary, with much missing.
 Schauenburg, *Perseus,* pl. 34, 2.
 (a) Athena reflecting the gorgoneion in the presence of Hermes and Perseus, two women and a nude youth, (b) maenad, Dionysos and nude youth.

Situla

149 Rome, Villa Giulia 18003.
 Ausonia 7, p. 119; *CVA* 1, IV Dr, pl. 1–2; Pickard-Cambridge, *Theatre,* fig. 23; *LAF,* no. 135 (ill.); Helbig-Speier iii, p. 641, no. 2706; M.-L. Säflund, *E. Pdmt. at Olympia,* p. 132, fig. 86; detail: Squarciapino, *Annuario* 30–32, 1952–4, p. 135, fig. 3.
 (a) Pelops, Oinomaos and Hippodamia, preparing for the chariot race, (b) mostly missing, except for part of a standing woman to l.
 Cf. especially with Louvre CA 227 (no. 146).

Bell-krater

150 Taranto 52407 (frr.).
 APS. p. 23, no. (ii), pl. 6, fig. 27; Paribeni, *Immagini,* colour-pl. 16.
 (a) Death of Orpheus, (b) woman with cista between two youths (only the top of the woman's head and the top of the r. youth's head survive).
 Note the winged helmet worn by Orpheus, which should be compared with that on the head on the neck of Ruvo 409 (*EAA* i, colour-plate opp. p. 506) by the Painter of Copenhagen 4223, which is probably also that of Orpheus.

Calyx-kraters

151 B.M. F 275.
 APS, p. 48, no. 20, pl. 27, fig. 126; Noël Oakeshott, *JHS* 55, 1935, p. 230, fig. 1 (where associated with the Painter of the Birth of Dionysos); *PhV*2, no. (xviii a); Schauenburg, *RM* 79, 1972, pl. 24, 3.
 (a) Maenad adjusting kottabos-stand for Dionysos, who is reclining on a couch between a silen pouring wine into a calyx-krater and a maenad with a tambourine; above – female mask, (b) woman with cista between two youths.

*152 New York, Metr. Mus. L. 63.21.6 (on loan from Mr. & Mrs. Jan Mitchell). PLATE 67, 1–2.
 Formerly Hearst Estate 2351, ex Durham; Parke-Bernet, *Sale Cat.* 5 April 1963, no. 101; *PhV*2, no. (xxi), pl. 14b; Handley, *JHS* 93, 1973, p. 106, pl. 1 b.
 (a) Dionysos reclining on couch, woman playing harp, maenad and satyr; above – frontal female mask, (b) woman between two nude youths.
 Very close to B.M. F 275.

*153 Bari, Lagioia coll. PLATE 67, 3–4.
 *PhV*2, no. (xvi).
 (a) Symposium – woman, two men on couch served by satyr holding wine-skin; above – female mask, (b) draped woman with phiale between two nude youths.
 The Maltese dog sniffing at the white mouse in front of the banqueters adds a touch of humour to the scene on the obverse.

154 Madrid 11050 (L. 327).
 Ossorio, pl. 12, 2; Leroux, pl. 38, 2; Schauenburg, *Gymnasium* 64, 1957, fig. 14; Christiansen, *Gr. Vasen,* pl. 32; *APS,* p. 48, no. 21.
 (a) Dionysos and maenad (Ariadne ?) in a deer-drawn chariot followed by a silen with kottabos-stand, (b) three youths, l. seated, r. holding strigil.

155 Lecce 4089, from Rocavecchia.
 NSc 1934, p. 188, fig. 6; *APS,* p. 48, no. 19.
 (a) Youthful Dionysos, seated maenad and satyr, (b) woman and nude youth.

*156 Charlecote Park (Warwick), Sir Montgomery Fairfax-Lucy. PLATE 69, 1–2.
 AJA 63, 1959, p. 149, no. 11.
 (a) Two satyrs boxing in presence of maenad with torch and thyrsus, (b) half-draped youth and
 woman with phiale.
157 Naples 1977 (inv. 82130).
 FR iii, p. 176, fig. 92, pl. 150, 1.
 (a) Maenad with narthex entering building, followed by four satyrs carrying a wine-skin, (b) Dionysos
 between two maenads.

Column-krater

158 Bologna 571.
 CVA 3, IV Dr, pl. 15, 1–2; *APS*, p. 50, no. 1.
 (a) Maenad and silen with thyrsus and krater, seated Dionysos, and maenad plucking at her drapery,
 (b) four draped youths.

Lebetes gamikoi

159 Bari 1330–1, from Ruvo.
 (a) Standing woman, woman at laver, standing woman with fan, standing woman with bird leaning
 against pillar, (b) woman, Eros flying with wreath to seated youth.
 Lid: female heads.
160 Ruvo 1537.
 (a) Seated woman with phiale, Eros above, nude youth and draped woman with mirror, (b) draped
 woman and nude youth.
 On the knob of the lid: (a) and (b) female head.
161 Louvre K 196.
 APS, p. 48, no. 16; Schauenburg, *RM* 79, 1972, pl. 17, 1.
 (a) Seated woman between woman and youth; head of woman peering through window in the back-
 ground, (b) woman and youth.
 On the lid: (a) and (b) head of woman.
 Cf. with Louvre CA 227 and Naples 1978 (nos. 146–7).
*162 Basel, Antikenmuseum (on loan from a Swiss private collection). PLATE 68, 2–3.
 Münzen und Medaillen, *Cat.* 40, 13 Dec. 1969, pl. 50, no. 118.
 (a) Couple seated together between two women, with Eros flying above, (b) woman with cista
 between standing nude youth and seated youth.
 The youths on the reverse of this vase should be compared with those on the reverse of the skyphos
 Sydney 53.31, especially for the treatment of the face and hair.

Pelikai

163 Benevento 372.
 L'Arte nel Sannio, fig. 5.
 (a) Seated woman with cista, beside and above whom is a standing woman with fan and chaplet,
 nude youth leaning on stick, seated woman with himation drawn over her head as a veil, (b) seated
 woman, half-draped youth with strigil, nude youth with r. arm enveloped in drapery, which he holds
 up with l. hand.
164 Bari 5592.
 Schauenburg, *RM* 79, 1972, pl. 22, 1.
 (a) Woman, nude youth, seated woman and woman with fan; window, top l., (b) youth, woman
 and missing figures.
165 Taranto 52388, from Contrada Vaccarella, T. 61.
 NSc 1940, pp. 484–5, figs. 50–51.

Pelikai (continued)

(a) Seated youth, woman leaning against pillar, woman with fan, (b) woman with wreath and phiale, nude youth with stick.

Close in style to Louvre K 196 (no. 161).

166 Taranto 51183, from Contrada Solito (1934).

CVA 2, IV Dr, pl. 37, 1–3; *NSc* 1940, p. 323, figs. 13–14.

(a) Nude youth, Eros offering phiale to seated woman holding fan, (b) seated youth, and standing woman with cista.

Dish (with flat handles)

167 Bari 6457.

Schneider-Herrmann, *Paterae,* no. F 7.

A. Woman seated between standing woman with cista and nude youth with wreath, woman with ball. B. Woman with chaplet and phiale, seated nude youth, nude youth with phiale and strigil.

Dish (with loop handles)

168 Bari 8258.

Schneider-Herrmann, op. cit., no. 207.

(a) Two women and two youths, (b) youth and two women.

Close in style to Louvre K 196 (no. 161).

Hydriai

*169 Paris, Cab. Méd. 980. PLATE 68, 1.

De Ridder, *Cat.* pl. 29; Diehl, *Die Hydria,* pl. 46, 3.

Shoulder: Two women and two youths with spears around a naiskos, in which is a vase (cf. nos. 8/30–31 and Lecce 3544, no. 15/69).

Below: youth pursuing woman between seated youth and standing woman.

170 Louvre N 2852 (ED 638).

Diehl, op. cit., pl. 44, 2; Ginouvès, *Balaneutike,* pl. 48, fig. 148.

Two women bringing offerings to a stele, on top of which is a hydria.

171 Chertsey B 60.

Woman seated on altar in front of Ionic column between woman with fillet and nude youth with mirror in r. hand and l. enveloped in drapery.

The central figure of the seated woman has been extensively repainted and her head is modern; the youth to r. is very much in the style of the Painter of Athens 1714 and the vase, if not by his hand, is very close to him.

(ii) LESS IMPORTANT VASES

(a)

This sub-division contains about half of the extant vases of the Painter of Athens 1714 and these may be regarded more or less as typical of his ordinary work in the "Plain" style tradition, as distinct from the more elaborately decorated vases in (i). No vase represents more than three figures on either side and, with very few exceptions (e.g. no. 172, which shows two youths at a naiskos, or 196 which shows a seated warrior with spear and helmet), the subjects are Dionysiac or genre. Pursuit scenes are very popular (e.g. nos. 192, 198–200, 202–4, 210–2), especially on bell-kraters, generally with a Dionysiac flavour (satyr and maenad; Dionysos and woman). The scenes on the obverses of these vases correspond closely with those on the reverses of the more elaborate vases (e.g. nos. 152–3, 155–6, 161, 163, 166), as may be seen from a comparison between no. 175 and no. 156 in that respect. We note the frequent recurr-

ence of the draped woman wearing a peplos (with or without overfall), usually with a light stripe down the side (as on no. 175).

The youths on the reverses follow a very consistent pattern; the one to left normally has a "sling" drape (e.g. nos. 172, 175, 178, 186, etc.), but sometimes his body is partly frontal with the upper part left bare (as on the reverse of no. 156; cf. nos. 177, 196, 198, 200, 210–2); the youth to right generally has a "sleeve" drape and holds a stick (as on nos. 175, 178, 186, 211–2); the stick is occasionally omitted (e.g. nos. 192, 198, 210), and sometimes the youth is completely enveloped in his cloak (e.g. nos. 172, 194, 197, 199). A recurrent feature of the "sleeve" drape is the black edge to the "sleeve", with two parallel lines descending from it (as on nos. 178, 192, 197, 205–6, 211–2, 214, 218; cf. with the Dijon Painter); note also the wavy line which commonly runs across the top of the himation of the youth to right (e.g. nos. 202–3, 205–8). The meanders are almost always accompanied by saltire squares, with large strokes at the centre of each side. Small palmette scrolls regularly appear on each side of the picture on bell-kraters (e.g. nos. 196–8, 200, 203, 206–8, 212–4).

Amphorae

172 Milan, "H.A." coll. 246.
 CVA 1, IV Dr, pl. 28.
 (a) Two nude youths, l. with spear, r. with strigil, at naiskos in which is a nude youth, (b) three draped youths.
173 Matera 10369, from Timmari.
 (a) Nude youth with drapery behind his back, draped woman leaning on pillar, (b) two draped youths.
174 Ruvo 708.
 (a) Woman with chaplet, and nude youth with fillet, (b) two draped youths.
175 Warsaw 198118.
 CVA, Poland 7, pl. 34.
 (a) Youth with phiale and woman with chaplet beside an altar, (b) two draped youths.
176 Once London, Melchett coll. 50.
 Strong, *Cat.* pl. 42, 2.
 (a) Seated nude youth with phiale, standing woman with wreath, (b) two draped youths.
 The woman on (a) is very similar to the one on the Warsaw vase.
176a Geneva, private coll.
 (a) Woman with ball, and youth with wreath, at stele, (b) two draped youths.
 Cf. with nos. 175–6.

Pelikai

177 Hobart 29.
 Hood, *Gr. V. in the Univ. of Tasmania*, p. 31, pl. 29.
 (a) Woman seated on cista, and youth holding fillet, (b) two draped youths.
178 Paris, Cab. Méd. 903.
 (a) Nude youth with strigil and draped woman with mirror, (b) two draped youths.
179 Taranto 20363.
 Trendall, *Ceramica*, pl. 24, 1.
 (a) Woman with cista, and nude youth leaning on stick, (b) two draped youths.
180 Taranto 9934/441, from Rutigliano.
 (a) Woman with wreath and phiale, nude youth with stick and drapery over l. arm, (b) two draped youths.
181 Groningen, Univ. Arch. Inst.
 (a) Youth and woman, (b) two draped youths.

Pelikai (continued)

182 Ruvo 1239.
 (a) Woman with cista, and nude youth with stick, (b) two draped youths.
183 Matera 12546, from Ginosa.
 Mus. Naz. di M., pl. 37, 3.
 (a) Woman offering duck to seated youth, (b) two draped youths.
184 Verona 167.
 CVA, IV D, pl. 7, 1.
 (a) Nude youth with cista, and woman seated on Ionic capital, (b) two draped youths.
185 Baranello 135.
 Dareggi, *Ceramica italiota nel Museo di B.*, no. 16, pl. 12; and *Cat.* no. 68, pl. 27.
 (a) Woman and nude youth, with drapery over l. arm, (b) two draped youths.
186 Bari, Malaguzzi-Valeri coll. 54.
 (a) Draped woman with cista, seated nude youth with mirror, (b) two draped youths.

Hydriai

187 Naples Stg. 617.
 Standing woman holding wreath and fan, and woman holding fillet and cista, running towards
 altar.
188 Taranto 8108.
 Woman with cista, and nude youth with strigil, moving to r.
189 Louvre K 23.
 Standing nude youth, with l. arm enveloped in drapery, woman with cista, seated on altar.

Column-kraters

190 Havana, Lagunillas coll.
 Ex Sotheby, *Sale Cat.* 17 April 1950, no. 67; *APS*, p. 48, no. 11.
 (a) Maenad, satyr, and Dionysos running to l., (b) three draped youths.
191 Trieste 1796.
 APS, p. 48, no. 12.
 (a) Dionysos, maenad and satyr running to r., (b) three draped youths.
192 Bari 12210.
 (a) Satyr with wreath and situla, woman with cista and flute, satyr with horn and wine-skin, (b) three
 draped youths.
193 Taranto 8092, from Montescaglioso.
 Trendall, *Ceramica*, pl. 24, 2.
 (a) Dionysos with thyrsus and phiale, maenad with torch and tambourine, silen with situla, all
 moving to r., (b) three draped youths.
194 Copenhagen 278 (B–S. 211).
 CVA, pl. 250, 2; *APS*, p. 48, no. (ii).
 (a) Dionysos with maenad and satyr, (b) three draped youths.

Bell-kraters

195 Kassel Market, R. Schumann.
 Die Weltkunst, vol. 44, no. 12, June 15, 1974, p. 1087 (ill.).
 (a) Satyr playing the flute, maenad holding up tambourine, and Dionysos with thyrsus, all moving
 to l., (b) three draped youths.
196 Aleria (Corsica). Broken.
 (a) Woman with oenochoe and phiale, seated warrior, youth with strigil, (b) three draped youths.
197 Bari 1184.
 (a) Youth with thyrsus resting against pillar, woman with thyrsus seated on altar, young satyr with

double-flute, (b) three draped youths.
198 Athens 1714.
 APS, p. 47, no. 1, pl. 27, figs. 123–4.
 (a) Dionysos and maenad, (b) two draped youths.
199 Vatican V 16 (inv. 18069).
 VIE, pl. 29 a and 31 d; *APS*, p. 47, no. 3.
 (a) Satyr following maenad, (b) two draped youths.
200 Madrid 11084 (L. 353).
 APS, p. 47, no. 4.
 (a) Satyr and maenad running to left, (b) two draped youths.
201 Compiègne 1028.
 CVA, pl. 26, 21 and 28.
 (a) Woman with tambourine and satyr, (b) two draped youths.
202 Monopli, Meo-Evoli coll. 950.
 (a) Satyr with phiale and thyrsus moving l., followed by maenad with tambourine, (b) two draped
 youths.
203 Vienna 882.
 APS, p. 58, no. 3, pl. 34, figs. 165–6 (Valletta Painter).
 (a) Maenad with tambourine and young satyr with thyrsus running to l., (b) two draped youths.
204 Once New York Market.
 Parke-Bernet, *Sale Cat.* 24 April 1970, no. 262, ill. on p. 133, and 1 Dec. 1972, no. 199 (ill.).
 (a) Silen with tambourine, and maenad with torch and thyrsus, running to l., (b) two draped youths.

In *APS* (p. 51) two of the vases listed below (nos. 205 and 211) were attributed to the Painter of Bologna 589, who was seen as a close follower of the Painter of Athens 1714. It is now clear that, although they form a compact group, which goes closely with the amphorae nos. 172–6 above, they are by the latter's own hand. The treatment of the draped youths on the reverses is very characteristic (cf. nos. 205–6, 211 which may be taken as typical), as is the extensive use of hook- and drop-folds.

205 Bologna 589.
 CVA 3, IV Dr, pl. 23, 3 and 4; *APS*, p. 51, no. 1.
 (a) Satyr with drinking-horn, and seated maenad, (b) two draped youths.
*206 Parma C 97. PLATE 69, 3–4.
 CVA 2, IV D, pl. 4.
 (a) Dionysos with thyrsus and situla following maenad with wreath and thyrsus, (b) two draped
 youths.
207 Cremona 591.
 Pontiroli, *Cat.*, no. 58, pl. 46.
 (a) Satyr with thyrsus, and maenad running to r. with dish and tambourine, (b) two draped youths.
208 Bari, private coll.
 (a) Maenad with situla, young satyr with dish and thyrsus, (b) two draped youths.
209 Warsaw 198108.
 CVA, Poland 7, pl. 24.
 (a) Youth with spear, and woman with phiale at altar, (b) two draped youths.
210 Basel Z 305 (ex Rancate, Züst coll.).
 (a) Satyr and maenad, running to l., (b) two draped youths.
211 Copenhagen 293 (B–S. 216 B).
 CVA 6, pl. 253, 1; *APS*, p. 51, no. 2.
 (a) Satyr and maenad running to r., (b) two draped youths.

Bell-kraters (continued)

212 Vatican T 6 (inv. 17945).
 VIE, pl. 23 h and pl. 24 h; *APS,* p. 47, no. 2.
 (a) Satyr following maenad, (b) two draped youths.
213 Once Vienna 1114.
 (a) Woman with thyrsus and dish of offerings, nude youth with strigil, (b) two draped youths.
214 Karlsruhe B 3156.
 (a) Maenad with thyrsus and situla, Dionysos with torch and thyrsus, (b) two draped youths.
215 Brindisi 338.
 Benita Sciarra, *Brindisi e il suo Museo,* pl. 16; *Ricerche e Studi* 6, 1972, p. 6, fig. 2; Benita Sciarra,
 Musei d'Italia 9. *Brindisi, Mus. Arch. Prov.* p. 13, fig. 70.
 (a) Maenad with tambourine, Dionysos with wreath and thyrsus, (b) two draped youths.
216 Taranto 123518.
 (a) Woman with tambourine, nude youth with stick, (b) two draped youths.
217 Sèvres 13.
 CVA, pl. 33, 10–11 and 14; *APS,* p. 68, no. (ii).
 (a) Seated Dionysos, with thyrsus and phiale, nude youth with wreath, (b) nude youth and draped
 youth.
218 Nocera, Fienga coll., inv. De F. 581.
 (a) Draped woman with cista, nude youth with tambourine, (b) two draped youths.

Bell-krater (fragment)

219 Gravina, from Cozzo Presepe (BSR excavations, 1969).
 (a) Missing, (b) part of the draped youth to r.

(b) THE GROUP OF COPENHAGEN 335

In *APS* (p. 52) several of the vases listed below were attributed to the Painter of Copenhagen 335, but it now seems clear to us that they, like those previously attributed to the Painter of Bologna 589, are in fact by the Painter of Athens 1714 himself, since they have so many points in common with the vases in sub-division (a) above, especially in the treatment of the standing draped woman (e.g. nos. 220–1) and of the youths on the reverses.
We may note the following as particularly characteristic of the vases in this group:
(a) there is usually a comparatively wide reserved band around the head, and the hair tends to be less curly;
(b) the draped youths follow closely on those on the reverses of the vases in (ii) (a), but the wavy line across the top of the himation is more pronounced, and often takes the form of a "lightning flash" (e.g. nos. 220, 222–4, 227–8, 231, 243); the youth to right often has a "sleeve" drape, with the border of the "sleeve" shown as a flat C, below which are two parallel lines running down to the hem-line (e.g. nos. 220–1, 223–5, 231, 233) – a slight development from the type already noted on nos. 205–6 above; the overhang on the himation of the youth to left often has a pronounced S-like border (e.g. nos. 227–9, 231, 238–41);
(c) the ivy pattern on the necks of the column-kraters is usually widely spaced, often with only three leaves (e.g. nos. 220–1, 223–5, 227, 229–32; cf. with nos. 6/183–5 above); the vertical bands which serve to frame the pictures cut into the meander or wave-pattern below them (as on nos. 220–1, 223–5, 227–9; and also on nos. 192–4 above).

Column-kraters

220 Copenhagen 335 (B–S. 210).
 CVA 6, pl. 250, 1; *APS,* p. 52, no. 1.
 (a) Youth seated between athletic with strigil and woman with wreath, (b) three draped youths.
220a Once Naples, Woodyat coll.
 Sale Cat. (April 1912), no. 100, pl. 5, 1.
 (a) Dionysos seated between a satyr and a maenad, (b) three draped youths.
221 St. Louis, City Art Museum 25.38.21.
 Percy, *C.A.M. Bull.* 7, 1922, p. 12, fig. 6.
 (a) Nude youth, seated nude youth with strigil, draped woman plucking at drapery on l. shoulder,
 (b) three draped youths.
222 Bologna 584.
 CVA 3, IV Dr, pl. 16, 1–2.
 (a) Dionysos, satyr with torch and situla, and maenad with tambourine, moving to r., (b) three
 draped youths.
223 Naples Stg. 299.
 (a) Satyr with thyrsus and fillet, maenad with cista and torch, both running r., (b) three draped youths.
224 Vatican V 4 (inv. 18031).
 VIE, pl. 26 g and h; *APS,* p. 52, no. 3.
 (a) Silen persuing maenad, (b) two draped youths.
225 Trieste S 402.
 APS, p. 48, no. 13; *CVA,* IV D, pl. 6, 3–4.
 (a) Satyr, maenad with tambourine, and seated Dionysos, (b) three draped youths.
226 Madrid 32649 (P. 114).
 (a) Satyr with thyrsus, maenad with thyrsus and dish of eggs, seated nude youth with stick, (b) three
 draped youths.
*227 B.M. 1969.1–14.1. PLATE 69, 5–6.
 (a) Silen with torch and maenad running to right, (b) two draped youths.
228 Vatican V 6 (inv. 18034).
 VIE, pl. 26 c and f; *APS,* p. 52, no. 5.
 (a) Satyr pursuing maenad, (b) two draped youths.
229 Vienna 839.
 APS, p. 52, no. 6.
 (a) Maenad and satyr, (b) two draped youths.
 No berries with the ivy leaves on the neck.
230 Vienna 780.
 (a) Maenad with tambourine and satyr with wreath running to r., (b) two draped youths.
231 Bari 8008.
 (a) Dionysos with thyrsus, maenad with thyrsus and situla, satyr with wreath, (b) three draped
 youths.
232 Bari 911.
 (a) Satyr with thyrsus and tympanum, seated youth with thyrsus and phiale, nude youth with
 drapery, (b) three draped youths.
233 Naples 2349 (inv. 81873).
 APS, p. 52, no. 4; Schauenburg, *AA* 1977, p. 202, figs. 5–6.
 (a) Nude youth seated between woman with cista and athlete with strigil, (b) three draped youths.
 The mascaroon volutes on this krater, like those on the Attic vase 2205 (*ARV*2 1118, 20), seem
 to be an addition on the part of a nineteenth century restorer (see Schauenburg, op. cit., pp. 194–204
 and *JdI* 89, 1974, pp. 163–4, notes 76 and 76a).

Column-kraters (continued)

234 Naples 2054 (inv. 81706).

(a) Warrior beside horse, woman with raised foot, holding bead fillet, (b) three draped youths, l. with strigil.

235 Bassano del Grappa, Chini coll. 76. Much repainted.

(a) Dionysos with thyrsus and torch, maenad with tambourine, and satyr playing the flute, (b) three draped youths.

236 Montpellier, Soc. Arch. 271.

(a) Young satyr with raised foot, holding horn and thyrsus, between standing woman with thyrsus and dish of fruit and woman plucking at drapery on r. shoulder, (b) three draped youths.

237 Naples Stg. 451.

(a) Seated woman with phiale, Dionysos with thyrsus, satyr with wreath, (b) three draped youths, l. and r. with strigils.

Bell-kraters

238 Barletta 163.

(a) Maenad with thyrsus and phiale running to l., followed by satyr with chaplet and wine-skin, (b) two draped youths.

239 Bari 3725, from Bitetto.

(a) Woman with thyrsus and tambourine, seated Dionysos with phiale and thyrsus, (b) two draped youths.

240 Bari, Ricchioni coll. 4.

(a) Satyr with thyrsus and wine-skin, woman with phiale and torch, (b) two draped youths, as on Bari 3725.

241 Andria, Ceci Macrini coll. 6.

(a) Satyr with thyrsus, maenad with thyrsus moving r., (b) two draped youths.

241a Taranto, from Rutigliano, T. 39.

(a) Maenad with thyrsus, satyr with phiale and situla, (b) two draped youths.

242 B.M. old cat. 1302.

(a) Woman with oenochoe and phiale, and nude youth with piece of drapery over l. shoulder, (b) two draped youths.

243 Louvre K 9 (N 2805).

APS, p. 53, no. 2.

(a) Silen with torch pursuing woman playing with ball and holding tambourine, (b) two draped youths. The reverse is very close to that of B.M. 1969.1–14.1 (no. 227), especially the r. youth.

Pelikai

244 Bonn 1774.

APS, p. 53, no. (iv), pl. 30, fig. 144.

(a) Youth with stick, woman with phiale and fan, moving to r., (b) two draped youths.

245 Zurich Market, Arete.

(a) Woman with phiale by stele, youth with drapery over l. shoulder, (b) two draped youths.

(iii)

The two following vases stand very close to those in the Group of Copenhagen 335 and may be by the painter's own hand. The Eton column-krater is of most unusual shape; it had been heavily overpainted, especially on the obverse, and, after cleaning, little of the original design now remains.

Column-krater (of special shape)

246 Windsor, Eton College.

Ex Deepdene, Hope coll.; Tillyard, *Hope Vases,* no. 229, pl. 32, 3.

(a) Two Amazons fighting a griffin, (b) maenad with thyrsus and phiale, satyr with torch, both running to r.

Oenochoe (shape 3)

247 Copenhagen 341 (B–S. 251 A).
 CVA, pl. 264, 2.
 Seated nude youth with phiale, and standing draped woman.

4. ASSOCIATES AND IMITATORS OF THE PAINTER OF ATHENS 1714

This section contains a few groups of vases which seem to be by close followers or imitators of the Painter of Athens 1714.

(i) THE PAINTER OF VATICAN V 2

In *APS* (p. 47) the bell-krater Madrid 11086 was attributed to the Painter of Athens 1714, and it is certainly very close to his work, especially the vases associated with Copenhagen 335. There are, however, differences in the drawing of the faces and in the treatment of the drapery of the youth to left on the reverse and we would now prefer to see this vase as the work of an imitator. The other vases in this division seem to be the work of the same hand.

Bell-kraters

248 Madrid 11086 (L. 230).
 APS, p. 47, no. 10.
 (a) Nude youth with stick and woman with phiale and alabastron, (b) two draped youths.
249 Vatican V 2 (inv. 18029).
 VIE, pl. 25 b and pl. 24 j; *APS*, p. 53, no. (i).
 (a) Nude youth and woman, (b) two draped youths.
 Note the egg pattern under the pictures.

Pelikai

250 Once Milan Market.
 Finarte, *Cat.* 5, pl. 47, no. 89.
 (a) Woman seated between youth and woman holding cista, (b) seated youth and woman with alabastron and phiale.
251 Taranto 61418, from Ruvo.
 (a) Nude youth with stick and drapery behind his back, seated woman with wreath and alabastron, (b) two draped youths.

Oenochoe (shape 3)

252 Taranto 114574, from Taranto.
 Nude youth and woman with wreath and fillet.

With the above compare:

Olpe (oenochoe, shape 5a)

253 Altenburg 326, 1.
 CVA 3, pl. 104, 1–3; *APS*, p. 53, no. (iii) (where associated with Vatican V 2).
 Woman bouncing ball, and Eros, with a floral between them.

Lebes gamikos

254 Karlsruhe B 41.
 CVA 2, pl. 69, 1–2.

Lebes gamikos (continued)

(a) Nude woman and seated woman at laver, with two Erotes flying above, (b) woman with bird, and youth with sprig (see *JHS* 1954, p. 229).

The lid (pl. 69, 5—6) does not belong and is somewhat later.

(ii)

The treatment of the draped youths on the reverses of nos. 255—6 associates them with those in the Group of Copenhagen 335. The maenad on the Madrid krater should be compared with the woman on no. 256.

Column-kraters

255 Once San Simeon 5584 (PC 7799), then Parke-Bernet, *Sale Cat.* 5 April 1963, no. 97, ill. on p. 35.
 (a) Woman with basket on her head, followed by two Oscan youths, one playing the lyre, the other carrying torch and situla, (b) three draped youths.
256 Naples, Biblioteca dei Gerolomini.
 (a) Woman with oenochoe and phiale moving to l., followed by nude youth with wreath and thyrsus and nude youth with torch and phiale, (b) three draped youths.

Bell-krater

257 Madrid 11025 (L. 358).
 APS, p. 43, no. (i).
 (a) Dionysos with thyrsus and phiale following maenad with situla and torch, (b) woman with sword and scabbard, and youth at altar.

(iii) THE LAING PAINTER

A very minor artist of poor quality; note his use of half-*halteres* and of crossed rectangles, with dots in the intersections, as adjuncts in the field.

Column-kraters

258 Newcastle-upon-Tyne, Laing Gallery.
 (a) Woman with tambourine and phiale, warrior with shield and spear, (b) two draped youths.
259 Havana, Lagunillas coll.
 (a) Warrior with spear and shield, standing woman with phiale and wreath, (b) two draped youths.

5. A VOLUTE-KRATER DEPICTING ACHILLES AND PENTHESILEA

The following vase, at present on loan to the Antikenmuseum in Basel and shortly to be published in detail in *AntK* by M. Jacques Chamay, should be considered here:

Volute-krater

260 Basel Antikenmuseum, on loan.
 (a) Achilles and Penthesilea, (b) satyr with situla, maenad with wreath and thyrsus, seated Dionysos with cup, standing maenad with tambourine.
 Neck: (a) swastika meander with hollow, starred squares in added white, (b) janiform female head between scrolls and palmettes with bell-flowers.
 Mascaroons: (a) applied frontal female heads with white flesh, (b) profile heads in white facing inwards.

The subject of the obverse (see Schauenburg, "Achilleus in der unteritalischen Vasenmalerie", in *BJbb* 161, 1961, p. 226; Brommer, *VL*[3], p. 354; Kemp-Lindemann, *Darstellungen des Achilleus,* pp. 189 ff.) is not uncommon on South Italian vases and finds a parallel on

Adolphseck 178 and Trieste S 380, both by the Lycurgus Painter. On the present vase the representation includes Nike, who holds a wreath over the head of Achilles, as does the small Eros sent on his mission by Aphrodite in the upper right-hand corner. She is balanced on the opposite corner by a trumpeter not unlike the one figured on horseback on the Amazonomachy on the reverse of Ruvo 1096 by the Sisyphus Painter (no. 1/52). It is not unlikely that these Amazonomachies and Penthesilea scenes look back to some lost great painting in view of the many elements they have in common.

The reverse shows one of the Dionysiac scenes that regularly appear on the volute-kraters of the Iliupersis Painter and his circle, and is particularly close in style to the Painter of Athens 1714, so much so that we are tempted to attribute the vase to his own hand, in which case it would rank as his masterpiece. Those of his vases to which it stands closest are nos. 152–4, especially the first, on which we note the same elegant drawing and a marked resemblance between the standing women and the seated male figures on the reverse of the volute-krater. The drawing of the drapery, especially that of the two maenads, is very much in the painter's manner, notably the overfall with the wavy border and the piece of drapery across the front of the body and over one arm (cf. nos. 152, 156, 170). The composition of the reverse is also very like those regularly appearing on the reverses of the Iliupersis Painter and the Painter of Athens 1714, and though the use of the upright crosses in the squares with the meanders is rare in both these painters a parallel will be found on Naples 1978 (no. 147).

On the other hand, the vase has a number of elements both of decoration and in the drawing which set it slightly apart from the work of either of these two painters and they perhaps find closer parallels on some of the vases by their immediate followers discussed in Chapter 15, notably the volute-krater Ruvo 1094 (no. 15/14) on which we see a similar treatment of the mouth and a preference for heads with a slight downward inclination, which is less common on the vases in the present chapter (cf. also with Ruvo 1619, or 15/13).

The decoration on the neck of both sides is highly remarkable and without parallel on the vases of either of the two painters referred to. On the obverse is a swastika meander in added white, accompanied by hollow squares shown in simple perspective, with a star in the centre – a pattern which later becomes very popular (e.g. with the Baltimore Painter). It must be derived from architectural ornament and often appears on the bases of naiskoi (e.g. on Taranto 51011 by the Ginosa Painter, no. 14/102 below and Naples 2192 by the Chiesa Painter, no. 14/145), as well as on the terracotta decoration of some of the monuments themselves. It is also frequently found in mosaics (e.g. on the floors of a house in Athens; Travlos, *Pictorial Dictionary*, p. 398, fig. 512, and of the Theatre House at Corinth, *Hesperia* 45, 1976, pl. 24), and an excellent example in perspective will be found on one from Morgantina of the middle of the third century B.C. (*La mosaique gréco-romaine* II, pl. 3). On the reverse is a janiform female head, rising from an acanthus leaf, with a spiralling stem on either side ending in a fan-palmette and adorned with bell-shaped flowers (cf. no. 11 by the Iliupersis Painter); the double head is so far without parallel in Apulian.

The mascaroons on the obverse take the form of the usual female masks, with flesh in added white, applied to the roundels; on the reverse, however, they are painted on, a very rare practice, for which a parallel will be found on Naples Stg. 31 (no. 100), by a close associate of the Iliupersis Painter. On this vase, too, there are no swan-heads on the shoulder at the handle-joins, and the two are so alike in shape that they might well be the work of the same potter, which would provide further evidence for the connection of the Basel krater with the Iliupersis workshop.

Until the appearance of the fuller publication by M. Chamay, when more details of the vase will be available, we should prefer to reserve our final judgement. That the vase is closely to be connected with the Iliupersis Painter, the Painter of Athens 1714 and their colleagues there seems to be no doubt, but a specific attribution is at the moment open to question.

CHAPTER 9

FOLLOWERS OF THE PLAIN STYLE TRADITION (A)
PAINTERS INFLUENCED BY THE DIJON GROUP

Introduction

The vases in this chapter, which for the most part may be dated in the second quarter of the fourth century, illustrate the continuation of the "Plain" style tradition and follow closely on from the work of the Dijon Painter and his circle, although they also reflect the influence of the Iliupersis Painter and the Painter of Athens 1714 in their increasing use of "Ornate" devices and of more elaborate pattern-work. The Painter of Athens 1680 also has a close connexion with the Felton Painter, especially in the drawing of faces.

Noteworthy is the growing popularity of the quartered square, with a dot in each quarter, to accompany the meanders, although saltires are still extensively used (especially by the Painter of Athens 1680). The "sling" drape, which was common with the Dijon Painter, now tends to become slightly extended to produce a "saucer" effect, which is used, fairly frequently from this time onwards (e.g. in the Group of Geneva 2754 and the by Painter of Athens 1680 and the Avignon Painter; cf. Pl. 97, type A1).

Vase production at this period increases steadily, and the extreme uniformity of style within a given workshop often makes it difficult to distinguish between individual painters. For that reason many of the sections are concerned with groups of related vases rather than with single painters, although, where possible, an attempt has been made to identify them. Comparatively few of the artists or vases discussed in this chapter were dealt with in *APS*, since at that time their work had not been defined; some of their vases were associated with, or placed near to, the then known painters, but a great deal of new material now permits a much more detailed classification to be made.

These vases are contemporary with, and in some cases later than, those of the Snub-Nose Painter, whose work represents a parallel development from the Dijon Painter. As the Snub-Nose Painter had a large number of followers, who stand in close relationship also to the Varrese Painter, it seemed advisable to devote separate chapters to the workshops associated with these two artists (Chapters 12 to 14). It is, however, important to compare their vases with those discussed below, which it is difficult to arrange in a strictly chronological order because of the large measure of stylistic overlap between the several groups.

1. THE GROUP OF VATICAN V 14

The vases in this group are closely connected with the work of the Dijon Painter, as may be seen by a comparison between no. 1 below (with static figures) and nos. 6/90, 109, 118, and

132 or between no. 2 (moving figures) and nos. 6/103, 133–35. Between the vases in (i) and (ii) there is a considerable affinity, and they might be the work of the same painter, though at present we prefer to keep them apart.

(i) THE BRIENNER PAINTER

Named after the vase (no. 1) formerly in the Brienner Gallery, this painter stands particularly close to the Painter of Karlsruhe B 9 (cf. nos. 6/17–20) and to the Dijon Painter (cf. nos. 6/90, 101–103) in both his compositions and the treatment of drapery and of the youths on the reverses. The youth to left usually has a fairly long overhang down the left shoulder, with a long wavy border (nos. 1–3), the youth to right a wavy lower hem-line (nos. 1 and 3); between the two is a pair of *halteres*. The ivy leaf in the field on the obverse of no. 3 reappears frequently on the vases in (ii); a single scroll with drop leaf is normally used to frame the pictures (no. 3 is an exception).

Bell-kraters

* 1 Once Zurich Market (ex Munich, Brienner Gallery). PLATE 70, 1–2.
 Galerie am Neumarkt, *Auktion XXII,* 16 April 1971, pl. 6, no. 82.
 (a) Youth with mirror and phiale, woman with wreath and cista, beside an altar, (b) two draped youths.
* 2 Paris, Cab. Méd. 930. PLATE 70, 3–4.
 (a) Woman with phiale, and satyr with situla and tambourine moving r. towards stele, (b) two draped youths.
 3 Catania MB 4333.
 (a) Nude youth with phiale and wreath, standing woman with phiale and bunch of grapes, (b) two draped youths.
 4 Brindisi 336.
 (a) Maenad with tambourine, and satyr with situla and phiale, (b) two draped youths.

(ii) THE PAINTER OF VATICAN V 14

The vases in this division follow closely on from those in (i), but note that now the overhang on the draped youth to left no longer has the characteristic wavy line down it, but instead a single wave along the border. The Painter of Vatican V 14 sometimes shows the right youth with hand extended but without a stick (nos. 5–6). He regularly uses a quartered square with dots to accompany his meanders, which are continuous, but often rather carelessly drawn. White head-bands appear on the male figures on the obverses but not on the reverses; the stephanai worn by women have thick rays. Phialai (with a central black dot), ivy leaves and rosettes appear in the field.

Bell-kraters

(a)

 5 Vatican V 14 (inv. 18047).
 VIE, pls. 29 c and 31 b.
 (a) Youth with phiale, and woman with egg and tambourine, (b) two draped youths.
* 6 Bari, private coll. PLATE 70, 5–6.
 (a) Seated nude youth with phiale, woman holding wreath in each hand, (b) two draped youths.
 7 Zagreb 19.
 Damevski, no. 20, pl. 9, 2.
 (a) Seated nude youth with phiale, standing woman with sash and cista, (b) two draped youths.

8 Bassano del Grappa, Chini coll. 80.
 (a) Youth with phiale followed by woman with bunch of grapes and cista, (b) two draped youths.
9 Once Reggio Cal., Diego Vitrioli coll. XIII.
 Putorti, *Ausonia* 4, 1909, p. 153, fig. 17 = *ItAnt* 5–6, p. 236, fig. 17.
 (a) Nude youth with stick and bird, draped woman with wreath and phiale, resting l. elbow on column, (b) two draped youths.
10 Once Paris Market (C. Platt).
 (a) Young satyr with situla and tambourine, draped woman with wreath and phiale, seated youth with thyrsus, (b) two draped youths.
11 Sèvres 11.
 CVA, pl. 33, 7, 9, and 13.
 (a) Woman with wreath and cista, seated Dionysos with branch, (b) two draped youths.

(b)

The vases in this sub-division represent a slightly more developed phase of the painter's activity. Several are linked (nos. 12–16) by a diptych of unusual form (with a horizontal line, parallel to the stylus, across the top of the binding strings) between the draped youths on their reverses. Otherwise they closely resemble those in (i), with rather neater drawing (especially on Ruvo 539, no. 14) and rather more elaborate pattern-work below the handles, twice (nos. 13–14) with a trefoil between the scrolls of the side-palmettes. They should also be compared with the work of the Snub-Nose Painter, especially his early vases like Bologna 590 and Vatican V 18 (nos. 12/1 and 3).

Bell-kraters

12 Bologna 595.
 CVA 3, IV Dr, pl. 24, 1–2.
 (a) Woman with cista and seated nude satyr with phiale, (b) two draped youths.
13 Brunswick AT 222.
 CVA, pl. 35, 1–3, and pl. 37, 2.
 (a) Maenad with thyrsus and situla, followed by satyr with torch and tambourine, (b) two draped youths at stele.
14 Ruvo 539.
 Sichtermann, K 55, pl. 90. Photos: R.I. 64. 1223–4.
 (a) Woman with situla and tambourine, and seated Dionysos with kantharos and thyrsus, (b) two draped youths.

Pelike

15 Catania MC 4385.
 (a) Seated nude youth with fillet and phiale, woman with mirror, resting l. arm on pillar and holding cista in l. hand, (b) two draped youths.
 Close to nos. 12–14 above, with the same diptych on the reverse.

Column-kraters

All three have a multiple zig-zag pattern on the rim.

16 Cortona.
 (a) Seated Oscan warrior and woman with dish of offerings, (b) two draped youths.
17 Matera 11673, from Timmari, T. 7.
 Popoli anellenici, p. 39.
 (a) Nude youth with dish of cakes and situla running to r. following woman with torch and tambourine, (b) two draped youths.

Column-kraters (continued)

* 18 B.M. F 302. PLATE 71, 1–2.
 (a) Youth with bunch of grapes and phiale, and woman with situla and dish of cakes at stele on plinth,
 (b) two draped youths.

(c)

The following vases, which come from the same tomb as no. 17, form a compact group and look also to be by the same painter:

Hydria

19 Matera 11672, from Timmari, T. 7.
 Seated woman with grapes and phiale, Eros before her, with r. foot raised on rock-pile, holding fillet and mirror.

Lebetes gamikoi

20 Matera 11674.
 (a) Seated woman with mirror and phiale, (b) seated Eros with wreath.
21 Matera 11675.
 (a) Nude youth with grapes and phiale, (b) woman with rosette and phiale.

Epichysis

22 Matera 11676.
 Seated woman.

(iii) THE PAINTER OF WARSAW 147091

Four vases may be attributed to the hand of this painter; they are linked by

(a) the similarity of the meanders and dotted squares, and, on the two bell-kraters, the tall scroll with single drop-leaf beside the handle-palmettes,
(b) the treatment of the draped youths on the reverses,
(c) the diptych, with the stylus facing left instead of right,
(d) the rosettes and phialai in the field.

The woman on the Warsaw krater (no. 23) is very close to the one on B.M. F 302 (no. 18) and holds a similar basket of cakes. Compare also the hanging bunches of grapes, the berried laurel branches, and other adjuncts.

Column-krater

23 Warsaw 147091.
 CVA, Poland 7, pl. 20, 3–4 and pl. 21, 3–4.
 (a) Nude youth leaning on stick holding wreath in l. hand and phiale in r. beside altar on which is a thymaterion, to r. draped woman holding bunch of grapes and dish of cakes, (b) two draped youths.

Bell-kraters

* 24 Paris, Cab. Méd. 938. PLATE 71, 3–4.
 (a) Woman with thyrsus and phiale coming up to nude youth leaning on pillar, with thyrsus in r. hand and phiale in l., (b) two draped youths.
25 Naples, private coll. 2.
 (a) Woman with fillet and cista, satyr with bunch of grapes and phiale, (b) two draped youths.

Hydria

25a Taranto, from Rutigliano, T. 2.
 Nude youth and draped woman.

(iv) CLOSELY CONNECTED VASES

The following vases are closely connected in style with the work of the Painter of Vatican V 14, and may be by his own hand. Note the use of b.f. laurel on the rims of nos. 26 and 28. Here the meanders are divided by saltires and not the quartered squares used in (ii) and (iii) above. The drawing is neat, and Bologna 573 (no. 26) should be compared with Ruvo 539 (no. 14) for the standing women on the obverses and the draped youths on the reverses.

Column-kraters

26 Bologna 573.
 CVA 3, IV Dr, pl. 15, 3–4.
 (a) Maenad, Dionysos and young satyr with wreath and thyrsus, (b) two draped youths.
* 27 Bari 12066. PLATE 71, 5–6.
 (a) Dionysos with thyrsus and phiale with woman bending forward over raised foot beside altar and holding wreath in r. hand and thyrsus in l., (b) two draped youths.
27a Lecce 768.
 CVA 2, IV Dr, pl. 29, 3 and pl. 28, 7.
 (a) Woman with tambourine, and nude youth with torch and phiale, (b) two draped youths at altar.
27b Once London Market, Christie's, *Sale Cat.*, 12 July 1977, no. 149, pl. 34.
 (a) Seated Dionysos with thyrsus, standing woman with phiale and situla, (b) two draped youths (as on Lecce 768).
28 Naples 2030 (inv. 81713).
 (a) Seated woman with thyrsus, nude youth with wreath and thyrsus, (b) two draped youths.
29 Hartford (Conn.), Wadsworth Athenaeum 1949.463.
 (a) Woman with branch and tambourine, nude youth with torch and phiale, both running to r., (b) two draped youths.

Hydria

30 Altamura 5.
 Woman with fillet, and youth with branch, at white pillar on top of which is a hydria.

Oenochoe (shape 3)

31 Once London Market, Sotheby, *Sale Cat.* 29 July 1970, no. 149.
 Eros with outstretched hands and woman with fan running to r.

(v) RELATED VASES

(a)

The three following vases, which are by a single hand, are related in style to the work of the Painter of Vatican V 14. The figures have prominent noses (especially on nos. 33–34) and the borders of the youths' himatia are rather thick and angular.

Column-kraters

32 Vatican X 2 (inv. 18102).
 VIE, pl. 34 c and 35 c.
 (a) Standing woman with thyrsus and wreath, seated nude youth with phiale and thyrsus, (b) two draped youths.
33 Naples, Gerolomini.
 (a) Seated woman with wreath and phiale approached by Oscan warrior with wreath and spear, (b) two draped youths.

Column-kraters (continued)

34 Once New York Market, Sotheby-Parke-Bernet, *Sale Cat.* 22 Nov. 1974, no. 238 (ill.).
 (a) Woman bending forward over raised foot, with mirror in r. hand and wreath in l., facing nude youth holding phiale and thyrsus, (b) two draped youths.

(b)

The following vases are also connected in style with the work of the Painter of Vatican V 14 and look back to vases by the Dijon Painter like Zagreb 8 (no. 6/101; cf. also 6/103, 131, 133).

Bell-kraters

35 Naples Stg. 392.
 (a) Woman with branch and phiale, and Eros running to l., (b) two draped youths, with palmette between them.
36 B.M. F 291.
 (a) Maenad with tambourine and thyrsus running to l. followed by satyr with wreath and situla, (b) two draped youths, l. with stick, r. with wreath.

With the above compare:

Bell-krater

37 Bari 6322.
 (a) Standing woman with tambourine and bird, seated woman with mirror, (b) two draped youths.

2. THE GROUP OF GENEVA 2754

The Group of Geneva 2754 includes several different painters, whose works are linked by various stylistic features which they have in common, in particular the treatment of the standing draped woman with clearly defined breasts, divided by a fold-line of her peplos, and of the youths on the reverses. The variety of "sling" drape which produces a "saucer"-like effect, an early stage of which we had noted on nos. 1 and 27 above, now comes into greater use [e.g. nos. 38, 40, and particularly nos. 52—54 in (ii)].

(i) THE PAINTER OF GENEVA 2754

The Painter of Geneva 2754 is connected in style with the Painter of Vatican V 14, especially in his rendering of the standing draped woman, with fairly high girdle, a black stripe running down the bent leg, and rows of parallel fold-lines (often doubled) down the lower part of the peplos (cf. with Ruvo 539, no. 14). He also looks back to the work of the Dijon Painter, and in particular that of his followers like the Rodin Painter, the side-scrolls framing the pictures on nos. 38—9 being very like the latter's (cf. 6/194—5). The reverse youths have curly hair, and a rounded chin (e.g. nos. 38, 39, 42); the one to left has a long wavy border to the overhang, the one to right a wavy black line across the top of his himation and at the bottom hemline. An oblong window often appears in the field or a mesomphalic phiale with a ring of dots.

Bell-kraters

* 38 Geneva 2754. PLATE 72, 1—2.
 (a) Woman with mirror and tambourine, nude youth with phiale, (b) two draped youths.
 39 Lecce 651.
 CVA, IV Dr, pl. 27, 3 and 4.
 (a) Eros with wreath and tympanum, seated woman with ribbon and bunch of grapes, (b) two draped youths.

40 London, Soane Museum 40 L (*Cat.* 529).
 (a) Woman with tambourine, nude youth with phiale and thyrsus, (b) two draped youths.
41 Bassano del Grappa, Chini coll. 79.
 (a) Young satyr with foot raised on rock, holding out kantharos in r. hand, draped woman with bunch of grapes and ball, (b) two draped youths.
 Cf. with Paris, Cab. Méd. 915 (no. 43).

Column-kraters

* 42 Madrid 32654 (P. 121). PLATE 72, 3–4.
 (a) Seated Dionysos with bunch of grapes and phiale, standing maenad with wreath and thyrsus, (b) two draped youths, r. with phiale, between two stelai.
43 Paris, Cab. Méd. 915.
 (a) Oscan warrior holding shield and two spears standing before woman holding phiale and wreath, (b) two draped youths, l. with stick and r. with phiale.
44 Gravina.
 (a) Oscan warrior bending forward over raised foot and holding two spears and pilos, woman with oenochoe, seated Oscan warrior with phiale and spear, (b) three draped youths.

Amphorae

45 Milan, "H.A." coll. 311.
 CVA 1, IV D, pl. 27.
 (a) Standing nude youth with wreath and phiale, seated nude youth with bunch of grapes and phiale at white stele on broad base, decorated with black and white fillets, (b) two draped youths.
46 Taranto 4432, from Ruvo.
 (a) Woman with wreath and fillet, youth with phiale and branch, and drapery over l. arm, at white stele, (b) two draped youths.
 Cf. the reverse with that of Turin 3663 (no. 48).

Pelikai

47 Milan, "H.A." coll. 407.
 (a) Seated nude youth with branch and phiale, standing draped woman with mirror and wreath, (b) two draped youths.
 For the draped woman on the obverse cf. nos. 42–3 and for the bottom hem-line of the youths' himatia no. 53.
48 Turin 3663.
 CVA, IV D, pl. 10, 7–8.
 (a) Nude youth with bird and wreath, seated woman with grapes and tambourine turning her head back to l. to look at him, (b) two draped youths.
 The reverse is almost a replica of that of "H.A." 407 (no. 47), and the youth to r. is very like the corresponding one on Geneva 2754 (no. 38).
48a Rome, Rotondo coll. 82.
 (a) Seated woman with phiale, Eros with tambourine and bunch of grapes, (b) two draped youths.
 Very close in style to no. 48.

CONNECTED VASES

The following vases are connected in style with the Painter of Geneva 2754 either through the standing draped woman on the obverse (no. 49) or the youths on the reverse (nos. 50–1).

Column-krater

49 Nuremberg 3519.
 (a) Seated nude youth with thyrsus and phiale, standing draped woman with wreath and cista, (b) two draped youths.

Bell-kraters

50 Vidigulfo, Castello dei Landriani (once Manduria, Arnò coll.).
 Sale Cat. no. 75 (ill.).
 (a) Woman, and youth with phiale and bunch of grapes, (b) two draped youths.
51 Zagreb 3.
 Damevski, no. 18, pl. 9, 5 and pl. 13, 4.
 (a) Standing maenad with thyrsus and tambourine, seated Dionysos with phiale and thyrsus, (b) two
 draped youths.
 Cf. also with the Painter of Sydney 68.

(ii) THE PAINTER OF LECCE 669

The three vases by this painter are closely linked by the draped youths on the reverses; the
one to left has an extended "saucer" drape, with a wavy border to the overhang, the youth to
right has the right arm outstretched to hold a stick. Both have a wavy bottom hem-line. The
fan-palmettes accompanying the side-scrolls on Lecce 669 (no. 52) look back to some vases
by the Painter of Vatican V 14 (e.g. nos. 13–14). Rows of double fold-lines are standard on
the women's peploi (cf. also no. 14); the treatment of the breasts on nos. 53 and 54 is very
similar, with rows of fold-lines between them, a slight variant on that of the Painter of Geneva
2754. The meanders are accompanied by saltires, not quartered squares.

Bell-kraters

52 Lecce 669.
 CVA, IV Dr, pl. 24, 1 and 6.
 (a) Nude youth with wreath leaning on stick, woman with phiale and branch, (b) two draped
 youths.
* 53 Once New York Market, Eisenberg (formerly Washington 170387). PLATE 72, 5–6.
 Parke-Bernet, *Sale Cat.* 4 Dec. 1970, no. 336, ill. on p. 84.
 (a) Nude youth with branch and phiale, woman with wreath and mirror, (b) two draped youths.

Column-krater

54 Copenhagen 334 (B–S. 247).
 CVA, pl. 252, 2.
 (a) Oscan youth with two spears and phiale, and woman with mirror and wreath at altar, (b) two
 draped youths.

(iii) THE PAINTER OF SYDNEY 68

The draped women on the vases by the Painter of Sydney 68 should be compared with
those of the two preceding painters. Note particularly the rows of double fold-lines across the
himatia of the youths on the reverses and the drawing of the eye, in which the pupil is shown
as a small dot. The vases should also be compared with the work of the Painter of Athens 1680,
to whose hand Sydney 68 (no. 55) was originally ascribed, and of the Avignon Painter, on
whose reverses (e.g. nos. 99–100) similar double lines may be observed.

Bell-kraters

* 55 Sydney 68. PLATE 73, 1–2.
 APS. p. 50, no. 4.
 (a) Eros with phiale approaching woman with duck and thyrsus, (b) two draped youths.
* 56 Los Angeles 62.27.2. *CVA* Pl. 41, 1–2. PLATE 73, 3–4.
 (a) Standing woman with thyrsus and phiale, seated nude youth with kantharos and thyrsus, (b) two
 draped youths.

Pelikai

57 Vienna 2168.
 (a) Eros with wreath and phiale pursuing woman with fillet and branch, (b) two draped youths.
58 Ruvo 1707. In bad condition, with some repainting.
 (a) Seated youth, woman running up with ball and branch, (b) two draped youths.

3. THE CHRYSLER GROUP

The Chrysler Group includes the painter himself and a few artists whose work is connected with his in style. They follow on from the Group of Geneva 2754.

(i) THE CHRYSLER PAINTER

The Chrysler Painter, who takes his name from the bell-krater in the Chrysler Museum (no. 59), has a certain individuality of style, although his work must be connected with that of the painters in the preceding divisions, as may be seen from a comparison between the drapery of the female figures and of the youths on the reverses. On the latter the wavy border to the overhang of the left youth is very pronounced (cf. with that on nos. 59–62) and the other has a "sleeve" drape over the bent left arm, with the typical "bracket" edge, like that regularly adopted by the Painters of Geneva 2754 and of Sydney 68. He invariably uses saltire squares with long strokes in them, and there is a variety of ornamental patterns accompanying the side-scrolls beside the handle-palmettes – diamond florals (nos. 59–60), fan-palmettes (nos. 60–61), simple florals with black lines (nos. 59, 61). The satyr on no. 59 is repeated on Lecce 779; note also the berried laurel between the two figures on the obverses of these vases, which appears also on the other two attributed to him, and the hanging fillets in the background.

Bell-kraters

* 59 Norfolk (Va.), Chrysler Museum. Repainted. (b) PLATE 73, 5.
 (a) Satyr with thyrsus dipping kantharos into banded pail, woman with phiale and tambourine, (b) two draped youths.
59a Once London Market, Sotheby, *Sale Cat.* 8 Nov. 1976, no. 330, pl. 9, 1.
 (a) Young satyr with thyrsus and tambourine facing maenad with thyrsus, (b) two draped youths.
* 60 Lecce 779. (b) PLATE 73, 6.
 CVA 2, IV Dr, pl. 22, 7 and 5.
 (a) Young satyr with situla bending down below grape-vine, dancing maenad with thyrsus and wreath, (b) two draped youths.
61 Vatican V 26 (inv. 18059).
 VIE, pl. 30 e and fig. 11.
 (a) Draped woman with sash and phiale, seated nude youth with kantharos and thyrsus, (b) two draped youths.

Pelike

62 Bologna 536.
 CVA 3, IV Dr, pl. 9, 1–2.
 (a) Half-draped youth with wreath, woman seated on box holding phiale, (b) two draped youths.
 Note the curious oval shape of the the fold-lines at the top of the himation of the r. youth.

(ii) THE PAINTER OF LOUVRE K 12

The two vases by this painter form a pair. Note the rock-piles with black centres (cf. Brussels A 3378, no. 69), the drawing of the women's breasts and their drapery, and the

treatment of their hair. Both vases have almost identical pattern-work and the long tongues reaching some distance on to the handles at the joins are most unusual.

Bell-kraters

* 63 Louvre K 12 (N 2982). PLATE 74, 1–2.
 (a) Nude youth bending forward over raised foot, holding mirror and situla, seated woman with branch and wreath, (b) two draped youths.
* 64 Louvre K 133. PLATE 74, 3–4.
 (a) Woman seated on rock with mirror and phiale, standing nude youth with drapery behind his back, (b) two draped youths.

(iii) THE KIRZENBAUM PAINTER

Note the wavy line along the lower border of the himation of the youth to right on the reverses, as well as the trefoil in the side-scrolls flanking the picture.

Bell-kraters

(a)

65 New Brunswick (N.J.), Mr. G. Kirzenbaum.
 (a) Young satyr with torch and situla, maenad with tambourine and thyrsus, (b) two draped youths.
66 Florence, private collection.
 (a) Seated woman with phiale, satyr with situla and thyrsus, (b) two draped youths.
67 B.M. F 293.
 Schauenburg, *AA* 1973, pp. 225 ff., figs. 9–11.
 (a) Satyr with raised foot, holding wreath and situla, draped woman with mirror and thyrsus, (b) two draped youths (repainted).

(b)

The following vase looks to be connected with the work of the Kirzenbaum Painter, especially in the treatment of the youths on the reverse:

68 Barcelona 352.
 (a) Satyr with thyrsus and phiale seated on rock, maenad with kantharos, thyrsus and situla, (b) two draped youths.

(iv) THE PAINTER OF BRUSSELS A 3378

The two vases attributed to this painter are very close in style and treatment, especially of the youths on the reverse. The draped women on the obverses should be compared with those on Copenhagen 334 (no. 54) and on the Chrysler krater (no. 59).

Bell-kraters

* 69 Brussels A 3378. PLATE 74, 5–6.
 (a) Young satyr with l. foot raised on rock, holding wreath and tambourine, draped woman with situla and thyrsus leaning l. arm on pillar, (b) two draped youths.
* 70 Dayton (Ohio), Art Institute R. 101.1. (on loan from Mrs. Frank Brown) PLATE 75, 1–2.
 (a) Woman with foot raised on rock, holding tambourine in l. hand and wreath in r., seated Dionysos with phiale and thyrsus, (b) two draped youths.

(v) THE PAINTER OF GENEVA 13108

The Painter of Geneva 13108 looks like a late follower of the Painter of Karlsruhe B 9. Characteristic of most of his vases is the use of a saltire square with fine dots in the quarters (e.g. nos. 71–73). Also typical is the use of a small floral with a central black dot between the

scrolls which serve to frame the pictures (nos. 71, 73). His thyrsi have a curious head with scroll-like branches immediately below it (as on nos. 71 and 74). His draped youths are rather like those by the Painter of Brussels A 3378, with similar rows of parallel fold-lines on the overhang and across the body, but they are less carefully drawn and their heads are small in proportion to the body.

Some of the vases in this group are discussed by K. Schauenburg in "Apulischer Krater mit Jagdszene in der Kieler Antikensammlung", in *AA* 1973, pp. 221—231, in connexion with the Kiel krater attributed to the Latiano Painter, whose work, though somewhat later (see Chapter 14, 10), is related to that of this painter.

Bell-kraters

* 71 Geneva 13108. PLATE 75, 3—4.
 Schauenburg, op. cit., pp. 227—8, figs. 12—15.
 (a) Eros with thyrsus and seated draped woman with phiale and branch, (b) two draped youths.
 72 Gravina.
 (a) Young satyr with raised l. foot, holding wreath and ivy-trail, seated woman with phiale, (b) two draped youths.
* 73 Reading 161.51 RM. PLATE 75, 5—6.
 Schauenburg, op. cit., pp. 229—30, figs. 16—18.
 (a) Woman with tambourine and kantharos, nude youth with phiale and fillet, (b) two draped youths.
 74 Paris, Cab. Méd. 937.
 De Ridder, *Cat.,* p. 560, fig. 133.
 (a) Nude youth with bunch of grapes and thyrsus, draped woman with fillet and mirror, (b) two draped youths.

(vi) THE PAINTER OF MILAN "H.A." 437

The two following vases, which are by a single hand, seem also to be connected with the Painter of Geneva 13108 by the treatment of the drapery and the thyrsus, also by the meanders which do not meet in the centre, though here they are accompanied by saltire squares with strokes, not dots.

Bell-kraters

 75 Milan, "H.A." coll. 437.
 (a) Maenad with phiale and thyrsus moving l., followed by nude youth with wreath, stepping over altar, (b) two draped youths beside an altar.
 76 Bari, Lagioia coll.
 (a) Woman with wreath and phiale, nude youth with thyrsus and torch, both running r. towards altar, (b) two draped youths.

4. THE HAVERFORD GROUP

The Haverford Group, named after the bell-krater in Haverford College (no. 77), includes a number of vases which may be attributed to the same hand (the Haverford Painter), and others closely related to his work. He has a distinctive style, especially in his drawing of the eye, the pupil of which appears as a small dot between two almost parallel eyelids, with a slightly curved eyebrow above. His female figures are slender; their facial features are not prominent and they wear peploi with a wavy lower hem-line, through which the bent leg is clearly visible. Male figures sometimes have a row of tight curls round the top of the head (e.g. nos. 77—8) and may wear a red head-band. The youths on the reverses are characteristic and uniform. The one to left has the right shoulder bare and holds a stick in his extended right hand; there is a fairly long over-

hang, with a wavy edge. The other youth is enveloped in his himation, which covers the bent right arm in front of his body; below the neck is a diagonal black border-line with a slight hook at the top. The lower border is comparatively straight with a small wave at the far end.

On some vases (nos. 77–8, 84) there are plain meanders under the pictures only; on others they go round the vase, sometimes accompanied by quartered squares.

(i) THE HAVERFORD PAINTER

(a)

Bell-kraters

* 77 Haverford 1. PLATE 76, 1–2.
 Comfort, *Attic and S. Italian painted vases at Haverford College,* no. 1, pl. 1.
 (a) Nude youth with thyrsus running to l., followed by woman with mirror and phiale, (b) two draped youths.
* 78 Bari 6338. PLATE 76, 3–4.
 (a) Nude youth seated on rock-pile, woman bending forward to offer him a wreath, (b) two draped youths.
 79 Monopoli, Meo-Evoli coll. 946.
 (a) Seated woman with branch holding out phiale to Eros, (b) two draped youths.
 80 Bitonto, private coll.
 (a) Woman with ball and branch coming up to seated woman with cista and thyrsus, (b) two draped youths.

Column-krater

 81 Cambridge GR 3/1968 (ex Christie's, *Sale Cat.* 11 June 1968, no. 194, 1).
 (a) Maenad with thyrsus, and Dionysos with dish and thyrsus, (b) two draped youths.
 The style descends from that of the column-kraters in the sub-group of Copenhagen 335 (Painter of Athens 1714), but the drawing of the faces and the treatment of the drapery on the reverse show it to belong here.

(b)

The vases in this sub-division, which have rather more interesting subjects, look, from the drawing of the eyes and the rendering of the drapery on the reverses, to be by the same hand as those in (a). The small ivy leaves on the neck connect no. 82 with no. 81.

Column-krater

 82 Copenhagen 2 (B–S. 246).
 CVA, pl. 252, 1.
 (a) Satyr with table of cakes, boy with rabbit, and draped youth with knife approaching altar beside a herm, (b) two draped youths.

Bell-krater

* 83 Naples 2013 (inv. 81941). PLATE 76, 5–6.
 (a) Young satyr with situla and thyrsus running to l., followed by maenad with dagger and rabbit, (b) two draped youths.

Pelike

 84 Naples 2144 (inv. 81716).
 (a) Nike with phiale and wreath bending forward in front of seated nude youth with phiale, (b) two draped youths.

(c)

The following vases look like the work of a later imitator of the Haverford Painter; it is not impossible that they represent a late phase of his own work, as the draped youths on the reverses have much in common with his.

Bell-kraters

85 Bari 5600.
 (a) Nude youth with wreath in r. hand and drapery over l. arm following woman running to r., with thyrsus and phiale, (b) two draped youths.
 Compare the treatment of the youths' drapery, especially the lower hem-lines, with that on Geneva 13108 (no. 71) and the draped woman with the one on no. 80.

86 Leningrad inv. 542 = St. 1392.
 (a) Woman with wreath and cista seated on rock-pile, draped woman with mirror, nude youth, (b) two draped youths.
 The use of chequers with the meanders is unusual but the reverse is very close to that of Bari 6329.

* 87 Bari 6329. PLATE 76, 7–8.
 (a) Nude youth with phiale seated on hollow rock, standing woman with wreath and cista, (b) two draped youths by altar.

(ii) VASES CONNECTED IN STYLE OR COMPARABLE

Column-krater

88 Rhineland, private coll.
 Antiken aus rheinischem Privatbesitz, p. 57, no. 81, pl. 37, 1.
 (a) Nude youth with thyrsus and wreath, seated woman with phiale, satyr with torch and thrysus, (b) two draped youths.
 The vase is somewhat repainted but the male figures on the obverse should be compared with those on no. 82.

Bell-krater

89 Taranto 51023.
 (a) Satyr with thyrsus and beaded wreath, woman with mirror and cista moving to r., (b) two draped youths.
 The two adjacent saltire squares on the obverse find a parallel on Vienna 2168 (no. 57); cf. the draped youths on nos. 80 and 85.

5. THE LAGIOIA GROUP

A small group of vases which is connected in style and treatment with those in the Group of Geneva 2754 and which, in the use of saltires with large dots, as on the vase in (ii), provides a link with the work of the Painter of Athens 1680.

(i)

Note the use of diamond-shaped florals and also of flowers between the figures. Lecce 781 (no. 90) should be compared with Lecce 651 (no. 39) for the seated women.

Bell-kraters

90 Lecce 781.
 CVA, IV Dr, pl. 24, 12 and pl. 25, 1.
 (a) Seated woman with branch and phiale, standing woman with mirror and fillet, (b) nude youth with cista and seated woman with fan.

Bell-kraters (continued)

91 Bari, Lagioia coll.

(a) Satyr with branch and phiale moving to l. and looking back at woman with bunch of grapes in r. hand and tambourine in l., (b) two draped youths.

On the diptych above the draped youths is an inscription E... NIKA.

The influence of the Dijon Painter and his followers (cf. Altamura 3, no. 6/179) is clear, especially on the running woman and the reverse youths.

(ii)

Note the parallel wavy lines in the bottom corners of the youths' himatia and the way the crossed squares join the meanders.

Bell-kraters

92 Louvre K 134.

(a) Half-draped youth seated on rock and cloaked woman with bird, (b) two draped youths.

93 Bari 6336.

(a) Maenad with thyrsus and tambourine, seated Dionysos with wreath and thyrsus, (b) two draped youths.

(iii)

With the above compare:

Bell-krater

94 Bonn 81.

(a) Seated woman resting r. hand on tambourine and holding phiale in l., nude youth with wreath and thyrsus, (b) two draped youths.

Note the wavy hem-line of the woman's peplos, the diamond-shaped florals and cf. the "saucer" drape of the l. youth on the reverse with that on no. 93.

Pelikai

95 Taranto 24092.

(a) Standing woman with wreath and phiale, seated nude youth, (b) two draped youths.

96 B.M. F 329.

(a) Eros with beaded wreath and phiale standing before seated woman with mirror and fan, (b) two draped youths, r. with strigil.

Cf. the seated woman with those on Lecce 781 and the drawing of the youths' himatia with that of nos. 92–3.

(iv) THE PAINTER OF MOSCOW MK 54

The two following vases, which are by one hand, should belong to this group by reason of the florals (cf. nos. 90–91) and the dotted saltires (cf. Bonn 81, no. 94). The youths on their reverses are almost replicas; note the "saucer" drape of the one to left. In the field are narrow oblong windows, with a black line down the middle. The floral decoration suggests a connexion with the Egg and Wave Group (see below Chapter 11, section 10, and cf. no. 11/203).

Bell-kraters

97 Reggio Cal. 6975.

(a) Nude youth with thyrsus and tambourine followed by woman with sash and ball, (b) two draped youths, r. with palm branch.

98 Moscow MK 54.

(a) Maenad with fawnskin across body and cloak across lower part of body and over l. arm, in

three-quarter view, with torch and tambourine moving to l., followed by satyr with situla, (b) two draped youths.

6. THE AVIGNON PAINTER

The style of the Avignon Painter owes much to the work of the Dijon Painter, as may be seen by comparing his running women and draped youths (as on nos. 99, 105–6) with those on nos. 6/101–4 by the latter.

Like the Painter of Athens 1680, he favours swirling drapery for women and a "saucer" drape for the left youth on the reverse. The youth to right normally has a "sleeve" drape over the bent left arm, with an upward curve for the edge and two parallel lines descending below it (e.g. nos. 99, 100, 101, 103).

The meanders are accompanied either by saltires or quartered squares with dots (enclosed on no. 99).

Lepastai and phialai appear as decorative adjuncts in the field.

(i)

Bell-kraters

* 99 Avignon 112 A. (b) PLATE 77, 1.
 (a) Young satyr with torch and thyrsus, maenad with phiale and thyrsus, running to l., (b) two draped youths.
 For the diamond florals cf. nos. 90–91, 94, 97–8.
*100 Hobart 25. (b) PLATE 77, 2.
 Hood, *Gr. V. in the University of Tasmania*, p. 31, pl. 21a–b.
 (a) Dionysos and maenad, (b) two draped youths.
 No pattern-work below the handles.

Column-kraters

 101 Vatican Z 12 (inv. 18139).
 VIE, pl. 34 g and pl. 35 g.
 (a) Nude youth with thyrsus and phiale standing in front of seated woman with thyrsus, (b) two draped youths.
 Very close to the Avignon krater.
 102 Bari 20170, from Gioia del Colle, T. 7.
 Scarfì, *MonAnt* 45, 1960, cols. 275 ff., figs. 108–111.
 (a) Dionysos and maenad, (b) two draped youths.
*103 Vatican X 4 (inv. 18104). PLATE 77, 3–4.
 VIE, pl. 34 e and pl. 35 e; Rallo, *Lasa*, pl. 4, 2.
 (a) Woman with thyrsus and phiale, youth with long, curling hair, holding branch, (b) two draped youths (as on Bari 20170).

Squat lekythos

 104 Bari 20174, from Gioia del Colle, T. 7.
 MonAnt 45, 1960, col. 283, fig. 116, 2.
 Female head.

(ii)

The two following vases form a pair and are slightly less careful in execution. They should be compared with the work of the Verona Painter.

Bell-kraters

*105 Salerno 163, from Pontecagnano. PLATE 77, 5–6.
 Patroni, *RassStorSal* 3, 1940, p. 25, figs. 59–60.
 (a) Woman with phiale followed by young satyr with wreath and thyrsus, (b) two draped youths.
 106 Bologna 592.
 CVA 3, IV Dr, pl. 22, 3–4.
 (a) Woman with thyrsus and wreath followed by satyr with torch, (b) two draped youths by altar.

(iii)

The two following bell-kraters, which are by the same hand, provide a link between the Avignon Painter and the Painter of Geneva 13108. The obverse of no. 107 is closely connected with the latter (note the typical crossed squares), while the reverse is nearer the work of the former (cf. with no. 99), and is almost duplicated by that of no. 108. On the latter vase the crossed squares have solid black triangles in the four quarters, as on the cista in the right hand of the woman on no. 107.

Bell-kraters

 107 Deruta (Perugia), Magnini coll. 6.
 Dareggi, no. 9, pl. 8.
 (a) Eros with situla, seated woman with cista and thyrsus, (b) two draped youths.
 108 Lecce 680.
 CVA 2, IV Dr, pl. 25, 8.
 (a) Standing woman with wreath, seated nude youth with phiale and thyrsus, (b) two draped youths.

7. THE PAINTER OF ATHENS 1680

The Painter of Athens 1680 (*APS*, pp. 49–50) has many stylistic features in common with the other painters who follow on from the Dijon Painter and his associates, but his work should also be compared with that of both the Painter of Athens 1714 and, in particular, the Felton Painter, who seems to have influenced his drawing of women, especially in motion, and his rendering of faces and drapery (cf. no. 130 with Ruvo 1549, no. 7/55). He makes less use of drop-folds than the Painter of Athens 1714 and, like the Maplewood Painter, favours double lines running down the drapery. He is particularly fond of representing figures in rapid movement, with the result that his draperies are often swirling.

We may note that:

(i) on the reverses the l. youth often has a "saucer" drape, the r. normally holds a stick in his extended r. hand; the upper border of the latter's himation is shown as a black line with a slight curl at each end; the lower border has a pronounced wave (as has that of the l. youth). Sometimes the central area of the body is enclosed between rows of curving lines in the form of an oval (e.g. nos. 110, 114–5, 121, 123, 129, 132; cf. no. 5/64 and 66 by the Hoppin Painter). When the upper part of the body is bare, the nipples are clearly indicated.

(ii) nude youths often have a piece of drapery over their arm and behind their back (e.g. nos. 111 and 113) with swirling fold-lines, or else one arm enveloped in drapery with a whirligig effect (e.g. nos. 128, 137).

(iii) the hair tends to straggle slightly (e.g. nos. 116, 122–124); women wear radiate stephanai, and youths often have white head-bands; the mouth tends to have a pronounced downward curve, sometimes with an obtuse angle (e.g. nos. 110–11).

(iv) the meanders are normally accompanied by saltire squares with large dots in the four intersections; the top and bottom sides of the squares are not drawn independently; on column-kraters the framing-panels stop above the meander-band, which always terminates with a crossed square.

His subjects are mainly repetitive, mostly Dionysiac or pursuit scenes; the Kiel pelike (no. 137) with the birth of Helen is a notable exception.

(i)

Column-kraters

109 Athens 1680.
 APS, p. 50, no. 1, pl. 29, figs. 133—4.
 (a) Maenad with tambourine, and satyr with wreath, (b) two draped youths.
110 Bryn Mawr P 232.
 APS. p. 50, no. 2.
 (a) Satyr, maenad and Dionysos running to r., (b) three draped youths.
111 Ruvo 603.
 Sichtermann, K 57, pls. 92 and 95.
 (a) Satyr, Dionysos and maenad running to r., (b) three draped youths, with white head-bands.
112 Taranto 4480/104.
 (a) Youth with torch and phiale, woman with wreath and mirror, (b) two draped youths, r. with strigil; palmette between them.
113 Naples, Gerolomini. Repainted.
 (a) Maenad with tambourine, Dionysos with thyrsus and phiale, (b) two draped youths.
 The crossed squares have strokes instead of dots, but the drawing of the reverse youths, and especially the borders of their drapery, shows the vase to belong here.
114 Once New York Market, Sotheby-Parke-Bernet, *Sale Cat.* 26 Sept. 1972, no. 283 (ill.).
 (a) Seated woman with tambourine, and nude youth with wreath and thyrsus, (b) two draped youths, with white head-bands.
 Goes closely with the Gerolomini krater.
115 B.M. 1928.1—17.66.
 (a) Woman with nestoris between two seated Oscan warriors, l. with two spears, r. with kantharos and two spears, (b) three draped youths.
 Slightly cruder in style.

Bell-kraters

*116 Taranto 8109, from Montescaglioso. PLATE 78, 1—2.
 (a) Maenad with ball and tambourine running to l., followed by satyr with outstretched arms, (b) two draped youths.
 Early work; close to the Gerolomini column-krater.
117 Poznan 1903.697 (once Berlin F 3300).
 CVA, Poland 3, Poznan, pl. 4, 4; *APS*, p. 50, no. 5.
 (a) Satyr and maenad, (b) two draped youths.
118 Paris, Rodin 972.
 CVA, pl. 33, 1—2.
 (a) Nude youth with wreath in r. hand and drapery over l. arm running to r., (b) woman with phiale and wreath running to r.
119 Taranto 19525.
 (a) Seated Eros and draped woman with phiale, (b) two draped youths.
120 Taranto 124990.
 (a) Maenad with fillet and tambourine, young satyr with wreath and mirror, (b) two draped youths.
121 Mattinata, Sansone coll.
 (a) Standing woman with phiale, seated youth with thyrsus, (b) two draped youths.
*122 Once Frankfurt Market, De Robertis. PLATE 78, 3—4.
 De Robertis, *Lagerliste* II, no. 54.

Bell-kraters (continued)

(a) Woman with branch and phiale with 2 sprays, resting l. arm on pillar, satyr with wreath, (b) two draped youths by pillar.

123 Lecce 780.

CVA 2, IV Dr, pl. 24, 2.

(a) Maenad with dish of cakes, seated Dionysos with kantharos and laurel branch, satyr with two flute-reeds resting r. arm on pillar, (b) three draped youths.

*124 Matera 156619, from Città di Tricarico. PLATE 78, 5–6.

Mus. Naz. di M., pl. 55, 1.

(a) Nude youth with torch and skin over l. arm, half-draped woman with tambourine, (b) two draped youths.

Amphorae

125 Leningrad inv. 502 = St. 1288.

(a) Woman and youth at stele, (b) two draped youths.

126 Padua, Casuccio coll. 18.

(a) Eros with foot on rock-pile leaning forward to offer phiale to woman with mirror, (b) two draped youths.

127 Lecce 843.

CVA 2, IV Dr, pl. 43, 1 and 4.

(a) Youth with phiale with sprays, woman with egg and wreath, (b) two draped youths with pillar between.

Goes closely with the Padua amphora.

128 Milan, "H.A." coll. 438.

CVA 1, IV D, pl. 26.

(a) Woman with bunch of grapes and cista running to l. followed by nude youth with wreath, (b) two draped youths at stele.

Pelikai

*129 Neath (Glam.), Elis Jenkins coll. PLATE 79, 1–2.

Jenkins, *Dillwyn's Etruscan Ware*, ill. on pp. 5 and 7.

(a) Woman with mirror and open box running to l., followed by Dionysos with wreath and thyrsus, (b) two draped youths.

130 Taranto.

von Matt and Zanotti-Bianco, *La Magna Grecia*, fig. 218.

(a) Woman running to l. with tambourine in both hands, nude youth with wreath in r. hand and drapery over l. arm, (b) two draped youths.

*131 Basel Market, MuM, *Sonderliste R* (1977), no. 70. PLATE 79, 3–4.

(a) Woman running to l. with tambourine in l. hand, nude youth with wreath, drapery over both arms and behind his back, (b) two draped youths.

132 Taranto 127364.

(a) Woman with raised foot and nude youth with fillet, (b) two draped youths.

133 Milan, "H.A." coll. 409.

(a) Nude youth with wreath, woman with tambourine, (b) two draped youths.

Close to Milan, "H.A." 438 (no. 128).

134 Toulouse 26.352.

(a) Seated nude youth with wreath (large sash above him), standing woman with alabastron and dish; between them, a palm, (b) two draped youths.

Close to Milan, "H.A." 438 (no. 128).

135 Louvre K 546.

(a) Seated Eros with tambourine and phiale, from which a standing woman is picking some object (fruit ?), (b) two draped youths.

135a Taranto, from Rutigliano, T. 2.

(a) Standing woman with wreath and phiale, seated Eros with fillet, (b) two draped youths.

136 B.M. F 320.

(a) Seated woman with mirror and wreath, nude youth bending forward leaning on stick; above — seated Eros with fillet, (b) standing woman with wreath, seated nude youth with stick; large sash above.

137 Kiel B 501.

(a) Birth of Helen — Helen emerging from the egg on an altar between Leda and a nude youth to r., with Eros kneeling above, (b) draped woman with wreath and phiale, seated nude youth with bunch of grapes.

Hydriai

138 Leningrad inv. 531 = St. 1176.

Woman with mirror and wreath, and youth with wreath, at a tomb-monument consisting of a white pillar on a three-stepped base with an egg on top.

139 Leningrad inv. 533 = St. 882.

Two women at a stele on top of which is a kalathos.

140 Taranto, Baisi coll. 39. Badly preserved.

Eros with wreath bending forward in front of seated woman holding phiale and bunch of grapes.

Dish

141 Milan, "H.A." coll. 219. Repainted.

Schneider-Herrmann, *Paterae*, no. 63, pl. 7.

I. Woman with fan resting r. arm on pillar, Eros with mirror seated on rock-pile.

A. Seated Eros with cista, woman with wreath leaning on laver, seated woman with fan and mirror.

B. Woman with spray, seated nude youth with phiale, Eros bending forward over raised foot.

Oenochoe (shape 3)

142 Once London Market, Sotheby, *Sale Cat.* 29 June 1970, no. 149.

Eros and woman with fan and bunch of grapes, moving to r.

(ii) CLOSELY CONNECTED VASES

The following are very close to the Painter of Athens 1680 and might be by his own hand.

Bell-kraters

143 Naples 1838 (inv. 81450).

(a) Woman running to l. with situla and thyrsus, nude youth with wreath and thyrsus, (b) two draped youths.

144 Bastia, Museum, from Aleria.

(a) Woman running to l., followed by satyr with wine-skin, (b) two draped youths.

Pelike

145 Padua, Casuccio coll. 17.

(a) Eros flying with ribbon towards youth leaning on stick in front of woman with phiale seated on rock-pile, (b) two draped youths, with white head-bands.

Hydriai

146 Taranto, from Ceglie del Campo.

Youth with laurel branch and wreath, seated woman with open box and branch.

Hydriai (continued)

147 Reggio Cal. 7035, from S. Arcangelo.
 APS, p. 52, no. 3, pl. 31, figs. 145 and 147.
 Youth with phiale, and woman with wreath and bird, moving to r.
 Below handles: owls (cf. nos. 6/35 and 8/113).

(iii) RELATED VASES

Amphora

148 Reggio Cal. 7002.
 (a) Seated nude youth with phiale and stick, standing woman with "chaplet", (b) two draped youths.

Pelike

149 Palermo, Mormino coll. 723.
 (a) Draped woman with r. foot on rock, holding bunch of grapes in r. hand and phiale in l., (b) Eros
 with wreath moving towards altar.
 Compare with the work of the Felton Painter, to which this vase is strikingly close.

8. THE ALTROCK PAINTER

The two vases attributed to this painter look back to the work of the Painter of Karlsruhe B 9,
but are closer in spirit to the Painter of Athens 1680. Note on the reverse of no. 150 the way
in which the leaf of the palmette scroll cuts out part of the youth's himation (cf. the reverse
of Parma C 97 by the Painter of Athens 1714, no. 8/206).

Bell-krater

150 Munich, Altrock coll.
 (a) Woman holding oenochoe on r. shoulder and tambourine in l. hand, Dionysos with phiale and
 thyrsus, leaning on drapery-covered pillar, satyr with torch, (b) three draped youths.

Dish

*151 Bari 6455. Schneider-Herrmann, *Paterae* no. F19, pl. 5, 4. PLATE 79, 5–6.
 (a) Nude youth with palm branch, woman bringing fillet to amphora standing on two-stepped base,
 nude youth with strigil, and draped woman with phiale of offerings, (b) nude youth with wreath
 running to l., followed by two women, one with mirror, the other with palm-branch.
 The two women on (a) are very close to the one on the Altrock krater.

9. THE SCHLAEPFER PAINTER

The Schlaepfer Painter is an artist of some importance whose work, while parallel to that of
other followers of the Dijon Painter, also reflects very clearly the influence of the Iliupersis
Painter, notably on vases like Amsterdam 3478 (no. 160), with its b.f. vases in front of a grave
monument (cf. nos. 8/44, 45, 107, 111, 114 above) or Adolphseck 185 (no. 161).
 As particularly characteristic of the Schlaepfer Painter's work we may note:

(a) the treatment of women's drapery; the fold-lines are very clearly defined; there is usually a double stripe
 running down the front or side of the peplos; seated women often have a piece of drapery over their
 knees, with a very wavy border in the lower corner just above the feet (e.g. nos. 157–9, 162–4).

(b) the drawing of women's breasts, which tend in profile to be pointed (e.g. nos. 152, 160, 163) with the
 nipple clearly visible beneath the peplos; the hair is generally caught up in a simple sphendone, sometimes
 with a radiate stephane.

(c) the treatment of the draped youths on the reverses: the l. youth has a pronounced stomach bulge; across

the top of the r. youth's himation there is a flat S-shaped black line; there is a black border rather like a crook on the lower part of the l. youth's himation (e.g. nos. 152 and 165) and sometimes an S-shaped squiggle at the corner of the overhang (e.g. nos. 156–7, 170).

(d) the presence normally of a pair of *halteres* above the draped youths; on some of the later vases (e.g. nos. 167, 169–70) this is replaced by a diptych with two dots each side.

(e) the carelessly drawn meanders and the large and heavy saltire squares accompanying them, which are often left open at the top and bottom (e.g. nos. 155, 160–3).

The subjects are more varied than usual and include funerary (nos. 160–1), mythological (no. 165), Dionysiac (nos. 155, 167–8) and even phlyax (nos. 173–5) scenes. Some of his earlier vases (e.g. nos. 152–3, 156–7) should be compared with those of the Painter of Karlsruhe B 9.

(i) EARLY WORK

Bell-kraters

152 Vatican V 9 (inv. 18037).
 VIE, pl. 23 e and pl. 24 e; *APS,* p. 57, no. (v).
 (a) Woman with wreath, phiale and sash, Dionysos with thyrsus, (b) two draped youths.
153 Bari 20739, from Conversano, T. 8.
 NSc 1964, pp. 131 ff., figs. 39–40.
 (a) Standing woman with phiale, and seated Dionysos with thyrsus, (b) two draped youths, r. with strigil.
 Very close to Vatican V 9.

Pelikai

154 Adolphseck 191.
 CVA, pl. 86, 4–5.
 (a) Seated woman with phiale and Eros with wreath, (b) two draped youths at altar.
155 Durrës, from the necropolis.
 Archéologia 78, Jan. 1975, p. 14 (ill.); *L'Art Albanais* (Exhibition Cat., Petit Palais, 1974–5), no. 137 (ill.).
 (a) Woman with wreath and phiale, satyr with torch, (b) two draped youths.
 Cf. the wreath with that on no. 164.
156 Reggio Cal. 1149. In bad condition.
 (a) Woman with cista of offerings, nude youth with drapery round l. arm and oenochoe in r. hand, from which he is pouring a libation at a stele, (b) two draped youths.
157 Exeter 45/1931.1.
 (a) Eros with wreath and seated woman with phiale, (b) two draped youths, r. holding wreath above altar.
158 Paris, Petit Palais 333. Repainted.
 CVA, pl. 27, 4–5; Schauenburg, *JdI* 87, 1972, p. 266, figs. 11–12.
 (a) Four women at a laver above which is Eros pouring water from a hydria, (b) woman seated between nude youth with tambourine and Eros with alabastron.
 For the seated woman cf. nos. 157, 162–3.

Olpe (masks at the handle-joins)

159 Budapest 75. 40 A, from Rionero.
 Szilágyi, *BMNH* 46–7, 1976, p. 58, no. 22*b*.
 Eros standing in front of half-draped seated woman.
 Inscribed in red wash on the base: ΓΑΚΕΙΡΟΙ ΑΝΔΡΟΦΥΚΤΑΙ.
 Cf. the head of the seated woman with that of the women to r. of the monument on Amsterdam 3478 (no. 160).

Amphora

*160 Amsterdam 3478 (*Gids* 1506). PLATE 80, 1.
 CVA, Scheurleer 2, IV Db, pl. 5, 3–4; *Gr. Etr. en Romeinse Kunst*, pp. 49–50, figs. 47–8.
 (a) Two seated youths and two women with offerings at statue of youth on pedestal, on the base
of which are two amphorae and a kylix, (b) seated youth with spear between woman with phiale
and oenochoe, and youth.
 The pattern-work is very similar to that on the hydria Adolphseck 185 (no. 161).

Hydriai

 161 Adolphseck 185.
 CVA 2, pl. 84; Schauenburg, *RM* 80, 1973, pl. 82, 1.
 Six women at a naiskos, in which is a standing woman with mirror.
 Below handles: female heads.
*162 Harrow School Museum. Detail: PLATE 80, 2.
 Half-draped youth with phiale standing in front of seated woman with mirror.
 163 Lecce 790.
 CVA 2, IV Dr, pl. 42, 5.
 Nude youth with wreath and phiale, seated woman with tambourine.

Squat lekythos

 164 Bari 1316, from Conversano.
 Youth with wreath, seated woman with phiale, standing woman with mirror and wreath.

(ii) DEVELOPED STYLE

The flat S across the top of the himatia of the youths to right on the reverses (cf. nos.
152–3 above) is more pronounced, with a much heavier line (nos. 165–71).

The drapery of the youths should be compared with that on some of the vases by the
Judgement Painter and also, notably in regard to the rounded belly, with those by the Painter
of the London Pelikai (*APS*, p. 26, pl. 8; below, Chapter 10, 1).

Bell-kraters

*165 Berne, Dr. R. Schlaepfer. Repainted. PLATE 80, 3–4.
 (a) Satyr with bow, seated Herakles on lion-skin, woman with wreath and situla; bucrane and phiale
above, (b) three draped youths.
 166 Milan 1583 (deposito). Much repainted and in very bad state.
 (a) Standing woman with fan and bunch of grapes, seated woman with branch and phiale, youth
with wreath and drapery over l. arm, (b) three draped youths.
 167 Bologna 596.
 CVA 3, IV Dr, pl. 25, 1–2.
 (a) Woman with dish of cakes, seated Dionysos with kantharos and thyrsus, (b) two draped youths,
l. with stick, r. with wreath.
 168 Florence, private coll. 7.
 (a) Woman with situla and tambourine, Dionysos with kantharos and thyrsus, (b) two draped
youths.
 169 Bassano del Grappa, Chini coll. 77;
 (a) Eros with wreath and phiale, seated half-draped maenad with mirror and thyrsus, (b) two draped
youths, l. with stick, r. with wreath.
 170 Bari 6320.
 (a) Youth with situla and phiale, draped woman with wreath, both moving to l., (b) two draped
youths.

Calyx-krater

*171 B.M. F 273. PLATE 80, 5.
 (a) Capering papposilen and half-draped woman (white flesh) reclining on couch and playing kotta-
bos, (b) two draped youths.

Skyphos

172 Taranto I.G. 6400.
 (a) Eros with wreath and egg, (b) woman moving l. with wreath and mirror.

Oenochoai (shape 3).

173 Taranto 20424.
 CVA 1, IV Dr, pl. 16, 1; *PhV*2, p. 64, no. 120; Belli, *Tesoro di Taras*, ill. on p. 175.
 Phlyax with mirror and tambourine in front of woman seated on rock with a phiale in her hand.
*174 Taranto, Ragusa coll. 123. PLATE 80, 6.
 Phlyax holding up tambourine in l. hand.
175 Taranto 114090, from the Rione d'Italia.
 Lo Porto, *BdA* 49, 1964, p. 19, fig. 10; *PhV*2, p. 65, no. 123.
 Phlyax striding to r., with basket-crown on his head.
 Very close to no. 174.

(iii) COMPARABLE

The two following vases may be compared with the work of the Schlaepfer Painter.

Hydria

176 Once Vienna, Matsch coll.
 CVA, pl. 14, 1.
 Standing woman with mirror, and seated nude youth with phiale and thyrsus.

Bell-krater

177 Lecce 773.
 CVA 2, IV Dr, pl. 17, 1—3; Herbig, *Pan*, pl. 24, 2. Photo: R.I. 62.1214.
 (a) Pan dancing while a seated silen plays the flute, (b) two draped youths.

10. THE MONTPELLIER GROUP

The vases in this group again stand in very close relationship to the work of the Dijon Painter
(e.g. 6/160) and his followers (especially the Group of Ruvo 892; nos. 6/183—6), in the treat-
ment of the standing draped women (as on nos. 178, 181), as well as of the youths on the
reverses (note the border of the overhang, and the bracket-like line marking the edge of the
"sleeve" on the youth to right). The saltire squares with large strokes are also typical.

(i) THE MONTPELLIER PAINTER

Characteristic are the dotted ground-lines, the rendering of women's breasts and drapery,
and the drawing of the head of the youth to right on the reverses (e.g. nos. 178—180), with
solid black hair, an indented ear, a long nose and a small mouth.

Column-krater

*178 Montpellier, Musée Fabre 837—1—1116. PLATE 81, 1—2.
 (a) Youth with shield and two spears seated between woman with tympanon and youth with wreath
and sash, (b) woman between two draped youths.

Pelikai

179 Bologna 542.
 CVA 3, IV Dr, pl. 12, 3–4.
 (a) Nude youth with stick and wreath, draped woman with sash, (b) two draped youths.
180 Ruvo 735.
 Photos: R.I. 72.53–4.
 (a) Standing woman holding open box and bead-chain above kalathos, seated nude youth with bird perched on r. hand, (b) two draped youths.

Amphorae

*181 Ruvo 886. PLATE 81, 3–4.
 Photo: R.I. 72.57.
 (a) Draped woman with phiale, and nude youth with phiale at Doric grave monument, tied with fillet, (b) two draped youths.
182 Adolphseck 183.
 CVA, pl. 83, 1–3.
 (a) Draped woman with cista, and nude youth with spray at Ionic grave monument tied with fillet, (b) two draped youths.

(ii) VASES CONNECTED IN STYLE

(a)

The following vase, which has been extensively repainted, looks from the treatment of the draped youths on its reverse to be closely connected with the Montpellier Painter, and possibly by his own hand (cf. with nos. 180–1).

Amphora

183 Baranello 154. Much repainted.
 (a) Half-draped youth with branch and wreath, standing in front of seated woman with fan, (b) two draped youths.

(b)

Amphora

*184 Taranto, Baisi coll. 40. (b) PLATE 81, 5.
 (a) Woman with wreath, and youth with phiale, at Ionic grave monument, (b) two draped youths.

Pelikai

185 Rome, Conservatori 82. In bad condition.
 CVA 2, IV D, pl. 38, 1–2.
 (a) Woman with wreath, and youth, at stele, (b) two draped youths.
*186 Leningrad inv. 529 = St. 1240. (b) PLATE 81, 6.
 (a) Nude youth with wreath and stick, woman holding cista resting l. arm on pillar; fan between them, (b) two draped youths.

11. THE MAPLEWOOD PAINTER

The Maplewood Painter, who takes his name from the location of no. 187 in the J.V. Noble collection, is an important artist, whose style reflects the influence of the Dijon Painter and his followers, from whom he perhaps derives his fondness for representing youths or warriors in Oscan dress, usually a striped tunic with vertical rows of dots.

His treatment of draped youths should be compared with that of the Montpellier Painter

(e.g. nos. 178–180). He normally prefers a drape over the left shoulder for the left youth and an akimbo drape, with "sleeve" for the right. Occasionally they may wear white head-bands.

His drawing is neat; note especially the small mouths. Women tend to wear a white radiate stephane; on standing female figures the fold-lines tend to run in pairs down the peplos. The breasts are usually set fairly well apart, without fold-lines between them (e.g. nos. 188, 191, 193, 195, 197).

The ivy-pattern on the necks of column-kraters generally leaves a fairly large space above and below; the central dot of the berries is usually large; the framing panels stop above the meander pattern below the picture; quartered squares with dots regularly accompany the meanders.

Column-kraters

*187 Maplewood (N.J.), J.V. Noble coll. PLATE 82, 1–2.
 Parke-Bernet, *Sale Cat.* 9 April 1953, no. 153 (ill.); *Gli Indigeni,* fig. 17.
 (a) Nike flying to crown Oscan warrior grasping hand of Oscan youth with oenochoe, woman with nestoris holding wreath before Oscan warrior on horseback, (b) maenad with thyrsus and wreath, Dionysos with phiale and thyrsus, satyr with situla and torch.

*188 Once Milan Market. PLATE 82, 3–4.
 Sale Cat., Finarte 5 (14 March 1963), no. 90, pls. 48–49; *Gli Indigeni,* fig. 36. Photos: R.I. 57.778–9.
 (a) Combat scene with four Oscan warriors and Nike flying to crown the victor, (b) woman with oenochoe offering wreath to seated warrior, standing warrior to r.

189 Vatican T 10 (inv. 18042).
 VIE, pl. 30 h, and p. 122, fig. 14; *Gli Indigeni,* fig. 21.
 (a) Woman pouring libation to seated Oscan warrior, standing warrior to r., (b) three draped youths.
 The obverse design is very close to the reverse of the preceding vase.

190 Leningrad inv. 1204 = St. 883.
 (a) Duel between bearded Greek with horse, spear in l. hand and two spears in r., and Oscan with shield and spear, (b) three draped youths.

191 Leningrad inv. 1973.
 (a) Oscan warrior with phiale and shield seated between woman with branch and wreath and nude youth holding fillet, (b) nude youth with branch and phiale running to l. followed by woman with bunch of grapes and thyrsus.

192 Vatican T 11 (inv. 18043).
 VIE, pl. 30 l, and p. 122, fig. 15.
 (a) Woman with situla holding wreath above head of seated Oscan warrior, to l. warrior with lyre, to r. warrior with shield and two spears, (b) woman between two draped youths.

193 Paris, Cab. Méd., Delepierre 61.
 (a) Maenad with thyrsus, fawnskin and tambourine, Dionysos with thyrsus and phiale, satyr with torch and situla, all moving to r., (b) three draped youths.

*194 Edinburgh 1956.461. PLATE 82, 5–6.
 (a) Maenad with thyrsus and phiale, and seated Dionysos with wreath and thyrsus, (b) two draped youths.

195 Andover, Phillips Academy.
 (a) Woman with thyrsus and phiale, seated youth with thyrsus, (b) three draped youths.

196 Matera 12412.
 Lo Porto, *Penetrazione,* pl. 59, 2–3.
 (a) Oscan youth with two spears, woman pouring libation from oenochoe into phiale held by seated warrior with shield and spear, Oscan youth with pilos, (b) youth with oenochoe, draped woman, and youth (mostly missing).

Calyx-krater

197 B.M. F 274.
 El. Cér. ii, pl. 43.
 (a) Woman with two spears (Artemis ?) riding on a deer between a woman with torch and a young satyr, (b) maenad with thyrsus and phiale, seated youth with torch and thyrsus.

Bell-kraters

198 Naples 2039 (inv. 81468).
 (a) Young satyr, with thyrsus and situla, bending forward over raised foot to pour from an oenochoe into a phiale held by seated maenad, (b) two draped youths (as on no. 194).
199 Tokyo, Bridgestone Museum 79.
 Mizuta I, no. 6, pls. 8–9.
 (a) Woman with wreath and mirror, and nude youth with drapery over l. arm, (b) two draped youths.

Amphora

200 Milan, "H.A." coll. 217.
 CVA 1, IV D, pl. 24.
 (a) Youth with wreath and phiale, woman with sash and wreath at naiskos in which is draped youth, (b) three draped youths.

Pelike

201 Bari 5263.
 (a) Seated Eros with phiale into which draped woman with cista is pouring a libation, (b) two draped youths.

VASES RELATED IN STYLE

(a)

The following vase is closely related to the work of the Maplewood Painter, if not by his own hand.

Amphora

202 Vatican W 2 (inv. 18099).
 VIE, pl. 38 c and f.
 (a) Youth with phiale and fillet, woman with fillet and basket at naiskos in which is a draped youth, (b) two draped youths.

Compare the youth in the naiskos with the corresponding figure on Milan "H.A." 217 and the draped youths with those on the reverse of Vatican T 11.

(b)

Column-kraters

203 Adolphseck 181.
 CVA, pl. 81, 2–3.
 (a) Woman with branch and phiale seated between Oscan warrior bending forward over raised foot and holding wreath and shield, and Oscan warrior with spear and shield, (b) three draped youths.
204 New York 96.18.28.
 (a) Woman with cista and branch, and Oscan youth with torch and two spears moving to r., (b) two draped youths.

12. THE PAINTER OF THE BARI ORESTES: THE LETET AND GOLETA GROUPS

Like the vases by the Montpellier and Maplewood Painters the vases in this section, which are mainly column-kraters and pelikai, continue what we may call the Dijon tradition and provide connecting links with the work of the Painter of Athens 1680 and the Avignon Painter. The central youth on the reverse now normally has a frontal body with the head in profile to the left and his left arm is bent at the elbow with a "sleeve" drape; the overhang on the youth to left has a thick black wavy border, which sometimes looks like a flat S.

(i) THE PAINTER OF THE BARI ORESTES

It is interesting and rare to find a mythological subject on the column-kraters in this chapter; Bari 1366 shows us Orestes kneeling on the altar, trying to protect himself from the attack of a menacing Fury, while Apollo looks on calmly, bow in his upraised right hand and laurel-branch in his left. The draped youths on all three kraters are almost replicas, with minor variations. Note on no. 205 the stylus in the diptych above the youths which points to left instead of to right, as is more usual (cf. also nos. 23—5 above).

Column-kraters

*205 Bari 1366. (b) PLATE 83, 1.
 Moret, *Ilioupersis,* pl. 49, 1.
 (a) Orestes on the altar between Fury, with serpent and torch, and Apollo, (b) three draped youths.

*206 New York 96.18.42 (GR 640). (b) PLATE 83, 2.
 (a) Woman with nestoris, and two Oscan youths, all moving to l., (b) three draped youths.
 For the nestoris without rotelle cf. no. 13/54 by the Varesse Painter.

 207 Louvre K 521. Repainted.
 (a) Oscan youth bending forward over raised foot to offer wreath to seated woman with phiale, Oscan youth with drinking-horn and spear; to r., nestoris on Ionic column, (b) three draped youths.

(ii) THE LETET GROUP

The Group takes its name from the former owner of the Budapest column-krater (no. 208). The vases are connected with those in the previous division by the treatment of the central draped youths; note also the "bracket"-shaped line at the edge of the "sleeve", a prototype of which will be found on the vases in the Group of Ruvo 892 (e.g. nos. 6/183—6 above). There are curved lines forming an ellipse, or oval, on the himation beside the bent arm (e.g. nos. 208—9, 211), which should be compared with those on the vases of the Painter of Athens 1680 (nos. 110, 114—5, 121, 123, 129, 132 above).

(a)

Column-kraters

*208 Budapest 57.5 A (ex Letet 135). (b) PLATE 83, 3.
 G. and R. Guide, pl. 24, 2.
 (a) Youth in Oscan dress, seated woman holding nestoris and branch, and Oscan youth, drawing an oenochoe from a b.f. column-krater, (b) three draped youths.

*209 Louvre N 2623 (ED 626). (b) PLATE 83, 4.
 (a) Oscan warrior with two spears standing beside horse, Nike with fillet; shield, top l., (b) three draped youths.

With the draped youth to right on the reverses of the two above vases, compare that upon:

Calyx-krater

 210 Copenhagen 332 (B–S. 217). (Continued next page)

Calyx-krater (continued)

> *CVA*, pl. 235.
> (a) Orestes at Delphi, (b) woman with palm branch and cista between two draped youths.

Pelike

*211 Bari, Lagioia coll. (b) PLATE 83, 5.
> (a) Seated half-draped youth with branch and phiale, standing woman with wreath, (b) two draped youths.

(b)

Pelike

212 Ravenna, Prof. Bendandi.
> (a) Nude youth with fillet standing before seated woman; Eros flying above to crown youth, (b) two draped youths.
> The youth to r. should be closely compared with the two to r. on no. 213.

Column-kraters

*213 Montpellier, Musée Fabre 837—1—1117. (b) PLATE 83, 6.
> (a) Woman pouring libation to seated Oscan warrior holding phiale, Oscan warrior with kantharos and spear standing to r., (b) three draped youths.
214 Trieste S 384.
> *CVA*, IV D, pl. 9, 1—2.
> (a) Two Oscan warriors and two women with offerings, (b) three draped youths.

(iii) THE GOLETA GROUP

(a)

The vases in this sub-division all show as part of the obverse scene a horse, not very well drawn, with its head turned slightly round from its body and one of its forefeet raised. They have thin necks and small heads and should be compared with those by the Lycurgus Painter (Chapter 16).

Column-kraters

215 Bonn 96.
> (a) Amazonomachy — Amazon with axe and pelta, beside a horse, attacking prostrate Greek, while another Greek comes up with shield and spear, (b) three draped youths.
> The b.f. animals on the rim of (a) are a modern addition.
216 Goleta (Calif.), Mr. J. Whitehead (ex Hearst 2411; ex Ruesch coll., *Sale Cat.* pl. 14).
> (a) Woman offering libation to departing Oscan warrior with horse, to l. Oscan warrior with spear, (b) three draped youths.
217 Ruvo 406.
> Sichtermann, K 62, pl. 101. Photo: R.I. 64.1216.
> (a) Departure of Oscan warrior — woman holding horse; warrior and woman offering libation, (b) two draped youths; small boy with aryballos, and nude youth scraping himself with strigil.

(b)

The figures on the reverse of Ruvo 406 (no. 217) suggest that the two following vases might also find a place in this context (cf. also with nos. 4/49 and 51):

Bell-kraters

218 Vatican V 10 (inv. 18030).
> *VIE*, pl. 28 b and d.

(a) Youthful Herakles resting club on lion-skin, Athena with spear, nude youth, (b) three draped youths.

219 Zagreb 11.
 Damevski, no. 30, pls. 11, 2 and 14, 1.
 (a) Young satyr with situla moving to l., followed by woman with chaplet and thyrsus, (b) two draped youths beside altar.

(c)

With the above compare:

Column-krater

220 Vatican V 39 (inv. 18072).
 VIE, pls. 32 c and 33 c.
 (a) Dionysos with thyrsus between woman with branch and woman with situla, (b) three draped youths.

13. THE VERONA PAINTER

The Verona Painter follows on directly from the Avignon Painter and is very close in style to the Rueff Painter; he looks rather like a crude imitator of the Dijon Painter and his drawing is very slovenly. The following may be noted as characteristic of his work:

(i) the treatment of the fold-lines at the waist of his female figures — the breasts are left plain, and below them is a series of short vertical lines running upwards from the girdle, which is generally looped with dotted ends (e.g. nos. 221–2, 224, 226, 230–1).

(ii) women's hair sticks out in a bunch at the back, with a radiate stephane, often with three widely-spaced rays, (e.g. nos. 221–3, 230–1).

(iii) the l. youth on the reverse normally has a "saucer" drape (cf. with the Avignon Painter), the r. a "sleeve"; in the bottom corners of their himatia are two or three sideways-U folds; the overhang of the l. youth's himation has a double wave (like a badly drawn 3), as on no. 222; occasionally there are hook-folds on the lower part of the himatia or beside the bent arm (nos. 222–3).

(iv) the meanders are very carelessly drawn and accompanied by saltire squares with strokes in the intersections, also very carelessly placed.

The work of the Verona Painter must be contemporary with that of the Thyrsus Painter (i.e. towards the middle of the fourth century), with which it has much in common (see Chapter 10, 5).

Pelikai

221 Verona 168.
 CVA, IV D, pl. 7, 2.
 (a) Woman with cista leaning against pillar, youth with wreath, (b) two draped youths.
*222 Bari 6274. PLATE 84, 1–2.
 (a) Youth with palm branch and thyrsus, woman with kantharos seated on rock, (b) two draped youths.
223 Reading 150.51 RM.
 (a) Woman juggling balls, nude youth with phiale and palm branch moving to r., (b) two draped youths at stele.
*224 Bari, Lagioia coll. PLATE 84, 3–4.
 (a) Woman with situla and tambourine, nude youth with kantharos and fillet, (b) two draped youths.
225 Bari, Lagioia coll.
 (a) Youth with stick and phiale, draped woman with wreath and box, (b) two draped youths.

Bell-kraters

226 Castlecoole 2.
 (a) Dionysos with thyrsus and phiale into which draped woman, holding up cista in l. hand, is about to pour wine from a kantharos in her r., (b) two draped youths. (Cf. with the Avignon Painter nos. 105–6 for the drapery of the l. youth).
227 Matera 155054, from Ferrandina. In bad condition, with much missing.
 (a) Standing woman with thyrsus, satyr; palmette between, (b) two draped youths.
 Cf. with no. 225.
228 Bari, Macinagrossa coll.
 (a) Satyr with torch and situla, maenad with kantharos and thyrsus, (b) two draped youths (cf. with no. 224).
229 Gravina, from Botromagno, T. 5.
 (a) Woman with cista and tambourine, nude youth with wreath and thyrsus, (b) two draped youths.
230 Bologna 600.
 CVA 3, IV Dr, pl. 22, 5–6.
 (a) Satyr with thyrsus and dish of offerings, maenad with tambourine and thyrsus, (b) two draped youths by bloodstained altar.
230a Vidigulfo, Castello dei Landriani 250.
 Ex Milan Market, Casa Geri, *Sale Cat.* Nov. 1971, no. 429.
 (a) Seated nude youth holding phiale in l. hand, into which draped woman with thyrsus is pouring wine from a kantharos, (b) two draped youths.
 Very close to no. 230.

Column-krater

*231 Nocera, Fienga coll. 565 (De F. 521). PLATE 84, 5–6.
 (a) Woman with dish of cakes, seated nude youth with wreath and spear, standing woman, (b) three draped youths.

Hydriai

232 Karlsruhe B 771.
 CVA, pl. 81, 2.
 Two women at an altar.
233 Boston L. 229.65.
 Woman with fan and woman with sash and phiale.
234 Milan, "H.A." coll. 442.
 Nude youth resting raised foot on rock, draped woman coming up with branch; kalathos between them.
235 Kiev 92.
 Draped woman with cista and youth with wreath, resting l. arm on pillar; kalathos between them.
236 Leningrad inv. 4555.
 Woman holding wreath, and youth, each side of an apple-tree.
237 Madrid, Palacio de Liria CE 26.
 Blanco Freijeiro, *Zephyrus* 15, 1964, p. 74, no. 10, fig. 24.
 Warrior with shield and spear, woman with wreath and cista.
238 Ruvo 785.
 Athlete with strigil, woman bouncing ball.

Oenochoai (shape 3)

239 Mainz 182.
 Nude youth with phiale, and woman with bunch of grapes.

240 Bari 6382.
 Standing Dionysos with thyrsus; tree, woman with cista by altar.
241 Milan, "H.A." coll. 277.
 Seated youth with phiale, woman with cista and thyrsus.

VASES CONNECTED IN STYLE

Oenochoai (shape 3)

242 Sydney 91.
 Nude youth with phiale, and woman with wreath at altar.
243 Bari, Lagioia coll.
 Woman with branch and cista standing beside a flaming altar on to which a satyr is pouring wine
 from a kantharos.
244 Leningrad inv. 1696 = St. 1388.
 Woman with bunch of grapes bending forward over raised foot, Eros with rosette-chain.

14. THE RUEFF PAINTER

The Rueff Painter is an artist of rather poor quality, very closely associated in style with the
Verona Painter, and, like him, looking back to the Dijon Painter and especially to the Avignon
Painter (cf. Salerno 163 and Bologna 592, nos. 105—6, for the "saucer" drape of the youth
to left on the reverse with nos. 245—9). His close relationship with the Verona Painter may be
seen by comparing nos. 245—9 with the Nocera column-krater (no. 231), but we may note a
few points of difference:

(i) the drawing of women's breasts and the treatment of the fold-lines at the waist;
(ii) the youth to l. on the reverse who invariably has a double bulge at the top of his himation just behind
 the neck; this also appears on several of the other youths (e.g. on nos. 247—9, 251—6);
(iii) the meanders which are smaller and are accompanied by quartered squares with dots; on some vases,
 instead of meanders below the pictures, we find chevrons (nos. 256—7, 261), flat S's with dots (nos.
 251, 255) or wave pattern (no. 251), patterns which also occur on the rims of column-kraters.

The draped youth to left regularly has a "saucer" drape, inclining sharply downwards (cf.
the Avignon and Verona Painters); on the youths to right there is usually a thick black stripe
running diagonally down the top of the himation; when the left arm is bent there is a "sleeve"
draped with two parallel black lines below it and a wavy line round the edge. The reverses are
particularly close to those of the Verona Painter, but distinguished by the double bulge, which
does not appear on his work, although the Verona pelike (no. 221) is getting close to it.

In addition to balls, diptychs, rosettes and fillets in the field, we may note on several vases
(e.g. nos. 255—6, 263) a diptych which looks like a pair of rectangular *halteres*.

The vases in (i) look slightly earlier than those in (ii), but all are closely linked; the latest
(nos. 261—3) are particularly careless in their drawing, but have all the hall-marks of the
painter.

(i)

Column-kraters

*245 New York 1974.23 (ex Rockefeller coll.; American Art Galleries, *Sale Cat.* 21—22 Jan. 1910, no.
 269). PLATE 85, 1—2.
 (a) Woman with branch and cista, seated Oscan youth with phiale into which another Oscan youth
 is pouring wine from a kantharos, holding a spear in his l. hand, (b) three draped youths.
 Cf. with Nocera 565, by the Verona Painter.

Column-kraters (continued)

246 Once London Market, Sotheby, *Sale Cat.* 24 Feb. 1975, no. 202.
 (a) Nike pouring libation to seated warrior, (b) two draped youths.
*247 Naples 2323 (inv. 81707). PLATE 85, 3–4.
 (a) Warrior with shield and two spears, Nike with phiale seated on rock, (b) two draped youths.
247a Once London Market, Christie's (ex du Chastel coll.).
 (a) Standing woman holding up cista of cakes, seated Oscan warrior with two spears and shield, standing Oscan warrior with phiale and spears, (b) three draped youths.
248 Barletta 657.
 (a) Woman with cista and fillet, holding kantharos over phiale held out by seated Dionysos with thyrsus, satyr with raised foot holding kantharos and situla, (b) three draped youths.

Bell-krater

*249 Basel Market, MuM. PLATE 85, 5–6.
 (a) Woman, Dionysos with kantharos at an altar, satyr with kantharos and phiale, (b) three draped youths.

(ii)

Column-kraters

250 Once Munich Market, Rueff (13/3/61).
 (a) Woman with cista and fillet, followed by warrior with shield and two spears, and prisoner with hands tied behind his back, (b) three draped youths.
251 Reading 87.35.34.
 CVA, pl. 29, 6 and pl. 31, 6; *Gli Indigeni,* fig. 39.
 (a) Warrior with shield and two spears and two prisoners with bound hands, (b) three draped youths.
252 Palermo 2249 (old inv. 836).
 (a) Woman pouring libation to seated Oscan warrior, holding cord binding prisoner standing to r., (b) three draped youths.
253 Kiel, Kunsthalle (ex Berlin F 3284).
 (a) Satyr, Dionysos and maenad, all moving to l., (b) three draped youths.
253a Geneva 21952.
 (a) Maenad with thyrsus and situla, youthful Dionysos seated with thyrsus and phiale, above which a satyr holds a kantharos, (b) three draped youths.
254 Basel Market, MuM. Much of the obverse missing.
 (a) Nude youth with phiale and palm branch, seated between satyr and draped woman with cista, (b) three draped youths.

Bell-kraters

255 Vatican V 24 (inv. 18057).
 VIE, pl. 30 d and pl. 31 l.
 (a) Maenad and satyr, (b) two draped youths.
256 Copenhagen 67 (B–S. 278).
 CVA 6, pl. 253, 3.
 (a) Satyr with thyrsus and situla, maenad with cista and thyrsus, (b) two draped youths.
257 Vienna 4015.
 (a) Maenad with thyrsus and cista, followed by young satyr with situla and thyrsus, (b) two draped youths.
258 York 23.
 (a) Satyr with thyrsus and situla, maenad with cista and thyrsus, (b) two draped youths.

259 Agrigento C 2037.
 (a) Satyr with thyrsus and situla followed by woman with cista of offerings and thyrsus, (b) two draped youths.
260 Matera 10766, from Timmari.
 (a) Satyr with thyrsus and situla, draped woman with cista and branch, (b) two draped youths.

Amphora

260a Taranto, from Rutigliano, T. 2.
 (a) Woman with branch and mirror, and nude youth with phiale and branch, at stele on top of which is a large egg, (b) two draped youths.

(iii)

Amphora

261 Bologna 530.
 CVA 3, IV Dr, pl. 3, 5–6.
 (a) Woman with cista and seated nude youth with phiale, (b) two draped youths at stele.
 Late and very crude.

Pelikai

262 Milan, ex Riquier coll.
 (a) Seated woman with cista, and nude youth with phiale, (b) two draped youths.
263 Leningrad inv. 1192 = St. 1103.
 (a) Woman with mirror and cista, youth with wreath and shield, (b) two draped youths.

CONNECTED IN STYLE

Bell-krater

264 Vatican V 22 (inv. 18055).
 VIE, pl. 30 b and pl. 31 j.
 (a) Woman with situla and cista, satyr with tambourine and thyrsus, (b) two draped youths.
 Cf. also with the work of the Wolfenbüttel Painter.

CHAPTER 10

FOLLOWERS OF THE PLAIN STYLE TRADITION (B)
THE JUDGEMENT GROUP AND ASSOCIATED VASES;
THE THYRSUS AND LAMPAS PAINTERS

1. The Judgement Group
2. The Group of Boston 00.348
3. The Berkeley Group
4. The Dechter Group
5. The Thyrsus Painter
6. The Lampas Group

Bibliography

Most of the groups or painters discussed in this chapter are listed in *APS* on pp. 18 f., 28 f., and 77–83, and *Addenda,* pp. 425 and 432–3. Short notices by A. Stenico will be found in *EAA* on the Judgement Painter (ii, 921), the Thyrsus Painter (vii, 880) and the Lampas Painter (iii, 464); the last is dealt with in some detail by Cambitoglou in *BSR* 19, 1951, pp. 39–42 and by Lidia Forti in *Atti M Grecia* n.s. 8, 1967, pp. 99–112. On the Dechter Painter see Trendall in *Festschrift Brommer*, pp. 285–7.

Introduction

The preceding chapter dealt with a series of painters in the tradition of the "Plain" style whose work was particularly influenced by the Painter of Karlsruhe B 9 and the Dijon Painter (Chapter 6), although not unaffected by the Iliupersis Painter and his school; in the present chapter we shall consider two large groups of vases, the first of which reflects the influence of some of the painters discussed in Chapter 4 (notably the Adolphseck Painter and the painters of the Long Overfalls Group), the second (the Thyrsus and Lampas Painters) that of the Truro and Lecce Painters and their associates (Chapters 5, 4–7).

1. THE JUDGEMENT GROUP

This group takes its name from the Judgement Painter (*APS,* pp. 28–9), near to whom we may now place a number of other painters and vases, some of considerable interest and significance, including the Painter of Boston 00.348, who in *APS* (p. 18) was associated with the Ariadne Painter. A great deal of new material has recently come to light in the area of the Judgement Painter, who may now be studied in a somewhat broader context than was previously possible.

(i) THE "PAINTER OF THE LONDON PELIKAI" AND THE "REHEARSAL PAINTER"

In *APS* (pp. 25–27) reference is made to the "Rehearsal Painter" and the "Painter of the London Pelikai". In the light of the new evidence it now seems that their work, especially that of the latter, should be more closely associated with the Brooklyn-Budapest Painter in Early Lucanian (*LCS*, pp. 107 ff), and here again we seem to have the same sort of relationship as we observed above in the TARDOL Group (see pp. 53–54) between an Apulian and a Lucanian workshop.

To the hand of the "Painter of the London Pelikai" the following vases may now be attributed:

(a)

Pelikai

1 B.M. F 181.
 APS, p. 27, no. 1, pl. 8, fig. 35.
 (a) Woman with mirror seated to r. on klismos between nude youth and draped woman holding cista
 and box, (b) two draped youths.

2 B.M. F 182.
 APS, p. 27, no. 2, pl. 8, fig. 36.
 (a) Woman with mirror seated to l. on klismos between nude youth and draped woman holding up
 an alabastron, (b) three draped youths.

3 Ruvo 549.
 APS Addenda, p. 426, no. 3; Sichtermann, K 33, pl. 49. Photo: R.I. 64.1239.
 (a) Nude youth with strigil in l. hand and drapery over l. arm, draped woman with wreath and situla,
 (b) two draped youths.

Lekythos

4 Naples 2342 (inv. 82156).
 Nude youth with drapery over l. arm, seated woman with cista, on top of which is a squat lekythos.

(b)

Pelikai

5 Ruvo 457.
 APS Addenda, p. 426, no. 4; Sichtermann, K 48, pl. 48, 2. Photos: R.I. 64.1242, 66.1711.
 (a) Nude youth leaning on pillar, Nike with branch and wreath, (b) two draped youths.

6 Prague 2/73.
 (a) Nude youth with stick, draped woman with fillet and branch, (b) two draped youths.

7 Bari 6273.
 (a) Standing woman with cista, and half-draped youth, holding fillet, seated on altar, on base of
 which is a hydria, (b) two draped youths.

8 Bari, Lagioia coll.
 (a) Draped woman holding box, nude youth with stick and strigil, leaning on pillar, (b) two draped
 youths.

9 Naples 2271 (inv. 81729).
 APS, p. 27, no. (i).
 (a) Woman with dish of offerings and nude youth, both running to l., (b) two draped youths.

Squat lekythos

10 Toulouse 26.140. Much repainted.
 Nude youth with strigil, seated half-draped woman by altar, nude youth holding up box, draped
 woman, seated nude youths with cista and b.f. squat lekythos (cf. no. 11).

Bell-kraters

11 Japan, private coll.
 Greek and Etruscan Arts, no. 27 (ill.).
 (a) Nude woman with mirror, resting l. hand on laver, young satyr with squat lekythos to r., (b) two
 draped youths.

12 Munich, Altrock coll.
 Bielefeld, *Pantheon* 24, 1966, p. 253, fig. 1; *APS Addenda,* p. 426; Chamay, *Genava* n.s. 24, 1976,
 p. 285, fig. 5.
 (a) Satyr with knife, and woman pouring water on to tunny-fish on chopping-block, (b) two draped
 youths, l. with strigil.

Bell-kraters (continued)

13 Naples Stg. 486.
 (a) Woman with torch and tambourine followed by satyr holding situla in r. hand and carrying
b.f. calyx-krater on shoulder, (b) two draped youths.

<div align="center">(c)</div>

Closely connected the the above in style are four vases, of which the first three were
attributed in *APS* (p. 26) to the "Rehearsal Painter":

Bell-krater

14 Oxford 1944.15.
 APS, p. 26, no. 1; Clairmont, *Parisurteil*, K 189, pl. 39; *EAA* vi, p. 693, fig. 802.
 (a) Hermes with Hera, Athena and Aphrodite, (b) nude youth with phiale between two half-
draped youths, l. with strigil, r. with wreath.

Hydriai

15 B.M. F 92.
 APS, p. 26, no. 2.
 Electra, holding vase, Orestes seated by pillar inscribed with his name, woman with sash.
16 B.M. F 96.
 APS, p. 26, no. 3.
 Woman with parasol, seated nude youth, standing youth with phiale and stick.
 Forms a pair with the preceding vase.
17 Louvre N 2594.
 Reinach-Millingen 18.
 Woman and youth beside pillar inscribed ΦΟΙΝΙΞ (cf. the inscribed pillar on no. 15).

Between the vases in (a) and (b) we may note a few minor points of difference — on the
former the meanders start at the bottom and are accompanied by thick saltires, on the latter
the meanders vary, the crosses are thinner and the laurel-wreaths above are different; in (b)
the rendering of the hair is sketchier, and the youths on the reverses do not wear white head-
bands. However, comparison in other details makes it difficult to think of them as the work
of two distinct painters.
 We note on all the frequent appearance of several stock figures:

(i) a standing woman with her hair caught up in a sphendone. She wears a peplos, gathered in at the
 waist, with very strongly marked fold-lines and a double black stripe running down it. Her breasts
 are large and protrude somewhat beneath her drapery; they are left free of fold-lines (e.g. nos. 1—3,
 7—8, 12). She may have a piece of drapery behind her back and over her arms (nos. 1, 3) or over
 one arm and held in the other hand (nos. 2, 7, 8); the Nike on no. 4 is a simple variant of this figure.
(ii) a standing nude youth with semi-frontal body, head in profile, and a short cloak draped around part
 of his body. The anatomical markings are clearly defined; the nose is pointed, the fingers long (e.g.
 nos. 1—6, 8).
(iii) the draped youths on the reverses, who may be typed as follows:
 (a) facing to r. — r. arm bent at the elbow and pointing upwards at an angle of about 45°; long
 overhang, with wavy border; lower hem-line wavy, especially above the ankle (e.g. nos. 1, 5, 9).
 As a variant, the r. shoulder may be left bare and the arm extended to hold a stick (nos. 6—8,
 11) or a strigil (nos. 2, 12, 13).
 (b) facing to l. — l. arm bent at elbow, with "sleeve" drape; downward curving black line on edge,
 with two black lines descending below it to the lower hem-line, which corresponds with that on
 the youth to l., with a similar wave above the ankle down to behind the l. foot (e.g. nos. 2, 6).

More commonly the r. arm, instead of being concealed beneath the cloak, which then looks rather like a collar round the neck, is extended to hold a stick (nos. 1, 2, 5, 8, 9, 11, 13) or a sash (no. 7). On nos. 11—13 there is a wavy black line below the row of diagonal folds across the top of the cloak; note particularly on no. 1 the series of parallel V-shaped lines across the lower part of the abdomen (exactly as on *LCS* nos. 561, 572, 581 by the Brooklyn-Budapest Painter).

If we compare the stock figures referred to above with the corresponding ones on vases by the Brooklyn-Budapest Painter (see *LCS*, pp. 107 ff., pls. 55—58), it seems almost impossible not to come to the conclusion that all these vases are the work of a single painter. His early work, which would include the vases formerly attributed to the "Painter of the London Pelikai" (cf. also *LCS*, nos. 558—572), may well have been subjected to a strong Apulian influence, but as his later vases include several nestorides (*LCS*, nos. 581—9), which must undoubtedly be Lucanian, he is probably better regarded as a Lucanian than an Apulian and in this respect finds a close parallel in the Dolon Painter.

The hydriai B.M. F 92 and F 96 (nos. 15—16), formerly attributed to the "Rehearsal Painter", to which must now be added Louvre N 2594 (no. 17), seem also to be his work. Electra on F 92 and the maid with the parasol on F 96 should be compared with the standing women on nos. 1—3 and with those on *LCS*, nos. 568, 575, 582 and 590; the seated nude youths with those on no. 7 and on *LCS*, nos. 575, 577 and 581. Note also on F 96 the cross to mark the nipple of the woman's right breast — this is particularly characteristic of the Brooklyn-Budapest Painter (*LCS*, p. 111; nos. 576, 578, 589—90, etc.). Further correspondences in points of detail (e.g. the tambourines, wreaths, sashes, etc.) and in the decorative patterns will readily be found, and these vases, as a whole, form a very consistent group.

The Rehearsal krater (no. 14) seems, by reason of its reverse, to stand a little apart, but a careful study of the treatment of the drapery, the use of a cross to indicate the nipple, the drawing of the faces, and of the youths' hair shows that it goes very closely with nos. 15—17 and should therefore also be associated with the Brooklyn-Budapest Painter, especially with such vases as *LCS*, nos. 581, 587, 590—1.

Between these vases and the work of the Judgement Painter there is undoubtedly a strong stylistic affinity, probably indicative of a common source of inspiration.

(ii) THE JUDGEMENT PAINTER

The Judgement Painter takes his name from the bell-krater B.M. F 167 (no. 26) representing the Judgement of Paris. In style he looks back to the Schiller and Adolphseck Painters in Chapter 4 — compare, for example, the obverse of Ruvo 637 (no. 22) with that of nos. 4/19 and 20 by the Schiller Painter, also with no. 4/49 by the Adolphseck Painter, who clearly had a considerable influence on his treatment of the drapery of the youths on the reverses, especially in their "sleeve" drape and the hand thrust into the cloak (cf. Ruvo 637 = no. 22 with Adolphseck 179 = 4/51). However, a certain deterioration in the quality of the drawing is perceptible, which on his later vases (e.g. nos. 23—28) becomes almost slovenly, especially on the reverses.

(a)

The two vases in this sub-division seem to represent an early phase in the Judgement Painter's career, with rather neater drawing. His characteristic treatment of the face, especially the eyes, nose and mouth is well illustrated by the seated Nike on the obverse of no. 18; the pupil of the eye is a small black dot, the eyebrow is small and arched, the nose very small with a curved line to mark the nostril, the mouth tightly closed, the chin fairly heavy and rounded. The drapery has fine fold-lines with occasional hooks; the borders are clearly defined with

thick black lines. The standing female figures should be compared with those on nos. 14–17 above.

On these two vases the meanders are continuous but do not join at the centre; on no. 18 we note a most unusual pattern in which two half-meanders replace the more normal crossed square. On the youth to right on the reverse of no. 19 we note the sleeve drape, which re-appears on some of the later vases (e.g. nos. 22, 23, 29).

Pelike

* 18 Taranto 117503. PLATE 86, 1–2.
 Belli, *Tesoro di Taras,* pl. 173 (colour).
 (a) Zeus holding out cock to Ganymede, between Nike seated to l., and Hera standing to r.; above –
 Aphrodite, Eros with fillet, and bust of papposilen, (b) Dionysos with phiale and thyrsus seated on an
 altar between woman with fillet and dish, and woman with torch and situla.

Calyx-krater

 19 Vatican V 8 (inv. 18036).
 VIE, pl. 25 d and g.
 (a) Maenad with torch, and Dionysos with dish and thyrsus, (b) two draped youths.
 Compare the maenad with the woman to l. on the reverse of no. 18.

(b)

The Bari column-krater (no. 20) makes a good transitional piece linking the earlier to the more developed style; compare the woman to left on the obverse with those on the reverse of no. 18 and the obverse of no. 19, and note the slight change that has taken place in the draw-ing of the drapery, although the heads and faces are very similar. Ruvo 637 (no. 22) may be taken as typical of the Judgement Painter's standard vases – the dotted pupil of the eye, the arched eyebrow, the fold-lines on the drapery (but not over the breasts) are thoroughly charac-teristic (cf. nos. 23, 25–6, 28–30). The seated woman should be compared with those on nos. 20 and 28–29; the draped youths have now assumed their more or less canonical form – compare the one to left with those on nos. 23–25 and 29, noting the slight deterioration that has taken place in the drawing on nos. 25–26. This is very clear on no. 26, also in the youth to right as compared with nos. 24–25. The Judgement Painter has a liking for athletes on his reverses, particularly on no. 28, but also no. 26. The subjects on the obverses are often of some interest – Dionysos on a mountain lion on no. 23, Poseidon and Amymone on no. 24, the Judgement of Paris on no. 26, the death of Callisto on no. 27a, funerary scenes on nos. 29–30. He also likes people with a row of round objects above their hands (e.g. nos. 22, 29; cf. the "skewer of fruit" in Paestan; Beazley, *AJA* 48, 1944, p. 357).

Column-krater

 20 Bari 6255.
 APS Addenda, p. 426, no. (i), pl. 116, fig. 9.
 (a) Youth with shield and spear between two women, (b) woman with phiale between two draped
 youths.

Bell-kraters

 21 Louvre N 2818.
 (a) Standing woman with phiale of offerings beside stele, seated Dionysos with thyrsus; bell-krater
 to r., (b) two draped youths beside a stele, with a looped fillet above.

* 22 Ruvo 637. PLATE 86, 3–4.

(a) Seated woman holding situla, with tambourine beside her, Dionysos with thyrsus, satyr with thyrsus beside pillar-altar, (b) three draped youths.

Closely connected with Bari 6255 by the treatment of the women on the obverses.

* 23 Swiss Market, Ascona, Galleria Casa Serodine. PLATE 86, 5–6.

(a) Eros, Dionysos with kantharos riding a lion led by a maenad with a tambourine, (b) draped youth, nude youth about to be crowned by draped youth.

* 24 Bari 6332 (Polese 142). (b) PLATE 87, 1.

APS, p. 29, no. 2 (Painter of the B.M. F 57); *Coll. Polese*, p. 25, no. 45, pl. 14.

(a) Poseidon, Amymone and young satyr, (b) nude youth between two draped youths.

24a Bari, D'Agostino coll.

(a) Nike in biga, (b) three draped youths.

* 25 Leningrad inv. 1165 = St. 1229. (b) PLATE 87, 2.

(a) Satyr with wreath, seated Dionysos with phiale and thyrsus, woman with situla and phiale, (b) three draped youths.

* 26 B.M. F 167. (b) PLATE 87, 3.

APS, p. 29, no. 1; Clairmont, *Parisurteil*, K 188, pl. 38.

(a) Hera, Paris, Hermes and Aphrodite, (b) nude youth with strigil between two draped youths.

The drapery of the reverse youths and the pattern-work below the handles relate this vase to the Schiller Group.

27 Milan, ex Riquier coll.

(a) Woman with tambourine seated by spring (rocky area with two hydriai), silen with thyrsus over l. shoulder playing the flute, (b) two draped youths beside a pillar (for the l. youth cf. Bari 6332; no. 24).

Calyx-krater

27a Cremona, Museo Civico (Dordoni collection).

Stenico, *Quaderni Ticinesi* 6, 1977, pp. 73 ff.; Trendall, *AntK* 20, 1977, pp. 99–100.

(a) The death of Callisto (see pp. 165–6 above) – to l. Hermes with the infant Arcas, Callisto seated with Lyssa standing beside her; to r., Artemis and Apollo, (b) standing maenad with palm-branch, seated Dionysos resting l. arm on tambourine. The reverse is badly damaged; part of the maenad and the head of Dionysos are missing.

All the figures on the obverse are inscribed, and here we have the fullest version of the Callisto legend. On this vase (unlike nos. 7/10, 12 and 25) she is not yet undergoing transformation into a bear (cf. the coins of Orchomenos – *Historia Numorum*2, p. 451; Cook, *Zeus* ii, p. 229, fig. 158).

Amphora

28 Brussels R 403.

CVA 2, IV F, pl. 2, 2; *APS*, p. 29, no. 2, pl. 9, figs. 43–4.

(a) Warrior in naiskos, with woman and seated youth to l., and youth and seated woman to r., (b) four nude youths, three standing and one seated, the three to l. holding strigils.

Pelike

* 29 Bourges D 863.1.60. (b) PLATE 87, 4.

(a) Seated Eros above l. with wreath, woman with three balls resting l. arm on pillar, seated woman with alabastron, (b) woman with phiale between two draped youths.

Hydria

30 Trieste S 436.

CVA 1, IV D, pl. 1, 4 and 8.

Two women, l. with phiale, r. with cista at a monument consisting of a box standing on a stepped plinth, of which the lower element is solid black.

The following vase, which has been extensively repainted, should also probably be attributed to the Judgement Painter:

Lebes gamikos

31 Altenburg 303.
 CVA, pl. 108, 1–3.
 (a) Seated woman and nude youth with phiale, (b) seated nude youth and woman with cista.

(c)

The following vase is very near in style to the work of the Judgement Painter (especially no. 29) and is probably by a close imitator; cf. also with the vases by the Painter of Boston 00.348.

Column-krater

32 Paris, Rodin 3.
 CVA, pl. 36, 3–5.
 (a) Woman with open box and seated youth with thyrsus, woman with phiale and seated half-draped youth, (b) four draped youths.

(d)

The following vase is associated in style with the Judgement Painter (cf. the drapery, the head and eyes):

Bell-krater

* 33 Boston 1976.144. PLATE 87, 5–6.
 (a) Orestes at Delphi – Orestes kneeling by the omphalos with Athena to l. and Apollo to r.; below – two sleeping Furies, (b) seated nude youth with tendril between two women, l. with thyrsus, r. with palm branch.

(e)

Also connected with the Judgement Painter, especially by the drawing of the figures on the obverse, is the following vase, which in *APS* (p. 29) was assigned along with Bari 6332 (no. 24) to the "Painter of B.M. F 57", who no longer exists. The seated woman in three-quarter view is remarkably like Amymone on the latter vase, but the reverses are very different, and it seems better to detach this vase from the painter himself, though it is probably a product of his workshop.

Bell-krater

34 B.M. F 57.
 APS, p. 29, no. 1, pl. 10, fig. 45.
 (a) Youth with spear and sword, seated woman wearing veil, woman with mirror and box (Orestes, Electra and Chrysothemis ?), (b) three draped youths.

(iii) THE PAINTER OF HEIDELBERG U 6

The Painter of Heidelberg U 6 is most successful as a paninter of phlyax vases; the draped youths on the reverses of nos. 35–6 are very like those of the Judgement Painter (e.g. no. 25). His old crones (nos. 35–6) have extremely expressive faces, witness the contemptuous look on the one to left on no. 35, or the upbraiding wife on no. 36, to whose tongue-lashing her goggle-eyed husband has no obvious riposte. The Oxford krater (no. 37) is an entertaining trifle – "a phlyax hailing the bus to Hermes St." Helios on no. 38 is less well drawn; the nimbus recalls those on the two oenochoai by the Felton Painter (nos. 7/62–3), and the thunderbolt above

has clearly put the fear of Zeus into the horses, which seem uncertain which direction to follow.

(a)

Bell-kraters

35 Heidelberg U 6.
 PhV², p. 32, no. 29; *CVA*, pl. 75, 2 and 4.
 (a) Two gossiping women, (b) two draped youths.
* 36 Vienna 466. PLATE 88, 1–2.
 PhV², p. 47, no. 66.
 (a) Wife upbraiding husband, (b) two draped youths.
37 Oxford 1932.517.
 PhV², p. 41, no. 51, pl. 5a.
 (a) Phlyax with stick, (b) herm.
38 Vienna 1131.
 AZ 1848, pl. 20; Cook, *Zeus* i, p. 337, fig. 269; Schauenburg, *JdI* 58, 1943, p. 66, fig. 8, and
 Helios, note 383.
 (a) Helios in quadriga, (b) woman with phiale between two draped youths.

(b) CONNECTED IN STYLE

Bell-krater

39 Matera 9984.
 APS Addenda, p. 427, no. (x); Lo Porto, *Penetrazione,* pl. 31, 1–2. Photos: R.I. 66.1313–4.
 (a) Nude youth with strigil and woman with fillet seated on rock, (b) two draped youths.
 Cf. the youth to r. on the reverse with those on nos. 35–6.

(iv) OTHER VASES CONNECTED WITH THE JUDGEMENT PAINTER

The vases in this division are connected with the work of the Judgement Painter by the treatment of the drapery (note particularly the appearance of the double black stripe) and the poses of the figures. They are not the work of a single painter, although linked together by various elements in common, and also connected with the vases in the Group of Boston 00.348.

Amphorae

(a)

* 40 Naples 2289 (inv. 82136). PLATE 88, 3.
 Patroni, p. 138, fig. 93.
 (a) Two women and two youths at a grave monument, on top of which is a calyx-krater, (b) woman
 and three draped youths at a stele.
* 41 Copenhagen, Thorwaldsen 130. (b) PLATE 88, 4.
 APS, p. 81, no. (iii), pl. 40, fig. 204.
 (a) Seated woman with parasol between nude youth and woman holding the legs of Eros, who has a
 bird in his hands, (b) woman with thyrsus between two draped youths.
 Cf. the youths with those on the Naples amphora.

(b)

* 42 Andover, Phillips Academy 177. (b) PLATE 88, 5.
 APS, p. 41, no. (vi), pl. 18, fig. 86.
 (a) Woman with thyrsus and tambourine between two nude youths, (b) two draped youths.

Amphorae (continued)

(c)

43 Liverpool, Merseyside Museum 1977.114.33 (ex Grasmere, Danson coll. 34).
 (a) Nude youth with spear offering casket to seated veiled woman beside a stele on top of which is
a kalathos; to r. woman bends forward over raised foot, with wreath in r. hand, (b) two draped youths.
 This vase is known to us only from indifferent photographs but the draped youths on the reverse,
the double stripe down the drapery of the woman to r., and the solid black centre of the monument
(cf. no. 30), and the upright crosses accompanying the meanders (cf. nos. 40 and 42) incline us to
think that it might belong here.

(d)

Perhaps also connected, although the condition of the obverse makes any definite attribution
difficult, is the following:

Pelike

44 Altenburg 346.
 CVA, pls. 89–91; *APS*, p. 41, no. (iv).
 (a) Youth offering cista to woman seated on klismos, towards whom Eros flies with a wreath and
over whose head a maid holds a parasol, (b) three nude athletes.

(v) THE COTUGNO PAINTER

Two phlyax vases by the same painter might perhaps find a place in this context, since the
woman on the reverse of Bari 8014 is similar to some of those on other vases in this section.

Bell-kraters

* 45 Bari 8014 (ex Cotugno coll.). (b) PLATE 88, 6.
 *PhV*2, p. 28, no. 20, pl. 1a; *LAF*, no. 202 (ill.).
 (a) Phlyax scene on stage – woman with fillet between two phlyakes (Dionysalexandros ?), (b) woman
with thyrsus between two draped youths.
46 Taranto 107937.
 *PhV*2, p. 44, no. 60, pl. 1b; Lo Porto, *BdA* 49, 1964, pp. 16–17, figs. 5–6.
 (a) Phlyax scene – consultation of Apollo at Delphi, (b) three draped youths.

2. THE GROUP OF BOSTON 00.348

In *APS* (p. 18) the Painter of Boston 00.348 was associated with the Ariadne Painter, and
there is little doubt that his work, and especially the New York statue vase (no. 47) which is
connected with him, is strongly influenced by that artist. We now see that he is much nearer
to the Judgement Painter and to the Berkeley Painter, as we noted in *APS Addenda*, pp. 425
and 432, and most of his work must belong to the period just before the middle of the fourth
century.

(i) THE NEW YORK STATUE VASE

Column-krater

* 47 New York 50.11.4. (b) PLATE 89, 1.
 APS, p. 19, no. (i), *Addenda*, p. 425; *EAA* vi, p. 237, fig. 252; *BABesch* 47, 1972, p. 39, fig. 9;
Bothmer, *Greek Vase Painting* (*BMMA*, Fall 1972), no. 27 (ill.); Robertson, *History of Greek Art*,
pl. 152a.
 (a) Artist painting marble statue of Herakles in the presence of Zeus, Nike and Herakles, (b) Athena

and a Dioskouros, with Pan and Hermes above to l., and below, Eros chasing a bird.

The vase is fully discussed by Bothmer in *BMMA*, Feb. 1951, pp. 156–161. The style is to be associated with that of some of the later vases of the Ariadne Painter and also with the Painter of Boston 00.348, especially in regard to the treatment of the drapery of Athena (cf. with the Boston krater) and the profiles of the male figures.

(ii) THE PAINTER OF BOSTON 00.348

The first two vases attributed to this painter (nos. 48–9) show the connexion with the Ariadne Painter; both have interesting and unusual subjects on the obverses, and are closely linked by the remarkable similarity of their reverses and by the pattern-work. We note the double stripe down the peplos of the flute-playing maenad on the reverse of no. 49, which provides a link with the work of the Judgement Painter. This is even closer in the two later vases (nos. 50–51), which are cruder in style and show a marked deterioration in the quality of the drawing. Their reverses should, however, be studied in conjunction with those of nos. 48–9 (especially no. 50 with no. 49), where the correspondence in pose and anatomical details are striking. The little Maltese dog on the obverse of no. 48 reappears on the reverse of no. 50, on the obverse of which the madness of Lycurgus is treated in an original way – not only has the building an elaborately decorated pediment, but above it appears the upper part of a woman, presumably Lyssa, the cloak billowing around her replacing the more normal nimbus.

(a)

Bell-kraters

* 48 Boston 00.348. (b) PLATE 89, 2.
 APS, p. 18, no. 1, pl. 5, fig. 22; *Greek Gods and Heroes* (MFA, Boston), p. 29, fig. 15.
 (a) Athena playing the flute and looking at her reflection in a mirror held by a nude youth; to l. maenad, seated Zeus and papposilen chasing Maltese dog, to r. Marsyas, (b) silen with torch, Dionysos and maenad with thyrsus moving to l., silen with thyrsus turning away to r.

49 Vatican T 2 (inv. 17941).
 VIE, pl. 28 a and c; *APS*, p. 18, no. 2.
 (a) Scene from a tragedy, (b) silen with wine-skin, Dionysos with thyrsus, maenad playing the flute, and silen with tambourine, all running to l. over rocky ground.

(b)

Column-kraters

50 Ruvo n.i. 32.
 Sichtermann, K 48, pls. 80–81; *APS Addenda*, p. 425, no. 3. Photos: R.I. 64.1217–8.
 (a) Madness of Lycurgus, (b) silen with situla, Dionysos with thyrsus followed by Maltese dog, silen with wine-skin, all moving to l.

51 Jerusalem, Israel Museum 72.15.26. Once San Simeon 5582 (SSW 10440); then Parke-Bernet, *Sale Cat.* 5–6 April 1963, p. 34, no. 93.
 PhV², p. 95, no. (xxii); *APS Addenda*, p. 425, no. (i); *Jan Mitchell Gift, Cat.* no. 20 (ill.).
 (a) Silen with thyrsus, seated Dionysos with thyrsus, about to be crowned by flying Eros, seated maenad with tambourine beside a b.f. calyx-krater, standing maenad; above, to l. – frontal female mask, (b) silen, Dionysos with thyrsus, and maenad.

The drawing is very poor, but the style and composition are very similar to those of the Ruvo krater.

(iii) VASES CLOSELY RELATED IN STYLE

(a)

The two following vases are closely connected with the work of the Painter of Boston 00.348.

Lebes gamikos

* 52 Once Roman Market, ex Signorelli coll. 231. (b) PLATE 89, 3.
 Sale Cat. pl. 10; Moret, *Ilioupersis,* pl. 7, 2.
 (a) Rape of Cassandra, (b) standing woman; seated woman with Eros flying above.
 Cf. also with Naples 2924 (no. 8/121 above).

Hydria

53 B.M. F 93.
 APS Addenda, p. 425, no. (ii), pl. 116, fig. 7.
 Woman standing on vase-bedecked steps of Ionic grave monument between bearded man and woman.

(b)

 The following vase should be compared with the above (e.g. no. 52) and also with the work
of the Berkeley Painter:

Squat lekythos

53a Basel Market, Palladion.
 Katalog (1976), no. 42 (ill.).
 Woman running off to l. with ball, woman with ball and cista in front of table, one leg of which is
 grasped by a kneeling girl, standing woman.

3. THE BERKELEY GROUP

(i) THE BERKELEY PAINTER

The Berkeley Painter is connected in style with the Painter of Boston 00.348 and also with the
Thyrsus Painter, with whom he must be almost exactly contemporary.

 He is a painter of inferior quality who imitates both the Judgement Painter and the Painter
of Boston 00.348; from the former he derives his standing female figures with the double
stripes down the drapery, while his reverses (especially of nos. 54–5) seem nearer to the
latter's work. He is fond of drawing a series of short fold-lines across the bent leg of running
figures (as on nos. 54, 56); there are often large quantities of fine fold-lines on the lower part
of the peploi; the mouth tends to be large, flat and curved downwards; his three-quarter faces
are very badly drawn.

(a)

Column-kraters

54 Gotha 79.
 CVA, pl. 82; *APS,* p. 81, no. (ii).
 (a) Thiasos — two maenads carrying a fawn, bust of silen above; seated Dionysos with thyrsus,
 satyr and silen, (b) maenad with situla, seated Dionysos with kantharos and thyrsus, silen holding
 b.f. bell-krater into which another silen is about to pour wine from an amphora.
55 Barletta 658.
 Schauenburg, *Charites,* pl. 27; *APS,* p. 81, no. (i). Photos: R.I. 54.1162–3.
 (a) Silen and seated maenad with thyrsus, Dionysos with thyrsus and seated silen with wine-skin,
 satyr-boy with knife and skyphos, (b) Dionysos with thyrsus, maenad with situla, and silen with
 wine-skin, all moving to r.
 The animals on the rim of the obverse are modern.
 Cf. with no. 41 above, connected with the Judgement Painter.

(b)

Lebes gamikos

56 Berkeley 8/447 A.
 APS, p. 80, no. 1, pl. 41, fig. 205.
 (a) Eros with fillet flying after woman bouncing ball, (b) seated woman and nude youth with spear.

Amphora

57 Deruta (Perugia), Magnini coll. 4.
 Dareggi, *Cat.*, no. 10, pl. 9.
 (a) Woman with phiale of eggs, seated nude youth with bird on knee, (b) two draped youths.

Pelikai

58 Catania MC 4364.
 APS, p. 80, no. 2, pl. 41, fig. 209.
 (a) Seated youth with spear between youth with spear and draped woman, (b) standing woman with cista and nude youth with spear beside an altar on top of which is a pomegranate.
* 59 Vienna 903. (b) PLATE 89, 4.
 APS, p. 80, no. 3.
 (a) Seated youth and woman, (b) seated youth holding pilos and spear, and dog.
60 Naples Stg. 329.
 APS, p. 80, no. 5.
 (a) Standing woman and seated woman, (b) Eros seated, with goose.

Bell-kraters

* 61 Amsterdam Market, Ancient Art. PLATE 89, 5–6.
 (a) Satyr with torch and maenad holding tambourine, both moving to r., (b) two draped youths, r. with r. shoulder bare.
62 Vienna 1115.
 Moret, *Ilioupersis*, pl. 77; Schauenburg, *Festschrift Brommer*, p. 250, pl. 70, 4.
 (a) Fury with torch, Orestes kneeling on the base of the omphalos, which he is clutching, (b) woman and dog.
63 Bari 1399, from Gioia del Colle.
 APS, p. 81, no. 8.
 (a) Seated Dionysos, boy, and nude woman, (b) two draped youths.

Squat lekythos

64 North German private coll.
 Ex Zurich Market, Koller, *Sale Cat.* 32 (Oct.–Nov. 1974), no. 3373; Schauenburg, *Kunst der Antike – Schätze aus norddeutschem Privatbesitz* (1977), no. 305, ill. on p. 357.
 Nude youth, seated woman with mirror, over whom a maid holds a parasol.

Oenochoe (shape 3)

65 Palermo, Mormino 787.
 Woman with oenochoe and phiale, nude youth with fillet and oenochoe, seated nude youth with go-cart.

Epichysis

66 Marburg 105.
 APS, p. 81, no. 6.
 Seated woman approached by running youth with cista.

(ii) COMPARABLE VASES

The following should be compared with the work of the Berkeley Painter:

Pelikai

67 Taranto, Parenzan coll.
 APS Addenda, p. 432, no. (v).
 (a) Above – Aphrodite in chariot drawn by two Erotes, one carrying a white statue of Nike, the other a kantharos and an oenochoe; below – woman seated on klismos bouncing a ball beside a woman sleeping on a couch, (b) seated youth, woman, and youth.
68 Palermo, Mormino 742.
 (a) Female tumbler, (b) draped woman with ball.
 This is a very minor vase, but the treatment of the faces and the drapery is very much in the manner of the Berkeley Painter.

(iii) CONNECTED

The following vase should be connected with the Berkeley Painter, especially in the treatment of the mouths.

Pelike

69 Warsaw 147105.
 *PhV*2, p. 77, no. 173, pl. 11 b; *APS Addenda,* p. 432, no. (vi).
 (a) Bearded man with pinax, mask suspended from flower, duel between two nude men in presence of a third, (b) two Amazons (?).

4. THE DECHTER GROUP

The Dechter Group, named after the collection in Los Angeles which contains nos. 70 and 79, includes the work of the Dechter Painter and some other vases associated with him. See Trendall, *Festschrift Brommer,* pp. 285 ff.

(i) THE DECHTER PAINTER

(a)

The Dechter Painter is an artist of some importance, albeit of rather inferior quality; he painted a number of vases with interesting subjects which fall stylistically into two main groups, the first of which contains four pelikai, forming two matching pairs. Two of the pelikai, both in private collections (nos. 70–71), represent on the obverse a woman seated upon a box or a klismos, placed on a low platform the edge of which is decorated with egg pattern; she is flanked by a youth and a woman. Both reverses are also alike, with three draped youths in very similar poses; a notable characteristic is the way in which one leg appears very visibly beneath the drapery. Both the seated women are shown frontally; they have staring eyes and wear a sleeved chiton with very fine fold-lines and a piece of drapery over their lap. Both standing women have a double stripe running down the side of their peploi. The connexion with the work of the Judgement Painter is apparent, but these vases should also be compared with those by the Bendis Painter in the Long Overfalls Group (e.g. nos. 4/179, 182), which look like their prototypes. The other two pelikai, which are similar in shape and decoration, show a woman resting her hand on the head of Eros and standing beside a seated figure, bearded on no. 72, beardless on no. 73, who holds a trident and must be Poseidon. Despite the absence of a hydria, the woman is most likely to be Amymone, and this is reinforced by

the presence of Eros. On no. 73 Poseidon sits upon a mountain-like rock, on no. 72 this is not in evidence, but a wary-eyed feline crouches beside him.

On the reverses there are to left and right draped youths similar to those on the other two pelikai, but the central figure is now different, a draped woman on no. 72, a nude athlete with strigil and aryballos on no. 73. All four have two bands of decoration on the neck — an upper and larger one with palmettes or laurel, a narrower one below with egg pattern. On the Dechter pelike the meanders are accompanied by chequers, elsewhere by saltires.

Pelikai

* 70 Los Angeles, Dechter coll. (b) PLATE 90, 1.
 Galerie am Neumarkt, *Auktion XIX,* 19 Nov. 1970, pl. 10, no. 56; Sotheby's, *Sale Cat.* 27 March
 1972, pl. 11, no. 148; then Charles Ede Ltd., *Gr. Pottery from S. Italy* (1973), no. 34 (ill.); Trendall,
 Festschrift Brommer, pl. 76, 1–2.
 (a) Seated woman with fan between nude youth with stick and draped woman, (b) three draped
 youths.

 71 Naples, private coll. 102.
 Trendall, op. cit., pl. 76, 3–4.
 (a) Seated woman with mirror below a window between standing woman with open box and nude
 youth with bird, (b) three draped youths; to r., pillar inscribed ΤΕΡΜΩΝ.

* 72 New York, Mark Davison (on loan to the Metropolitan Museum, L. 1972.30.1). PLATE 90, 2.
 Trendall, op. cit., pl. 74.
 (a) Eros with wreath, Amymone and seated Poseidon with trident, (b) draped woman between
 two youths.

 73 Turin 4497.
 CVA, IV D, pl. 8, 3–4; Trendall, op cit., pl. 75, 1–2.
 (a) Eros, Amymone and seated Poseidon with trident, (b) nude youth between two draped youths.

(b)

In the second group we may note a further deterioration in the quality of the drawing, but the rendering of the eye, the drapery, the frontal faces, and the youths on the reverse show the vases to be the work of the same painter. Compare also the window above the scene on the obverse of Catania 4225 (no. 75) with that on no. 71, the seated woman with those on nos. 71–2, and the mountain-like elevation supporting the woman beside her with that on which Poseidon is seated on no. 73. On all the vases in this group we may note the large staring eyes, as well as the large dab of black which marks the pubic hair on the nude male figures. The reverses favour athletic scenes (nos. 76, 78–9); note the visible leg of the youth to right on the reverse of the Bari krater (no. 78), which repeats the type on no. 70. Many other similar connecting links may easily be found. Here again the subjects are of interest — bridal scenes on nos. 75–6, 79, mythological on no. 77 and Dionysiac on no. 80.

Amphora

 74 Brooklyn 62.147.6.
 APS Addenda, p. 425, no. (iii), pl. 115, fig. 5.
 (a) Nude youth with spear, woman offering crown to seated nude youth, nude youth beside him
 with his r. hand on his shoulder, (b) nude youth with spear between seated woman and nude youth
 with strigil.

Pelike

 75 Catania MB 4225 (L. 769).
 Libertini, *Cat.,* pl. 91.

Pelike (continued)

(a) Veiled woman clasping the hand of woman seated on throne, to r. woman kneeling by open box, and kalathos; above, to l., two small Erotes flying toward the seated woman; in the centre, a window; to r. woman with fillet and youth with torch and spears, (b) two women seated one on each side of a laver in which Eros is seated, flanked by nude women; above: woman's head in window, and to r. woman with box.

Bell-kraters

* 76 Ruvo 1050. (b) PLATE 90, 3.

(a) Standing woman clasping the hand of seated woman, whom Eros is crowning; to r. kneeling woman opening white box, youth with torch and two spears, (b) Nike with staff and two phialai, nude youth with targe, nude youth holding up aryballos; between the front two, a dog with fore-leg raised.

 77 Leningrad inv. 208 = St. 1609.

Schauenburg, *Perseus,* pl. 32, 1.

(a) Silen hiding face, Perseus holding up the gorgoneion, Athena with two spears and shield, (b) standing woman with two-reeded flute, seated woman with lyre, nude youth with stick.

 78 Bari 20752, from Conversano.

NSc 1964, p. 138, figs. 43–45.

(a) Woman with harp, seated Dionysos with thyrsus, satyr, (b) two nude athletes and draped woman holding up aryballos.

 78a Zurich Market, Galerie Fortuna 73.

(a) Woman with mirror seated on klismos between nude youth bouncing ball and draped woman, (b) two draped youths at a stele.

The immediate precursor of the Dechter krater (no. 79); the obverses of the two are remarkably alike, though the treatment on this vase is somewhat simpler.

 79 Los Angeles, Dechter coll., ex Sotheby, *Sale Cat.* 15 July 1971, no. 151.

(a) Seated woman between nude youth with phiale and standing woman with mirror, (b) nude youth with strigil between two draped youths.

 80 Foggia, from Salapia T. 2 (28 Oct. 1970).

NSc 1974, pp. 490 ff., no. 6, figs. 9–12.

(a) Woman with tambourine, seated Dionysos with phiale and thyrsus, satyr with phiale and situla, (b) woman with cista between two draped youths.

(c)

The two following pelikai, which are closely connected in style (cf. Athena on no. 81 with the helmeted warrior on no. 82), provide a convenient link between the vases in sub-division (b) above and those in (d). The figures on the obverse of no. 82 should be compared with those on Ruvo 1050 (no. 76) which they strongly resemble, while the youths on the reverse are closer to those on nos. 83–84. The eye is treated in the painter's characteristic fashion, so is the drapery, especially of the standing woman on the reverse of no. 81 and the seated woman on no. 82.

Pelikai

* 81 Vienna 690. (b) PLATE 90, 4.

Laborde i, pl. 93 = *RV* ii, p. 210, 2.

(a) Herakles wrestling with the Nemean lion in the presence of Athena, (b) woman holding helmet and shield between nude youth putting on greaves and nude youth holding spear.

 82 Geneva Market, Galerie Faustus (ex London Market, Sotheby).

Sotheby's, *Sale Cat.* 12 July 1976, no. 445, ill. on p. 78; Galerie Faustus, *Antiquités* (Oct. 1976), no. 53 (ill.).

(a) Warrior with shield between standing woman and seated woman, (b) two draped youths with a stele between them, and another stele to r.

(d)

The two vases in this sub-division look like later developments from the above. The Andromeda krater in Christchurch (no. 83) gives an unusual treatment of the subject (see Phillips, *AJA* 72, 1968, pp. 1 ff.; *Ill.Gr.Dr.*, pp. 63—4 and 78—82), in which the two columns to which the heroine has been bound have been given a pediment, transforming them into a sort of temple; perhaps the artist had a stage setting in mind. To left is a helmeted Perseus with *harpe* and spear, to right Kepheus seated on a box, with a kalathos of offerings beside him (cf. no. 75). On the reverse is a draped woman between two youths (cf. no. 72), the one to left with a remarkably visible leg. Above is a large pair of *halteres* shown sideways (cf. no. 4/186 by the Dioskouroi Painter in the Long Overfalls Group). The Palermo krater (no. 84) is connected with the Christchurch vase by the two youths on its reverse, who are very like their counterparts, with similar wavy white head-bands and prominent stomachs. The obverse is in poor condition, but the Dionysos should be compared with the one on no. 80.

Bell-kraters

* 83 Christchurch 116/71 (ex London Market, Sotheby). PLATE 90, 5–6.
 Sotheby, *Sale Cat.* 29 March 1971, no. 80, ill. opp. p. 22; *FA* 24—5, 1969—70, pl. 4, 1.
 (a) Andromeda bound to two columns of a temple between Perseus and Kepheus, (b) draped woman between two draped youths.

84 Palermo 1026.
 (a) Seated Dionysos and silen with phiale and oenochoe; to r., b.f. bell-krater, (b) two draped youths.

(ii) VASES RELATED IN STYLE

(a)

Bell-krater

84a Bari, Ricchioni coll. 6.
 (a) Artemis seated on rock, holding bow in r. hand, with l. hand on fawn's head, Apollo holding laurel branch; Doric column to r., (b) woman with fillet, youth with targe, and youth with spear.

(b)

Amphora

85 Bari, Lagioia coll.
 (a) Woman with oenochoe and dish of offerings beside an Ionic grave monument with a nude youth holding a spear, (b) two draped youths.

(c)

The following should be compared with the work of the Judgement Painter and the Dechter Painters:

Bell-krater

86 Vatican V 7 (inv. 18035).
 VIE, pl. 25 c and g.
 (a) Satyr with oenochoe and tambourine, seated woman with flute, seated Dionysos with kantharos and narthex, (b) woman with situla, nude youth and draped woman, all running to l.

Squat lekythos

87 Zurich Market, Arete.
 Woman running to l. with fillet and dish.

5. THE THYRSUS PAINTER

The Thyrsus Painter (see *APS*, pp. 77 ff.) is a productive but rather inferior artist whose work is connected with that of the Lecce Painter in his later phase (cf. no. 88 with nos. 5/225, 227), and of the Truro Painter and some of the other painters grouped around them (Chapter 5, 6–7). His drawing is apt to be exceedingly sketchy, his figures look as if they have been done in considerable haste and sometimes an arm will completely disappear (e.g. nos. 107, 133); in its later stages his work might almost be described as barbarised. The lines to indicate anatomical details are very angular, ribs are shown as a series of short parallel lines, the eyes are triangular and staring, with a small dot for the pupil. On women's peploi the folds appear as a row of parallel lines descending from the waist, often with a double black stripe down the side (e.g. nos. 91–2, 101, 107), occasionally enlivened with a few drop-folds (e.g. no. 103). Many of his figures carry a beaded thyrsus, hence his name.

His subjects are monotonous — mostly woman and youth, with thyrsi in their hands; sometimes an Eros joins the company (e.g. nos. 88, 102, 104, 134). His drawing of windows is characteristic, a vertical line with horizontals top and bottom in a reserved rectangle (nos. 91, 103).

Many of the smaller vases attributed to the Thyrsus Paninter have recently been found at Paestum (the find-spot also of most of his vases in Madrid). It may be that at a later stage in his career he migrated there from Apulia, where he must have begun his work in view of its close connexions with that of the Lecce Painter and the fact that many of his vases were found in Taranto. He seems to have been active between c.360 and 340 B.C., though his latest work may go down into the thirties.

(i)

Pelikai (shape 1)

(a) WITH TWO OR THREE FIGURES ON THE OBVERSE

88 Taranto I.G. 4610 (old no. 4803).
 CVA 2, IV Dr, pl. 38, 1–3; *APS*, p. 77, no. 1.
 (a) Woman with mirror seated between nude youth and Eros, (b) standing woman and seated woman, each with wreath.
 Fairly early work, showing strongly the influence of the Lecce Painter.

89 Ruvo 835.
 APS, p. 77, no. 2.
 (a) Woman seated between two youths, (b) two draped youths.

90 Naples 2223 (inv. 81717).
 (a) Draped youth and woman with tambourine, (b) seated woman with tambourine and nude youth with thyrsus.

91 Los Angeles 62.27.5.
 CVA, pl. 42, 4–6.
 (a) Woman holding thyrsus, nude youth with drapery over l. arm, (b) woman with ball, and nude youth.
 Cf. with Malibu 71 AE 248.

* 92 Taranto, Baisi coll. T. 18 (43). PLATE 91, 1–2.
 (a) Draped woman and nude youth, (b) maenad with thyrsus, nude youth.

(b) WITH SINGLE FIGURES

93 Lecce 699.
 CVA 2, IV Dr, pl. 37, 1; *APS*, p. 77, no. 3.
 (a) Running maenad with thyrsus, (b) running youth with thyrsus.

94 Lecce 700.
 CVA 2, IV Dr, pl. 38, 13; *APS*, p. 77, no. 4.
 (a) and (b) Running woman.
95 Sydney 82.
 APS, p. 77, no. 5.
 (a) Youth, (b) woman.
96 Madrid 11208.
 APS, p. 77, no. 6.
 (a) and (b) Maenad with thyrsus.
97 Providence, Annmary Brown Memorial Library.
 (a) and (b) Maenad with thyrsus.
98 London, Society of Antiquaries.
 (a) Running maenad with thyrsus and phiale, (b) running maenad with thyrsus.
99 Turin 4131.
 CVA, IV D, pl. 8, 1–2; *APS*, p. 77, no. 7.
 (a) Youth with thyrsus, (b) woman with wreath running to r.
100 Basel 1921.370.
 (a) Running woman, (b) head of youth to r.

Bell-kraters

101 Lecce 634.
 CVA 2, IV Dr, pl. 17, 5 and pl. 18, 2; *APS*, p. 78, no. 8.
 (a) Woman and youth with thyrsi, (b) woman and youth with thyrsus.
102 Paris, Rodin 1051.
 CVA, pl. 38, 5–6; *APS*, p. 78, no. 9.
 (a) Woman and youth, (b) Eros and woman.
103 Malibu, J. Paul Getty Museum 71 AE 248.
 APS, p. 78, no. 10, pl. 40, fig. 202; Parke-Bernet, *Sale Cat.* 4 Dec. 1970, no. 237, ill. on p. 84 (ex Washington, N.M. 170388).
 (a) Nude youth and woman with wreath and thyrsus, (b) two draped youths.
104 Naples Stg. 469.
 APS, p. 78, no. 11.
 (a) Two women with a small Eros between them, (b) woman with phiale, and youth with thyrsus.
105 Brindisi 558.
 APS, p. 78, no. 12; Benita Sciarra, *Musei d'Italia* 9. *Brindisi, Mus. Arch. Prov.* p. 30, fig. 186.
 (a) Youth and woman with thyrsi, (b) silen with phiale and woman with thyrsus.
106 Madrid 11029 (L. 355).
 APS, p. 78, no. 13.
 (a) Woman with thyrsus, seated woman with phiale and Eros, seated above to r., (b) woman with thyrsus and phiale, and youth with thyrsus, the former moving l., the latter r.
107 Stoke-on-Trent, Hanley Museum.
 APS, p. 78, no. 14, pl. 40, fig. 201.
 (a) Woman and youth with thyrsi, (b) youth and woman with thyrsi.
108 B.M. old cat. 1309.
 APS Addenda, p. 432, no. 14 bis.
 (a) Seated woman with phiale, and youth with thyrsus, (b) woman with thyrsus and youth running to l.
109 Bari, Lagioia coll.
 (a) Nude youth with drapery over l. arm, (b) woman with thyrsus.

Oenochoai (shape 3)

110 Taranto 52482.
 CVA 2, IV Dr, pl. 33, 5; *APS*, p. 78, no. 15.
 Woman with thyrsus and nude youth.

111 Taranto 50254.
 NSc 1936, p. 135, fig. 25; *APS*, p. 78, no. 16.
 Seated woman with thyrsus, and youth.

112 Taranto 50255.
 NSc 1936, p. 135, fig. 25; *APS*, p. 78, no. 17.
 Seated woman and youth.

113 Taranto 107726, from Taranto (Via Emilia, 21.8.1957).
 APS, p. 78, no. 22.
 Woman and youth with thyrsi.

114 Taranto 101471, from Taranto (Pizza Sardegna, 1.7.1955).
 Woman with thyrsus, and nude youth.

115 Taranto 101586, from Taranto (Piazza Sardegna, 1.7.1955).
 APS Addenda, p. 432, no. (iii a).
 Seated woman with phiale, and standing woman.

116 Taranto 116886, from Taranto (Via Tirrenia, 24.2.1960).
 APS Addenda, p. 432, no (iii b).
 Woman following youth holding bunch of grapes.

117 Taranto 105490, from Taranto (Via Emilia, 26.5.1956).
 APS, p. 78, no. (i).
 Two youths, each with a bunch of grapes.

118 Naples, private coll. 57.
 Seated woman and nude youth with thyrsus.

119 Ferrara, from Val di Pega, T. 45a.
 APS, p. 78, no. 18.
 Woman with thyrsus and youth with drapery over l. arm.

120 Ferrara, from Val di Pega, T. 45a.
 APS, p. 78, no. 19.
 Woman with thyrsus and youth with drapery over l. arm.

121 Bari, Cirillo De Blasi coll. 11.
 Woman and nude youth, both with thyrsi.

122 Brindisi 548. In bad condition.
 Eros flying towards seated woman with thyrsus.
 Note the florals with elliptical centres; cf. Leningrad 464 and 1195.

123 Foggia 208.
 Youth with thyrsus, woman with tambourine and silen with torch.

124 Taranto 4608.
 APS, p. 79, no. (iii).
 Youth with thyrsus.

125 Taranto 6421, from Brindisi.
 Youth with thyrsus beside column.

126 Taranto 54933, from Contrada Vaccarella (Via Argentina, 9.5.1950).
 APS, p. 78, no. 20.
 Maenad with thyrsus.

127 Taranto 54935, from Contrada Vaccarella.
 APS, p. 78, no. 21.
 Maenad with thyrsus.

128 Monopoli, Meo-Evoli coll. 314.
 Maenad with thyrsus.
129 Rome, private coll.
 APS Addenda, p. 430, no. 23 bis.
 Silen with thyrsus.
130 Madrid 11508 (L. 486).
 APS, p. 78, no. 23.
 Flying Eros.
131 Detroit 62.112.
 Woman running to r. and looking back l.
 Crude style.

Oenochoe (shape 7)

131a Fragment from the wreck of the *Colossus* C/8171.
 Woman with thyrsus in l. hand bouncing ball.

Oenochoe (shape 10)

132 Madrid.
 Standing woman.

Lebetes gamikoi

133 Madrid 11446 (L. 355). The lid does not belong.
 APS, p. 78, no. 24, pl. 40, fig. 205.
 (a) Woman with thyrsus and Eros, (b) Eros.
134 Madrid 11448 (L. 333).
 APS, p. 78, no. 25.
 (a) Woman between nude youth and Eros, (b) woman between two nude youths, with drapery over
their shoulders.
 These two vases, which may well have been found at Paestum since they come from the Salamanca
coll., go very closely in style with the vases from Paestum in (ii) below.
135 Vienna 1057.
 APS, p. 78, no. 26.
 (a) Woman, (b) youth.
136 Bari 20150, from Gioia del Colle, T. 6.
 Scarfì, *MonAnt* 45, 1960, 263, figs. 97–8; *APS Addenda,* p. 430, no. 26 bis.
 (a) Running woman with ball, (b) nude youth with strigil.
137 Monopoli, Meo-Evoli coll. 499.
 (a) Youth with thyrsus, (b) woman with thyrsus and phiale.

Hydriai

138 Lecce 3794.
 APS, p. 66, no. (i).
 Woman seated on rock and standing woman with fillet.
139 Geneva 14143.
 APS, p. 78, no. 27.
 Woman and youth with thyrsi.
140 Vienna 834.
 Seated woman with phiale, and nude youth with thyrsus.
141 Florence, private coll.
 Woman with thyrsus running to r. and looking back l.

Hydriai (continued)

142 Pontecagnano 3613, from T. 762.
 Woman with thyrsus.

Squat lekythoi

143 Rome, private coll.
 APS Addenda, p. 430, no. 28 bis.
 Woman with phiale, youth, woman with wreath, youth leaning on pillar.
144 Bonn 87.
 APS, p. 78, no. 28.
 Seated woman between woman and youth with thyrsus.
145 Madrid 11525 (L. 473).
 APS, p. 78, no. 24.
 Woman with thyrsus, and Eros.
146 Madrid 11528 (L. 472).
 APS, p. 78, no. 25.
 Running woman with thyrsus, and woman.
147 Madrid 11520 (L. 462).
 Running Eros.
148 Leningrad inv. 464 = St. 1287.
 Eros with phiale seated to l. on rock-pile.
 Cf. with Brindisi 548 (no. 122).

Squat lekythoi (special shape)

149 Reading 151.51 RM.
 APS, p. 78, no. 31, pl. 40, fig. 200.
 Youth with thyrsus, woman with thyrsus and woman with wreath.
 Late.
149a Taranto Market (ex Ragusa coll.).
 Photos: R.I. 68.4616–18.
 Woman with phiale, youth running to r., woman with wreath and youth leaning on stele.
150 Madrid 11575 (L. 474).
 Seated woman and Eros flying towards her.

Skyphoi (Corinthian type)

151 Winchester, College Museum.
 APS, p. 79, no. 35.
 (a) Woman, (b) youth.
152 Naples 1973 (inv. 82012).
 APS, p. 79, no. 36.
 (a) Woman with thyrsus, (b) Eros.
153 Madrid 11393 (L. 340).
 APS, p. 79, no. 37.
 (a) Woman with thyrsus, and small flying Eros, (b) woman with phiale, and youth with thyrsus at stele.
154 Madrid 11397 (L. 498). Much repainted.
 APS, p. 79, no. 38.
 (a) Woman with thyrsus, (b) Eros with fillet.
155 Taranto, from Taranto.
 APS, p. 79, no. 39.

Skyphoi (Corinthian type) *continued*

 (a) Nude youth, (b) maenad with thyrsus and tambourine.

156 Bari, Loconte coll. 9.

 (a) Nude youth with thyrsus, drapery over l. arm, (b) maenad with thyrsus.

Skyphoi

157 Louvre K 46.

 APS, p. 79, no. 40.

 (a) Seated youth, with thyrsus, and woman, (b) seated youth and Eros.

158 Vienna 476.

 APS, p. 79, no. 40 bis.

 (a) Draped woman, (b) nude youth.

159 New York, Iris Love coll. S.I. 17 a–b (frr.).

 (a) Three seated women and one moving off to r., (b) seated woman with phiale, nude youth, woman and nude youth running off to r.

Stemless Cups

160 Madrid 11278 (L. 515).

 APS, p. 79, no. 41.

 I. Woman with thyrsus. A. Woman with thyrsus. B. Woman.

161 Madrid 11281 (L. 514).

 APS, p. 79, no. 42.

 I. Seated woman. A. and B. Running woman.

Dish

162 Trieste S 425.

 CVA, IV D, pl. 15, 1–2; *APS*, p. 79, no. 47; Schneider-Herrmann, *Paterae*, no. 208.

 (a) Woman with thyrsus and nude youth with wreath, (b) woman and nude youth with thyrsi.

Lekanides

163 Madrid 11312 (L. 523).

 APS, p. 79, no. 43.

 (a) Woman with thyrsus, (b) woman, moving r., with outstretched arms.

164 Madrid 11310 (L. 525).

 APS, p. 79, no. 44.

 (a) Woman with thyrsus, (b) Eros flying to r.

165 Madrid V. 13–33.

 APS, p. 79, no. 45.

 Two women with phialai running to r.

Lekanis lid

166 B.M. old cat. 1636.

 APS, p. 79, no. 46.

 (a) Draped woman, (b) flying Eros.

Askos

167 Taranto.

 APS Addenda, p. 432, no. 48.

 (a) Woman with cista, (b) Eros.

Neck-amphorae

It should be noted that this is a very rare shape in Apulian and as these vases are all in what may be called the painter's Paestan manner they provide further confirmation of their possible manufacture there, since the neck-amphora is a common shape at Paestum.

168 Copenhagen 319 (B–S. 256).
 CVA, pl. 239, 1; *APS*, p. 79, no. 32.
 (a) Eros, (b) woman.
169 Geneva MF 248.
 APS, p. 79, no. 33.
 (a) Maenad with thyrsus, (b) running woman with phiale.
170 Naples 1898 (inv. 81786).
 APS, p. 79, no. 34.
 (a) Woman, (b) youth.

(ii) VASES FROM PAESTUM

The following vases, found recently in or near Paestum, seem to be the work of the Thyrsus Painter himself rather than that of a local imitator.

(a) FROM TOMB 31 IN THE CONTRADA LICINELLA

Neck-amphora

171 Paestum 20392.
 (a) Running woman with thyrsus, (b) nude youth with drapery over l. arm.

Pelike

172 Paestum 20388.
 (a) and (b) Seated draped woman, with l. arm outstretched.

Skyphos

173 Paestum 20389.
 (a) Woman with thyrsus, and youth, (b) two women with thyrsi.
 Very crude, like 20388.

Oenochoe (shape 1)

174 Paestum 20390.
 Eros flying towards seated half-draped woman with phiale.

Oenochoe (shape 6)

175 Paestum 20394.
 Running woman with thyrsus.

Stemless Cup

176 Paestum 20387.
 I. Draped woman with thyrsus. A. and B. Running woman.

Lekanis

177 Paestum 20393.
 (a) Running youth, (b) standing woman with thyrsus.

(b) FROM TOMB 124 IN THE CONTRADA LICINELLA

Amphora

178 Paestum 24110.
 (a) Woman with thyrsus, (b) woman running to r.

Pelike

179 Paestum 24108.
 (a) Draped woman moving r., (b) draped woman with phiale.

(c) FROM TOMB 23 IN THE CONTRADA ANDRIUOLO

Neck-amphora

180 Paestum 21353.
 (a) Woman, (b) woman with r. arm raised.

Skyphos

181 Paestum 21356.
 (a) Woman with thyrsus, (b) woman with thyrsus, moving r. and looking back to l.

Squat lekythos

182 Paestum 21355.
 Seated woman.

Lekanis

183 Paestum 21354.
 (a) and (b) Female head.

(d) FROM TOMB 30 (1971) IN THE CONTRADA ANDRIUOLO

Amphora

184 Paestum 25032.
 (a) Draped woman with thyrsus, (b) nude youth with thyrsus.

Lebes gamikos

185 Paestum 25036.
 (a) Woman with thyrsus, (b) nude youth with thyrsus, moving to r.

Skyphos

186 Paestum 25037.
 (a) Nude youth with phiale, and woman, (b) woman with phiale, and nude youth with thyrsus.

Hydria

187 Paestum 25033.
 Woman with thyrsus moving to r.

Squat lekythoi

188 Paestum 25034.
 Nude youth with thyrsus, and draped woman with thyrsus.
189 Paestum 25035.
 Woman with thyrsus, and Eros flying to r.

(iii) VASES NEAR IN STYLE OR COMPARABLE

(a)

Nos. 190–2 should also be compared with the work of the Berkeley Painter.

Dish

*190 B.M. F 133. PLATE 91, 3–4.
 (a) Three maenads in a Bacchic orgy, (b) reclining woman playing the flute while nude youth and
nude woman dance.
 The central figure on (a) may well be intended to represent Pentheus dressed as a maenad, since the
other two figures are clearly attacking.

Pelike

*191 Once London Market, Sotheby. PLATE 91, 5.
 Sotheby's, *Sale Cat.* 4 May 1970, no. 118, ill. opp. p. 40.
 (a) Eros flying to crown woman with phiale seated in front of nude youth, (b) seated youth and
woman with spear.

Skyphos fragment

192 Los Angeles, Neuerburg coll.
 (a) Woman holding white bird, Eros flying across, seated woman with bird in l. hand, (b) missing.

(b) MINOR VASES

Lebetes gamikoi

193 Lecce 725.
 CVA 2, IV Dr, pl. 56, 5; *APS,* p. 80, no. (iv).
 (a) and (b) Woman.
194 Madrid 11459.
 APS, p. 80, no. (v).
 (a) Woman with cista and mirror, (b) Eros.

Pelikai

195 Vienna 838.
 (a) Standing woman, seated half-draped youth with strigil and thyrsus, (b) woman seated on chair,
satyr with foot raised on rock.
196 Reading 45.8.2.
 CVA, pl. 31, 1–2; *APS,* p. 80, no. (vi).
 (a) Youth, (b) woman.
197 Bologna 421.
 CVA 3, IV Er, pl. 5, 5–6; *APS,* p. 80, no. (vii).
 (a) Satyr, (b) woman.
198 Zurich 2655.
 APS, p. 80, no. (viii); *CVA* 1, IV D, pl. 43, 1–2.
 (a) and (b) Woman.
199 Taranto 6244 (old inv. 5651), from Crispiano.
 APS, p. 80, no. (ix).
 (a) Nude youth running to r., (b) woman with thyrsus and phiale.
200 Lecce 746.
 CVA 2, IV Dr, pl. 40, 21; *APS,* p. 80, no. (x).
 (a) Youth approaching stele, (b) youth at stele.
201 Once London Market, Sotheby, *Sale Cat.* 29 April 1969, no. 122.
 (a) Running woman, (b) nude youth.

Bell-krater

201a Zurich Univ. 2647.
 CVA 1, IV D, pl. 40, 1–2.
 (a) Draped woman, (b) Eros.

Amphora

202 Bari 6358.
 (a) Woman with lekythos approaching stele, (b) Eros running to l.

Skyphos (Corinthian shape)

203 Berlin F 3223.
 APS Addenda, p. 432, no. (xv).
 (a) and (b) Running woman.

Oenochoe (shape 3)

204 Taranto 4747, from Taranto.
 APS, p. 80, no. (xiii).
 Woman and youth with thyrsus.

Lekanis

205 Vienna 291.
 APS, p. 81, no. 9.
 Two Erotes.

Epichysis

206 Ruvo 1417.
 Sichtermann, K 89, pl. 143, 2; *APS Addenda,* p. 433, no. (viii), where compared with the Lampas
 Painter.
 Eros shooting arrow at woman holding mirror.

Lekythos

207 Berlin F 4120.
 Standing woman with wreath, in front of whom is a bird.

6. THE LAMPAS GROUP

(i) THE LAMPAS PAINTER

The Lampas Painter has been discussed in some detail by Cambitoglou in *BSR* 19, 1951,
pp. 39–42, and again in *APS,* pp. 81–83, and a further study of his style has been made by
Lidia Forti in *Atti M Grecia* n.s. 8, 1967, pp. 99–112 (= Forti). He is a painter of consider-
able originality both of style and of treatment of subjects and, since most of his vases come
from Canosa, he may well have had his workshop there. His style reflects the influence of
the Thyrsus Painter and runs aprallel with that of the Berkeley Painter (see section 3); he
was probably active around the middle and in the third quarter of the fourth century. He
particularly favours the mug (oenochoe, shape 8 B), and, for decoration, various animals.

Mugs (Oenochoai, shape 8 B)

208 Karlsruhe B 304.
 CVA, pl. 76, 3; *APS,* p. 82, no. 1.
 Three nude youths in a torch-race.
209 Reading 25.50 RM.
 BSR 19, 1951, pl. 5, 2–4; *APS,* p. 82, no. 2.
 Seated woman, Eros with phiale and wreath, bird above laver.
210 Milan, Scala 340.
 APS, p. 82, no. 3.
 Nude woman with torch and phiale by stele.
211 Budapest 53.603.
 APS Addenda, p. 433, no. 3 bis.
 Seated woman with torch.

Mugs (Oenochoai, shape 8 B) *continued*

212 Taranto I.G. 8877, from Canosa.
 APS, p. 82, no. 6; Forti, op. cit., pl. 46 d.
 Youth, seated woman, Eros and seated woman.
*213 Taranto 8883, from Canosa. PLATE 91, 6.
 APS, p. 82, no. 7; Forti, pl. 46 c.
 Bird, Eros, seated woman, Eros and bird.
214 Taranto, from Canosa.
 APS, p. 82, no. 9.
 Seated woman and Eros. On lid: female head.
215 Corsham (Wilts.), Eden coll. 5.
 Seated woman and nude woman with tambourine.
216 Taranto 8867, from Canosa.
 APS, p. 82, no. 10, pl. 41, fig. 206.
 Seated woman with bird, palm branch and dog.
217 Brussels, Errera coll. 16.
 APS, p. 82, no. 12, pl. 41, fig. 208.
 Woman seated between swan and Eros.
218 Rhineland, Schlotter coll.
 Antiken aus rheinischem Privatbesitz, p. 66, no. 89, pl. 40, 2.
 Maltese dog coming up to seated woman holding phiale and wreath.
219 Oxford 1879.212 (V 438).
 BSR 19, 1951, pl. 7, 3–4; *APS*, p. 82, no. 4.
 Cat.
220 Oxford 1879.213 (V 439).
 BSR 19, 1951, pl. 6, 4; *APS*, p. 82, no. 5.
 Cock.
221 Taranto 8930, from Canosa.
 CVA 1, IV Dr, pl. 8, 1; *APS*, p. 82, no. 8.
 Cat and mouse.

Mugs (Oenochoai shape 8 N)

222 Karlsruhe B 306.
 CVA 2, pl. 76, 1; *APS*, p. 82, no. 13.
 Woman and dog.
223 Karlsruhe B 307.
 CVA 2, pl. 76, 2; *APS*, p. 82, no. 14.
 Eros.
224 Oxford 1934.17.
 BSR 19, 1951, pl. 6, 1–3; *APS*, p. 82, no. 15.
 Woman bouncing ball.
225 Truro, Cornwall County Museum.
 BSR 19, 1951, pl. 7, 1–2; *APS*, p. 82, no. 16.
 Youth chasing deer.
226 Brussels, Errera coll.
 APS, p. 82, no. 7.
 Seated Nike, duck and perhaps another figure.

Lekanis

227 Taranto 8889, from Canosa.

APS, p. 82, no. 18.

(a) Crouching woman, holding wreath, and goose, (b) seated Eros and duck.

Lekanis lids

228 Preston A 349.

(a) Eros with wreath and tambourine, (b) woman seated on rock.

229 Auxerre L 12.

Rolley, *Cat.* p. 11, pl. 2, c.

Seated Eros.

230 Trieste 7619.

Bird; seated woman with wreath.

231 Barcelona 345.

Kneeling woman feeding bird from phiale in her l. hand.

232 Karlsruhe B 938.

CVA 2, pl. 76, 5; *APS*, p. 82, no. 19.

Female head.

233 Reading 137.51 RM.

APS, p. 82, no. 20.

Female head and bird.

234 New London (Conn.), Lyman Allyn Museum 1955.1.83.

(a) Bird to l., (b) fan-palmette.

Minor work.

Pyxis lid

235 B.M. 1915.1–13,1.

(a) and (b) Female head, as on Karlsruhe B 938.

Pelikai

236 Taranto, from Canosa.

APS, p. 82, no. 21, pl. 41, fig. 210.

(a) Eros with bird and tambourine, and woman with wreath, (b) Eros with tambourine, duck, woman with mirror.

237 Taranto 8890, from Canosa.

APS, p. 82, no. 22.

(a) Eros with tambourine, and woman, (b) nude youth with wreath, and woman.

Dish (with flat handles)

238 Bari 926.

Forti, op. cit., pl. 47.

I. Nereids with arms of Achilles. A. Eros flying between two women. B. the like.

Chous

239 Oxford 1885.666 (V 442).

APS, p. 83, no. 25.

Cock.

Cup

240 Amsterdam 1934 (*Gids* 1482).

APS Addenda, p. 433, no. 27.

I. Woman seated on rock with phiale and sceptre. A. and B. Eros seated on rock.

(ii)

The following vases, which form a compact group in style, stand a little apart from those in (i), though still very close to the painter himself.

Mug (Oenochoe, shpae 8 B)

241 Taranto 8868, from Canosa.
 APS, p. 82, no. 11.
 Woman with tambourine, woman with phiale and bunch of grapes, Eros with tambourine.

Choes

242 Taranto 8874, from Canosa.
 APS, p. 83, no. 23.
 Eros with tambourine and situla, Psyche with tambourine.
243 Taranto, from Canosa.
 APS, p. 83, no. 24.
 Woman with situla and bunch of grapes, youth with torch.

Lekanis

244 Taranto 9010, from Canosa.
 (a) Seated woman, (b) seated woman with phiale.

(iii) RELATED VASES

Skyphos

245 Chicago University.
 APS, p. 83, no. (i), pl. 41, fig. 207.
 (a) Woman with oenochoe and cista, (b) nude youth with sash.

Lebes gamikos

246 Bari 6361.
 (a) Standing woman with bunch of grapes, (b) seated woman with mirror.

Lekanis

247 Bari, Colombo coll. 18.
 (a) Seated Eros with phiale, (b) seated woman with phiale and wreath.

Plates

248 Taranto 8894.
 CVA 1, IV Dr, pl. 7, 1; Forti, op. cit., pl. 46a; *APS*, p. 83, no. (iii).
 Actaeon.
249 Louvre K 632.
 Schauenburg, *AA* 1958, 26, fig. 3; *APS*, p. 83, no. (iv).
 Chimaera.
250 Amsterdam, Prof. A. Zadoks-Jitta.
 Het Dier als motief in de antieke Kunst (1963), no. 213; *Klassieke Kunst uit particulier bezit* (1975), no. 577.
 Chimaera.

(iv)

The following vase is connected in style with the Lampas Painter and should also be compared with the work of the Berkeley Painter:

Pelike

251 Warsaw 198924.
 CVA, Poland 7, pl. 38; *APS Addenda*, p. 433, no. (vi).
 (a) Nude youth and draped woman beside a Doric column, (b) two draped youths.

With this vase might also be considered two lekanides in Angers (284–15 and 16; De Morant, *Cat.*, pls. 21–22), but the photographs do not permit of a certain attribution.

CHAPTER 11

OPERA MINORA

Smaller vases from the workshops of the Iliupersis Painter and the followers of the Hoppin Painter

1. The Zaandam Group 2. The Monash Group
3. The Waterspout Group 4. The Group of Lecce 727
5. The Choes Group 6. Two phlyax vases 7. The Meer Group
8. The Group of the Dresden Amphora
9. The Wellcome and Turin Groups
10. The Egg and Wave Group 11. The Painter of Reggio 1157
12. The Scala Group and the Group of Altenburg 331
13 Associated Vases

Introduction

During the second and third quarters of the fourth century there is a considerable increase in the production of vases of small dimensions (i.e. between 10 and 20 cm. in height), such as choes, pelikai, squat lekythoi, and skyphoi. These are at times decorated with two-figure compositions, but mostly with single figures — a draped woman, Eros or a nude youth, and, a little later, a female head. In style they are closely associated with the major vases from the workshops of the Hoppin, Felton and Iliupersis Painters and their immediate followers, among whom the Truro Painter, who himself decorated a number of such vases (e.g. nos. 5/103—120, 142—166), deserves special mention. The influence of the school of the Dijon Painter may be noted on some of the earlier vases, as also on the work of the Iliupersis Painter himself.

Broadly speaking, the minor vases listed in this chapter (i.e. those not already specifically attributed to a given painter) reflect the influence of the Iliupersis Painter and the Painter of Athens 1714 (notably the Zaandam and Monash Groups) or of the followers of the Hoppin Painter, like the Truro and Thyrsus Painters, and, not infrequently, a combination of the two, as with the Wellcome and Egg and Wave Groups, where the drawing of the figures follows the Iliupersic tradition, but the pattern-work is more like that of the Hoppin Painter.

Although it is not easy to provide a clearly defined classification for many of these vases, we have endeavoured to divide them into various stylistic groups; where it has been possible to determine the identity of a specific painter, this has been done. A number of vases which do not seem to fit precisely into any one of the various groups, or on which we have only scant information, are listed together at the end. The lists are not intended to be exhaustive, but aim to give a good, representative selection of the principal types of smaller vases. A common feature on many of them is the presence on the underside of the foot of a thick cross painted on in a pinkish-red wash.

1. THE ZAANDAM GROUP

Of the minor vases, those in the Zaandam Group are probably closest in style to the work of the Iliupersis Painter, and the figures on them should be compared with those on the necks of his volute-kraters (e.g. B.M. F 160, no. 8/8) or on his smaller vases (e.g. 8/19).

(i) THE ZAANDAM PAINTER

The Zaandam Painter, who is named after the lebes gamikos in a private collection in Zaandam (no. 1), has a preference for lebetes gamikoi and skyphoi, which he decorates with a single figure on each side, usually one female and the other male. The pictures are normally framed between simple palmette-scrolls, curving outward at the top, with a single drop leaf above and below the central scroll; windows drawn in perspective (cf. the Painter of Athens 1714), quartered balls or phialai, and dotted bunches of grapes regularly serve as decorative adjuncts in the field.

Women are often represented as bending forward over one raised leg; they wear a peplos with a V-opening beneath the outstretched arm, as on many of the vases by the Iliupersis Painter. The pupil of the eye is a dot, the chin is rounded, and the mouth slightly open, with some emphasis upon the lower lip. His mirrors are very characteristic and usually have a black disk in the centre.

Lebetes gamikoi

* 1 Zaandam, Takens Bremma coll. PLATE 92, 1–2.
 (a) Woman with raised foot, holding bunch of grapes, (b) nude youth with bunch of grapes and mirror.

1a Trieste, private coll.
 (a) Woman with raised foot, holding bunch of grapes (as on no. 1), (b) standing Eros.

2 Brussels A 147.
 CVA 2, IV Db, pl. 8, 4 1–b.
 (a) Woman holding mirror, (b) seated Eros holding wreath.

3 Leningrad inv. 428 = St. 1297.
 (a) Woman holding wreath, resting l. foot on rock, (b) Eros holding grapes in l. hand.

4 Leningrad inv. 431 = St. 1278.
 (a) Seated woman holding wreath and phiale, (b) youth with wreath and mirror, standing by altar.

5 Bonn 122 (lid may not belong).
 (a) Seated woman with bunch of grapes and cista, (b) youth holding bunch of grapes and mirror.

5a Bari, Perrone coll. 50.
 (a) Standing woman with bunch of grapes and mirror, (b) nude youth with bunch of grapes and mirror.

6 Taranto. from Via Capecelatro, T. 42.
 CVA 2, IV Dr, pl. 37, 5–6.
 (a) Standing woman with bunch of grapes and cista, (b) seated nude youth with wreath and cista.

7 Bari 1332, from Rutigliano.
 (a) Draped woman with cista, (b) Eros.

8 Taranto 8103.
 (a) Draped woman with raised foot, holding phiale, (b) nude youth with bunch of grapes and cista.

9 Basel Market, MuM.
 (a) Seated woman with phiale, (b) Eros.

Squat lekythos

9a Trieste, private coll.
 Eros with phiale and seated half-draped woman with wreath; between them, a stele.

Skyphoi

10 Zagreb 318.
 Damevski, no. 78, pl. 38, 1–2.
 (a) Draped woman with wreath and phiale, (b) nude youth with wreath and phiale.

* 11 Zagreb 42. PLATE 92, 3—4.
 Damevski, no. 72, pl. 37, 1—2.
 (a) Seated woman with phiale and mirror, (b) Eros with phiale.
 12 Sèvres 224.
 CVA, pl. 32, 9 and 13.
 (a) Draped woman moving to r., (b) seated Eros with mirror.
 13 Naples 2083 (inv. 82002).
 (a) Seated woman with wreath and cista, (b) Eros with mirror.
* 14 Once Milan Market, Casa Geri. PLATE 92, 5—6.
 Casa Geri, *Sale Cat.* 16 Dec. 1970, no. 730.
 (a) Draped woman bending forward over raised foot, holding mirror in r. hand, (b) Eros with
 mirror.
 15 Milan 269.
 CVA 1, IV D, pl. 12.
 (a) Draped woman with thyrsus, (b) satyr with wreath and mirror.
 Very close to the preceding skyphos.

Cup skyphoi

 16 Brussels A 1381.
 CVA 2, IV Db, pl. 8, 3.
 (a) Draped woman with bunch of grapes and mirror, (b) satyr with mirror.
 17 Naples Stg. 598.
 (a) Woman bending forward over raised foot and holding mirror, (b) nude youth with bunch of
 grapes and mirror.
 18 Bologna 484.
 CVA 3, IV Er, pl. 6, 14—15.
 (a) Seated woman with bunch of grapes and phiale, (b) seated satyr with situla.
18a Essen, Ruhrlandmuseum 71.177A.
 Antike Keramik (Ausstellung Ruhrlandmuseum, 1973), no. 44.
 (a) Seated woman with tambourine, (b) seated satyr with cista.
* 19 North Germany, private coll. (ex Munich Market). PLATE 92, 7—8.
 Ulla Lindner, *Lagerliste* 3, no. 27 (ill.); Hornbostel, *Kunst der Antike — Schätze aus norddeutschem
 Privatbesitz* (1977), no. 302, ill. on p. 353.
 (a) Seated woman with bunch of grapes and phiale, (b) kneeling satyr with phiale and torch.
 20 Trieste S 493.
 CVA 1, IV D, pl. 31, 1—2.
 (a) Satyr with mirror, (b) female head.

Lekanis

 21 Ruvo 496.
 Sichtermann, K 95, pl. 142, 1.
 (a) Seated woman with phiale, (b) kneeling satyr with wreath.

(ii) CLOSELY CONNECTED VASES

The following vases are closely connected with the work of the Zaandam Painter: note
especially the treatment of the satyrs on nos. 23—25, of the seated women and the Erotes
on the two stemless cups, as well as the presence of windows drawn in perspective and the use
of rosettes and quartered balls as adjuncts. They should also be compared with the vases in
the Waterspout Group.

Hydria

22 B.M. F 98.
 Woman with cista, youth leaning on drapery-covered pillar.

Skyphos (Corinthian type)

23 Prague, Mus. Appl. Art 1161.
 APS, p. 76, no. (vii), pl. 39, fig. 198.
 (a) Woman with wreath and mirror, (b) satyr with situla and torch.
23a Bassano del Grappa, Chini coll. 154.
 (a) Draped woman with phiale, (b) nude youth with palm branch.

Oenochoe (shape 3) = *Chous*

23b Los Angeles Market, Summa Galleries inv. 272.
 Draped woman with phiale, and nude youth with wreath at stele.

Oenochoai (shape 5) = *Olpai*

24 Budapest 50.171.
 Seated satyr with mirror and cista.
25 Bucharest, private coll. (Petre Codită).
 CVA 2, pl. 42, 4–6.
 Satyr pursuing woman with cista.

Cup skyphoi

26 Basel, MuM.
 (a) Seated half-draped woman with cista, (b) Eros flying to r. with bead-chain.
27 Basel, MuM.
 (a) Seated woman with phiale, (b) kneeling Eros with mirror and phiale.
28 Ruvo 919.
 (a) Seated half-draped woman, (b) seated Eros.

Epichyseis

29 Ruvo 927.
 Kneeling Eros.
30 Adolphseck 175.
 CVA, pl. 75, 9–10.
 Seated woman facing seated satyr with thyrsus.
31 Adolphseck 176.
 CVA, pl. 75, 11–12.
 Seated satyr facing seated woman.
32 Once London Market, Folio Fine Art.
 Seated woman and nude youth with phiale.

2. THE MONASH GROUP

As with the vases in the Zaandam Group those in the Monash Group are also very close in style to the minor works of the Iliupersis Painter (cf. with 8/8 and 19), although the running woman on no. 33 clearly looks back to the Dijon Painter (cf. with nos. 6/131 and 133). The krater recently found at Putignano (no. 34) makes a pair with the Monash krater; both have the same patterns on the handle-zones, egg on the obverse, inverse wave on the reverse (cf. also no. 42). The combination of egg and wave is popular on the smaller vases, especially pelikai and skyphoi,

as also are the running or striding nude youths, with a strigil or a wreath in one hand, and the other often enveloped in, or holding, a piece of drapery.

Calyx-kraters

* 33 Melbourne, Monash University 127/69/73 (ex London Market, Folio Fine Art). PLATE 93, 1–2.
 Folio Fine Art, *Cat.* 48 (Sept. 1967), no. 620 (ill.).
 (a) Running woman with wreath and cista, (b) nude youth.
 34 Taranto, from Putignano.
 Atti XIO CStMG, 1971, p. 326, pl. 89 a–b.
 (a) Woman running to r. with cista, (b) nude youth running to l. with stick, drapery over l. arm.

Bell-kraters

 35 Winterthur 310.
 APS, p. 73, no. (lv), pl. 38, fig. 192.
 (a) Nude youth running, (b) seated youth.
 36 Lecce 4827.
 (a) Seated woman with phiale, (b) nude youth with strigil, running to l.

Pelikai

 37 Stuttgart 4.249 (old no. 154).
 CVA, pl. 47, 3–4.
 (a) Running woman with wreath and phiale, (b) nude youth with strigil by altar.
 38 Turin 4501.
 CVA 1, IV D, pl. 25, 1–2; *APS*, p. 72, no. (xxxvi).
 (a) Woman with phiale running to r., (b) youth with strigil and wreath.
 39 Lecce 690.
 CVA 2, IV Dr, pl. 39, 4; *APS*, p. 72, no. (xxxi).
 (a) Draped woman with phiale, (b) nude youth with stick, moving to r.; drapery over l. arm.

Oenochoai (shape 3) = *Choes*

 40 Bari, Merlin coll. 38.
 Woman running to l. towards altar, with wreath in r. hand and cista in l.
 41 Ravenna, Prof. Bendandi.
 Woman running to l.
 41a Cologne, private coll.
 Woman with torch running to l. followed by young satyr.
 For the pose of the satyr cf. Vatican V 5 (3/116).
 42 London Market, Charles Ede.
 Ex Sotheby, *Sale Cat.*, 14 June 1976, no. 187.
 Nude youth with stick and wreath by altar.
 Cf. the wave-pattern on the neck with that on the two calyx-kraters (nos. 33–34).

 The following oenochoe, which is not well preserved, looks to belong here from the treatment of the woman's drapery (cf. with nos. 40–41).

 43 Milan 252.
 CVA 1, IV D, pl. 15, 1.
 Satyr with wreath, maenad holding up tambourine, both moving to r.

3. THE WATERSPOUT GROUP

Like the vases in the Monash Group, those in the Waterspout Group, which takes its name from the chous formerly on the Zurich Market (no. 44), showing a woman collecting water in

a phiale from a spout up above it, are still fairly close to the work of the Iliupersis Painter. As generally characteristic we may note:

(a) the use of a white radiate stephane with three or four spikes as a head-dress for women, and a white chaplet with a single spike in front for youths,

(b) the clear division of the female breasts, separated by the fold-lines on the drapery which covers them.

There is a limited use of adjuncts in the field — rosettes, phialai, ivy leaves and windows appear most frequently.

(i)

Oenochoe (shape 3) = *Chous*

* 44 Once Zurich Market, Arete. PLATE 93, 3.
 Nude youth with wreath in r. hand and drapery over l., seated woman holding out phiale beneath a waterspout.
 Note the inverse wave below the design; cf. with nos. 33—34 and 42.

Squat lekythoi

* 45 Palermo, Mormino 741. PLATE 93, 4.
 Eros with tambourine, seated woman with phiale and bunch of grapes.
 46 Brussels R 352.
 CVA 2, IV F, pl. 1, 3.
 Woman with bird, and youth with strigil at stele.
 46a Bari, D'Agostino coll.
 Seated woman with cista and box, nude youth, with r. foot raised on pillar, holding strigil in r. hand.
 47 Würzburg 826.
 Langlotz, *Cat.*, pl. 248.
 Woman with cista, and Eros seated on laver.
 48 Hamburg 1917.1080.
 Woman with phiale, and seated nude youth.
 49 Bari, Cotecchia coll. 57.
 Standing woman with sash and cista, seated nude youth with tendril.
 49a Freiburg Market, Günter Puhze.
 Eros with cista running to r. after woman.
 50 Once London Market, Sotheby, *Sale Cat.* 26 April 1971, no. 165; then Charles Ede.
 Nude youth with cista, and seated woman.

(ii)

The following are very close to the vases in (i), especially in the treatment of women's drapery. Note the clearly defined fold-lines, and the drawing of the leg beneath the drapery.

Amphora

 51 Aberdeen 681.
 (a) Draped woman with thyrsus, (b) Eros with bird on r. hand.

Pelikai

 52 Bari 20171, from Gioia del Colle T. 7.
 Scarfì, *MonAnt* 45, 1960, cols. 279 f., figs. 112—3; *APS Addenda*, p. 431, no. (xxxix c).
 Standing draped woman with mirror, running r. towards altar.
* 53 Cambridge, Mus. Class. Arch. 73. PLATE 93, 5—6.
 (a) Draped woman with mirror and wreath, (b) nude youth with strigil and bunch of grapes.

53a Madison, Univ. of Wisconsin 70.18.8.
 (a) Standing draped woman with cista and wreath, (b) nude youth with drapery over l. arm moving to r.
54 Lecce 689.
 CVA 2, IV Dr, pl. 37, 2.
 (a) Draped woman with dish, (b) nude youth with cista.
54a Perugia, Mus. Arch. 159.
 (a) Woman running to r. with tambourine, (b) Eros.
55 Once New York Market, Sotheby-Parke-Bernet, *Sale Cat.* 7 Dec. 1973, no. 56.
 (a) Eros with mirror and wreath, moving to l., (b) female head.

Oenochoai (shape 3) = *Choes*

* 56 Malibu, Getty Museum 71 AE 361 (ex Washington 197241). PLATE 93, 7.
 Woman running to l. with mirror and wreath.
57 Darmstadt, J. Sille coll.
 Woman running to l. with phiale.
57a Chester, Grosvenor Museum 403. F. 1976.
 Seated woman with mirror in r. hand (cf. with no. 58).

Squat lekythos (with flat body)

58 Como C 70.
 CVA, IV D, pl. 12, 1.
 Woman with wreath and phiale running to l.

Squat lekythoi

59 Once London Market, Charles Ede, ex Sotheby, *Sale Cat.* 18 May 1970, no. 133.
 Woman with wreath beside altar.
60 Once London Market, Folio Fine Art, ex Sotheby, *Sale Cat.* 19 July 1969, no. 274, 2.
 Woman moving to l., and bouncing ball with r. hand.
61 Sèvres 139.
 CVA, pl. 32, 2, 6, and 28.
 Woman with phiale by altar.
62 Sèvres 140.
 CVA, pl. 32, 4, 8, and 11.
 Half-draped woman with mirror.

(iii)

Oenochoai (shape 3) = *Choes*

63 Brussels R 382.
 CVA 2, IV F, pl. 1, 2; *APS,* p. 76, no. (viii).
 Woman holding cista.
64 Taranto.
 CVA 2, IV Dr, pl. 34, 5; *APS,* p. 71, no. (xxii).
 Woman with mirror and palm branch.
65 Karlsruhe B 63.
 CVA 2, pl. 70, 8; Van Hoorn, fig. 414; *APS,* p. 71, no. (xvii).
 Woman with mirror running to r.
66 Once London Market, Folio Fine Art, *Cat.* 64 (1969), no. 702 (ill.); *APS Addenda,* p. 431, no. (xvi b).
 Woman with phiale running to r. towards a table of offerings.

Pelikai

67 Edinburgh 1926.532.
 APS Addenda, p. 431, no. (xxxix f).
 (a) Woman running to l., holding mirror, (b) youth with strigil.
68 Taranto.
 CVA 2, IV Dr, pl. 34, 1–2; *APS*, p. 72, no. (xxxv).
 (a) Running youth with strigil, (b) woman with bird, bouncing ball.

(iv)

Very small vases connected in style with the above.

Skyphoi (of Corinthian shape)

* 69 Edinburgh 1872.23.26. PLATE 93, 8.
 APS Addenda, p. 431, no. (li a).
 (a) Running woman with wreath and phiale, (b) youth with wreath.
* 70 Edinburgh 1956.478. PLATE 93, 9.
 APS Addenda, p. 431, no. (l a).
 (a) Running youth with egg and wreath, (b) running youth.
 71 Turin 4475.
 CVA 1, IV D, pl. 4, 1–2.
 (a) Nude youth running to l., (b) woman running to l.
 72 Bourges 891.5.84.
 (a) Draped woman, (b) nude youth with dish.
 Cf. with the work of the Snub-Nose Painter and his school.

Oenochoai (shape 3) = *Choes*

 73 Brooklyn 60.129.1.
 D. von Bothmer, *American Art from N.Y. Private Colls.* pl. 92, no. 253; *APS*, p. 71, no. (xx).
 Young satyr moving to r., and drinking out of b.f. chous.
 74 Vienna.
 Van Hoorn, *Choes,* fig. 404; *APS*, p. 71, no. (xxi).
 Young satyr with situla and torch running to r.
 75 Maplewood, (N.J.), J.V. Noble Coll.
 Schauenburg, *RM* 65, 1958, pl. 40, 1; *APS*, p. 70, no. (iv).
 Seated silen (Marsyas ?) with flute in each hand.
 76 Sèvres 83.
 CVA, pl. 32, 20; *APS*, p. 71, no. (xix).
 Youth with tambourine running to r.
 77 Stockholm, C.E. Galt.
 APS, p. 73, no. (xlvi).
 Nude youth with stick and wreath moving to l.
 78 Once London Market, Folio Fine Art.
 Nude youth with palm branch.
 79 Taranto, Baisi coll. 79.
 Nude youth with stick in r. hand, drapery over l. arm.

Squat lekythoi

 80 Once Zurich Market, Arete.
 Eros with cista and wreath.

81 Lecce 743.
 CVA 2, IV Dr, pl. 49, 9.
 Eros with ball and wreath.

(v)

Oenochoe (shape 8) = *Mug*

82 Naples Stg. 589.
 Satyr with wreath and situla, seated woman with mirror, seated youth with phiale and fan.

Oenochoe (shape 3) = *Chous*

83 Bari 6355.
 Young satyr with thyrsus and situla, moving to l.

Lekanides

84 Bari, Macinagrossa coll. 38.
 (a) Seated woman with bird, (b) kneeling satyr with thyrsus, drinking from chous.
85 Cork, University College (J. 1268).
 Eros chasing bird, seated woman with phiale, seated woman.

4. THE GROUP OF LECCE 727

The vases in this group are very close to those in the Waterspout Group, but the faces of the figures are less rounded and have sharper noses. Women's drapery often has a dot-stripe border. Eros is highly popular.

Skyphos

* 86 Lecce 727. PLATE 93, 10.
 CVA 2, IV Dr, pl. 31, 1 and 3.
 (a) Eros with mirror beside altar, (b) seated nude youth with wreath and thyrsus.

Skyphos (of Corinthian shape)

87 Berne 12419.
 Aus der Antikensammlung, no. 84, note 87, pl. 39.
 (a) Eros with mirror and bunch of grapes, (b) draped woman with alabastron.

Pelike

88 Once London Market, Folio Fine Art.
 (a) Eros with mirror, (b) draped woman.

Squat lekythoi

89 Como C 71.
 CVA, IV D, pl. 12, 2.
 Draped woman with bunch of grapes and cista by altar.
89a Hamburg 1917.1074.
 Eros with phiale and wreath moving to l.

Oenochoai (shape 3) = *Choes*

90 Lecce 708.
 CVA 2, IV Dr, pl. 40, 2.
 Eros with phiale moving r. toward stele.

Oenochoai (shape 3) = *Choes (continued)*

91 Once London Market, Sotheby's, *Sale Cat.* 1 April 1969, no. 185 (then Folio Fine Art, *A Collection of Greek Pottery*, no. 89, ill.).
 Eros to l. with wreath by altar.

92 Once London Market, Christie's, *Sale Cat.* 7 Dec. 1971, no. 100.
 Eros to r. with wreath and phiale by altar.

Stemless cup

93 San Francisco, M.H. de Young Memorial Museum 715.
 I. Maenad with thyrsus and fillet, Eros with mirror and bunch of grapes.

 The pointed leaf pattern round the rim of the interior and between the handles on the exterior finds a parallel on the shoulder of the squat lekythos B.M. F 107 by the Suckling Painter (no. 15/1), with which it should be contemporary.

5. THE CHOES GROUP

(i) THE CHOES PAINTER

The Choes Painter, who was identified in *APS* (p. 74), is named after the shape he prefers to decorate and sometimes depicts in use upon his vases. With him we come to a painter who, while still closely connected in style with the work of the Iliupersis Painter, also reflects, especially in his treatment of women's drapery, the influence of the Hoppin Painter and his followers like the Truro Painter, as may be seen by a comparison between his vases and pieces like nos. 5/75, 86–90. It should be noted that the nestoris Naples 2326, attributed in *APS* (p. 74, no. 6) to the Choes Painter has now been placed in the Hoppin Group (no. 5/88); the correspondence between the draped figures wearing a cloak drawn diagonally across the body and bunched up over the bent left arm is particularly striking (e.g. on no. 98).

As characteristic of the work of the Choes Painter and his group we may note the drooping shoulders of the nude youths and their mannered poses (e.g. the extended arm, with the fore-arm and hand bent downwards, as on nos. 98–106), and the frequent presence of a woman, as on Vienna 856 (no. 98), whose cloak is draped across her body and envelops the bent right arm, with wavy lines to mark the borders, and whose hair is tied up in a saccos with a knot on top.

Many of the vases were found in Taranto itself, and they often have a red cross painted on the underside of the foot — perhaps a mark of the factory in which they were made.

(a)

The influence of the Iliupersis Painter may be noted on the vases in this sub-division especially in the drawing of the youths' heads.

Oenochoai (shape 3) = *Choes*

94 Taranto 22808.
 Nude youth with strigil, leaning on stick and bending forward towards seated woman with wreath and palm branch.

95 Taranto 22812.
 Standing woman with fillet and cista, nude youth with raised foot, holding strigil.

96 Taranto 20384, from Via Crispi.
 Youth with bird perched on l. hand, holding wreath, and seated woman with phiale.

97 Taranto 20389, from Contrada Vaccarella.
 Nude youth with wreath and stick, with l. foot resting on a stone, woman with situla.

98 Vienna 856.
 APS, p. 74, no. 4, pl. 39, fig. 193.
 Youth with drapery over l. arm, draped woman with cista.
98a Freiburg Market, Günter Puhze, *Kunst der Antike* (*Cat.* 1977), no. 134.
 Nude youth, with drapery over his arms and behind his back, holding dove in r. hand, standing
 draped woman.
99 Houston, de Ménil coll.
 Hoffmann, *Ten centuries that shaped the West,* no. 201, ill. on p. 441 (attribution by A. Oliver Jr.).
 Nude youth with wreath, and drapery over l. arm, seated woman on rock-pile.
100 Zurich Market, Arete.
 Nude youth with strigil and stick, woman with mirror.
*101 Zurich Market, Arete. PLATE 94, 1.
 Nude youth with ball and palm branch, seated woman with wreath.
102 Taranto, Ragusa coll. 173.
 APS Addenda, p. 431, no. 5 bis, pl. 120, fig. 26.
 Nude youth with strigil and cat, woman pointing to drapery-covered pillar.

Squat lekythos (with flat body)

103 Once London Market, Charles Ede.
 Greek Pottery from South Italy (1971), no. 27, ill.
 Nude youth bending forward over raised foot, with wreath in r. hand and drapery around l., stand-
 ing woman holding sash above altar.
 Goes very closely with Vienna 856 (no. 98).

(b)

The four choes in this sub-division form a very compact group, the first two showing
figures holding b.f. choes in their hands. They are close in style to those in (a) and are probably
the work of the same painter.

Oenochoai (shape 3) = *Choes*

104 Taranto 22428.
 Van Hoorn, *Choes,* fig. 396a; *APS,* p. 74, no. 2.
 Woman and youth with b.f. chous at altar.
105 Taranto 22803.
 Van Hoorn, *Choes,* fig. 396b; *APS,* p. 74, no. 3.
 Two youths holding b.f. choes at altar.
106 Louvre K 38.
 Van Hoorn, *Choes,* fig. 398; *APS,* p. 74, no. 5.
 Two youths, l. with stick, r. with wreath.
107 Taranto 4618.
 Satyr with situla and torch, youth with phiale and thyrsus moving to l.

(ii) VASES CONNECTED IN STYLE

There are a good many vases which are connected in style with, or comparable to, the
work of the Choes Painter and which repeat, with minor variations, his stock figures of nude
youth and draped woman — especially the latter with the cloak drawn across her body and
wearing a saccos (cf. nos. 115—8 with nos. 98 and 102).

Oenochoai (shape 3) = *Choes*

108 Once Norwich, Castle Museum.
 APS, p. 74, no. (i).
 Youth with stick and strigil, woman with ball at stele.

Oenochoai (shape 3) = *Choes (continued)*

109 Rome, private coll.
 APS Addenda, p. 431, no. (vi).
 Woman with wreath, and nude youth with wreath by altar.
110 Trieste S 519.
 CVA, IV D, pl. 21, 7–8; *APS,* p. 76, no. (ix), pl. 39, fig. 194.
 Nude youth with stick, seated woman with mirror.
111 Turin, private coll.
 Woman with mirror and nude youth with strigil beside altar.
112 Bari 6352.
 Nude youth with situla and woman with torch, both running to l.
113 Taranto 22819, from Via Japigia (25/4/1939).
 Young satyr seated on pointed amphora, holding thyrsus and tambourine.
114 Taranto 52562, from Contrada Vaccarella.
 NSc 1941, p. 482, fig. 48.
 Young satyr pursuing duck to l.

Pelikai

115 Zagreb 1080.
 APS, p. 72, no. (xxxvii), pl. 38, fig. 188; Damevski, no. 48, pl. 19, 1–2.
 (a) Draped woman with cista, (b) nude youth with stick.
116 Liverpool 50.60.65.
 APS, p. 72, no. (xxxviii), pl. 38, fig. 191.
 (a) Draped woman catching ball, (b) nude youth with drapery over l. arm.
*116a Monopoli, Meo-Evoli coll. 496. PLATE 94, 2.
 (a) Seated woman with cista, and nude youth with fillet resting l. arm on drapery-covered stick,
 (b) young satyr with tambourine and thyrsus.
 The youth on (a) is very close to the one on the Turin oenochoe (no. 111).

Skyphoi

*117 Oxford G 1146. PLATE 94, 3.
 (a) Draped woman with tendril, (b) seated nude youth with palm branch.
117a Taranto, from Rutigliano, T. 38.
 (a) Running woman, (b) youth with strigil.
118 Turin, private coll.
 Acme 24, 1971, pp. 208–211, pls. 5–6, figs. 9–10 and 13.
 (a) Draped woman with wreath, (b) satyr with situla and torch.
119 Mainz O. 12964 (fr.).
 (a) Nude youth and woman.

(iii) COMPARABLE VASES

(a)

Oenochoai (shape 3) = *Choes*

120 B.M. F 99.
 CVA 2, IV Ea, pl. 4, 8; *PhV*2, p. 61, no. 110.
 Phlyax Herakles and woman with chous.
121 Once London Market, Sotheby, *Sale Cat.* 29 June 1970, no. 147.
 Capering satyr, and draped woman with wreath.

Squat lekythos

122 Bari, Macinagrossa coll. 43.
 Draped woman holding phiale and oenochoe.

(b)

The following vases, decorated with nude youths, should be connected with the above. Note the flat mouths.

Oenochoai (shape 3) = *Choes*

123 Vienna 978.
 Van Hoorn, *Choes*, fig. 397; *APS*, p. 75, no. (iii).
 Nude youth with strigil.
124 Zurich Univ. 2668.
 Van Hoorn, *Choes*, fig. 519; *CVA* 1, IV D, pl. 43, 6–7; *APS*, p. 75, no. (iv).
 Nude youth with strigil.
125 Altenburg 255.
 CVA 2, pl. 64, 4–5; *APS*, p. 72, no. (xliii).
 Nude youth with feline on r. arm, drapery around l.

Pelike

126 Bari 20092, from Gioia del Colle, T. 4.
 Scarfi, *MonAnt* 45, 1960, cols. 235–6, figs. 75–76; *APS Addenda*, p. 431, no. (xxxix a).
 (a) Nude youth with strigil in r. hand, stick and drapery in l., (b) nude woman with wreath.
 For the treatment of the r. breast cf. the skyphos in St. Gallen (no. 164).

6. TWO PHLYAX VASES

The two mugs listed here, both by a single hand, are decorated with very similar phlyax scenes, which, on stylistic grounds, should find a place in this general context. The running woman with a torch on no. 127 is very much in the Iliupersis tradition and should, in particular, be compared with the similar figures on the neck of Louvre CA 227 by the Painter of Athens 1714 (no. 8/146), which she very closely resembles. The draped woman to left on both the mugs recalls some of the comparable figures on the vases in the Choes group.

The scene on each is much the same — one phlyax (on no. 127 he is younger and still has black hair) is arguing with a woman, who seems to show very little interest in him, while another, white-haired and shown in full face on both vases, stands impassively by, with a rather knowing smile. The scene on no. 127 is concluded by a woman running up with a torch, which suggests that it is taking place at night; she does not appear on the second mug.

Oenochoai (shape 8 B) = *Mugs*

127 Taranto 4656.
 *PhV*2, p. 66, no. 131 (where bibliography).
 Woman, phlyax, old phlyax, and woman coming up with torch and wreath.
128 Bochum S 995.
 Ex Hesperia Art, *Bull.* XLIX, no. 17; then Basel, MuM; then Sotheby, *Sale Cat.* 3 Dec. 1973, no. 147, ill. on p. 93.
 Draped woman and phlyax, old phlyax.

7. THE MEER GROUP

The group takes its name from the amphora no. 129 in Meer. Characteristic is the striding figure, with a cloak draped around the body, one arm akimbo and the drapery swirling out

beneath it (nos. 129, 131–3). Across the folds running down the top of the cloak there may be a black wavy line (nos. 134–5). The draped women on nos. 134–6 and especially on no. 134 should be compared with those on nos. 98 and 115–6; the connexion with the Choes Group is abundantly clear.

(i) THE MEER PAINTER

Amphora

129 Meer (Belgium), private coll.
 (a) Woman running to l. with wreath, (b) nude youth with stick.

Pelike

*130 Geneva 13201. PLATE 94, 4–5.
 (a) Draped woman with sash, (b) nude youth with stick.

Squat lekythoi (with flat bodies)

131 Naples, private coll. 29.
 Nude youth with strigil moving to l., followed by draped woman.
132 Northampton, Castle Ashby.
 Nude youth running to l., followed by draped woman.

Squat lekythos

133 Taranto, inv. Viola 1390.
 CVA 2, IV Dr, pl. 37, 4; *APS,* p. 71, no. (xiii).
 Woman with wreath, running to r. Cf. with nos. 135–8.

Oenochoai (shape 3) = *Choes*

134 Once London Market, Charles Ede.
 Greek Pottery from S. Italy V (1977), no. 20 (ill.).
 Nude youth with strigil and stick, and draped woman.
135 Taranto, Baisi coll. 77.
 Woman running to l. with chous in r. hand.
*136 Zurich Market, Arete. PLATE 94, 6.
 Woman running to r. and bouncing ball with r. hand.
137 Turin 4439.
 CVA 1, IV D, pl. 19, 3; *APS,* p. 71, no. (xviii).
 Woman bouncing ball and running to l.
138 New Haven, Yale University 260.
 Baur, *Cat.,* p. 95, fig. 27 and p. 159; van Hoorn, *Choes,* fig. 412.
 Woman running to r.
139 Once London Market, Charles Ede, *Cat.* 86, no. 4 (ill).
 Ex Sotheby, *Sale Cat.* 29 March 1971, no. 143.
 Draped youth with wreath running l. towards altar.
140 Once London Market, Folio Fine Art, *Cat.* 75, no. 201 (ill.).
 Nude youth with strigil, running to l.; drapery over r. arm.
141 Hamm 1571.
 Budde, *AA* 1948–9, col. 153, fig. 27; *APS,* p. 72, no. (xlii).
 Nude youth striding to l. pursuing bird.
142 Once Manduria, Arnò coll., later Rome Market, *Sale Cat.* no. 87.
 APS Addenda, p. 431, no. (xxiii a).
 Nude youth.

(ii) RELATED IN STYLE

The following vase, from the treatment of the draped youth on its reverses, looks to be related to the above:

Pelike

143 Lecce 712.
 CVA 2, IV Dr, pl. 36, 9.
 (a) Running woman with mirror, (b) draped youth with strigil.

8. THE GROUP OF THE DRESDEN AMPHORA

The vases in this division are linked by the draped woman wearing a peplos, with a black stripe running down from the girdle over the bent leg, and a black bead necklace and by the standing nude youth. The draped woman sometimes turns her head to look in the opposite direction, with a consequential twist to the body (nos. 148–51); she often has a rather elongated bunch of hair at the back of her head.

Amphora

*144 Dresden 525. PLATE 94, 7–8.
 (a) Draped woman with ball and wreath, (b) nude youth with phiale.

Skyphoi

145 Bari, Cotecchia coll. 51.
 (a) Draped woman with thyrsus and phiale, (b) nude youth with wreath and bird.
145a Bari 20757, from Conversano, T. 9.
 NSc 1964, p. 143, figs. 53–4, no. 4.
 (a) Draped woman, (b) nude youth.

Oenochoe (shape 3) = *Chous*

146 Laon 37.1090.
 APS, p. 80, no. (xiv).
 Draped woman with mirror and phiale beside a stele.

Pelikai

147 Lecce 688.
 CVA 2, IV Dr, pl. 36, 13; *APS*, p. 73, no. (liii).
 (a) Draped woman with cista and wreath, (b) nude youth, bending forward over raised foot and holding stick and strigil.
148 Once Manduria, Arnò coll., later Rome Market, *Sale Cat.* no. 83 (ill.).
 APS Addenda, p. 431, no. (xxxix e).
 (a) Draped woman, (b) nude youth, with stick and strigil.
149 Bari, Cotecchia coll. 59.
 (a) Draped woman with phiale by altar, (b) nude youth with drapery over l. arm and stick in r. hand.
150 Mannheim Cg 10.
 CVA, pl. 42, 1–2; *APS*, p. 72, no. (xxxix), and *Addenda*, p. 431.
 (a) Woman with wreath and cista, (b) nude youth with stick.
151 Cambridge, Mus. Class. Arch 76.
 (a) Woman with dish and tambourine, (b) Eros with mirror.
152 Turin 4711.
 CVA 1, IV G, pl. 8, 1–2; *APS*, p. 75, no. (ii).
 (a) Woman with ball, (b) youth with stick.

Pelikai (continued)

153 Lecce 706.
 CVA 2, IV Dr, pl. 41, 2 and 7; *APS*, p. 72, no. (xxx).
 (a) Woman bouncing ball, (b) youth holding drapery.
154 Hamburg A 53.
 APS, p. 72, no. (xxxiv).
 (a) Woman with mirror and wreath, (b) youth running.

 (ii)

Skyphos

*155 Zagreb 41. PLATE 95, 1–2.
 Damevski, no. 71, pl. 32, 1–2.
 (a) Woman with ball, (b) nude youth with strigil.

Lebes gamikos

156 Turin 4706.
 CVA, IV G, pl. 8, 3–4.
 (a) Draped woman with phiale, (b) nude youth with strigil, drapery over l. arm.

 (iii)

Lebes gamikos

157 Meer, private coll. Sy. 8.
 (a) Draped woman with phiale running to l., (b) seated Eros with mirror.

Cup skyphos

158 Bologna 485.
 CVA 3, IV Er, pl. 6, 16 and 17; *APS*, p. 72, no. (xxvi).
 (a) Running woman, (b) running youth.

Skyphoi

*159 Zagreb 319. PLATE 95, 3–4.
 Damevski, no. 79, pl. 39, 1–2.
 (a) Woman with branch and phiale, (b) nude youth with stick.
*160 Basel Market, MuM. PLATE 95, 5–6.
 (a) Seated woman facing head of youth, (b) seated nude youth, clasping r. knee.
161 Limoges 79.74.
 CVA, pl. 28, 3 and pl. 31, 1; *APS Addenda*, p. 431, no. (li b).
 (a) Seated woman with thyrsus and bird, (b) nude satyr with tambourine.
*162 Bari (Modugno), Parmigiani coll. 3. PLATE 95, 7–8.
 (a) Woman with phiale running to l., (b) nude youth with strigil in r. hand and drapery over l. hand.
*163 Dresden ZV 855. PLATE 95, 9–10.
 (a) Draped woman with phiale and mirror, (b) nude youth with stick and wreath.
164 St. Gallen I.27.
 (a) Draped woman with dish and wreath, (b) silen with thyrsus and wine-skin.

 (iv)

 The following is connected with the above, but cruder in style.

Skyphos

165 Turin 4456.
 CVA, IV D, pl. 24, 1–2.
 (a) Draped woman with phiale and wreath, (b) nude youth, with drapery over l. arm.

(v)

The vases in this sub-division are characterised by the presence of a draped woman wearing a peplos, with a row of vertical fold-lines between the breasts and the girdle, and a black bead necklace. The quality of the drawing is very poor.

Squat lekythoi

166 London Market, Charles Ede.
 Cat. 98 (Oct. 1974), no. 4 (ill.).
 Seated woman with bird on lap.
167 Prague, Museum of Applied Arts 11501.
 APS, p. 73, no. (lix).
 Seated woman with mirror in r. hand.
167a Bari, Cavalcanti coll. 16.
 Woman moving to l.
168 B.M. F 117.
 Seated woman with phiale in r. hand.
169 Kiev 130.
 Standing woman with mirror in l. hand.
170 Bari 20175, from Gioia del Colle, T. 7.
 Scarfì, *MonAnt* 45, 1960, col. 283, fig. 116 c.
 Standing woman with mirror in l. hand (replica of no. 169).

Hydria

171 Once New York Market, Sotheby-Parke-Bernet, *Sale Cat.* 8 May 1976, no. 338 (ill.).
 Standing woman with mirror in r. hand.

With the above compare:

Squat lekythos

172 B.M. F 111.
 Nude youth with strigil in r. hand and drapery over l. arm, woman with cista seated by pillar inscribed [ΕΥ] ΤΥΧΙΑ.

An even cruder version of this type may be seen on:

Squat lekythos

173 Schwerin 755.
 CVA, pl. 55, 1–2.
 Draped woman moving to l.

9. THE WELLCOME AND TURIN GROUPS

Both the Wellcome and Turin Painters are fond of decorating skyphoi, normally with a single figure on each side.

(i) THE WELLCOME GROUP

(a) THE WELLCOME PAINTER

The Wellcome Painter is to be connected in style with the Choes Painter and with the vases in the Group of the Dresden Amphora. Note, in particular, the black stripe which runs down the side of the peploi worn by his standing women, sometimes with a slight kink at the knee when the leg is bent (e.g. no. 174; cf. with nos. 147, 149, 163). Again we may note the rows

of fold-lines running down from the breasts to the girdle (nos. 144, 166 ff.) and the extended arms; faces are neatly drawn.

Skyphoi

*174 London, Wellcome Museum R 394/1936. PLATE 96, 1.
 APS, p. 75, no. 3.
 (a) Woman balancing balls above stele on top of which is a cista, (b) youth.

175 Turin 4479.
 CVA, IV D, pl. 1, 5–6; *APS Addenda,* p. 432, no. 5.
 (a) Draped woman with thyrsus and phiale, (b) nude youth with thyrsus.

176 Bologna 508.
 CVA 3, IV Gr, pl. 3, 10–11; *APS,* p. 75, no. 4.
 (a) Draped woman, (b) nude youth with bird.

177 Moscow 475.
 APS Addenda, p. 432, no. 6.
 (a) Woman running to l., holding wreath, with bird perched on l. hand, (b) flying Eros holding fan.

178 Leningrad inv. 326 = St. 1185.
 APS Addenda, p. 432, no. 7.
 (a) Woman, bouncing ball, (b) nude youth with strigil beside altar.

179 Matera.
 APS Addenda, p. 432, no. (iii a).
 (a) Running woman with mirror and fillet, (b) Eros.

Pelike

180 Geneva 14981.
 APS, p. 75, no. 5.
 (a) Woman with wreath, (b) youth with strigil and stick.

(b) VASES RELATED IN STYLE

Skyphoi

181 London, Soane Museum 11 L (*Cat.* 528).
 APS, p. 75, no. 2, pl. 39, fig. 196.
 (a) Woman with tendril, (b) youth with stick.

*182 Sydney 49.11. (b) PLATE 96, 2.
 APS, p. 75, no. 1, pl. 39, fig. 195.
 (a) Woman with ball and situla, (b) nude youth with wreath and stick.

182a B.M. F 124.
 CVA 2, IV Ea, pl. 7, 5; *PhV*2, p. 57, no. 94; Richter, *Perspective,* fig. 189.
 (a) Phlyax at a door, from which a woman is looking out, (b) satyr holding a piece of drapery in both hands.
 The pattern-work is very like that on Sydney 49.11.

183 Frankfurt 1060.
 APS Addenda, p. 432, no. (vi a).
 (a) Woman bouncing ball and running to altar, (b) nude youth with strigil and palm-branch.

*184 Matera. (b) PLATE 96, 3.
 APS Addenda, p. 432, no. (iii b). Photos: R.I. 66.1301–2.
 (a) Draped woman with mirror, (b) nude youth with strigil.

185 Taranto 54419, from Valesio.
 (a) Woman with phiale, (b) nude youth with phiale and wreath.

186 Hamburg 1917.1089. (b) PLATE 96, 4.
 APS, p. 75, no. (iv).
 (a) Dancing woman with tambourine, (b) youth with three balls by altar.

(ii) THE TURIN PAINTER AND RELATED VASES

(a) THE TURIN PAINTER

The vases of this painter are close in style to those in the Wellcome Group (cf. with Sydney 49.11, no. 182). Characteristic is his rendering of the nude male figure, with horizontal lines for the pectoral muscles and a broad U for the pelvic girdle.

Skyphoi

187 Turin 4141.
 CVA 1, IV D, pl. 4, 3–4; *APS*, p. 76, no. 1.
 (a) Draped woman with fillet, (b) nude youth with stick.
188 Turin 4458.
 CVA 1, IV D, pl. 5, 3–4; *APS*, p. 76, no. 2.
 (a) Draped woman with fillet, (b) nude youth with stick.

Skyphos (Corinthian shape)

189 Turin 4477.
 CVA 1, IV D, pl. 5, 1–2; *APS*, p. 76, no. 3.
 (a) Draped woman with oenochoe, (b) nude youth with strigil.

(b) VASES RELATED IN STYLE

Skyphoi

190 Turin 4124.
 CVA 1, IV D, pl. 5, 5–6; *APS*, p. 76, no. (i).
 (a) Draped woman with phiale, (b) nude youth with oenochoe.
191 Turin 4559.
 CVA 1, IV D, pl. 6, 5–6.
 (a) Nude youth resting r. arm on pillar, (b) draped woman with tambourine.

Squat lekythos

192 Turin 4410.
 CVA 1, IV D, pl. 7, 3.
 Two draped women, l. with cista, r. with fillet.

Lebetes gamikoi

193 Turin 4491.
 CVA 1, IV D, pl. 21, 4–5; *APS*, p. 73, no. (xlviii).
 (a) Seated woman with phiale, (b) nude youth with wreath.
194 Turin 4492. Reverse in bad condition.
 CVA 1, IV D, pl. 21, 6.
 (a) Eros with wreath and bunch of grapes, woman with phiale and wreath, (b) seated woman offers phiale to nude youth.
195 Evora, Palace of Vila Vicosa.
 Rocha Pereira, *Gr. V. in Portugal*, pls. 48–49; *APS Addenda*, p. 432, no. (xlvii a).
 (a) Draped woman with wreath, (b) nude youth with strigil.
196 Buncrana, Swan coll. 686.
 (a) Eros flying towards seated woman, (b) nude youth with wreath and woman with mirror.

(c) COMPARABLE VASES

With the two skyphoi Turin 4124 and 4559 compare:

Skyphoi

197 Turin 4465.
 CVA 1, IV D, pl. 6, 1–2.
 (a) Nude youth, (b) draped woman.
198 Turin 4463.
 CVA 1, IV D, pl. 6, 3–4.
 (a) Eros moving to r., (b) draped woman, with a piece of drapery over each arm.

10. THE EGG AND WAVE GROUP

This group (see *APS*, p. 74, note 47) consists mainly of skyphoi, decorated with an egg pattern round the obverse rim and a wave pattern on the reverse. The style shows the influence of the Iliupersis Painter, but the drawing of the wreaths and the use of diamond-shaped florals are derived from the painters of the Hoppin workshop (cf. also with Reggio 6975, no. 9/97). The vases in (i) seem to be the work of a single artist, who may be called the Egg and Wave Painter.

(i) THE EGG AND WAVE PAINTER

Skyphoi

All have diamond-shaped florals, often with two parallel lines across them and a dot on one or both sides of these.

*199 Reggio Cal. 6980. PLATE 96, 5.
 APS, loc. cit., no. 2.
 (a) Woman with mirror and wreath, (b) nude satyr with phiale + ivy leaf and situla.
200 Reggio Cal. 6981.
 APS, loc. cit., no. 1.
 (a) Seated woman, (b) Eros.
201 Turin 5405.
 CVA, IV D, pl. 25, 3–4; *APS*, loc. cit., no. 4.
 (a) Woman with cista and wreath, (b) youth running to r.
202 Taranto 107317, from Manduria.
 (a) Woman with cista moving to r., and looking back l., (b) Eros with phiale and wreath.
203 Reggio Cal. 1326.
 (a) Woman with dove perched on l. hand and wreath in r., (b) nude youth with drapery over l. hand.

(ii) VASES RELATED IN STYLE

Skyphoi

(a)

The two following are of somewhat finer quality than the rest:

*204 Reggio Cal. 1160. PLATE 96, 6.
 APS, loc. cit., no. 3.
 (a) Woman with cista and wreath, (b) youth with phiale.
205 Athens 1491.
 (a) Woman with cista and thyrsus, (b) nude youth with bunch of grapes and thyrsus.
 Note the bell-shaped flowers with the palmette-scrolls.

(b)

206 Rome, Conservatori 24.
 CVA 2, IV D, pl. 37.
 (a) Draped woman with wreath and fillet, (b) youth with torch and phiale + ivy leaf.
207 Once Manduria, Arnò coll., *Sale Cat.* no. 74 (ill.).
 APS Addenda, p. 432, no. (vi c).
 (a) Eros with phiale and fillet seated on rock, (b) seated half-draped woman with fillet and tambourine.
208 Mississippi, University (ex Robinson coll.).
 CVA 3, IV Dr, pl. 23.
 (a) Running woman with phiale and wreath, (b) nude youth with phiale, and drapery round l. arm.
209 Philadelphia L. 29.44.
 (a) Draped woman, (b) young satyr with torch and situla moving to r.

(c)

210 Hildesheim 264 LO/CX.
 (a) Woman with phiale and situla moving to r. and looking l., (b) satyr with phiale and thyrsus by altar.
211 Berlin F 3226.
 APS, p. 75, no. (v).
 (a) Draped woman with fillet, (b) nude youth with wreath and phiale.
212 Copenhagen 497 (B–S. 252).
 CVA, pl. 241, 1; *APS,* p. 75, no. (vi).
 (a) Woman with phiale, (b) youth with strigil.
213 Berlin F 3221.
 (a) Draped woman with sash and box, (b) nude youth with strigil, drapery over l. arm.
214 Monopoli, Meo-Evoli coll. 497.
 (a) Woman with cista, (b) Eros with bird and egg.
215 Geneva I 530.
 APS Addenda, p. 432, no. (v a).
 (a) Draped woman with phiale and wreath, (b) nude youth with phiale and wreath.

Skyphos (of Corinthian shape)

216 Turin 4471.
 CVA IV D, pl. 19, 4–5; *APS,* loc. cit., no. 5.
 (a) Woman with wreath and cista, (b) youth with fillet and phiale.
 Cf. also with Altenburg 331.

Pelikai

217 Reggio Cal. 1150.
 APS, loc. cit., no. 6.
 (a) Woman with phiale, (b) youth with phiale.
218 Turin 4500.
 CVA, IV D, pl. 10, 1–2; *APS,* loc. cit., no. 7.
 (a) Eros with wreath, (b) woman with phiale and wreath.

11. THE PAINTER OF REGGIO 1157

A very minor painter associated with the Truro and Thyrsus Painters. Note the flat profiles of his faces, the tightly closed mouths, and the somewhat rectangular chins.

Pelikai

219 Reggio Cal. 1157.
 APS, p. 77, no. 1, pl. 40, fig. 199.
 (a) Woman with mirror at stele, (b) youth with phiale running to l.
220 Copenhagen 297 (B–S. 255).
 CVA, pl. 239, 2.
 (a) Seated woman, with mirror, (b) nude youth with strigil by stele.

With the above compare:

Squat lekythos

221 Leningrad inv. 461 = St. 1291.
 APS Addenda, p. 432, no. (i).
 Youth with ball, and woman with tambourine, running to l.

12. THE SCALA GROUP AND THE GROUP OF ALTENBURG 331

These two groups, consisting mainly of skyphoi of low quality, are related in style to the vases in the preceding sections.

(i) THE SCALA GROUP

Skyphoi (of Corinthian shape)

222 Milan, Scala, Alb. 337.
 APS, p. 71, no. (ix), pl. 37, fig. 185.
 (a) Woman with mirror running to r., (b) nude youth with grapes and palm-branch running to r.
223 Sèvres 222.
 CVA, pl. 32, figs. 5, 18 and 31; *APS*, p. 71, no. (x).
 (a) Woman running to r., (b) nude youth with cista running to r.
224 Milan, Scala, Alb. 338.
 APS, p. 73, no. (xlix), pl. 38, fig. 189.
 (a) Woman with mirror, (b) nude youth with grapes and strigil.
225 Milan, Scala, Alb. 339.
 APS, p. 73, no. (l), pl. 38, fig. 190.
 (a) Woman with mirror running to l., (b) nude youth with strigil and wreath running to l.

Pelike

226 Warsaw 138512.
 APS Addenda, p. 431, no. (lii a).
 (a) Youth holding palm-branch, running to r., (b) woman holding phiale and wreath, running to l.
 Comparable with Milan, Scala 337 (no. 222).

Cup skyphos

227 Once Manduria, Arnò coll., later Rome Market, *Sale Cat.* no. 80 (ill.).
 APS Addenda, p. 431, no. (xxvi a).
 (a) Nude youth moving to l., (b) woman.

(ii) THE GROUP OF ALTENBURG 331

Skyphoi (of Corinthian shape)

228 Altenburg 331.
 CVA, pl. 113, 1, 3, and 5.
 (a) Seated woman holding wreath and phiale, (b) nude youth holding phiale and wreath.

229 Turin 4466.
 CVA, IV D, pl. 20, 1–2.
 (a) Eros holding branch and phiale, (b) woman holding wreath and cista.
230 Turin 4470.
 CVA, IV D, pl. 26, 1–2.
 (a) and (b) Woman with phiale running to l.
231 New York 06.1021.213.
 (a) Draped woman with phiale and wreath, (b) nude youth.
232 Bari 7786.
 (a) Draped woman with mirror and wreath, (b) running woman with mirror.
233 Meer, private coll. La 71.
 (a) Draped woman with bunch of grapes and phiale, (b) Eros with wreath.
234 Milan, Scala.
 (a) Woman with bunch of grapes and phiale, (b) nude youth with wreath and strigil.

13. ASSOCIATED VASES

A selection of minor vases which belong to this general area but which, in many cases through lack of detailed information, cannot as yet be more precisely classified.

Pelikai

235 Philadelphia L. 64.25.
 APS, p. 72, no. (xxvii).
 (a) Woman, (b) youth.
236 Hamburg 1875.194.
 APS, p. 72, no. (xxviii).
 (a) Woman, (b) youth.
237 Lecce 693.
 CVA 2, IV Dr, pl. 38, 10; *APS*, p. 72, no. (xxxiii).
 (a) Woman with wreath, running to r., (b) nude youth with wreath, running to r.
238 Laon 37.1070.
 APS, p. 72, no. (xxix).
 (a) Woman with phiale and mirror, (b) woman with mirror and phiale.
*239 Boston 90.160. PLATE 96, 7.
 APS, p. 72, no. (xxxii), pl. 38, fig. 187.
 (a) Woman running to r., (b) youth running to r.
240 Lecce 696.
 CVA 2, IV Dr, pl. 36, 8; *APS*, p. 73, no. (liv).
 (a) Woman, (b) seated youth with phiale and thyrsus.
241 Taranto 61262.
 (a) Woman with wreath by altar, (b) nude youth with wreath, drapery over l. arm.
242 Once London Market, Sotheby, *Sale Cat.*, 29 June 1970, no. 143.
 (a) Woman with wreath, (b) nude youth with torch.
242a Bari 20741, from Conversano, T. 9.
 NSc 1964, p. 138, figs. 46–7.
 (a) Woman with tambourine, (b) youth with torch.
 Close in style to, and by the same hand as, no. 242.
243 Bari 1231.
 APS, p. 73, no. (lx).
 (a) Woman with phiale, (b) woman.

Pelikai (continued)

244 Leningrad inv. 5595.
 (a) Woman with mirror and phiale approaching altar and looking back to l., (b) Eros with mirror
 beside an altar.
245 Moscow 622.
 (a) Standing woman with mirror, (b) youth seated on altar, holding wreath.

Lebetes gamikoi

246 Madrid 11464.
 APS, p. 73, no. (lvii).
 (a) Woman with cista running to l., (b) youth running to l.
247 Reggio Cal. 6995.
 APS, p. 71, no. (vii).
 (a) Youth holding aryballos, (b) woman playing with ball.

Janiform Kantharos (satyr-head/female head)

248 Once Lucerne Market — Ars Antiqua, *Antike Kunst: Angebot* (Dec. 1964) 20, no. 84, pl. 13.
 APS Addenda, p. 431, no. (xii a).
 (a) and (b) Running youth.

Stand

249 Hamburg A 65.
 APS, p. 71, no. (xvi), pl. 37, fig. 186.
 (a) Running woman with wreath and tambourine, (b) running woman with dish of offerings.

Epichyseis

250 Taranto 8130, from Roccanova.
 Youth with wreath, seated woman with phiale, woman bouncing ball.
 Round the body: vine leaves.
251 Reggio Cal. 6990.
 Seated woman with mirror, Eros flying towards her with wreath.
252 Leningrad inv. 4556.
 Eros bending forward to pick up a piece of drapery, two nude women kneeling by wash-bowl.
 Cf. also the two epichyseis 497 and 498 (St. 1294) which look to be a little later and approaching
 the manner of the Darius Painter.

Skyphoi

253 Taranto.
 CVA 2, IV Dr, pl. 34, 3; *APS*, p. 71, no. (viii).
 (a) Nude youth with wreath and phiale, (b) draped woman.
254 Turin 4135.
 CVA 1, IV D, pl. 3, 1–2; *APS*, p. 71, no. (xi).
 (a) Nude youth with wreath and stick, (b) draped woman with mirror running to l.
255 Leningrad inv. 5597.
 (a) Woman with wreath and phiale running to l., (b) nude youth with wreath and phiale.
256 Ruvo 764.
 (a) Running woman with phiale and wreath, (b) nude youth with phiale.
257 Taranto 8100, from Montescaglioso.
 (a) Maenad with tambourine and thyrsus, (b) capering satyr with torch and situla.
258 Taranto 8148, from Roccanova.
 (a) Eros by altar, (b) seated woman with flower.

259 Erbach 43.
 (a) Draped woman with fillet, (b) draped woman with ball.

Kantharoid skyphos

260 Berlin F 3380.
 (a) Woman with wreath running to l., (b) nude youth with drapery over l. arm.

Hydriai

261 Matera 10367.
 Standing woman with sash and mirror, woman with phiale moving to r.; between them, a kalathos.
262 Godalming, Charterhouse.
 APS, p. 72, no. (xl).
 Woman running.
263 Naples.
 APS, p. 73, no. (lviii).
 Youth running to r.
264 Bari, Sette Labellarte coll. 34.
 Nude youth with stick in r. hand and drapery over l. arm.

Squat lekythoi

(a) WITH TWO FIGURES

265 Taranto 8131, from Roccanova.
 Nude youth with drapery over l. arm and bunch of grapes, draped woman with branch and phiale, moving to r.
266 Leningrad inv. 4234.
 Kneeling Eros watching female tumbler on turn-table.
267 Taranto 8096, from Montescaglioso.
 Nude youth with fillet, woman with alabastron.

(b) WITH A SINGLE FIGURE

268 Stockholm 54.
 Standing woman holding grapes and phiale.
269 Reggio Cal. 1154.
 Woman with wreath.
270 Berlin F 4130.
 Woman with bunch of grapes and cista.
271 Vienna 949.
 Woman with sash and unbound wreath by altar.
272 Moscow 468.
 Standing woman with ball and phiale.
273 Leningrad inv. 1695 = St. 1289.
 Seated woman with parasol, looking back to r.
274 Lecce 828.
 CVA 2, pl. 50, 9; *APS*, p. 71, no. (xiv).
 Woman running.
275 Turin 4408.
 CVA 1, IV D, pl. 22, 6; *APS*, p. 71, no. (vi).
 Youth with phiale and tambourine.
276 Chur K 51.
 Nude youth with wreath and dish, moving to l.

Squat lekythoi (continued)

277 Aberdeen 728.1.
 APS Addenda, p. 432, no. (iii c).
 Nude youth with stick and phiale moving r. towards altar.
278 Lecce 3573.
 CVA 2, IV Dr, pl. 49, 4.
 Draped youth with thyrsus beside pillar.
279 Bari, Lagioia coll.
 Eros with wreath and phiale.

Squat lekythos (with flat body)

280 Once Manduria, Arnò coll., later Rome Market, *Sale Cat.* no. 85.
 APS Addenda, p. 431, no. (vi a).
 Youth and seated woman (cf. with Lecce 724).

Oenochoai (shape 3) = *Choes*

(a) WITH TWO OR THREE FIGURES

281 Rome, private coll.
 Eros with bird, woman playing with cat, woman leaning on laver.
282 Bari 6352.
 Boy with situla, and woman with torch, moving to l.
*283 Los Angeles, Sydney Port. PLATE 96, 8.
 Ex Sotheby, *Sale Cat.* 29 June 1970, no. 144.
 Two nude youths running to l.
284 Trieste 1409.
 Woman with thyrsus followed by satyr with outstretched arms.
285 Deruta (Perugia), Magnini coll. 211.
 Dareggi, no. 14, pl. 12, 1.
 Seated nude athlete with strigil, nude athlete with wreath leaning l. arm on pillar.

(b) WITH A SINGLE FIGURE

286 Karlsruhe B 1882.
 CVA 2, pl. 70, 9; Van Hoorn, *Choes,* fig. 466; *APS,* p. 71, no. (xxiii).
 Woman running.
287 Hamburg A 55.
 APS, p. 72, no. (xxiv).
 Woman running to r.
288 Taranto 109828, from Taranto (Via Abruzzi, T. 5).
 APS, p. 72, no. (xxv).
 Woman with cista running to r.
289 Laon 37.1090.
 APS, p. 80, no. (xiv).
 Woman at stele.
290 Paris, Musée Rodin 894.
 CVA, pl. 37, 7; *APS,* p. 70, no. (iii).
 Nude youth grasping spear in r. hand, with drapery over l. arm.
291 Taranto 117504, from Taranto.
 Carter, *Sculpture of Taras,* pl. 72 d.
 Nude youth with sash.
 Very close to the Truro Painter.

292 Meer (Belgium), private coll.
 Nude youth with drapery over l. arm standing by altar.
293 Compiègne 1013.
 Van Hoorn, *Choes,* no. 469, fig. 401; *APS,* p. 72, no. (xlv).
 Youth juggling with three balls.
294 Geneva I 561.
 Van Hoorn, *Choes,* fig. 400; Beck, *Album,* pl. 55, no. 283.
 Youth running to l.
295 Brooklyn 03.283.
 APS, p. 72, no. (xliv).
 Seated youth.
296 Lecce 701.
 CVA 2, IV Dr, pl. 40, 5.
297 Taranto, Baisi coll. 81.
 Seated satyr with phiale and wreath.

Oenochoai (shape 8) = *Mugs*

298 Godalming, Charterhouse.
 APS, p. 72, no. (xli).
 Woman running.
299 Bari 20176, from Gioia del Colle, T. 7.
 MonAnt 45, 1960, 286, fig. 117; *APS Addenda,* p. 431, no. (xli a).
 Running youth.

THE SNUB-NOSE AND VARRESE PAINTERS
AND THEIR ASSOCIATES

The three chapters (12—14) which follow list a large number of vases, mainly bell- or column-kraters and pelikai, which may be grouped around two artists of considerable significance — the Snub-Nose Painter and the Varrese Painter. These vases are, in general, remarkably uniform in shape, subject-matter, style and treatment, and to some extent represent a further stage in the development of the "Plain" style around the middle of the fourth century B.C., and thus could be regarded as representing the second generation after the Tarporley Painter. The earlier vases reflect, in particular, the influence of the Dijon Painter and his school, as may be seen from the treatment of the draped youths on the reverses.

Between the work of the Snub-Nose Painter and the Varrese Painter there is a very close relationship; this is clearly manifest in their treatment of the youths on the reverses, but no less in the composition and in the posing of the figures on the obverses. The Varrese Painter decorated a substantial number of larger vases and over a hundred smaller ones — most of the other painters confine themselves to the latter, and comparisons are therefore best made between vases of this kind. If the two principal painters did not in fact work together, they must at least have had adjacent workshops, so close are the stylistic inter-connexions between their vases and between those of their associates and followers. As a result, it is not always easy to individualise the various painters.

From this period onwards the draped youths on the reverses fall into more definite stock types, which may be broadly classified as follows, and of which typical examples may be seen on Plate 97.

(i) Facing right:

A. (Plate 97, 1). Right hand with "sling" drape, usually pointing slightly upwards; wavy hem-line on overhang, straight line across the bottom, ending in a double curl, sometimes with a similar curl confronting it in the left corner (as often on the vases of the Varrese Painter).

A1. (Plate 97, 2). The sling is sometimes greatly extended to produce an almost "saucer"-like effect (cf. the Schulman Painter).

B. (Plate 97, 3). Similar to A, but with the right arm extended and holding a stick, leaving right shoulder bare.

(ii) Facing left:

C. (Plate 97, 5). Right arm bare and extended with stick (CX without = Plate 97, 7); left arm enveloped in drapery with "sleeve" effect; border ending in wavy line in bottom right corner. Sometimes there is a wavy line to mark the edge of the "sleeve"; across the top of the himation runs a diagonal black line, often with a slight hook at the top or bottom.

When there are three youths on the reverse, the one in the centre may sometimes assume either of two variants of this pose, in which the body is shown in a substantially frontal position, with the head turned either to the left (CL = Plate 97, 6) or to the right (CR = Plate 97, 4). The former pose is sometimes, though comparatively rarely, used for the youth on the right, when there are only two youths on the reverse.

D. (Plate 97, 8). The right arm is slightly extended but covered beneath the drapery

to produce a "collar"-like effect; "sleeve" drape as in C for the left arm.

E. (Plate 97, 9). Right arm projecting in front beneath the himation as in D, left slightly bent with radiating folds instead of "sleeve", resulting in an effect of flatness.

F. (Plate 97, 10). Right arm bare and extended, holding stick, otherwise as E (without stick = FX; Plate 97, 11; frontal body with head turned to left = FL, as on no. 12/62).

From now on the youths on the reverse will be designated simply by the appropriate letters, except in cases where they do not conform to the above classification or the specific types are not known.

Reference may perhaps here be made to an object which now begins to appear with increasing frequency on Apulian vases. It resembles a small ladder, sometimes with a single string of beads down the centre, and an excellent example may be seen on the dinos B.M F 303 (no. 12/151 below, Plate 107; cf. Ruvo 407, no. 12/90, Plate 103, 1). Wegner (*Das Musikleben der Griechen*, pp. 66 and 269) interpreted it as a "xylophone", in the light of its appearance on a later Apulian pelike in Copenhagen (316; *CVA* 6, pl. 261; Wegner, op. cit., pl. 24) in a context associated with music and the dance, and earlier writers like Heydemann and Albizzati had referred to it as an "Apulian sistrum" (see Macchioro-Parra *RivStAnt* n.s. 13, 1911, pp. 474–5). Its precise function has been the subject of much discussion (see Cook, *Zeus* ii, pp. 124 ff.; Goodenough, *Jewish Symbols in the Greco-Roman Period* viii, pp. 148 ff., especially p. 151, note 242; Schneider-Herrmann in *Festoen*, pp. 517–526, where some of the more significant representations are listed). That it served a musical purpose is now clear from the scene represented on a squat lekythos in the Ruhrlandmuseum in Essen (no. 15/44a), which shows a seated woman playing the instrument, while a veiled woman (cf. no. 7/53) dances to its accompaniment. Otherwise it is more usually found in scenes associated with the cult of the dead, and it not infrequently appears as if hanging on a wall. The late H.R.W. Smith (*FS*, pp. 130–2) suggested that it might be identified as the *platage* of Archytas, which must have been a musical instrument of some sort, since Aristotle (*Pol.* 1340 b 26 = Diels, *Fr. der Vorsokratiker*, p. 424, no. 10) refers to its use by children as a rattle. In the form in which we see the object on vases, it seems to be typically Apulian, since it is not found in Attic and occurs in other South Italian fabrics only during the Apulianizing phase – e.g. in Campania on vases by the CA and APZ Painters (e.g. *LCS*, pp. 454 ff., nos. 16–19 and pp. 502 ff., nos. 430, 479, 496–7, 501–2), and at Paestum on those of the Aphrodite Painter (e.g. the oenochoe Paestum 20295, on which it is held by Aphrodite at the Judgement of Paris – Greco, *Il P. di Afrodite*, pls. 10 and 13a; detail in *Festoen*, p. 518, fig. 1) or on the somewhat later Danae hydria (*ArchReps* 1972–73, p. 34, fig. 2), where it hangs upon the wall. It first appears on Apulian vases shortly before the middle of the fourth century B.C. and thereafter achieves a high degree of popularity, since it is represented on several hundred vases; later a similar instrument may be seen held in the hands of a group of terracotta figurines of women, from Kharayeb in Syria (Chehab, *Les terres cuites de Kharayeb*, pp. 38 f., pl. 42; *Festoen*, pp. 522–3, and fig. 8).

Signora Zancani-Montuoro has very kindly pointed out to us that a somewhat similar instrument was found during her excavations at Macchiabate near Francavilla Marittima in Grave T. 60 (to be published in *Atti M Grecia*, 1977), in a context which enables it to be dated to the first half of the eighth century B.C. It has volute finials and consists of tight spirals of bronze on wooden cores, arranged one above the other in fifteen rows; it closely resembles the psalteries held by two of the women in a relief on an ivory pyxis from Nimrud, now in the B.M. (inv. 118179; Barnett, *Nimrud Ivories*, pp. 78–79, 191, no. S 3, pls. 16–17; Rimmer, *Ancient Musical Instruments of Western Asia*, p. 40, pl. 7a), and probably of about the same date.

If, then, the object is to be identified as the *platage* of Archytas, it must have been a refinement of, or a variation on, an already-existing musical instrument. It is certainly significant that the so-called "xylophone" first appears on Apulian vases at precisely the period (c.360—50 B.C.) when Archytas was ruler of Tarentum and that it is depicted with such frequency upon vases after that date, which suggests that it must have been in common use. Archytas was also credited with the invention of a "toy bird which actually flew" (Aulus Gellius x, 12, 9—10, quoting Favorinus), a mechanical dove made of wood, which could make short flights. It would probably be pressing matters too far to suggest that the rather artificial-looking bird, with a string attached to it, which we see in actual flight or perched upon someone's hand on various vases (e.g. Ruvo 1535 = no. 15/25; Leningrad 544 = no. 12/67, Plate 102, 1; Naples 1934 = no. 14/52, Plate 119, 5) has any connexion with this invention, but it may be worth noting in passing that both "xylophone" and bird may be seen together on a Campanian hydria by the APZ Painter in the Villa Giulia (22593; *LCS,* p. 507, no. 497, pl. 199, 2; *Festoen,* p. 521, fig. 6).

Chapters 12 and 13 deal with the work of the Snub-Nose and Varrese Painters and their close associates; Chapter 14 with various groups of vases by different painters who seem to have been strongly influenced by these two artists. It is not easy to draw a hard and fast line between associates and followers in this area, but, in general, those painters who are more or less contemporary with the Snub-Nose and Varrese Painters and whose work is closest to theirs have been dealt with in Chapters 12 and 13, the others in 14. Most of the vases in the first two chapters must be dated in the second quarter of the fourth century or around 350 B.C,; many of those in Chapter 14 go well into the second half of the century and are contemporary with the work of the Darius Painter and his school. Once again it is difficult to draw precise boundaries but it seemed appropriate to deal at this point with the immediate followers of the Snub-Nose and Varrese Painters, whose work may be thought of as continuing the "Plain" style tradition. Those who follow the more monumental or "Ornate" tradition will be discussed in Chapter 17 at the beginning of Volume II, since their vases are closely connected in style with some of those by the Darius Painter; the later "Plain" style vases will be dealt with after the work of the Darius and Underworld Painters has been reviewed, since they strongly reflect the influence of both these artists.

The work of the Varrese Painter (and a few of his followers) includes some vases of larger dimensions (volute-kraters, amphorae, loutrophoroi, etc.) decorated with mythological, or dramatic scenes and with naiskoi or stelai, as well as many more others (bell-kraters, pelikai, etc.) decorated with the Dionysiac or genre scenes that are typical of the the followers of the "Plain" style tradition. Here, then, we find clear signs of the slow fusion of the two styles, although it would appear that the distinction between them continues to be valid for some time, as there are many painters whose work is confined to the one or the other. The "Plain" vases, however, include many decorative elements taken over from the "Ornate" and there is a good deal more added white and yellow, though as yet not other colours. The vases in the "Ornate" style by the Varrese and Chiesa Painters should be compared with those of the Lycurgus Painter and his school, and even more closely with those of the Gioia del Colle Group, which they often greatly resemble (especially for the naiskos and stele scenes).

CHAPTER 12

THE SNUB-NOSE PAINTER AND HIS CLOSE ASSOCIATES

1. The Snub-Nose Painter 2. The Group of Lecce 660
3. The Woburn Abbey Group 4. The Painter of Ruvo 407—8
5. The Laterza Painter 6. The "H.A." Group
7. Vases linking the "H.A.", Varrese and Dublin Situlae Painters

1. THE SNUB-NOSE PAINTER

Bibliography

Bianca Maria Scarfì, 'Due pittori apuli della seconda metà del IV secolo a.C.', in *Arch Class* 11, 1959, pp. 185—188.

Bianca Maria Scarfì, 'Nasi camusi, pittore dei', in *EAA* V, pp. 353—4.

Introduction

The Snub-Nose Painter was first identified by Dr. Bianca Maria Scarfì (loc. cit.), who attributed to his hand the column-kraters Bari 2206 and 20025, Bologna 581, the bell-krater Lecce 4811 (no. 18), an oenochoe in Lecce and the oenochoe Vatican Y 11 (no. 37). We have detached the three column kraters and the Lecce oenochoe as later work by other hands and have built up the work of the Snub-Nose Painter himself around Lecce 4811, which may be taken as very typical of his developed style.

His earlier work descends directly from that of the Dijon Painter; this is very clear from a comparaison of the two-figure compositions with running women (cf. nos. 2, 5—11 with nos. 6/102—3, 131, 133) and of the draped youths on the reverses, especially the one to left with the "sling" drape (type A; cf. nos. 1—17 with nos. 6/95, 131—2). Note, however, that on vases by the Snub-Nose Painter the bottom hem-line is treated somewhat differently, that "sleeve" drapes are rare, and that on the right youth's himation (type F), there is usually a small kink at the end of the upper border-line (e.g. nos. 1, 7, 13, 17, 28).

The drawing of women's breasts is very characteristic — both are clearly demarcated, one normally projecting slightly outwards, and separated by the fold-lines on the drapery which covers them (e.g. nos. 1, 3, 5, 7).

Further, more decorative adjuncts now appear and there is a far more extensive use of added white and yellow than on the work of the Dijon Painter. The meander frieze is almost always accompanied by dotted quartered-squares and this also suggests a later dating. The early work of the Snub-Nose Painter should probably be put in the fifties, but most of it must fall around and shortly after the middle of the fourth century.

(i) EARLY WORK

The vases in this division form a remarkably homogeneous group; the obverses have two-figure compositions with one male and one female, the reverses draped youths of types A and F, usually with a single pair of *halteres* above them (no. 3 is an exception, with a dotted phiale) and often with a simple palmette-scroll between them (e.g. nos. 5, 7, 10, 13). This device appears more frequently upon the later vases, with an increasing elaboration of the palmettes. On nos. 1—2 the meander frieze runs only below the pictures; otherwise it runs right round the vase, with fan-palmettes beneath the handles usually supported by two side-scrolls, between

which are smaller leaves or dots (e.g. nos. 5—10). The meanders are invariably accompanied by quartered squares with dots.

Women frequently carry a cista divided diagonally in front (e.g. nos. 3, 6, 7, 9) or a tambourine (nos. 2, 5, 8); the field above the picture on the obverse is filled with a variety of decorative adjuncts, including bucranes, fillets, wreaths, rosettes and windows.

Bell-kraters

1 Bologna 590.
 CVA 3, IV Dr, pl. 23, 1—2.
 (a) Satyr with situla and phiale, seated woman with wreath, (b) A + F.

2 Zagreb 15.
 Damevski, no. 32, pl. 8, 2.
 (a) Woman with filleted branch and tambourine moving to r. behind nude youth with situla, (b) A + F.

3 Vatican V 18 (inv. 18051).
 VIE, pl. 29 g and pl. 31 f.
 (a) Woman with torch and cista, youth with wreath and branch, running to l., (b) A + F (the head of the l. youth is repainted).

4 Deruta (Perugia), Magnini coll. 3.
 Dareggi, no. 16, pl. 13.
 (a) Seated woman with branch, nude youth with bunch of grapes and thyrsus, (b) A + F.

5 Bologna 599.
 CVA 3, IV Dr, pl. 23, 5—6.
 (a) Youth with thyrsus and beaded wreath followed by woman with thyrsus and tambourine, both moving to r., (b) A + F.

* 6 Milan, Soprintendenza (sequestro). PLATE 98, 1—2.
 (a) Woman with mirror and cista moving to l. followed by Eros with wreath and fillet, (b) A + F.

* 7 Milan, "H.A." coll. 428. PLATE 98, 3—4.
 (a) Woman with thyrsus and cista, nude youth with wreath and branch, both moving to r., (b) A + F.

8 Once Berlin Market, Gerda Bassenge, *Sale Cat.* no. 19, 20 May 1972, no. 2485, ill. on p. 322.
 Ex Schiller coll., Zahn, *Cat.*, pl. 32, no. 411.
 (a) Nude youth with branch and phiale moving to l., followed by draped woman with thyrsus and tambourine, (b) A + F.

9 Buncrana, Swan coll. 718.
 (a) Nude youth with mirror and phiale, draped woman with wreath and cista, moving to r.; bucrane above, (b) A + F.

10 Madrid 11083 (L. 352).
 (a) Nude youth with branch and phiale following draped woman with wreath and thyrsus, moving to r., (b) A + F.

11 Compiègne 1061.
 CVA, pl. 23, 10—11.
 (a) Youth with wreath and phiale, woman with torch and tambourine, moving to r., (b) A + F.

12 Leningrad inv. 549 = St. 1395.
 (a) Standing maenad with thyrsus and tambourine, seated Dionysos holding up phiale beneath two bunches of grapes; between them, a plant, (b) A + F.

13 Lecce 605.
 CVA 2, IV Dr, pl. 27, 2 and 6.
 (a) Eros with foot raised on rock, holding wreath and bunch of grapes, draped woman with oenochoe and branch, (b) A + F.

13a Rome, Villa Giulia 50740.

 Mingazzini, *Cat. Castellani* ii, no. 712, pl. 180, 4 and 6.

 (a) Youth with thyrsus collecting grape-juice in a phiale, woman with wreath and fillet, (b) A + F (printed in reverse in the *Catalogue*).

14 Amsterdam, Prof. van Regteren Altena.

 Klassieke Kunst uit particulier Bezit (Leiden, 1975), no. 575.

 (a) Seated woman with branch and dish of cake, nude youth with beaded wreath and drapery over l. arm, (b) A + F.

* 15 Bari 932. PLATE 98, 5–6.

 (a) Standing woman with thyrsus and dish of offerings, seated satyr with wreath and thyrsus, (b) A + C.

 The reverse is unusual in having the youth to r. as type C instead of the normal F; the obverse links it with Lecce 660 in the treatment of the woman's drapery with the black stripe running down the centre.

(i) DEVELOPED STYLE

The bell-kraters Lecce 609 and Trieste S 398 (nos. 16–17) provide an excellent link between the earlier and the more developed vases. Their reverses follow closely on from those in (i), except that there are sometimes three figures and type C becomes more popular (cf. nos. 16–17), especially for the youth in the centre, whose body is often shown frontally, with the head turned to right (no. 18) or to left (no. 19). They should be compared with those by the Varrese Painter on vases like Boston 92.2648 (no. 13/50), whom they very closely resemble. The side-scrolls of the handle-palmettes often have trefoils between them (nos. 16–19) and more decorative adjuncts appear in the background. Note the rocky pillar on which the woman on no. 18 rests her arm; this is to become a very common feature in later Apulian. On a few of the vases there are no longer any dividing lines between the women's breasts (e.g. nos. 24 and 26; cf. with nos. 29–31).

Bell-kraters

* 16 Lecce 609. (b) PLATES 99, 1 and 97, 1, 5.

 CVA 2, IV Dr, pl. 21, 5.

 (a) Satyr, maenad and Dionysos, all moving to r., (b) A + C + F.

17 Trieste S 398.

 CVA, IV D, pl. 5, 2 and 6.

 (a) Satyr with torch and situla, maenad with wreath and thyrsus, Dionysos with kantharos and thyrsus, all moving to r., (b) A + C + F.

* 18 Lecce 4811, from Rocavecchia. (b) PLATES 99, 2 and 97, 4, 10.

 Bernardini, *Scavi di R.* p. 20, figs. 19–20; Scarfì, op. cit., p. 186, no. 6, pl. 65.

 (a) Maenad leaning on rock-pillar, seated Dionysos with mirror and phiale, satyr with raised foot, holding torch and situla, (b) A + CR + F.

19 Lecce 662.

 CVA 2, IV Dr, pl. 19, 5 and pl. 20, 6.

 (a) Satyr with thyrsus and situla, Dionysos seated with thyrsus and phiale, maenad with raised foot, holding wreath and branch, (b) A + CL + E.

20 Milan, Soprintendenza (sequestro).

 (a) Woman with bunch of grapes and phiale moving l., followed by satyr, (b) A + F.

21 Reggio Cal. 1161.

 (a) Woman with bunch of grapes and phiale, running to l., followed by satyr with situla, (b) A + F.

22 Taranto 55574, from Conversano.

 (a) Standing woman with branch and cista, seated youth with bunch of grapes and phiale, (b) B + F.

Column-kraters

23 Louvre K 122.
 (a) Youth with thyrsus and wreath, woman with tambourine and thyrsus, (b) B + CX, holding up wreath.
24 B.M. F 300.
 (a) Youth with branch and phiale, woman with wreath and thyrsus, (b) A + F.
25 Reading RM 148.51.
 (a) Oscan warrior with spear and wreath, warrior with phiale and two spears seated on rock, woman with fillet and situla, (b) A + C + E.
26 Trieste S 401. Detail of (b) PLATE 97, 9.
 Gli Indigeni, fig. 34.
 (a) Two Oscan youths with torch and lyre respectively, following woman with torch and situla, (b) A + CR + E.

Pelikai

27 Louvre K 108.
 (a) Woman with mirror and cista resting l. elbow on pillar, nude youth with wreath, l. arm enveloped in drapery, (b) A + F.
28 Reggio Cal., from Metaponto.
 (a) Nude youth with branch and phiale, seated woman with fan, (b) A + F.

(iii) CLOSELY ASSOCIATED VASES

The following vases are very close in style to the work of the Snub-Nose Painter:

(a)

Note on the vases in this sub-division the characteristic drawing of the female breasts — they are widely spaced, with no fold-lines in between them (cf. nos. 24 and 26 above), but two or three above and below (as on no. 29) — and the use of double lines on the drapery.

Column-kraters

* 29 Vienna 663. PLATE 99, 3.
 (a) Satyr with thyrsus and bunch of grapes, maenad with phiale and thyrsus, Dionysos with thyrsus, all moving to l., (b) A + CR + E.
30 Seattle Cs 20.2.
 Galerie Fischer, *Sale Cat.* 20 Aug.–4 Sept. 1937, pl. 32, no. 837.
 (a) Satyr with branch and situla, Dionysos with phiale and thyrsus, maenad with basket and thyrsus, all moving to l., (b) A + F + C.

Bell-krater

* 31 Milan, Soprintendenza (sequestro). (b) PLATE 99, 4.
 (a) Nude youth with branch, phiale and spray, and drapery over l. arm, moving to l. followed by woman with torch and tambourine, (b) A + F.

(b)

Bell-kraters

32 Bari 7924, from Bitonto.
 (a) Woman with thyrsus and beaded wreath moving to l., followed by nude youth with thyrsus in r. hand and drapery over l. arm, (b) A + E.
33 Berlin F 3308.
 (a) Eros with situla and bunch of grapes, draped woman with tambourine and bunch of grapes, both moving to r., (b) A + C.
 Very close to no. 32.

(iv) MINOR VASES

The following smaller vases stand close to the Snub-Nose Painter and might well be minor works from his hand; those in (b) are of somewhat later date and show a more developed style.

(a)

Oenochoai (shape 3)

34 Bari 8645.
 Nude youth with thyrsus and phiale, woman with wreath and situla.
35 Zurich Market, Bank Leu.
 Satyr with situla and phiale, maenad with tambourine and thyrsus.
36 Once Zurich Market, Koller, *Cat.* 33, no. 4194.
 Seated nude youth with thyrsus and phiale, woman with wreath and thyrsus.

(b)

Oenochoai (shape 3)

37 Vatican Y 11 (inv. 18117).
 VIE, pl. 43 a; Scarfì, op. cit., p. 186, no. 4, pl. 62, 2.
 Satyr with thyrsus and situla following woman with mirror and wreath.
38 Trieste S 439.
 CVA, IV D, pl. 22, 1–2.
 Maenad with thyrsus and situla following woman with mirror and wreath.
39 Berlin F 3314.
 Satyr running to l., with palm branch and wine-skin.

Askos

40 Taranto, Ragusa coll. 61.
 Seated woman with tambourine, young satyr with bunch of grapes.

(v) COMPARABLE VASES

The two following vases should be compared with those by the Snub-Nose Painter:

Bell-kraters

41 Lecce 771.
 CVA 2, IV Dr, pl. 23, 1 and pl. 25, 2.
 (a) Youth with branch and tambourine following woman with mirror and thyrsus to r., (b) A + F.
* 42 Vienna 919. PLATE 99, 5–6.
 (a) Maenad with thyrsus and tambourine moving to l., followed by nude youth with wreath in l. hand and drapery over his arms and behind his back, (b) A + F.

2. THE GROUP OF LECCE 660

The vases in this group are very closely connected with those by the Snub-Nose Painter (cf. the treatment of the seated or standing women on the obverses, especially with Bari 932 = no. 15, and of the draped youths on the reverses). The following characteristics should be noted:

(a) a thick black stripe is often used to separate the breasts of women (e.g. nos. 43–44, 46, 48); it may also appear in a thinner form, as on nos. 47, 49, 51)

(b) women are often represented seated upon a pile of white rocks, with one leg slightly drawn back, and holding some object (generally a phiale, as on nos. 43, 44, 49) in their hands; the peplos is gathered in at the waist by a narrow black ribbon-girdle, and on standing figures a black stripe sometimes runs down the lower part of the garment over the leg (nos. 46, 47), which is often very clearly shown beneath the drapery.

Hair is worn in a chignon at the back with a reserved outline; there is a beaded or radiate stephane above the brow

(c) on the himatia of the draped youths on the reverses, which on nos. 43—45 are particularly close to those by the Snub-Nose Painter, we should note the regular presence of a wavy black line running diagonally across the top of the himation of the youth to r. (e.g. nos. 44—5, 47—50), and of a *detached* zig-zag in the bottom corners, often of both himatia (nos. 44—5, 47—50, 52)

(d) on bell-kraters there is a double scroll beside the palmette-fan below the handles; crossed squares are rarely found with the meanders, which are fairly large, unconnected and, in general, do not meet in the middle.

<div align="center">(i) THE PAINTER OF LECCE 660</div>

<div align="center">(a) EARLY WORK, CLOSELY LINKED TO THAT OF THE SNUB-NOSE PAINTER</div>

The following vases form a compact sub-group and clearly illustrate the close connexion between their painter and the Snub-Nose Painter. Note the large flower held by the youth on no. 44, a good example of the influence of contemporary "Ornate", where such flowers play a regular part in the subsidiary decoration (see Chapter 15); from now on they will appear with increasing frequency upon "Plain" style vases.

Bell-krater

* 43 Louvre K 129. PLATE 100, 1—2.
 (a) Seated woman with phiale, Eros with fan and wreath, (b) A + D.

Pelikai

* 44 Matera 10208. (b) PLATE 100, 3.
 (a) Seated woman with phiale, nude youth with flower and stick, drapery over l. arm, (b) A + C.
 45 San Francisco, Mr. G.W. Winemiller.
 (a) Nude youth with phiale standing in front of seated woman with mirror, (b) A + F.

With the above compare, especially for the treatment of the draped woman, the following:

Amphora

 46 Bari, De Blasi coll. 19.
 (a) Standing woman with wreath and cista, seated nude youth with phiale and stick, (b) B + D.

<div align="center">(b) DEVELOPED STYLE</div>

In the painter's more developed phase we may note that he moves from a type A youth to left on the reverses (as favoured by the Snub-Nose Painter) to type B; otherwise the youths closely resemble those on nos. 43—45 above. Of particular interest is the way in which the fold-lines beneath the arm of the youth to left on no. 48 begin with a small dot; this seems to reflect the influence of the Varrese Painter, where such a practice is common. Note also on the same vase between the two youths the appearance of a stele surmounted by an ivy-leaf: this becomes more widely used on reverses by the followers of the Snub-Nose and Varrese Painters.

On nos. 54 and 55 appear naiskoi of simple form, with Doric (instead of the more usual Ionic) columns but without a pediment; in each is a seated youth in added white, holding a phiale, with a fillet hanging immediately in front of him. It is interesting to note the use of an "Ornate" motif on what is essentially a "Plain" style vase; the decoration on the neck of no. 55 is another example of this, and illustrates the merging of the two styles at this period.

Bell-kraters

* 47 Lecce 660. PLATE 100, 5—6.
 CVA 2, IV Dr, pl. 26, 3 and 6.
 (a) Woman with filleted wreath and tambourine, seated Eros with phiale, (b) B + F.

* 48 Frankfurt Market, De Robertis (ex Zurich, Bank Leu). (b) PLATE 100, 4.
 De Robertis, *Lagerliste* II, no. 53.
 (a) Woman with cista and tambourine following satyr with torch and situla, (b) B + F, at altar,
above which is an ivy-leaf.

49 B.M. F 292.
 (a) Eros with wreath and mirror, woman seated on rock-pile, with phiale and wreath, (b) B + F.

50 Matera 12544.
 (a) Woman with mirror and cista, nude youth with situla and phiale, (b) B + F, at an altar, above
which is an ivy leaf.

51 Bari, Preverin coll. 1.
 (a) Seated Dionysos with thyrsus and phiale, woman coming up with dish of cake and branch,
(b) B + F (mostly missing).

Column-kraters

52 Palermo n.i. 2225.
 (a) Seated woman with phiale, Oscan warrior with pilos in r. hand, two spears and shield, (b) B + F.

52a Okayama (Japan), RO coll. 11.
 Mizuta IV, no. 26, pls. 5—6.
 (a) Woman resting l. arm on pillar, with cista and fillet in r. hand, situla in l., and seated satyr with
phiale and torch, (b) B + E.

53 Vienna 708.
 Gli Indigeni, fig. 18.
 (a) Woman pouring libation into phiale held by seated Oscan warrior, to r. Oscan warrior with situla
and two spears bending forward over raised foot, (b) B + A1 + C.

Amphora

* 54 Naples 2029 (inv. 82390). PLATE 101, 1—2.
 (a) Nude youth with phiale seated on drapery in a naiskos, (b) A + D.

Loutrophoros

55 Naples 2887 (inv. 82391).
 (a) Nude youth with strigil and phiale seated in naiskos, (b) B + F.
 The obverse makes a pair with no. 54; the youths on the reverse are not well preserved, but look to
to be fairly close to those on no. 52.

Hydria

56 Matera 10206.
 Woman with phiale, and nude youth with wreath and branch, at stele.

(ii) CLOSELY CONNECTED VASES

The vases in this division form a closely related group which, if not by the Painter of Lecce
660 himself, are very near to his work. On the overhang of the himation on the youth to left
there is a long, thick, wavy black border. There is no dividing line between the women's breasts,
which are left free of fold-lines. Note the flowers on nos. 57 and 61, and the uncrossed dotted
squares on no. 61 (cf. no. 53).

Column-kraters

57 Bologna 574.
 CVA 3, IV Dr, pl. 18, 1—2.
 (a) Seated Oscan warrior with spears and phiale, standing woman with wreath and cista, (b) B + F.

Column-kraters (continued)

58 B.M. 1965.1—21.4.
 (a) Oscan warrior with shield and spear, seated warrior with phiale and spear, standing woman,
 (b) B + F + E.
* 59 Stockholm, Medelhavsmuseet 1960.1. PLATE 101, 3—4.
 (a) Oscan youth with oenochoe and phiale, woman running to l. with wreath and branch, (b) B,
 with strigil, + F.
 60 Milan, "H.A." coll. 218.
 (a) Woman with oenochoe and phiale, Oscan warrior with r. foot raised on rock-pile, holding spear
 and shield, (b) A + F.
* 61 Ruvo 529. PLATES 101, 5—6 and 97, 6.
 (a) Woman with wreath and dish of cake, seated between Oscan warrior with spear and phiale and
 Oscan warrior with two spears, (b) A + CL + E.
 62 Bassano del Grappa, Chini coll. 72.
 (a) Oscan warrior with shield holding out kantharos to draped woman with phiale, leaning l. arm
 on pillar; to l. horse beside a tree, (b) A + FL + F.
 63 Lecce 783.
 CVA 2, pl. 29, 1—2.
 (a) Youth with two spears between two women, (b) A + F + CX, with wreath.
 64 Manchester IV C 1a. Very badly preserved.
 (a) Oscan youth with situla, woman with torch and basket, Oscan youth with wreath, (b) A + CX,
 with wreath + CX, with strigil.

(iii) COMPARABLE VASES

 The following vase looks to be connected in style with the other vases in the Group of
Lecce 660 — cf. the seated woman with the one on no. 49 and the double curl in the bottom
corner of the himation on the youth to right on the reverse with that on nos. 61—2; also the
head of the youth to left with the corresponding one on no. 47.

Bell-krater

 65 Turin, private coll.
 (a) Nude youth with mirror and seated woman with phiale and wreath, (b) B + C.

 The following badly-battered vase should probably also find a place in this context — com-
pare the wavy lines in the bottom corners of the youths' himatia with those on nos. 61—62,
and also on no. 65 above:

Amphora

 66 Mannheim Cg 315. Badly preserved.
 CVA, pl. 41, 3 and 5—6.
 (a) Youth with lyre in naiskos, (b) A + E (?).

3. THE WOBURN ABBEY GROUP

The vases in this group, which takes its name from the very typical bell-krater in Woburn Abbey
(no. 68), are also still close in style and treatment to the work of the Snub-Nose Painter, but
have certain clearly-defined characteristics of their own, which serve to distinguish them. Per-
haps the most obvious of these is the regular use of a saltire square (more accurately a rectangle)
with small dots between the intersections (e.g. on nos. 67—71), but we may also note the
following:

(a) the frequent appearance of a standing draped woman, with the r. leg slightly flexed, wearing a peplos with a fine stripe running down the side over the bent leg; there is usually *no* dividing line between the breasts, and the area between them is normally left free of fold-lines (e.g. nos. 67—70)

(b) on the reverses the draped youth to l. (normally type B), has a pronounced wavy border on the overhang of his himation (e.g. no. 68); the r. youth (normally type C) has a line across the top of his cloak, *not* wavy as with the Group of Lecce 660, but sometimes with a kink at the lower end (as on nos. 68, 70, 72); in the bottom corners of both himatia the hem-line ends in a double curl. Below the outstretched r. arm of the l. youth, the himation tends to bunch up into two clearly marked folds, with an indented area between their ends (as on nos. 68, 71, 72); a similar phenomenon may be observed also on some of the youths to r. (e.g. on no. 68). When both youths hold sticks the hand of the youth to l. may be slightly below that of the other (e.g. nos. 68—69).

(i) FORERUNNER

The following vase, with the characteristic dotted saltire and drawing of the women's breasts, looks to be a very early work of the Woburn Abbey Painter:

Bell-krater

* 67 Leningrad inv. 544 = St. 1324. PLATE 102, 1.
 CRStP 1877, ill. on p. 263 = *RV* ii, 61, 4.
 (a) Woman with bunch of grapes in r. hand and bird on string in l., nude youth with mirror and beaded wreath beside an altar, (b) A + F.

(ii) THE WOBURN ABBEY PAINTER

Bell-kraters

* 68 Woburn Abbey. (b) PLATE 102, 2.
 AJA 60, 1955, p. 350.
 (a) Standing draped woman with thyrsus and dish of offerings, seated nude youth with wreath and thyrsus, (b) B + C.

69 Zagreb 2.
 Damevski, no. 25, pl. 10, 4.
 (a) Nude youth with thyrsus and phiale, woman with wreath seated on rock-pile, (b) B + C.

70 Freiburg Market, Puhze.
 (a) Seated woman with phiale and nude youth with wreath and thyrsus, (b) B + C.

71 Frankfurt Market, De Robertis.
 (a) Draped woman with thyrsus and phiale + spray, seated nude youth with wreath and branch, (b) B + D.

Column-krater

72 Bologna 575.
 CVA 3, IV Dr, pl. 19, 1—2.
 (a) Woman with wreath and dish of offerings, seated Oscan warrior with kantharos and spear, (b) B + C.

Amphorae

73 Bologna 529.
 CVA 3, IV Dr, pl. 3, 1—2.
 (a) Woman with phiale and nude youth with open wreath and drapery enveloping l. arm, (b) B + C.

74 Frankfurt Market, De Robertis.
 Lagerliste II, no. 51 (ill.).
 (a) Youth with fillet and woman with wreath by naiskos in which is a plant, (b) B + C.

Amphorae (continued)

* 75 Naples 1996 (inv. 82148). PLATE 102, 3—4.
 (a) Nude youth with branch and wreath, woman with "xylophone" and phiale at stele, (b) B + C.
 76 Bologna 527.
 CVA 3, IV Dr, pl. 1, 3—4.
 (a) Nude youth, with wreath and drapery enveloping l. arm, woman with fillet and phiale at stele,
 (b) A + C.

Pelikai

 77 Portland 26107.
 (a) Nude youth with phiale standing in front of seated woman with branch, (b) B + C.
 78 Turin 4511.
 CVA, IV D, pl. 9, 3—4.
 (a) Youth with phiale, and draped woman with wreath, resting l. arm on pillar, (b) B + C.

Hydriai

 79 Como C 59.
 CVA, IV D, pl. 5, 2.
 Eros with foot raised on hollow rock, bending forward with phiale and bead wreath towards stand-
 ing draped woman with mirror in r. hand.
 79a Barcelona.
 Nude youth with strigil and cista, seated woman with wreath.
 The seated woman is very similar to those on nos. 70 and 77.

(iii) VASES RELATED IN STYLE

Amphorae

(a)

 80 Trieste S 392.
 CVA, IV D, pl. 16, 1—2.
 (a) Nude youth with alabastron and woman with fillet and cista at a stele, (b) B + C.
 81 Once London Market, Sotheby's, *Sale Cat.* 18 May 1970, no. 132, later Harrod's.
 (a) Woman with mirror and youth with rosette-chain and stick at stele, (b) B + C.

(b)

 82 Once Agrigento, Giudice coll. 577.
 (a) Woman with bunch of grapes and phiale, seated nude youth with phiale, (b) two draped youths.
 83 Lecce 830.
 CVA 2, IV Dr, pl. 43, 2 and 5.
 (a) Woman with wreath and phiale, youth with rosette-chain at stele, (b) B + F.

Column-kraters

 84 Naples, Ruggiero coll.
 (a) Oscan warrior with two spears and shield, seated woman with open cista and branch, (b) B + F.
 85 Santa Barbara, Avery Brundage coll. 3/253.
 Greek Art in private colls. of S. California, no. 63 (ill.).
 (a) Dionysos with thyrsus and phiale, seated maenad with thyrsus, (b) B + D.
 85a Once London Market, Sotheby's, *Sale Cat.* 7 Dec. 1976, no. 274, pl. 29, 3.
 (a) Oscan warrior with two spears and phiale, seated woman with wreath and fan, (b) two draped
 youths.
 The obverse is very close to that of no. 85.

Bell-kraters

86 Leningrad inv. 1200 = St. 1400. In poor condition.
 (a) Satyr with thyrsus, woman with phiale seated on hollow rock, (b) B + E.
87 Bologna 594.
 CVA 3, IV Dr, pl. 25, 5—6.
 (a) Draped woman with thyrsus and cista, seated satyr with torch and thyrsus, (b) B + F, with
 palmette between them.

(iv) THE PAINTER OF BARI 6407.

The two following vases, which are by a single painter, look to be connected with nos.
84—85a above. On the himation of the youth to right, who has a particularly lugubrious appear-
ance, there is a decided kink in the centre of the fold-line running across the top.

Column-krater

88 Bari 6407.
 (a) Nude youth with thyrsus and dish of cake, satyr with fillet and situla moving to l., (b) B + F.

Amphora

* 89 Nocera, Fienga coll. 558 (De F. 681). PLATE 102, 5—6.
 (a) Seated woman with mirror and cista, nude youth with raised foot, holding wreath and branch,
 (b) B + F.

4. THE PAINTER OF RUVO 407—8

The Painter of Ruvo 407—8 is very close to the Woburn Abbey Painter and uses similar dotted
saltires in the rectangles accompanying the meanders; the latter do not meet at the centre,
where the terminal lines often run parallel to each other (as on nos. 90—93, 96—97).

His draped youths are tall, with extremely short legs in comparison to the long thighs (e.g.
nos. 90—93); the youth to left is normally of type B, with a long overhang.

Ruvo 407 and 408 make a closely matched pair. The treatment of the naiskos on these and
on nos. 92—93 is of interest; it rests upon a base of which the central element is slightly inset
and decorated with an ornamental pattern in added white. The pediments are black, as are also
those of the two stelai on the reverses of Ruvo 407—8; the latter stand on a rectangular plinth
and at the bottom of the shaft is a decorative motif in black.

An unusual feature of the decoration on the amphorae is the presence immediately above
the tongue-pattern on the neck of a decorative band of zig-zags, egg-pattern, saltires, etc. on
both sides of nos. 90—93.

The vases in (b), while seemingly the work of the same painter (cf. the dotted saltires, the
treatment of the draped youths, the black pediment of the stele on no. 96), are rather less
careful in execution. On all of them there is a double-dotted diptych above the draped youths
(cf. no. 93); the two amphorae (nos. 96—97) have b.f. scroll work on the neck between the
handle-joins.

A later development from the work of this painter may be seen in such vases as Verona 166.

(a)

Amphorae

* 90 Ruvo 407. PLATE 103, 1—2.
 (a) Youth with "xylophone" and standing draped woman with mirror and wreath at naiskos, in
 which is a youth with phiale and spear seated on a hollow rock (with black centre), (b) B + D, at a
 stele tied with a black fillet.

Amphorae (continued)

* 91 Ruvo 408. PLATE 103, 3—4.
 (a) Draped woman with tambourine and alabastron, and nude youth with phiale and white fillet at
naiskos in which is a nude youth with crossed legs, holding a sheathed short sword in his l. hand and
a stick in his r., which is enveloped in drapery, (b) B, holding phiale, + D, at a stele tied with a black
fillet.
 92 Milan, "H.A." coll. 276. The obverse much repainted.
 (a) Woman with branch and filleted wreath, and nude youth with phiale, at naiskos in which is seated
nude youth with phiale and stick, (b) B + E, at a stele tied with a black fillet.
 93 Milan, "H.A." coll. 314. The reverse somewhat repainted.
 (a) Draped woman with beaded wreath and stick, and nude youth holding mirror in r. hand and
bunch of grapes in l., with drapery over r. arm, at a naiskos in which is a flowering plant, (b) B + F,
with diptych above.
 94 Leningrad inv. 975 = St. 1079.
 (a) Nude youth with stick, drapery behind back, and woman with wreath and cista at stele tied with
white fillet, (b) B + C.
* 95 Bari 6377. PLATE 103, 5—6.
 (a) Youth with wreath and woman with phiale and wreath at tomb monument (Doric column on
base), (b) B + C, with an altar between them and a sash above.

(b)

Amphorae

 96 Nimes 891.25.43.
 (a) Seated woman with wreath and cista, and nude youth with mirror and bunch of grapes, leaning
on stick, beside a stele tied with black and white fillets, (b) B + D, with an altar between them.
 97 Adolphseck 184.
 CVA, pl. 83, 4—6.
 (a) Woman with cista and fan at stele with nude youth holding mirror, (b) B + C.

Bell-kraters

 98 Agrigento C 949.
 (a) Satyr with raised foot holding kantharos and situla, seated woman with two phialai and fan,
(b) B + D.
 99 Ampurias, Museo Monográfico (ex A. Salvador).
 Hispania Graeca ii, p. 168, pl. 110, no. 135.
 (a) Youth with cista and woman with thyrsus and tambourine, (b) B + E.

5. THE LATERZA PAINTER

The Laterza Painter, who takes his name from the find-spot of two very typical vases, Taranto
22555—6 (nos. 113 and 118), is close in style to the Woburn Abbey Painter, as may be seen
from a comparison of their female figures and draped youths, but his heads and faces have a
more rounded look.

Women wear a peplos with a high girdle; the breasts are clearly shown, one often projecting
(e.g. nos. 102—107). The women are generally either moving to right or seated upon a rock-
pile, which tends to emphasise the somewhat disproportionate length of thigh and leg (e.g.
nos. 102, 104).

The draped youths are modelled upon those of the Woburn Abbey Painter, with a similar
extended wavy border to the overhang of the cloak on the left youth, a double curl in the

lower corners, and an indent to the folds below the outstretched arm. The youths are slightly heavier in appearance, and their hair is often curly.

Note the presence on the reverses (e.g. nos. 102, 104) of a narrow stele with a row of dots across the top between horizontal black lines. On some vases (e.g. nos. 102–3, 118, 120–22) the quartered squares have strokes in them in place of dots (cf. no. 57 above); on others, hollow squares or circles (nos. 106, 113). The field is well filled with adjuncts such as wreaths, phialai, balls, rosettes, diptychs, or fillets, and branches of berried laurel often appear between the figures on the obverses (e.g. nos. 100, 106–7). On the reverses there is often a diptych (with two vertical bands) above the youths; also disks, with six or seven triangular divisions (as on nos. 101, 106–7, 113).

On bell-kraters the standard decoration below the handles is a large fan-palmette flanked by two scrolls with small leaves between them.

Noteworthy is the group of six vases by this painter from Tomb 229 at Salapia (see Tinè, *ArchStorPugl* 29, 1973, p. 156, fig. 17).

Bell-kraters

100 Parma C 102.
 CVA 2, IV Dr, pl. 5.
 (a) Woman with wreath and phiale following nude youth with bunch of grapes and thyrsus moving to r., (b) B + F.

101 Zagreb 16.
 Damevski, no. 33, pl. 10, 3.
 (a) Nude youth with thyrsus and phiale moving l. followed by woman with dotted wreath and thyrsus, (b) B + C.

102 Once London Market, Sotheby, *Sale Cat.* 9 July 1974, no. 100 (ill.).
 (a) Nude youth with branch and phiale, drapery over l. arm, seated woman with thyrsus, (b) B + C.

103 Once London Market, Sotheby, *Sale Cat.* 23 Feb. 1976, no. 330, ill. on pl. 13.
 (a) Woman with tambourine running to l., followed by nude youth with wreath and thyrsus, (b) two draped youths.

104 Foggia 131701, from Salapia, T. 188.
 (a) Seated woman with patera and tambourine, nude youth with phiale, wreath and thyrsus, l. arm enveloped in drapery, (b) A + C.

105 Foggia 131665, from Salapia, T. 188.
 (a) Dionysos with thyrsus and wreath, woman with cista and thyrsus, (b) B + F.

*106 Foggia 132047, from Salapia, T. 229. PLATE 104, 1–2.
 (a) Satyr with thyrsus and situla, woman with wreath and cista, moving to l., (b) B + C.

*107 Foggia 132057, from Salapia, T. 229. PLATE 104, 3–4.
 (a) Woman with branch and phiale, youth with wreath and thyrsus moving to r., (b) B + C.

108 Foggia 132058, from Salapia, T.229.
 (a) Seated woman with phiale, Eros with wreath and fillet, (b) B + C.

109 Foggia 132059, from Salapia, T. 229.
 (a) Youth with thyrsus and phiale, woman running to r. with wreath and thyrsus, (b) B + CX.

110 Foggia 132060, from Salapia, T. 229.
 (a) Satyr with filleted branch and phiale, woman with rosette-chain and thyrsus moving to l., (b) two draped youths.

111 Foggia 132061, from Salapia, T. 229.
 (a) Seated Eros with fillet, standing woman with branch and fan, (b) B + F.

112 Marseilles 2950.
 (a) Woman with wreath and cista moving to l., followed by satyr with situla and thyrsus, (b) B + CX, holding up a wreath.

Bell-kraters (continued)

*113 Taranto 22555, from Laterza. PLATE 104, 5–6.
 (a) Nude youth seated with thyrsus and phiale, standing woman with wreath and branch, (b) B + C.
 114 Milan, "H.A." coll.
 (a) Woman with cista and bead wreath, moving to l., followed by nude youth with phiale and branch, drapery over l. arm, (b) B + C.
 115 Naples 2087 (inv. 81418).
 (a) Seated Dionysos with thyrsus and phiale, woman with tambourine and thyrsus, (b) B + C.
 116 Naples 980 (inv. 81939).
 (a) Nude youth with wreath and phiale, seated woman with wreath, (b) B + C.
 117 Gravina, from Botromagno T. 32.
 Lattanzi, *Atti XII° CStMG* 1972, pl. 40, 1.
 (a) Satyr with branch and mirror, woman with wreath and fan moving to l., (b) B + F.

Pelike

*118 Taranto 22556, from Laterza. PLATES 105, 1–2 and 97, 7.
 (a) Nude youth with strigil and wreath, seated woman with fan, (b) B + CX.

Amphorae

 119 Taranto 61433, from Ruvo.
 (a) Woman with bunch of grapes and patera, nude youth with rosette-chain at naiskos in which is a nude youth with a stick and with drapery over l. arm, (b) B + F.
 120 Lund KM 27.502.
 (a) Woman with bunch of grapes and fillet, seated youth with branch at naiskos in which is a three-flower plant, (b) B + C.
 The reverse is very close to those of nos. 75–6 by the Woburn Abbey Painter.

Column-kraters

 121 Madrid 32682 (P. 221).
 (a) Two Oscan warriors and seated woman with dish and branch, (b) A + C + C.
*122 Boston 76.66. PLATE 105, 3–4.
 (a) Nude youth with thyrsus and phiale, draped woman with wreath and thyrsus moving to r., (b) B + F.

Hydria

 123 Gravina, from Botromagno T. 32.
 Lattanzi, loc. cit.
 Woman with cista and wreath, nude youth with flower, moving to l.

 With the above compare the following:

Bell-krater

 124 Once London Market, Sotheby's, *Sale Cat.* 9 July 1974, no. 99 (ill).
 (a) Satyr with thyrsus and dish of cake, maenad with wreath and thyrsus, (b) B + C.

6. THE "H.A." GROUP

The vases in this group provide a close connecting link between the Snub-Nose and the Varrese Painters. It is not altogether easy to decide whether they should be discussed here or in the following chapter, but since the "H.A." Painter obviously derives his style from that of the Snub-Nose Painter (especially nos. 16–18), it is not inappropriate to place him here.

(i) THE "H.A." PAINTER

The "H.A." Painter takes his name from the two amphorae in the "H.A." collection in Milan (364 and 446; nos. 125–6 below), which form a matching pair, each depicting on the obverse pieces of armour in a naiskos and on the reverse two remarkably similar draped youths with a dotted wreath above. The latter clearly owe much to those on the later vases of the Snub-Nose Painter (e.g. nos. 16–18), but it will be noted that the left youth is now more regularly type B instead of A and that the youths facing left (normally type C) have a pronounced kink at the end of the black line which runs diagonally down the top of their himatia (e.g. nos. 125–8, 133; cf. with nos. 13, 16–17, 28 by the Snub-Nose Painter). The bottom hem-line is usually straight with a curl in the corner; sometimes this is matched by another wavy line (e.g. on nos. 127, 130), which reproduces the pattern regularly used by the Varrese Painter.

The standing draped women are also modelled on those by the Snub-Nose Painter (e.g. nos. 13, 15, 25), but here they often have a piece of drapery over both arms and behind their back (as on nos. 125, 127–8, 135), or rest one arm on a pillar (nos. 130, 132; cf. with Lecce 4811, no. 18 by the Snub-Nose Painter).

As adjuncts in the field on the obverses we should note the double bunch of grapes (nos. 128, 135; cf. nos. 84–85a above), the white-edged ivy leaves (nos. 128–132), rosettes and fillets, and the dotted wreaths, either closed as on nos. 130, 135, 137, or open, with bucrane, as on nos. 136, 138. On the reverses there is usually either a diptych or a pair of *halteres* above the youths; closed wreaths appear on nos. 125–6, 128, 130.

Amphorae

*125 Milan, "H.A." coll. 364. PLATES 105, 5–6 and 97, 3.
 CVA 1, IV D, pl. 31.
 (a) Woman with phiale and wreath, and nude youth with patera and bunch of grapes at naiskos in which is a shield on a table, (b) B + C.

 126 Milan, "H.A." coll. 446.
 CVA 1, IV D, pl. 32.
 (a) Youth with fillet and alabastron, woman with mirror and wreath at naiskos in which is a pilos and a shield, (b) B + F.

126a Richmond (Virginia), Museum of Fine Arts.
 Ex Summa Galleries, *Cat.* 1 (1976), no. 32 (ill.).
 (a) Woman with patera and bunch of grapes, youth with fillet and phiale at naiskos, in which is a seated youth holding spear and shield, (b) B + C.

 127 Brussels R 405.
 CVA 1, IV Db, pl. 2, 3.
 (a) Warrior with fillet, spear and shield in naiskos; to l., nude youth with wreath and stick, drapery over l. shoulder; to r., woman holding up wreath in r. hand, (b) A + C + FX, with strigil.

Pelike

127a Vidigulfo, Castello dei Landriani 263.
 (a) Woman with mirror and wreath, seated nude youth with phiale and branch, (b) A + C.

Column-kraters

*128 Altamura 1. (b) PLATE 106, 1.
 (a) Oscan warrior with dish of cake, two spears and shield seated between woman with tambourine and filleted wreath and Oscan youth with kantharos and spear, (b) B + C + C.

Column-kraters (continued)

129 Leningrad inv. 557 = St. 809.
 (a) Oscan warrior between standing woman with situla and dish of cake, and seated woman, with cista, (b) A + C + C.

*130 Ruvo 793. PLATE 106, 2–3.
 (a) Oscan warrior with phiale and two spears seated between two standing women, l. with wreath and situla, r. with dish of cake and fillet, resting l. elbow on pillar, (b) A + C + C.

131 Taranto (sequestro).
 (a) Oscan warrior with two spears bending forward over raised foot toward seated woman with dish of cakes and branch, standing woman with rosette-chain, resting r. arm on pillar, (b) A + C + C.

132 Leningrad inv. 558 = St. 1212.
 Gli Indigeni, fig. 23.
 (a) Oscan warrior with phiale and two spears standing between seated woman with fruit-branch and woman with ivy-trail resting l. arm on pillar, (b) A + C + C.

133 Bologna 580.
 CVA 3, IV Dr, pl. 18, 3–4.
 (a) Maenad with thyrsus and tambourine following Oscan youth with phiale and thyrsus, (b) B + F, with palmette between them.

134 Francavilla Fontana, Braccio coll.
 Argentina, *La città natia,* p. 271.
 (a) Oscan youth with branch and dish of offerings running l., followed by woman with thyrsus and bunch of grapes, (b) B + C, with palmette between them.

135 Taranto 8847.
 (a) Seated Eros with phiale, woman with wreath and branch, (b) B + C, with palmette between them.

136 Athens 1679.
 Gli Indigeni, fig. 29.
 (a) Woman with branch and cista of cakes, Oscan youth with wine-skin and branch, (b) B + F.

137 Naples, Gerolomini.
 (a) Eros with foot raised on rock holding branch and two phialai, seated woman with branch and thyrsus, (b) B + F.

Bell-kraters

*138 Matera 10207, from Timmari. PLATE 106, 4.
 (a) Nude youth with thyrsus and phiale moving to l., followed by woman with tambourine and thyrsus, (b) B + F.

*139 Udine 1665. (b) PLATE 106, 5.
 Borda, *Ceramica italiota,* no. 17 (ill.).
 (a) Dionysos with thyrsus and phiale running to l. followed by maenad with mirror and thyrsus, (b) B + F.

140 Winterthur 311.
 (a) Seated nude youth with beaded wreath and thyrsus, woman with phiale and thyrsus, (b) B + F.

141 Bari, Macinagrossa coll. 14.
 (a) Maenad with thyrsus and tambourine, Dionysos with filleted wreath and thyrsus, young satyr with situla and torch, all moving to r., (b) B + CX + CX (the extended hands of the youths have been repainted).

(ii) VASES RELATED IN STYLE TO THE ABOVE

(a)

The following vases which are in very bad condition, look to be closely connected with the work of the "H.A." Painter — cf. the woman on no. 142 leaning against a pillar with the one

on no. 130, and the treatment of the himatia of the draped youths on the reverse with that on nos. 128, 133, 135; note also the open dotted wreath on the reverse (cf. nos. 135, 136, 138).

Pelike

142 Mainz O. 7269.

 (a) Standing woman with wreath, seated nude youth with phiale, woman with wreath leaning against pillar; above, Eros flying with open box, (b) B + FX, with phiale, + D.

Amphora

143 Dublin 1880.352 (J. 510).

 (a) Nude youth with wreath and phiale, moving to l., followed by woman with bunch of grapes, (b) B + F.

(b)

Bell-kraters

144 Matera 10992.

 (a) Woman holding up wreath in r. hand, tambourine in l., nude youth with dish of cake and thyrsus, moving to r., (b) B + F.

 Cf. with Taranto 8847.

145 Matera, from Pomarico.

 (a) Woman with torch, nude youth with thyrsus and phiale, woman with fillet, (b) C + C with wreath.

146 Milan, ex Riquier coll.

 (a) Nude youth with thyrsus and phiale, drapery over l. arm, woman with fan seated on rock, (b) B + F.

147 Florence, La Pagliaiuola 111.

 (a) Eros with wreath and tambourine, woman with grapes and thyrsus, moving to r., (b) B + F.

(c) THE BRACCIO PAINTER

 The two following vases, by a single painter, are also very close in style to the work of the "H.A." Painter:

Bell-kraters

148 Francavilla Fontana, Braccio coll.

 Argentina, *La città natia,* ill. on pp. 271—2.

 (a) Woman with thyrsus and phiale following nude youth with situla and thyrsus to r., (b) A + F, with stele between them.

 The diptych on the reverse with three horizontal and three vertical lines without any dots is repeated on the vases in the Crossed Diptych Group (see Chapter 14, 2 (ii) below).

*149 Naples 1834 (inv. 81440). (b) PLATE 106, 6.

 (a) Maenad with thyrsus and phiale following Dionysos with bunch of grapes and thyrsus, (b) A + F.

(d)

 With the Florence krater (no. 147) compare the following, which is in bad condition with many details missing or repainted, in regard to the treatment of the running woman on the obverse and the draped youths on the reverse.

Bell-krater

150 Once London Market, Christie's, *Sale Cat.* 16 July 1975, no. 183, and 27 April 1976, no. 174.

 (a) Satyr with thyrsus and phiale running to r. behind draped woman with wreath and thyrsus, (b) A + C.

7. VASES LINKING THE "H.A.", VARRESE AND DUBLIN SITULAE PAINTERS

The three vases in this section provide connecting links not only between the work of the "H.A." and Varrese Painters, but also with the Painter of the Dublin Situlae (see Chapter 15, 2). It is easy to find parallels between the various figures on both the body and the lid of the B.M. dinos (no. 151) and those on vases by the Varrese Painter — notably the woman bending forward over her raised foot (cf. 13/1, 14, 24), the running woman with her cloak flapping behind her back (13/5), the treatment of the breasts of the woman with the "xylophone" (13/5 and 33). The scene as a whole may be compared with that on the Basel dinos (13/14); and the chequer pattern with those on nos. 13/23 and 29. Note also the use of small dots to start the fold-lines, as well as the drawing of the faces and the drapery. The treatment of the eyes is slightly different, but the general resemblance is striking. The dinos is particularly close to the vases in the sub-group of Vatican X 6 (nos. 13/21 ff.), even in its decorative adjuncts and ornamental patterns.

The calyx-krater in the Dechter collection (no. 152) seems to go closely with the dinos, especially in the treatment of the standing draped woman on the obverse (note the piece of drapery across the lower part of the body) and the running woman on the reverse. The krater has an unusually elaborate moulded base for an Apulian vase, which associates it with some of the larger vases of the "Ornate" style. Note the wreath around the head of Dionysos and the white necklace, both of which will be found again on vases in the Schulman Group (Chapter 14, section 9).

Dinos (with lid)

*151 B.M. F 303. PLATE 107, 1—5.
 (a) Symposium — three banqueters reclining on a couch beneath a grape-vine between, to l., a woman playing the flute approached by a woman carrying a "xylophone" and dish of offerings and, to r., a woman putting incense on an incense-burner and a young satyr, (b) woman with raised foot holding out wreath to seated Dionysos, satyr with torch to l. and satyr with kantharos to r.
 Lid: Eros holding fillet in both hands, between two seated women, l. with wreath, r. with mirror, to l. a seated woman with cista, to r. a woman running up with a sash.
 The style of drawing on this vase, especially the drawing on the lid connects it also with the Iliupersis Painter (Chapter 8).

Calyx-krater

152 Los Angeles, Dechter coll.
 Ex New York Market, Parke-Bernet, *Sale Cat.* 24 April 1970, no. 317, ill. on p. 159; 7 Dec. 1973, no. 59 (ill.).
 (a) Woman with wreath, fillet and filleted branch standing in front of seated Dionysos, who holds phiale and thyrsus, (b) woman with wreath and cista running to l. and looking back to r.

The following vase looks to be closely associated in style with the B.M. dinos (no. 151), especially with the figures on its lid. The treatment of the women's drapery, however, is slightly different, notably in the area of the breasts.

Dish (with knob handles)

*153 B.M. F 459. PLATE 107, 6.
 Schneider-Herrmann, *Paterae,* no. 107.
 I. Head of woman in white surrounded by olive wreath. A. Eros between two women, l. with branch and mirror, r. with tambourine. B. Youth with wreath, woman with fan seated on cista, youth with strigil, and woman with mirror and box.

CHAPTER 13

THE VARRESE PAINTER AND HIS CLOSE ASSOCIATES

1. The Varrese Painter
2. Associates and Imitators of the Varrese Painter
3. The Wolfenbüttel Painter

1. THE VARRESE PAINTER

Bibliography

A.D. Trendall, *JbBerlMus* 12, 1970, pp. 175–8.
K. Schauenburg, *JdI* 89, 1974, pp. 143 ff.
A.D. Trendall and A. Cambitoglou in *Ap. Grabvasen*, pp. 115–7.

Introduction

The Varrese Painter takes his name from the Varrese hypogeum at Canosa (Tinè Bertocchi, *Pittura funeraria apula,* p. 26; G. Andreassi, "Note sull' Ipogeo Varrese", in *ArchStorPugl* 25, 1972, pp. 233–259; see also Nachod, *RM* 29, 1914, pp. 286 ff.), in which two of his larger vases were found (Taranto 8922 and 8935). He is a prolific painter, to whose hand some 160 vases may now be attributed, and he has a very characteristic style which owes much to the work of the Snub-Nose Painter and even more to the "H.A." Painter (see Chapter 12, section 6), whose vases, together with B.M. F 303 (no. 12/151) above, provide a clear connecting link between the two.

The Varrese Painter had a considerable following (see Chapter 14) and it is not always easy to distinguish between some of his work and that of his immediate followers, who imitated him very closely and adopted several of his mannerisms (e.g. the use of a dot to begin a fold-line, the parallel lines between the breasts, etc.). His school also had a considerable impact upon the workshop of the Darius Painter, and many of the latter's smaller vases, as also of the Underworld Painter and his followers, look like continuations of the Varresian style, with the result that it is very difficult to draw hard and fast lines between them, although the later products reflect the more fluid manner of drawing which is so typical of later Apulian red-figure (cf. the Painter of the Truro Pelike). These will be dealt with in Volume II.

In the work of the Varrese Painter we may note a number of constantly recurring elements; these include several stock figures in varied poses, his very characteristic manner of representing drapery, and a remarkably uniform treatment of decorative patterns and adjuncts in the field. Among the more significant of these are:

(i) *Stock-figures*

(a) A standing nude youth, with one arm enveloped in a piece of drapery, sometimes with his legs crossed;
(b) a nude youth seated on a piece of folded drapery;
(c) a standing woman, with one of her legs, which often looks to be very slender, slightly drawn back and clearly visible beneath the drapery;
(d) a seated woman, with one leg in front of the other;
(e) a woman with one foot raised, bending forward, one arm resting on the upraised thigh.

(ii) *Drapery*

(a) Multiple parallel fold-lines appearing on the drapery, especially vertically down the supporting leg, often in bunches of three or four, and across the legs of seated figures — round the neck are two or three parallel curved fold-lines;

(b) the "bracketing" of the breasts between curving lines, with several parallel cross-folds in between them;

(c) the fold-lines often beginning or ending in a small dot;

(d) the use of a "shawl"-drape — it is particularly common on the vases in the sub-group of Vatican X 6 (e.g. nos. 21, 22, 28, 31—33); note also the appearance of a vertical black stripe running down the chiton or peplos, and, less commonly, an inserted stripe of lozenge-pattern (as on nos. 5, 23, 24, 35) like that used by the Lycurgus Painter;

(e) the drapery of the youths on his reverses which follows closely upon the types used by the Snub-Nose and "H.A." Painters — we may note his fondness for a "sleeve" drape (Types C and D), often with a flat C to mark the edge of the "sleeve"; there is normally a diagonal black line, with a slight hook at one end, across the top of the himation, and, almost invariably, two wavy lines in the bottom corners (e.g. nos. 8, 13, 37—40); characteristic also is the double curved line below the bent arm just above the sleeve (as on nos. 37—39, 56, 65—67, 70).

(iii) *Patterns and adjuncts*

(a) Below the picture — meanders with quartered squares, in each section of which is a black dot or circle, and sometimes a hollow square (e.g. nos. 5, 25, 33); saltires and chequers are also used, but less frequently; wave-pattern is occasionally found on the smaller vases;

(b) below the handles of bell-kraters and pelikai — scrolls with drop leaves (larger on the pelikai) or trefoils;

(c) on the neck of column-kraters — rounded ivy, with a large black disk in the centre of the berries;

(d) as adjuncts in the field on the obverses: rosettes, dotted wreaths, bunches of grapes; on the reverses: *halteres* and quartered disks or balls — the standard arrangement is a *halter* between two disks (e.g. nos. 78—83, 90—93) but many variations are possible, and a phiale or a wreath may be used as substitutes and occasionally a window (no. 40);

(e) on the bases of stelai (or naiskoi) a floral pattern with a three-dot flower (e.g. nos. 3, 6, 9, 22, 41, 43), which is characteristic of the painter (cf. the floral chain held by the figures on nos. 1, 6 and 7), as is his use of a black and white triglyph-metope frieze (e.g. nos. 3, 4, 61);

(f) rocks usually shown as hollow, with black centres outlined in white (e.g. nos. 52, 58, 65, 67, 82—3, 89, 95, 99, 136, 143) — if the black is omitted, then a thick crescent-shaped band of white, with a row of dots above it, is used to outline the rocks (e.g. nos. 78, 80, 94, 100—1, 135);

(g) ground-lines consisting of large white dots.

His figures generally have a rather solemn look; the mouths are small, with a slight downward curve, and his treatment of the eye is in the Iliupersic tradition. Women's hair is often shown emerging from the *kekryphalos* in the form of a "top-knot", tied with a white ribbon; a small radiate stephane is worn above the brow.

Of particular importance is the Varrese Painter's use of added colours on the figures in the naiskos on Taranto 8922 (no. 1), on which orange-yellow, purple and crimson now make their appearance. It is probable that figures such as these inspired the decorators of the so-called Gnathia vases, which appear about this time (c.360—350 B.C.), and are often decorated with figures in applied colours very like those used on the Taranto hydria (cf. the Melbourne lekythos D 17/1972, with a flute-player and Eros — *ArtBullVic* 1973, pp. 9 ff., figs. 6—8 and colour-plate 1 b; see also Lidia Forti, *La Ceramica di Gnathia,* pls. 6, 8, 17; and J.R. Green, *Gnathia Pottery in Bonn,* pp. 2 ff. for a discussion of the origins of this style). It is very probable that some of the vase-decorators of this period used both techniques (see Green, *BICS* 15, 1968, pp. 34 ff., and 18, 1971, pp. 30—38); certainly from this time onwards the Gnathia technique will be used with increasing frequency for the decoration on the necks of volute-kraters and the shoulders of amphorae, the main scenes on which are painted in red-figure.

The work of the Varrese Painter falls into two main divisions, one containing his larger

vases, which are of better quality and more elaborately decorated, the other of an extensive number of less distinguished vases, generally depicting two figures derived from his larger compositions — a youth and a woman, one seated and the other standing, or bending slightly forward over one foot raised on some sort of eminence, a pose extensively copied by many of his associates and followers.

(i) LARGER VASES

The larger vases depict mythological, naiskos or Dionysiac scenes and find close parallels on the similar vases of the Lycurgan school and on those which come between the Lycurgus and the Darius Painters. We see a growing fondness for the representation of naiskos scenes, following the tradition established by the Iliupersis Painter; no. 9 is a good example of the canonical type with two youths and two women bearing offerings, grouped around a naiskos on (a) and a stele on (b). More interesting are the vases with mythological scenes, several of which look to have been inspired by Greek drama (e.g. the representations of Niobe on nos. 3, 4 and 22, or of Pelops and Oinomaos on no. 5), as is certainly the case with the two phlyax vases (nos. 11–12), both of which depict the actual stage. Two of these vases (nos. 5 and 11) bear inscriptions, the only ones to appear on the painter's work. The connexion between the vases in this division and the work of the Darius Painter may clearly be seen by comparing nos. 4–5 and 24–25 with some of the latter's earlier vases like B.M. F 279 and Leningrad 4323.

We might also note the Varrese Painter's liking for representing large metal vases with ribbed decoration (e.g. on nos. 3–5), a practice followed by the Painter of Bari 12061 (see Chapter 14, section 6, iv); such decoration is actually used on the lower part of no. 34. He is also fond of representing figured situlae (e.g. on nos. 12–14, 18, 35) and large cistae with dot-clusters or white triangles in the four quarters.

The plants in the naiskoi on nos. 21, 22, and 42 are the forerunners of a long series (see Schauenburg, *RM* 64, 1957, pp. 198 ff.), like the female head springing from acanthus on the shoulder of the reverse of no. 4. We should also note the growing size of the amphora, which from now on will be regularly decorated with two registers of figures scenes, separated by a narrow frieze of fish or of floral pattern, sometimes accompanied by a female head.

(a)

Hydriai

* 1 Taranto 8922, from Canosa (Tomba Varrese). PLATE 108, 1.
 Trendall, *Ceramica,* pl. 28, 1; Schauenburg, *JdI* 81, 1974, p. 142, fig. 5.
 Woman in purple cloak and woman in orange-pink cloak in a naiskos with Ionic columns and a stepped structure above, with an amphora on each side of it and a sphinx on top; to r. and l. three women with offerings.
 The drawing is better than in most of his other vases, and the figures in the naiskos show the connexion with contemporary polychrome and Gnathia vases. The woman to l., with raised foot, is very typical of his standard manner.
 For the stepped pyramid-like structure on top of the naiskos see, in particular, "Greek and Roman Pyramids" by N. Neuerburg in *Archaeology* 22, 1969, pp. 111ff., in which the amphora Karlsruhe B 5 is illustrated together with his own fragment no. 8/81; cf. also the lost vase illustrated in Raoul-Rochette pl. 30 (no. 8/80).

2 Taranto 51013, from Ginosa.
 Trendall, *Ceramica,* pl. 28, 2.
 Woman with branch and dish of cakes, and woman with filleted wreath and phiale at a naiskos, in

Hydriai (continued)

which is a standing woman resting against a pillar and holding up a mirror.

It should be noted that this vase comes from the same tomb as nos. 14/102–103 by the Ginosa Painter, one of the followers of the Snub-Nose Painter, and thus reinforces the connexion between his school and that of the Varrese Painter.

Amphora (of special shape)

* 3 Bonn 99. (b) PLATE 108, 2.

Schauenburg, *RM* 64, 1957, pl. 37, 1–2; Trendall, *RA* 1972, p. 313, fig. 4; *Ap. Grabvasen,* pl. 32a.

(a) Niobe standing between two amphorae in a naiskos with four women (two seated and two standing) grouped around, (b) four women at a naiskos in which is a large amphora with lid.

For the interpretation of the scenes on this and the preceding vase see *Ill.Gr.Dr.* III.1, 23, and *RA* 1972, pp. 309–316. The shape is unusual, being nearer to a neck-amphora; for the white rays on the neck cf. no. 22.

Amphorae

* 4 Taranto 8935, from Canosa (Tomba Varrese). Detail of (a): PLATE 109, 1.

Il Museo di Taranto, p. 65; Schauenburg, *RM* 64, 1957, pl. 44, 1; Arias, *Storia,* pl. 163, 2; Paribeni, *Immagini,* pl. 19 (colour), no. 17; Trendall, *RA* 1972, p. 315, fig. 5; *Ap. Grabvasen,* pl. 33a.

(a) Shoulder: woman holding flower in each hand, rising from calyx.

Body: (i) Niobe seated on a tomb-monument between two amphorae (cf. nos. 1 and 3); to l. two women and aged Tantalus who is entreating her; to r. aged woman (the nurse ?), and woman with offerings,

(ii) all around — women, youths and Eros.

(b) Shoulder: r.f. female head in profile to l. with acanthus and palmettes.

Body: (i) three women and two seated youths,

(ii) continuation of above.

Note pattern on the neck of the obverse between the handle-joins; it consists of crossed double-volutes and is destined to become popular in later Apulian (Jucker, *Blätterkelch,* fig. 126; cf. nos. 16/57 and 78).

* 5 B.M. F 331. PLATE 109, 2–4.

Details: *NSc* 1910, p. 137, fig. 12; Cook, *Zeus* i, pl. 3; Squarciapino, *Annuario* 30–32, 1952–4, p. 137, fig. 5; M.–L. Säflund, *E. Pdmt. Olympia,* p. 135, figs. 90–91.

Above: (a) Pelops and Oinomaos making libation at the altar of Zeus (ΔΙΟΣ) before the race, (b) seated youth and standing woman between a youth and woman on each side.

Below: (a) Women and two youths with offerings at a funeral monument.

Neck: (a) female head in floral surround.

Most of the principal figures on the obverse have their names inscribed beside them (Pela..., Periphas, Hippodam[ia, Pelops, Oinomaos, Myrtilos, Eros, Aphrodite). The scene is repeated in somewhat greater detail on a later amphora in the De Blasi collection in Bari. For the legend of Pelops see Lacroix, *BCH* 100, 1976, pp. 327 ff.

6 B.M. F 333.

(a) Youth with fillet, and woman with ivy-trail at a naiskos in which is a nude youth with two spears, (b) youth and woman at stele.

7 Once Paris Market (Segrédakis, 1947), ex Hope 231 (Christie's, *Sale Cat.* 8 June 1937, no. 137).

(a) Nude youth in naiskos, with two youths and two women around, (b) woman with raised foot, holding fillet, and youth with floral chain and phiale, at a naiskos in which is a shield.

For the floral chain, cf. nos. 1 and 6; and for the shield in the naiskos nos. 12/125–6 above.

Pelike

8 Altenburg 349.

CVA 3, pl. 95, 1–3.

(a) Woman with fan, youth with fillet and wreath at naiskos in which is a seated woman holding a "xylophone", (b) A + CL + D.

Oenochoe (shape 1)

8a Naples Stg. 318. Badly damaged and repaired, with a good deal missing.

Séchan, *Études*, p. 262, fig. 83.

White-haired man kneeling at feet of youth wearing Phrygian helmet and holding cithara, woman between two posts (tree-trunks ?), holding fillet and phiale, standing youth with two spears and crown, seated white-haired woman with cloak over her head.

The scene here depicted has not yet been satisfactorily explained (see *Él.Cér.* ii, p. 235; *CRStP* 1862, p. 150; Séchan, op. cit. p. 263, takes it to represent the aftermath of the rescue of Andromeda), but the style and manner of drawing are typical of the Varrese Painter (cf. the seated woman with the old woman to r. of Niobe on no. 4 or beside the tomb on no. 22, and note the typical fold-lines on the drapery over her breast).

Volute-kraters

* 9 B.M. 1933.6–13.7. Broken and repaired, with several large fragments missing. PLATE 110, 1–3.

Schauenburg, *JdI*, 89, 1974, p. 166, fig. 36 and p. 168, fig. 38.

(a) Warrior in naiskos, with two youths and two women around, (b) two women and two youths at stele with kylix on top.

Neck: (a) frontal female head, wearing stephane, in floral surround, (b) palmette.

Mascaroons: (a) female heads (one missing), (b) Amazonomachy.

10 Naples Stg. 690.

(a) Seated woman and youth to l., and seated youth and woman to r. of a naiskos in which are a warrior and a youth, (b) two youths and two women at a stele with kylix on top (cf. no. 9).

Neck: (a) woman rising from calyx (cf. no. 4).

Calyx-kraters

11 B.M. F 269.

PhV², no. 81; *Ill.Gr.Dr.* IV, 21.

(a) Phlyax scene – Daidalos and Enyalios (inscribed) fighting in front of Hera seated on throne, (b) woman and youth.

12 Naples 118333 from Armento.

PhV², p. 53, no. 83.

(a) Phlyax scene, (b) woman with torch and cista, nude youth with situla, both running to l.

Bell-krater

13 Basel Market, MuM.

(a) Satyr with thyrsus and situla, seated Pan with lagobolon and syrinx, woman with rosette-chain and mirror leaning on rock-pillar, (b) B + D + CX; palm-leaves between them.

The way in which the rock-pillar is joined up to the rock on which Pan is seated is most unusual.

Dinos (on stand)

14 Basel, Antikenmuseum S. 33.

Ap. Grabvasen, pp. 114–123, pls. 29–31.

Youth reclining on couch with Dionysos between satyr serving wine in a kantharos from a situla and woman playing the flute; seated half-draped youth and woman with wreath and "xylophone"; nude youth with phiale, seated woman with wreath and cista; youth with wreath leaning on stele, seated woman with phiale and thyrsus looking r. at nude youth holding kantharos, with l. arm enveloped in drapery; woman with wreath and phiale bending forward over raised foot in front of seated youth with branch; standing woman with wreath, youth with raised foot stretching out r. hand toward seated woman with thyrsus and phiale.

Lids (of dinoi ?)

15 Berlin F 3369. (Badly damaged).
 Eros, seated woman; two other figures (almost completely missing), probably a youth and seated woman.
16 Naples Stg. 424.
 Two women, youth, and Eros.

Situla (type 1)

17 Naples Stg. 530. Repainted.
 (a) Above: Eros flying towards seated woman with mirror; below: woman seated between two nude youths, (b) youth seated between two standing women, l. bending forward over raised foot.

Situla (type 2)

18 San Simeon 5505 (SSW 10456; PC 7800).
 Standing woman with flute, seated Dionysos with phiale and thyrsus, woman bending forward over raised foot and holding oenochoe and situla, seated youth with thyrsus, standing woman with oenochoe and dish, seated nude youth, standing woman resting l. elbow on pillar, seated nude youth with thyrsus and phiale, standing Pan with syrinx and lagobolon.

Squat lekythos

19 Ruvo 1558.
 Woman with cista standing beside tree, seated frontal woman crowned by youth, Eros flying above with alabastron, drpaed woman with flapping cloak.

Hydria (frr.)

20 Brunswick (Maine), Bowdoin College 1927.4 (Herbert, *Cat.*, no. 219).
 Amazonomachy.
 Parts of two Amazons are preserved; the style is close to that of B.M. F 331.

(b) THE SUB-GROUP OF VATICAN X 6

This sub-division contains a number of vases, closely inter-connected by their style and drawing, which look to be a little later than those in (a). Note in particular:

(i) the rendering of the drapery: the whirligig effect around the enveloped arms of youths (nos. 21, 24, 30, 33); the "shawl"-like draping across the front of the women's bodies (as on nos. 21, 22, 28, 31, 33, 35; with a slight variation on nos. 25, 29, 30); the cross-folds on the legs of seated women (nos. 22–25, 28, 31, 32, 34); a "cascade" effect on nos. 25, 28, 29; the lozenge-patterned inserted stripe on nos. 23, 24, 25; the embroidered patterns on nos. 23, 25.
(ii) the frequent appearance of a draped woman bending forward over one raised foot, with a series of parallel fold-lines descending from the thigh and a wavy border between the two feet (nos. 22–25, 30, 34).
(iii) the continued use of parallel fold-lines between the breasts of women (nos. 22–27, 31–33) — the breasts are also shown clearly separated with a dividing line between them (nos. 21, 25, 30, 31, 33, 34), which is sometimes fairly thick with small horizontal lines on either side of it (as on nos. 27, 30, 31, 32, 35), as is later copied by the Painter of MNB 1148, whose work will be discussed in Volume II.

(a)

Volute-krater

21 Vatican X 6 (inv. 17163). Much repainted.
 VIE, pl. 53; *EAA* iv, p. 751, fig. 210; Kerenyi, *Eleusis*, p. 143, fig. 40; Helbig-Speier i, p. 710, no. 991.

(a) Warrior in naiskos beside a horse, spearing a youth, with two women and four youths with offerings around, (b) four youths and two women grouped about a naiskos in which is a plant.

Neck: (a) griffin chariot with Dionysos and followers (cf. Vian, no. 400, pl. 48, and the New York situla 56.171.64; no. 16/17 below), (b) palmettes.

Mascaroons: female heads.

The plant in the naiskos can hardly be a poppy, since the seed-pod is not smooth, it is more probably a giant thistle, as on Ruvo 1372 and Dublin 1880.1106 (nos. 15/36 and 37 below) by the Painter of the Dublin Situlae.

Loutrophoros

22 Naples 3246 (inv. 82267). Restored, with a good deal missing.

Spinazzola, *Arti*, pl. 210; Borda, fig. 35; Trendall, *RA* 1972, p. 311, fig. 2.

(a) Niobe in shrine with Leto, Artemis and Apollo above to l., Hermes and Zeus to r.; in centre: l. maid with jewel-box and seated old woman, r. old man (Tantalus) and youth; below — two seated women, with various objects between them, (b) nine women around a shrine in which is a plant.

Shoulders: female heads amid florals (repainted).

For the subject cf. Bonn 99 and Taranto 8935 (nos. 3–4). The style is very close to that of no. 21 (cf. the standing women to l. on the reverses, wearing a shawl).

Pelike

23 San Simeon, Hearst 5609 (SSW 10460; PC 7706).

(a) Youth with lyre (? Apollo) on couch with two women on either side; above: Eros and two seated women between two standing women, r. resting on laver, (b) above — three women, l. with raised foot, the other two seated; below: standing woman, seated woman, nude youth, seated woman with flower, nude youth with branch (note also p. 342, no. 28).

Squat lekythoi

24 Zurich Univ. 2654 (old cat. 2412; B. 567).

CVA, IV D, pl. 34, 4–8.

Woman leaning forward over raised foot, holding doll, seated woman facing youth holding "xylophone", seated woman with cista, standing woman with mirror.

* 25 Paris, Cab. Méd. 1047. Repainted. PLATE 110, 4–6.

Above: two Erotes (l. with fillet flying to incense-burner; r. seated with phiale) between two seated women.

Below: woman with mirror seated on hollow rock, woman with fan leaning on laver; seated youth in Phrygian cap playing harp, woman with fillet and two phialai, seated Oriental youth with two spears, woman leaning forward over raised foot.

Situla (type 2)

26 Sèvres 6899.

CVA, pl. 34, 4–6 and 9.

(a) Youth holding spears and sheathed sword, resting r. arm on pillar, Artemis Bendis seated on hollow rock, with dog beside her, seated youth with syrinx and branch, (b) Eros with branch and phiale, and woman with wreath and thyrsus running to r.

Cf. the hollow rock with that on no. 25.

(β)

The vases in this sub-division go very closely together by reason of the drawing of the faces and the rendering of the drapery.

Volute-krater

27 B.M. F 282, from Bari (found with F 284). Foot is missing.

Volute-krater (continued)

Detail: Anderson, *Military Theory and Practice*, pl. 15.

(a) Warrior, wearing pilos and with two spears over his shoulder, in naiskos, with two youths and two women around, (b) two youths and two women at stele.

Neck: (a) female head to r. rising from calyx amid florals.

Lebes gamikos

28 Naples Stg. 321. Much repainted.

Macchioro, *JdI* 27, 1912, p. 289, fig. 15.

(a) A loving couple with two Erotes and three women, (b) seated woman with mirror between a youth and a woman with a dish of offerings; above — Eros with fillet.

Lid: (a) standing woman with cista and bunch of grapes, (b) running draped woman, with mirror, cista and bunch of grapes.

Situla (type 2)

29 Naples 2867 (inv. 81862). The repainting has now been removed, leaving the vase in very fragmentary condition.

Pernice, *Hell. Kunst in Pompeji* iv, p. 14, fig. 17 and p. 24, fig. 36; Macchioro, *JdI* 27, 1912, p. 279, fig. 8.

(a) Seated woman, standing woman, Eros with wreath above head of seated male figure (Apollo ?) beside whom is a lyre and whose hand and shoulder are grasped by a woman with raised foot; above to r. seated woman with harp, (b) komos: above to l. Eros with wreath, nude youth and woman with tambourine, nude youth with situla and kottabos-stand running to r.

Chequer pattern with the meanders, as on the San Simeon pelike (no. 23).

Hydria

30 Naples, Stg. 37. Much repainted.

Shoulder: seated woman, nude youth with rosette-chain, seated woman with mirror facing seated woman holding bead necklace, half-draped youth seated to r., woman with wreath and phiale.

Central band: r.f. female head in profile to l. amid florals.

Body: seated youth with stick and phiale, woman with raised foot holding floral chain and box, seated nude youth with branch, draped woman with fillet, nude youth with crossed legs facing r.

The vase has been extensively repainted and attribution is difficult, but there are many Varresian features, especially in the rendering of the drapery and the profile heads; note also the ribbed amphora beside the seated women on the shoulder.

Dishes (with flat handles)

31 Leningrad inv. 395 = St. 766.

Schneider-Herrmann, *Paterae*, no. F 20.

I. White wreath; on handles, panthers.

A. Standing woman with mirror and fillet, seated nude youth with branch and phiale, Eros with alabastron, and standing woman, with bunch of grapes, sash and cista.

B. Standing youth with wreath and phiale, seated woman with fan and open box, Eros flying with alabastron and fillet toward seated nude youth, standing woman with mirror and basket.

32 B.M. F 458.

Schneider-Herrmann, *Paterae*, no. F 10, pl. 4, 2.

I. Hovering Eros with filleted wreath and phiale in floral surround.

A. Eros with iynx between two seated women, l. with dish, r. with phiale and bunches of grapes.

B. Youth with phiale between two women, l. with wreath and ball, r. with rosette-chain and cista.

Very close in style and treatment to no. 9.

Dish (with snake handles)

* 33 B.M. F 460. PLATE 111, 1.
 Schneider-Herrmann, *Paterae*, no. 201, pl. 12, 3.
 I. Vine. A. Seated woman with phiale over which a bird is hovering, standing shawl-draped woman
 with fan and open box, nude youth with wreath. B. Woman with wreath and phiale seated between
 woman running up with branch and mirror and nude youth with palm branch.

Nestoris (type 1)

 The figured scenes are confined to the upper portion of the vase; the lower part, which is
separated from the upper by a band of lotus-buds and palmettes, is decorated with gadroons.
On the rotelle are Orpheus heads in relief. The inside of the rim of the mouth is decorated with
ivy leaves and berries; above the pictures is a laurel wreath (with white berries on the obverse)
with a rosette in the centre.
 The vase is the subject of a detailed study by K. Schauenburg in *JdI* 89, 1974, pp. 137 ff.

 34 Kiel, private coll.
 Schauenburg, loc, cit., figs. 1–4 and *Kunst der Antike – Schätze aus norddeutschem Privatbesitz,*
 no. 311, ill. on p. 363.
 (a) Standing draped woman, woman with raised foot taking something from a phiale held out by a
 seated nude youth, standing draped woman with cista, who touches his shoulder with her r. hand and
 turns her head to r. to look at seated nude youth with branch, (b) mostly missing — part of seated
 woman, wing of Eros, lower part of standing woman.

Situla (type 2)

* 35 Los Angeles Market, Summa Galleries inv. 71. PLATE 111, 2–4.
 (a) Woman with fillets and phiale, Dionysos with kantharos and thyrsus seated beneath a grape-vine,
 maenad with oenochoe and thyrsus leaning against laver beside which sits a sleeping silen, (b) Dionysos
 with phiale and thyrsus seated between two standing women, l. with situla and wreath, r. with rosette-
 chain and branch.
 This vase goes very closely in style with no. 34, and, like it, must be accounted one of the Varrese
 Painter's better works.

(γ)

 The following vase stands very close in style to those in (β) (cf. especially the shawl-drape
of the standing woman), and the youths on the reverses are very much in the Varresian manner.
The rendering of the faces and the hair on the obverse is, however, different from the painter's
usual style, and it is possible that the vase is by a close imitator rather than by the painter
himself.

Column-krater

 36 Mannheim 143.
 CVA, pl. 44, 1–2.
 (a) Oscan youth with lyre seated between Oscan youth with situla and dish of cake and "shawl"-
 draped woman with wreath and cista, (b) B + CL (with cista) + C.

(ii) LESS ELABORATELY DECORATED VASES

 The vases in this division, which comprise the bulk of the painter's work, mostly consist
of kraters, pelikai and hydriai normally decorated with two or three figures which are repeated
with minor variations from vase to vase. The reverses usually figure either three draped youths
(see pp. 314–5 above) with *halteres* and quartered disks above their heads or two youths with

a *halter* between two disks. Note especially the frequent appearance of the two parallel wavy lines in the outer bottom corners of the himatia.

Amphorae

37 Taranto 61432, from Ruvo.
(a) Woman with wreath and cista, nude youth with floral chain and phiale, at naiskos in which is seated nude youth, (b) A + F + D.
38 Frankfurt Market, De Robertis.
Lagerliste I, p. 25 (ill.).
(a) Woman with branch and bunch of grapes, and nude youth with fillet and strigil, beside a stele tied with black and white fillets, (b) A + C.
39 Bologna 525.
CVA 3, IV Dr, pl. 1, 1–2.
(a) Woman with branch and youth with phiale and branch at stele, (b) A + C.
40 Bologna 526.
CVA 3, IV Dr, pl. 1, 5–6.
(a) Woman with branch and youth with raised foot at stele, (b) B + D.
41 Frankfurt Market, De Robertis.
(a) Nude youth with stick and spray and draped woman with mirror, leaning on pillar, at a stele tied with black and white fillets, (b) B + D.
42 Leningrad inv. 509 = St. 1210.
Schauenburg, *JdI* 73, 1958, p. 75, fig. 22.
(a) Youth with phiale, and woman with fillet at a shrine in which is a flowering plant, (b) B + E.
* 43 Bari 6109. PLATE 112, 1–2.
(a) Woman and seated youth at stele, (b) A + C.
44 Basel Market, MuM, *Sonderliste R* (1977), no. 71.
(a) Seated woman and youth bending forward over raised foot beside stele tied with black and white fillets, (b) A + FX, with ball.
45 Agrigento R 193.
Griffo and Zirretta, *Museo Civico,* ill. on p. 113.
(a) Nude youth with raised foot, holding fillet and wreath, draped woman with phiale seated above cista at a stele, (b) A + E, with palmette between them.
46 Bari 6373.
(a) Woman with cista, seated on rock, nude youth with branch in r. hand and l. enveloped in drapery, (b) A + E, two palm-leaves between them.

Lebes gamikos

47 Policoro 32233, from Roccanova.
Adamesteanu, *Basilicata antica,* p. 212.
(a) Seated woman with fan, standing youth with rosette-chain, his r. arm enveloped in drapery, (b) standing nude youth with mirror and phiale, and seated woman; between them, a flower, above, a wreath.
Lid: female heads.

Calyx-krater

48 Naples Stg. 363.
Schauenburg, *RM* 69, 1962, pl. 14, 1.
(a) Pan between two seated women, l. with tambourine, r. with phiale and wreath, (b) woman with wreath and phiale, and seated nude youth with branch.

Column-kraters

49 Taranto 4431/102.
(a) Seated woman with dish of cakes and filleted wreath between Oscan warrior with two spears and kantharos and standing Oscan youth wearing loincloth and holding branch and two spears, (b) A + C + F.

50 Boston 92.2648.
JbBerlMus 12, 1970, p. 178, fig. 13; *Greek Vases from the Boston M.F.A.* (Exhibition *Cat.*, Museum of S. Texas, March 12 – May 2, 1976), no. 41, ill. on p. 31.
(a) Seated youth with fruit-branch, woman with oenochoe and basket of cakes, seated youth with kantharos, (b) B + E + CX.

51 Naples Stg. 33.
(a) Woman offering libation to seated Oscan warrior, standing woman with cista and bunch of grapes, (b) B + D + C.

* 52 Sarasota, Ringling Museum 1693. PLATE 112, 3–4.
(a) Oscan warrior seated to l. between two standing warriors with spears, (b) B + C + F.

53 Syracuse. (Badly damaged).
(a) Woman with wreath and basket of cakes, seated Oscan warrior with spears, (b) B + C + F.

54 New York 06.1021.215.
Canessa coll. (1904), p. 42, no. 130.
(a) Woman seated between two warriors, (b) B + F + C.
For the nestoris cf. no. 9/206 by the Panter of the Bari Orestes.

55 Oxford 1952.106.
Ashmolean Report, 1952, pl. 6.
(a) Two warriors in combat (one speared), third warrior running up from r., (b) A + C + E.

56 B.M. F 299.
(a) Warrior seated on folded drapery, woman with phiale leaning against laver, seated warrior, (b) A + C + E.

Bell-kraters

Beneath the handles are:

(a) double scroll with plain floral, (b) scrolls with trefoil, (c) single scroll with drop leaf.

(a) DOUBLE SCROLL WITH PLAIN FLORAL

57 Taranto 128019, from Gravina (Parco S. Stefano, T. 16).
(a) Seated nude youth with phiale and branch, woman with foot raised, holding bunch of grapes and wreath, (b) A + F.

58 Genoa.
CVA, IV Dr, pl. 6, 1–2.
(a) Woman seated on rock-pile, and nude youth with wreath, (b) A + E, with palmette between them.

59 Zagreb 13.
Damevski, no. 27, pl. 9, 1.
(a) Satyr with situla and kantharos, maenad with tambourine and thyrsus, (b) B + E.

60 Berkeley 8/3823.
(a) Seated woman with palm branch and phiale, nude youth with branches, (b) A + FX, holding palm branch, with palmette between them.

61 Agrigento R 180.
Griffo and Zirretta, *Museo Civico,* ill. on p. 111.
(a) Youthful Herakles, wearing lion-skin and holding club and dish of offerings, approaching an altar, to r. of which stands Nike, holding a kantharos, (b) A + F.
Note the triglyphs on the altar, cf. with Bonn 99 and Taranto 8935 (nos. 3–4).

Bell-kraters (continued)

62 Catania MC 4389.
 (a) Woman with phiale and wreath, seated nude youth with phiale, (b) A + D.
 Close in style and treatment to no. 61.

(b) SCROLLS WITH TREFOIL

63 Columbia, University of Missouri 62.39.
 Trau Sale Cat. 16 Nov. 1954, pl. 5, no. 240.
 (a) Woman seated beneath tree between two standing youths, (b) B + D + CX.

64 Bari, Macinagrossa coll. 5.
 (a) Seated Dionysos with thyrsus and phiale, maenad with wreath and thyrsus, Pan with pan-pipes and spray, (b) A + F + F.

65 University of Mississippi (ex Robinson coll.).
 CVA 3, IV D, pl. 24, 1.
 (a) Seated youth with branch, and woman with phiale and wreath, (b) B + C.

66 Nocera, Fienga coll. 548 (De F. 680).
 (a) Maenad with thyrsus and phiale, seated Dionysos with wreath and thyrsus, (b) B + C.

67 Once London Market, ex Nostell Priory.
 Christie's, *Sale Cat.* 20 April 1975, no. 17, pl. 5, 1–2.
 (a) Nude youth with branch and phiale, seated woman with branch, (b) B + C.

68 Sèvres 10.
 CVA, pl. 33, 4–6.
 (a) Youth with phiale, resting l. elbow on column, and seated woman, (b) B + C, with palmette between them.

69 Reggio Cal. 1137. Badly damaged.
 (a) Woman with oenochoe, and youth with kantharos and thyrsus, moving to r., (b) B + C, with palmette between them.
 Late.

70 Bologna 598.
 CVA 3, IV Dr, pl. 25, 3–4.
 (a) Woman with cista and branch, following nude youth with phiale and thyrsus moving to l., (b) B + C (cf. with nos. 38–9, 67).

(c) WITH SINGLE SCROLL AND DROP LEAF

71 Bari 6337.
 (a) Woman with wreath and tambourine following nude youth with wreath and phiale, (b) B + C.

72 Bari (deposito). Broken and repaired.
 (a) Nude youth with drapery over r. arm, and seated woman with phiale, (b) B + C.

73 Bari, De Blasi coll. 11.
 (a) Nude youth with thyrsus and phiale + spray, seated woman with thyrsus, (b) B + C.

74 Catania MC 4341.
 (a) Nude youth with spray and wreath, seated woman with phiale, (b) A + C.

75 Hamburg.
 (a) Standing nude youth with phiale, seated woman with branch, (b) A + E, with palmette between them.

76 Bari 13714.
 (a) Standing woman with phiale and leaf, seated nude youth with branch, (b) A + E.

77 Leningrad inv. 541 = St. 1242.
 (a) Seated youth with phiale, and woman holding wreath and mirror, (b) two draped youths.

78 Vatican V 15 (inv. 18048).
 VIE, pl. 29 d and 31 c.
 (a) Youth with wreath and phiale in front of seated woman holding branch, (b) A + C, with palmette between them.

79 Trieste 1792 (Obl. 36).
 (a) Standing nude youth with phiale, seated youth with branch, (b) A + C, with palm-leaf between them.

80 Lecce 776.
 CVA 2, IV Dr, pl. 25, 4.
 (a) Seated nude youth with phiale, standing woman with fruit-branch and wreath, (b) A + C.

81 Bologna 430 (P. 707).
 CVA 3, IV Er, pl. 4, 1–2.
 (a) Seated nude youth with phiale, woman with fruit-branch bending forward over raised foot, (b) A + D, with palm-leaf between them.

* 82 Basel Market, MuM. PLATE 112, 5–6.
 (a) Standing woman with wreath and phiale, nude youth seated on rock, holding flower, (b) A + E, with palmette between them.

83 Amsterdam, Prof. van Regteren Altena.
 Klassieke Kunst uit particulier Bezit (Leiden, 1975), no. 569.
 (a) Woman seated on rock holding phiale, nude youth with branch, drapery over l. arm, (b) A + F, with palmette between them.

84 New York, Iris Love coll. S.I. 19.
 (a) Youth with wreath and phiale, seated woman with palm branch, (b) missing.

85 Louvre N 2977.
 (a) Youth with branch and phiale, woman with filleted branch and wreath, (b) B + C.

86 Naples 1873 (inv. 82629). In very bad condition.
 (a) Standing nude youth with drapery over l. arm, seated woman with branch, (b) B + C.

The following bell-kraters are decorated with single-figure compositions:

87 Taranto 100558, from Gioia del Colle (M. Sannace, 1954, T. 4).
 (a) Woman with branch and phiale running to r., (b) Eros flying to r. with fillet and phiale.

88 Naples 2182 (inv. 82909).
 (a) Nude youth with phiale seated on rock, (b) woman with branch and phiale standing beside altar.

Pelikai

The pelike is a very popular shape with the Varrese Painter, and there are three standard types of decorative pattern-work beside the handle-palmettes:

(a) a tall scroll with a single drop leaf below it (cf. type (c) for bell-kraters),
(b) two scrolls, each with a drop leaf below it,
(c) scrolls with fans or florals instead of drop leaves (comparatively rare).

On the neck there is normally laurel between reserved bands, often pointing in opposite directions on obverse and reverse; on the obverse there may be a row of white dots beneath it. Above the draped youths there are quartered disks and *halteres;* sometimes the latter are replaced by a phiale.

(a) WITH TALL SCROLL AND SINGLE DROP LEAF

89 Bologna 540.
 CVA 3, IV Dr, pl. 10, 1–2.
 (a) Youth holding wreath and dish, woman seated on rock, (b) A + D.

Pelikai (continued)

90 Bologna 534.
 CVA 3, IV Dr, pl. 8, 1–2.
 (a) Seated woman holding dish, and standing youth with mirror, (b) A + D.

91 Mariemont G. 137.
 Cat., pl. 43.
 (a) Standing woman with phiale, seated nude youth with palm branch, (b) A + E, with sash between them.

92 Berlin inv. 32032.
 (a) Seated woman with wreath and cista, standing youth with wreath, (b) A + E.

93 Trieste S 430.
 CVA, IV D, pl. 20, 3–4.
 (a) Standing woman with phiale, youth seated on drapery, (b) A + E, with palm-leaf between them.

94 Warsaw (ex Rome Market).
 (a) Youth with raised foot, and seated woman holding plant, (b) A + E.

95 Trieste 1783.
 (a) Woman with foot raised offering wreath and phiale to nude youth seated on rock-pile holding branch, (b) A + E, with dotted leaves between them.

96 Policoro 32258. In poor condition, with parts of both sides missing.
 (a) Standing woman with cista and mirror, seated nude youth with fruit-branch, (b) A + E.

96a Once London Market, Christie's, *Sale Cat.* 12 July 1977, no. 114, pl. 22, 3.
 (a) Standing woman with cista and wreath, nude youth with phiale seated on rock, (b) two draped youths.

97 Catania MC 4389.
 (a) Standing woman with phiale and wreath, seated nude youth with phiale, (b) A + D.

98 Trieste 1829 (Obl. 38).
 (a) Woman with raised foot, and youth with phiale seated on drapery, (b) A + D.

99 Altenburg 312.
 CVA 3, pl. 98, 4–6.
 (a) Woman with foot raised holding out phiale to Eros seated on rock (b) A + D.
 The obverse is cruder than usual, but the reverse is almost identical with that of Trieste 1829 (no.98).

*100 Matera 9691, from Montescaglioso. PLATE 113, 1–2.
 NSc 1947, p. 134, fig. 3 a–b.
 (a) Woman with raised foot, holding mirror and wreath, seated nude youth with phiale, (b) A + E.

*101 Vienna 1158. PLATES 113, 3–4 and 97, 8.
 Schauenburg, *JdI* 89, 1974, p. 144, fig. 9.
 (a) Nude youth with phiale, seated woman, with branch, (b) A + D.

102 Catania MB 4380 (L. 781).
 Libertini, *Cat.*, pl. 91.
 (a) Youth with palm branch and phiale, and seated woman, (b) A + D.

103 Milan, "H.A." coll. 402.
 (a) Seated woman with cista, youth with wreath and drapery over l. arm, (b) A + D.

104 Turin 4508.
 CVA, IV D, pl. 9, 5–6.
 (a) Seated woman with palm branch, nude youth with phiale, (b) A + E.

(b) WITH TWO SCROLLS AND DROP LEAVES

105 Malibu, J. Paul Getty Museum 71 AE 253.
 (a) Nude youth with phiale seated on drapery, standing woman with wreath and bunch of grapes, (b) B + D.

106 B.M. F 319.
 Schauenburg, *JdI* 89, 1974, p. 146, fig. 11.
 (a) Seated woman with wreath and phiale, youth with branch, l. arm enveloped in drapery, (a) A + D.
107 Louvre K 107. Repainted.
 (a) Standing woman with wreath and phiale, resting l. arm on pillar, nude youth with foot raised on rock, holding tendril, (b) B + F.
108 Matera 11004, from Timmari, T. 2.
 (a) Woman with mirror and branch, seated nude youth with phiale, (b) B + C.
109 Leningrad inv. 501 = St. 1089.
 (a) Woman with wreath and phiale, seated youth with branch, (b) two draped youths.
110 Bari 6278.
 Trendall, *Ceramica*, pl. 29.
 (a) Youth seated on drapery, and woman with "xylophone" and wreath, (b) B + D.
111 Paris, Rodin 667.
 CVA, pl. 33, 4—5.
 (a) Nude youth and woman with phiale and fruit-branch, (b) A + F.

(c) WITH SCROLLS AND FANS OR FLORALS

112 Basel 1906.303.
 (a) Woman with mirror and wreath bending forward over raised leg towards nude youth seated on drapery, (b) B + E.
 In style this vase goes closely with Trieste 1829, Altenburg 312 and Matera 9691 (nos. 98—100), all of which show a very similar woman bending forward over her raised foot, with a wavy hem-line between it and the foot on the ground.
113 Rome, Villa Giulia 25145. Top broken off.
 Cultrera, *MonAnt* 24, 1916, pl. 16, no. 34.
 (a) Woman with mirror and wreath, and seated youth with phiale, (b) B + E.
114 Bari, Colombo coll. 12.
 (a) Seated woman with wreath and mirror, nude youth with branch and floral chain, (b) A + E.
114a Vidigulfo, Castello dei Landriani 374.
 Ex Milan Market, Casa Geri, *Sale Cat.* Nov. 1971, no. 432.
 (a) Youth bending forward over raised foot, with phiale in r. hand and wreath in l., in front of woman seated beside rock-pile, with phiale in r. hand and bunch of grapes in l., (b) A + E.
 The florals are rather more elaborate than those on no. 114 and include two dotted flowers; for the rocks with black centres outlined in white cf. nos. 99, 136, 143.
115 Ruvo 758.
 (a) Standing woman with wreath, nude youth seated on drapery, (b) A + E.

The following pelikai are decorated on the upper part only:

116 Vienna 886.
 Schauenburg, *JdI* 89, 1974, p. 144, fig. 8.
 (a) Seated woman with phiale and wreath, seated nude youth with mirror, (b) woman seated on rock, holding cista and wreath.
 The pattern-work is similar to that on the Colombo and Ruvo pelikai.
117 Louvre K 27.
 Millin I. 29.
 (a) Woman putting incense on burner, woman seated on folding stool, holding fan, (b) seated Eros with phiale, woman with raised foot, holding mirror; bird flying between them.

Oenochoai (shape 1) *(continued)*

148 Naples Stg. 566.
 Seated nude youth, standing woman with filleted wreath and bunch of grapes, seated nude youth with flower.
149 Naples Stg. 298.
 Nude youth (mostly missing), seated woman with mirror, nude youth with bunch of grapes.
150 Basel Market, MuM.
 Seated woman with open box, Eros facing her with raised foot, holding wreath and mirror, seated woman with branch.

Oenochoe (shape 2)

151 Bari 1038.
 Woman with beaded wreath and palm branch, Eros with phiale.

Oenochoai (shape 3)

152 Altenburg 320.
 CVA, pl. 104, 6.
 Standing woman, and youth seated on drapery, with branch.
153 Lecce 695.
 CVA 2, IV Dr, pl. 38, 2.
 Nude youth with raised foot, and youth seated on drapery, holding phiale.
153a New York, Iris Love coll. 70.
 Standing nude youth with wreath and phiale, nude youth with branch seated on rock-pile.
154 Monopoli, Meo-Evoli coll. 2.
 Seated woman with wreath and cista, nude youth with branch, l. arm enveloped in drapery.
155 Matera 12936, from Ferrandina.
 NSc 1947, p. 153, fig. 1.
 Satyr with thyrsus and situla, woman with tambourine and branch.
156 Milan, ex Riquier coll.
 Seated woman with wreath and phiale, nude youth with palm branch and drapery over l. arm.

Oenochoe (shape 5 = *Olpe*)

156a Altenburg 310.
 CVA, pl. 104, 4–5.
 Youth with wreath bending forward over raised foot in front of woman with phiale seated on box.

Squat lekythos

157 Louvre K 210.
 Eros with phiale, seated on folded drapery.

Askoi

158 Vienna 4439.
 Nude youth with phiale, woman seated on rock, with palm branch.
159 Ruvo 681.
 Woman with fillet and cista, seated nude youth with branch.
*160 Ruvo 860. PLATE 113, 6.
 Youth with wreath and mirror, seated woman with phiale.

2. ASSOCIATES AND IMITATORS OF THE VARRESE PAINTER

In this section are grouped together the works of a number of different painters, who model their styles closely upon that of the Varrese Painter. Note especially the drawing of women's

breasts and of the drapery across them, which is very much in the Varresian manner; also the treatment of the draped youths on the reverses, especially the detached curlicues in the bottom outer corners of their himatia.

(i) THE PAINTER OF CONSERVATORI 164

This painter uses dotted saltires like those of the Woburn Abbey Painter (Chapter 12, 3); beside the handle-palmettes are scrolls with cinquefoils (cf. no. 13 by the Varrese Painter). Between the draped youths there is often an altar with black lines or dots (cf. the Laterza Group, Chapter 12, 5), and above it a bucrane (no. 161) or an ivy leaf (nos. 162–3). Note also the closed wreath above them on no. 161, which recalls those on the vases in the "H.A." Group. The field is well filled with decorative adjuncts on the obverse, and on the two Conservatori kraters (nos. 161–2) there is an elaborate flowering plant (cf. 12/44–5) between the two figures. The female head in three-quarter view in the tondo on no. 164, rising from acanthus with an elaborate floral background, recalls the heads on the necks of contemporary volute-kraters or on the shoulders of amphorae (see Chapter 15) and gives another instance of the growing effect of the "Ornate" style on otherwise "Plain" vases.

Bell-kraters

161 Rome, Conservatori 164.
 CVA 2, IV D, pl. 40, and pl. 42, 3.
 (a) Seated woman with branch and phiale, Pan with syrinx and lagobolon, (b) B + C.
162 Rome, Conservatori 180. In bad condition.
 CVA 2, pl. 41 and pl. 42, 1–2.
 (a) Youth with phiale and seated woman with wreath; between them, a flower, (b) B + C.
*163 Basel Market, MuM, *Sonderliste R* (1977), no. 73. PLATE 114, 1–2.
 (a) Youth with oenochoe and wreath, woman seated on rock holding branch and dish of cake, (b) B + C.

Dish

*164 B.M. F 457 PLATE 114, 3–4.
 Schneider-Herrmann, *Paterae*, no. 105.
 I. Three-quarter face female head rising from acanthus in a floral setting. A. Seated youth with phiale and seated woman with wreath and cista. B. Seated woman with cista and seated youth with bunch of grapes, branch and phiale.
 The seated women on A and B are very close to the one on no. 161.

(ii) THE PAINTER OF VATICAN V 19

(a)

All three of the bell-kraters by this painter represent a draped woman running to left, with a black stripe down the lower part of her peplos, which follows very closely the line of the bent left leg beneath it. There is also some form of plant between the two figures on the obverses. The draped youths are in the Varrese tradition, but should also be compared with those by the Laterza Painter (e.g. no. 12/113, pl. 104, 6). Beside the handle-palmettes is a double scroll with drop leaves between.

Bell-kraters

165 Vatican V 19 (inv. 18052).
 VIE, pl. 29 h and pl. 31 g.
 (a) Nude youth with thyrsus and wreath running to l., followed by draped woman with torch and wreath, (b) B + C.

Bell-kraters (continued)

166 Lecce 3786.
 NSc 1934, p. 186, fig. 4.
 (a) Nude youth with thyrsus and phiale, moving to l., followed by woman with wreath and branch,
 (b) B + C.
167 Brussels Market, Hauteville.
 (a) Nude youth with thyrsus and phiale moving to l., followed by woman with thyrsus, (b) two
 draped youths.

(b) VASES CONNECTED IN STYLE

The two following bell-kraters are connected in style with the above (and with the Varrese Painter), but their state of preservation is not such as to permit of a more definite attribution.

Bell-kraters

168 Bologna 429. In bad condition; foot modern.
 CVA 3, IV Er, pl. 5, 1–2.
 (a) Nude youth with thyrsus and tambourine, seated woman with thyrsus, (b) B + C.
169 Stockholm N.M. 13.
 (a) Woman with raised foot holding bunch of grapes and kantharos in front of seated nude youth
 with phiale, (b) B + E, with dotted leaf between them.

(iii) RELATED DISHES

(a) THE PAINTER OF RUVO 553

On all these dishes the scene in the tondo is surrounded by a wreath of white laurel with berries. The style is close to that of the Painter of Conservatori 164.

Dishes

170 Ruvo 553.
 Schneider-Herrmann, *Paterae,* no. 51.
 I. Woman with beaded wreath and cista running l. and looking back to r. A. Seated Eros with
 wreath, seated woman with fan and filleted branch. B. Seated nude youth with branch and phiale
 approached by woman with wreath and cista.
171 Los Angeles, Dechter coll.
 Once London Market, Sotheby, *Sale Cat.* 6 Dec. 1971, no. 132, pl. 19 a; ex Basel, MuM, and
 New York Market, Emmerich, *Art of Ancient Italy* (1970), p. 46, no. 73 (ill.); Schneider-Herrmann,
 Paterae, no. 34.
 I. Seated woman with wreath and tambourine. A. Youth with thyrsus and phiale, woman with
 ivy leaf and tambourine. B. Satyr with situla and mirror, seated woman with wreath and thyrsus.
172 Matera 9940.
 Lo Porto, *Penetrazione,* pl. 41, 2–4; Schneider-Herrmann, *Paterae,* no. 36.
 I. Woman with phiale and wreath seated on rock-pile. A. Woman with wreath and phiale seated
 on rock-pile. B. Seated Eros with phiale.

(b) THE PAINTER OF RUVO 542

Dish (flat-handled)

173 Ruvo 542.
 Schneider-Herrmann, *Paterae,* no. F 8.
 A. Eros with hoop and phiale between two women seated on rock-pile. B. Two nude women at a
 laver, with woman to l. holding fillet in both hands.

Oenochoe (shape 2)

174 Taranto 4746.

Woman with bunch of grapes and phiale standing in front of seated Eros holding mirror.

(iv) THE PAINTER OF TRIESTE S 422

The Painter of Trieste S 422 looks rather like a "poor relation" of the Varrese Painter. His name vase is very much in the latter's manner (cf. the seated woman). The draped youths by the two artists have many points of resemblance; note especially the second wave in the bottom outer corners of the himatia; also the wavy line down the top of the himatia on the youths to right.

The drawing is, however, far inferior to most of that by the Varrese Painter and might be compared with that on some of the vases in Chapter 14.

Pelikai

175 Trieste S 422.

CVA, IV D, pl. 20, 1–2.

(a) Seated woman with phiale and Eros with bead-wreath, (b) BX + CX, holding phiale.

176 Liverpool 27.11.99, 86.

(a) Seated nude youth with phiale, standing woman with mirror and wreath, (b) A + F.

177 Vienna 934.

Tischbein V, 17.

(a) Nude youth with wreath and phiale, standing woman with mirror and branch enveloped in mantle, (b) A + FX, holding strigil.

(v) VASES CONNECTED IN STYLE WITH THOSE IN THE PRECEDING DIVISIONS

Pelikai

(a)

178 Leningrad inv. 503 = St. 1241. Repainted.

(a) Draped woman with cista, seated Eros with mirror, (b) A + C.

179 Leningrad inv. 515 = St. 1093.

(a) Eros with filleted wreath and fan, seated woman with phiale and branch, (b) A + F.

(b)

180 Once Rome Market.

(a) Woman with fan, seated youth with phiale, small Eros and seated woman with wreath; Eros flying above, (b) nude youth seated between two women.

181 Once Rome Market.

(a) Seated woman with wreath and phiale, (b) standing woman with phiale and wreath.

182 Once Manduria, Arnò coll., then Rome Market.

Sale Cat., pl. 4, no. 78.

(a) Seated Eros with branch, (b) woman moving to l., holding cista and branch.

The pattern-work (scroll and drop leaf) beside the fans is identical with that on the preceding vase, as is the treatment of the women on the reverses.

183 Once Manduria, Arnò coll., then Rome Market.

Sale Cat., pl. 4, no. 77.

(a) Seated Eros with tambourine, thyrsus and phiale, (b) standing woman with thyrsus, phiale and tambourine.

With the above compare:

Pelike

184 Oslo O.K. 7774.

 (a) Seated woman with phiale and Eros with mirror and wreath, (b) Eros with alabastron and wreath, seated woman with phiale.

3. THE WOLFENBÜTTEL PAINTER

This Painter, who takes his name from the former location of the bell-krater now in the Kestner Museum, Hanover (no. 188), is placed here rather than in the next chapter because of the close affinity between his draped youths and those of the Varrese Painter (cf. nos. 186–8 below with nos. 50, 52, 58, 75, 92, 112, etc.).

 Another characteristic of the draped youths by the Wolfenbüttel Painter is the horizontal wavy line at the bottom of the overhang on type B (e.g. nos. 185–9) and particularly the two folds projecting upward immediately behind the neck, which are to be seen on almost all his vases; the youth to right normally type F, has a wavy line running down the top of his himation, with a sharp upward bend beside the neck (e.g. nos. 185–7). Above the youths there is often a diptych with two vertical lines, a horizontal stylus, and a dot in each of the upper sections. Beside the handle-palmettes are double scrolls, sometimes with small drop leaves between them.

 On the later vases the drawing tends to become very scrappy.

(i)

Column-krater

185 Catania MB 4246.

 (a) Oscan youth with thyrsus, phiale + spray, woman with situla and thyrsus, (b) B + F.

Bell-kraters

186 Catania MB 4338 bis (L. 739).

 Libertini, *Cat.* pl. 84.

 (a) Woman with thyrsus and phiale moving l., followed by nude youth with bunch of grapes and thyrsus, (b) B + F.

187 Dresden 516.

 (a) Satyr with thyrsus and situla, woman with phiale and thyrsus moving to r., (b) B + F.

*188 Hanover 1966.75 (ex Wolfenbüttel, Dr. E. Kästner). PLATE 114, 5–6.

 (a) Woman with mirror and cista moving l., followed by Eros with wreath and palm branch, (b) B + F, with palmette between them.

Amphora

189 Brussels R 404.

 CVA 1, IV Db, pl. 2, 1.

 (a) Warrior in naiskos; to l., draped woman holding phiale and wreath, to r., nude youth with raised foot, holding mirror and branch, (b) B + D + C.

 This vase is very close to the work of the Varrese Painter and should also be compared with Brussels R 405 (no. 12/127) by the "H.A." Painter, but the treatment of the youth to l. shows it to belong here.

(ii)

Bell-kraters

190 Bologna 603.

 CVA 3, IV Dr, pl. 27, 5–6.

 (a) Woman with mirror and phiale followed by Eros with wreath and branch, (b) B + F.

*191 Taranto 54428. PLATE 115, 1–2.
 (a) Satyr with situla, phiale and fillet, woman with wreath and cista, both moving to r., (b) B + F.
192 Monopoli, Meo-Evoli coll. 10.
 (a) Nude youth seated with thyrsus and phiale, standing woman with wreath and thyrsus, (b) B + F.
193 Turin 4152.
 CVA 1, IV D, pl. 26, 5–6.
 (a) Seated woman with cista, nude youth with torch and situla, (b) B + F.
194 Naples 1944 (inv. 81653).
 (a) Satyr with thyrsus and situla, woman with phiale and wreath running to r., (b) B + C, with phiale.

Column-krater

194a Taranto, Moretti coll. 24.
 (a) Satyr with thyrsus and situla following maenad with phiale and thyrsus, (b) B + F.

(iii)

Bell-krater

195 Palermo n.i. 2242 (old no. 1116).
 (a) Woman bending forward over raised foot, holding alabastron in r. hand and situla in l., seated Dionysos with phiale and thyrsus, (b) B + F, with stele between.

Column-kraters

*196 Naples Stg. 456. PLATE 115, 3–4.
 (a) Standing woman with dish of cakes, seated Oscan warrior with kantharos, spear and shield, (b) B + F.
*197 B.M. F 297. PLATE 115, 5–6.
 (a) Woman with situla in l. hand bending forward over raised l. foot to offer wreath to seated Oscan warrior with phiale in r. hand and two spears in l., (b) B + F.
198 Los Angeles, Mr. Arthur Silver (ex coll. Fr. D. Kirchner Schwarz, *Galerie Helbing*, 22–3 June 1914, no. 397, pl. 8).
 (a) Woman with cista of cakes moving to l., followed by youth with phiale and situla, (b) B + F.
199 Nocera, Fienga coll. 670 (De F. 517).
 (a) Oscan warrior bending forward over raised foot and holding fillet and situla, Oscan warrior seated beside shield with spear in r. and in l. phiale into which a woman pours a libation from an oenochoe, (b) B + CL + C.

(iv)

In this later phase of the painter's work we may observe the characteristic features of his earlier style, but we should also note that the youth to right tends to bend slightly forward. The quality of the drawing has deteriorated, especially on no. 204.

Pelikai

200 Paris, Cab. Méd. 902.
 (a) Woman running to l. with bunch of grapes and phiale, followed by nude youth with tambourine, l. arm enveloped in drapery, (b) B + C.
201 Andria, Ceci Macrini coll. 10.
 (a) Seated nude youth with branch and phiale, woman with fan and branch, (b) B + F.
202 Vatican Z 10 (inv. 18137).
 VIE, pl. 47 c and f.
 (a) Woman running to l. with mirror and bunch of grapes, followed by nude youth with phiale, l. arm enveloped in drapery, (b) B + D.
203 Taranto N 639, from Noicattaro.
 (a) Nude youth with mirror and phiale, woman with wreath and branch, (b) two draped youths.

Pelikai (continued)

204 Geneva 15032.
 (a) Nude youth with branch, phiale and fillet, seated woman with flower and palm branch, (b) B + C.

(v)

The following vase, of which the obverse is very close to those on nos. 196—7, may well also be by the Wolfenbüttel Painter, although the youths on the reverse differ somewhat from his usual types in that they wear white head-bands; compare, however, the fold- and hem-lines with those on nos. 188, 199 and note the diptych and palmette-scroll.

Column-krater

205 Nyon, Mlle. Dunant.
 Art Antique, no. 281 (ill.).
 (a) Seated Oscan warrior with spear, shield and phiale, standing woman with torch and bunch of grapes, (b) A + C.

(vi) VASES CONNECTED IN STYLE

Nestorides (type 1)

206 London, Society of Antiquaries.
 (a) Standing woman with situla and torch, seated Oscan warrior with phiale + spray in r. hand, l. touching rim of shield, (b) B + F.
207 Naples 2338 (inv. 81831).
 Borda, fig. 33; *Gli Indigeni,* fig. 12.
 (a) Seated Oscan warrior with shield, two spears and phiale, woman with raised foot, holding wreath in r. hand and cista in l., (b) Oscan warrior with torch and situla, woman with cista of cake.
 Below: band of fish.

CHAPTER 14

FOLLOWERS OF THE SNUB-NOSE AND VARRESE PAINTERS

1. The Group of Vatican V 50
2. The Group of Bari 8010 3. The Zagreb Group
4. The Ruvo 512 — Roermond Group
5. The Group of Vatican X 1
6. The Ginosa Group 7. The Chiesa Group
8. The Painter of Vienna 1072
9. The Schulman Group 10. The Latiano Painter

1. THE GROUP OF VATICAN V 50

This group consists of the Painter of Vatican V 50, and a few other painters or vases closely associated with him in style. Their favourite shape is the pelike, and the draped youths on the reverses are treated in a very characteristic manner throughout.

(i) THE PAINTER OF THE VATICAN V 50

The early work of this painter is particularly close to that of the Snub-Nose Painter as may be seen from a comparison of nos. 1—2 with his pelike in Reggio (no. 12/28, on which we may note the same seated woman as on no 1, with her cloak draped diagonally across the body and over the left shoulder. The draped youths on the reverses of nos. 1 and 2 are also extremely like those on the Reggio vase, especially the youth to left (type A). There are, however, slight differences in the rendering of the face and the hair and in the treatment of the hem-line at the bottom of the himatia. There can, however, be little doubt that the Painter of Vatican V 50 modelled his style upon that of the Snub-Nose Painter, although the drawing of the rock-piles on nos. 2 and 3 also suggests some influence from the Varrese Painter.

The pictures are framed between scrolls and fans, with minor variations from one vase to another; the windows in the field have the black opening slightly displaced to the left (as on nos. 1—2, 4); dotted wreaths with small white beads appear as adjuncts (nos. 3, 5). The draped youth to right, normally of type C, though sometimes holding a wreath or strigil instead of a stick (nos. 2, 3), has a long "sleeve" drape, usually with a single black line to mark the edge (nos. 1—3); between the two youths there is often a palm-leaf. Their hair tends to be curly on the top of the head; one of the women's breasts is usually rather pointed (e.g. nos. 3—5).

Pelikai

* 1 Catania MB 4359. PLATE 116, 1—2.
 (a) Eros with fillet and open box, and seated woman with wreath, (b) A + C.
* 2 Taranto 110085. PLATE 116, 3—4.
 (a) Draped woman with mirror and seated Eros with patera, (b) A + CX, with dotted wreath.
 3 Sydney 75.
 (a) Woman with fan and tambourine, seated Eros with mirror, (b) A + CX, with strigil.
 4 Vatican V 50 (inv. 18083).
 VIE, pl. 46 i and pl. 47 i.
 (a) Nude youth with mirror and fillet following draped woman with cista and wreath, (b) B + E.

Pelikai (continued)

5 Altenburg 333.
 CVA, pl. 97, 3, 6 and 9.
 (a) Seated nude youth with branch and phiale, draped woman with wreath and "xylophone",
 (b) B + D.
6 Louvre N 2625.
 (a) Woman with cista and sash, nude youth with wreath, seated on drapery, (b) B + D, with a palm-
 ette between them.

(ii) VASES CONNECTED IN STYLE

(a)

The two following vases, which are by a single hand, should be compared with the above:

Column-kraters

7 Vatican V 51 (inv. 18084).
 VIE, pls. 34 a and 35 a.
 (a) Eros with bunch of grapes and tambourine, seated woman holding phiale with spray, (b) B + C.
8 Leiden GNV 1. The obverse has been completely repainted.
 (a) Eros with wreath and tambourine, woman with phiale and thyrsus, both moving to r., (b) B + F.
 The reverse is very close to that of Vatican V 51.

(b)

The two following vases should also be compared, especially for the treatment of the draped
youths on their reverses:

Pelikai

* 9 Cambridge GR 5/1912. PLATE 116, 5–6.
 (a) Nude youth with raised foot, holding bunch of grapes and mirror, seated woman with open box,
 (b) B + D.
10 Norfolk (Va.), Chrysler Museum.
 (a) Seated Eros with phiale, standing woman with wreath and tambourine, (b) B + D.

(iii) THE PRESTON PAINTER

Characteristic of the work of this painter is the use of white head-bands on the draped
youths on the reverses, who otherwise are close in treatment to those on the other vases in this
section.

Pelikai

11 Catania MB 4394 (L. 782).
 Libertini, *Cat.*, pl. 91.
 (a) Woman bending forward over raised foot, holding branch and wreath, seated nude youth with
 torch and phiale, (b) B + D.
12 Preston.
 (a) Nude youth with foot raised on rock-pile, holding mirror and stick, seated woman with phiale
 and branch, (b) B + D.
13 Vatican Z 18 (inv. 18145).
 VIE, pl. 48 c and f.
 (a) Seated woman with mirror and phiale, nude youth with drapery behind l. arm, (b) B + D.
14 Cork, University College J. 1271.
 (a) Woman with mirror and filleted wreath, bending forward over raised l. foot towards nude
 seated youth with phiale, (b) A + CL.

Perhaps in this context the following vase should find a place:

Pelike

15 Bari, Colombo coll. 13.
(a) Eros with wreath and branch, seated woman with a duck on her lap, (b) B + CX, holding up strigil.

The seated woman on the obverse should be compared with the one on Catania MB 4359 (no. 1); the drawing of the youths' himatia on the reverse recalls that of the Preston pelike (no. 12), but their feet are much larger and more clumsy. The foot of the pelike which is quite different from those of all the others looks to be a modern addition, perhaps originally from a hydria.

(iv) THE PAINTER OF TRIESTE S 432

This painter is connected with the Painter of Vatican V 50 by the drawing of the youths on the reverses (cf. nos. 16–18 with nos. 1--2); note the two projecting folds of the himation immediately in front of the neck of the left youth (type A), and the slight kink at the end of the black line running diagonally across the top of the himation on the youth to right (cf. the Snub-Nose Painter; no. 12/28). The windows on no. 18 are shown in perspective, as is commonly done on later vases. Note the double reserved line below the patterns on the neck (e.g. on nos. 16–19; cf. with no. 4).

Pelikai

16 Trieste S 432.
CVA, IV D, pl. 20, 5–6.
(a) Seated half-draped woman with phiale, and Eros with mirror and iynx, (b) A + F.

17 Catania MC 4363.
(a) Standing woman with wreath, phiale and bunch of grapes, seated half-draped youth with fillet and branch, (b) A + F.

18 Brussels R 373.
CVA 2, IV Db, pl. 6, 1.
(a) Seated woman with branch and phiale, nude youth with beaded wreath and stick, (b) A + F.

The reverse is very close to that of Trieste S 432; note also the way in which the fold-lines cross the the legs of the seated woman.

19 B.M. F 322. Broken and repaired, with much missing.
(a) Woman with wreath seated on rock-pile, turning head to r. to face nude youth with phiale, bending forward over raised foot, l. arm enveloped in drapery, (b) A + F.

20 Berlin F 3270.
(a) Seated nude youth with phiale and branch, seated woman with "xylophone", (b) A + C, beside two pillars.

21 Policoro 32718.
(a) Seated youth with branch and phiale, standing woman with fan and wreath; flower between them, (b) B + D.

22 Taranto 4481/242.
(a) Standing nude youth with branch and phiale, woman with fan and bunch of grapes, (b) B + FX, with strigil.

2. THE GROUP OF BARI 8010

(i) THE PAINTER OF BARI 8010

A comparison between the reverse of Bari 8010 and those of nos. 1–2 and 16–17 above, especially for the left youth (type A), shows the connexion with the Painters of Vatican V 50

and Trieste S 432; cf. also the youths to right on nos. 26—7 with their counterparts on nos. 1—3 for the treatment of the "sleeve". The scrolls framing the pictures are less elaborate than on the preceding vases; note particularly the use of saltires with dots in the intersections, which is common to all the vases (cf. the Woburn Abbey Painter). The looping of the drapery between the knees of the youth on the obverse of Bari 8010 is of interest (cf. also nos. 172—3 below by the Schulman Painter); this is a particularly common device on the vases from the workshops of the Darius and Underworld Painters (see Volume II), and its use here suggests that the vases below should be dated early in the second half of the fourth century, as also does the triangular flower on no. 25, which is very typical of pre-Darian and Darian vases.

It should be noted that the reverses of B.M. F 321 and 313 (nos. 26—27) are very close in style to those of the Woburn Abbey Painter (e.g. nos. 12/70, 74, 75), and it is possible that the Painter of Bari 8010 may represent a later phase of that artist's work.

Pelikai

```
*  23   Bari 8010.                                                    (b) PLATE 117, 1.
           (a) Woman with fan seated beside kalathos, nude youth with tambourine,  (b) A + D.
   24   Warsaw 198106.
           CVA, Poland 7, pl. 44.
           (a) Seated woman with branch, Eros with mirror and fillet,  (b) A + F.
*  25   Zurich Market, Galerie Fortuna 14 M.                          PLATE 117, 2—3.
           Ex Koller, Cat. 33, no. 4190.
           (a) Seated nude youth with phiale, woman with raised foot, holding flower and fillet,  (b) A + F.
*  26   B.M. F 321.                                                   (b) PLATE 117, 4.
           (a) Nude youth with raised foot, holding fan and wreath, seated woman with phiale and spray,
       (b) B + D.
*  27   B.M. F 313.                                                   (b) PLATE 117, 5.
           (a) Draped woman with mirror leaning l. arm on pillar, with phiale and spray, nude youth with
       wreath in r. hand, l. enveloped in drapery,  (b) B + C.
           Makes a pair with F 321 (no. 26).
```

The following vase should be compared with the work of the Painter of Bari 8010 (especially nos. 23—25) and also with the vases in the next division (e.g. nos. 30—31).

Amphora

```
   28   Athens 1682.
           (a) Seated nude youth with phiale, woman with mirror and fruit-branch,  (b) A + D.
```

(ii) THE CROSSED DIPTYCH GROUP

This group takes its name from the typical diptych, with three horizontal and three vertical lines crossing it, which appears on several of the vases in it (e.g. nos. 29, 30, 32, 40; cf. with the bell-krater in the Braccio collection, no. 12/150).

The drawing is not of high quality and tends to look rather scrappy. The youth to left on the reverse is normally of type A; on the himation of the youth to right (normally type C) there is often a slight kink at the lower end of the line that runs across the top of his himation (as on nos. 29—32), which should be compared with that on no. 25 above. The bottom hem-line is straight with a small double curve in the corner. The stele, which sometimes appears between the draped youths, has a triangular top (e.g. on nos. 30, 36, 40—41), which finds a parallel on Bari 8010 (no. 23), as does the use of saltire squares with dots on the Nimes amphora (no. 30). The *halteres* between the draped youths on the reverses of nos. 33—34 are particularly clumsy (cf. also nos. 37, 39).

On the necks of nos. 32–33 and 35, it will be noted that the laurel pattern meets in a central diamond — this is substantially confined to the vases in this group and serves as a ready means of identification.

(a) THE CROSSED DIPTYCH PAINTER

Amphorae

29 Matera 10503.
 (a) Seated woman with branch and cista, nude youth with phiale, (b) B + F.

* 30 Nimes 891.25.41. (b) PLATE 117, 6.
 (a) Seated woman with filleted wreath and phiale, standing nude youth with wreath in r. hand, drapery over l. arm, (b) A + C.

31 Bologna 528.
 CVA 3, IV Dr, pl. 2, 5–6.
 (a) Seated woman with phiale and branch, nude youth with bunch of grapes and branch at Ionic stele, (b) A + C.
 This and the Nimes amphora both have a band of zig-zags on the neck below the laurel wreath.

Pelikai

* 32 Matera 11279, from Timmari. PLATE 118, 1–2.
 (a) Standing woman with palm branch and bunch of grapes beside altar, seated nude youth with wreath and palm branch, (b) A + C.

* 33 Monopoli, Meo-Evoli coll. 968. PLATE 118, 3–4.
 (a) Nude youth with phiale, drapery over l. arm, woman with wreath and branch, running to r., (b) A + C.

34 Milan, "H.A." coll. 333.
 (a) Nude youth with bunch of grapes and phiale, drapery over l. arm, moving to l. followed by draped woman with wreath, (b) A + C.

Hydria

35 Berlin, private coll.
 Ex De Bayet coll., Brussels; Berlin Market, Lepke, *Sale Cat.* 19 March 1909, no. 74; then Gerda Bassenge, *Sale Cat.* no. 19, 20 May 1972, no. 2486 (ill. on p. 320) and no. 21, 1973, no. 2686, p. 314; *Antiken aus Berliner Privatbesitz* (Dec. 1975), no. 252 (ill.).
 Nude youth with branch and flower, woman with situla and bunch of grapes at stele, on top of which is a kantharos.
 The draped woman is very close to the one on Matera 11279 (no. 32); she should also be compared with the similar figures on the hydriai of the Underworld Group (see Volume II), with which this vase must be almost contemporary. Note the contiguous saltires in the meander frieze below the picture (cf. no. 38).

Bell-krater

36 Vatican V 32 (inv. 18065). In bad condition.
 VIE, pl. 30 g and fig. 12.
 (a) Standing woman with thyrsus and cista, seated nude youth with wreath, (b) A + F, with pillar between.
 The head of the l. youth has been restored.

Column-krater

37 Bryn Mawr P 231.
 (a) Warrior holding horse by the bridle, seated woman with phiale, (b) A + CR, holding up cista, + C.

Probably also here should be placed the following very battered vase, the obverse of which is comparable to that of Vatican V 32 (no. 36), and which has contiguous saltires with the meander pattern as on no. 35:

Bell-krater

38 Verona 90.
 CVA 1, IV D, pl. 4, 1.
 (a) Woman holding phiale, seated nude youth with cista, and branch, (b) A + C.

(b)

The following bell-kraters form a compact group, probably by the same painter as the vases in (a) — note the stelai with triangular tops on nos. 40—41, and the crossed diptych on no. 40 — but they have been considerably repainted, and precise attribution is therefore open to question. All have dotted saltires as on several of the vases in (a).

Bell-kraters

39 Turin 5404.
 CVA 1, IV D, pl. 26, 3—4.
 (a) Seated nude youth with phiale, woman with raised foot, holding tambourine and mirror, (b) A + F, with stele between them.

40 Nimes 008.69. The reverse has been repainted.
 (a) Standing draped woman with mirror and cista, seated Eros, (b) A + F, with stele between them.

40a Taranto, Leoncini coll. 47.
 (a) Woman with mirror and tambourine, nude youth with stick and thyrsus running to r., (b) A + C.

41 Meer (Belgium), private coll. OT 37. Much repainted.
 (a) Nude youth with wreath and phiale, drapery over l. arm, seated woman with branch, (b) A + C, with stele between them.

42 Naples Stg. 383.
 (a) Woman with branch and mirror, nude youth with wreath, drapery over l. arm, moving to r., (b) B + C.

(c) RELATED VASES

Pelikai

* 43 Geneva 18189. PLATE 118, 5—6.
 (a) Woman with cista and fan, seated nude youth with wreath, (b) two draped youths, l. with phiale and stick, r. with ball on string.

44 Hamburg 1908.243.
 (a) Seated woman with mirror and phiale, nude youth with fillet, l. arm enveloped in drapery, (b) A + CX, with phiale.
 The youths on the reverse have white head-bands, but otherwise are very close (especially the one to r.) to those on the preceding vase, which looks to be by the same hand as this (cf. the treatment of the woman's drapery).

45 Paris, Cab. Méd. 909.
 (a) Standing woman with branch and phiale, Eros seated on hollow rock with wreath; bird with fillet flying above, (b) A + CL.

(iii) THE PAINTER OF OXFORD 1959.204

A painter of poor quality, connected in style with the Painter of Bari 8010.

Pelikai

46 Oxford 1959.204.
 (a) Draped woman with phiale, and nude youth, with drapery behind back, holding wreath in upraised

r. hand and branch in l., (b) draped woman and draped youth (D).

Cf. the scrolls beside the handle-palmettes with those on the Hamburg pelike (no. 44).

47 Louvre CA 3206. Broken with much missing.

(a) Nude youth and woman with phiale; between them a branch, (b) B + C, with palmette between them.

CONNECTED

Pelike

48 Once London Market, Folio Fine Art.

Christie's, *Sale Cat.* 11 June 1968, no. 88, 1.

(a) Woman with thyrsus and situla, seated nude youth with phiale and branch, (b) standing woman and woman seated on rock.

3. THE ZAGREB GROUP

(i) THE ZAGREB PAINTER

The first two bell-kraters (nos. 49–50) well illustrate the characteristic style of this painter. These two vases are much alike, except that the placing of the figures on the obverse of the Zagreb krater is reversed on the other. On the himatia of the draped youths, who are usually tall and slender, both the overhang on type B and the "sleeve" on C and D can be very long (nos. 49–51). Both vases have wave-pattern below the pictures, dots at the handle-joins and a simple scroll with smaller leaves beside the handle-fans. Quartered disks and phialai appear in the field. There is a tendency for the feet to cut into the reserved band above the wave-pattern (e.g. nos. 49–50, 52). The Naples krater is similar, but the pattern-work is more elaborate; compare, however, the draped youths with those on nos. 49–51, and also with those on no. 53. The small dots with which the fold-lines sometimes start (e.g. on no. 50) betoken the influence of the Varrese Painter.

Bell-kraters

49 Zagreb 10.

Damevski, no. 26, pls. 10, 1 and 15, 2.

(a) Seated woman with thyrsus and phiale, satyr with wreath, (b) B + C.

* 50 Paris, Cab. Méd. 934. PLATE 119, 1–2.

(a) Young satyr with bunch of grapes and situla, seated draped woman with cista and thyrsus, (b) B + D.

* 51 Bari 12034. PLATE 119, 3–4.

(a) Standing woman with bunch of grapes, seated nude youth with phiale and thyrsus, (b) two draped youths.

* 52 Naples 1934 (inv. 81436). PLATE 119, 5–6.

(a) Seated satyr holding up wreath and phiale, standing woman holding dove on a string in r. hand and tambourine in l., (b) B + C.

Column-kraters

53 Vatican V 49 (inv. 18082).

VIE, pl. 32 i and pl. 33 i.

(a) Seated nude youth with thyrsus and phiale, woman with torch and tambourine, (b) B + C.

54 Bologna 581.

CVA 3, IV Dr, pl. 17, 3–4; Scarfi, *ArchCl* 11, 1959, p. 186, no. 5, pl. 63.

(a) Maenad with thyrsus and tambourine followed by Oscan youth with phiale, (b) B + C.

(ii) THE MONTESCAGLIOSO PAINTER

Named after the find-spot of the three vases attributed to him.

Column-krater

55 Matera 9952.
Lo Porto, *Penetrazione,* pl. 39, 3—4. Photos: R.I. 66.1309—10.
(a) Woman with basket of cakes and torch, Oscan warrior with kantharos and two spears, (b) B + F.

Amphora

56 Matera 9938.
Lo Porto, op. cit., pl. 38, 2—3.
(a) Youth with cista and woman with patera at stele tied with fillets, (b) B + C.

Hydria

57 Matera 9948.
Lo Porto, op. cit., pl. 39, 1—2.
Woman with branch and cista, youth with kantharos and branch at stele tied with fillets (as on previous vase).

4. THE RUVO 512 — ROERMOND GROUP

A group of vases, closely interconnected by the treatment of the female figures and the draped youths, which again clearly reflects the influence of both the Snub-Nose and the Varrese Painters.

(i) THE PAINTER OF RUVO 512

The drawing of the "sleeve" of the youth to right (type C) is very characteristic. The bent arm, which is foreshortened to give it almost the look of a rounded stump, is enveloped in the himation with a semi-circular line around the lower part of it (cf. with the Varrese Painter, e.g. nos. 13/66—68, 81); beneath this there is a slight "sleeve" effect, upon which there is sometimes an S- or double S-shaped fold-line (e.g. nos. 58, 60—62). The painter likes dotted closed wreaths (e.g. nos. 58, 62, 63; cf. with nos. 1, 4—5, 9), diptychs with three vertical and two horizontal lines, and dots in each of the sections (e.g. nos. 58, 60—61; cf. with no. 9); the hair of youths is curly. Matera 11036 (no. 63) is a late piece, but it illustrates most of the chief characteristics of the painter's style and shows the influence of later followers of the Varrese Painter, like the painters in the Schulman Group (see below, section 9). The pattern-work is also far more elaborate.

(a)

Column-krater

* 58 Ruvo 512. PLATE 120, 1—2.
(a) Oscan warrior with raised foot, holding two bunches of grapes and dotted wreath, seated woman with phiale and branch, (b) B + C.
Note the treatment of the rock on which the woman is seated which should be compared with that of the Varrese Painter.

Bell-kraters

59 Bologna 601.
CVA 3, IV Dr, pl. 24, 3—4.
(a) Youth with thyrsus following woman with cista and situla, (b) B + C.

* 60 Frankfurt X 2629. PLATE 120, 3–4.
 Schaal, pl. 55a.
 (a) Nude youth with filleted torch and situla, standing draped woman with wreath and phiale,
(b) B + C.
 61 Matera 11170, from Timmari.
 (a) Seated satyr with thyrsus and phiale, woman with tambourine and thyrsus, (b) B + C.
 62 Milan 235.
 CVA, IV D, pl. 3.
 (a) Woman with thyrsus and tambourine, seated youth with two phialai and thyrsus, (b) B + C.
* 63 Matera 11036, from Timmari. PLATE 120, 5–6.
 (a) Satyr with thyrsus pouring from oenochoe into phiale held by seated Dionysos, woman with
wreath and thyrsus, (b) B + D + C.

Amphora

63a Bologna 515.
 CVA 3, IV Dr, pl. 2, 1–2.
 (a) Draped woman with cista and filleted wreath, nude youth with fillet and cista at stele, (b) B
+ FX, with phiale.
 Cf. the reverse with that of no. 62.

(b) CONNECTED VASES

Bell-kraters

 64 Policoro 32014. Much of the reverse is missing.
 (a) Woman with thyrsus and tambourine, satyr with situla and thyrsus, (b) B + D.
 65 Foggia 131280, from Salapia T. 156.
 (a) Young satyr with thyrsus and dish of cake moving l., followed by Dionysos with fillet and
thyrsus, (b) A + F.

(ii) THE PAINTER OF BARI 6408

Column-kraters

 66 Bari 6408.
 (a) Eros with situla and cista, seated woman with filleted wreath and thrysus, (b) B + C.
* 67 Philadelphia L. 64.230. (b) PLATE 121, 1.
 (a) Running woman with thyrsus and cista followed by nude youth with beaded wreath and
phiale, (b) B + C.
 68 Once Zurich Market, Galerie am Neumarkt, *Cat.* 16 April 1971, pl. 9, no. 84.
 (a) Running woman with thyrsus and phiale followed by satyr with wreath and situla, (b) B + E.
 69 Montevideo.
 Bausero, *Los vasos antiquos* (1963), p. 10, fig. 2.
 (a) Woman with bunch of grapes and tambourine running to l., followed by Oscan youth with
phiale and situla, (b) two draped youths.

(iii) THE ROERMOND PAINTER

This painter, who is named after the column-krater formerly in Warwick Castle and now
in Roermond (no. 70), favours Dionysiac scenes on his obverses; the reverses are very char-
acteristic and are reminiscent of those by the Snub-Nose Painter, except that now it is the
youth to right who has the "saucer" drape (type D or E). When he is of type D the "sleeve"
has a clearly defined black border, with two vertical lines running down from it to the double-S
curve marking the outer corner of the cloak (as on nos. 70–71).

Column-kraters

70 Roermond, Gemeentemuseum (ex Warwick Castle).
 Christie's, *Sale Cat.* 11 June 1968, no. 201; *Klassieke Kunst uit particulier Bezit* (Leiden, 1975), no. 573.
 (a) Youth with thyrsus and phiale, woman with wreath and cista, both moving to r., (b) B + E.
* 71 Bochum S 12 (ex Fulda, Dr. Welz). (b) PLATE 121, 2.
 Neugebauer, *Antiken aus deutschem Privatbesitz,* no. 182, pl. 81.
 (a) Seated nude youth with thyrsus and phiale, standing woman with wreath and cista, (b) B + E.
72 Once Naples, Woodyat coll. (*Sale Cat.,* pl. 5, no. 103).
 (a) Dionysos seated between maenad with thyrsus and tambourine and young satyr with kantharos and thyrsus, (b) three draped youths.
* 73 Milan, "H.A." coll. 369. (b) PLATE 121, 3.
 (a) Maenad with thyrsus, skin and tambourine, seated Dionysos with phiale and thyrsus, satyr with torch and situla, (b) A + CR + E.
* 74 Nocera, Fienga coll. 564 (De F. 518). (b) PLATE 121, 4.
 (a) Woman with raised foot holding wreath and situla, seated youth with phiale and thyrsus (cf. Taranto 4743 = no. 81), satyr with torch and thyrsus leaning on pillar, (b) A + C + E.
75 Trieste S 399.
 CVA, IV D, pl. 7, 1−2.
 (a) Oscan warrior, with spear in l. hand and kantharos in r., beside horse at altar, woman with wreath in r. hand and nestoris in l., bound prisoner, (b) A + C + E.

(iv) THE PAINTER OF GENEVA MF 290

This is an inferior artist, connected in style with the above.

(a)

Column-kraters

* 76 Geneva MF 290. PLATE 121, 5−6.
 (a) Dionysos seated between maenad with wreath and situla and young satyr with torch and thyrsus, (b) B + D + D.
77 Altenburg 341.
 CVA, pls. 101, 4; 102, 2; 105, 7.
 (a) Eros with mirror seated between woman with wreath and thyrsus and woman with fan and thyrsus, (b) B + D + FX, with strigil.
78 Vatican V 43 (inv. 18076).
 VIE, pls. 32 f, and 33 f.
 (a) Woman with fan and cista, Eros with torch and fillet, (b) B + F, with a stele between them.

Oenochoe (shape 1)

79 Stuttgart 4.269 (old no. 159).
 CVA, pl. 51, 1−3 and 6.
 Eros, with torch in l. hand, pouring wine from an oenochoe into a phiale held by a seated woman; to r., Pan with wreath and thyrsus.
 Close to Altenburg 341 (no. 77).

(b) CONNECTED

Column-krater

80 Würzburg 858.
 Langlotz, *Cat.* pl. 246 (ex Woodyat coll., *Sale Cat.* pl. 5, no. 152).
 (a) Woman with dish of cakes, resting r. arm on pillar, seated Oscan warrior with two spears in r. hand, holding out phiale in l., into which an Oscan youth pours wine from a skin, (b) A + E + D.

(c) COMPARABLE

Column-krater

81 Taranto 4743, from Ceglie.
 CVA 1, IV Dr, pl. 12, 1–3.
 (a) Maenad with thyrsus and wreath, seated Dionysos with phiale and thyrsus, young satyr with situla and thyrsus, (b) CR + F.

5. THE GROUP OF VATICAN X 1

This group follows on from the Painter of Ruvo 512. Characteristic is the frequent appearance of the double-S (double wave) on the overhang or the "sleeve" of draped youths, in reverse on types A or B, as it faces outward (e.g. nos. 89–90).

(i) THE PAINTER OF BARI 898

(a)

This painter's work is very close to that of the Painter of Ruvo 512; the wavy fold-lines on the overhang or "sleeve" are more extensive. On the necks of the column-kraters the ivy leaves are accompanied by triple-dot clusters. Legs are disproportionately short in relation to the thighs.

Bell-krater

* 82 Bari, Sette Cirillo coll. 3. (b) PLATE 122, 1.
 (a) Seated Dionysos with bunch of grapes and phiale, standing woman with tambourine and thyrsus, (b) B + D.

Column-kraters

* 83 Bari 898. (b) PLATE 122, 2.
 (a) Woman with cista moving l., followed by Eros with tambourine and fillet, (b) B + C.
84 Bari 5594.
 (a) Seated Oscan warrior with branch, woman with phiale and tambourine, (b) B + C.
85 Once Nostell Priory; Christie's, *Sale Cat.* 30 April 1975, no. 18.
 (a) Seated Eros with cista of cake, woman with situla and thyrsus, (b) B + C.
86 Once London Market, Sotheby, *Sale Cat.* 14 June 1976, no. 214.
 (a) Seated Eros with dish of cake, approached by woman with filleted wreath and thyrsus, (b) B + C.
 Late.

(b) CLOSELY RELATED VASES

Column-kraters

87 Lecce 832 (= 5177).
 CVA 2, IV Dr, pl. 29, 4 and pl. 28, 8.
 (a) Seated nude youth with thyrsus and cista, standing woman with tambourine and bunch of grapes, (b) B + C.
88 Bari 6381.
 (a) Seated woman with wreath and dish of cake, nude youth with tambourine and thyrsus, (b) B + C.

(ii) THE PAINTER OF VATICAN X 1

The work of this painter seems to represent a slightly later development from that of the Painter of Ruvo 512, and the double S's are even more pronounced (e.g. on nos. 89–90); it is contemporary with the vases of the followers of the Darius and Underworld Painters in

the third quarter of the fourth century and should be compared with vases like Toronto 403 and Chini coll. 81 (see Volume II).

Column-kraters

89 Vatican X 1 (inv. 18101).
 VIE, pl. 34 b and pl. 35 b.
 (a) Seated woman with mirror and phiale, nude youth with rosette-chain resting l. arm on pillar, with thyrsus in l. hand, (b) A + C, with altar + ivy leaf between them.

90 Vatican Z 11 (inv. 18138).
 VIE, pl. 34 f and pl. 35 f.
 (a) Woman running to l. with thyrsus, open box and rosette-chain, followed by nude youth with situla and thyrsus, (b) A + C, with palmette between them.

91 Frankfurt Market, De Robertis, *Lagerliste* II, no. 52 (ill.).
 (a) Woman with tambourine and open box moving to l., followed by nude youth with filleted wreath and thyrsus, (b) B + D.

92 Once New York Market (ex coll. Alejandro Groizard).
 NSc 1884, p. 249, no. 18.
 (a) Seated woman with branch and fillet, Oscan youth with nestoris, shield and spear, Oscan youth with foot on rock, holding torch, spear and shield, (b) B + D + C.

93 Madrid, Palacio de Liria CE 32.
 Blanco Freijeiro, *Zephyrus* 15, 1964, p. 81, no. 26, figs. 48–9.
 (a) Oscan youth with mirror and phiale followed by woman with wreath and cista, (b) B + C.
 Late.

Bell-kraters

94 Bassano del Grappa, Chini coll. 82.
 (a) Woman with fan and cista moving to l., followed by Eros with situla, (b) A + C.

95 Bari 23062.
 (a) Satyr with mirror and situla, seated woman with tambourine and thyrsus, (b) A + C.

Closely connected with the work of this painter, as may be seen from the treatment of the woman and nude youth on the obverse (cf. with nos. 89–90) and the S borders to the overhang and "sleeve" of the two youths on the reverse, is the following:

Bell-krater

96 Lecce 4244, from Lecce.
 NSc 1934, pp. 179–80, figs. 1–2; Bernardini, *Lupiae,* pp. 65–6, figs. 33–4.
 (a) Woman with wreath and cista, moving to l., followed by nude youth with tambourine and palm branch, (b) B + C.

(iii) THE PAINTER OF VIENNA 1051

The drawing of the peplos over the women's breasts with a central dividing line between them provides a connecting link with the work of the Chiesa Painter. The himatia of the draped youths are treated in a manner very similar to that of the Painter of Vatican X 1. The facial features of women, especially the nose and mouth, are small.

Pelikai

* 97 Vienna 1051. PLATE 122, 3–4.
 (a) Seated woman with phiale, nude youth with foot raised on rock-pile, holding filleted wreath and mirror, (b) B + CX.

Pelikai (continued)

98 Zagreb 1071.
 (a) Woman with bunch of grapes and phiale standing in front of seated nude youth with mirror and branch, (b) B + D.

Bell-krater

99 Vatican V 31 (inv. 18064).
 VIE, pl. 30 f.
 (a) Young satyr, holding mirror and rosette-chain, bending forward in front of seated woman with phiale, ball and patera; to r., lily, (b) A + C (badly damaged).

(vi) THE B–C PAINTER

This is a late painter to whose hand at present two pelikai may be assigned. His figures are elongated, but his treatment of the draped youths follows on closely from that of the vases in the preceding divisions.

Pelikai

*100 Benevento 359. PLATE 122, 5–6.
 (a) Seated nude youth with phiale, standing draped woman with cista and branch, (b) A + F.
 101 Capua 8349 (P. 100).
 CVA 4, IV D, pl. 2, 9 a–b.
 (a) Seated woman and nude youth, (b) A + E, with a stele between them.

6. THE GINOSA GROUP

The Ginosa Group takes its name from the find-spot of Taranto 51011–2 and 51014 (nos. 102–3, 109); it should be noted that a hydria from the same tomb (51013) is attributed to the Varrese Painter (no. 13/6) and this suggests an association between him and the vases in this group, which is reinforced by a comparative study of their treatment of naiskos scenes and of draped youths. Close parallels will also be found between the vases of the Ginosa Group and those by the "H.A." Painter (cf. for example, Philadelphia L. 64.26 = no. 104 with "H.A." 446 = no. 12/126), who provides one of the clearest connecting links between the vases grouped around the Snub-Nose Painter and the work of the Varrese Painter. The Ginosa Group is also of importance as providing a link, especially in its preference for white head-bands on its draped youths, with the Schulman Painter and his associates (see below, section 9), as well as with the contemporary painters of the "Ornate" style, and the Gioia del Colle Group (see Chapter 17).

(i) THE GINOSA PAINTER

The work of the Ginosa Painter is very close to that of the Painter of Lecce 660 (see Chapter 12, section 2), and the possibility that they are in fact one and the same should not be overlooked, although certain points of difference will be noted. The two painters have the following elements in common:

(a) the use of a thick black line to divide women's breasts (cf. nos. 12/43–45 with nos. 102 and 104 below)
(b) the treatment of the draped youths on the reverses; compare, for example, those on the reverses of nos. 12/47–48 and 54 with those on no. 102; the close parallels in the drawing of the himatia are obvious (wavy border to overhang, detached zig-zag in bottom corner, wavy line down the top of the himation on the youth to r.)
(c) the rendering of the seated youths in the naiskos (cf. nos. 12/54–55 with nos. 102–3).

We may note as particularly characteristic of the Ginosa Painter:

(i) his drawing of draped youths — the points of resemblance with those by the Painter of Lecce 660 have already been noted, but now they usually wear white head-bands; type C has a long, cylindrical "sleeve" with a slightly curving black line along the edge, which may take the form of a flattish C (e.g. nos. 102, 110), and his slightly protruding stomach is often demarcated with double lines (e.g. nos. 104–5, 109)

(ii) the treatment of the draped, standing woman, sometimes with a piece of drapery over one arm, sometimes resting one arm on a pillar (e.g. nos. 102, 104–5, 108–9)

(iii) the male figure bending slightly forward over one raised foot, as on nos. 105, 107, 108.

The two Taranto amphorae from the Ginosa tomb make a matching pair, and it should be noted that on the first the youths do not wear white head-bands (cf. also nos. 110, 112–3), but otherwise correspond very closely to those on the second, which in turn match those on the Philadelphia amphora. The stylistic links between the different vases by this painter are unusually clear, and we may also note his use of a band of wave-pattern beneath the tongues on the necks of his amphorae (reverses of nos. 102–3, obverse of no. 104) and his fondness for flowers and rosette-chains (cf. also the Group of Lecce 660).

Amphorae

102 Taranto 51011, from Ginosa (2/7/33).

(a) Youth with wreath, phiale and fillet, and woman with open cista and fillet in r. hand, and bunch of grapes in l., leaning on pillar, at a naiskos in which is a standing warrior with two spears and shield, (b) B + C + CX, with strigil.

Note the white swastika-meander pattern accompanied by reserved saltires on black on the base of the naiskos (cf. with Bari 20027 = no. 123 below).

103 Taranto 51012, from Ginosa.

(a) Woman with cista and fillet, youth with raised foot, holding wreath and bunch of grapes, at naiskos in which is a youth with two spears seated on drapery, (b) B + B, with strigil + C.

*104 Philadelphia L. 64.26. PLATE 123, 1–2.

(a) Woman with wreath and cista, and youth with phiale and alabastron, at naiskos in which is a hanging pilos and a shield (cf. Milan, "H.A." 446, no. 12/126), (b) B + C.

Column-kraters

*105 Milan, "H.A." coll. 335. PLATE 123, 3–4.

(a) Oscan youth with foot raised on rock, holding out kantharos and situla to seated Oscan youth with two spears and shield, draped woman with wreath in r. hand resting l. arm on pillar, (b) B + CR, with strigil, + C.

106 Vienna 800.

(a) Woman with beaded wreath and basket of cakes, seated Oscan warrior with phiale and two spears, Oscan warrior with wreath and spear, resting l. elbow on pillar, (b) BX + C + D.

107 Once Lucerne Market, Galerie Fischer, *Sale Cat.* 16 Nov. 1954, no. 241, ill. on pl. 4.

(a) Warrior with foot raised, holding bunch of grapes and oenochoe, seated woman with dish of cakes, warrior with wreath and spear, seated warrior, (b) woman seated between youth and woman. Cf. also with the work of the Maplewood Painter.

Bell-kraters

*108 Milan, "H.A." coll. 418. PLATE 123, 5–6.

(a) Young satyr with foot raised on rock, holding kantharos and situla, seated Eros with triple flower, woman with rosette-chain resting l. elbow on pillar and holding mirror in l. hand, (b) B + D + C.

109 Taranto 51014, from Ginosa.

(a) Seated Dionysos with thyrsus and phiale, draped woman resting l. arm on pillar, holding rosette-chain and cista, (b) B + C.

110 Madrid 11089 (L. 354).
 (a) Woman with thyrsus and basket of cakes resting r. arm on pillar, seated youth with rosette-chain and cista, (b) B + C.
111 Matera 150122.
 (a) Seated nude youth with palm branch, woman with phiale and thyrsus, (b) A + C.

CONNECTED IN STYLE

The following vase is connected in style with the work of the Ginosa Painter and with the vases in division (ii); cf. also with no. 50 by the Zagreb Painter.

Pelike

111a B.M. F 318.
 (a) Nude youth with wreath and phiale, draped woman with mirror and tambourine; between them, a flowering plant, (b) A + C.

(ii) THE GROUP OF THE SOTHEBY AMPHORAE AND LOUVRE K 74

(a)

The two Sotheby amphorae (nos. 112–3), which have at present disappeared from sight, form a matching pair in subject and style. On the obverse of both is a flowering plant inside a naiskos of simple form set on a basis decorated with a white scroll pattern (cf. no. 103 above); beside it are a youth and woman with various offerings in their hands, the former standing to left on no. 112 and to right on no. 113. On the reverses are two tall draped youths holding sticks, with various adjuncts (*halteres,* an open dotted wreath, phialai, a sash or a window) in the field above. They are very close to those on no. 102 above.

With these two amphorae may be associated three hydriai with naiskos scenes flanked by very similar youths and women. The swastika meander accompanied by plain black squares which decorates the base of the naiskos on no. 116 finds an interesting parallel in a surviving fragment of the architectural decoration of an actual tomb monument — Taranto, Tomb 30 = Carter, *The Sculpture of Taras,* pl. 66 b — although of somewhat later date.

Amphorae

*112 Once London Market, Sotheby. PLATE 124, 1–2.
 Sotheby, *Sale Cat.* 18 June 1968, no. 110, ill. opp. p. 62; Christie's, *Sale Cat.* 8 July 1969, no. 126; Sotheby, *Sale Cat.* 29 March 1971, no. 161, ill. opp. p. 40.
 (a) Youth with phiale, and woman with long-handled patera at a naiskos in which is a plant with a large flower, (b) B + C, with a stele between them.
*113 Once London Market, Sotheby. PLATE 124. 3–4.
 Sotheby, *Sale Cat.* 18 June 1968, no. 108, ill opp. p. 62; Christie's, *Sale Cat.* 8 July 1969, no. 127; Sotheby, *Sale Cat.* 29 March 1971, no. 162, ill. opp. p. 40.
 (a) Woman with raised foot, holding wreath and phiale, and youth with long-handled patera at a naiskos in which is a plant, (b) B + C.

Hydriai

114 Bari 8013.
 Woman with mirror seated in naiskos between to l. woman with flower and alabastron, to r. nude youth with patera and strigil.
115 Vatican Z 25 (inv. 18152).
 VIE, pl. 41 k and fig. 20 b.
 Woman with cista and mirror, and youth with patera, at naiskos in which is a flowering plant.

Hydriai (continued)

116 Taranto 54085, from Egnazia.
 Woman in naiskos; to l., woman resting r. arm on pillar and holding wreath in l. hand, to r., nude youth with drapery behind his back and branch in l. hand.

(b)

Associated in style with the above are three dishes, all decorated with female heads in the tondo and one or two figures on each side of the exterior. The heads are of some interest as providing a connecting link with a number of smaller vases decorated solely in this way, which will be listed and discussed in Volume II.

Dishes

117 Philadelphia L. 64.23.
 Schneider-Herrmann, *Paterae* no. 110, pl. 14, 2.
 I. Female head, with mirror; white grape-vine around (as on nos. 118–9). A. Seated woman with phiale and beaded wreath, seated Eros with fan. B. Nude youth with tambourine and situla running to l., followed by woman with mirror and cista.

*118 The Hague, Schneider-Herrmann coll.184 (ex Basel, MuM; ex London Market, Sotheby). PLATE 124, 5–6.
 Sotheby, *Sale Cat.* 27 Nov. 1967, no. 124 (ill.); *Art in Ancient Italy*, p. 45, no. 72 (ill.); Schneider-Herrmann, *Paterae*, no. 111.
 I. Female head with mirror; white grape-vine around. A. Seated Eros with phiale and bead wreath, seated woman with mirror and cista. B. Seated woman with cista and bunch of grapes, seated nude youth with wreath and phiale.

119 Cefalù 37.
 Schneider-Herrmann, *Paterae*, no. 116.
 I. Female head, with rosette; white grape-vine around. A. Flying Eros with phiale and beaded wreath. B. Seated woman with phiale and filleted laurel-branch.

(c)

Volute-krater

*120 Louvre K 74. PLATE 125, 1–2.
 Él. Cér. iv, pl. 89.
 (a) Youth with wreath and phiale, woman with sash and cista at plinth on which stands the statue of a youth resting his arm on a pillar, with a krater and an oenochoe beside him; a lyre to l., and a patera to r., (b) woman and youth at stele, on top of which is a kantharos.
 Neck: (a) female head in profile to l. amid tendrils with two flowers.
 Mascaroons: frontal female heads wearing Phrygian helmets.

This is a vase of some importance for both subject and style. Representations of free-standing statues on Apulian vases are not very common — they go back to the Gravina Painter at the turn of the century (e.g. no. 2/3) and appear on some of the volute-kraters of the Iliupersis Painter (e.g. nos. 8/9, 10 and 12). Of these Milan "H.A." 285 (8/10) is closest to the present vase, on which the statue is done in an orange-pink shade, with the drapery in crimson-red; this, in association with the added white of the two vases flanking the statue and on its plinth, gives the picture a slightly polychrome look, reminiscent of the Varrese Painter's hydriai in Taranto (nos. 13/1–2) and provides another instance of the meeting of the "Ornate" and "Plain" styles around the middle of the century.

The figures of the draped women on both sides of the vase are very close to those of the Ginosa Painter, especially on Vienna 800 (no. 106), as well as to those on the Vatican hydria (no. 115).

(iii) THE PAINTER OF B.M. F 336

The Painter of B.M. F 336, who favours funerary scenes on his vases, stands close to the Painter of the Sotheby Amphorae, and is strongly under the influence of the Ginosa Painter, as may be see from a comparison of the decoration on the base of the naiskos on Bari 20027 (no. 123) with that on Taranto 51011 (no. 102). This swastika-meander pattern, accompanied by black squares with reserved saltires in the form of four connected dots, is frequently used on the nasikoi in the Gioia del Colle Group and later by the Patera Painter, whose follower, the Ganymede Painter, is particularly fond of plants in naiskoi (cf. *Ap Grabvasen,* pls. 12–13).

The draped youths on the reverses show slight variations from the standard types. On the left the youth's head faces right but his body is frontal, with the himation over the left shoulder and the left arm slightly akimbo; the right youth holds a stick in his extended right arm and conforms to type F. There is a thick black line across the upper part of the himation, and a wavy one in the bottom right corner.

A feature of interest is the black-figured amphora with a fillet round the neck which appears on the Dechter hydria (no. 121) below the right handle and on a plinth on the obverse of B.M. F 336 (no. 122). The latter recalls the similar vase on Naples 1964 by the Schiller Painter (no. 4/31 above); these vases should also be compared with the b.f. volute-krater on Naples 2253 (in the Group of the St. Louis Pelike, no. 7/109 above) on which the saltires with small dots accompanying the meanders are also very like those on the Dechter hydria. On Sèvres 47 (no. 124) we have a ribbed metal vase in the naiskos, recalling those by the Varrese Painter (e.g. Bonn 99, no. 13/3); cf. also with Bari 5261 (no. 127 below).

Hydria

*121 Los Angeles, Dechter coll. (ex London Market, Sotheby). PLATE 125, 3.
 Sotheby, *Sale Cat.* 9 Dec. 1974, no. 122.
 Woman with mirror and wreath in naiskos, resting l. arm on pillar; to l., woman with fillet and mirror bending forward over raised foot, to r., woman with branch and fan.
 To l. beneath the handle is a kalathos with a mirror, to r., a b.f. amphora, with a fillet round the neck.

Amphorae

*122 B.M. F 336. PLATE 126, 1–2.
 (a) Woman with wreath and phiale, nude youth with wreath and staff beside a b.f. amphora on a plinth, (b) CR + F, with a Doric column between them.
*123 Bari 20027, from Gioia del Colle T. 2, no. 22. PLATE 126, 5.
 Scarfì, *MonAnt* 45, 1960, 167 ff., figs. 22–5.
 (a) Woman with phiale and nude youth with wreath at naiskos, in which is a flowering plant, (b) CR + F.
 124 Sèvres 47.
 CVA, pl. 37, 4–7.
 (a) Seated youth with sash and phiale, standing woman with wreath and basket of offerings at naiskos in which is a ribbed amphora, (b) CR + F, with small stele between them.

CONNECTED

Bell-krater

 125 Bari, Macinagrossa coll. 15.
 (a) Nude woman adjusting kottabos-stand beside reclining banqueter holding kylix, (b) CR, with strigil + F.

(iv) THE PAINTER OF BARI 12061

This painter provides us with an interesting group of vases linked together (a) by the presence in the naiskoi of ribbed metal vases (cf. the Varrese Painter, nos. 13/3—5 and Sèvres 47 = no. 124), and (b) by the presence of a draped woman with the left leg bent, and a black stripe running down the drapery which covers it and following the line of the leg (e.g. nos. 126—7, 129). This phenomenon may also be observed on the column-krater in the collection of Mlle. Dunant (no. 13/227), which was at first thought to belong to this group, but is now seen as nearer to the Wolfenbüttel Painter.

The treatment of the women's drapery, especially across the breasts, associates the vases with those of the Ginosa Painter.

Amphora

*126 Bari 12061. PLATE 126, 3—4.
 (a) Youth with branch and draped woman with fillet and branch at naiskos in which is a volute-krater with a fillet tied to each handle, (b) A + C.

Hydriai

127 Bari 5261.
 Youth with l. foot raised on rock-pile, holding alabastron and beaded wreath, and standing woman with mirror and branch beside a naiskos in which is a ribbed amphora on a three-legged stool.

128 Trieste S 393.
 CVA, IV D, pl. 2, 2 and 6.
 Two women, l. with cista and fillet, r. with phiale and branch, at a naiskos in which stands a hydria on a pedestal.

Situlae (Type 2)

*129 Once Roman Market (Photos: R.I. 57.288—9). (b) PLATE 126, 6.
 (a) Eros flying to crown Dionysos seated between maenad with thyrsus and wreath and young satyr with raised foot, holding wreath and situla, (b) seated youth with thyrsus and cista, woman with torch and thyrsus.

130 Naples Stg. 353.
 (a) Woman with thyrsus, swan, seated woman with mirror and tambourine, nude youth with torch and branch, Eros above flying towards the seated woman, (b) satyr bending forward over raised foot and holding torch, seated woman with fillet and thrysus.

Oenochoai (shape 3)

131 Vienna 530.
 Woman with alabastron and tambourine leaning forward over l. foot raised on rock-pile, seated Dionysos with thyrsus and phiale, silen with torch and situla.

132 Once New York Market (ex Basel, MuM).
 Art of Ancient Italy, no. 75, ill. on p. 48.
 Seated Dionysos with thyrsus and phiale, woman with torch and situla enveloped in mantle.

(v) THE NIMES PAINTER

The Nimes Painter is associated in style with the Ginosa Painter and the Painter of B.M. F 336, and regularly uses saltires with small dots, as on the Dechter hydria (no. 121). He also favours simple naiskos scenes, in which we note a greater use of added red on the drapery. His amphorae regularly have a band of egg pattern below the tongues on the obverse, and wave on the reverse. The right youth on the reverse has the typical wavy line at the top of his himation, but he is now rather broader, and instead of having a stick holds up a wreath or strigil. The

lower hem-line is continuous and ends in a series of wavy curves.

(a)

Amphorae

133 Milan, "H.A." coll. 411.
CVA 1, IV D, pl. 33.
(a) Woman with mirror and wreath seated on rock-pile in naiskos; fillet on either side, (b) B + FX, with wreath.
Shoulder: white female head in profile to l.

134 Frankfurt. Foot mostly modern.
(a) Youth in naiskos seated on red cloak, holding branch and wreath; fillet on either side, (b) B + F, like those on the Milan amphora.
For the youth in the naiskos cf. Naples 2029 and 2887 (nos. 12/54—55).

135 Once Paris Market, Hôtel Drouot, *Sale Cat.*, 20 June 1973, no. 44 (ill.).
(a) Youth in naiskos seated on red cloak, with r. hand on shield and l. holding up wreath; fillet on either side, (b) two draped youths.
Shoulder: frontal female head.
The obverse is very close to that of Milan "H.A." 411 and of the Frankfurt amphora.

136 Once Paris Market, Hôtel Drouot, *Sale Cat.*, 20 June 1973, no. 43 (ill.).
(a) Woman with mirror and bead-chain seated in naiskos, with a hydria beside her, and a piece of red drapery over her legs, (b) A + E.

Column-krater

137 Naples 2090 (inv. 82407).
(a) Woman with foot raised, holding cista and bunch of grapes in r. hand, seated youth in Oscan dress with phiale of offerings (ivy leaf above), thyrsus and situla, (b) B, with wreath + F.

(b)

Amphora

*138 Nimes 891.25.40. PLATE 127, 1—2.
(a) Youth with l. foot raised on rock-pile holding wreath in r. hand and bunch of grapes in l. in front of seated woman with phiale and bead-wreath, (b) A + F.

Pelike

139 Warsaw 198140.
CVA, Poland 7, pl. 42.
(a) Eros bending forward over raised foot, with wreath in r. hand, seated half-draped woman with phiale and wreath, (b) A + F, with strigil.

Bell-kraters

*140 Nocera, Fienga coll. 562 (De F. 751). PLATE 127, 3—4.
(a) Standing woman with wreath and phiale, seated Eros with phiale and wreath, (b) B + F, with wreath.

*141 Milan, "H.A." coll. 396. PLATE 127, 5—6.
(a) Eros with wreath and mirror, seated woman with phiale and branch, (b) A + F, with strigil.

7. THE CHIESA GROUP

(i) THE CHIESA PAINTER

The Chiesa Painter, who takes his name from the owner of the volute-krater (no. 142) at present on loan to the Antikenmuseum in Basel, is an artist of some significance, since like several of the painters in the Ginosa Group, he decorates vases in both the "Plain" and the

"Ornate" manner, and these provide further connecting links between the standard smaller vases from the Snub-Nose and Varrese workshops and those of larger dimensions with more elaborate subjects by the Gioia del Colle Painter and his colleagues, which will be discussed in Volume II.

Particularly characteristic of his work is the drawing of the female breasts, one of which is usually shown as a semi-circle, the other, rather smaller but more projecting, is often pointed: the woman on the reverse of no. 142 well illustrates the standard form (cf. also nos. 143, 145–7). The treatment of nude male figures, and especially of the piece of drapery which envelopes one arm, is strongly under the influence of the Varrese Painter; the draped youths on the reverses, who wear white head-bands, are related to those in the subsequent groups discussed in this chapter, although the drawing of their himatia should be compared with that on the vases by the Painter of Vatican X 1 and his associates.

His naiskoi (e.g. on nos. 142–5) all have fairly high bases, mostly decorated with varieties of scroll pattern (cf. with nos. 103, 114–5, 121) or on no. 145 with swastika meanders (see p. 223 above) accompanied by hollow squares in added white, with a smaller square in the centre. Those on nos. 142 and 145 have ceiling-beams, but those on the hydriai (nos. 143–4) do not (cf. nos. 114–6 and 121); all have a high architrave and either a disk or a rosette in the centre of the pediment. The four figures grouped around the naiskos on no. 142 follow the normal chiastic system, but on no. 145 we have two seated youths above and two standing women below; all hold standard offerings, among which the "xylophone" in the left hand of the seated woman on no. 142 may be noted. The neck of the Chiesa krater shows a profile head of Orpheus in a floral setting which has now become rather more elaborate (cf. with Louvre K 74, no. 120), and includes lilies and dianthus, as well as the common four-petalled flower (probably a rock-rose), amid spiralling stems and tendrils, springing from an acanthus plant.

Volute-krater

*142 Basel, Antikenmuseum (on loan from Dr. F. Chiesa). PLATE 128, 1–2.

(a) Youth with bird perched on r. hand beside a laver in a naiskos; to l., seated nude youth with wreath and phiale + spray, standing draped woman with bunch of grapes and cista; to r., seated woman with mirror and "xylophone", nude youth bending forward over raised foot, holding patera and strigil, (b) woman with bunch of grapes and mirror, nude youth with flower and branch at stele.

Neck: (a) head of Orpheus in floral setting.

Mascaroons: (a) female heads with white flesh, (b) female heads.

Hydriai

*143 Once London Market, Sotheby. PLATE 128, 3.

Sotheby, *Sale Cat.* 18 June 1968, no. 109, ill opp. p. 62; 17 Dec. 1968, no. 212.

Seated woman with mirror in naiskos, with woman to l. resting elbow on pillar, and holding alabastron and fillet, and, to r., youth with patera and branch.

144 Bari 880.

Woman with cista and mirror, woman with patera and cista at naiskos in which are a seated woman with open box and, bending over in front of her, woman holding kalathos.

Amphora

145 Naples 2192 (inv. 82382).

(a) Bearded man putting red cloak on stool, and youth with helmet and shield, in a naiskos surrounded by two seated youths above, l. with phiale, r. with filleted oenochoe, and below to l., standing woman

with mirror, and to r., woman with raised foot, holding mirror, (b) seated youth and seated woman above, and below, woman and youth, coming up to a tall stele with a kylix on top.

Bell-kraters

*146 Lecce 667. (b) PLATE 128, 4.
 CVA 2, IV Dr, pl. 26, 12 and pl. 27, 5.
 (a) Standing woman with thyrsus and cista, seated Eros with fan, (b) B + C, with laurel-branch between them.
*147 Lecce 767. (b) PLATE 128, 5.
 CVA 2, IV Dr, pl. 24, 3–4.
 (a) Seated woman with mirror and phiale, satyr with raised foot holding torch and laurel-branch with bunch of grapes, (b) B + C, with pair of *halteres* between them.

Oenochoe (shape 3)

148 Frankfurt Market, De Robertis, *Lagerliste* II, no. 56 (ill.).
 Seated woman with bunch of grapes and phiale, nude youth holding up flower in r. hand (as on reverse of no. 142).

(ii) VASES RELATED IN STYLE

(a)

Pelikai

149 Paris, Cab. Méd. 910.
 (a) Nude youth with bunch of grapes and branch, seated woman with tambourine and phiale, (b) A + C.
 Note the diptych on the reverse, with the stylus vertical instead of horizontal.
150 Naples 2010 (inv. 81813).
 (a) Standing woman with wreath and mirror, seated Eros with phiale, (b) B + D.

(b)

Amphora

151 Matera 11014, from Timmari, T. 2.
 (a) Nude youth with branch and cista, woman running to r. with filleted wreath and mirror, (b) B + D.

Pelikai

152 Matera 11003, from Timmari, T. 2.
 (a) Woman with mirror and phiale, Eros with tambourine and bunch of grapes, (b) B + C.
153 Louvre K 106.
 (a) Seated youth with branch and phiale, woman with foot raised on rock-pile holding alabastron and fillet, (b) B + D.
*154 Policoro 32755, from Battifarano. (b) PLATE 128, 6.
 Atti XI⁰ CStMG, pl. 11, 1.
 (a) Seated woman with branch and phiale, nude youth with wreath resting l. arm on pillar, (b) A + C.
155 Basel 1906.308.
 (a) Woman with patera and bunch of grapes running to r. after nude youth with torch and branch, (b) A + C.

Hydria

156 Matera 10629.
 Woman with mirror and cista, and nude youth, with situla and branch.

8. THE PAINTER OF VIENNA 1072

The Painter of Vienna 1072 looks back to such vases as Vatican V 12 in the Schiller Group (no. 4/39 above), but the treatment of his draped youths is closely connected with that of the Chiesa Painter and of some of the painters in the Schulman Group; the context in which Bari 20148 (no. 159) was found (see *MonAnt* 45, 1960, cols. 256 ff.) suggests a date for the tomb in the second half of the fourth century B.C.

Characteristic of the painter is the treatment of women's hair in a high curling mass sticking upwards from the back of the head (cf. nos. 157–8); note also the clear demarcation of the fold-lines on the drapery, and the pronounced kink in the centre of the black line running down the top of the himation of the youths to right on the reverses (reminiscent of the Schlaepfer Painter). The meanders are accompanied by saltire squares with strokes.

Bell-kraters

*157 Vienna 1072. PLATE 129, 1–2.
 (a) Maenad with thyrsus and phiale, and Dionysos resting l. elbow on pillar and holding bunch of grapes beside a banded bucket, (b) B + F.
*158 Once Milan Market, Casa Geri. PLATE 129, 3–4.
 Casa Geri, *Sale Cat.* 10 , 16 Dec. 1970, no. 732.
 (a) Seated woman with tambourine, satyr with fillet and thyrsus, (b) B + F.

Calyx-krater

159 Bari 20148, from Gioia del Colle, T. 6.
 Scarfi, *MonAnt* 45, 1960, col. 259, figs. 93–4.
 (a) Maenad with wreath and tambourine, Dionysos seated with phiale and thyrsus, (b) B + F.

The following vases are connected in style with the work of this painter. Note especially the treatment of the draped youths on the reverse of no. 160, between whom is a large suspended tablet bearing the inscription XAIPE. The running woman on the reverse of the Taranto calyx-krater is very like the one on Lecce 635, particularly in the rendering of the fold-lines and the drawing of the leg beneath the drapery. Both vases have hanging bunches of grapes above the picture on the obverse (cf. with no. 157).

Bell-krater

160 Lecce 635.
 CVA 2, IV Dr, pl. 24, 8 and 10.
 (a) Woman with fillet and phiale running to l. followed by young satyr with situla and torch, (b) B + C.

Calyx-krater

161 Taranto 123768, from Contrada Solito, T. 5.
 (a) Seated maenad with branch, holding up phiale in l. hand beneath bunch of grapes, young satyr reclining on couch and playing the flute, satyr with palm branch, (b) woman running to l. with phiale, followed by nude youth with bunch of grapes and phiale.

With the above, especially no. 160, the following should be compared:

Calyx-krater

161a Deruta (Perugia), Magnini coll. 196. Recomposed from fragments, with some pieces missing; foot modern.
 Dareggi, no. 17, pl. 14.
 (a) Dionysos with thyrsus and phiale leaning on pillar, woman holding up a vessel below a window,

satyr running up with torch, (b) B + C.
 Cf. also with Reggio 1138 (no. 14/200).

9. THE SCHULMAN GROUP

The Schulman Group, which takes its name from the Schulman Painter, perhaps its most charact-
eristic artist, contains a large number of vases, on which, in general, the youths on the reverses
wear white head-bands. This practice has already been observed on several vases in the preced-
ing sections (e.g. by the Ginosa, Nimes and Chiesa Painters), but it is especially typical of the
Schulman Painter and his circle. They, in turn, seem to have exerted a strong influence upon
the school of the Patera Painter, in which the smaller vases show a remarkably similar treatment
of the draped youths. Also characteristic of the Schulman Painter and his followers is the
multiple wavy line at the edge of the overhang on the himatia of types A and B; note also the
way in which the outer bottom corners of the himatia tail off into a long rectangle, down
which runs a corkscrew-like curl (as on nos. 168–170, 172–3).

(i) THE SCHULMAN PAINTER

The Schulman Painter, named after the calyx-krater in the Schulman collection in Boston,
is an important artist with a highly individual style, which, however, reflects the influence both
of the Snub-Nose Painter and his associates, and of the Varrese Painter, especially in his choice
of decorative patterns, like the scrolls with trefoils or drop-leaves beside the handle-palmettes.
A double scroll with trefoil between is the most common form. The meanders are accompanied
by saltire or quartered squares.

The reverse youths look back to those of the Laterza and Ginosa Painters (Chapter 12,
sections 5 and 6); between them may be a palmette-scroll or a stele on which is painted what
looks like a looped fillet with dotted ends (e.g. nos. 168, 170, 172, 178), unless it is meant to
represent bloodstains. Above them there are often *halteres,* typically with a white dot in the
centre (e.g. nos. 163, 167–171), rosettes or a simple diptych with three or four vertical strokes
and a horizontal one to represent the stylus. On some vases the arm of the youth to left projects
a long way outwards beneath his cloak, producing a somewhat exaggerated "saucer" effect, as
on nos. 182, 186, 188 (type A1).

Note the appearance on the obverses (e.g. nos. 172–3) of a youth with a piece of drapery
looped between his knees; we have already noted this pose on no. 23 above and it is frequently
adopted in the circle of the Darius and Underworld Painters.

The seated women (as on nos. 168–170), and women bending forward over a raised foot
(e.g. on nos. 171, 179, 188), show the same characteristics as those on the vases of the Varrese
Group and underline the close stylistic relationship between them.

The subjects are mostly Dionysiac and the painter likes thyrsi with a diamond-shaped head
(e.g. nos. 171–2, 178).

(a)

Bell-kraters

162 Lecce 663.
 CVA 2, IV Dr, pl. 24, 9.
 (a) Standing woman with mirror and wreath, seated nude youth with phiale and thyrsus, (b) B + D,
 with palmette between them.
*163 Lecce 751. PLATE 129, 5–6.
 CVA 2, IV Dr, pl. 21, 7.
 (a) Dionysos with phiale and thyrsus seated between woman with bunch of grapes and mirror and

Bell-kraters (continued)

young satyr with kantharos and thyrsus, (b) B + F.

The reverse should be compared with those by the Painter of Vienna 1072.

164 Reading 87.35.33.
CVA, pl. 30, 2.
(a) Satyr with torch and situla following draped woman with cista and bunch of grapes, (b) B + F.

165 Trieste 1790 (Obl. 37).
(a) Dionysos with thyrsus and bunch of grapes, draped woman with phiale, (b) B + F.

166 Berkeley 8/4510.
(a) Nude youth with kantharos and bunch of grapes standing before seated woman with tambourine and thyrsus, (b) B + E.

167 Naples 2113 (inv. 81368).
(a) Woman with bunch of grapes and cista, nude youth with tambourine and branch, moving to l., (b) B + F.

*168 Once London Market, Sotheby. PLATE 130, 1–2.
Sotheby, *Sale Cat.* 16 July 1968, no. 161.
(a) Woman with wreath and tambourine seated on rock, young satyr with raised foot, holding torch and situla, (b) B + F.

*169 Sydney 69. PLATE 130, 3–4.
(a) Satyr with kantharos and situla bending forward over raised foot to offer seated woman kantharos and situla, (b) B + F.

170 Philadelphia L. 64.243. In bad condition.
(a) Seated woman with bunch of grapes and tambourine, satyr bending forward over raised foot, holding phiale + ivy leaf and situla, (b) B + F.

171 Bari, Tagarelli coll. 2.
(a) Woman with raised foot, holding cista and bunch of grapes, seated nude youth with phiale and thyrsus, (b) B + F.

(b)

Calyx-krater

*172 Boston, Mrs. Schulman (ex Hearst Estate 5524). (b) PLATE 130, 5.
Parke-Bernet, *Sale Cat.*, 5 April 1963, no. 90.
(a) Seated woman with fan, nude youth leaning on laver, young satyr with raised foot, holding situla and kantharos, (b) B + F.

Pelike

173 Policoro, from Roccanova.
(a) Woman with branch and phiale seated on rock-pile, youth with wreath leaning on pillar, with drapery looped over one knee (as on the Schulman vase), (b) two draped youths.

Bell-kraters

174 Zoetermeer, Mrs. E.G. van Seggelen Mayer.
Klassieke Kunst uit particulier Bezit, no. 576.
(a) Woman with wreath and mirror moving to l. followed by Eros with two phialai and a bunch of grapes, (b) B + F.

175 S. Pietro Vernotico, Dr. Cucci.
(a) Nude youth with phiale, and woman with open box and thyrsus, running to r., (b) B + F.

176 Taranto 135597, from Mesagne.
(a) Satyr with torch and situla, seated maenad with thyrsus and tambourine, (b) B + F.

177 Taranto 54208, from Oria. Foot modern and reverse in very bad condition.
(a) Eros with flower, seated woman with tambourine, nude youth with phiale and thyrsus resting l. arm on pillar, (b) B + F.

178 Taranto 54339.
 (a) Maenad with raised foot, holding bunch of grapes, seated Dionysos with thyrsus and phiale, satyr with torch and situla, (b) B + F.
179 Sèvres 10048. In very bad condition.
 CVA, pl. 35, 20–22.
 (a) Maenad, Dionysos and satyr, all moving to r., (b) B + F.
180 Lecce 640.
 CVA 2, IV Dr, pl. 21, 6 and pl. 22, 3.
 (a) Maenad, Dionysos and young satyr with situla, all running to r., (b) B + F, with a stele between them and three balls above it (cf. no. 166 and no. 187).
180a Liechtenstein, private coll.
 (a) Bearded Pan with torch and situla, Dionysos with phiale, alabastron and thyrsus, woman moving to r., with cista and mirror, (b) B + F.
181 Paris, Rodin 2.
 CVA, pl. 33, 3.
 (a) Draped woman with phiale and thyrsus seated between young satyr with raised foot and satyr with kantharos and thyrsus, (b) B + E.
*182 Milan 268. Detail of (b) PLATE 97, 2.
 CVA, IV D, pl. 1, 1–2.
 (a) Draped woman with phiale and thyrsus seated between satyr, with thyrsus and situla, and youth with phiale and thyrsus, (b) A1 + F.
 The obverse is very close to that of Rodin 2 (no. 181).
183 Lucera 560.
 (a) Seated Eros with phiale and spray, woman bending forward to l. over raised foot, holding mirror and branch, (b) B + C.
184 Lucera 561.
 (a) Seated woman with thyrsus, nude youth with wreath, (b) two draped youths.
 Note the form of the *halteres* with almost semi-circular depressions (cf. nos. 182, 187).

Oenochoe (shape 1)

185 B.M. F 374.
 Seated youth with thyrsus and phiale, seated woman with mirror (cf. nos. 181–2).

(c)

The following form a connected group with finely drawn drapery and, on the obverse, youths with long hair falling in curls on to their shoulders. The draped youth to left is normally of type A1; the Sotheby krater (no. 189) represents a late stage of the painter's work.

Bell-kraters

186 Lecce 661.
 CVA 2, IV Dr, pl. 20, 2 and 5.
 (a) Dionysos and woman with mirror seated beside basket of offerings between maenad with thyrsus and tambourine, and satyr with torch and thyrsus, (b) A1 + FL, with wreath + F. The upper part of the central youth is repainted.
187 Warsaw 147092.
 CVA, Poland 7, pl. 26.
 (a) Dionysos between seated maenad with phiale and maenad with foot raised, holding mirror and wreath, (b) B + C, with a stele between them, as on no. 180.
188 Once Agrigento, Giudice 146.
 Sale Cat. pl. 7.

Bell-kraters (continued)

(a) Eros crowning Dionysos, who is seated between two maenads, l. leaning against pillar, r. holding fillet and thyrsus, (b) three draped youths.

189 Once London Market, Sotheby.
 Sotheby, *Sale Cat.* 27 Nov. 1967, no. 160 (ill.), and 18 June 1968, no. 103.
 (a) Satyr with situla, maenad with thyrsus and mirror, seated Dionysos with phiale, and woman with wreath and branch, (b) A1 + CX, with wreath + C.

Pelike

190 Naples 2023 (inv. 81804).
 (a) Eros flying with fillet towards youth holding phiale in l. hand, with elbow resting on dotted pillar, and facing woman with "xylophone" seated on rock, (b) nude youth with phiale in l. hand and drapery over arm.

(d) COMPARABLE

With the above compare:

Column-krater

191 Turin, private coll.
 (a) Woman with mirror and tambourine, seated woman with thyrsus, holding phiale into which a young satyr with foot raised is pouring wine from an oenochoe, (b) A1 + F.

(ii) THE DION GROUP

The Dion Group is named after the Sèvres krater (no. 192) on the reverse of which is a tablet inscribed to Dion (cf. no. 160 above). The drawing is neat and both treatment and subjects are close to the Schulman Painter, even to the use of a white dot in the centre of the quartered disks on the reverse of no. 193. The draped youths are also like his, though the treatment of the bottom corners of their himatia is different; their heads tend to be small in proportion to the body. The meanders are usually accompanied by saltires.

(a)

Bell-kraters

192 Sèvres 9.
 CVA, pl. 33, 2, 8 and 12.
 (a) Satyr with torch and situla, Dionysos with kantharos and situla, maenad with tambourine, all running to r., (b) B + D, with a stele between them and a tablet inscribed ΔΙΩΝΙ above.

193 Lecce 611.
 CVA 2, IV Dr, pl. 21, 4 and 1.
 (a) Dionysos with phiale and thyrsus seated between satyr with torch and maenad with bunch of grapes and thyrsus, (b) B + F.

194 Jerusalem, Israel Museum.
 (a) Seated satyr with thyrsus and wreath, draped woman with cista and thyrsus, (b) two draped youths.

195 Naples 3420 (inv. 81663).
 (a) Woman with cista and fan, Dionysos with thyrsus, satyr with situla, (b) B + C + F.

(b)

Bell-kraters

196 Lecce 769.
 CVA 2, IV Dr, pl. 21, 2.
 (a) Satyr with thyrsus and situla, maenad playing the flute, Dionysos with thyrsus, and maenad with tambourine and thyrsus, (b) three draped youths (l. B, r. F; centre with r. arm enveloped and l. akimbo).

*197 York 24. PLATE 130, 6.

 (a) Draped woman with thyrsus and mirror, seated Eros with phiale, (b) B + CX, with strigil; stele
between them.

 The draped woman on the obverse should be compared with those by the Painter of Vienna 1072.

198 Naples 2161 (inv. 81382).

 (a) Seated woman with wreath and cista, standing nude youth with wreath and branch, (b) B + C,
with sash between them.

 The reverse is very badly preserved; the youths seem close to those on the other vases in this group.
The obverse has affinities with the vases of the Schulman Painter.

Column-krater

199 Bari 875.

 (a) Oscan youth with spear and dish of cakes running to l., followed by woman with filleted wreath
and tambourine, (b) B + C, with palmette between them.

(c) COMPARABLE

The following vase should be compared with the above:

Bell-krater

200 Reggio Cal. 1138.

 (a) Dionysos with torch and thyrsus running to l., followed by young satyr with kantharos and situla,
(b) BX, with cista + C.

 The youth with the cista is the precursor of a type popular with the Patera Painter.

(d) CONNECTED VASES

The two following vases, which are by a single hand, are connected in style with those of
the Dion Group and the Schulman Painter.

Bell-kraters

201 Bari 6268.

 (a) Satyr with wreath and phiale, seated maenad with thyrsus and tambourine, youth with rosette-
chain and phiale, (b) A + CR, with outstretched r. arm + C.

202 Trieste 1697.

 (a) Woman with torch and fan, nude youth with tambourine, satyr with mirror and bunch of grapes,
(b) B + C + F.

The following vase is also connected in style, particularly with York 24 (no. 197), and also
with the Schulman Painter, although the draped youths do not wear white head-bands:

Pelike

203 Copenhagen, Ny Carlsberg H 50.
 Bildertafeln, pl. 21.

 (a) Nude youth with phiale seated between Eros and woman with mirror and bunch of grapes,
(b) B + D.

(iii) THE BOCHUM PAINTER

The Bochum Painter is a close colleague of the Schulman Paninter and like him has a fond-
ness for an extended wavy border to the overhang of the himation on types A and B. He is an
uninspired painter and his figures have a rather heavy look. There are numerous adjuncts in the
field which tend to give his pictures a rather cluttered look — among these we may note beaded
wreaths with fillets, rosettes, phialai, sashes, windows and bucrania. Dishes of cakes appear on

several of his obverses. Like the Schulman Painter and others in this general group he depicts women with a cloak wrapped across their bodies, to leave a very small portion of one breast visible (cf. nos. 108–9 with nos. 182–3, 188, 197).

(a)

Column-kraters

*204	Bochum, Ruhr University S 576.	(b) PLATE 131, 1.

 Cat., p. 142, no. 122.

 (a) Seated Oscan warrior with spear and shield, standing draped woman with dish of cakes and wreath, (b) A + F.

*205	Philadelphia L. 64.229.	(b) PLATE 131, 2.

 (a) Seated woman with branch and basket of cake, Oscan warrior with phiale and two spears, (b) B + FX, with strigil; between them, a stele, above which is an ivy leaf.

206 Gravina.

 (a) Woman with raised foot holding basket of cake and wreath in r. hand above altar on to which a seated Oscan warrior is pouring wine from an oenochoe, (b) two draped youths.

Pelike

207 Once London Market, Christie's, *Sale Cat.* 6 Dec. 1972, no. 257, pl. 9, 2.

 (a) Seated youth with branch and phiale, draped woman with cista; above: Eros flying with fillet, (b) B + CX, with strigil.

(b)

Bell-kraters

*208	Hanover 1906.159.	PLATE 131, 3.

 (a) Nude youth with kantharos seated between two standing women, (b) B + F.

*209	Paris, Cab. Méd. 929.	(b) PLATE 131, 4.

 (a) Nude youth with bunch of grapes and phiale, seated woman with egg and thyrsus, (b) B + F.

210 Lecce 659.

 CVA 2, IV Dr, pl. 27, 1.

 (a) Woman with cista and wreath following Eros with wreath and situla moving to r., (b) B + F.

*210a	Liège, private coll.	PLATE 131, 5–6.

 (a) Woman with cista and thyrsus following nude youth with phiale and branch, (b) B + F.

 Close in style to no. 210.

211 Palermo 2224 (old inv. 1811).

 (a) Eros with phiale and bunch of grapes bending forward over raised foot to seated woman with tambourine and thyrsus, (b) B + F.

(iv) THE HELBIG–GRAPE VINE GROUP

(a) THE HELBIG PAINTER

The Helbig Painter is close to the Schulman Painter, and especially to such vases as Taranto 54339, Sèvres 10048 and Lecce 661 (nos. 178–9, 186). His compositions tend to be on a slightly ampler scale, with three or four figures on the obverse, but his draped youths on the reverses follow the Schulman tradition, with their white head-bands, "saucer" drapes, and the way in which the corners of their himatia tail off and are decorated with a wavy black line. They should also be compared with those on nos. 193 and 196–7. Note also the more extensive use of decorative adjuncts like rosettes, bucrania, fillets, wreaths, etc., as with the Bochum Painter; the presence of *halteres* with white dots in the centre (e.g. on nos. 212, 215) emphasises the connexion with the Schulman Painter.

Bell-kraters

*212 Copenhagen, Ny Carlsberg, H 46 (inv. 2249). PLATE 132, 1–2.
 Bildertafeln, pl. 20; *von Leesen Sale Cat.*, pl. 1, no. 43.
 (a) Satyr with situla and torch, Dionysos with kantharos between two women, l. with phiale, r. with cista and bunch of grapes, (b) B + D + F.

 213 Brno, Museum of Applied Arts.
 (a) Young satyr with thyrsus, Dionysos seated with thyrsus and dish of cake, woman with wreath and tambourine, (b) three draped youths.

*214 Louvre S 4049. The foot is modern. PLATE 132, 3–4.
 Millin II 16.
 (a) Satyr with torch, maenad with "xylophone" seated beside Dionysos on altar, Eros, (b) woman seated between two draped youths (B, with phiale + E).

(b) THE GRAPE-VINE GROUP

The group is so named from the grape-vine which appears on the obverse of nos. 215–6. The style is not unlike that of the vases in the Helbig Group and comes nearest to that of the larger pre-Darian vases, and indeed of the Darius Painter himself, to whose reverses these vases approach very closely. The reverse youths are normally tall and wear white head-bands; they are closely related to those on nos. 168, 170, 172, 178 by the Schulman Painter and their drapery may also be compared with that on the vases in the Barletta Group, with few fold-lines over the body, and curlicues in the bottom corners of the himatia. Heads tend to be small in proportion to the body; women often wear a white tiara, with long spikes. The palmettes below the handles are particularly elaborate, with branching side-scrolls. A Sicilian parallel will be found on the kalyx-krater Lipari 2241 (*Meligunìs-Lipára* ii, pls. 86–88).

Bell-kraters

*215 Karlsruhe 65/100. (b) PLATE 132, 5.
 PhV², no. 170; *Gr. V. des Badischen Landesmuseums*, pl. 51 (colour); Melchinger, *Das Theater der Tragödie*, fig. 34.
 (a) Woman with "xylophone" and mirror, Dionysos holding phlyax mask, seated maenad, and Pan with oenochoe and situla, (b) woman seated between two draped youths (B + D).

 216 Ugento, private coll.
 (a) Old silen with Dionysos, seated beneath a grape-vine, between seated woman and standing woman with oenochoe, (b) woman with bunch of grapes between draped youth and nude youth with phiale and branch.

The following vase, while associated in style and compostion with the above (note especially the radiate stephanai of the women), looks to be somewhat earlier and of rather better quality; it may perhaps have served as a prototype for nos. 215–6:

Volute-krater

 217 Ruvo 1431.
 Sichtermann, K 56, pl. 91. Photo: R.I. 64.1201.
 (a) Dionysos seated on an altar with a young satyr before him, between two maenads, l. with alabastron, r. with mirror and thyrsus, (b) satyr and seated maenad with tambourine and mirror.

(v) THE PITTSBURGH GROUP

The vases in this group follow on closely from those of the Dion Group with a very similar treatment of the draped youths on the reverses. One phenomemon is particularly noteworthy; on the reverse youths the drapery has comparatively few fold-lines, and the area between the arm and the bent leg of the youth to right is left empty, often assuming a cylindrical look, as

is clearly to be seen on nos. 220–223. The "sleeve" on this youth is sometimes considerably prolonged. Two vases (nos. 220–1) represent running women; the lower hem of their drapery has a scalloped effect. The successors of these vases, like Matera 10280 or Bari, Sette Cirillo coll. 4, will be discussed in Volume II in the Como Group, since they reflect the influence of the Underworld Painter.

<div align="center">(a)</div>

Bell-kraters

*218	Lecce 655.	(b) PLATE 132, 6.

 CVA 2, IV Dr, pl. 26, 8 and 10.
 (a) Seated Eros with tambourine, woman with filleted wreath and thyrsus, (b) B + E, with fillet between them.

*219	Matera 10064.	PLATE 133, 1–2.

 (a) Satyr with thyrsus and situla moving l., followed by woman with beaded wreath and filleted branch, (b) B + C.

<div align="center">(b)</div>

Pelikai

 220 Louvre K 99 (N 2453).

 (a) Running woman with tambourine and cista, followed by Eros with wreath and bunch of grapes, (b) A + CL.

*221	Louvre K 109 (N 2627).	(b) PLATE 133, 3.

 (a) Running woman with mirror and phiale, followed by nude youth with kantharos, (b) A + C.

<div align="center">(c)</div>

Pelikai

 222 Pittsburgh, Carnegie Museum 2983/7031.

 Scribner, *Cat.*, pl. 41, 1.
 (a) Woman with wreath and phiale, seated nude youth with bunch of grapes, (b) B + D.

*223	Once Zurich Market, Galerie am Neumarkt.	PLATE 133, 4.

 Galerie am Neumarkt, *Sale Cat.* 16 April 1971, no. 79, pl. 1; Parke-Bernet, *Sale Cat.* 24 April 1970, no. 324, ill. on p. 162.
 (a) Woman with wreath and bunch of grapes, seated Eros with cista, (b) B + D.

 224 Vienna 4367.

 (a) Woman with branch and phiale, moving to l., followed by nude youth with wreath and filleted laurel-branch, l. arm enveloped in drapery, (b) B + D.

Amphora

*225	Louvre K 84 (N 2405).	PLATE 133, 5–6.

 (a) Nude youth with knotty stick and wreath, seated woman with cista, (b) B + D.

<div align="center">(vi) THE BARLETTA GROUP</div>

<div align="center">(a) THE BARLETTA PAINTER</div>

 The early work of the Barletta Painter as exemplified by nos. 226–7 is close in style to the vases of the Pittsburgh Group, as may be seen from a comparison of the draped youths on their reverses, or of the running woman on the obverse of no. 227 with those on nos. 220–1. Signs of his individual style, however, are already apparent in his fondness for crooked sticks, and particularly in his drawing of heads and faces. Hair is slightly curly on top, the chin is pronounced and his figures have a rather determined look (cf. nos. 230–2).

Bell-kraters

226 Barletta 656.
 (a) Standing woman with fan and fillet, seated nude youth with phiale + wreath and thyrsus, (b) B
 + F.
*227 Matera 10481. PLATE 134, 1—2.
 (a) Satyr with thyrsus and phiale, maenad with thyrsus and tambourine, both running to l., (b) B +
 C, with palmette between them.
228 Louvre CA 3193.
 (a) Dionysos with thyrsus and phiale moving l., followed by Eros with bunch of grapes and fillet,
 (b) B + E.
229 Once London Market, Sotheby, *Sale Cat.* 9 July 1974, no. 102 (ill.).
 (a) Woman with wreath and bunch of grapes, Dionysos with cista and thyrsus, satyr with situla and
 phiale, (b) B + C.

Column-kraters

*230 Naples 2036 (inv. 81714). PLATE 134, 3—4.
 (a) Seated Oscan warrior with spear and phiale, standing woman with wreath and branch, (b) B + F.
231 Bari 878.
 (a) Seated Oscan warrior and Oscan wearing conical hat, holding wine-skin, (b) B + C.
 Close to the Schulman Painter.

Pelike

*232 Matera 10278. PLATE 134, 5—6.
 (a) Seated woman with cista and bunch of grapes, Eros with fan and wreath, (b) B + D.

(b) VASES CONNECTED IN STYLE

Pelikai

233 Naples 2025 (inv. 81815).
 (a) Nude youth with fan, seated woman with phiale, (b) A + E.
234 Taranto (sequestro).
 (a) Seated woman with phiale, nude youth leaning on stick, holding wreath and cista with fillet,
 (b) two draped youths.
235 Florence, private coll.
 (a) Woman with cista running l., followed by nude youth with drapery over l. arm, (b) B + C.

(c)

We come now to a slightly later development from the vases in (a). The quartered squares
are still filled with circles, and the meanders follow the same pattern as those on no. 230, but
the figures are drawn with greater freedom, and there is a stronger sense of movement. The
draped youths do not have white head-bands, but their heads are still very small and their faces
resemble those on the preceding vases. The adjuncts are similar, as are the Oscan youths, one
of whom (on no. 236) it should be noted has a beard. The two women on nos. 236—7 with
baskets of cakes on their heads are unusually animated. Chevrons are regularly used on the
outer rim of the mouth of column-kraters.

Column-kraters

*236 Altamura 2. PLATE 135, 1—2.
 (a) Woman with torch in r. hand, situla in l., and basket of cakes on her head moving to r. between
 two Oscans, l. with lyre, r. with two spears in r. hand and cake in l., (b) B + CL, without stick + C.

Column-kraters (continued)

*237 B.M. F 301. PLATE 135, 3—4.
 Gli Indigeni, fig. 31.
 (a) Woman with basket of offerings on her head between two Oscan youths, all running to l.,
(b) B + C + C.
 The reverse is very like that of the preceding vase.

238 Trieste S 389.
 CVA, IV D, pl. 8, 1—2; *Gli Indigeni,* fig. 24.
 (a) Woman seated between two Oscan warriors, (b) A + C + C.

239 Rome, Villa Giulia 26979.
 CVA 1, IV Dr, pl. 3, 5—6.
 (a) Woman with thyrsus and situla, seated nude youth with kantharos and wreath, satyr with torch
and thyrsus, (b) B + CX + E.

(d)

The following, which form a compact group, seem to represent one stage further on from
the vases in (c). The draped youths are treated in much the same way, but in an even more
fluid manner; the curlicues in the bottom corners of their himatia are very characteristic. The
quartered squares contain circles in the four divisions, as in (c), and the meanders are flatter
and wider.

Column-kraters

240 Dresden 518 (H 4. 27/83).
 (a) Oscan warrior with two spears and shield, draped woman with wreath, cista of cakes and flower-
chain, (b) B + F.
*241 Vatican V 38 (inv. 18071). Detail of (b) PLATE 97, 11.
 VIE, pl. 32 b and pl. 33 b.
 (a) Woman with cista of cakes between two Oscan warriors, (b) B + D + FX.

Bell-kraters

242 Madrid 32655 (P. 132).
 (a) Satyr with thyrsus and situla running to l. and looking back at Dionysos with torch and thyrsus,
(b) B + F.

243 Bari 927.
 (a) Woman with phiale and wreath, seated Eros with cista and fillet, (b) B + F.

(e)

The following vase is connected in style with those in (c) and (d) above:

Column-krater

244 Bari 20025, from Gioia del Colle, T. 2.
 Scarfì, *ArchCl* 11, 1959, p. 185, no. 1, pl. 60; *MonAnt* 45, 1960, cols. 151 ff., fig. 21, and pl. 2,
fig. 20.
 (a) Dionysos, maenad, and satyr with torch and situla, all moving to r., (b) A1 + C + F.

(vii) THE BEARDED OSCANS GROUP

We have already noted a bearded Oscan on no. 236; the two on nos. 247 and 249, who give
the name to this group, not only have a pointed beard but also large drooping moustaches.
They wear the typical conical fur pilos. Women generally have a double stripe running down
the centre of their peploi.

The reverse of the Philadelphia krater (no. 247) reflects the influence of the Schulman Painter.

The meanders are often accompanied by saltires with dots. The ivy leaves on the necks of the column-kraters are rounded, with a large black disk in the centre of the berries between them.

(a)

Column-kraters

*245 Naples Stg. 4. (b) PLATE 135, 5.
 (a) Woman with phiale between two Oscan youths, l. with branch, r. with situla, (b) A + C + E.
*246 Milan, "H.A." coll. 448. (b) PLATE 135, 6.
 (a) Woman bending forward over raised foot, holding wreath in r. hand and bunch of grapes in l., seated Oscan warrior with phiale and two spears, standing Oscan with situla and two spears, (b) A + C + E.
 247 Ruvo 718.
 Sichtermann, pl. 103; *Gli Indigeni,* fig. 28. Photos: R.I. 64.1208–9.
 (a) Seated woman receiving libation from Oscan youth; to r., bearded warrior with conical helmet, spear and wreath, (b) A1 + F + C.
 248 Warsaw 198117.
 CVA, Poland 7, pl. 22, 1–2, 1–2, and pl. 23.
 (a) Woman seated between two Oscan warriors, (b) B + F + C.
 249 Philadelphia L. 64.42.
 (a) Two Oscans about to sacrifice a sheep over an altar; to r., woman with dish of cakes, (b) D + F + C.
 250 San Simeon 5549 (SSW 9962).
 (a) Bearded man reclining between Oscan youth and woman with wreath, (b) B + F + C; the central youth without head-band.

(b)

The following form a compact group, linked to those in (a) by the bell-krater Bologna 602. Note the use of saltire squares, with carelessly placed dots in the four quarters.

Bell-kraters

 251 Bologna 602.
 CVA 3, IV Dr, pl. 27, 1–2.
 (a) Woman with mirror and phiale moving l., followed by nude youth with situla and thyrsus, (b) A + D, with a stele between them.
 252 Naples 1939 (inv. 81651).
 (a) Standing woman with thyrsus and tambourine, seated Eros with phiale, (b) B + F.
 253 Naples 2015 (inv. 81366).
 (a) Woman with phiale and thyrsus, Eros with situla, (b) B + C.

Pelikai

*254 Milan, "H.A." coll. (b) PLATE 136, 1.
 (a) Nude youth holding up wreath in r. hand, stick in l. with drapery over arm, draped woman with phiale and "xylophone" beside kalathos of offerings, (b) A + C.
 255 Naples 2392 (inv. 81805).
 (a) Woman with raised foot holding beaded wreath and fillet, seated youth with phiale and branch, (b) A + D.
*256 Catania MC 4365. (b) PLATE 136, 2.
 (a) Seated nude youth with branch and phiale, standing woman with wreath, (b) A + C.

10. THE LATIANO PAINTER

The Latiano Painter, named after the find-spot of Taranto 135755 (no. 257), is a late painter, whose style seems to be derived from that of the painter of the vases in the Bearded Oscans Group. The Kiel vase is discussed by K. Schauenburg in *AA* 1973, pp. 221 ff., where a list of related vases is given, and the connexion noted with B.M. F 293, which we now attribute to the Kirzenbaum Painter in the Chrysler Group (no. 9/67 above). The subjects, at least on nos. 257 and 259, are of greater interest than usual, but the quality of the drawing has sadly deteriorated.

Bell-kraters

*257 Taranto 135755, from Latiano. PLATE 136, 3—4.
 (a) Papposilen with wine-skin beside krater, maenad with wreath and thyrsus, leaning against pillar, satyr with situla and thyrsus; Eros above, flying with fillet towards the maenad, (b) A1 + C + E.
*258 Hanover W.M. V 2. (b) PLATE 136, 5.
 Schauenburg, loc. cit., pp. 223 ff., figs. 5—8.
 (a) Woman leaning forward over foot resting on rock-pile to offer phiale to seated nude youth holding flowers, (b) A1 + C.
*259 Kiel B 513. (b) PLATE 136, 6.
 Schauenburg, loc. cit., pp. 221 ff., figs. 1—4.
 (a) Youth on horseback striking down with sword at deer between two leafless trees, (b) B + CX, with palmette between them.

RELATED IN STYLE

Bell-krater

 260 Trapani 3599.
 (a) Seated Eros with phiale, woman resting r. arm on pillar, with bunch of grapes in l. hand and mirror in r., (b) A1 + F, with palmette between them.

BETWEEN THE ILIUPERSIS AND THE LYCURGUS PAINTERS – THE RISE OF THE BAROQUE STYLE

1. The Suckling-Salting Group
2. The Group of the Dublin Situlae
3. The V. and A. Group 4. The Group of Vatican W 4
5. The Painter of Lecce 3544 6. The Group of Naples 1763

Introduction

In the Introduction to Middle Apulian (p. 183) we noted that between the Iliupersis and the Lycurgus Painters there comes a group of vases which, by reason of the more elaborate nature of their decoration, may be regarded as marking the beginning of the Baroque style in Apulian vase-painting. The history and significance of the term "Baroque" are well set out by Dr. Margaret Lyttleton in the first chapter of her *Baroque Architecture in Classical Antiquity* (Thames and Hudson, 1974). One of its essential characteristics is richness of decoration which, as has already been mentioned in connexion with the work of the Iliupersis Painter, in Greek architecture begins to manifest itself towards the end of the fifth century B.C., with a considerable advance in the fourth, as exemplified upon such buildings as the Tholos and the Temple of Asclepios at Epidaurus or the temples at Tegea, Nemea and Delphi in the second quarter of that century. A parallel development will be seen on Apulian vases around the middle of the century on which, by comparison with those of the Iliupersis Painter or the Painter of Athens 1714, there is a much greater elaboration of the ornamental decoration as well as of the drapery worn by the principal figures. A good example of this new development will be seen on the Salting pelike (no. 6, Pl. 137, 5), where, beneath the couple on the couch, is an elaborate floral, rising from an acanthus-leaf base and spreading out laterally on either side with scrolls and palmettes interspersed with several varieties of flowers, on which the details are picked out in added white and yellow. It is an extension of the floral pattern-work which surrounded the female head on the neck of the Iliupersis Painter's volute-krater in Boston (no. 8/11), but to find it transferred to the body of the vase is a completely new development (cf. also nos. 35–36). On Louvre K 35 (no. 11, Pl. 139, 1) the floral decoration becomes almost more important than the mythological scene it surrounds and covers a far greater proportion of the available surface of the vase – once again we note the acanthus base, the spiralling scrolls of the tendrils that spring out from the stems of the plant, the fan-palmettes with their curving leaves, and the small, often bell-shaped, flowers. Such exuberance has a short spell of popularity early in the second half of the century, when we find a number of smaller vases, especially alabastra (see Schauenburg, "Unteritalische Alabastra" in *JdI* 87, 1972, pp. 258 ff., esp. figs. 14, 16–17, 22–24, 26) and squat lekythoi, decorated with a single figure or a female head in a very elaborate floral setting, with an occasional larger vase treated in the same manner (e.g. pelikai – Bari 20149, *MonAnt* 45, 1960, col. 261, fig. 95; Taranto, Ragusa coll. 111; Kassel 561, *CVA* 2, pl. 77, 1; Canberra, U.H. 6, *Gr. V. in University House*, pp. 5–6, fig. 6 (nos. 16/77–79); hydriai – Naples 2922, Jucker, *Das Bildnis im Blätterkelch*, fig. 124; Palermo 2250, Schauenburg, *JdI* 78, 1963, p. 308, fig. 14; once Signorelli coll., *Sale Cat.* no. 262, pl. 10). Thereafter such decoration is more generally confined to the necks of volute-kraters or the shoulders of amphorae and loutrophoroi, where

in the later fourth century (e.g. on the vases of the Ganymede and Baltimore Painters) it achieves a remarkable degree of intricacy.

Another aspect of the new desire for richness will be seen in the treatment of the drapery. On the vases of the Iliupersis Painter, except for certain mythological figures wearing more elaborate costumes, which may have been to some extent influenced by theatrical performances, the drapery is comparatively simple; now, even in genre scenes, it is much more richly decorated. Thick black borders appear regularly (e.g. nos. 1, 4, 6, 7), of which prototypes will be found in the work of the Felton Painter and his contemporaries (e.g. no. 7/49; cf. also 7/41 and 8/103 and 143), and inset stripes with lattice or similar patterns down them (cf. with Iphigenia on no. 8/3 by the Iliupersis Painter), for which there are parallels on the contemporary vases of the Varrese Painter (e.g. no. 13/5) and which are particularly favoured by the Lycurgus Painter.

Increasing use is also made of the face, shown either as fully frontal or in three-quarter view, as a vehicle for the expression of emotion, especially sorrow or pain (cf. Ruvo 1094, no 32), and in this we may perhaps see a distant reflection of a similar tendency in sculpture, particularly noticeable in the works of Scopas (see A. F. Stewart, *Skopas of Paros*, p. 74), just as Praxitelean influence is perhaps to be seen in the more frequent appearance of figures leaning against a pillar in a relaxed pose, often with one leg crossed in front of the other (e.g. on nos. 2, 19 — cf. with the satyr of Praxiteles, Richter, *Sculpture and Sculptors*, p. 205, fig. 56, but note also its much earlier appearance on the amphora no. 2/3 by the Gravina Painter), and in the treatment of women's hair with the central parting and triangular forehead (e.g. nos. 1, 21, 43, 44), which that sculptor seems to have favoured (Richter, op. cit. p. 201).

In the representations on the vases bridal scenes, or the toilet of the bride, begin to play a more important role. At times they may have a mythological connexion (e.g. Paris and Helen on Ruvo 1619, no. 13), but mostly they look to be simply genre scenes. Aphrodite and Eros take a significant part (e.g. nos. 6—9, 13) and such presentations, especially on pelikai, become increasingly popular in later Apulian (see Bendinelli, *"Antichi vasi pugliesi con scene nuziali"*, in *Ausonia* 9, 1919, pp. 185 ff.). They are characteristic of the growing interest in romantic, and even sentimental, themes of which the punishment of Eros on the Taranto lebes (no. 15) is a good example. A stock figure in the bridal scenes is the seated woman, normally above to left, sometimes shown in three-quarter view, who looks down upon what is taking place beneath her with a somewhat detached interest.

The painters in this chapter are less inclined to depict funerary scenes, and naiskos vases are comparatively rare. They appear, to a limited extent, in the Group of Lecce 3544 (e.g. nos. 69—71), and more frequently in the Group of Naples 1763, which lead on to the vases of the Gioia del Colle Group or by the Painter of Copenhagen 4223 (see Chapter 17 in Volume II) and, in the next generation, to those of the Patera workshop, on which they are commonly depicted, usually with a stele scene on the reverse. Thus we may note at this point the beginning of the development of two different streams of monumental vase-painting in the "Ornate" style, one following the Lycurgan tradition with a preference for mythological or dramatic subjects on the obverses (e.g. the Darius and Underworld Painters), the other continuing on from the Gioia del Colle Painter and his followers and depicting mainly naiskos scenes (e.g. the Patera and Ganymede Painters).

1. THE SUCKLING-SALTING GROUP

The group takes its name from the suckling scenes on nos. 1 and 2 and from the pelike (no. 6), formerly in the Salting collection, and now in the Victoria and Albert Museum.

In style the vases are still fairly close to the work of the Iliupersis Painter and the Painter of Athens 1714 (cf. especially the reverse of nos. 6 and 7 and the woman with the stool on the obverse of the latter; also the saltires on nos. 7–9), but we note a slight increase in the use of added white, the particular fondness for black borders on the drapery (e.g. nos. 1, 5, 7, 22), as well as the greater elaboration of the decorative pattern-work. Frontal and three-quarter faces appear frequently: they have not yet assumed the tormented look, characteristic of the Lycurgus Painter, but the inclination of the head (e.g. on B.M. F 107, no. 1) suggests a rather more sentimental approach. The strong emphasis on the breasts and, in particular, the nipples finds a parallel on several of the Iliupersic vases (e.g. nos. 8/5, 11, 20–21).

(i) THE SUCKLING PAINTER

Squat lekythoi

* 1 B.M. F 107. PLATE 137, 1.
 Cook, *Zeus* iii, pl. 15, 1; *LAF,* no. 18 (ill.); Kerenyi, *Heroes,* pl. 18.
 Infant Herakles suckled by Hera, in the presence of (to l.) Aphrodite, Eros and Athena with spear and aegis, (to r.) Iris and a seated woman (Alcmena ?).
 The frieze of pointed leaves with berries on the shoulder should be compared with that on the cup in San Francisco (no. 11/93 above); the seated woman to r. recalls those of the Schlaepfer Painter (e.g. nos. 9/160, 162–4).

 2 Taranto I.G. 4530.
 RA 1936, ii, pp. 147–8, figs. 1–2; Cook, *Zeus* iii, pl. 15, 2; Wuilleumier, *Tarente,* pl. 47, 2–3; Arias, *Storia,* pls. 160–161; *Italy's Life,* no. 26, p. 111 (colour); *ClGrArt,* fig. 351; Boardman, *Gr. Art*[1], fig. 182, *Gr. Art*[2], fig. 181; (detail) Richter, *Perspective,* fig. 182; Kerenyi, *Heroes,* pl. 18.
 Woman holding swan beside a chest full of Erotes, Aphrodite suckling an Eros, with two others flying around; woman with parasol and wreath beside two wrestling Erotes, nude youth leaning against pillar, with a feline on his r. hand.

 3 Munich 3271. (Very badly preserved).
 Seated woman, youth embracing woman, Eros kneeling on couch beside loving couple over whom a woman holds a parasol; Eros beside a laver, woman opening box and looking back to l.

Fragment

 4 Present whereabouts unknown.
 Woman playing harp and female figure (Nike ?) holding fillet.

(ii) CLOSELY RELATED

The following vase, which survives only in fragments, one part in the Baisi collection in Taranto and the other once on the Swiss market, should find a place in this context, although it is slightly coarser in sytle than nos. 1–2. The drawing of the breasts and the drapery over them (cf. the seated woman with Hera on no. 1) and of the hair and the three-quarter faces is very similar. The top-knots of the two women to right on the obverse recall those on some of the vases in the Kyminnon Group (e.g. nos. 7/107–9; cf. also the drapery of the standing woman on 7/109), a late offshoot of the Felton Painter, with which the pelike must be contemporary; they are very fashionable at this time (cf. the Varrese Painter, the Painter of the Dublin Situlae, and the circle of the Lycurgus Painter).

Pelike

* 5 Taranto, Baisi coll. 89 + Zurich Market, Arete. PLATE 137, 2–4.
 (a) Eros with phiale, seated woman with palm-branch, standing woman with phiale, head of woman below, (b) the upper part of two women and two youths.
 The Baisi fragment joins the Zurich fragment at the figure of Eros on (a), the r. arm, head and

Pelike (continued)

wings of whom appear on the former, the l. side of his body, with the l. hand holding a phiale, and part of his l. wing on the latter.

(iii) THE SALTING PAINTER

This division includes several vases of particularly high quality, with well-composed pictures and excellent drawing. The floral decoration on nos. 6 and 11 has already been referred to; it leads on to that of the vases by the Painter of the Dublin Situlae (nos. 35–36) and of Ruvo 423 and 425 (nos. 41–2) and marks the beginning of the Apulian "baroque" style. The fold-lines on the drapery are fine and dense; note also the ripple effect of the meeting of the outer black borders on the drapery of the standing women on nos. 6 and 7. The pose of the couple on the couch on no. 6 is very typical of such bridal scenes and is repeated on a number of later vases, including a few by the Lycurgus Painter. Nos. 6–9 well illustrate the influence of the Iliupersis Painter and the Painter of Athens 1714. A popular motif on these vases is the figure seated on a *klismos* (e.g. nos. 7–10), who is modelled on the similar figure on Bari 5592 by the latter (no. 8/164).

Pelikai

* 6 London, V. and A. 2493.1910 (ex Salting). PLATE 137, 5–6.

 (a) Couple (Dionysos and Ariadne) embracing on couch between two women, with Eros above, (b) youth crowning seated woman, kalathos, standing draped woman, holding drapery with both hands behind her back.

* 7 Once London Market, Sotheby, *Sale Cat.* 9 Dec. 1974, no. 124, ill. on p. 75; ex Frankfurt Market, De Robertis. PLATE 138, 1–2.

 (a) Woman putting down stool, veiled woman holding bird in front of seated half-draped youth; above: seated woman with fan, Eros flying with wreath, (b) nude youth, woman with foot raised on block, holding phiale and wreath, nude youth with strigil.

 8 Ruvo 1128.

 Sichtermann K 49, pl. 82. Photo: R.I. 64.1240.

 (a) Maid with parasol, seated half-draped woman, woman holding fillet, seated youth; Eros hovering above, (b) seated woman between two nude youths.

* 9 Bari 915. PLATE 138, 3–4.

 Puglia, p. 162, fig. 150 b.

 (a) Seated woman, Eros with duck flying towards woman seated on *klismos*, youth with phiale, (b) seated woman with youth and woman.

 10 Berlin F 3163. Terribly repainted.

 (a) Seated woman between youth with open box and standing woman with mirror and fan; Eros above, with wreath and phiale, (b) nude youth with branch and phiale seated between half-draped youth and woman with wreath.

Oenochoe (shape 3)

* 11 Louvre K 35 (S 1594; CA 2190). PLATE 139, 1.

 Schauenburg, *AuA* 10, 1961, pl. 1, 1.

 Boreas carrying off Oreithyia.

 Cf. for decoration Palermo 2250 (*JdI* 78, 1963, pl. 308, fig. 14), and for the "scalloped" leaves the pelikai Moscow 733 and Zurich 2656 (nos. 7/30–31 above).

Situla (type 2)

 12 Naples 2859 (inv. 81860).

 (a) Young satyr fluting, seated Dionysos in three-quarter face with kantharos and thyrsus, young

satyr with raised foot, holding phiale, (b) standing maenad holding fillet in both hands, seated maenad holding up tambourine, satyr.

Goes with the Sotheby pelike (no. 7 above).

Lebes gamikos

* 13 Ruvo 1619. Detail of (a): PLATE 139, 2.
El Cér iv, pl. 72–3; Bendinelli, *Ausonia* 9, 1919, p. 187, no. V; Sichtermann K 67, pls. 106–7; Trendall, *Ceramica*, pl. 23. Photos: R.I. 64.1153–6.

(a) Helen on couch being decked by woman, Paris to r., Eros flying above, seated woman, maid tying Helen's sandal, (b) seated woman with fan, Eros flying to crown her, to l. woman with sash, to r. youth.

(iv) VASES RELATED IN STYLE TO THE SUCKLING AND SALTING PAINTERS

(a)

In this context perhaps should be placed a remarkable volute-krater which, while still closely connected in style with the work of the Iliupersis Painter and the Painter of Athens 1714 and comparable with the Achilles and Penthesilea krater (no. 8/260 above), has also a strong affinity to the vases in the Suckling-Salting Group.

Volute-krater

* 14 Ruvo 1094. (b) PLATE 139, 3.
W., p. 349, no. 1; *Japigia* 3, 1932, p. 268, fig. 49; Matz, *Dionysiake Telete*, pl. 3; Sichtermann K 36, pls. 52–54; Smith, *FS*, pl. 18. Photos: R.I. 62.1342–3, 64.1190–2.

(a) Punishment of Theseus and Pirithous, (b) youth, maenad pouring libation to seated youth, resting arm on shield and crowned by standing woman.

Neck: (a) griffin, swan and lion.

The representation on the obverse is unique in South Italian vase-painting since, although Theseus and Pirithous appear together in the Underworld on Karlsruhe B 4 and B 1549, this is the only vase to show their actual punishment, with one of the heroes already bound and the other in the process of being bound by a Fury with a particularly ferocious countenance. Their doom is watched by a bearded Pluto, with a bird-crowned sceptre (see Schauenburg, *RM* 82, 1975, pp. 207 ff.) and Persephone, who here holds two flaming cross-bar torches in her hands (instead of the more usual one, as on the reverse of Naples Stg. 11, no. 16/54 below; two being normal for Hecate).

The scene on the reverse, a libation to a young warrior, is very similar to those on some of the vases by the Iliupersis Painter (e.g. nos. 8/2, 8, 10, 11) with whom this vase was originally associated, but the even closer connexion with some of the vases in the preceding section may be seen by comparing the two women with those on the reverses of nos. 6, 9 and 13, especially the last where the resemblance between the woman with the wreath and the one with the sash is very clear; note also the characteristic double black stripe running down their drapery. Other such parallels can readily be found, and it seems that the painter of the Ruvo vase must, like the Salting Painter, have been a close associate of the Iliupersis Painter, but that he, in his treatment of suffering, as portrayed in the faces of the two heroes, has gone a little further in the rendering of violent emotion.

(b)

Lebes gamikos

15 Taranto.
Trendall, *JHS* 55, 1935, pl. 7, 3–4; Wuilleumier, *RA* 1936[2], pp. 154–5, figs. 5–6; Beck, *Album*, pl. 51, fig. 270.

Lebes gamikos (continued)

(a) Aphrodite about to punish Eros in the presence of a youth, (b) standing woman with cista, and woman seated on *klismos*.

The drawing is particularly neat; the white plants on the obverse should be compared with the somewhat similar-looking incense burner on no. 13 and the pose of the woman beside it with that of Aphrodite.

(v) THE GROUP OF THE YALE PELIKE

The Yale pelike (no. 16) is closely connected with the work of the Salting Painter in its treatment of the seated Dionysos in the centre of the obverse, who should be compared with the similar seated figures on nos. 7 and 8. Note the figure of the woman to left bending forward over her raised left leg and the "ripple" drapery of the woman to right (cf. nos. 1, 6, 7). The chequers accompanying the meanders connect the vase also with nos. 1 and 6. The figures on the reverse are a little more angular but otherwise comparable with those on nos. 6–9.

With the Yale pelike we may associate another (of type 1 and not type 2) in Naples (no. 17) with less elaborate decoration, but with a very similar laurel-pattern on the neck of its reverse. The two draped women standing to left on the reverses are very alike, especially in the rendering of the drapery, and we note the same angularity, especially in the face of the woman on the obverse leaning against the pillar; her bent leg is drawn in just the same manner as that of her Yale counterpart.

The two tall oenochoai in Naples (nos. 18–19) seem to belong here; the former has now been cleaned, but the latter is very overpainted. We may compare the woman bending forward over her raised foot with the similar one on the Yale pelike.

(a)

Pelikai

16 New Haven, Yale University 258.
 Baur, *Cat.* p. 157, fig. 64; Schauenburg, *JdI* 87, 1972, p. 264, figs. 8–9; *Gr. V. at Yale*, no. 68, ill. on p. 87.
 (a) Dionysos with phiale seated between two maenads, Eros seated above, (b) nude youth seated between two women, Eros flying with wreath above.
17 Naples 2014 (inv. 81929).
 (a) Woman with mirror seated between nude youth with "xylophone" and woman with fan, resting l. arm on pillar, (b) standing woman with branch and seated woman with phiale.

Oenochoai (shape 1)

18 Naples Stg. 574.
 Macchioro, *JdI* 27, 1912, p. 283, fig. 10.
 Seated Marsyas, Apollo with cithara, towards whom Nike comes up with a wreath.
19 Naples Stg. 328. Heavily repainted.
 Macchioro, loc. cit., p. 282, fig. 9 and p. 310, fig. 34.
 Woman with raised foot holding wreath, seated half-draped youth with phiale, woman holding up cithara in r. hand and leaning against laver, half-draped youth; above to l., seated Eros with phiale + sprays.

(b)

The vases in this sub-division are related in style to those in (a), and linked by the double stripe down the centre of the women's peploi, as well as by the row of fine white beads which runs round the outer edge of the wreaths.

Dish

20 Ruvo 817.
 Schneider-Herrmann, *Paterae,* no. 203.
 A. Woman with wreath and fillet, Eros with phiale, seated woman, woman with mirror and branch.
B. Nude youth with wreath, woman with bird perched on r. hand leaning l. arm on pillar, Eros flying
towards her with fillet, woman putting incense on a thymiaterion.

Pelike

21 Louvre K 95.
 Millingen, pl. 13; Schneider-Herrmann, *BABesch* 43, 1968, p. 68, figs. 6−7; Schauenburg, *JdI* 84,
1969, p. 37, fig. 7.
 (a) Aphrodite borne by two Erotes, (b) Eros with fan and wreath.
 The shape is unusual, with a very globular body, and a foot with a very marked *torus.*

(vi) OTHER COMPARABLE VASES

(a) THE GROUP OF OXFORD G 269

The Oxford pelike (no. 22) is clearly connected with the work of the Suckling and Salting
Painters, as may be seen from the treatment of the drapery (note the double stripes on nos. 22−23;
cf. nos. 6 b, and 13 b and 20), the drawing of the women's faces and the rendering of the hair.
The draped woman by the laver on no. 22 connects it with no. 23, on which Nike is treated in
a strikingly similar manner; the face of Europa on no. 24 should be compared with that of the
nude woman on no. 22.

Note the use of upright crosses with the meanders on no. 21 (cf. with no. 27).

Pelike

* 22 Oxford G 269 (V 550). PLATE 140, 1.
 El. Cér. iv, pls. 15−16; Gardner, *JHS* 25, 1905, pp. 77−8; Blinkenberg, *Cnidia,* p. 54, fig. 11;
Schauenburg, *JdI* 87, 1972, p. 276, fig. 36.
 (a) Toilet of the bride, with Eros hovering above, (b) two women, a youth and Eros.
 Blinkenberg draws the parallel between the figure of the nude woman and the Cnidian Aphrodite
of Praxiteles. For the dish standing on top of a column cf. no. 45, where it stands on top of a plinth.

Oenochoe (shape 3)

* 23 Zurich Market, Arete. PLATE 140, 2.
 Nike about to crown youthful Herakles; to l. seated nude youth with wreath, to r. Athena with
spear and owl; above, flying Eros with phiale.

Fragment

24 Kiel, private coll.
 Europa on the bull, with Eros flying above to crown her.
 The flying drapery of Eruopa with its pattern of white dots should be compared with that on the
Europa fragment in Copenhagen (13433; no. 16/50 below).

(b)

Lebes gamikos

25 Ruvo 1535.
 Sichtermann K 54, pl. 89. Photo: R.I. 64.1261.
 (a) Woman with dove on r. hand bending forward over raised foot towards half-draped youth seated
on stool; to r. draped woman with fan, resting r. hand on his shoulder; above, seated Eros with wreath,
(b) nude youth and seated woman.
 Lid: (a) and (b) female head.

Pelike

* 26 San Simeon, Hearst 5535 (SSW 10441; PC 7782), ex Durham. PLATE 140, 3—4.
 (a) Seated youth with bird perched on finger, woman dancer beside white pillar, crowned by Eros
 above, woman with mirror, (b) woman holding cista, and nude youth with fillet.

The San Simeon pelike (no. 26) is a vase of some interest since it provides a connecting
link between this group and that of Lecce 3544 (no. 69), as may be seen from a comparison
between the drawing of the head and face of the seated youth and that of the youth to the
right of the naiskos on Lecce 3544. The woman with the mirror should be compared with
the similar standing women on the reverses of nos. 6 and 8 and also with the woman to left
on Ruvo 1619 (no. 13); the long curly locks of the woman with filmy drapery leaning against
the pillar find counterparts on the vases by the Painter of the Dublin Situlae and the Lycurgus
Painter. The two figures on the reverse reflect something of the influence of the Varrese
Painter in the drawing of the drapery over the women's breasts and of that enveloping the
youth's left arm.

(c)

The two following vases are connected with those in the preceding sub-divisions, especially
in the treatment of the drapery and the faces, but show a more markedly individual style.
Note the drawing of the hair, with the emphasis on the individual locks (cf. the seated woman
above to left on the obverse of Oxford G 269, no. 22).

Dish

27 Ruvo 1617.
 Schneider-Herrmann, *Paterae*, no. 189; Sichtermann K 80, pl. 139. Photos: R.I. 64.1244—6.
 (a) Death of Pentheus, (b) seated silen playing the flute, and Dionysos seated between two
 maenads.

Calyx-krater

* 28 Bari, Malaguzzi Valeri coll. 52. PLATE 140, 5.
 (a) Phlyax scene — two phlyakes playing the flute as they dance around an altar; to l., old
 phlyax, to r., flute-player behind a tree, (b) draped youth, woman, and draped youth with bare
 torso.

This is a vase of unusual importance because of the representation on the obverse, which
gives a particularly good example of the improvised phlyax stage, the floor of which is clearly
shown, supported by four Ionic columns with a curtain draped behind them and approached
by a flight of steps, drawn in a rather primitive perspective. A point of special interest is that
the curtain, as well as being pinned to the floor of the stage is also attached to the trunk of a
living tree growing immediately in front of it. This seems to indicate that the performance is
taking place out of doors and that the stage has been set up behind the tree, which serves to
conceal the flute-player, who makes the actual music, while the dancing phlyakes simply
pretend to do so.

For the enclosed palmettes between the handles on the obverse cf. Louvre K 35 (no. 11),
the Taranto lebes (no. 15), and Oxford G 269 (no. 22). The peplos of the woman on the
reverse has the typical double black stripe running down it.

This vase should also be compared with the work of the Felton Painter (e.g. nos. 7/62—63
and 68), from whom the artist seems to have derived some of his inspiration.

The following vases should be compared with the above. Note especially:

(a) the rendering of drapery with fine, broken fold-lines, often following closely the contours of the leg, and with plain black borders
(b) the extensive use of shading
(c) the drawing of the hair, with individual locks,
(d) the small mouths, with a slight downward turn.

Pelike

29 Naples 3231 (inv. 81392).
 Patroni, p. 135, fig. 92; Bieber, *JdI* 32, 1917, p. 54, fig. 27; Pickard-Cambridge, *Theatre*, p. 84, fig. 12; Wegner, *Musikgeschichte*, figs. 71–2 (bibliography on p. 112); (detail) Richter, *Perspective*, fig. 171; Moret, *Ilioupersis*, pls. 34–35; Beck, *Album*, pl. 73, fig. 365. Photos: R.I. 65.2295–6.
 (a) Apollo and Marsyas, (b) theft of the Palladion.

Skyphos fragments

30 Heidelberg 25.06.
 CVA, pl. 89, 1.
 Head and arm of woman; head of woman playing harp.
 Goes closely with the Naples pelike; the fragment 25.05 (pl. 89, 2) looks to be by a different hand.
31 Greenwich (Conn.), Bareiss coll. 409 (Metr. Mus. Exhibition, *Cat.*, no. 120; L. 69.11.98).
 Schauenburg, *RM* 79, 1972, pl. 24, 2.
 To l., woman holding drapery; above r., head looking out of window; below, youth embracing woman on couch.

Also to be looked at in this context:

Pelike (upper part only preserved)

32 Paris, Cab. Méd. 4285.
 (a) Upper part of two women with Eros by tree, (b) face of woman who holds a parasol, head of woman, seated woman with bird.

2. THE GROUP OF THE DUBLIN SITULAE

The vases in this group well illustrate the development of the "baroque" style, of which we saw the beginnings in the Suckling-Salting Group. They are contemporary with the work of the Lycurgus Painter and each would seem to have influenced the other.

Three-quarter faces appear frequently; the pupils of the eyes are large and solid black. Hair tends to be curly, sometimes (as with Pentheus on the New York fragments, no. 34) shown as a mass of short curls against a reserved contour, anticipating the manner of the Branca Painter, and at others falling in long curls on the shoulders (as with the Lycurgus Painter). Women often wear their hair in a "top-knot" (cf. no. 5) and above the brow there is a stephane with widely-spaced spikes. Drapery may be elaborately patterned.

Grape-vines with carefully drawn leaves appear as decorative adjuncts (e.g. nos. 33–34); ground-lines consists of large white dots. The meanders are accompanied by quartered squares, with either a black dot or a smaller hollow square (e.g. nos. 33, 35, 37, 38, 41) in each section; sometimes there are saltires as well (e.g. no. 33), and on Ruvo 1500 the squares are dotted but uncrossed. The ogival decoration on the rim of Ruvo 1500 is comparable to that on Ruvo 415 and Milan "H.A." 236 by the Lycurgus Painter.

(i) THE PAINTER OF THE DUBLIN SITULAE

Dinos

* 33 B.M. F 304. PLATE 141, 1—3.

Dionysos with maenads beneath a grape-vine; satyr pouring wine into a calyx-krater; thiasos with four maenads and a satyr with torch and situla, and another with kottabos-stand and situla.

The maenad with the branch and phiale is particularly close to some of the figures on the reverses of the vases of the Lycurgus Painter; the rendering of the drapery should also be compared with that by the Varrese Painter.

Volute-krater (frr.)

* 34 New York 19.192.81, 2, 6, 8, 13 and 17. PLATE 141, 4.

(a) Death of Pentheus, (b) Titanomachy (Pegasus; Zeus and Nike in quadriga; dying Hyperion).

Compare the face of Pentheus with that of the maenad beside Dionysos on no. 33, whose drapery should also be compared with that of the seated figure immediately above him; note also the presence of a figured calyx-krater as on no. 33 and of dots between the rays of the stephane.

Situlae (type 2)

For earlier examples of this shape cf. the situlae by the Painter of Ruvo 1364 (nos. 7/41—43).

35 Dublin 1917.46 (= J. 520). Ex Hope coll. 245.

Tillyard, pl. 34, 1 and pl. 32; *Hope Heirlooms,* no. 18.

(a) Woman adjusting kottabos-stand, banqueter beneath vine, satyr with wreath and situla, (b) Eros and woman with wreath and cista.

The obverse is very close to B.M. F 304 (no. 33).

35a Once Los Angeles Market, Summa Galleries, inv. 332.

Cat. 2 (1977), no. 13 (ill.).

(a) Satyr with situla in l. hand, holding in r. an oenochoe above a phiale held out by a draped woman; seated Dionysos with thyrsus and sash, standing draped woman with wreath, (b) woman with situla and phiale running to l., followed by nude youth with wreath.

36 Ruvo 1372.

Japigia 3, 1932, p. 275, fig. 56; Sichtermann K 75, pls. 132—3. Photos: R.I. 64.1230.1.

(a) Nike flying amid flowers and thistles, (b) winged head in Phrygian cap (probably Orpheus).

It should be noted that two of the plants beside Nike are clearly giant thistles; they should be compared with the plant in the naiskos on Vatican X 6 (no. 13/21), which has sometimes been identified as a poppy.

* 37 Dublin 1880.1106 (= J. 519). PLATE 142, 1—2.

(a) Maenad with thyrsus and tympanum amid florals, (b) woman with thyrsus and phiale, and youth with wreath and branch, running to r.

Lebes gamikos (frr.)

38 Basel, H.A. Cahn coll. 227.

(a) Paris with Helen in the presence of women and Erotes, (b) mostly missing — to l. youth, youth embracing woman, head of woman; above — legs of Eros (?).

The surface of the vase is in very bad condition, but the rendering of the hair, the drawing of Helen's frontal face, and the elaborately-patterned drapery suggest that it might belong here. Note also the hollow squares within the quartered squares, as on nos. 33, 35 and 37.

Hydriai

39 Copenhagen 48 (B—S. 223).

CVA, pl. 258, 2.

Woman with fan and cista, nude youth with wreath and branch, both running to r.

39a Malibu, J. Paul Getty Museum 77 AE 17.
 Ex Los Angeles Market, Summa Galleries inv. 198.
 Woman bending forward over raised foot and opening box, seated woman with wreath and cista beside a white stele on a large square base.

(ii) THE GROUP OF RUVO 423

It is unfortunate that most of the vases in this group have either been heavily overpainted or else are in a rather poor condition. However, enough that is genuine remains to show that they are closely connected with the work of the Painter of the Dublin Situlae and the possibility that they are also by his hand should not be completely excluded.

The ornamental decoration is particularly elaborate and should be compared with that on the situlae (nos. 35–36) and also on the vases of the Salting Painter (especially nos. 6 and 11). Other parallels will readily be found in the drawing of the female heads in full-face or three-quarter view and in the elaborate patterning of the drapery.

Volute-krater (with mascaroons)

* 40 Kassel T 749. (b) PLATE 142, 3.
 (a) Youth with cithara seated in naiskos; to l., two nude youths and a woman; to r., woman with fillet and phiale, nude youth running up with bunch of grapes, (b) woman with cista and bunch of grapes, seated nude youth with branch holding out a phiale to a woman who pours wine into it from an oenochoe.
 Neck: (a) lion confronting griffin.
 Much of the obverse, especially the naiskos and the youth above to l., is modern; the reverse is in better condition and should be compared with the work of the Lycurgus Painter.

Amphorae

* 41 Ruvo 423. Repainted. Detail of (a): PLATE 142, 4.
 W., p. 350; *Japigia* 3, 1932, p. 272, fig. 53; Pickard-Cambridge, *Theatre*, fig. 13; *EAA* i, p. 415; Bieber, *Hist.*[2], fig. 117; Sichtermann K 71, pls. 114–6 and 117, 2; (detail) *BABesch* 47, 1972, p. 39, fig. 8. Photos: R.I. 62.1367–8, 64.1143–5.
 (a) (i) Stag attacked by griffins, (ii) Antigone before Creon at the shrine of Herakles, (iii) female head in floral surround, (iv) Amazonomachy, (b) (i) Stag attacked by lion and griffin, (ii) three women and a youth at a naiskos in which is a seated woman, (iii) female head in floral surround, (iv) Amazonomachy continued from (a).
 For the shrine of Herakles cf. the marble relief Athens N.M. 2723 representing Herakles Alexikakos beside a tetrastyle shrine (Travlos, *Pict. Dict.* pp. 139 ff., fig. 352), and an early fourth century relief in Boston (96.696; *Gr., Etr. and Roman Art*, p. 139, fig. 127), on which a vase is shown on top of the shrine. For similar representations on Attic vases see Metzger, *Représentations*, pp. 223 ff.

42 Ruvo 425. Pair to preceding; much repainted.
 W., p. 350; *Japigia* 3, 1932, p. 273, fig. 54; Sichtermann K 70, pls. 112–3 and 117, 1 and pl. 118. Photos: R.I. 62.1369–70; 64.1140–1.
 (a) (i) Bull between two griffins, (ii) youth with horse in naiskos with six figures around, (iii) female head in floral surround, (iv) Nereids bringing the armour of Achilles, (b) (i) Stag attacked by griffins, (ii) seated woman in naiskos with youths and women around, (iii) female head in floral surround, (iv) Nereids with armour, continued from (a).

In shape and decoration these two vases should be compared with B.M. F 331 (Pelops and Oinomaos) by the Varrese Painter (no. 13/5).

Pelike

* 43 Ruvo 1500. Much repainted. Detail of (b): PLATE 142, 5.
 Overbeck, *KM* pl. 25, 3; Clairmont, *HSCP* 15, 1957, p. 168, no. 26; Sichtermann K 74, pls. 128–131.

Pelike (continued)

> Photos: R.I. 62.1372–3; 64.1162–6.
>
> (a) (i) Apollo and Marsyas, (ii) female head with floral surround, (iii) Nereids with the armour of Achilles, (b) (i) Woman in naiskos with four others around, (ii) female head, (iii) continues from (a). Very closely associated in style with Ruvo 423 and 425.

The two following vases are very close in style to the above, and should also be compared with the early work of the Lycurgus Painter (nos. 16/1–4) and the vases in the Milan Orpheus Group (nos. 16/42–44).

Loutrophoros

44 Naples 3242 (inv. 82265). Recomposed from fragments; the earlier restorations have now been removed.

> Patroni, p. 174, figs. 118–9; Gow, *JHS* 58, 1938, p. 195, fig. 4; Schauenburg, *BJbb* 161, 1961, pl. 45, 2, and *JdI* 88, 1973, p. 5, fig. 4; Moret, *Ilioupersis*, pls. 98–100.
>
> (a) (i) Paris, Helen, Eros and women, (ii) frontal female head amid floral scrolls, (iii) Amazonomachy, (b) (i) Dionysos and Ariadne feasting in arbour with flute-girl and satyr, (ii) winged head in Phrygian cap amid floral scrolls, (iii) Amazonomachy continued from (a).
>
> Below the lower register are two bands of meanders, separated by white-edged rosettes. Such double rows are not common, but an earlier example appears on the Gravina Painter's volute-krater (no. 2/1) where there is a band of meander above one of palmettes, with, however, no decoration in between. On the volute-krater Leningrad 1718 (no. 16/55 below) there is a similar double row, separated by a band of fish, for which compare the nestoris Naples 2338 (no. 13/229). The figures in the upper register are very close to those in the same position on Ruvo 1500.

Squat lekythos

44a Essen, Ruhrlandmuseum 74.158 A3.

> *Antike Keramik* (Ausstellung Ruhrlandmuseum, Okt.–Nov. 1973), no. 41 (ill.).
>
> Standing woman with mirror, seated woman playing "xylophone", veiled woman dancing.
>
> For the veiled dancer cf. the reverse of Naples 3242 (no. 44) and no. 7/53 by the Felton Painter; for the other two women cf. the corresponding figures on Ruvo 1500 (no. 43). The scene is the *locus classicus* for the use of the "xylophone", on which see above pp. 315 and 316, in the General Introduction to Chapters 12–14.

3. THE V. AND A. GROUP

This is a group of vases broadly connected in style, in which one of the most characteristic features is the high top-knot on the heads of most of the women (cf. also no. 5 above).

(i) THE V. AND A. PAINTER

Two vases may at present be attributed to this painter, closely linked by the treatment of the drapery and the drawing of the faces, and, in particular, of the eyes. The scene on the obverse of no. 45 reminds us of that on Oxford G 269 (no. 22), where a similar flat-handled dish upon a base serves as a laver. Compare also the drawing of the breasts of the woman standing behind the seated woman on no. 46 with those of the maenad seated by Dionysos on B.M. F 304 (no. 33); note the frontal female head on the neck of no. 46, which should be compared with those on some of the contemporary volute-kraters or that on the Castle Ashby epichysis, no. 16/69. The drawing of the faces is a little coarser than that on the other vases so far discussed.

Pelike

* 45 London, V. & A. 4799.1901, from Ruvo. PLATE 143, 1–2.

> (a) Eros pouring water into a dish on a plinth (cf. no. 22) between a seated woman holding an

alabastron and a nude woman with a mirror, (b) seated woman with fan and standing woman with wreath.

Oenochoe (shape 1)

46 B.M. F 372. Broken and repaired.
Youth wearing winged sandals (Hermes ?), with staff and flower-spray, draped woman, seated woman on stool, nude youth, draped woman.
Neck: frontal female head.

(ii) VASES RELATED IN STYLE

(a)

Pelike

* 47 Madrid 11199 (L. 348). (b) PLATE 143, 3.
Ossorio, *Cat.*, pl. 40; Leroux, pl. 43; Schauenburg, *RM* 64, 1957, pl. 42, 1.
(a) Youth embracing seated woman beneath a window from which a veiled female head looks down flanked by two Erotes; to l. woman with mirror, to r. woman putting incense on burner (b) woman with phiale seated between Eros with wreath and tambourine, and woman with mirror and cista.

Alabastron

48 Boston 00.360. The mouth is alien.
CB ii, p. 43, Ghali-Kahil, *Hélène,* p. 195, no. 169, pl. 32, 3; Schauenburg, *JdI* 87, 1972, p. 278, figs. 34–36.
(a) Woman playing harp beside seated Menelaos (inscr.), who is crowned by Eros; to r. Helen (inscr.) standing with mirror, (b) woman with two phialai, and youth seated on box.

Dish (with flat handles, decorated with a griffin)

49 New York 06.1021.242.
Schneider-Herrmann, *Paterae,* no. F 9, pl. 4, 1.
A. Nude youth, woman with wreath and fan, seated woman, nude youth with raised foot, holding mirror and bunch of grapes. B. Woman with fillet and fan, seated woman with bird, Eros flying towards her, nude youth with palm-branch.
Compare the double rows of parallel fold-lines on the drapery of the standing women on the reverses of nos. 47–48 and on the New York dish, also the bent leg.

Oenochoe (shape 3)

50 Hamburg 1876.285.
Schauenburg, *JdI* 87, 1972, p. 263, fig. 7.
Eros with mirror and wreath, seated woman with filleted palm-branch, satyr with torch and situla.

(b)

The two following vases should be compared with those in (a) — the reverse of the Maplewood situla with that of Madrid 11199 (no. 47), especially for the standing woman wearing a peplos, the nude youth on the obverse of B.M. F 314 (no. 52) with the corresponding figure on no. 47, particularly for the pose and the rendering of the face and hair. Compare also the drawing of the drapery of the seated woman on no. 52 with that of Aphrodite on the situla. The influence of the Varrese Painter on the drapery is very obvious.

Situla (type 1)

* 51 Maplewood (N.J.), J.V. Noble coll. PLATE 143, 4–6.
Ancient Art in American private collections, no. 299, pl. 85; Martini, *Festschrift Brommer,* p. 228,

Situla (type 1) *continued*

pl. 61.

(a) Above – Eros and Aphrodite with open box; below – old man (paidagogos) with upraised stick in his hand, swan, and nude figure (Ganymede) moving to r., (b) nude youth seated between two women.

The subject finds a close parallel on the calyx-kraters Berlin F 3297 (no. 16/49) and Kiev 120, where the nude figure is clearly male and must be identified as Ganymede.

Note the cymation pattern on the mouth of the vase.

Pelike

52 B.M. F 314.

(a) Seated woman with open box between nude youth with strigil and woman; above – two Erotes holding branches, (b) woman seated on rock beneath tree, youth with wreath, small Eros flying above with ivy-trail.

(iii) THE SCHNEIDER-HERRMANN SUB-GROUP

The woman to right on the Schneider-Herrmann pelike (no. 53) is comparable with the similar figures on the vases of the Painter of the Truro Pelike (e.g. Nostell Priory 42 and Vatican V 41, see Volume II), but the drawing here is better. Note the treatment of the hair and also the acorn-frieze round the neck (cf. no. 50); the chequers with the meanders on the obverse relate the vase to those in section 1. The quartered disks in the field are common on vases in this general area (cf. nos. 45, 47).

Pelike

53 The Hague, Schneider-Herrmann coll. 22.

Schauenburg, 1.c., pp. 261–2, figs. 4–6; *Studiensammlung,* no. 116, pls. 48–9.

(a) Eros standing by laver between two women, (b) two draped youths (B + CX), with white head-bands.

Oenochoe (shape 1)

54 Bari, Lagioia coll.

Hermes with caduceus in l. hand pouring a libation from an oenochoe on to a flaming altar beside which stands Nike with phiale and bunch of grapes.

Plate

55 Naples 2680 (inv. 82028).

Eros with phiale seated on a white laver between a standing woman and a seated woman holding a "xylophone".

Very close in style and decoration to no. 53.

Dish (with flat handles)

56 Bari 6456.

Schneider-Herrmann, *Paterae,* no. F 14.

I. Eros with filleted wreath and branch moving to l. A. Seated nude youth with branch and phiale, woman with bunch of grapes and mirror. B. Standing nude youth with wreath and phiale, seated woman.

Cf. the seated woman wrapped in a cloak which flaps out behind her back with the one on no. 55; note also the very elongated bunch of grapes held by the woman on A; cf. with those on no. 58.

With the above, especially nos. 53 and 55, compare:

Bell-krater

57 E. Berlin inv. 4521.

(a) Satyr with phiale, Eros seated on edge of fishpond catching a fish, woman approaching with

wreath and thyrsus, (b) two draped youths (with white head-bands), l. with wreath, r. with palm-branch by altar.

(iv) CONNECTED VASES

(a)

Volute-krater

58 Bari 876.
 (a) Woman with alabastron and bunch of grapes, and youth with wreath and branch at a naiskos in which is a seated youth, with lyre suspended above, (b) woman with wreath and bunch of grapes between two satyrs, all moving to l.
 Compare the treatment of the woman with that on the preceding vases, and note the use of elongated bunches of grapes as a decorative adjunct on the reverse (cf. with no. 56). The saltires with the meander may also be compared with those on that vase.

(b)

Hydria

59 Policoro 38462, from Policoro.
 ArchReps 19, 1973, p. 37, fig. 8; *Festschrift Brommer,* pl. 75, 3.
 Shoulder: Poseidon and Amymone beside the fountain-house in which is a hydria; to r. Eros with branch, to l. Aphrodite.
 Body: Six Danaids, with hydriai, two of whom stand beside a large pithos, with reeds growing in front of it.
 Between the shoulder and the body is a band in added white of swastika meanders accompanied by hollow squares.
 On stylistic grounds this is not an easy vase to place. The pattern-work is appropriate for this general area (chequers, palmettes on the neck) and the Danaids have the characteristic "top-knots"; note also the double black stripes down their peploi.

4. THE GROUP OF VATICAN W 4

(i)

With the vases in this group we approach more closely to the style of the Lycurgus Painter and also to that of the Gioia del Colle Painter, who will be discussed in Volume II as one of the forerunners of the Darius Painter.

The vases in the present group still have much in common with those in the preceding sections, notably in the drawing of the three-quarter faces, the treatment of the drapery, and the decorative adjuncts. We should also note:

(a) the elongation of the figures and their more mature aspect,
(b) the combination in the drapery of fold-lines with open spaces,
(c) the use of fewer but heavier black lines.

On the reverse of no. 60 is a naiskos scene in which the figures of the youth and his dog are in red-figure and not, as usual, in added white. This is exceptional, but occurs again on some of the later vases, especially in the circles of the Darius and Baltimore Painters (e.g. Leningrad 4323, Moscow 747, New York 69.11.7, Baltimore 48.86). The nude youths on the reverse with their white head-bands should be compared with those (both nude and draped) on the vases of the Ginosa Group (Chapter 14, section 6) with which they are contemporary and closely connected; cf. also the draped woman on the obverse bending forward over her raised right foot and holding a floral chain with the similar figure on Taranto 8922 (no. 13/1), by the Varrese Painter.

Volute-krater

* 60 Vatican W 4 (inv. 17162). Details of (a): PLATE 144, 1−2.
 VIE, pl. 51; Helbig-Speier i, p. 709, no. 990.
 (a) Triptolemos, (b) two youths and two women at a naiskos in which is a r.f. youth with dog.
 Neck: (a) head in Phrygian cap (Orpheus ?) amid florals.
 Mascaroons: female heads with white flesh.

The same subject as on the obverse (departure of Triptolemos) will also be found on a small fragment in Amsterdam (inv. 2636) which represents the lower part of the body of Demeter, who holds a cross-bar torch in her left hand, and a small portion of one of the snakes which draw the chariot. To left is part of some elaborate scroll-work rising from an acanthus-leaf base, which suggests that the fragment should probably also be placed in this general context, though it does not seem to be by the same hand as no. 60.

Calyx-krater

* 61 Leningrad inv. 312 = St. 880. PLATE 144, 3−4.
 Stephani, *CRStP* 1862, pl. 5, 3, 2 = *RV* i, 13; Schauenburg, *Perseus,* pl. 36, 1.
 (a) Standing woman with phiale, woman seated on stool beside an incense-burner, youth with ram's horn (Dionysos ?) leaning against pillar, nude youth with branch, (b) draped woman with wreath and phiale between two nude youths, l. with wreath and stick, r. with bunch of grapes and stick.
 The figures on the reverse are close to those on the reverse of the Vatican krater; compare also the treatment of the women's drapery.

(ii)

With the two vases above compare the following:

Calyx-krater

* 62 Leningrad inv. 311 = St. 885. PLATE 144, 5−6.
 (a) Nude youth with drapery over l. arm leaning on stick, seated nude youth holding incense-burner and situla, draped woman with dish of cakes and fillet, (b) two draped youths, l. with wreath and r. with stick, with an altar between them.

Volute-krater

 63 Rome, Museo Barracco 233. Much overpainted.
 Schauenburg, *RM* 65, 1958, pl. 33, 2.
 (a) Triumph of Apollo, (b) woman and two youths.
 Neck: (a) two lions confronting.
 Mascaroons: female heads with white flesh.
 This vase has been too heavily repainted to allow of a definite attribution, but the figures on it are comparable with those on no. 62 and the drapery of Nike on the obverse should be compared with that of the seated woman on no. 61.

(iii)

Also comparable with Vatican W 4 are the vases in this division; on Parma C 96 (no. 64) we note the r.f. youth in the naiskos and the rather similar-looking figures which surround it. Here considerable emphasis is put upon the chin, which is more deeply indented than on the Vatican krater, and the faces are rather more angular.

Volute-krater

 64 Parma C 96.
 CVA, IV D, pl. 3.
 (a) Youth with sheathed sword and shield in naiskos with two seated women and two youths around,

(b) r.f. youth in naiskos with two spears and shield, two seated women and two youths around.

　　Neck: (a) female head in white in three-quarter view amid florals.

　　Mascaroons: female heads with white flesh.

Calyx-krater

65　Munich 7765. The foot is a replacement from another vase.

　　Lullies, *Vergoldete Terrakotta-Appliken aus Tarent*, pl. 34; Schneider-Herrmann, *BABesch* 45, 1970, pp. 88–9, figs. 3–4.

　　(a) Seated woman with branch and phiale, and Eros holding wreath, branch and bunch of grapes, (b) seated Eros holding filleted wreath and tambourine.

Dishes

66　Ruvo 639.

　　Schneider-Herrmann, *Paterae*, no. 197.

　　I. (a) Woman with fillet approaching seated Eros, holding bunch of grapes, (b) seated Nike with branch approached by nude youth with wreath and phiale. Tondo: seated youth with phiale. A. Eros with wreath seated to l. between two women, l. holding cista and tambourine, r. with foot raised, holding phiale in r. hand. B. Eros with phiale seated to r. between two women, l. with bunch of grapes and cista, r. with foot raised, holding wreath and branch.

　　A. has been considerably repainted.

67　Bari 925.

　　Schneider-Herrmann, *Paterae*, no. 195.

　　I. Seated satyr with kantharos and situla, seated woman with phiale and wreath, Eros with wreath, seated woman with fillet and tambourine, seated Eros with cista. These figures are grouped (the first three on top, and the other two below) around a triskeles in the tondo.

(iv)

　　Probably here also might be placed, especially on the evidence of its reverse, the following volute-krater, the obverse of which has been so heavily repainted as almost completely to obscure the original drawing:

Volute-krater

68　Ruvo 414. Much repainted.

　　Sichtermann K 69, pls. 110–111; Keuls, *Water Carriers in Hades*, pl. 6. Photos: R.I. 62.1350 and 64.1187–9.

　　(a) Scene from "The Locrian Maidens" (?) — two women (Cleopatra and Periboia) seated upon an altar between a bearded king and youth with pilos and two spears; above — Hermes, Athena and Apollo, (b) two youths and two women with offering at a stele.

　　Neck: (a) frontal female head amid florals (repainted).

　　Mascaroons: female masks with dark flesh.

　　Two other vases, (i) Leningrad 452 and (ii) Brussels, Errera collection, show the same subject, for which see Robert, *Arch. Hermeneutik*, pp. 371 ff. (figs. 281–283), Hauser, *ÖJh* 15, 1912, pp. 168–173 (figs. 108–109), Mingazzini, *RendPontAcc* 38, 1965–6, pp. 69 ff. (figs. 1–2), and Eva Keuls, op. cit. pp. 77 ff., pls. 6–7.

5. THE PAINTER OF LECCE 3544

This painter is an important artist whose work provides a connecting link between the later vases of the Iliupersis Painter and those of the Lycurgus and Gioia del Colle Painters.

Volute-kraters

The two following volute-kraters form a closely connected pair with animals on the neck and a very similar naiskos scene on the obverse. In each case the deceased would seem to have been connected with the stage, since on no. 69 there is a phlyax mask above and on no. 70 a lyre, while here the youth holds a long-haired female mask in his hand. Note also the row of four phialai in the panels below the naiskoi, the walls of which are not unlike those on Bonn 100 and B.M. F 352 (nos. 16/14 and 20) by the Lycurgus Painter.

The two reverses show four figures grouped around a naiskos on no. 69 and a stele on no. 70. Such scenes are not depicted by the Lycurgus Painter himself but find close parallels on the work of the Gioia del Colle Painter and his school (see Volume II). Note also the use of quartered squares with dots along with the meanders; again, this is not a Lycurgan practice.

69 Lecce 3544.
 CVA 2, pl. 33, 2–3 and pl. 34; Messerschmidt, *RM* 46, 1931, p. 75, fig. 32; *PhV*2, no. 168. Photos: R.I. 62.1229–32.
 (a) Actor in naiskos, with youths and women around, (b) three youths and a woman with offerings at a shrine in which is a large vase.
 Neck: (a) bull between two lions (Mingazzini, *Annuario* 45–6, 1967–8, p. 351, fig. 25).
70 Trieste S 383.
 *PhV*2, no. (xxvi); Schauenburg, *RM* 79, 1972, pls. 4–5. Photos: Alinari 40216–7.
 (a) Actor in a naiskos with three youths and women around, (b) two youths and two women with offerings at a grave-monument (Ionic column with kantharos on top).
 Neck: (a) griffin and lion.

Amphora

71 Naples 2203 (inv. 82385). Much repainted.
 (a) Youth in naiskos with horse; two youths and two women around, (b) seated youth and woman to l., seated woman and youth to r. of shrine, in which is a plant.
 Cf. also with Leiden GNV 154, no. 8/27 by the Iliupersis Painter.

The following vase, which is badly damaged and now in process of restoration, might be placed here although it should also be compared with the work of the Iliupersis Painter.

Amphora (?) (restored as a nestoris)

72 Berlin F 3260.
 Gerhard, *Trinkschalen* 23–24; cf. Schauenburg, *Gymnasium* 67, 1960, p. 181.
 (a) Shoulder — four white lions. Body — bearded man and young warrior in naiskos, with to l., seated woman with cista, seated youth with fan, woman bending forward with phiale, and to r., standing woman, seated youth with phiale, youth coming up with branch. (b) A naiskos containing a vase on a pedestal (cf. Lecce 3544) with to l., seated woman and approaching youth; to r., seated youth and woman approaching with fillet and cista.
 The two figures in the niaskos are inscribed Aineias and Anchises, but it has not been possible to check the authenticity of the inscriptions.

The following is also connected in style, and should be closely compared with the dish B.M. F 464, associated with the Iliupersis Painter (8/54).

Hydria

73 Ruvo 1058.
 Photo: R.I. 1972.59–61.
 Shoulder: Woman seated beside hydria, with bird on knee; nude youth and woman with phiale beside

an Ionic grave-monument on top of which is a patera of offerings and on the base an amphora on each side of the shaft; seated nude youth with two spears. Below: nude youth with wreath, woman with cista and fan, woman with alabastron and phiale, woman with mirror.

6. THE GROUP OF NAPLES 1763

The vases in this group, which still reflect something of the influence of the Iliupersis Painter, are connected in style with those in the Group of Ruvo 423 (cf. the youth in the naiskos on the reverse of no. 74 with Herakles in the *heroön* on the obverse of no. 41), and also with the work of the Lycurgus Painter. In the stele scenes on the reverses we may note the typical chiastic arrangement of the youths and women (see above p. 187 — and cf. the reverses of nos. 69 and 70), and we shall observe a similar practice on those of the vases in the Gioia del Colle Group (see Volume II, chapter 17). A more extensive use of added colour will be seen in the drapery of the figures in the naiskoi (cf. with no. 13/1 by the Varrese Painter), one of which is normally a bearded man. A horse is shown beside the youths in the naiskoi on on nos. 76—77 (cf. no. 71), and from now on it will make a regular appearance in this context (cf. the Attic grave-monument in Moscow, Diepolder, *Die attischen Grabreliefs,* p. 37, pl. 32). The stepped pyramid on the top of the naiskos on no. 75 finds a parallel on vases by the Iliupersis and Varrese Painters (see nos. 8/80—81 and 13/1 above).

The first two amphorae (nos. 74—75) are the work of a single painter; the others are probably also by his hand, but, as they are either in a very fragmentary state or else heavily repainted, it is hardly possible to make a definite attribution.

(i) THE PAINTER OF NAPLES 1763

Amphorae

74 Naples 1763 (inv. 82384).

(a) Bearded man with wreath and youth with stick in naiskos; to l., youth with raised foot and seated woman in three-quarter view with phiale; to r., seated woman with bunch of grapes and phiale and bearded man with wreath and branch, (b) r.f. youth with spear and pilos standing in naiskos; to l., woman bending forward and seated youth; to r., youth in three-quarter face leaning on stick, and seated woman with wreath and cista.

75 Karlsruhe B 5.

CVA 2, pl. 59, 1 and pl. 60, 1; *JHS* 74, 1954, p. 229; Neuerburg, *Archaeology* 22, 1969, p. 111.

(a) Seated bearded man clasping the hand of youth in a naiskos; to l., seated woman with wreath and open box, standing youth in three-quarter view, with fillet and phiale; to r., standing youth with wreath and phiale, seated woman with wreath and mirror, (b) two youths and two women at a stele — above: seated woman with phiale and wreath, seated youth with phiale, alabastron and wreath; below: youth and woman running up with offerings.

(ii) VASES CLOSE TO THE PAINTER IN STYLE AND PROBABLY ALSO BY HIS HAND

Amphorae

76 Munich, ex Lenbach coll. 345. Much repainted.

(a) Youth beside horse with bearded man in naiskos; to l., seated woman and nude youth, to r., seated nude youth and standing woman with branch and cista, (b) two youths and two women around a stele, on top of which is a kantharos.

Note the swastika and hollow square decoration on the base of the naiskos; the black laurel on the base of the stele may be compared with that on the reverse of no. 74.

77 Brussels, Errera coll. 41. In very bad condition.

(a) Bearded man with phiale and wreath, youth beside horse in naiskos, around which are four

Amphorae (continued)

figures, two seated youths above and two women below, (b) two youths and two women at a stele with a kylix on top (mostly missing).

78 Present whereabouts unknown.

(a) Bearded man seated between two youths in a naiskos; to l., seated youth with phiale, standing woman with phiale and wreath; to r., seated woman with phiale and fan, nude youths with wreath and fillet, (b) stele scene.

This vase is known to us only from old photographs, but the shape, decoration and pattern-work relate it closely to the other amphorae in this group, and the decoration on the base of the naiskos is similar to that on no. 76. The triglyph-metope frieze above the architrave on the naiskos finds a parallel on Naples 2195 and 2199 in the Gioia del Colle Group.

CHAPTER 16

THE LYCURGUS PAINTER AND HIS CIRCLE

1. The Lycurgus Painter
2. Close Associates
3. Later Followers — The Chamay and Chini Painters
4. Two Underworld Kraters

Bibliography

A.D. Trendall, *NMH*², p. 324, note 5; *VIE* i, p. 70; *JHS* 81, 1961, p. 224; *LCS*, pp. 159–161; *SIVP*², p. 20.

A. Rocco, 'Il mito di Troilo', in *ArchCl* 3, 1951, pp. 168–175.

M. Schmidt, *Der Dareiosmaler,* pp. 12 ff., pls. 1–3.

A. Stenico, "Licurgo, Pittore di", in *EAA* iv, p. 750.

Andrew Oliver Jr., "The Lycurgus Painter", in *BMMA* 21, 1962, pp. 25–30 (= Oliver).

G. Sena Chiesa, "Vasi apuli di stile ornato del Pittore di Licurgo ed a lui prossimi", in *Acme* 21, 1968, 327 ff. (= Sena Chiesa).

Introduction

In the work of the Lycurgus Painter and his close associates we see the culmination of the second phase in the development of the "Ornate" style. Their vases do not yet attain the monumental dimensions of those by the Darius and Underworld Painters, but their compositions are on a larger scale, often arranged on three or more levels, with ten or more characters taking part. We note also a greater skill in the rendering of perspective and in creating the illusion of spatial depth. The influence of the Iliupersis Painter and his followers is still very strong, but the effect of the "baroque" vases discussed in the previous chapter is also very clear in the elaboration of the ornamental decoration and of the drapery. The Lycurgan school favours mythological or dramatic subjects for the obverses and Dionysiac scenes on the reverses; funerary scenes with naiskoi or stelai, which play such a large part on the products of other workshops, are hardly found, though the bridal and couch scenes which appeared in the Salting Group occur with reasonable frequency. The vases of this group, which are mostly to be dated around the middle of the fourth century, should also be compared with those by the followers of the Snub-Nose Painter and by the Varrese Painter (cf. the draped women leaning on a pillar or bending forward over a raised foot); their influence is even more apparent on the vases of the next generation.

1. THE LYCURGUS PAINTER

Among the characteristic features of the Lycurgus Painter's work the following are worthy of particular note:

(a) a fondness for faces in three-quarter view (cf. with the Suckling-Salting Group and the Painter of the Dublin Situlae), with the head tilted slightly to one side and often with a rather anguished look, more expressive of pain or strain than on the vases in Chapter 15, and perhaps more strongly influenced by the Scopaic school of sculptors;

(b) a greater degree of mannerism or artificiality in the poses — e.g. the off-the-shoulder style of drapery (nos. 5, 10, 17, 22), the plucking at a piece of drapery above the shoulder (nos. 5, 11, 13, 14, 16, 20, 22); the frequent appearance of people leaning against pillars (nos. 6 b, 10 b, 16 b, 20, 22: cf. with B.M. F 331, no. 13/5, by the Varrese Painter or the Dechter hydria, no. 14/121), or bending forward over one raised

foot (nos. 14, 16 b, 18 b, 20, 21: cf. also with the Varrese Painter) — for both these poses many parallels can readily be found on the vases in Chapter 15 and in the work of the Snub-Nose and Varrese Painters and their followers;

(c) the hair is often long and curling (cf. the later vases of the Iliupersis Painter, and those of the Suckling-Salting Group), with the individual locks clearly indicated (nos. 2—6); women generally wear a *sphendone*, often with a radiate *stephane* and sometimes with a "top-knot". The chests of older men, gods or giants tend to be hairy (cf. nos. 5, 10, 12, 16);

(d) the drapery is elaborately patterned, with dot-stripe borders, embroidered stars, etc., and often has an inset stripe of lozenge-pattern (e.g. nos. 7, 10, 18; cf. with Andromeda on no. 7/70 by the Felton Painter); the sleeves and trousers of Orientals are decorated with a black and yellow zig-zag pattern (e.g. nos. 7, 11, 18). Women's drapery has a strong tendency to swirl;

(e) there is an extensive use of added white and yellow, especially for details and adjuncts; the reflecting pool, introduced by the Iliupersis Painter (nos. 8/11 and 17) becomes increasingly popular (e.g. nos. 1, 11, 16 b); it is often shown with a rocky edge, round which small plants may be growing;

(f) the reverses regularly show Dionysos seated in the centre surrounded by maenads and satyrs; at first they are on the same level (nos. 1, 6, 10), but later the number of figures is increased and they are disposed on different levels (nos. 11, 13—15);

(g) the necks and heads of his horses tend to look rather thin (e.g. nos. 11, 12, 13, 18);

(h) there is a better understanding of the use of overlapping planes (cf. no. 10) and of perspective;

(i) apart from the standard adjuncts (phialai, rosettes, windows, etc), a banded situla often appears, especially on the reverses (e.g. nos. 7, 10, 11, 14, 15, 17, 18); the figured calyx-krater on no. 17 should be compared with those on nos. 15/32—33;

(j) volute-kraters mostly have open-work handles, sometimes decorated with ivy or laurel (nos. 12, 16); mascaroons are less frequent (nos. 13 and 15). The decoration on the necks of the obverses follows the Iliupersic formula — animals (griffins) on nos. 10 and 11, figured scenes on nos. 12, 15, 16 and a female head on nos. 13 and 14.

(k) the meanders are always accompanied by saltire squares; the lower part of calyx-kraters may be ribbed (nos. 5—6, 9), as is also the volute-krater no. 12.

On the vases of the Lycurgus Painter, especially the reverses, we shall note a number of stock figures which recur with a monotonous regularity: in particular, a standing woman with one leg slightly flexed, and some object held in one or both of her hands (nos. 1—4, 13—15, 17), and a seated woman in three-quarter view looking down on the scene (nos. 4, 5, 11, 22), or in profile (nos. 1—3, 5, 13, 15, 21). Reference has already been made to the seated figure of Dionysos and to the woman leaning on a pillar, both of whom are frequently represented.

The Lycurgus Painter's vases depict an unusually large range of interesting subjects, most of which are drawn from mythology or drama (e.g. Boreas and Oreithyia, Achilles and Penthesilea, the apotheosis of Herakles, the garden of the Hesperides, the death of Troilos, the madness of Lycurgus, Pelops and Hippodamia, Parthenopaios, the death of Opheltes, Orestes at Delphi, the horses of Rhesos). Others show bridal or erotic scenes (nos. 2, 4, 21—22), with embracing lovers; only two depict naiskoi (nos. 14 and 20), on both of which the side-walls are decorated with scroll-pattern as on Lecce 3544 and Trieste S 383 (nos. 15/69—70). The greater interest in mythology is characteristic of artists like the Darius and Underworld Painters in the next generation, and they may well have been influenced in this regard by the practice of the Lycurgus Painter.

The obverse of Ruvo 1097 (no. 16) is of interest as showing the statue of Apollo within his temple (cf. Amsterdam 2579, no. 2/10, by the Painter of the Birth of Dionysos); the small strut which which supports the slightly raised right foot is clearly visible. The calyx-krater with an Arimasp fighting a griffin (no. 7) is a remarkable vase, since the subject more usually appears

upon the necks of volute-kraters (e.g. Leningrad 1710; Leiden, Arch. Inst., no. 40 — de Haan-van de Wiel, *BABesch* 45, 1970, pp. 118 ff.; Schneider-Herrmann, *BABesch* 50, 1975, pp. 271—2, figs. 14—15); in view of the floral setting one might reasonably assume that the painter has used for the main representation what would normally be a subsidiary scene. The setting recalls that of the Dublin and Ruvo situlae (nos. 15/35—16).

The influence of the Lycurgus Painter upon Lucanian, and especially on the Primato Painter, is discussed in *LCS*, pp. 159—60.

(i) EARLY WORK

Calyx-krater

* 1 Basel, Antikenmuseum (on loan from a private coll. in Rome). PLATE 145.
 Ariel Herrmann, *AntK* 18, 1975, pp. 85 ff., pl. 32, 3 and 5.

 (a) Above — Aphrodite and Eros; below — aegipan with thyrsus watching balding silen (Marsyas ?) clasping nude youth (Olympos ?) playing the flute beside a pool; to r., nude woman holding up cloak, (b) woman with branch and wreath, seated nude youth with phiale and branch, nude youth with bunch of grapes and branch, drapery over l. arm.

 For a discussion of the iconography and the compostion, and its relations with Hellenistic sculpture, see the article in *AntK* by Ariel Herrmann referred to above.

Pelikai

The two following pelikai, both considerably repainted, go closely together in style and decoration and seem to be early work, still closely connected with the Iliupersis Painter.

* 2 Milan, "H.A." coll. 236. PLATE 146, 1—2.
 Bendinelli, *Ausonia* 9, 1919, no. IV, p. 188, fig. 1; *RV* i, 325.

 (a) Embracing couple on couch, with three women and a youth around, and above Eros with wreath, (b) two youths and two women.

 3 Ruvo 415. Much repainted.
 Sichtermann K 80, pl. 83. Photo: R.I. 64.1238.

 (a) Eros and youth with four women, one seated by laver, (b) youth offering crown to seated woman, between standing woman to l. and youth to r.

With the above we may compare a lost pelike (formerly with Basseggio), of which drawings are preserved in the German Archaeological Institute in Rome (Photos: R.I. 77.1206—7), with (a) Eros flying towards a woman seated on a laver between a youth and a woman leaning on a pillar, (b) Eros with iynx above a laver flanked by a youth and a woman. The woman on the laver is very similar to the one seated beside the laver on Ruvo 415.

With these must go another badly battered pelike:

* 4 Taranto 4622 (upper part only). PLATE 146, 3—5.
 Bendinelli, loc. cit., p. 186, no. II; Schauenburg, *JdI* 87, 1972, p. 291, fig. 49.

 (a) Bride and groom on couch with Eros beside them; to l. three women, to r. woman putting incense on incense-burner; above: Aphrodite on swan, (b) above — Eros flying towards seated woman holding mirror and cista; below — draped woman, woman with fan crowning seated nude youth, woman with mirror.

 For the subject on the obverse cf. the Salting pelike in the V. and A. (see 15/6 above).

(ii) STANDARD STYLE

Calyx-kraters

* 5 B.M. F 271, from Ruvo. PLATE 147.
 Schmidt, p. 12, pls. 2—3; *EAA* iv, p. 750, fig. 909; Oliver, p. 27, fig. 2; Borda, pl. 7 (colour);

Calyx-kraters (continued)

Otto Brendel, *JdI* 81, 1966, p. 235, fig. 18; Deichgräber, *Lykurgie,* pl. 4; *Ill.Gr.Dr.* III.1, 15; Säflund, *E. Pdmt.,* p. 134, fig. 89; detail of reverse — Squarciapino, *Annuario* 30–2, 1952–4, p. 136, fig. 4.

(a) Madness of Lycurgus, (b) Pelops preparing for the chariot race.

Note the nimbus surrounding Lyssa on the obverse, and compare it with those on the Orestes and Actaeon oenochoai in Taranto, nos. 7/62–63 by the Felton Painter; for the tripod on the column cf. Taranto 14007 by the Iliupersis Painter (no. 8/21).

* 6 Milan ST. 6873. PLATE 148, 1–3.

Sale Cat. Finarte 5 (14 March 1963), no. 86, pls. 44–45; *BdA* 49, 1964, p. 404, fig. 1; *Ill.Gr.Dr.* III.4, 1.

(a) Parthenopaios seated on a couch between, to l., old man and woman, and to r., Atalanta; above — Apollo seated between Hermes and Ares; to l. and r. a tripod on an Ionic column in added white, (b) Dionysos seated on couch between satyr and maenad to left, and maenad to right (very fragmentary).

Cf. the drapery with that on nos. 5 and 9. Connected also with Amsterdam 2572 (no. 48), and with B.M. F 304. For the tripods on columns flanking the scene on the obverse cf. no. 5, and no. 8/21.

* 7 Naples, private coll. 1. PLATE 148, 4.

Schneider-Herrmann, *BABesch* 50, 1975, pp. 271–2, fig. 15.

(a) Arimasp attacked by griffin in a floral setting, (b) nude youth with stick offering wreath to seated nude youth beside a banded situla.

Fragments of calyx-kraters

8 Amsterdam 4669.

Oliver, p. 29, fig. 5; Moret, *Ilioupersis,* pl. 63, 2.

Amazon, kneeling with shield.

The typical lattice-pattern stripe runs down the centre of her tunic.

* 9 Bonn 147 (ex Fontana coll.). PLATE 149, 3.

AZ 1850, 193 ff., pl. 18 = *RV* i, 372, 1; *Antiken aus dem Akad. Km.,* p. 193, no. 220.

Man binding figure dressed in long chiton to tree, seated man (inscribed IΣΣ) with bound hands, draped figure.

Volute-kraters

* 10 B.M. 1931.5–11.1. PLATE 149, 1–2.

Walters, *JHS* 51, 1931, p. 89, fig. 2, pl. 4; *Enc Brit* s.v. Pottery: Porcelain, pl. 3, 5; Oliver, p. 29, fig. 6; *SIVP,* pl. 8; Moret, *Ilioupersis,* pl. 79.

(a) Boreas and Oreithyia, (b) Dionysos between youth and woman, leaning on pillar.

Neck: (a) two griffins.

11 Adolphseck 178.

CVA 2, pls. 76–79; Oliver, p. 28, fig. 4; Scherer, *Legends of Troy,* p. 96, fig. 77; detail of neck — Rallo, *Lasa,* pl. 13, 2.

(a) Achilles and Penthesilea, (b) Dionysos seated, with a maenad and two satyrs.

Neck: (a) griffins devouring stag.

Cf. the griffins with those on no. 10; cf. also B.M F 276 and Taranto 8129 (no. 40) for later examples of the same motive.

12 Leningrad inv. 1714 = St. 523.

W. p. 349, no. 5; (a) *ÖJh* 16, 1913, p. 155, fig. 80; Vian, *Rep. Gigant.,* no. 394, pl. 47; Cook, *Zeus* iii, pl. 8; Schauenburg, *AntK* 5, 1962, pl. 18, 3; detail: Chubova and Ivanova, fig. 47; Moret, *Ilioupersis,* pl. 61; *Greek & Rom. Ant. in the Hermitage,* pls. 76 (colour) and 77; (b) *Ill.Gr.Dr.* III.3, 25; neck: *FR* iii, p. 366, fig. 175; Moret, op. cit., pl. 47, 1.

(a) Gigantomachy, (b) death of Opheltes.

Neck: (a) Orestes at Delphi.

Note the way in which the legs of the giants in the lower register are cut off by the border-pattern, giving the impression that they are buried beneath the ground (cf. Bari 4399, no. 44 below, which looks as if it had drawn its inspiration from the same source).

13 Milan, "H.A." coll. 260.

 Bull.Nap. n.s. 3, pl. 14 = *RV* i, p. 481; Cook, *Zeus* iii, p. 513, fig. 324; Oliver, p. 30; Sena Chiesa 348 ff., pl. 4, figs. 7–8; *CVA* 1, IV D, pls. 7–9.

 (a) Apotheosis of Herakles; below: three women with hydriai quenching the flames of the pyre, (b) Dionysos seated between four women and a satyr holding a torch.

* 14 Bonn 100. PLATE 150, 1–2.

 Antiken aus dem Akad. Km., no. 222, pl. 104.

 (a) Three youths and two women around a naiskos in which is a youth leaning against a laver and playing with his dog, (b) Dionysos with two maenads and two satyrs.

 Neck: (a) female head in floral setting (Oliver, p. 30, fig. 7).

 Close in style to B.M. F 352 (no. 20); note in particular the fillets tied around the Ionic columns of the naiskos and the treatment of the side-wall on these two vases. The row of phialai below the floor of the naiskos recalls those on Lecce 3544 and Trieste S 383 (nos. 15/69–70).

15 Naples, Biblioteca dei Gerolomini.

 Passeri, pl. 260; *RV* i, 351; Rocco, *ArchCl* 3, 1951, pp. 168 ff., pl. 40; *LAF,* no. 6 (ill.); Bianchi Bandinelli and Paribeni, *L'arte dell' antichità classica* i, fig. 500.

 (a) Death of Troilos (cf. Taranto 100839; no. 24), (b) maenad seated with phiale and thyrsus surrounded by a seated youth and woman above, two standing women below, and a satyr pouring wine into a phiale from a black oenochoe.

 Neck: (a) Amazonomachy.

16 Ruvo 1097.

 W. p. 349, no. 18; *Japigia* 3, 1932, pp. 269–70, fig. 50–1; Sichtermann, K 72, pls. 119–122; detail of (b): *LAF,* no. 23, (ill.); Schneider-Herrmann, *BABesch* 47, 1972, p. 35, fig. 3; *Popoli e civiltà del l'Italia antica* ii, pl. 112; Keuls, *Water Carriers in Hades,* pl. 16. Photos: R.I. 62.1353–5; 64.1146–8.

 (a) Sacrifice to Apollo, (b) the garden of the Hesperides.

 Neck: (a) Herakles and the bull, (b) Dionysiac scene.

 Foot: Arimasps and griffins (cf. no. 7).

Situlae (type 1)

* 17 New York 56.171.64, from Ruvo. PLATES 150, 3–4 and 151, 1.

 NSc 1878, p. 378; Hôtel Drouot, *Sale Cat.* 18 March 1901, no. 57, ill. on pp. 20–21; *BMMA,* March 1957, p. 179; Oliver, pp. 26 ff., figs. 1, 3 and 8; Bothmer, *Gr. Vase-Painting* = *BMMA* 31.1, Fall 1972, p. 4 (ill.).

 (a) Dionysos in griffin-chariot, with to l. papposilen playing the pipes; below — seated half-draped woman with phiale, papposilen drawing wine from a calyx-krater in an oenochoe, seated woman with off-the-shoulder drapery, (b) Dionysos with phiale and thyrsus seated between maenad with oenochoe and tambourine and young satyr with wreath and box.

 On bottom of vase: female head in full face.

 For Dionysos in a griffin-chariot cf. the squat lekythos Berlin 3375 (Vian, *Gigantomachies,* no. 400, pl. 48) and Vatican X 6 (no. 13/21).

17a Okayama (Japan), Kurashiki Museum.

 (a) Eros with oenochoe and phiale standing beside woman seated on Ionic capital, holding kantharos and thyrsus, woman bending forward over raised foot; above to r., seated satyr holding dotted sash in both hands, (b) standing woman with cista, seated nude youth, young satyr.

Situla (type 2)

* 18 Naples 2910 (inv. 81863). (b) PLATE 151, 2.

 W. p. 350, no. 27; Schmidt, *Dareiosmaler,* pl. 1; *Italy's Life* no. 26, p. 72 (colour); *BABesch* 41,

Situla (type 2) *continued*

1966, p. 69, fig. 11; *LAF,* no. 14 (ill.); *Ill.Gr.Dr.* III.5, 7.

(a) Horses of Rhesos, (b) maenad, satyr with torch in l. hand pouring wine into phiale held by seated Dionysos, maenad with foot raised, holding mirror.

Amphora

19 Trieste S 380.

CVA, IV D, pls. 14—15; (a) Schauenburg, *Philologus* 104, 1960, fig. 2; Moret, *Ilioupersis,* pl. 97, 2; (b) Schauenburg, *AA* 1962, 775, fig. 19; Daltrop, *Die Kalydonische Jagd,* pl. 23; Moret, op. cit., pl. 71, 1.

(a) Achilles and Penthesilea, (b) boar hunt.

Hydria

* 20 B.M. F 352. PLATE 151, 3.

Detail: Richter, *Perspective,* fig. 193.

Two seated women above, woman with raised foot to l., and two standing women to r. of a naiskos, in which are mistress and maid.

Compare the treatment of the naiskos with that on Bonn 100 (no. 14).

Pelikai

* 21 Taranto, from Contrada Corvisea 13.4.29. PLATES 151, 4 and 152, 3.

(a) Two women, Eros flying to crown seated woman, youth at laver, (b) standing woman and seated woman.

* 22 Matera 11671, from Timmari, T. 7. PLATE 152, 1—2.

Popoli anellenici, p. 40, pl. 8.

(a) Seated woman, Eros pouring perfume from an alabastron on to a seated woman embracing a youth, between youth leaning on stick, with bird perched on r. hand, and woman with mirror and bunch of grapes, resting l. arm on pillar, (b) nude youth with phiale seated between woman with tambourine and nude youth holding up wreath in r. hand.

For the woman on the reverse cf. the reverses of Taranto 4622 and Naples 2910 (nos. 4 and 18).

Dish (frr.).

* 23 Cambridge, Mus. Class. Arch. UP 144. PLATE 152, 4.

Nereids with the arms of Achilles.

<h2 style="text-align:center">(iii) RELATED FRAGMENTS</h2>

The following fragments are very close in style to the work of the Lycurgus Painter and the first four might possibly be by his own hand.

Fragments

24 Taranto 100839.

Death of Troilos; combat between Greeks and Trojans (cf. no. 15).

25 Halle 212.

Robert, *Arch. Hermeneutik,* p. 361, fig. 275; Bielefeld, no. 73, pl. 14, 3; Séchan, *Études,* p. 339, fig. 101.

Poseidon.

26 Cambridge, M.C.A. 143.

Seated goddess on throne between woman and Aphrodite with iynx; above, lower parts of figures holding musical instruments.

27 Basel, H.A. Cahn coll. 265 (from a bell-krater).

Bellerophon attacking the Chimaera, with Pegasus to r., Nike flying down to crown him, and part of a seated figure above to l.

The fragment is ill preserved and the surface much abraded but the drapery of the seated figure top l. is very Lycurgan (cf. also the Pentheus fragment, no. 15/34), as are the black-marked stones in the foreground.

* 28 W. Berlin 30916. PLATE 152, 5.

Jason attacking one of the snakes drawing Medea's chariot.

29 Amsterdam 2563.

Madness of Lycurgus — above to l. Lyssa with nimbus, below, head and r. shoulder of Lycurgus, with axe in his hand; to l. seated figure (Dionysos) with narthex.

30 Chapel Hill, Prof. Immerwahr.

Ex Hesperia Art, *Bull.* XLVI, no. 23 (ill.).

Head of youth.

31 Cambridge, M.C.A. 142 (from a situla).

Dionysos with phiale and thyrsus seated beneath a grape-vine.

2. CLOSE ASSOCIATES OF THE LYCURGUS PAINTER

(i) THE PAINTER OF BOSTON 76.65

As yet, no minor vases of the kind attributed to the Iliupersis Painter and the Painter of Athens 1714 can be assigned with certainty to the hand of the Lycurgus Painter. Those by the Painter of Boston 76.65 come closest to filling this gap, and the obverses of nos. 32 and 33 are very close indeed to some of the reverses by the Lycurgus Painter (cf. the woman to l. on no. 32 with the corresponding figures on nos. 1, 2, 10, 12, 14, 22). The crossed squares on no. 32 remind us of those on the vases by the Painter of Athens 1680, but the draped youths are much closer to those by the Snub-Nose Painter and some of his followers (cf. with nos. 12/15—18, 47—48, 61, 100—109, and particularly 128 and 130), which would suggest a date in the latter part of the second quarter of the fourth century.

The obverse of no. 32 is closely linked to the reverse of Vatican AA 3 (no. 35) by the draped woman resting her right hand against her thigh and by the young satyrs, and the latter vase is connected with the Lycurgus Painter by the figure of the draped woman (Helen) leaning with crossed legs against a pillar (cf. nos. 6 b, 10 b, 22) and also by Aphrodite above, who plucks at her drapery in a very typical Lycurgan pose (cf. nos. 13, 16 b). The drawing of the hair, with the long curling locks falling down on to the shoulders, should also be compared with that on nos. 5, 13 and 21 by the Lycurgus Painter; this fashion continues on the vases of the Milan Orpheus Group.

Note in particular the drawing of the eye in which the pupil appears as a dot or a fine line, placed at the extreme end, near to the nose.

The pelike Vatican Z 15 (no. 36) is linked to the Boston column-krater (no. 32) by the draped youths on its reverse and to Vatican AA 3 (no. 35) by the seated woman on the obverse who strongly resembles Helen on that vase.

Column-kraters

* 32 Boston 76.65. PLATE 153, 1—2.

(a) Maenad, Dionysos and young satyr, with situla and tambourine, (b) A + C + F.

33 Princeton (N.J.), Miss Frances Follin Jones.

(a) Maenad with thyrsus and tambourine, seated Dionysos, young satyr with kantharos and situla, (b) A + C + C.

34 Once London Market, Sotheby's, *Sale Cat.*, 29 April 1974, no. 310 (ill.).

(a) Oscan youth leaning on pillar, seated Oscan youth with kantharos and spear, woman bending forward over raised foot, holding cista, (b) three draped youths.

Calyx-krater

* 35 Vatican AA 3 (inv. 17223). PLATE 153, 3—4.
 VIE, pl. 50 b and d; Ghali-Kahil, *Hélène*, pl. 31; *EAA* i, p. 504, fig. 681; Helbig-Speier i, p. 712,
 no. 993; Rallo, *Lasa,* pl. 12, 2.
 (a) Paris and Helen, with Pan, Aphrodite and Eros, (b) Dionysos seated between maenad with
 tambourine and satyr with thyrsus and situla.

Pelikai

 36 Vatican Z 15 (inv. 18142).
 VIE, pl. 46 c and f.
 (a) Eros with bunch of grapes and phiale, seated woman with wreath, enveloped in himation,
 (b) A + F.
 37 Basel 1906.302.
 (a) Eros with phiale, seated on rock, draped woman with wreath and fan, (b) A + F.

(ii) VASES CONNECTED IN STYLE

Column-krater

 38 Lecce 775.
 CVA 1, IV Gr, pl. 1 and pl. 2, 3; *Gli Indigeni,* fig. 14. Photo: R.I. 62.1209.
 (a) Woman with wreath and phiale, Oscan warrior receiving libation from woman holding nestoris,
 warrior with shield and two spears, (b) woman holding phiale and cista seated between half-draped
 youth with wreath and mirror and nude youth with stick, both wearing white head-bands.
 The draped woman to l. on (a) should be compared with those on the obverse of no. 32 and the
 reverse of no. 35.

Dish

* 39 Kiel, private coll. (A) PLATE 154, 1.
 Schauenburg, *JdI* 89, 1974, p. 177, fig. 45.
 I. Winged figure wearing Phrygian cap and holding thymiaterion and tambourine. White laurel
 around. A. Standing woman, seated woman with phiale, Eros with wreath and bunch of grapes, and
 woman leaning on pillar. B. Nude youth between two draped women (upper part missing) holding
 cista in l. hand.
 The drapery of the figure in the tondo is very Lycurgan; cf. also the woman leaning against the
 pillar, and the seated woman with the phiale with Aphrodite on the obverse of no. 35, as well as the
 rendering of the eyes.

Epichysis

 40 Taranto 8129, from Roccanova.
 Lullies, *Vergoldete Terrakotta-Appliken aus Tarent,* pl. 35; Arias, *Storia,* pl. 164.
 Pan seated on rock turning to look at woman bending forward over raised foot and holding phiale,
 seated woman with cithara, Eros with wreath, seated woman looking round at nude youth feeding
 swan.
 Round the body: two griffins attacking a spotted deer (cf. also B.M. F 276).

 With the above compare also the following, especially for the poses, the drapery and the
drawing of the faces, which link it also to the vases in the Milan Orpheus Group (esp. the
woman seated top left on the obverse, and the figures on the reverse):

Volute-krater

* 41 Bari 6270. PLATE 154, 2—5.
 La Collezione Polese, no. 83, pl. 20.
 (a) Statue of nude youth with red cloak over l. arm and spear in l. hand in Ionic temple, in front

of which is a calyx-krater between two phialai; to l. seated woman with dish of cakes and "xylophone", Hermes holding caduceus in both hands and leaning on laver; to r. Apollo with lyre, youth resting one foot on base of temple and holding sheathed sword, (b) Dionysos with tambourine and bunch of grapes seated above a small shrine, with seated woman and satyr with situla and thyrsus to l., and two women to r., one with fan and bunch of grapes, the other with rosette and phiale.

Neck: (a) head in Phrygian cap amid tendrils.

Mascaroons: female masks with (a) white flesh, (b) dark.

(iii) THE MILAN ORPHEUS GROUP

The vases in this group, which is named after the krater in the "H.A." collection in Milan (no. 42), are very close in style to the Lycurgus Painter and to the Painter of Boston 76.65.

Note the elaborately patterned drapery, the long curling hair, and the very Lycurgan grouping of the figures on the reverses (cf. nos. 42–3 with nos. 13–15). The Naples krater (no. 43) is particularly close to the Lycurgus Painter, but the maenad on the reverse with torch and situla should be compared with the corresponding one on the Orpheus krater, whom she most strikingly resembles. We may note also on nos. 43–44 the appearance of chequers with the meanders, a pattern so far not found on the vases of the Lycurgus Painter himself. The Bari gigantomachy krater (no. 44) should be compared with its Lycurgan counterpart (no. 12); here the scene is simplified and lacks the powerful figure of Zeus in the chariot, but the two Athenas and the earth-bound giants are similar, and both vases probably draw their inspiration from one of the great paintings of the period (for the iconographic background see von Salis in *JdI* 55, 1940, pp. 90 ff.; and F. Vian, *La Guerre des géants* and *Répertoire des gigantomachies*).

(a)

Volute-kraters

The three following, which are the work of one hand, all have mascaroons:

42 Milan, "H.A." coll. 270.
 Cat. pl. 2; *Acme* 21, 1968, pp. 354 ff., pl. 5, figs. 9–10; *CVA* 1, IV D, pls. 10–12; Moret, *Ilioupersis*, pl. 84; Smith, *FS*, pls. 11–13.
 (a) Orpheus among the Thracians, (b) seated Dionysos with maenads and satyrs (much repainted).
 Neck: (a) Amazon between two griffins.
 Mascaroons: Io masks.

* 43 Naples 3230 (inv. 82923). (b) PLATE 155, 1.
 Reuterswärd, *Polychromie*, p. 98, fig. 15; Davreux, fig. 52; Arias, *Storia*, pl. 170, 2 and pl. 171; Moreno, *RivIstArch* 13–14, 1964–5, p. 38, fig. 8; *Cl.Gr.Art*, fig. 359 (colour); *Hist.Hell.Eth.* III.2, p. 401 (colour); Moret, *Ilioupersis*, pls. 4–5. Photos: R.I. 72.1916–9.
 (a) Rape of Cassandra, (b) seated satyr with kantharos and thyrsus, maenad with tambourine and thyrsus, seated Dionysos with phiale and thyrsus, standing woman with torch and situla.
 Neck: (a) four-horse chariot with driver.
 Mascaroons: Io masks.

44 Bari 4399, from Ceglie.
 W. p. 349, no. 6; *Ausonia* 3, 1908, pp. 57 ff., figs. 1–3 and 7–9; Bieber, *JdI* 32, 1917, p. 42; von Salis, *JdI* 55, 1940, p. 96, figs. 6–7; Vian, *Gigantomachies*, no. 395, pl. 47; Paribeni, *Immagini*, pl. 15 (colour); *Puglia*, p. 163, fig. 152; Trendall, *Ceramica*, pl. 27.
 (a) Gigantomachy, (b) thiasos – maenad, satyr, seated Dionysos, maenad with sword and kid.
 Neck: (a) griffin and lion in added white, (b) griffin and lion.
 Mascaroons: female masks.

(b)

Volute-kraters

The two following have volute-handles without mascaroons. The Ruvo krater (no. 45) is close in style to the Milan Orpheus krater (no. 42) and should also be compared, especially in regard to the drapery and the rendering of the hair, with Vatican AA 3 (no. 35). The draped women on its reverse and that of no. 46 are very Lycurgan; for the head on the neck of the latter cf. also Ruvo 1372 (no. 15/36).

45 Ruvo 1089.
 RV i, 91; Sichtermann, K 37, pl. 55. Photos: R.I. 62.1356; 64.1167–8.
 (a) Theseus and Amazons, (b) two youths and two women.
 Neck: (a) bull and griffin.

46 Once Rome Market.
 (a) Warrior and boy in naiskos; to l., seated youth with phiale, and woman with cista; to r., seated woman, standing youth, and youth running up with wreath, (b) seated woman with phiale + 2 sprays, two seated youths, and a standing woman with mirror and bunch of grapes.
 Neck: (a) head in Phrygian cap in three-quarter view between scrolls and palmettes.

Pelike

47 Catania MB 4404 (L. 770).
 Libertini, *Cat.* pl. 90, 3–4.
 (a) Seated woman, to whom a small Eros is flying, between to l. woman with cista and nude youth, to r. aged woman wearing veil and seated woman; above — seated woman with phiale and seated youth beside tree, (b) woman seated between youth and woman; above — Eros flying between two seated women.

(c)

The following vase is connected in style with the above, especially in the treatment of the drapery (embattled borders, palmette decoration, embroidered patterns and rays).

Calyx-krater

48 Amsterdam 2572 (*Gids* 1498).
 CVA, Scheurleer 2, IV Db, pl. 4, 1; Beazley, *JHS* 47, 1927, p. 224, pl. 21, 1; Cantarella, *Euripides – I Cretesi*, p. 38, pl. 1.
 (a) Apollo and Hermes; below — Daidalos and Minos (inscribed), with a woman (Pasiphae ?) to r.

(iv) THE BERLIN GANYMEDE GROUP

The vases in this group, which are closely connected with the work of the Painter of Boston 76.65 and those in the Milan Orpheus Group, also provide a link with the Darius Painter (cf. the paidagogos on the left of the picture with those by that artist). The rendering of the hair, with the individual curling locks, of the breasts, and of the drapery finds many parallels on the vases in the two preceding sections. We may also note the presence of several small plants growing beside the dotted ground-lines on nos. 49 and 51, especially the four-petalled flower, which is to become very popular in the floral backgrounds of the Darius Painter and his followers.

The subject of Berlin F 3297 (no. 49) is of interest and represents Ganymede pursued by Zeus in the form of a swan, which the old paidagogos endeavours to drive off, without avail. The same subject is repeated on a situla in the J.V. Noble collection (no. 15/51 above; see also Martini, *Festschrift Brommer*, p. 228), on a fragment in the collection of M. Jacques Chamay in Geneva, and on a calyx-krater in Kiev (inv. 120), which will be discussed in Volume II. All

three are approximately contemporary and may have been inspired by some dramatic representation of the story about this time. A Paestan fragment by Python (Berlin F 3297a; *PP*, no. 153; Zahn, FR iii, p. 186, fig. 100) which depicts the head of a swan with the inscription ΓΑΝΥΜΗΔΗΣ must have shown the same scene.

The head and face of Ganymede is almost repeated as Europa on the Copenhagen fragment (no. 50), which must be by the same hand; the tendency to feminise the youthful male figure becomes even more pronounced with the Chamay Painter (e.g. no. 57).

The Naples krater (no. 51) has now been cleaned and the original repainting has been largely removed. Aphrodite on the obverse should be compared with her counterpart on the Berlin krater; the figures on the reverse are very Lycurgan in pose and treatment and particularly close to those on nos. 45–6.

Calyx-krater

* 49 Berlin F 3297, from Ruvo. PLATE 155, 2.
 (a) Above – Poseidon, Eros, Aphrodite and Hermes; below – paidagogos menacing swan, and Ganymede with cloak billowing out behind him, (b) satyr with situla and phiale, seated Dionysos, standing maenad.

Fragment

* 50 Copenhagen 13433. PLATE 155, 3.
 Breitenstein, *Gr. Vaser*, pl. 50, 2. Photos: R.I. 36.334–6.
 Europa and the bull, with bearded figure (Zeus ?) to r.

Bell-krater

* 51 Naples 690 (inv. 81946). Broken and restored. Detail of (b): PLATE 155, 4.
 Macchioro, *JdI* 27, 1912, p. 285, fig. 12; Trendall, *Festschrift Brommer*, pl. 75, 4.
 (a) Departure of Triptolemus; above – Apollo, Aphrodite and swan, Eros, (b) Poseidon and Amymone – above: Pan, Eros and woman and a youth; below – winged horse, Poseidon, Amymone and woman.

(v)

Two other vases, which look to be by a single hand, may also be considered here. The Taranto pelike (no. 52) shows a version of the Poseidon-Amymone legend (cf. no. 15/59), in which the former appears as a youthful god seated beside the spring, which, in the form of a lion's-head spout, trickles water down into the hydria placed below it by Amymone, who leans upon a laver, while Eros above reaches across to place a crown on her head. The three-quarter face of Amymone, with her long curling ringlets, her pose and drapery all find parallels on the preceding vases. The hydria in a private collection in Naples (no. 53) shows a very similar treatment – compare the woman leaning against the laver with Amymone, and the two lavers themselves. Some influence from the Varrese Painter should also be noted.

Pelike (type 2)

* 52 Taranto 124520. PLATE 155, 5–6.
 (a) Poseidon and Amymone, with Eros above, (b) draped woman with palm-branch and cista, nude youth with situla, thyrsus and phiale, both moving to l.

Hydria

53 Naples, private coll. 4.
 Eros standing on a white laver offering a crown to a draped woman standing to l., holding "xylophone" and mirror; to r. draped woman with wreath.

(vi) RELATED VASES

All the complete vases in this division have suffered considerably at the hands of the restorer, but all show strong Lycurgan influence in the drapery and poses of the figures.

(a)

Volute-krater

54 Naples Stg. 11, from Armento.

Séchan, p. 431, fig. 123; Stella, *Mitologia Greca,* p. 551; *Ill.Gr.Dr.* III.3, 40; Koch, *AntK* 18, 1975, pl. 15, 2; (b) Schauenburg, *JdI* 73, 1958, p. 66, fig. 11. Photos: R.I. 73.1707–9.

(a) Death of Meleager, (b) Underworld scene.

Neck: (a) frontal female head, (b) profile female head.

The subject of the obverse is most unusual but, thanks to the inscriptions, it can be identified as the death of Meleager; he is brought dying into the house by Tydeus, who is about to lay him down on a couch. His sister Deianeira rushes up to help, and another woman, probably Althaia, runs in with a despairing gesture, perhaps repenting too late of having caused her son's death. Below the building sit Peleus and Theseus in attitudes of deep dejection; beside them are their hounds and the rolled-up net and stakes used in the boar-hunt. To the right sits Aphrodite attended by a small winged figure whom one would expect to be Eros but who is inscribed ΦΘΟΝΟΣ, and below her is Oineus with hand on head in the conventional gesture of sorrow. The seated Aphrodite should be compared with some of her Lycurgan counterparts (e.g. on nos. 5, 11, 16 and 22) and, particularly, with the seated woman to r. on the Gerolomini krater (no. 15) and with Nike on no. 13.

The scene on the reverse shows Persephone and a youthful Pluto in their palace, with Herakles carrying off Cerberus below, watched by a Fury, and above to l. Apollo, and to r. a seated and a standing youth, probably Theseus and Peirithoos. Pluto should be compared with some of the seated figures on the vases of the Salting Group; he reappears in youthful guise on a hydria in a private collection in Mattinata, from the workshop of the Baltimore Painter.

(b)

Volute-krater

55 Leningrad inv. 1718 = St. 422. Much repainted.

W. 349, no. 16; *MdI* 5, pl. 11 = *RV* i, 138–9; detail: Chubova and Ivanova, fig. 31; Graham, *AJA* 62, 1958, pl. 83, 5; Moret, *Ilioupersis,* pl. 97, 1; Blavatsky, *Hist. Anc. Ptd. Pottery,* p. 226.

(a) Ransom of Hector, (b) Jason and the golden fleece.

Neck: (a) Amazonomachy, (b) riders between Ionic columns.

Below the picture is a band of fish; on the reverse the volutes have inset medallions with an Amazon fighting a Greek, in low relief.

Most of the figures on the obverse have their names inscribed beside them.

The carrying off of the body of Hector reminds us of the somewhat similar representation on Bari 3648 (no. 8/144) from the school of the Iliupersis Painter, but the present vase must be rather later, and the drapery, frontal figures and decoration connect it with the Lycurgan vases. Of particular interest is the frieze of fish which runs round the vase beneath the pictures between two bands of meanders accompanied by quartered squares; such decoration becomes more frequent on vases in the second half of the century (cf. the amphorae, Naples 3221, Berlin F 3241–2, Vatican X 5 and 7; also the nestoris Naples 2338 = no. 13/207). The composition of the reverse should be compared with that on Leningrad 1714 by the Lycurgus Painter (no. 12). For the medallions with scenes in relief on the handles of the reverse cf. B.M. F 283 (no. 8/7).

(c)

The following pelike, known to us only from a not very clear photograph, should also probably find a place here, if it is not by the Lycurgus Painter himself:

Pelike

56 Leningrad inv. 317 = St. 875.

 CRStP 1872, pl. 6 = *RV* i, p. 39, figs. 7–9; detail: Beck, *Album,* fig. 372.

 (a) Above – woman punishing child, standing woman, seated woman; below – woman with box, woman with cithara, seated woman, woman reading from scroll, woman resting r. arm on pillar, (b) above – seated woman with mirror, Eros with wreath; below – nude youth seated between two women, l. with phiale, r. with mirror and bunch of grapes.

3. LATER FOLLOWERS – THE CHAMAY AND CHINI PAINTERS

The vases listed in this section represent a further stage in stylistic development from the work of the Lycurgus Painter and his associates. They bring us down chronologically to the fore-runners of the Darius Painter (e.g. the Laodamia Painter) and to the earlier work of that painter himself (i.e. to the period between c.340 and 330 B.C.), to which they are very close in style. The influence of the Varrese Painter is also clear and, in view of the connexions with him and the Lycurgus Painter, we thought it reasonable to discuss these vases at this point (cf. pp. 387 – 392, where some of the former's later "Plain" style followers are dealt with), rather than defer them for consideration in Volume II.

(i) THE CHAMAY PAINTER

The Chamay Painter, named after the owner of the Geneva pelike, is an important artist, with an elegant and individual style of drawing, whose work should be compared with vases like Berlin F 3297 and Naples 690 in the previous section (nos. 49 and 51), since it seems to follow on directly from them.

We may note in particular the drawing of the drapery, with its multiple fine fold-lines, often in pairs, and thin black borders. Faces, especially in profile, are neatly drawn, less well, however, in three-quarter or frontal view (e.g. on Berlin F 3291, no. 60). Hair is shown as a mass of fine, separately-drawn curls, in diluted glaze. The breasts are rounded and set far apart; the drapery is tightly stretched over them, with a few parallel fold-lines after the fashion of the Varrese Painter.

Of considerable interest is the Chamay Painter's treatment of the nude male body, in which we observe an increasing tendency towards effeminacy. If we look at the nude youths on no. 57 or Herakles on no. 60, we cannot fail to note the essentially feminine appearance of the body itself – if its distinguishing male feature were removed, one would imagine it to be the body of a woman rather than a man (cf. also the figure of Ganymede on Berlin F 3297, no. 49). A similar tendency is also noticeable in contemporary sculpture and it becomes still more pronounced in the early Hellenistic period, when actual hermaphrodites may be represented.

The palmette decoration on the vases is unusually rich (particularly on the three hydriai – see Jacobsthal, *OGV*, pp. 150–1, pl. 111) and very well drawn; on the larger vases the meanders are accompanied by chequers. Note also the pattern on the neck of the pelike (no. 57), which consists of crossed double-volutes outlined in added white (cf. no. 13/4 by the Varrese Painter); this is a popular ornamental pattern on many of the larger vases in Late Apulian. The moulded egg-pattern round the mouths of the hydriai and the ribbing of the lower part of their bodies point to the influence of metal prototypes.

On nos. 62 and 63 we have an opportunity of seeing the sort of draped youths depicted by the Chamay Painter; they correspond with those of the contemporary artists in the "Plain" tradition, especially the followers of the Snub-Nose and Varrese Painters (e.g. the Ginosa and Chiesa Painters).

The three hydriai (nos. 58—60) form a matching set, with very similar decoration and compositions. On all, the picture is spread over the entire front of the vase, rising up without any interruption on to the shoulder. The compositions fall into three main registers, without any formal divisions, except occasional ground-lines. The first two both show the Judgement of Paris, the Naples version being slightly more elaborate and including a few additional figures and details, as well as a rather different placing of the principals. Berlin F 3291 (no. 60) represents the glorification of Herakles in a somewhat unusual setting, since the supporting figures include a woman fondling a small boy with a go-cart, a woman holding a harp (*trigonon*) with a bird support (a popular motif with the followers of the Darius Painter), a woman with a parasol opening a box (a variant on the similar group on Naples 3244) and a seated woman with a swan. Above to left, is a woman plucking at the drapery above her shoulder, very like the corresponding women on Naples 690 (no. 51). On the Chini dish (no. 61) is a woman with crossed legs leaning against a pillar and, indeed, we see throughout his work various of the stock figures we have noted as characteristic of the vases by and around the Lycurgus Painter.

Pelike

* 57 Geneva, J. Chamay coll. PLATE 156, 1—2.
 Art Antique (1975), no. 278 (ill.).
 (a) Above — Aphrodite in chariot drawn by Eros, with another Eros flying ahead; below — draped woman with nude youth holding up wreath, woman seated by nude youth (Apollo ?) holding cithara, two draped women standing beside a pillar, r. holding flute, (b) above — seated Aphrodite, with bunch of grapes and mirror, opposite Eros; below — nude youth (drapery caught between legs), seated woman with phiale and mirror, woman standing beside laver.

Hydriai

* 58 Berlin F 3290, from Ceglie. In very bad condition. PLATE 156, 3.
 Gerhard, *Ap. V.*, pl. 13; Jacobsthal, *OGV*, pl. 111 a and d; Diehl, *Die Hydria*, pl. 46, 2; Schauenburg, *JdI* 89, 1974, p. 148, fig. 13.
 Judgement of Paris.

* 59 Naples 3244 (inv. 82419). In a very battered state. Details: PLATE 157, 3—4.
 OGV, pl. 111 c; Pernice, *Hell. Kunst in Pompeji* iv, p. 15, fig. 21; Schauenburg, loc. cit., p. 149, fig. 14.
 Judgement of Paris.

* 60 Berlin F 3291, from Ceglie. PLATES 156, 4 and 157, 1—2.
 OGV, pl. 111 b; Herbig, *AM* 54, 1929, Beilage 56; Klein, *Child Life in Greek Art*, pl. 15 d; Neugebauer, *Führer*, pl. 80; Greifenhagen, *Führer*, pl. 98; detail — Zweierlein-Diehl, *Helena und Xenophon*, no. 14.
 Two seated women, l. with fan, r. with harp; woman and small boy with go-cart, goddess (Hera ?) seated on throne, Eros flying with fillet towards Herakles. Below — woman with parasol opening large box, seated woman feeding swan, youth in Phrygian cap with two spears.

Dish

 61 Bassano del Grappa, Chini coll. 88.
 Schneider-Herrmann, *Paterae*, no. 211.
 A. Seated woman with mirror and box, woman with fan resting l. arm on pillar, nude youth with bird. B. Seated woman with bunch of grapes and cista approached by woman with fan and phiale.
 Note the drapery over the shoulder and between the legs of youth on A.

Amphora

 62 Altenburg 339.
 CVA, pl. 94, 3 and 6, pl. 95, 6.

(a) Woman with fan and youth with branch at naiskos, (b) A1 + F.
Cf. also with Vatican W 2 (9/202).

Column-krater

63 Parma C 107.
 CVA 2, IV D, pl. 2.
 (a) Dionysos with thyrsus, maenad with torch and thyrsus, satyr with situla and dish of cakes, all moving to l., (b) B + C, with strigil + E.

Calyx-krater (frr.)

64 Amsterdam 2568.
 (a) Standing maenad with thyrsus and tambourine, seated Dionysos with phiale and thyrsus, standing maenad with grapes and thyrsus, arm of figure (satyr ?) holding torch, (b) missing.

(ii) CLOSELY CONNECTED VASES

(a) THE GROUP OF B.M. F 308

Once again the vases in this group are in a very bad state of preservation; although they look to be the work of a single hand, it is difficult to be certain that this is the case. They are very closely connected in style with the work of the Chamay Painter, notably in the drawing of the face, and the rendering of hair and drapery. Several of the stock figures referred to earlier are repeated on no. 65 – the woman leaning against a pillar, the seated woman with parallel double fold-lines across the drapery over her legs, the woman bending forward over one raised foot. The treatment of the breasts is also very similar, as is the composition on the hydria (no. 66), although the decorative pattern-work is less elaborate.

Pelike

65 B.M. F 308. Broken and repaired.
 (a) Seated woman surrounded by five women and Eros; above, two women, Eros and Aphrodite, (b) seated youth and woman, with youths and women around, and Eros hovering above.
 Neck: (a) Eros between two women.
 The small frieze on the neck is unusual and perhaps reflects the influence of the volute-krater, on which they are more commonly found.

Hydria

66 New York 07.128.1.
 Richter, *Handbook*[7], pl. 96 f; *Guide, G. & R. Ant.*, p. 24, fig. 32.
 Rape of Persephone.

Amphora

67 Naples 1766 (inv. 81944) from Ruvo. Heavily repainted with much missing.
 Gerhard, *Ap. V.*, pl. E, 10.
 (a) (i) Hypsipyle, Eurydice, Amphiaraos (?), Lycurgus, youth with two spears and attendant, (ii) seated nude youth, woman with wreath, seated youth, (b) (i) two seated women with youths, (ii) woman standing between two youths, woman and youth.
 Neck: (a) seated nude youth, woman with mirror, seated youth and woman, (b) female head in floral surround.

(b)

Oenochoe (shape 8)

* 68 Florence, La Pagliaiuola 116. PLATE 158, 1–2.
 The return of Alcestis (?) – above: Pan, with syrinx, seated woman with phiale, altar encircled by

Oenochoe (shape 8) *continued*

infula with bucrane, seated woman with cross-bar torch (Persephone ?), nude youth and satyr; below: Apollo and Admetus, Herakles, Alcestis between two small children, paidagogos and seated woman with phiale.

In style this vase owes much to the Varrese Painter — cf. the triglyphs on the altar with those on nos. 14/3, 4 and 61, the drawing of the drapery over the breasts, and the seated woman below to r. The treatment of the hair and of the faces in three-quarter view is, however, more in keeping with that on the vases in the preceding section and by the Chamay Painter (note especially the breasts of the two women seated beside the altar, the double fold-lines on the drapery over the legs, the long curling locks falling down on to the shoulders) and the off-the-shoulder drapery of the seated women looks back to the Lycurgus Painter.

The subject is unique in South Italian. Its interpretation is open to question, but it seems to represent the return of Alcestis from the Underworld. Herakles has brought her safely back, she has withdrawn her veil and the recognition scene has taken place, while to l. Apollo bids farewell to Admetus with a gesture of admonishment for the future. The only other representation of Alcestis in Apulian is on the great loutrophoros in Basel which is of about the same date as this vase, but closer to the monumental work of the Darius Painter and his forerunners (see *Ap. Grabvasen*, pp. 78—93, pls. 19—22 and colour-plate opposite p. 78).

Near in style to the above is an epichysis in Castle Ashby representing the Judgement of Paris — a theme we have already seen to be well liked at this time:

Epichysis

69 Castle Ashby, Marquis of Northampton.
 BullNap 5, pl. 6, 1; Beazley, *BSR* 11, 1929, p. 27, no. 40, pl. 11, 3.
 The Judgement of Paris.
 Round the body: female head in white with scroll-work.
 The principal figures are inscribed in tiny letters, not easy to read — Pallas, Eros, Alexandros, Hera, but of the other goddess's name (Aphrodite) little remains; she can hardly be Helen, as Panofka and Furtwängler thought (*AZ* 1881, p. 304; Beazley, loc. cit., p. 29).
 The drawing is neat and elegant; the drapery is rendered in the typical fashion of the vases in this area, tightly drawn across the breasts, or between the knees, with a number of fine, parallel fold-lines and a dot-stripe border.
 Beazley points out that elaborate scenes are unusual on vases of this shape — Taranto 8129 (no. 40 above) is another example, so is Berne 12406, which is a little later, and shows Zeus and Hera on Mt. Ida (Jucker, *Aus der Antikensammlung*, pls. 36—37, no. 81).

With the Castle Ashby epichysis compare the following, on which the drawing is less elegant; the florals surrounding the Eros on the neck and above the main picture should also be compared with those on the vases in (iii).

Squat lekythos

70 Taranto 117068.
 Seated woman with alabastron, loving couple, satyr-boy coming up with bird and cithara; above, Eros flying with wreath.
 Neck: seated Eros in floral setting.

(c) THE ACTAEON STAMNOS

The stamnos is a very rare shape in Apulian (see p. 23), only three other examples (nos. 1/104, 8/19a and Taranto 8876) being so far known. This vase shows very clearly the influence of the Varrese Painter, especially in the drawing of the fold-lines and the use of dots. The

treatment of the curly hair looks back to that on the vases of the Berlin Ganymede Group and forward to the Berlin-Branca Group. So far no other vases have been attributed to the painter of this stamnos, but he is clearly to be placed in this general group.

Stamnos

* 71 Paris, Cab. Mèd. 949. PLATES 158, 3–4 and 159, 3.

 Minervini, *Mon. Ant. Ined. Barone,* pl. 19; Hôtel Drouot, *Sale Cat.,* 23 April 1871, no. 13 (Piot); Schauenburg, *JdI* 84, 1969, p. 45, fig. 12 (where the iconography of Actaeon is fully discussed).

 (a) Actaeon (small horns on brow) seated, playing with a hound, between Pan, with syrinx and branch, and Artemis leaning on pillar; below to l., woman bending forward over raised foot; flowering plants in the field, (b) Dionysos with thyrsus and phiale seated between woman with bunch of grapes and mirror and young satyr with torch and situla.

(iii) THE CHINI FLORAL GROUP

(a) THE CHINI PAINTER

The work of the Chini Painter represents a slightly later development from that of the Painter of the Dublin Situlae and shows a similar fondness for elaborate floral settings (cf. no. 72). His reverses tend to be in a much plainer style and that of the Chini situla (no. 72) is closely comparable with the scenes on both sides of the lebes gamikos no. 73, especially in the treatment of the standing women. Note in particular the drapery of the woman seated on the Ionic column on no. 73, with the tight folds stretching between the breasts. The nude youth with their white head-bands and bandoliers are very like some of those on vases by the Darius Painter, with whom the Chini Painter must be about contemporary, and the floral decorations on nos. 72 and 74 find good parallels on many of the minor vases associated with that painter's workshop. The triangular flowers, possibly some variety of lily, are very characteristic and are later to pass into general use.

Situla (type 2)

* 72 Bassano del Grappa, Chini coll. 86. PLATE 159, 1–2.

 (a) Nike holding fillet, standing on flower in floral surround, (b) woman with bunch of grapes and torch, seated nude youth with phiale and branch, satyr with thyrsus.

Lebes gamikos

* 73 Once London Market, Sotheby, *Sale Cat.* 29 March 1971, no. 82, ill. opp. p. 22. PLATE 159, 4.

 (a) Woman taking sash from open box, woman seated on Ionic column turning her head to r. to look at nude youth with mirror, (b) woman with phiale seated on rock-pile between standing woman with mirror and nude youth with l. arm enveloped in drapery.

Alabastron

74 Oxford 1945.55.

 Ashmolean Museum, *Report of the Visitors* 1945, pl. 2 c; Schauenburg, *JdI* 87, 1972, p. 270, figs. 16–17.

 Amazon with axe, spears and *pelta* on a flower in a floral setting.

 The pose of the Amazon should be compared with that of Nike on no. 72; note also how her cloak swirls up behind her back in a manner strongly resembling wings.

Pelike

75 Vidigulfo, Castello dei Landriani 246.

 (a) Female head in profile to l. in floral setting, (b) Eros with situla and wreath, standing draped woman with phiale, fillet and wreath.

 The obverse should be compared with that of Bari 21049 (*MonAnt* 45, 1960, 261, fig. 95).

(b) CONNECTED

The following is connected in style with the work of the Chini Painter, especially in the rendering of the drapery and the female figures.

Lebes gamikos

76 Once Zurich Market, Galerie am Neumarkt, *Auktion XXII,* 16 April 1971, no. 86, pl. 8. Ex Munich, Brienner Gallery, and New York, Parke-Bernet, *Sale Cat.* 24 April 1970, no. 326, ill. on p. 164.

(a) Standing woman with wreath and open box, woman seated on klismos, with small bird in l. hand, and alabastron on her knee, nude youth with purse; above — seated Eros with branch, (b) Eros seated above a seated nude youth and a standing draped woman with wreath.

On knob of lid (shaped like an alabastron): kneeling Eros with phiale.

(c) RELATED VASES

The following vases are related to the work of the Chini Painter in their treatment of the floral settings.

Pelikai

77 Taranto, Ragusa coll. 111.

(a) Woman with phiale seated in floral surround, (b) woman running to l. with phiale and mirror.

78 Kassel T. 561 (ex Hope coll., Tillyard no. 241).

Schauenburg, *JdI* 78, 1963, p. 309, fig. 15; *CVA* 2, pls. 77 and 78, 1—2.

(a) Woman standing on flower in floral setting, (b) standing woman with cista and Eros seated on rock-pile with mirror and wreath.

The double crossed-volutes on the neck of the obverse recall those on the Chamay pelike (no. 57).

79 Canberra, Australian National University, U.H. 6.

Gr. V. in University House, pp. 5—6, figs. 6 *a—b.*

(a) Maenad with thyrsus and kid moving to l. in a floral surround, (b) standing draped woman with fillet and flute beside a couch on which a youth with a phiale is reclining; above, flying Eros with fillet, below to l. a volute-krater.

Note the filmy drapery of the maenad.

80 Louvre K 100 (ED 565).

(a) Eros to r., holding wreath, amid florals, (b) woman with branch and phiale.

4. TWO UNDERWORLD KRATERS

The two following kraters, both of which represent the Underworld on their obverses, seem to look back to a common prototype (perhaps a painting; cf. also Naples Stg. 11, no. 54). In the centre is the palace of Hades, with Orpheus playing his lyre on the left; below are denizens of the Underworld — Sisyphus rolling his stone, Hermes with his caduceus turning his head back to look at Herakles with Cerberus beside the banks of a stream or lake, and to right one or more of the Danaids, holding a hydria. Above, to left, are two youths and a woman (inscribed Herakleidai and Megara on the Naples krater), and to right two more youths, who may be identified as Pirithous and Theseus on the Karlsruhe krater, but on the Naples krater they are replaced by Pelops and Myrtilos with Hippodamia. On the Naples krater the three judges — Triptolemos, Aiakos and Rhadamanthys are shown to right of the palace in the centre; they do not appear on the Karlsruhe vase but on both there are Furies behind Orpheus (inscribed Poinai).

The Naples krater (no. 82), which is in a very poor state of preservation, looks back to the Varrese Painter, whose influence will be seen on many of the figures upon it. The Karlsruhe krater (no. 81) is nearer to the tradition of the Lycurgan school; note the gadroons on the

lower part of the body (also on Naples 3222), the nimbus round the head of Helios, the rendering of the drapery with its elaborate patterns, especially the white dot-clusters on the garment of Orpheus (cf. Madrid 11199, no. 15/47). Parallels will also be observed with the vases in the Milan Orpheus Group (cf. nos. 42—44), notably in the meanders and chequers and the treatment of the hair and drapery. The krater looks forward to some of the vases immediately preceding the Darius Painter, especially those by the Laodamia Painter (see Volume II, Chapter 18, 1).

Neither krater has mascaroons (as normally on such vases at this time). The palace of Hades is of interest — on the Karlsruhe krater the front columns have sphinx capitals (cf. Taranto 54959, no. 2/26), on Naples 3222 these are replaced by a caryatid on an acanthus column (cf. the acanthus column at Delphi). On both the ceiling-beams are clearly shown, and there are palmette acroteria; on the Naples vase the pediment is decorated with a mask flanked by Scyllae.

Volute-kraters

* 81 Karlsruhe B 4. PLATE 160, 1.

 CVA 2, pls. 62—3 and 64, 1—3; Keuls, *Water Carriers in Hades*, pl. 9; Moret, *Ilioupersis*, pl. 80.
 (a) Underworld scene with Orpheus, (b) Bellerophon slaying the chimaera.
 Neck: (a) Helios in quadriga, (b) r.f. head to l. in floral surround.
 Foot: (a) and (b) confronting griffins.
 Compare the figure of Hecate with that of the priestess on Naples 3230 (no. 43); the richly patterned drapery also finds parallels on nos. 42—44, 48. The reverse reflects the influence of the Lycurgus Painter.

* 82 Naples 3222 (inv. 81666), from Altamura. Much repainted. PLATE 160, 2.

 Spinazzola, *Arti*, pl. 203; Stella, *Mitologia Greca*, p. 439; *LAF*, no. 33 (ill.); White, *Perspective*, pl. 6b; Borda, p. 45, fig. 36; Säflund, *E. Pdmt. Olympia*, p. 134, fig. 88 (detail); Keuls, *Water Carriers in Hades*, pl. 10. Photos: Alinari 39174; R.I. 71.445—450.
 (a) Orphic underworld scene, (b) (i) Apollo with lyre seated between youths, woman and a satyr, (ii) couple, with youth and woman moving off l. and seated youth and woman to r., (iii) seated youth playing the flute, youth with sword menacing woman seated on rock, three youths.
 Neck: (a) Amazonomachy, (b) Helios with Eros and Eos (inscribed).
 Much of the lower register of the obverse and almost the whole of the reverse has been extensively over-painted, but enough that is genuine in the underworld scene remains to show its close stylistic connexion with the Karlsruhe krater.

These two kraters make a fitting conclusion to this volume, since they stand upon the threshold of Late Apulian as exemplified by the monumental vases of the schools of the Darius, Underworld and Baltimore Painters. They might well have been deferred for consideration at the beginning of Volume II, but they seem to us more closely allied in spirit to the work of the Lycurgus Painter and his followers.

A noteworthy feature of later Apulian is the proliferation of what may properly be called monumental vases — volute-kraters and amphorae approaching 150 cm. in height, and dishes exceeding 70 cm. in diameter — on which the main scenes, when not depicting funerary monuments, may include twenty or more figures, often arranged in three registers. Prototypes of such vases go back to the pioneers like the Sisyphus Painter and the Painter of the Birth of Dionysos, who may arrange their figures in registers, either formally separated by a band of pattern-work as on no. 1/51, or loosely divided into two main rows as on nos. 1/52, 2/8 and 9, or freely composed around a central group as on no. 2/6. The Iliupersis Painter favours the less formal type of composition in which the registers are not so clearly defined (cf. nos. 8/2, 6, 9, 20) and, in general, this applies also to the work of the Lycurgus Painter. In the

Group of Ruvo 423 and the Varrese Painter, however, we find again the formal separation of the two principal registers, now by a band of floral or similar decoration, in the former case (e.g. nos. 15/41—44) with a head in the centre, a practice also favoured in Late Apulian, where bands of fish may sometimes be used as an alternative (e.g. Berlin F 3241—2; Naples 3221, 3225; Vatican X 5 and X 7; Bari, Perrone coll. 14). The monumental multi-figured vase becomes increasingly popular in the second half of the century, and it is this sort of vase which almost inevitably comes to mind as typical of Late Apulian.

ADDENDA

The vases listed below, many of which were found in recent excavations in Apulia, came to our notice only after the type of the chapters concerned had already been set and we therefore thought it advisable to record them here rather than at the end of volume II. A few additional publications and new references are also included.

BIBLIOGRAPHY

Page xli (1). A. Mizuta, 'Die griechischen Vasen in Japan, IV — Lukanisch und Apulisch rotfigurig (3)', in *Balkan and Asia Minor Studies* III (Tokyo, 1977), pp. 73–86.

xliii (3, vii). E. De Juliis, 'Ricerche ad Arpi e a Salapia', in *Atti XIº CStMG 1973* (1976), pp. 389–395.

xliv (4, i). Marina Pensa, *Le rappresentazioni dell' oltretomba nella ceramica apula* (Rome, 1977).

xlv (4, iii). K. Schauenburg, 'Unteritalische Kentaurenbilder', in *ÖJh* 51, 1976–77, pp. 17–44.

K. Schauenburg, 'Die nackte Erinys', in *Festschrift Brommer* (1977), pp. 247–254.

CHAPTER 1

Pages 4–8: 1. The Painter of the Berlin Dancing Girl

Eight new vases by the Painter of the Berlin Dancing Girl have so far come to light in the excavations conducted in 1976 at Rutigliano, near Bari, by Professor F.G. Lo Porto, to whom we are most deeply indebted for providing us with details of them in advance of his own publication of the necropolis. The tombs so far excavated range in date from the seventh to the third centuries B.C., and most of the red-figured vases may be dated to the last third of the fifth and to the fourth century B.C. They include numerous Attic vases of high quality, mostly dating to c.430–400, a great deal of early Lucanian (especially Amykan, Intermediate Group and early Creusan), and a very large quantity of Apulian from the beginning of that fabric down to the time of the Underworld Painter and his followers towards the end of the fourth century. The find should, therefore, shed a good deal of new light upon the comparative chronology of Attic and Early South Italian vase-painting in the last three decades of the fifth century, as well as providing much further material for the study of Apulian in the fourth, and of this we hope to be able to take account in volume II.

Tomb 24 contained seven vases by the Painter of the Berlin Dancing Girl, of which four may be regarded as early work close in style to nos. 3–11, the other three representing his more mature phase, and including his two largest and finest extant vases (nos. 12a and b), which show him to be not inferior to the Sisyphus Painter in the decoration of monumental works. It is interesting to note among the vases two amphorae of panathenaic shape, one of which (no. 9a), at least, would seem to be earlier than the vases of similar shape by the Hearst Painter (see p. 10). Nos. 10a, 11b, 12a and b, 15a and b all have the dotted but uncrossed squares so characteristic of the painter, and the draped bearded man reappears on the reverses of three (nos. 11a, 15a and b; cf. with nos. 4, 5, 8, 9, 15).

The painter's fondness for Amazonomachies is also apparent (cf. nos. 5–7 and 15), and the newly-found amphora (no. 9a) probably represents his first attempt at this theme.

(i) EARLY WORK

Add to the reference at the end of no. 1: Lezzi-Hafter, *Der Schuwalowmaler,* no. S 57, pl. 115, and to no. 9: Ashmead and Phillips, *Cat. Classical Vases* no. 58, pls. 110–11.

Amphora

9a Taranto, from Rutigliano, T. 24.
 (a) Warrior with spear, shield and helmet bending forward over raised foot, as if to attack (b) mounted Amazon.
 Below the design: egg-pattern.

Hydria

10a Taranto, from Rutigliano, T. 24.
 Nike with a fillet held in both hands running forward towards nude youth.

Skyphos

11a Taranto, from Rutigliano, T. 24.
 (a) Nude youth holding stick and spear, with drapery over l. arm, woman with spear seated on rock,
 (b) draped youth and bearded man leaning forward on a stick.

Oenochoe (shape 3)

11b Taranto, from Rutigliano, T. 24.
 Athena, Cerberus, Herakles in frontal view, with lion-skin and club, resting l. foot on rock.

(ii) DEVELOPED STYLE

The new volute-krater (no. 12a) is the most important work of the painter so far known to us. In shape it is closely comparable with the volute-kraters of the Sisyphus Painter (nos. 51–53), and like no. 51 has figured scenes upon the neck on both sides; instead, however, of palmettes beneath the handles we have the figure of a standing youth, and this tends to create the impression of a continuous picture, as on the amphora (no. 12b). The volutes are decorated with ivy-pattern, as on those of the kraters by the Sisyphus Painter.

The main scene gives a remarkable version of the death of Memnon, notable for the presence of a small figure of Thanatos who leans down from a tree to touch the dying Memnon, as he collapses in the arms of Eos. The name of Memnon is misspelt MEMMΩN in the inscription beside him and this reminds us of a somewhat similar occurrence on the fragmentary krater Taranto 54955, which shows the upper part of Eos (EΩΣ) tearing her hair as if mourning for Memnon, of whom only the top of his helmet survives along with the inscription [M]EMNΩN, to which the painter has added another M just below the surviving one, as if he were unsure of the correct spelling.

No less interesting is the large amphora (ht. 52 cm.) representing Adrastos (AΔPAΣTOΣ) preparing for the expedition of the Seven against Thebes; he is shown holding up a large cuirass in the presence of a bearded warrior (possibly Amphiaraos), two younger warriors beside a biga (perhaps Tydeus and Polynices), together with a youth and a bearded man. Adrastos appears comparatively seldom in Greek vase-painting (see Brommer, *VL*[3], pp. 419 and 489; Beazley, *AJA* 54, 1950, p. 313) and even more rarely in South Italian; a calyx-krater recently found in Lipari (T. 1155; Bernabò Brea and Cavalier, *Il Castello di Lipari*[2], p. 126, fig. 124) shows his intervention in the quarrel between Tydeus and Polynices outside his palace in Argos, by the door of which his two daughters are standing.

The treatment of the figures on the volute-krater and the amphora is on a more monumental scale than on most of the painter's other vases, except the Lecce neck-amphora (no. 13), to which they stand closest in style. They provide excellent examples of the painter's art in his more developed manner. The two pelikai (one from T. 24, the other from T. 11) also belong to this period; both represent Amazonomachies in which a Greek warrior (on no. 15a named as

Peleus) attacks an Amazon mounted on a horse, as on the Melbourne pelike (no. 15), and both have reverse designs (bearded man between two draped youths) very like the one on that vase.

Volute-krater

12a Taranto, from Rutigliano, T. 24.
 (a) Neck: Amazonomachy.
 Body: Death of Memnon — to l. is a tree from the branches of which a small figure of Thanatos (ΘΑΝΑΤΟΣ) bends down to touch Memnon (ΜΕΜΜΩΝ) who collapses into the arms of Eos; in the centre Achilles (ΑΧΙΛΛΕΥΣ), to r. seated Athena.
 (b) Neck: horse-race (four riders; to r., two columns).
 Body: flute-player, draped youth with stick, athlete with discus, nude youth with *halteres*.
 Beneath the handles: l., draped youth; r., standing youth.

Amphora

12b Taranto, from Rutigliano, T. 24.
 The design, which runs right round the vase, represents Adrastos preparing for the expedition of the Seven against Thebes — (a) shield, bearded warrior resting foot on rock, young warrior with helmet, shield and spear beside a biga, behind which stands the bearded figure of Adrastos (ΑΔΡΑΣΤΟΣ), holding a cuirass, and (b) in front of the two horses, a draped youth wearing a helmet and holding a spear, a bearded man with a stick, and a draped youth.

Pelikai

15a Taranto, from Rutigliano, T. 24.
 (a) Peleus (ΠΕΛΕΥΣ) with spear and shield attacking mounted Amazon, (b) draped bearded man between two draped youths, r. with stick.
 Cf. with Melbourne 1391/5 (no. 15).
15b Taranto, from Rutigliano, T. 11.
 (a) Greek striding forward to fight Amazon on horse-back, (b) bearded man between two draped youths.

Page 17: 3. The Sisyphus Painter

Bell-kraters

62a Taranto, from Rutigliano, T. 9.
 (a) Nude athlete, nude athlete with discus, l. arm upraised, Nike with wreath, (b) three draped youths.
 Found with a hydria and a column-krater by the Amykos Painter and an Attic r.f. lekanis of c.430 B.C.
63a Tenefly (N.J.), Rogers coll.
 (a) Woman holding tendril, seated on klismos between nude youth with crossed legs leaning on stick, drapery over l. arm and beneath r., and draped woman holding mirror, (b) three draped youths (as on no. 62).

Page 22: To the bibliography of Amsterdam 2498, no. 95a, add: *Gr., Etr. en Romeinse Kunst*, p. 48, fig. 44.

Page 26:

To the three column-kraters (nos. 116—118) discussed on p. 26 as connected in style with the work of the Ariadne Painter may now be added a fourth, recently rediscovered in Lisbon by Dr Helena Rocha-Pereira to whose kindness we owe photographs of the vase and details of its history. In her book *Greek Vases in Portugal* (1962) she refers on pp. 12 ff. to Emil Hübner's remarks on certain vases in Portugal in his work *Die antiken Bildwerke in Madrid* (1862),

pp. 329 ff. and in an article in the *Bullettino dell' Istituto di Corrispondenza Archeologica* 1862, pp. 199 ff. In the former (p. 331) Hübner mentions a few vases in the collection of King Fernando, which had originally belonged to King Pedro V and were said to have been given to him by the Apostolic Nuncio, probably between 1855 and 1861. They were housed in the royal palace but vanished from sight after the revolution of 1910, which brought an end to the monarchy (*Gr. V. in P.*, p. 16). The article in *BdI* gives a fuller description of the vases among which, as no. 8 in his catalogue, are listed two large r.f. column-kraters, one depicting two warriors, a woman and Nike, the other a *komos*. These two vases have now been brought to light again by Dr Rocha-Pereira; the first is by the Amykos Painter, the second is by the same hand as the Boston boar-hunt krater (no. 118). The reverses of the two vases are remarkably alike, especially in the treatment of the drapery, except that on the Lisbon vase the second youth holds a wreath instead of a strigil and the fourth has a stick. The rim of the obverse is decorated with a frieze of b.f. animals and the neck on both sides has a panel of ivy-pattern.

118a Lisbon, The Palace of Belém P 548.
　　　Rocha-Pereira, *Gr. V. in P.*, p. 15.
　　　(a) Komos — woman with kottabos-stand, nude youth with torch and situla, woman with tambourine, youth with thyrsus, (b) four draped youths.

CHAPTER 2

Pages 30–33:　　　　　　　　　1. The Gravina Painter

　　The following vase was found in a very fragmentary condition at Gravina in 1976 and is probably to be attributed to the Gravina Painter, although it is difficult to be certain in its present state. Like his other vases, it is very close in style to the work of the Sisyphus Painter, especially in the drawing of the face in three-quarter view.

Hydria

5a Taranto, from Gravina, T. 1.
　　Nude youth with stick, draped woman holding up cista, woman in three-quarter view seated beside a column, with distaff in l. hand and spindle in r. (cf. the Oxford hydria, no. 1/14, by the Painter of the Berlin Dancing Girl), and a draped woman.
　　Beneath the handles: birds (of the one to r. only the head now remains).

Pages 33–36:　　　　　　2. The Painter of the Birth of Dionysos

　　The following fragments of a large vase also show the same treatment of the eyebrow as on nos. 13–14; the seated figure of Electra, with her inclined head, should be compared with that of Alcmena on no. 11.

Fragments

14a Basel, Cahn coll. 284. Badly preserved, with some incrustation.
　　Meeting of Orestes and Electra at the tomb — to l., woman holding metal oenochoe, white-haired woman with sash approaching the tomb-monument, on the l. side of which, resting against the base of the column Electra is seated, and on the r. Orestes, before whom are the legs of another man (Pylades ?), lower part of man seated on travel-pack (cf. Munich 3266, *Ill.Gr.Drama* III.1, 4, p. 43).

Page 36: To the bibliography of Amsterdam 2579, no. 10 add: *Gr., Etr. en Romeinse Kunst*, p. 52, fig. 50.

Pages 41—42: 4 (iii) ASSOCIATED FRAGMENTS

Fragment

29a Amsterdam, R.A. Scheurleer coll. 402.
 Head of woman beside tree.

CHAPTER 3

Pages 46—53: 1. The Tarporley Painter

Bell-krater

33a Taranto, Leoncini coll. 48.
 (a) Dionysos with thyrsus, maenad holding up tambourine, satyr with situla and torch, (b) three draped youths.

Pelike

45a Once London Market, Christie's, *Sale Cat.* 17 May 1977, no. 93, pl. 5.
 (a) Woman with sash and mirror running to l. and looking back at nude youth following with stick, (b) two draped youths.

Page 60: 4 (ii) THE PAINTER OF BOLOGNA 498

Pelike

102a Taranto, from Rutigliano, T. 20.
 (a) Draped woman with phiale, youth with chaplet, (b) two draped youths.

Oenochoai (shape 3)

102b Taranto, from Rutigliano, T. 20.
 Nude youth with drapery over l. arm and r. akimbo, draped woman playing with ball.
102c Taranto, from Rutigliano, T. 20.
 Running woman bouncing ball.

Pages 61—62: 5. Imitators of the Tarporley Painter

Pelike

115a Ithaca, Cornell Univ., Johnson Art Museum 74.74.7.
 (a) Woman with sash and lekythos on dish, youth with chlamys and pétasos, holding oenochoe in r. hand and shield in l., at a monument consisting of an Ionic column surmounted by a hydria rising from an acanthus base on a stepped plinth in front of a table (or altar), (b) nude youth following draped woman with sash and cista, running to r.,
 For the monument on (a) cf. that on B.M. E 505, no. 4/88 by the Eton-Nika Painter; the scene may represent the meeting of Orestes and Electra at the tomb of Agamemnon.

CHAPTER 4

Pages 77—79: 5. The Eton-Nika Painter and related vases

Bell-krater

91a Athens, Acheloös Gallery 458. Recomposed from frr.; central part of obverse missing.
 (a) Dionysos with thyrsus and kantharos, silen with fillet tied round l. arm beside a b.f. bell-krater, (b) two draped youths.
 For the b.f. bell-krater cf. no. 88; for the drapery of the youth to r. that on no. 84. The draped youths should also be compared with those on nos. 92—4. The egg-pattern round the rim finds a parallel on no. 94.

Pages 80–86: 6 (i) THE PAINTER OF THE LONG OVERFALLS
 (a)

Pelike

101a Once London Market, Charles Ede Ltd.
 (a) Standing draped woman holding handled cista, seated nude youth with phiale, (b) two draped youths.

 (b)

 The following vase is very close to nos. 119 and 119a:

Bell-krater

119b Athens, Acheloös Gallery 351.
 (a) Satyr with thyrsus pursuing woman with wreath and situla, (b) two draped youths.

Page 88: 6 (v) THE BENDIS PAINTER

 Add to the bibliography of the Boston krater, no. 168: *Gr. V. from the Boston M.F.A.* (Exhibition Cat., Museum of South Texas, March 12–May 2, 1976), no. 39, ill. on p. 29.

Pages 92–93: 7 (ii) THE PAINTER OF BOLOGNA 425

Column-krater

202a Once London Market, Christie's, *Sale Cat.* 12 July 1977, no. 145, colour-plate opp. p. 33 and pl. 31, 2.
 (a) Oscan youth with lyre and draped woman with black nestoris running to l., followed by frontal Oscan youth with torch, and draped woman with phiale, (b) four draped youths, a stele between the first two.

CHAPTER 5

Pages 103–111: 2. The Hoppin Painter

 Add to the vases in division (iii) (a):

Bell-krater

31a Hamburg, private coll.
 (a) Seated half-draped woman with tambourine and dancing silen, (b) two draped youths.

Fragment of krater

35a Basel, Cahn coll. 285.
 Woman seated on rock, with head turned back to r. to look at standing draped woman, holding some missing white objects (corn-stalks ?) in her upraised hands; to r., arm, shoulder and part of face of youth.

Page 112: 3 (ii) THE BUCRANE GROUP

 Add to the vases in sub-division (b):

Bell-krater (frr.)

79a Basel Market, MuM.
 (a) Nude youth wearing chlamys, seated youth wearing chlamys and Phrygian cap, and holding two spears, standing draped woman, (b) missing.

Page 127: 6 (i) THE ROHAN PAINTER

Oenochoe (shape 3)

242a Once London Market, Christie's, *Sale Cat.* 17 May 1977, no. 90, pl. 3, 1.
 Eros running to l., holding wreath in r. hand.

CHAPTER 6

1. The Painter of Karlsruhe B 9

Page 142: (iv) THE LATEST PHASE

The following bell-krater, once in the collection of Baurat Schiller in Berlin, and subsequently discovered in a badly damaged condition by Dr Karl Peters in a cemetery in Berlin-Pankow (see "Ein Vasenfund", in *Mélanges Mansel,* 1974, pp. 571–4), looks from what remains of the two youths on the battered reverse to be closely associated in style with, if not by the same hand as, nos. 55–61 above. We may note the presence of the same wavy line on the border of the overhang on the himation of the youth to left as on no. 61, and the lower part of the himation of the youth to right corresponds with that of those on nos. 57 and 60. The figures on the obverse should also be compared with those on nos. 55–57.

62a Xanten, Dr Karl Peters.
 Ex Berlin, Schiller coll.; Zahn, *Sale Cat.* 19–20 March 1929, no. 412, pl. 33; Peters, op, cit., pls. 175 and 176c.
 (a) Satyr with situla and phiale, seated woman with thyrsus, (b) two draped youths.

Pages 146–155: 4. The Dijon Painter

 Add to division (i):

Bell-krater

93a Taranto, from Rutigliano, T. 38.
 (a) Seated Dionysos with thyrsus and phiale, standing woman holding wreath and situla, (b) two draped youths, r. holding wreath.
 Found with a skyphos of the Choes Group (no. 11/117a).

Column-krater

99a Okayama (Japan), RO coll.
 Mizuta IV (1977), no. 25, pls. 2–4.
 (a) Woman with dish on head, standing woman with phiale, seated Oscan youth with spear, Oscan youth with spear bending forward over l. foot raised on rock, (b) three draped youths.
 Close in style to Naples Stg. 29 (no. 99); cf. also with nos. 146–7 for the subject of the obverse.

 Add to division (iv):

Column-krater

164a Hamburg Market.
 (a) Woman pouring libation from an oenochoe into a phiale held by a seated Oscan warrior with two spears and a shield, standing warrior with mirror, (b) three draped youths.
 Cf. with nos. 164–8.

Page 159: 5 (v) THE PAINTER OF BARI 1523

 Add to sub-division (a):

Bell-krater

198a Vidigulfo, Castello dei Landriani 262.
 (a) Satyr with situla and woman with dish of eggs, both running to r., (b) two draped youths, l., with stick, r. with strigil.
 The reverse is very close to that of Milan 226 (no. 198).

CHAPTER 7

Page 168: 2 (iii) VASES CONNECTED WITH THE BLACK FURY PAINTER

(b)

Add the following fragment, which is connected in style with no. 22 and also comparable with no. 12:

Fragment

22a Malibu, J. Paul Getty Museum.
> Part of female figure, with fawnskin over l. arm, upper part of woman in three-quarter view to l., laurel-tree, two women fleeing to r. (partly preserved).

Page 176: 5 (iii) VASES CONNECTED WITH THE FELTON PAINTER

The following pelike, known to us through the kindness of Dr Rocha-Pereira, is very close in style to the Minnesota pelike (no. 71), as may be seen from a comparison between the standing women on the obverse of the former and the reverse of the latter. The stance and drapery of both are almost identical, especially in the treatment of the fold-lines. Note also the presence of small reserved dots at the tips of the leaves on the laurel-wreath round the neck, as on no. 71, and the kalathos decorated with bands of net-pattern as on 56 (cf. the cistae on nos. 60 and 75). The treatment of the himatia of the youths on the reverse finds a parallel on some of the vases by the Dijon Painter and his followers.

Pelike

71a Lisbon, private coll.
> (a) Standing woman with bunch of grapes in r. hand and kalathos in l., seated nude youth with phiale, (b) two draped youths.
> The upper part of the body of the seated youth on (a) looks to have been retouched.

CHAPTER 8

Page 195: 1. The Iliupersis Painter

Stamnos

19a Okayama (Japan), Kurashiki Museum.
> (a) Above — Eros with open wreath, seated woman with phiale, standing woman holding up tambourine in l. hand; below — silen playing the flute, seated woman playing the harp, nude youth with thyrsus seated on rock, (b) nude youth with wreath and thyrsus seated on rock between standing woman with open box and woman plucking at drapery above r. shoulder.

This remarkable vase, of which our knowledge is due to the kindness of Mr Takuhiko Fujita, is a notable addition to the slender list of Apulian stamnoi (see p. 23), standing in shape between nos. 1/104 and 16/71. The figures on the obverse are very much in the manner of the Iliupersis Painter (cf. with those on nos. 7, 8, 11); those on the reverse, for which many parallels will be found on his other vases (e.g. nos. 11, 43, 67), should also be compared with some of those on the later work of the Dijon Painter (e.g. nos. 6/150, 154 for the rock, 164 and 168 for the two draped women), which they most strikingly resemble, thus further emphasising the close connexion between the two painters, already noted on p. 153.

Page 203: 2. Vases Associated with the Iliupersis Painter

The two following volute-kraters, which are by the same artist, who may be called the

Rhesus Painter, are very close in shape, style of drawing and subsidiary decoration to Ruvo 1722A (no. 102), which is probably also his work; they should also be compared with Dresden 521 (no. 143).

102a Berlin inv. 3157.
 Neugebauer, *Führer,* pl. 81; *Ill.Gr.Dr.* III.5, 8; Moret, *Ilioupersis,* pl. 86.
 (a) Horses of Rhesus, (b) above — satyr with situla between standing woman and seated woman; below — Dionysos seated between Eros and satyr.
 Neck: (a) confronting griffins.
102b B.M. F 276. Broken and repaired.
 (a) Rider and youth in naiskos with three youths and three women around, (b) thiasos — satyr, Dionysos and maenad, with two maenads and a satyr above.
 Neck: (a) two griffins attacking a deer.
 Note the series of metopes of athletes on the base of the naiskos (see Carter, *AJA* 74, 1970, p. 129, pl. 31, fig. 16).

The reverses of these two vases are strikingly similar, both representing Dionysiac scenes in two clearly separated rows with three figures in each. The same arrangement appears also on the reverse of a volute-krater, recently found at Rutigliano, which may now be added to the list.

102c Taranto, from Rutigliano, T. 2.
 (a) Two youths wearing piloi in a naiskos, with hands grasped together, r. youth holds shield and two spears; to l. and to r., three youths, one seated and two standing, looking to one another, (b) above — woman with fillet and wreath, seated woman with fillet and spray, satyr with thyrsus and tambourine; below — satyr with situla, seated Dionysos with phiale and thyrsus, maenad with raised foot, holding thyrsus to which a fillet is tied.
 Neck: (a) confronted griffins with a tree between (cf. no. 102a).

Pages 208–9: (v) (a) MINOR VASES ASSOCIATED WITH THE ILIUPERSIS PAINTER

Oenochoe (shape 8) = Mug

130a Cologne, private coll.
 Seated silen playing the flute, Herakles with oenochoe and club seated on lion-skin beside Dionysos, who is reclining on a couch and holding cup and thyrsus, maenad running up with phiale and thyrsus.

Oenochoe (shape 3)

140a Los Angeles Market, Summa Galleries, *Cat.* 1 (1976), no. 36 (ill.).
 Nude youth with thyrsus looking back at young satyr coming up with torch and thyrsus.

Hydria

140b Los Angeles Market, Summa Galleries, *Cat.* 1 (1976), no. 37 (ill.).
 Woman with fan and dish running l. towards a stele.
 The swirling drapery of the woman should be compared with that on some of the vases of the Dijon Painter (e.g. nos. 6/102, 113, 127), but the drawing of the face is closer to the manner of the Iliupersis Painter.

Page 215: 3. (ii) LESS IMPORTANT VASES BY THE PAINTER OF ATHENS 1714

Add to the list of pelikai:

178a Lisbon, private coll.
 (a) Standing woman with phiale, seated nude youth, (b) two draped youths.

GENERAL INTRODUCTION TO CHAPTERS 12 – 14

Page 315:

An interesting medieval parallel to the instrument from Macchiabate will be seen in the psaltery held by King David in an illustration in the Polirone Psalter (c. A.D. 1125) in Mantua – see Christopher Page, "Biblical Instruments in medieval manuscript illustration", *Early Music*, vol. 5, no. 3, July 1977, pp. 299–309, pl. 22 on p. 307, with detail on p. 299 (cf. also pls. 8 and 12–15 for other parallels). The psaltery certainly resembles the Macchiabate instrument (which must be something of the same kind), but is not like the "xylophone", which seems to represent a different musical tradition.

CHAPTER 12

Page 331: 6 (i) THE "H. A." PAINTER

Add:

Amphora

126b Los Angeles Market, Summa Galleries inv. 343.

(a) Nude youth with two spears in r. hand, resting l. arm on shield, in naiskos; to l., nude youth with fillet and phiale; to r., woman approaching with basket of cake, rosette-chain and wreath, (b) two draped youths.

Makes a pair with the Richmond amphora (no. 126a).

CHAPTER 13

1. The Varrese Painter

Page 341: (i) LARGER VASES – (b) THE SUB-GROUP OF VATICAN X 6

Add the following:

Oenochoe (shape 1)

25a Zurich Market, Galerie Fortuna C 180.

Standing woman with phiale, seated nude youth with branch, nude youth with crossed legs, holding branch in r. hand, with drapery wrapped around his l. arm.

Page 355: 2. (iv) THE PAINTER OF TRIESTE 422

176a Leningrad inv. 1195 = St. 1236.

(a) Standing draped woman with wreath, seated nude youth; Eros flying above, holding wreath in both hands, (b) seated nude youth with phiale, standing draped woman.

The reverse is very close to the obverse of no. 176, especially in the treatment of the seated youth and of the woman's drapery. The berried laurel with central rosette on the neck of (a) corresponds closely to the decoration on no. 175.

FIGURES

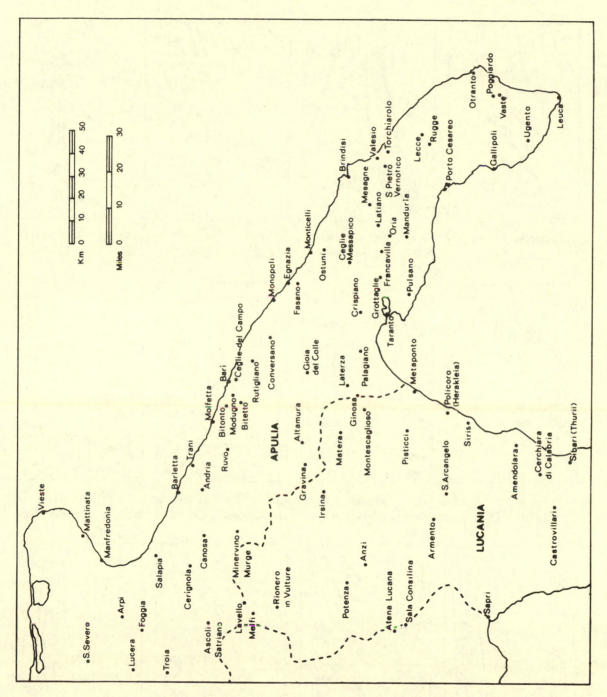

FIG. 1.

a) Tarporley Painter
N.Y. L.63.21.5 = 3/2

b) Tarporley Painter
N.Y. 17.120.241 = 3/61

c) Schiller Painter
B.M. 1929.5-13.2 = 4/21

d) Adolphseck Painter
Marseilles 2933 = 4/49

e) Prisoner Painter
Bari 2249 = 4/75

f) Long Overfalls Group
Verona 171 = 4/106

g) Long Overfalls Group
Luscombe Castle = 4/151

h) Long Overfalls Group
Boston, Vermeule = 4/168

i) Ptr. of Bologna 501
Bologna 501 = 4/234

j) Ptr. of Karlsruhe B9
Trieste S 412 = 6/10

k) Ptr. of Karlsruhe B9
Erlangen K 86 = 6/16

l) Dijon Painter
Matera 9690 = 6/107

FIG. 2.

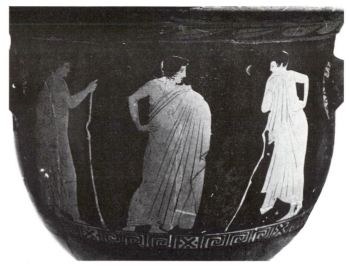

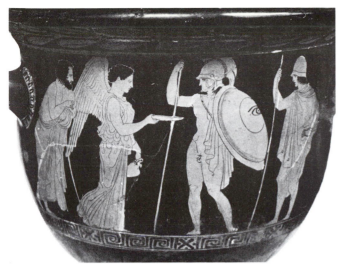

1–2. Benevento 348 (III)

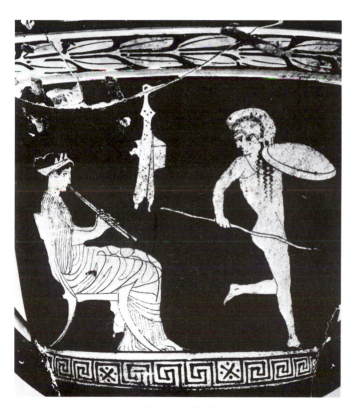

3. Louvre G 480

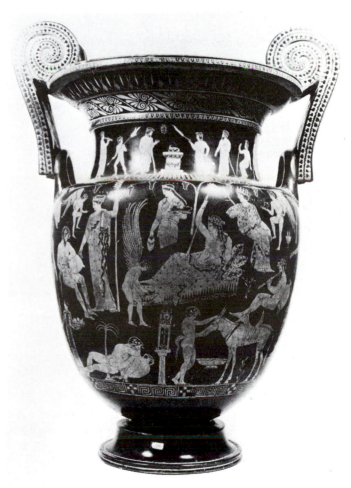

4. Ruvo 1093

PLATE 2 Painter of the Berlin Dancing Girl

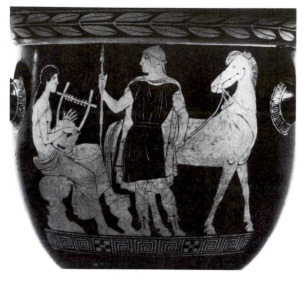
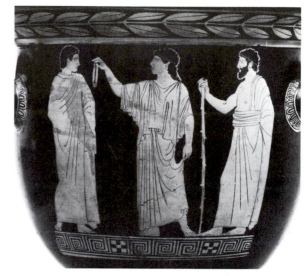

1–2. Once Anagni (1/12)

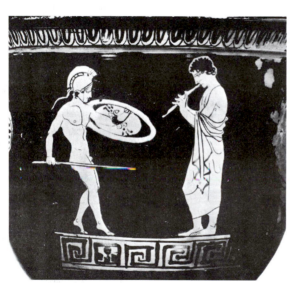

3–4. Taranto 61735 (1/1)

5–6. Boston, Prof. Oddy (1/7)

1. Oxford 1974.343 (1/14)

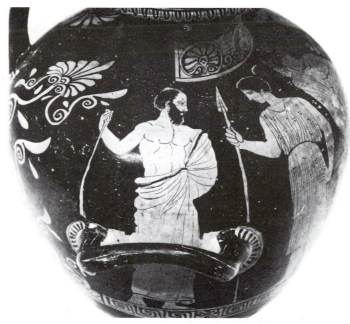

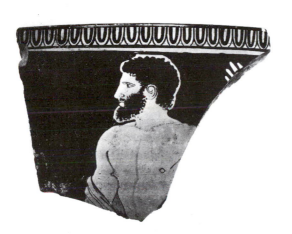

2. Paris, Cab. Méd. (1/16)

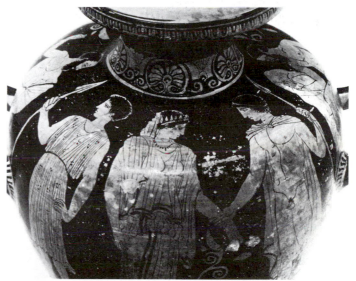

3. Taranto 12563 (1/17)

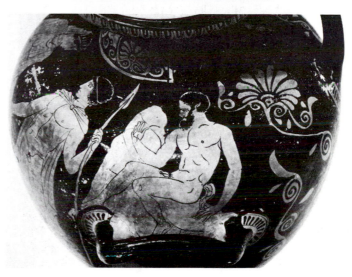

4(a,b,c). Taranto 134905 (1/18)

PLATE 4 The Hearst Painter

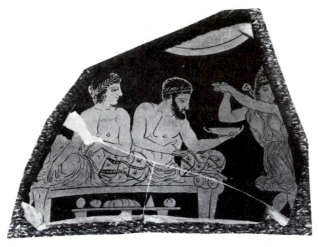

1(*a,b*). Basel, Cahn coll. 276, 278 (1/25a)

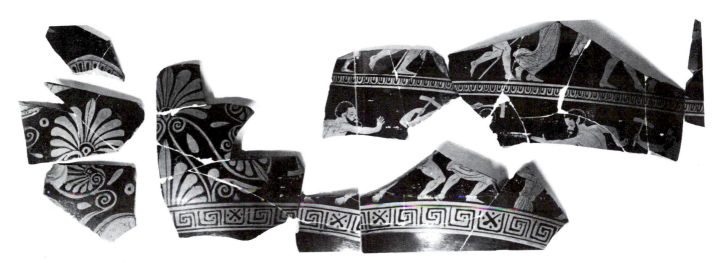

1(*c,d*). Basel, Cahn coll. 276, 278 (1/25a)

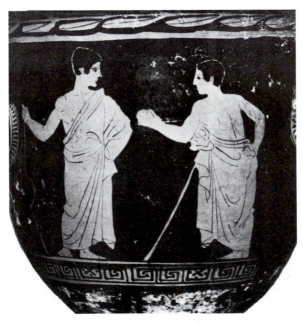

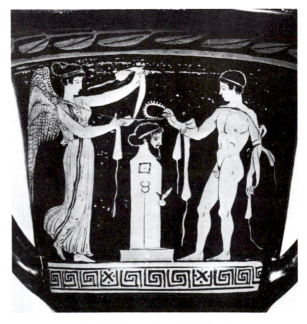

2. Lecce 574 (1/26) 3. Agrigento R 178A (1/34)

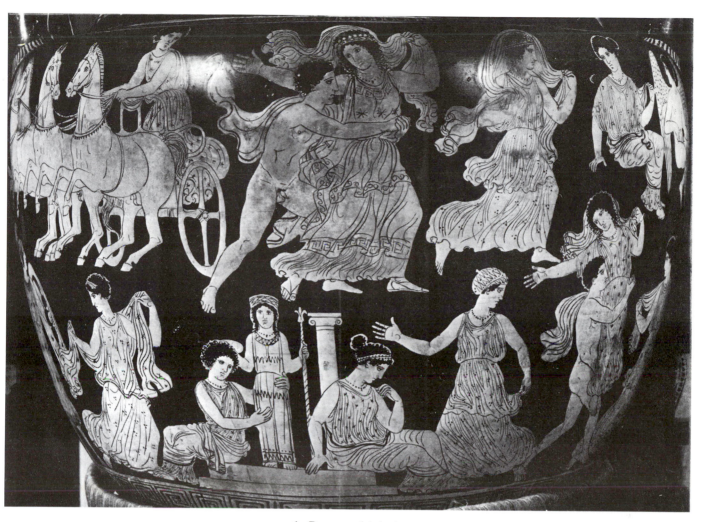

1. Ruvo 1096 (1/52)

2. Basel, private coll. (1/54)

PLATE 6 The Sisyphus Painter

1–2. Matera 9978 (1/63)

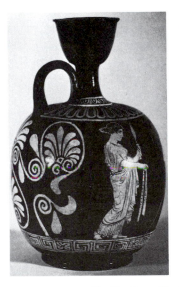

3. Louvre G 570 (1/75) 4(a,b). Once Zurich Market (1/84)

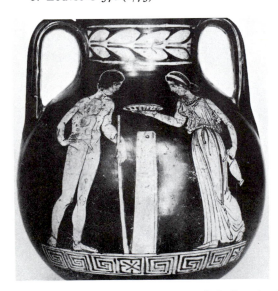
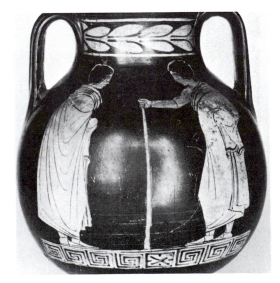

5–6. London U.C. 525 (1/88)

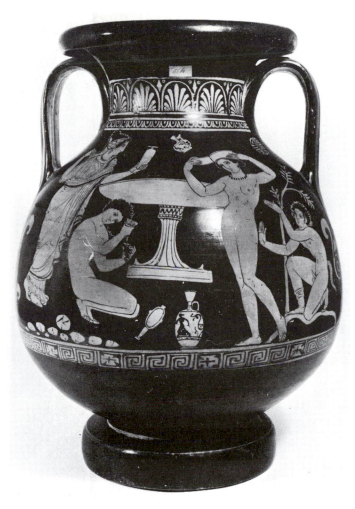
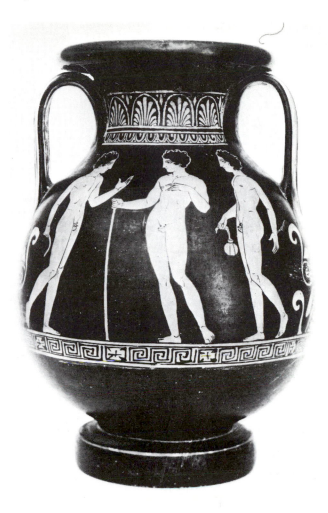

1–2. Ruvo 654 (1/89)

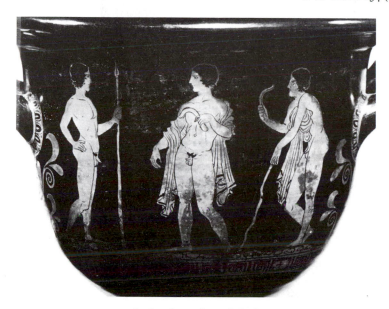

3. Leningrad 295 (1/91)

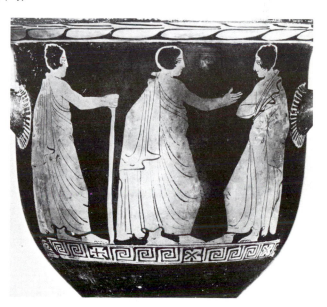

4. Naples 2149 (1/111)

PLATE 8 The Gravina Painter

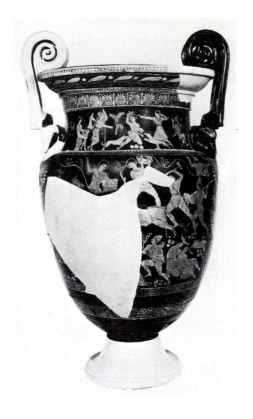

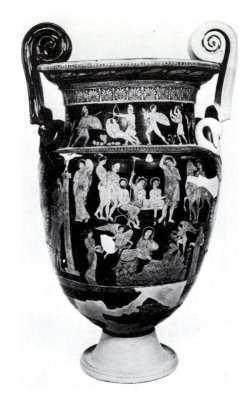

1–2. Taranto (2/1)

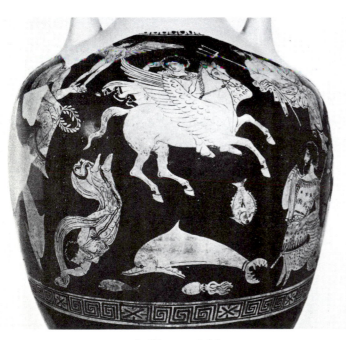

3. Taranto (2/2)

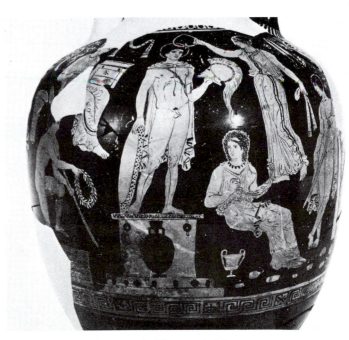

4. Taranto (2/3)

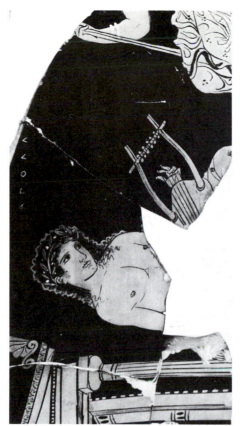

2(a,b,c). Amsterdam 2579 (2/10)

1(a,b,c). Taranto 8264 (2/6)

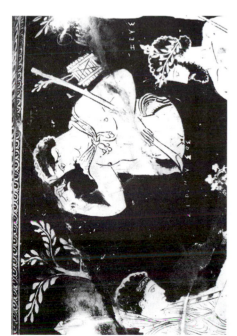

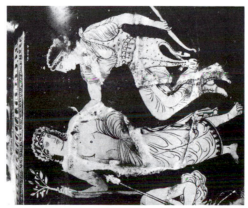

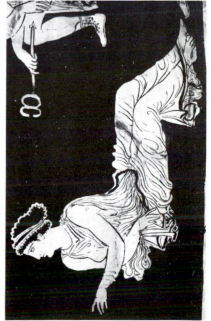

PLATE 10 The Painter of the Birth of Dionysos

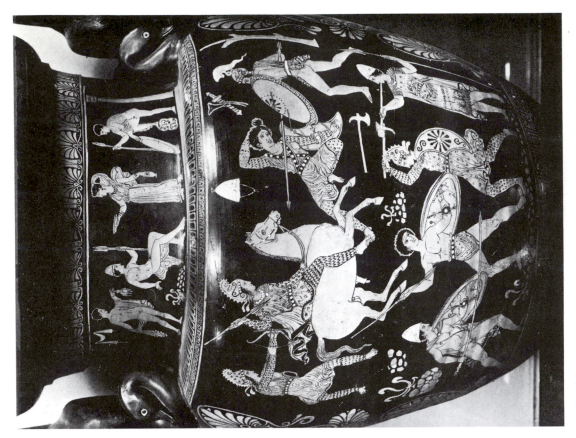

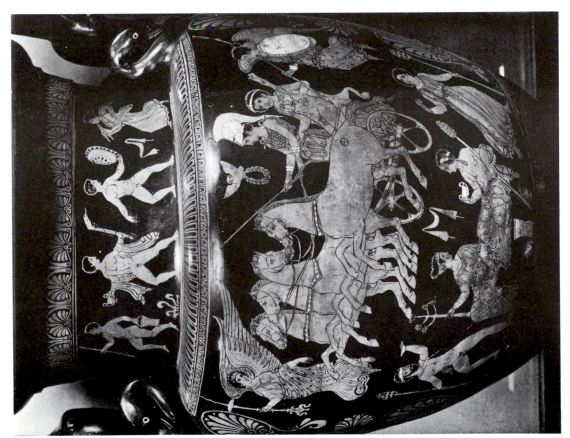

1–2. Brussels A 1018 (2/9)

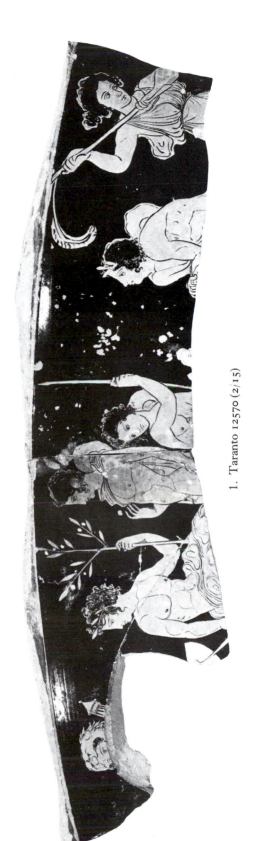

1. Taranto 12570 (2/15)

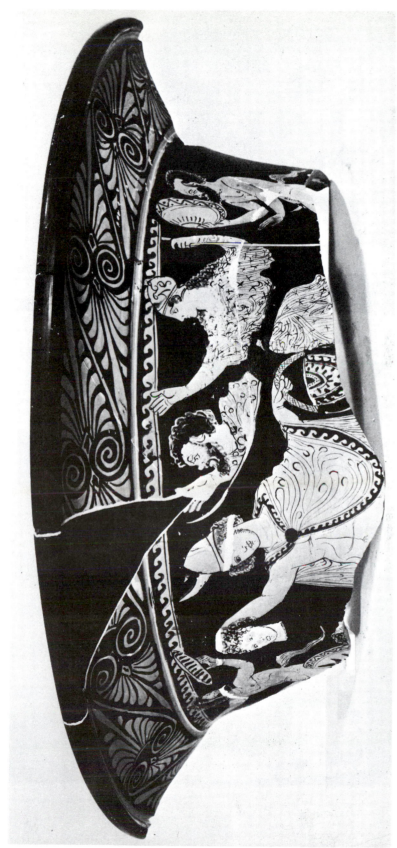

2. Taranto 124007 (2/18)

PLATE 12 Associated with the Painter of the Birth of Dionysos

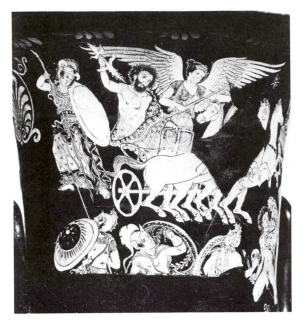

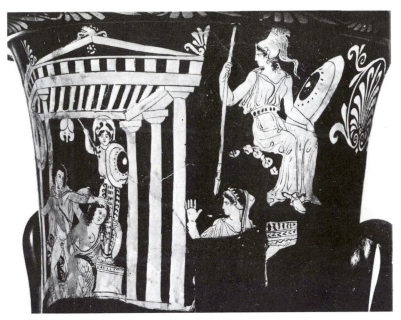

1(a,b). Taranto 52265 (2/24)

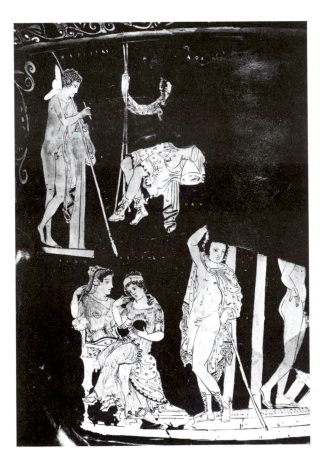

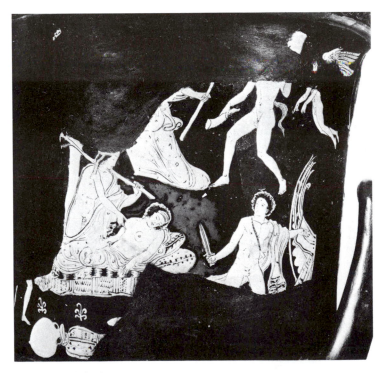

2(a,b). Taranto 52230 (2/25)

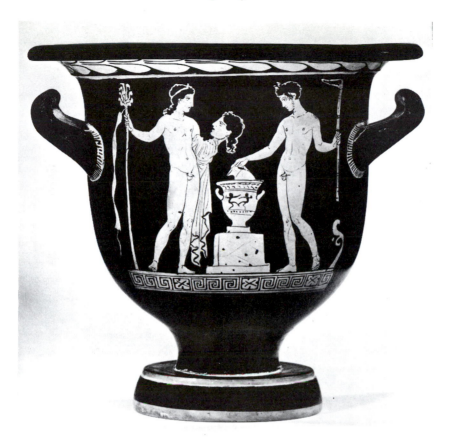

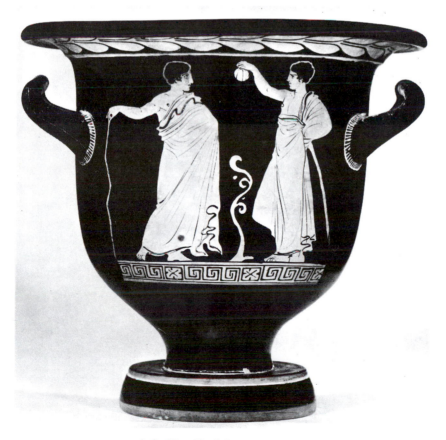

1–2. New York L. 63.21.5 (3/2)

PLATE 14 The Tarporley Painter

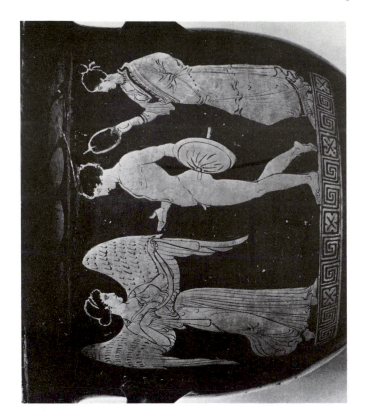

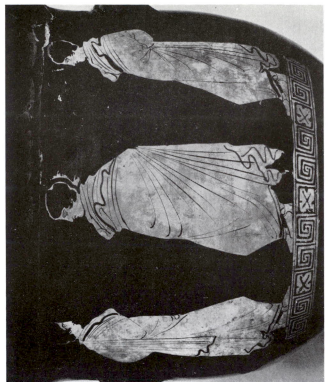

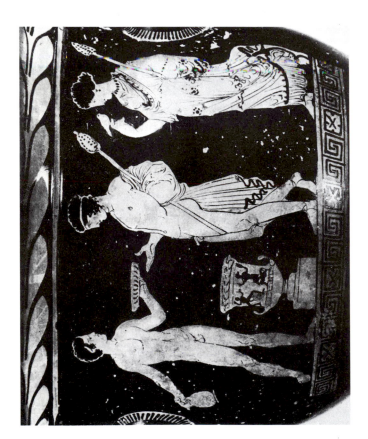

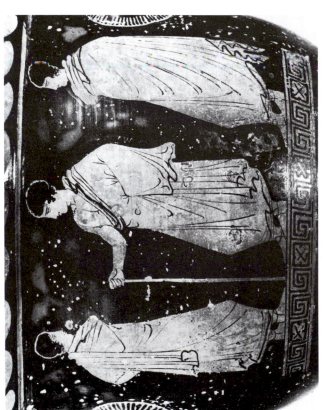

3–4. Fogg Museum 1960.359 (3/14)

1–2. Sydney 54.04 (3/13)

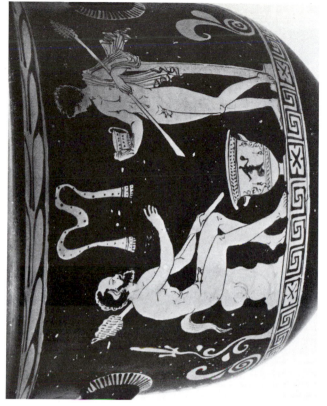

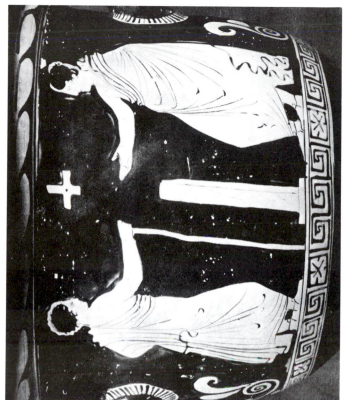

3–4. Once New York Market (3/33)

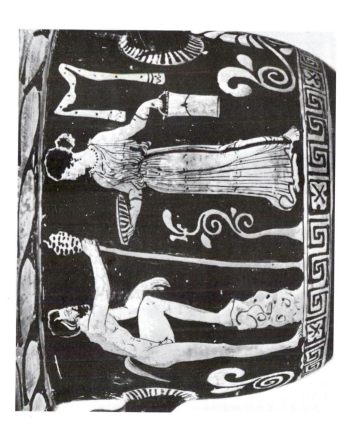

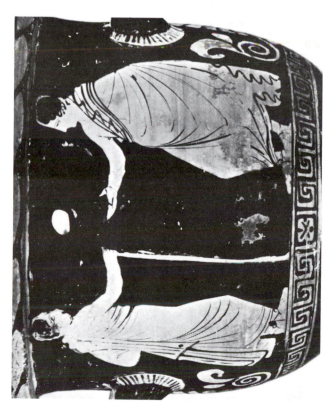

1–2. Taranto, Ragusa coll. 277 (3/3o)

PLATE 16 The Tarporley Painter

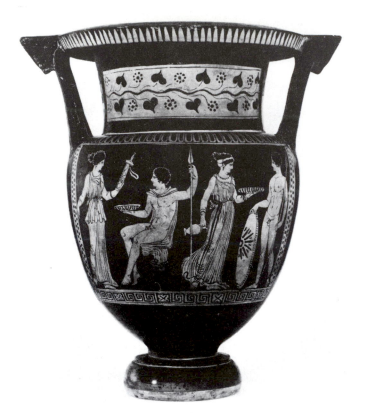

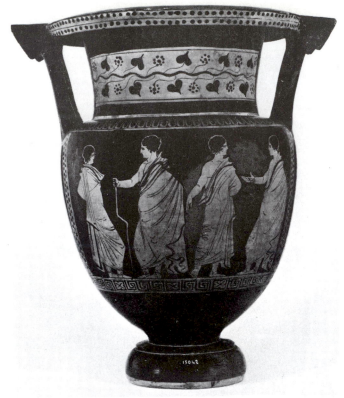

1–2. Geneva 15042 (3/60)

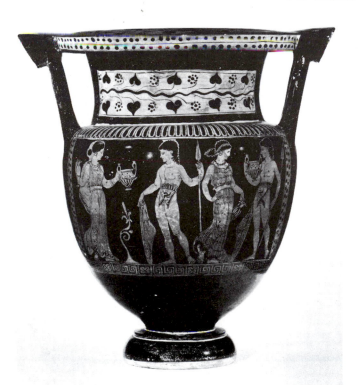

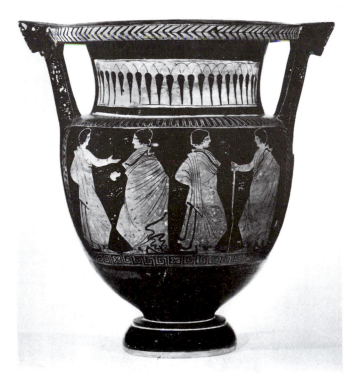

3–4. New York 17.120.241 (3/61)

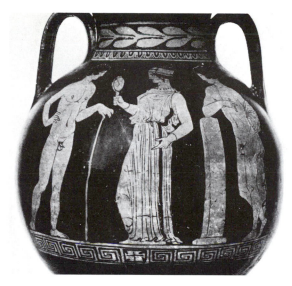
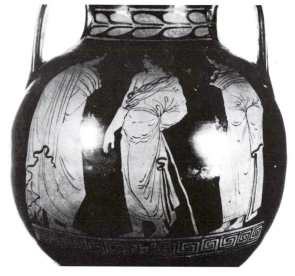

1–2. Syracuse 33713 (3/65)

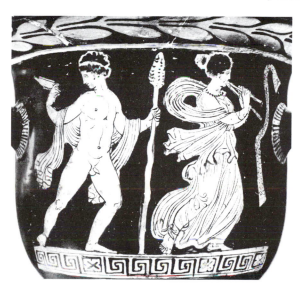
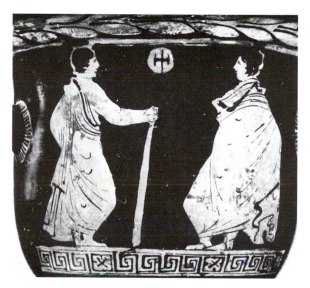

3–4. Erbach 33 (3/69)

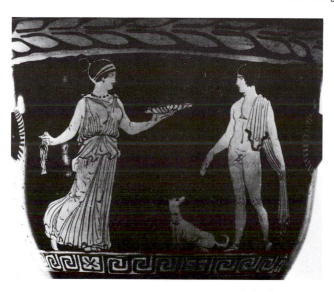
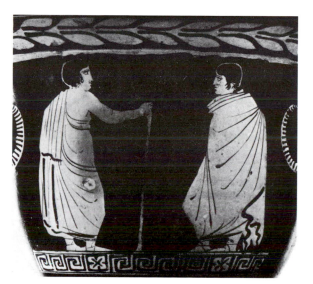

5–6. Once New York Market (3/77)

PLATE 18 The Group of Lecce 686; the La Rosiaz Painter

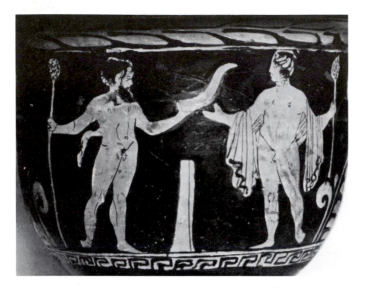
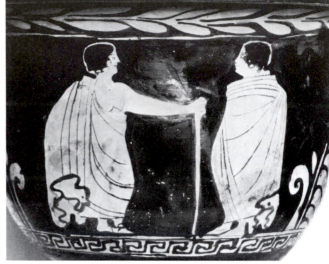

1–2. Taranto, Ragusa coll. 103 (3/80)

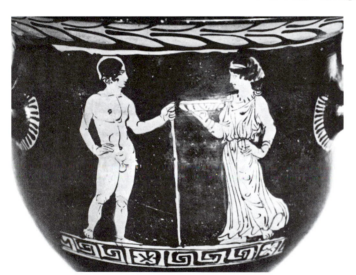
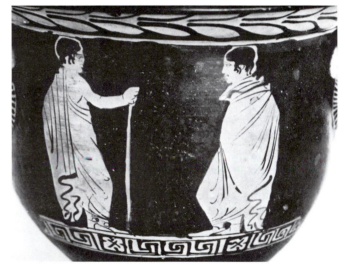

3–4. Bari, Macinagrossa coll. 19 (3/81)

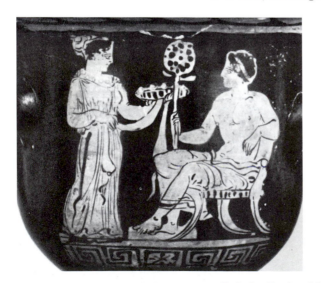
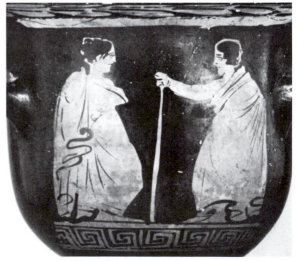

5–6. La Rosiaz, Mme. Ernst (3/85)

1–2. Naples 2191 (3/86)

3–4. Bari, Perrone coll. 1 (3/87)

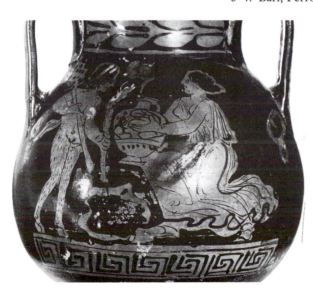
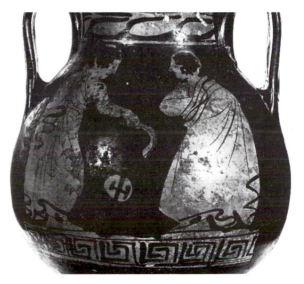

5–6. Marburg 34 (3/88)

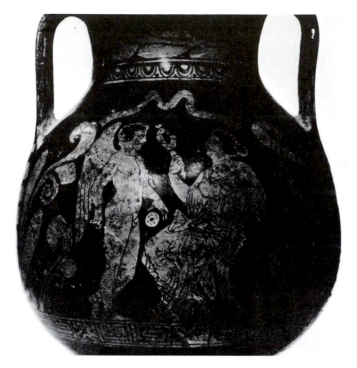
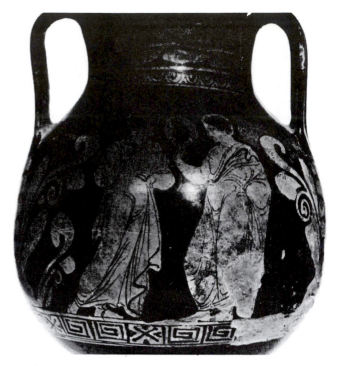

1–2. Policoro 33373 (3/90)

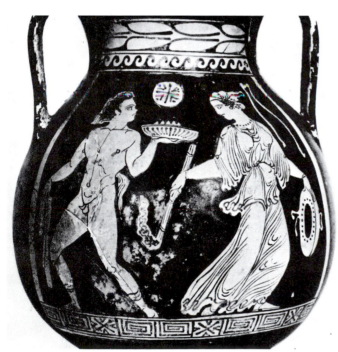
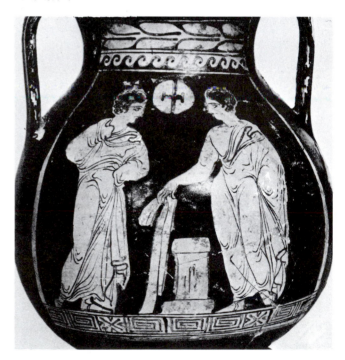

3–4. Taranto, Baisi coll. 42 = T. 21 (3/92)

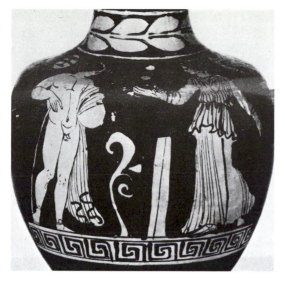

1. Naples 742 (3/94)

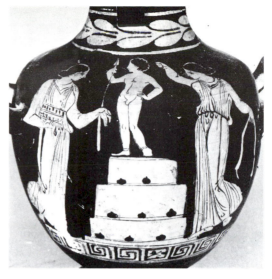

2. Louvre K 22 (3/95)

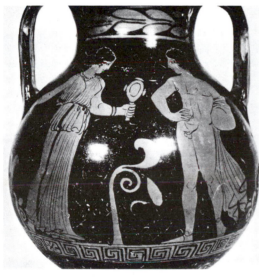

3–4. Taranto 110035 (3/101)

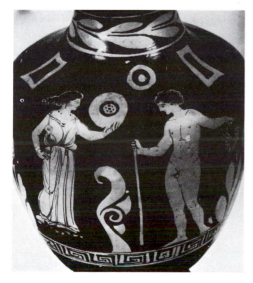

5. Sydney 71 (3/108)

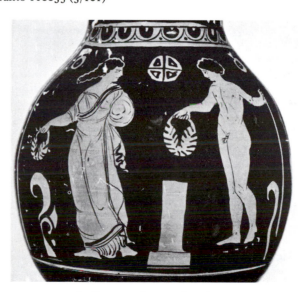

6. Rome, private coll. (3/110)

PLATE 22 The Schiller Painter

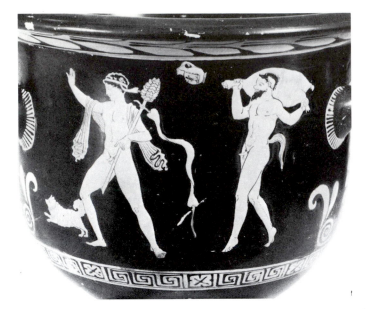
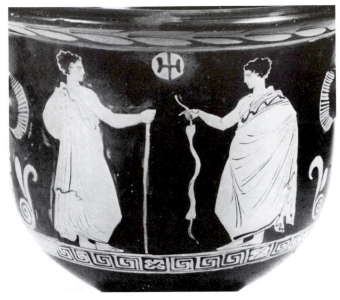

1–2. Once London Market (4/3)

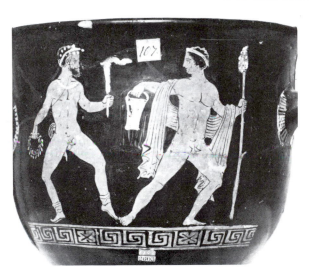
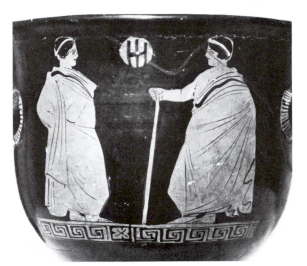

3–4. Naples 1862 (4/7)

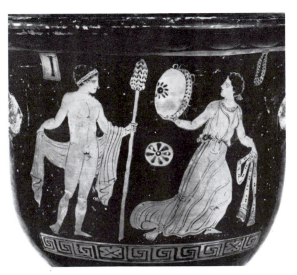
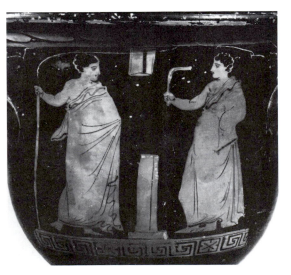

5–6. Once London Market (4/13)

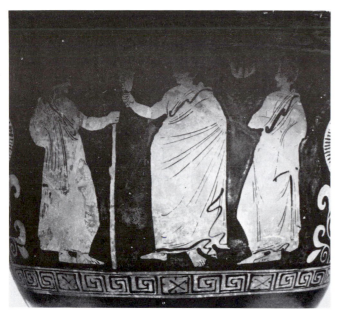

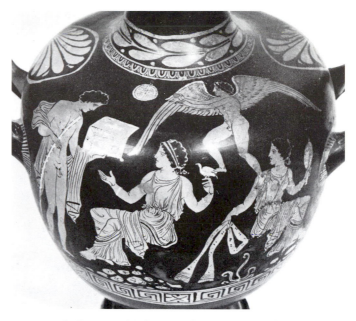

1. B.M. 1929.5–13.2 (4/21)

2. Bassano del Grappa, Chini coll. 71 (4/23)

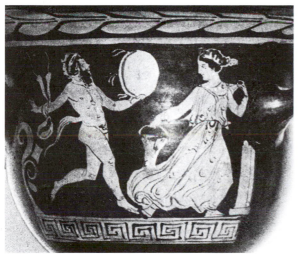

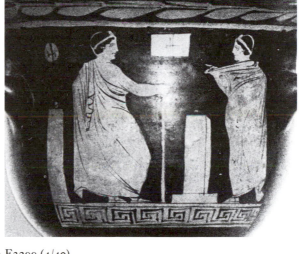

3–4. Hildesheim F3299 (4/40)

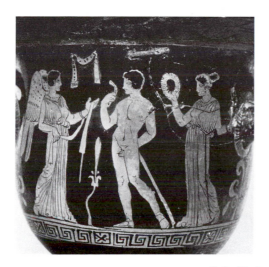

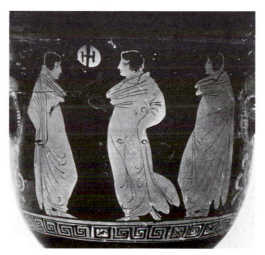

5–6. Bari 5595 (4/43)

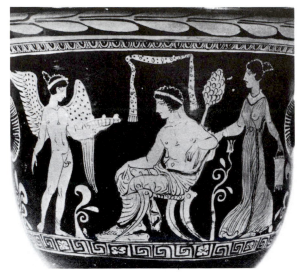
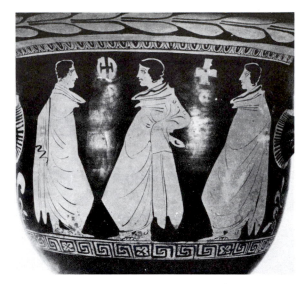

1–2. Nocera, Fienga coll. 547 (4/44)

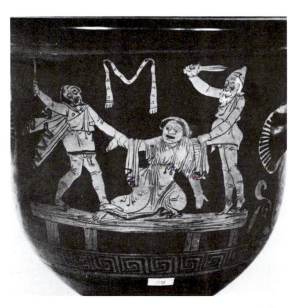
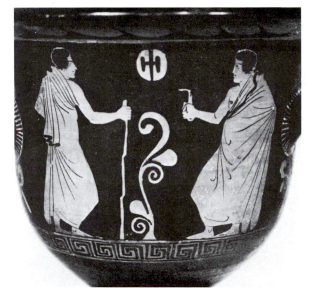

3–4. Ruvo 901 (4/46)

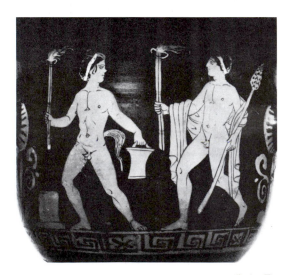
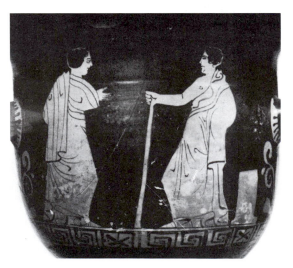

5–6. Zagreb 5 (4/48)

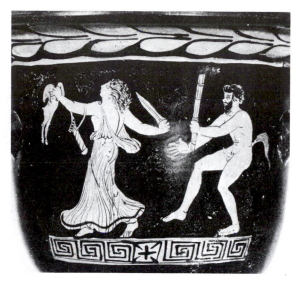
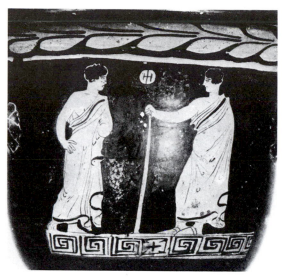

1–2. Nocera, Fienga coll. 521 (4/53)

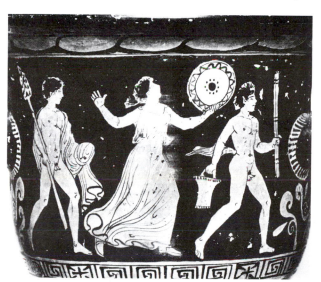
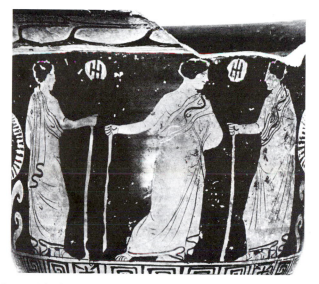

3–4. Naples Stg. 1 (4/54)

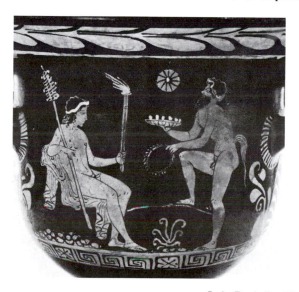
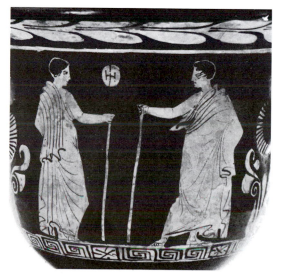

5–6. Bari, De Blasi coll. 12 (4/67)

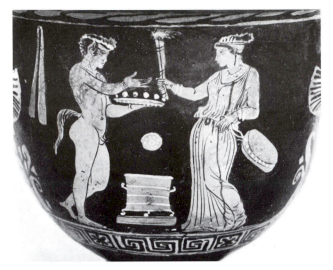
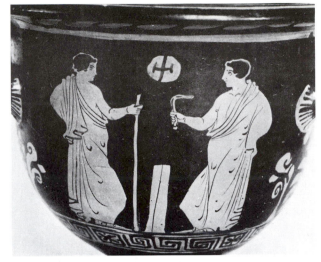

1–2. Bari, Macinagrossa coll. 17 (4/70)

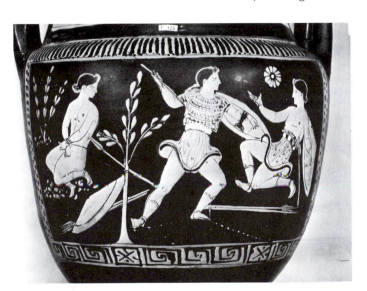
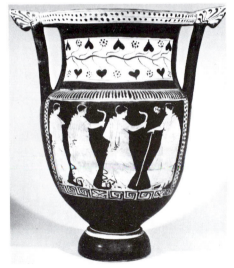

3–4. B.M. F 173 (4/73)

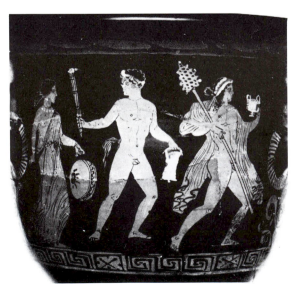
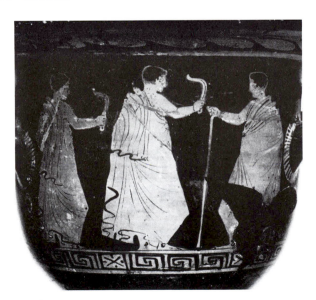

5–6. Bari 2249 (4/75)

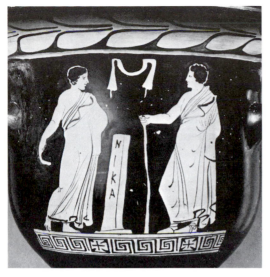

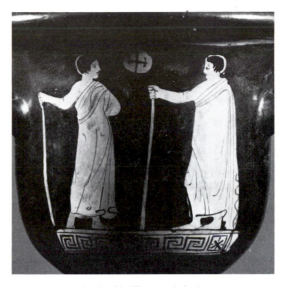

1. Bonn 79 (4/83) 2. Berlin F 3045 (4/92)

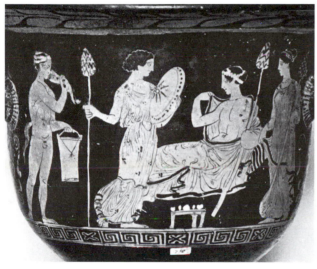

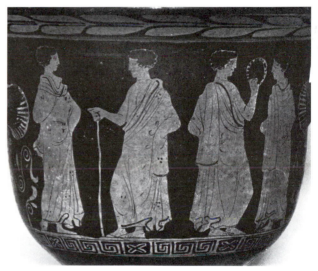

3–4. Ruvo 730 (4/97)

5(a,b). Syracuse 22663 (4/96) 6. Dijon 1198 (4/99)

PLATE 28 The Long Overfalls Group

1–2. Sydney 67 (4/107)

3–4. Vienna 734 (4/110)

5–6. Once Basel Market, MuM (4/117)

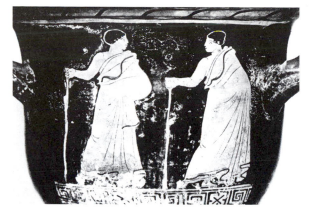

1–2. Naples 2040 (4/122)

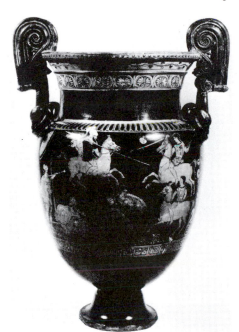
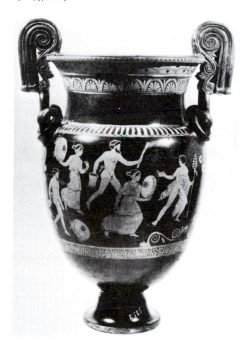

3–4. Leningrad 585 (4/140)

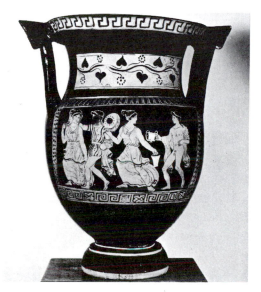
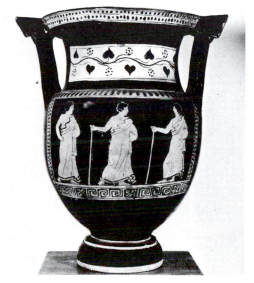

5–6. Louvre K 522 (4/141)

PLATE 30 The Long Overfalls Group

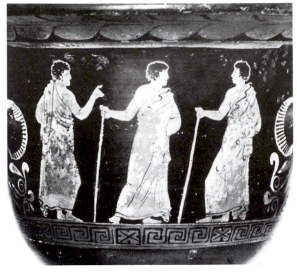

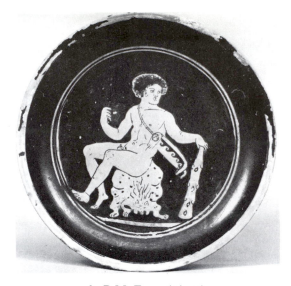

1. Ruvo 820 (4/142)

2. B.M. F 131 (4/153)

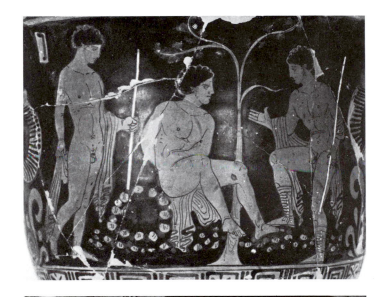

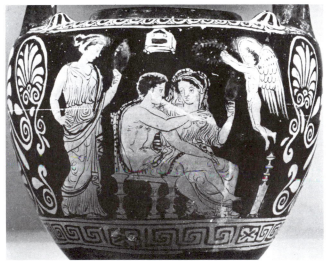

3. Paris, Cab. Méd. 953 (4/154)

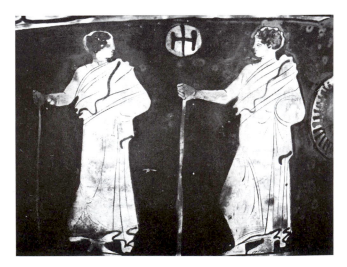

4–5. Potenza (4/171)

6. Paris, Cab. Méd. 428 (4/176)

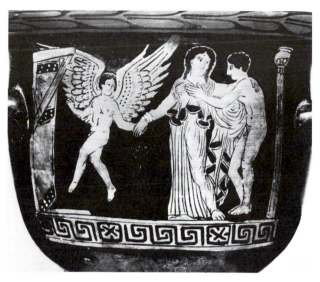
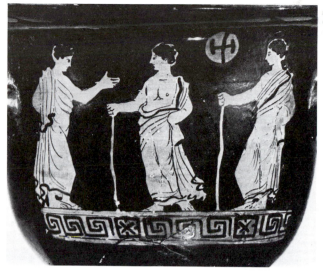

1–2. Sydney 66 (4/187)

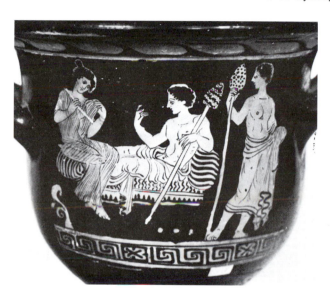
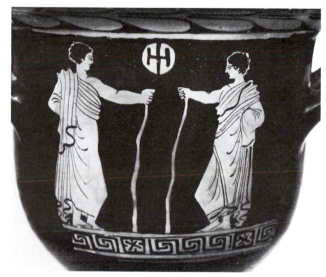

3–4. Ruvo 908 (4/188)

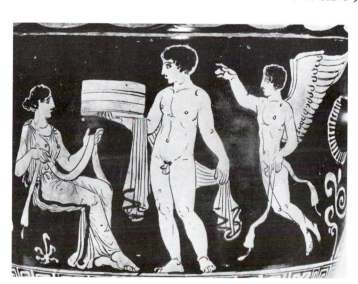
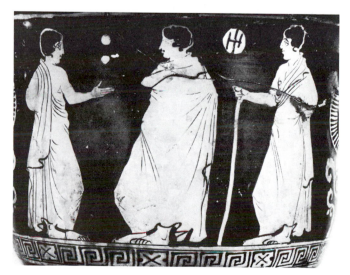

5–6. Sydney 46.48 (4/192)

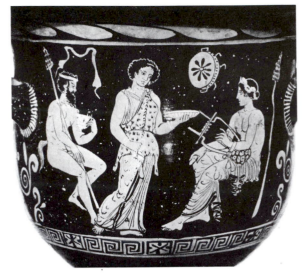
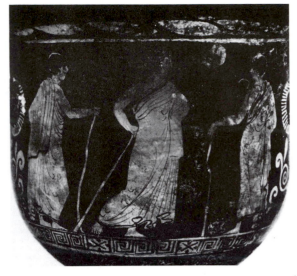

1–2. Madrid 11078 (4/201)

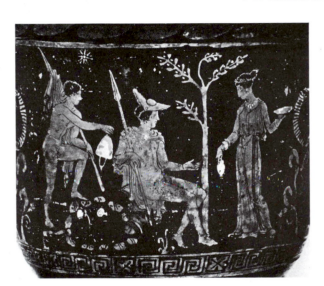
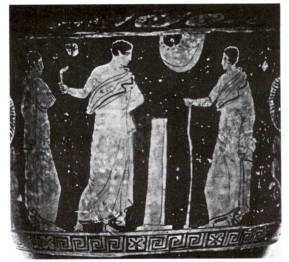

3–4. Ruvo 724 (4/209)

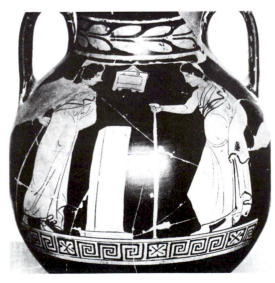
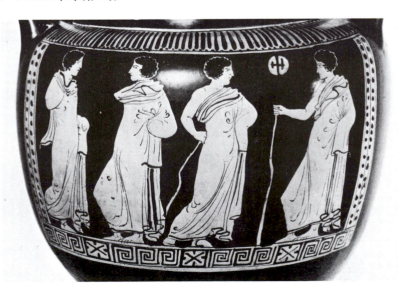

5. Naples Stg. 465 (4/213) 6. Oxford 1947.266 (4/215)

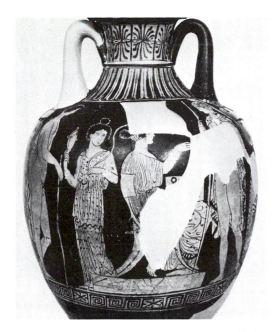
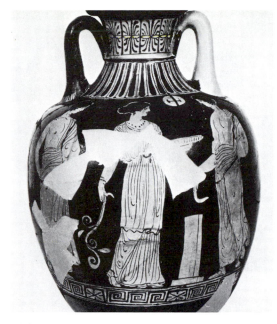

1–2. Taranto (4/221)

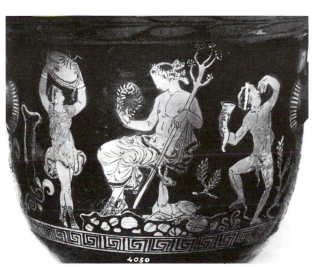
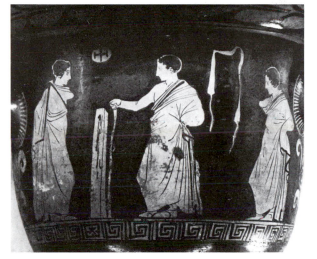

3–4. Florence 4050 (4/225)

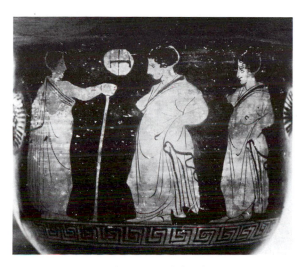
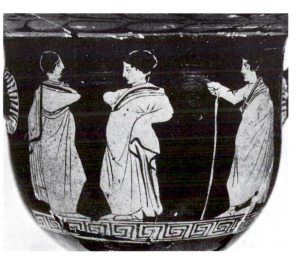

5. S. Agata 1 (4/224) 6. Bari, Loconte coll. 2 (4/226)

PLATE 34 The Eumenides Group

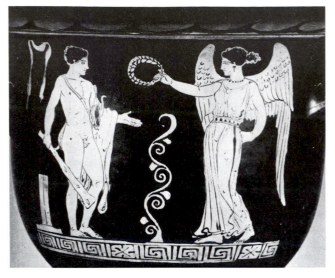

1. B.M. F 47 (4/231)

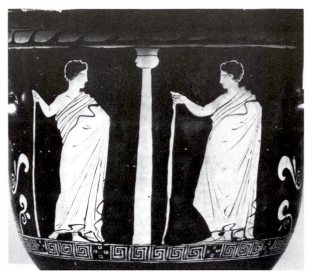

2. B.M. F 166 (4/232)

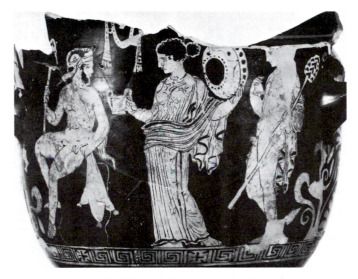

3. Villa Giulia 43995 (4/233)

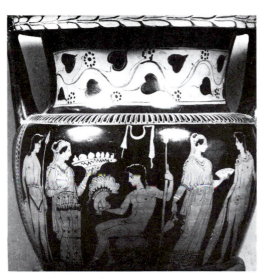

4. Ruvo 1090 (4/240)

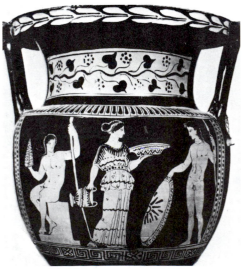

5. Taranto (4/241)

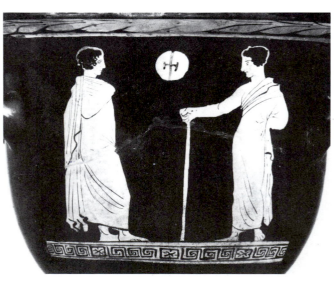

6. Würzburg H 4689 (4/245)

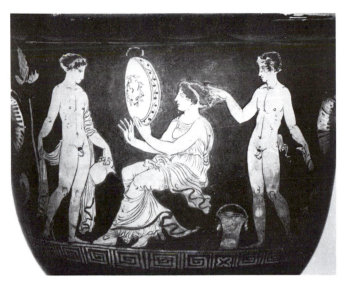

1–2. Mississippi (5/1)

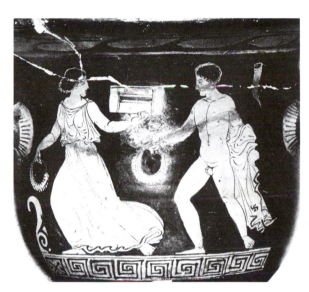
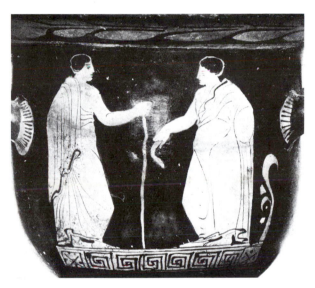

3–4. Naples 2094 (5/5)

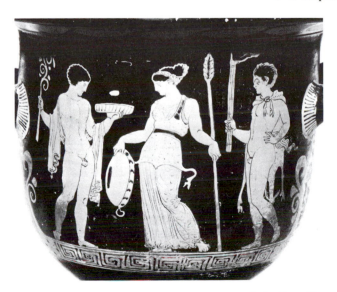
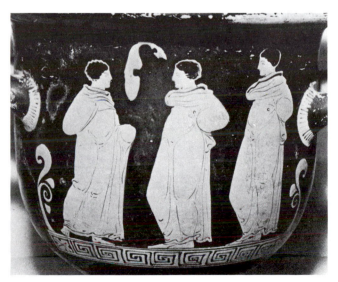

5–6. Once Geneva Market (5/14)

PLATE 36 The Hoppin Painter

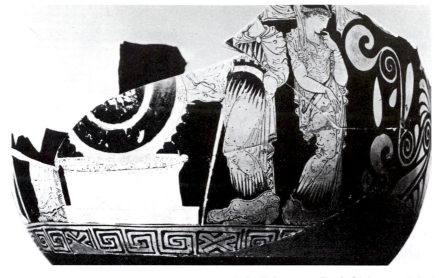

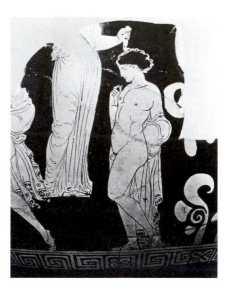

1–2. Princeton, Prof. Clairmont (5/34)

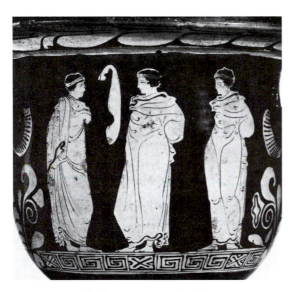

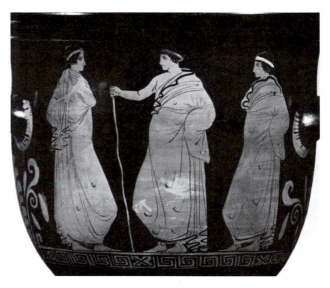

3. Geneva 15020 (5/36) 4. Basel Market, Palladion (5/50)

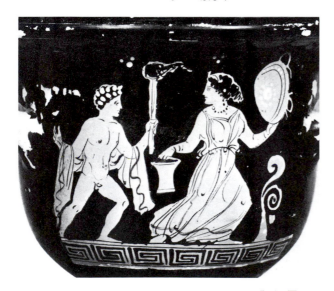

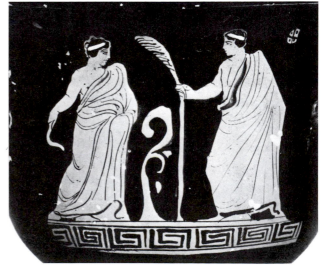

5–6. Taranto 61261 (5/52a)

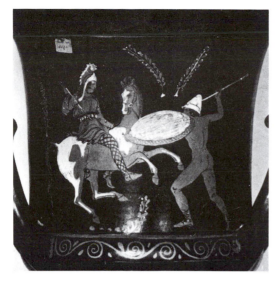
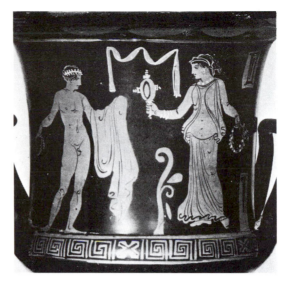

1–2. Bari 4400 (5/53)

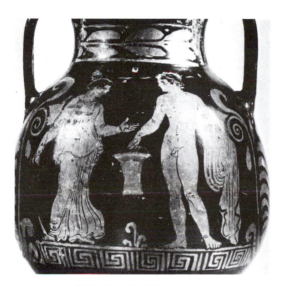
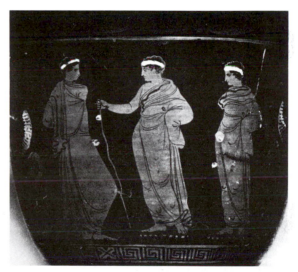

3. Philadelphia MS 4007 (5/54) 4. Lecce 766 (5/57)

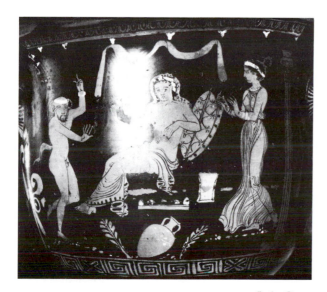
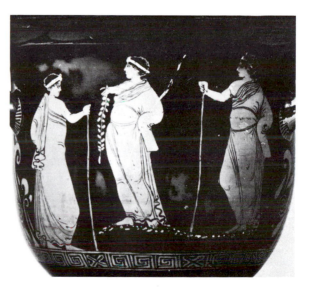

5–6. Geneva 15022 (5/64)

PLATE 38 Associates of the Hoppin Painter

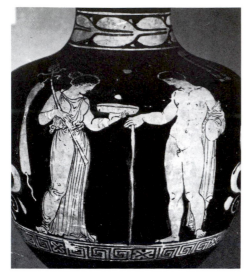

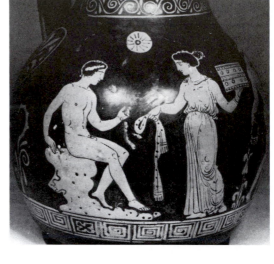

1. B.M. F 362 (5/74)

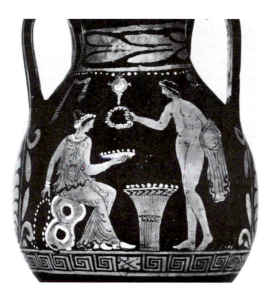

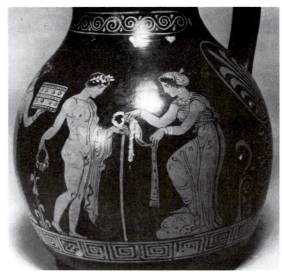

2–3. Once Zurich Market (5/75)

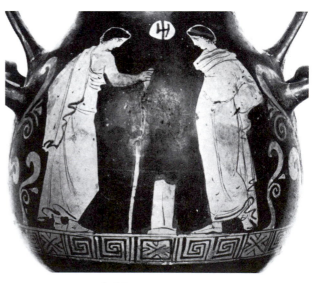

4–5. Chapel Hill, Packard coll. (5/83) 6. Naples 2326 (5/88)

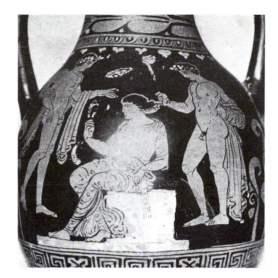

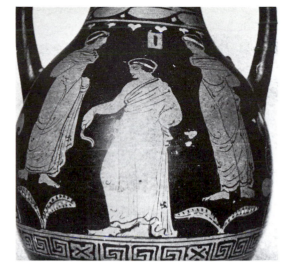

1–2. Naples 1947 (5/100)

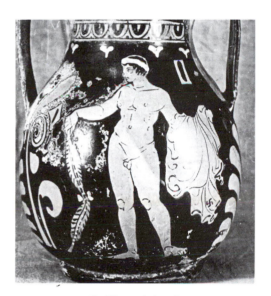

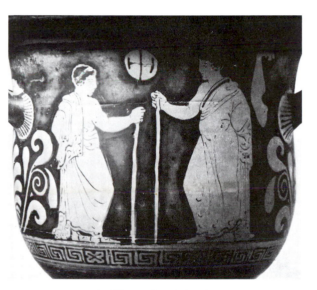

3. Truro (5/103)

4. Vienna 894 (5/125)

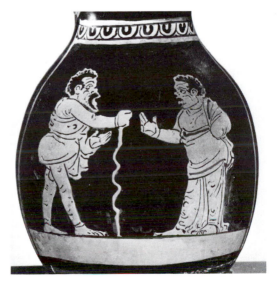

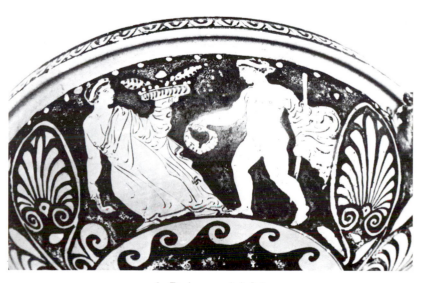

5. Sydney 75.02 (5/141)

6. Bari 21995 (5/185)

PLATE 40 The Lecce Painter

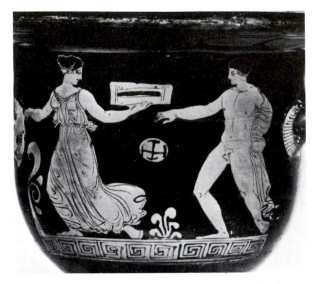

1–2. Geneva 13188 (5/196)

3–4. Oxford 433 (5/198)

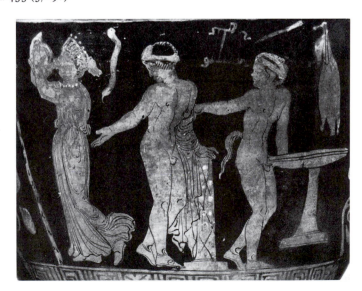

5. B.M. F 168 (5/208) 6. Utrecht 39 (5/209)

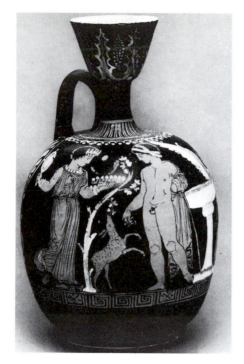
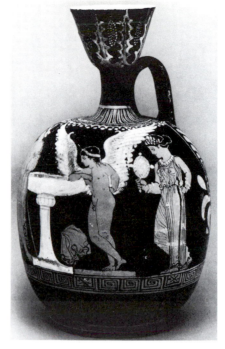

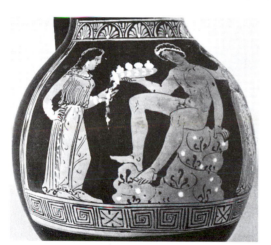
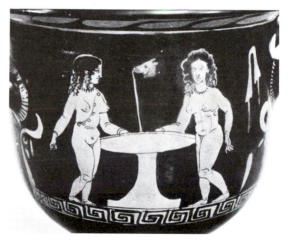

1–2. Swiss Market (5/227)

3. Zurich Market (5/231)

4. Bari, Macinagrossa coll. 16 (5/246)

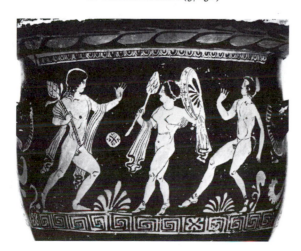
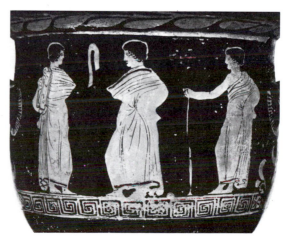

5–6. Florence, priv. coll. 108 (5/245)

PLATE 42　　　　　　　Followers of the Lecce Painter

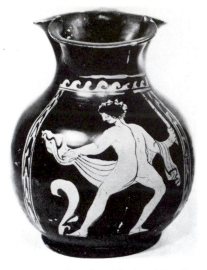

1. Once London Market (5/256)　　　2. London, V. and A. 1776–1919 (5/259)

3–4. Vienna 849 (5/261)

5–6. Munich 2395 (5/269)

1–2. Dresden 376 (5/279)

3–4. Turin, priv. coll. (5/294)

5. Naples 2865 (5/292)

6. Copenhagen 15032 (5/295)

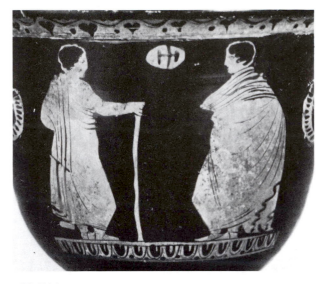

1–2. Naples 2186 (6/2)

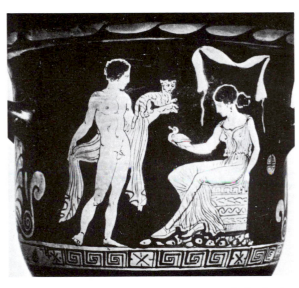
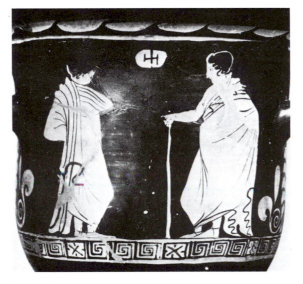

3–4. Agrigento C 1540 (6/9)

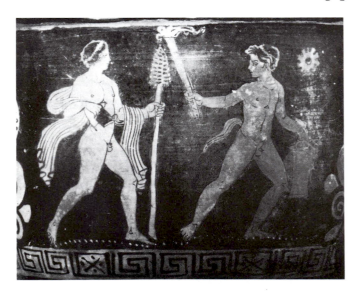

5–6. Erlangen K 86 (6/16)

1–2. Once Rome Market (6/18)

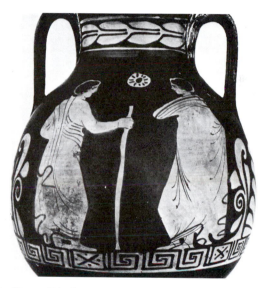

3–4. Karlsruhe B 770 (6/27)

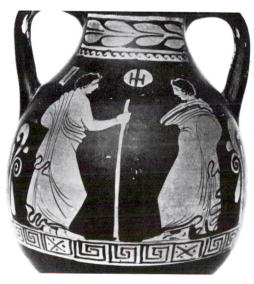

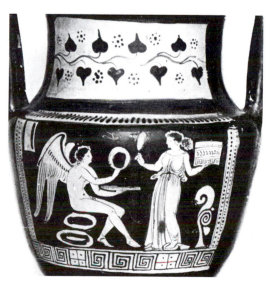

5. Benevento 378 (6/51) 6. Bari 6265 (6/53)

PLATE 46 The Dijon Painter

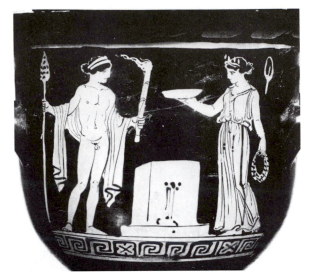

1–2. Taranto 61059 (6/90)

3–4. Sydney 46.03 (6/93)

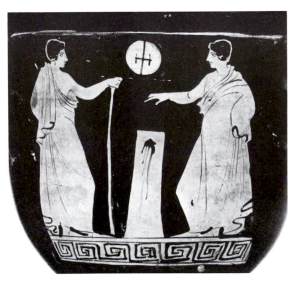

5–6. Los Angeles 62.27.3 (6/103)

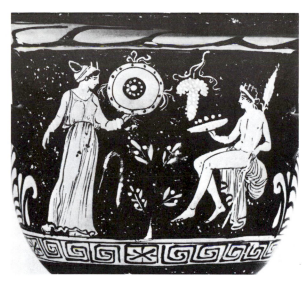
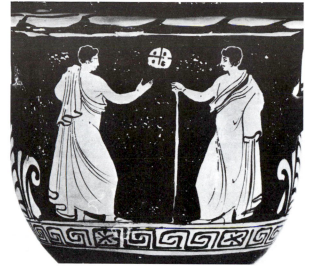

1–2. Matera 9690 (6/107)

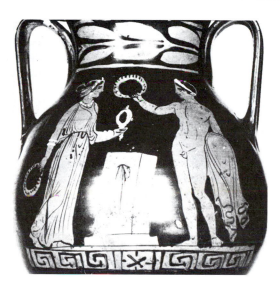

3–4. Bari 6280 (6/118)

5–6. Dresden 527 (6/119)

PLATE 48 The Dijon Painter

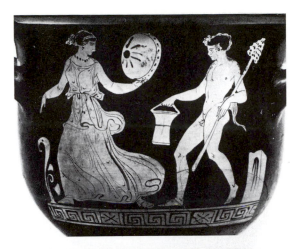

1. B.M. F 316 (6/126)

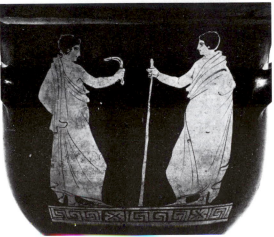

2–3. Matera 12475 (6/133)

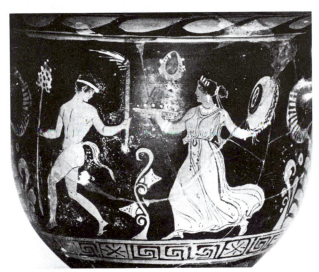

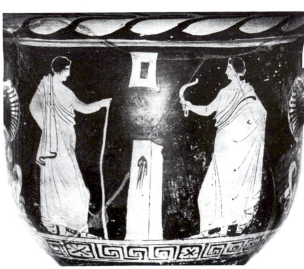

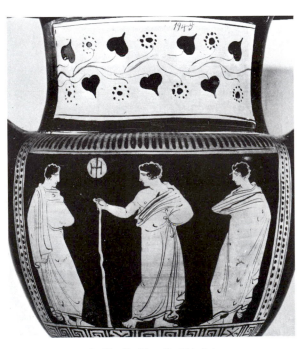

4–5. Naples Stg. 339 (6/139) 6. Berlin F 3289 (6/161)

PLATE 49

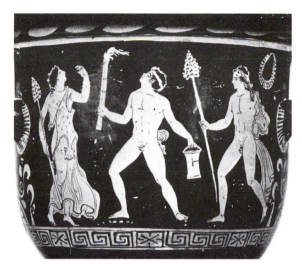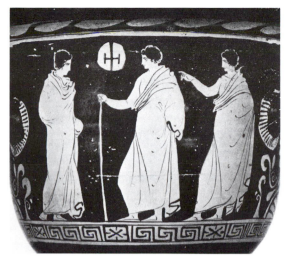

1–2. Naples 2065 (6/155)

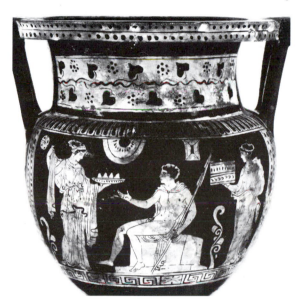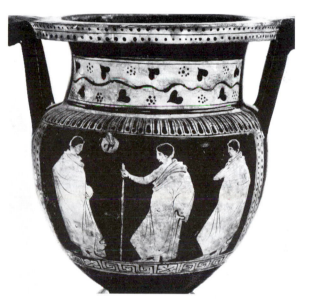

3–4. Gardiner (6/159)

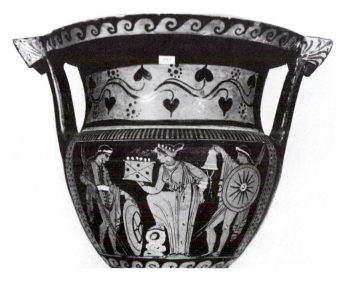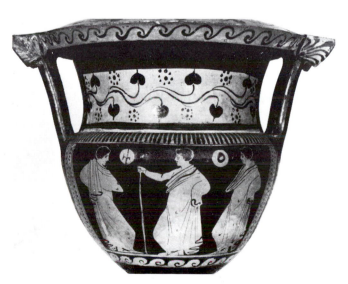

5–6. Ruvo 981 (6/167)

PLATE 50 The Dijon Painter and associates

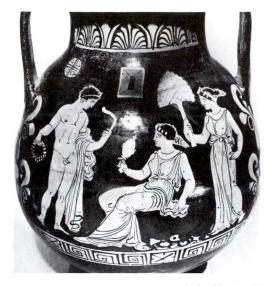
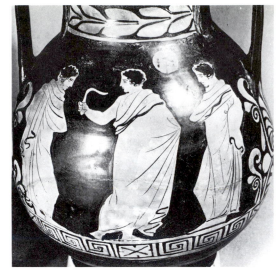

1–2. Venice High School (6/174)

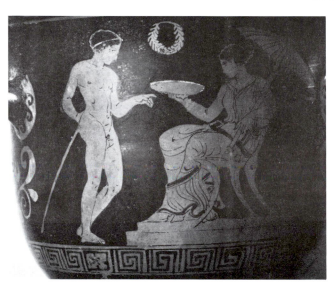
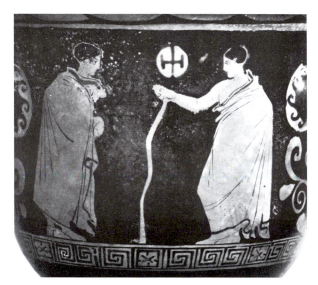

3–4. Vienna 549 (6/176)

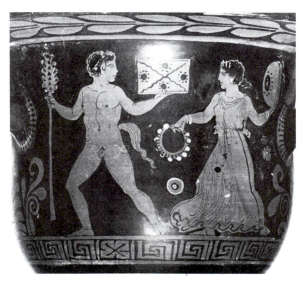
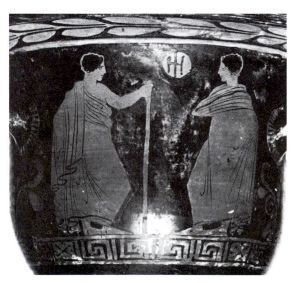

5–6. Altamura 3 (6/179)

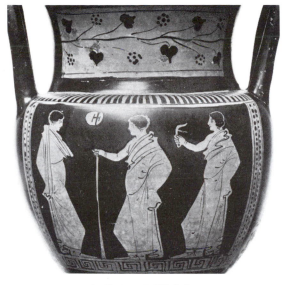
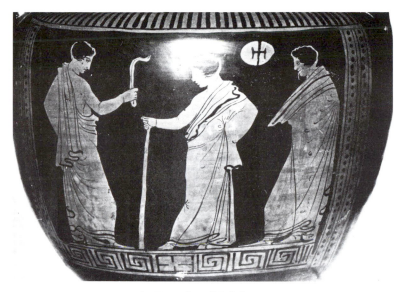

1. Bonn 98 (6/183) 2. Ruvo 892 (6/184)

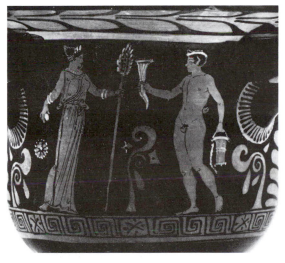

3–4. Milan, 'H.A.' coll. 375 (6/194)

5–6. Bari 1523 (6/197)

PLATE 52 The Graz Group

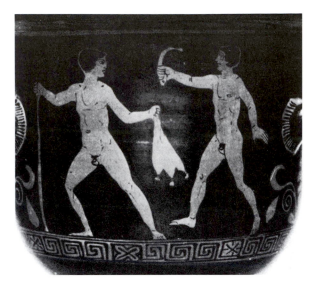

1–2. Bari 6325 (6/212)

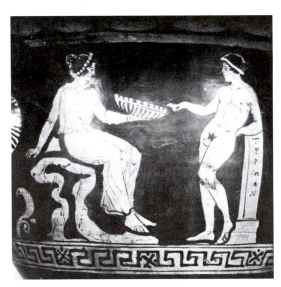
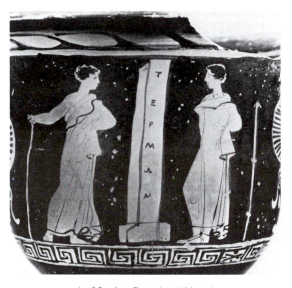

3. B.M. F 62 (6/215) 4. Naples Stg. 657 (6/217)

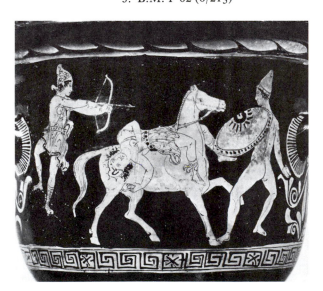
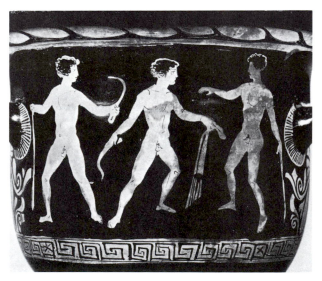

5–6. Naples 2409 (6/219)

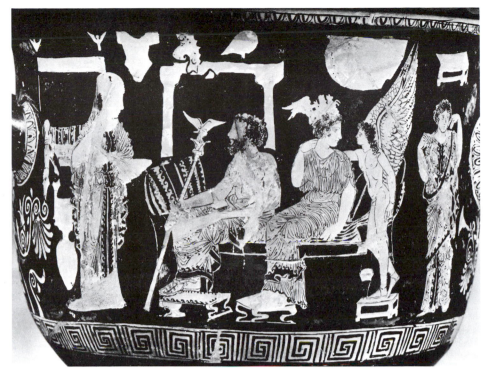

1. New York 16.140, Rogers Fund (7/1)

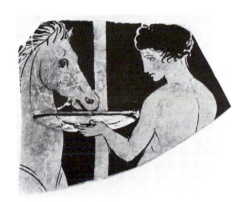

2. Amsterdam 2493 (7/6) 3. Amsterdam 3525A (7/7)

4–5. New York 20.195–6, Rogers Fund (7/8)

PLATE 54 The Black Fury Group

1. Princeton 59.114 (7/9)

2. Boston 13.206 (7/10)

3. Maplewood, Noble coll. (7/14)

4. Toronto 959.17.176 (7/15)

5. Fogg Museum 1952.33 (7/17)

6. Malibu 72 AE 128 (7/12)

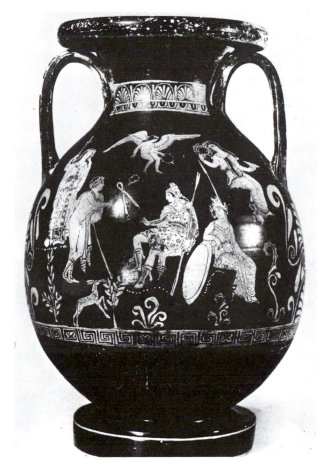

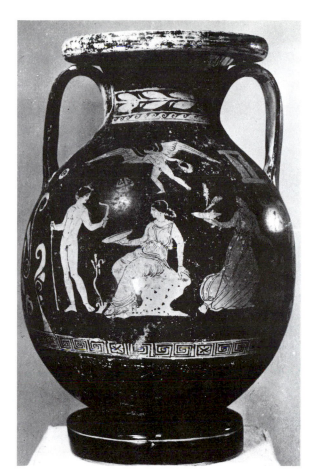

1–2. Moscow 733 (7/30)

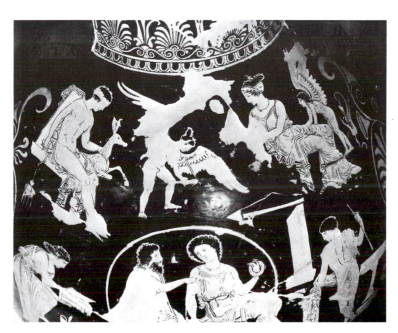

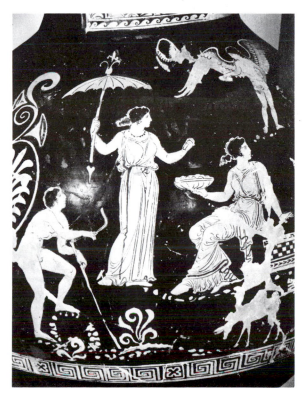

3–4. Zurich 2656 (7/31)

PLATE 56 The Painter of Ruvo 1364 and related vases

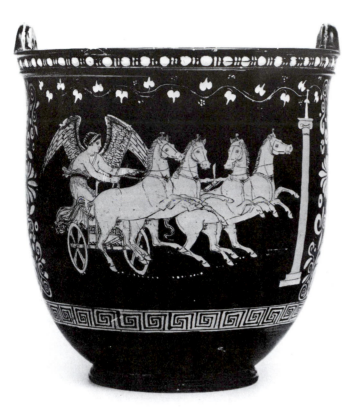
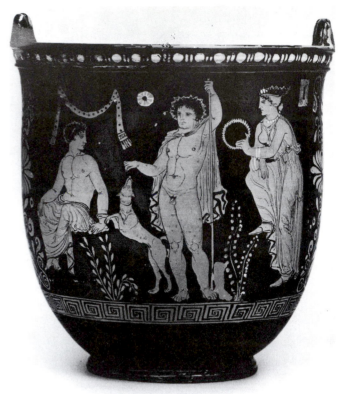

1–2. Swiss Market (7/42)

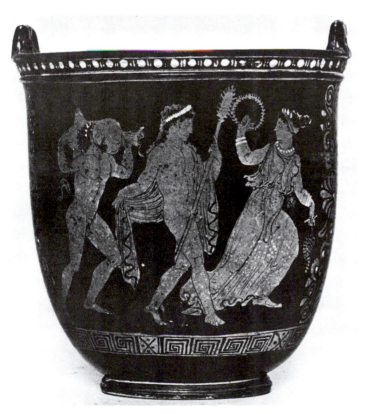
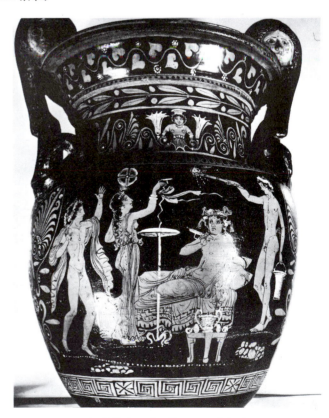

3. Ruvo 1364 (7/41) 4. Edinburgh 1873.21.1 (7/45)

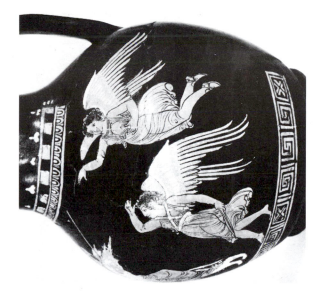

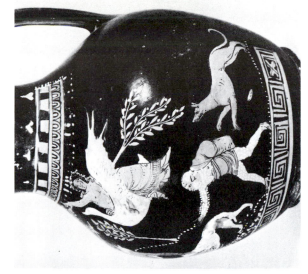

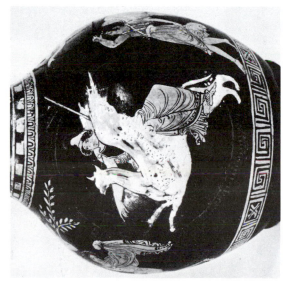

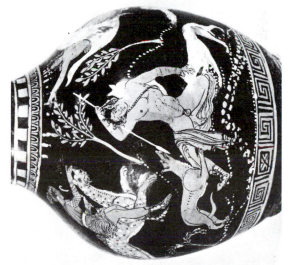

1. Taranto (Orestes) (7/62)

2. Taranto (Actaeon) (7/63)

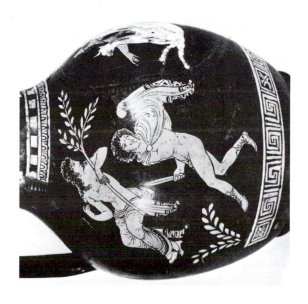

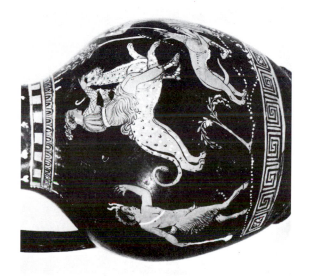

PLATE 58 The Felton Painter

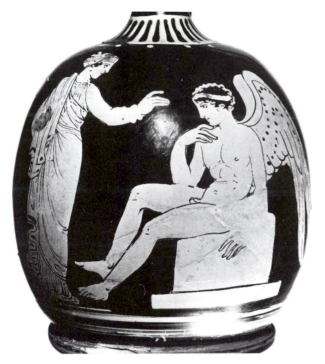

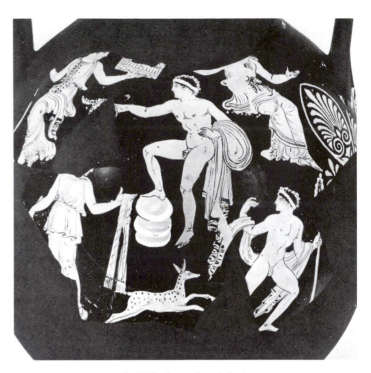

1. Oxford 1919.24 (7/69)

2. Würzburg 855 (7/70)

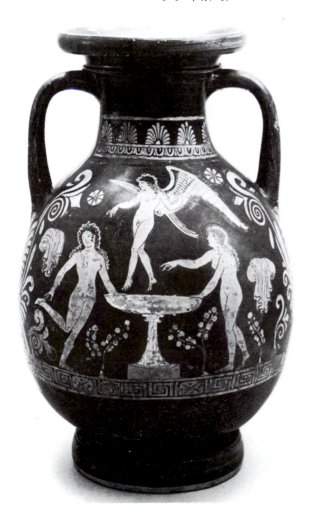

4. Naples Stg. 454 (7/74)

3. Minnesota 73.10.14 (7/71)

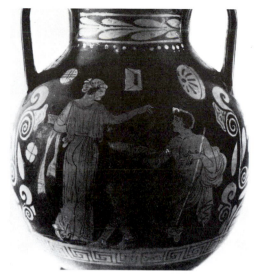

1. Milan, 'H.A.' coll. 241 (7/106)

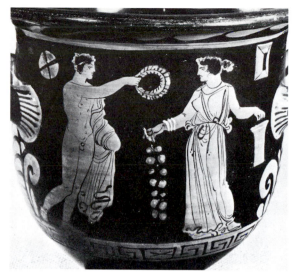

2. York 21 (7/107)

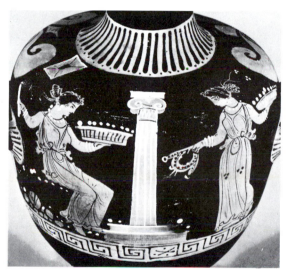

3. Geneva MF 242 (7/108)

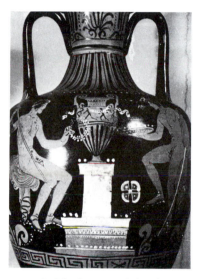

4. Naples 2253 (7/109)

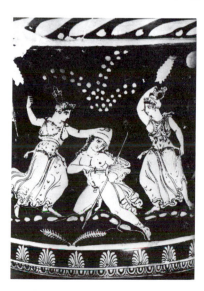

5. Ferrara T. 476 B (7/111)

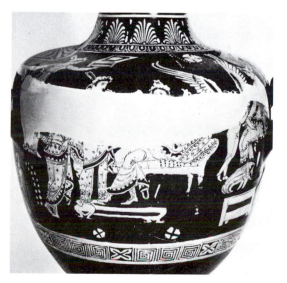

6. Taranto, Baisi coll. 41 (7/112)

PLATE 60 The Iliupersis Painter

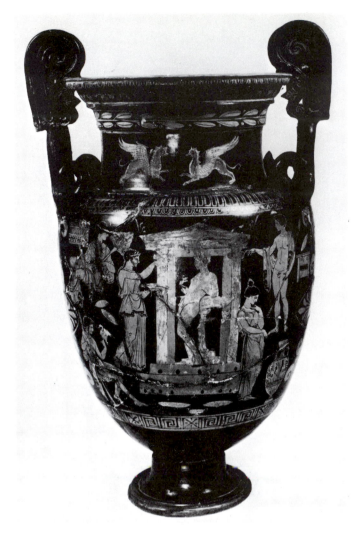

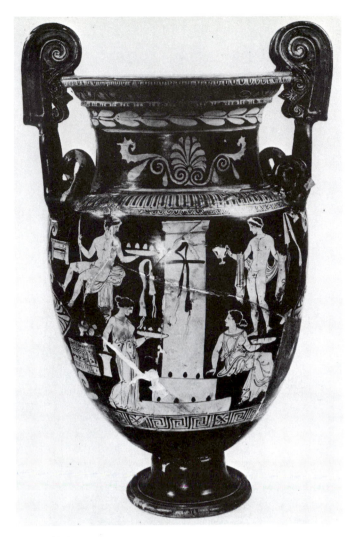

1–2. Leningrad 577 (8/1)

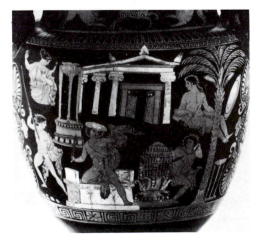

3. Milan, 'H.A.' coll. 239 (8/4)

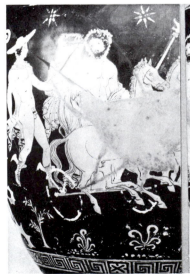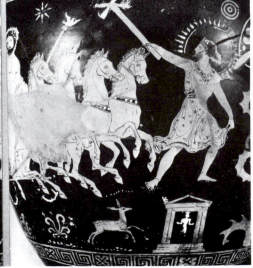

4. B.M. F 277 (8/5)

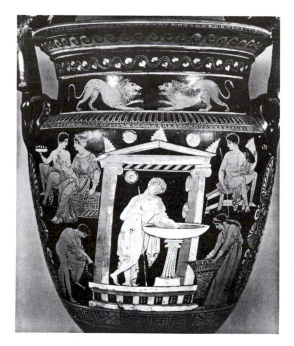
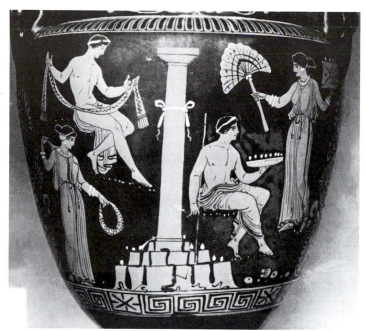

1–2. B.M. F 283 (8/7)

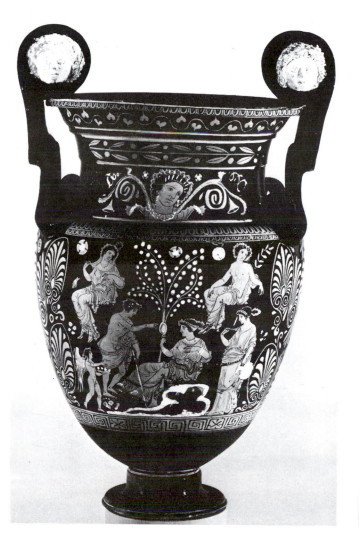
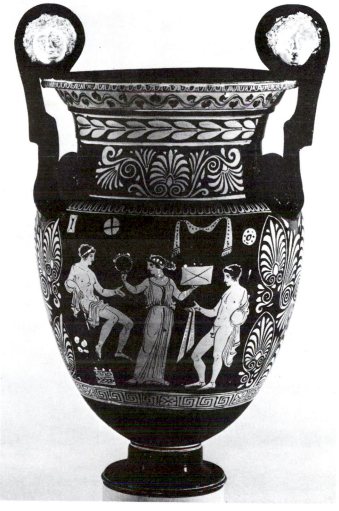

3–4. Boston 1970.235 (8/11)

PLATE 62 The Iliupersis Painter

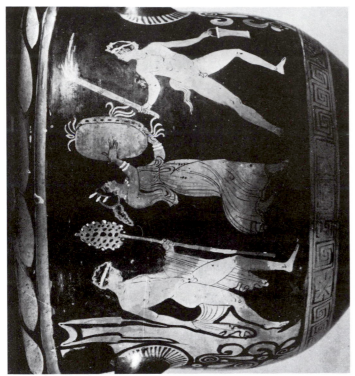

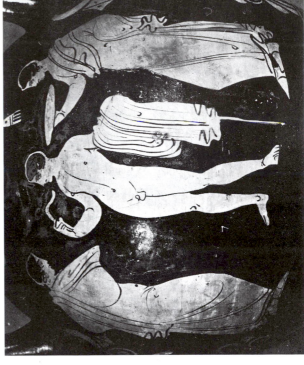

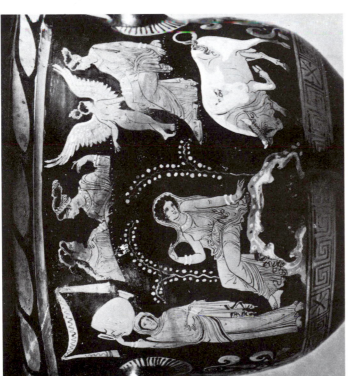

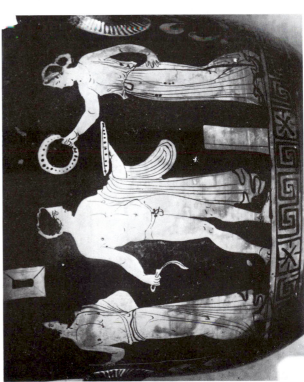

1–2. Louvre K 3 (8/17)

4. B.M. F 324 (8/25)

3. B.M. F 66 (8/18)

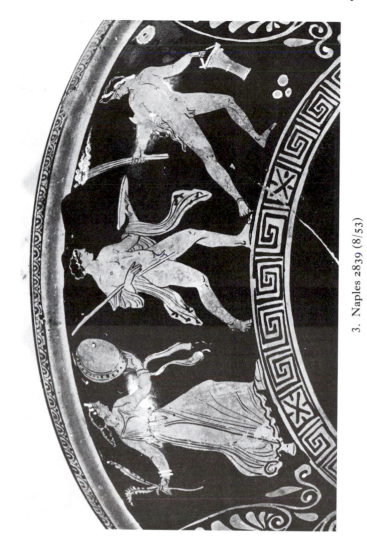

3. Naples 2839 (8/53)

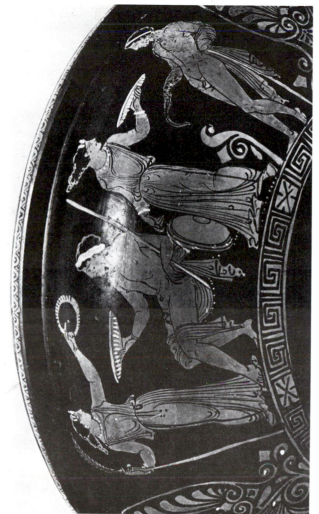

4. Ruvo 727 (8/57)

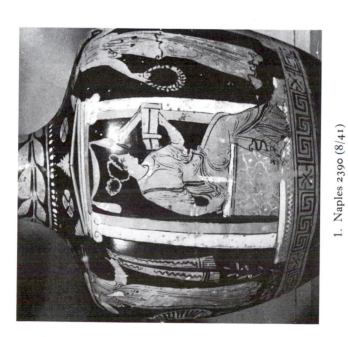

1. Naples 2390 (8/41)

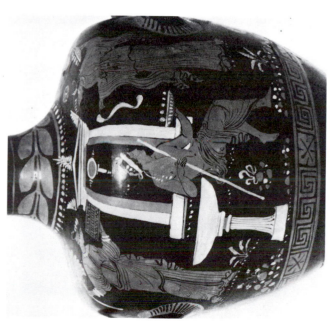

2. Once London Market (8/43)

PLATE 64 The Iliupersis Painter

1. B.M. F 461 (8/60)

3. Ruvo 1618 (8/67)

2. Once Zurich, Bank Leu (8/61)

4–5. Taranto, Baisi coll. 38 (8/72)

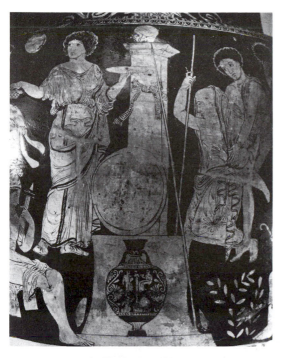

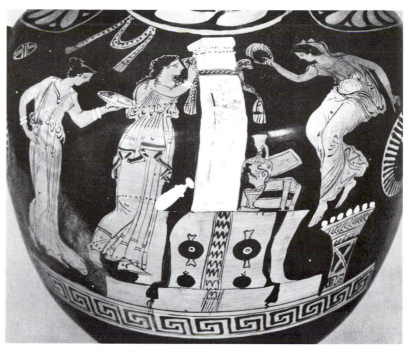

1. Bari 1394 (8/101)

2. New York 56.171.65, Fletcher Fund (8/114)

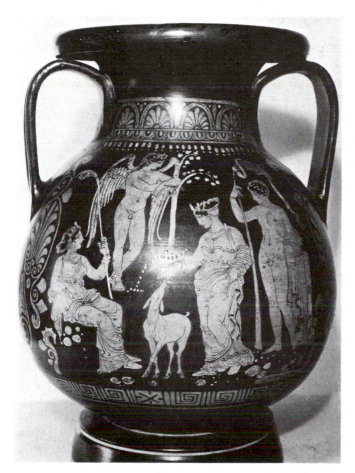

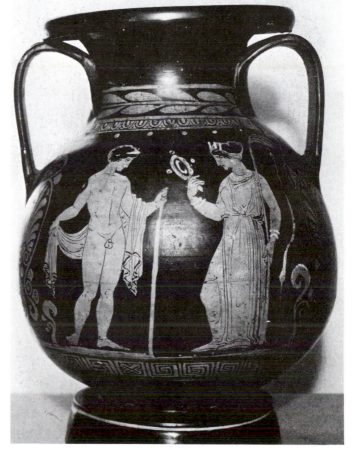

3–4. Vienna 4013 (8/122)

PLATE 66 Associated with the Iliupersis Painter

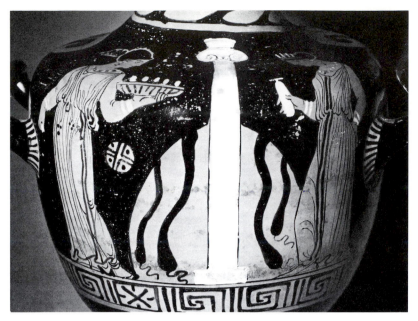

1. Vienna 532 (8/116)

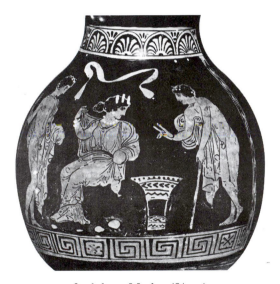

2. Athens Market (8/129)

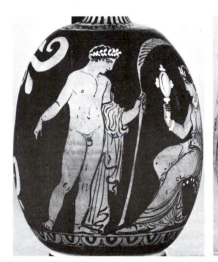

4(*a,b*). Zurich Market (8/131)

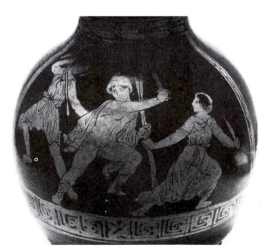

3. Sydney 73.02 (8/138)

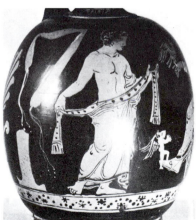

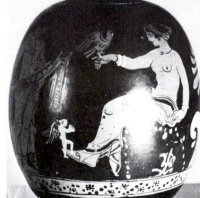

5(*a,b*). Basel 1921.386 (8/132)

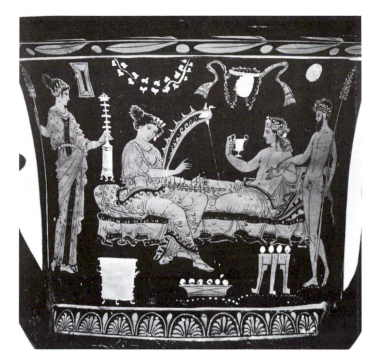
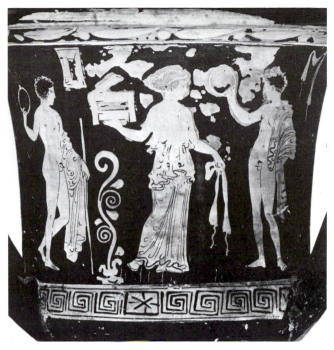

1–2. New York L. 63.21.6 (8/152)

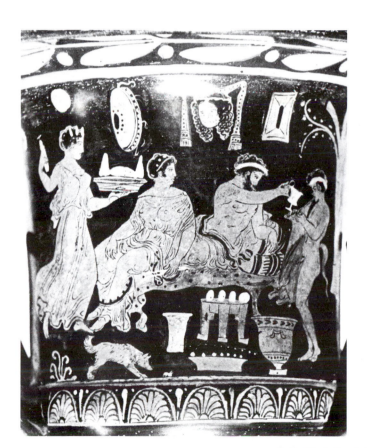
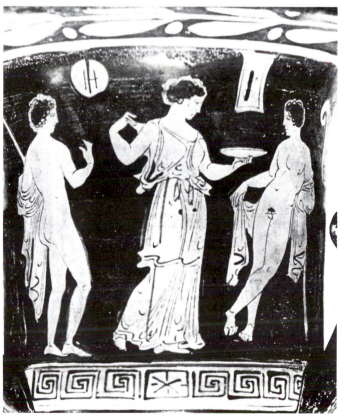

3–4. Bari, Lagioia coll. (8/153)

PLATE 68 The Painter of Athens 1714

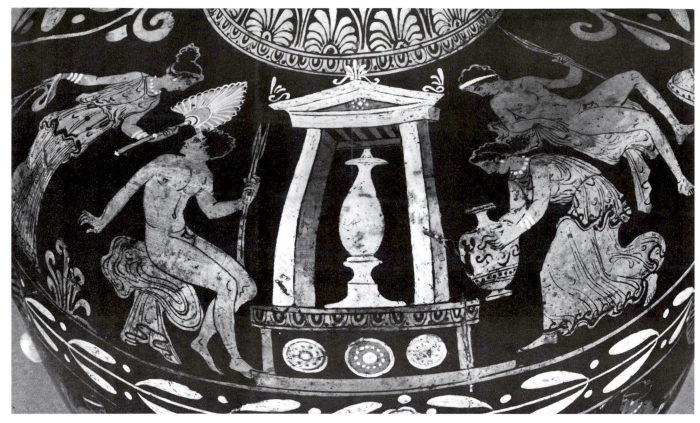

1. Paris, Cab. Méd. 980 (8/169)

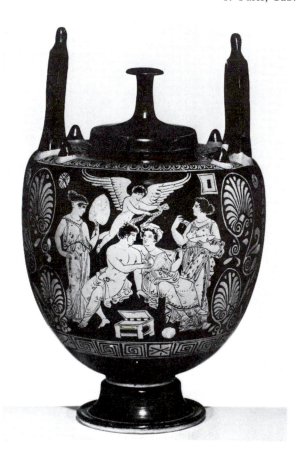
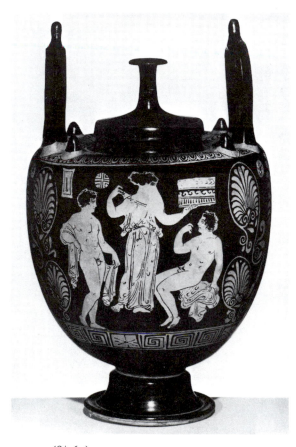

2–3. Basel, Antikenmuseum (8/162)

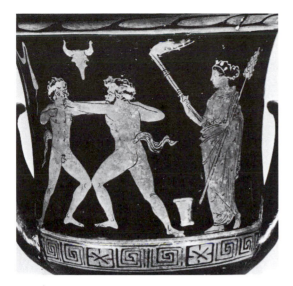

1–2. Charlecote Park 11 (8/156)

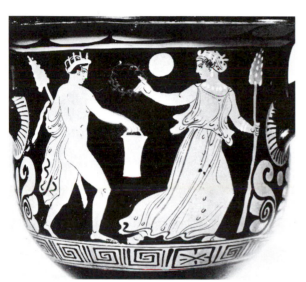
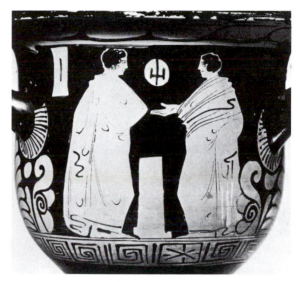

3–4. Parma C 97 (8/206)

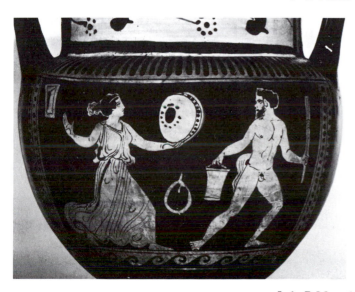
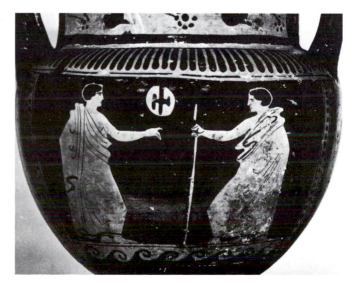

5–6. B.M. 1969.1–14.1 (8/227)

PLATE 70 The Group of Vatican V 14

1–2. Once Zurich Market (9/1)

3–4. Paris, Cab. Méd. 930 (9/2).

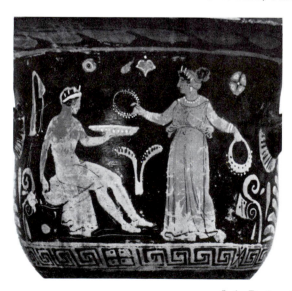
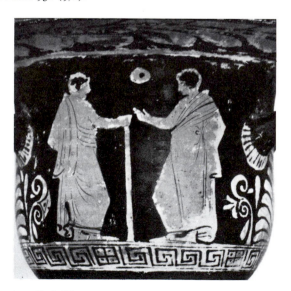

5–6. Bari, private coll. (9/6)

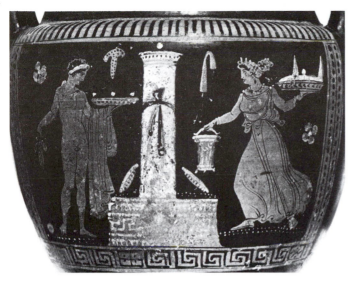
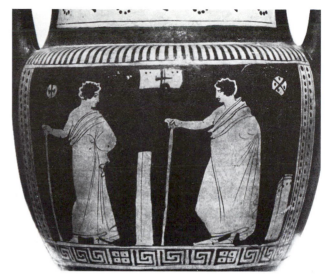

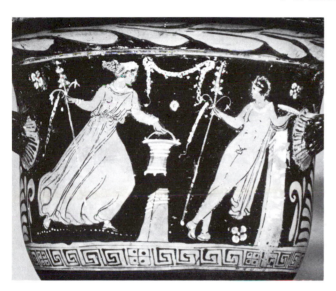

3–4. Paris, Cab. Méd. 938 (9/24)

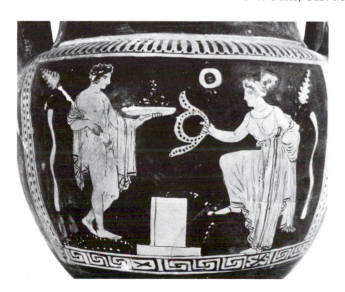

5–6. Bari 12066 (9/27)

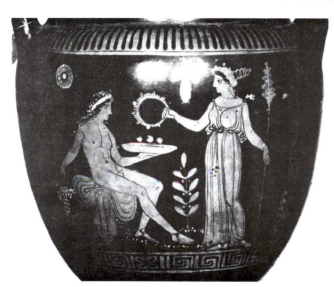

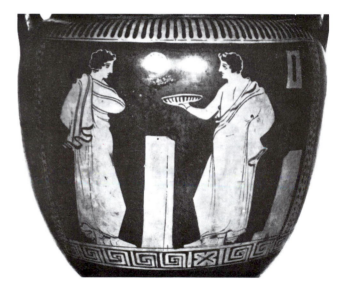

1–2. Geneva 2754 (9/38)

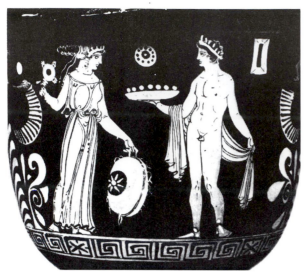

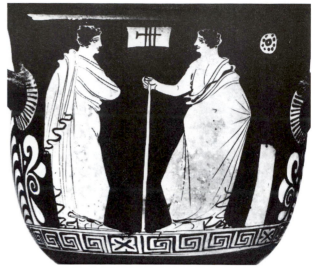

3–4. Madrid 32654 (9/42)

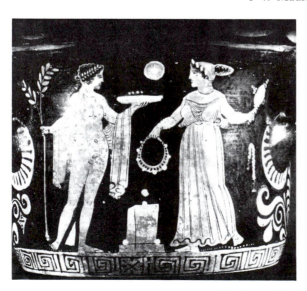

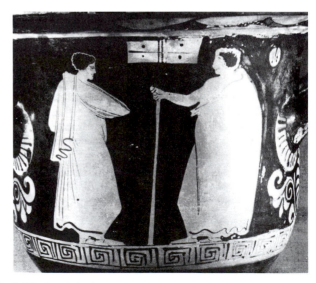

5–6. Once New York Market (9/53)

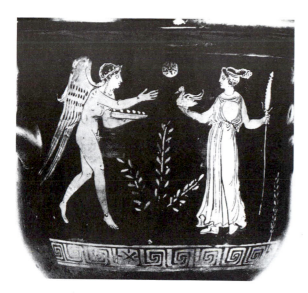
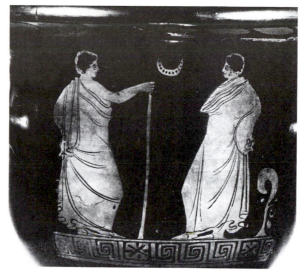

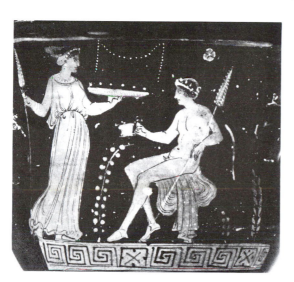
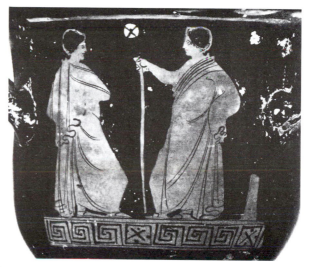

1–2. Sydney 68 (9/55)

3–4. Los Angeles 62.27.2 (9/56)

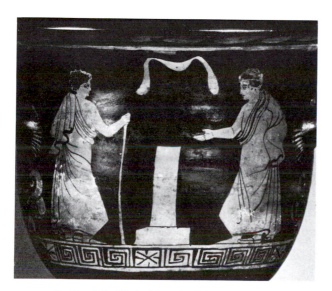
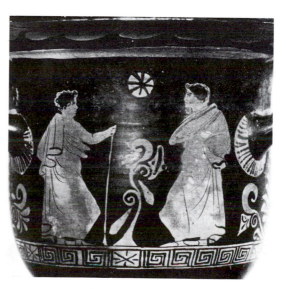

5. Norfolk (Va.), Chrysler Museum (9/59) 6. Lecce 779 (9/60)

PLATE 74 The Chrysler Group

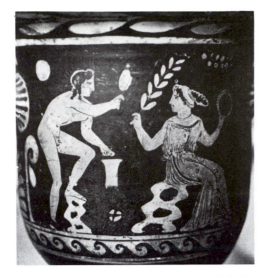
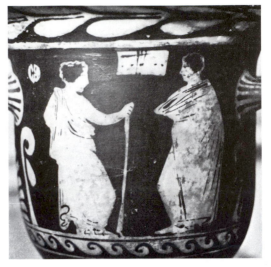

1–2. Louvre K 12 (9/63)

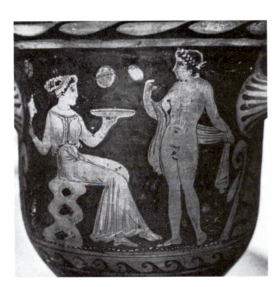
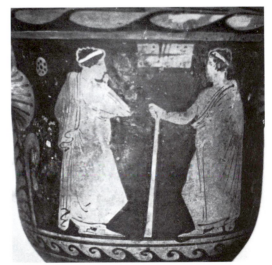

3–4. Louvre K 133 (9/64)

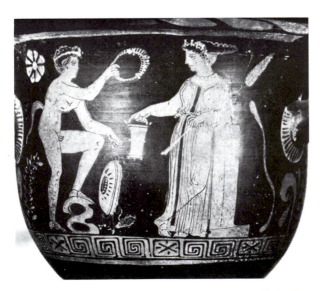
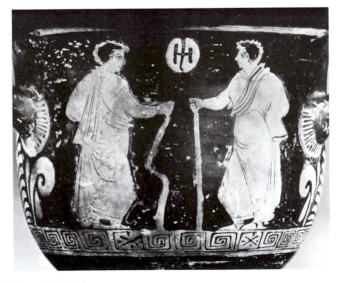

5–6. Brussels A 3378 (9/69)

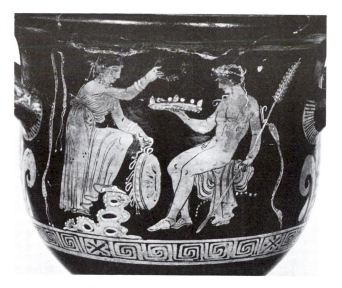
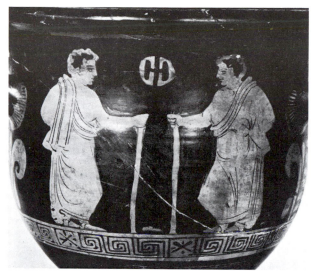

1–2. Dayton R. 101.1 (9/70)

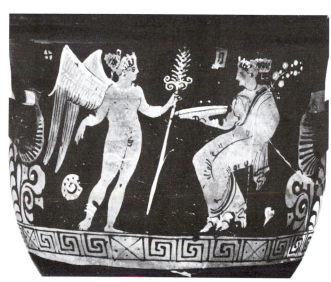
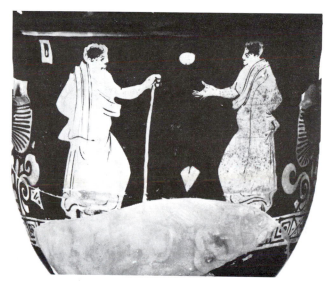

3–4. Geneva 13108 (9/71)

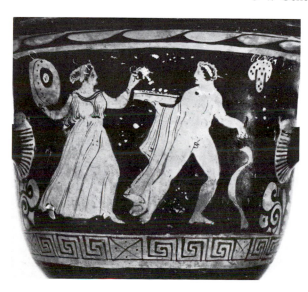
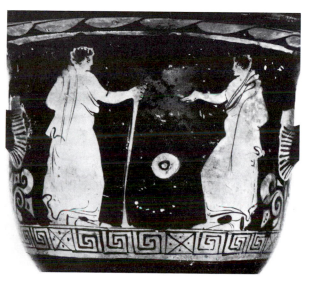

5–6. Reading 161.51 RM (9/73)

PLATE 76 The Haverford Group

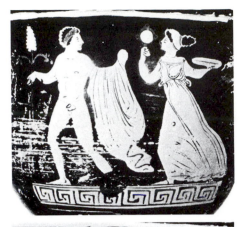
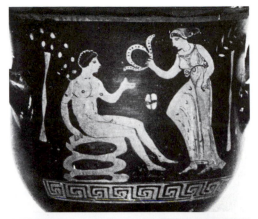

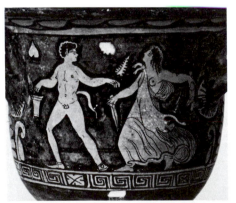
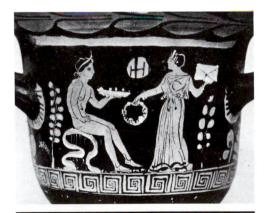

1–2. Haverford 1 (9/77) 3–4. Bari 6338 (9/78)

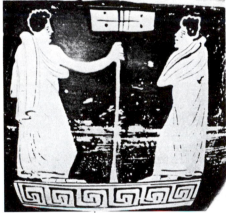
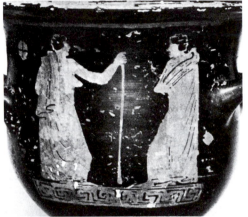

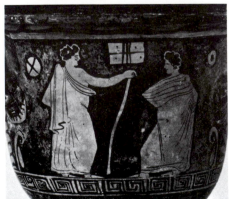
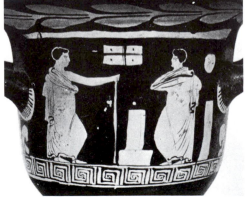

5–6. Naples 2013 (9/83) 7–8. Bari 6329 (9/87)

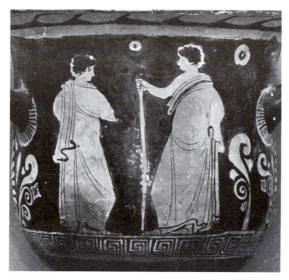

1. Avignon 112 A (9/99)

2. Hobart 25 (9/100)

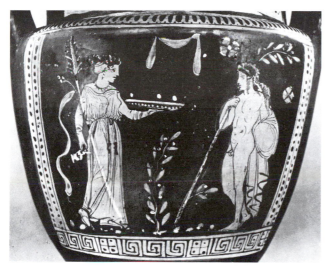

3–4. Vatican X 4 (9/103)

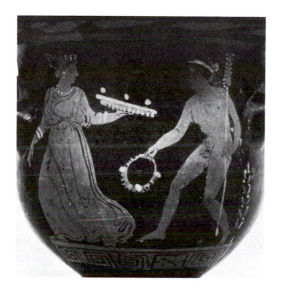

5–6. Salerno 163 (9/105)

PLATE 78 The Painter of Athens 1680

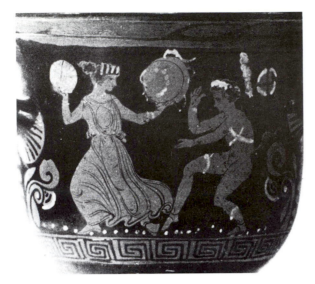

1–2. Taranto 8109 (9/116)

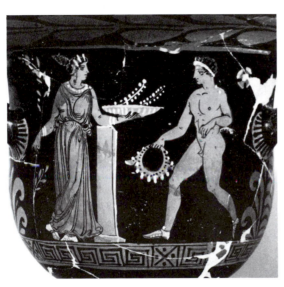
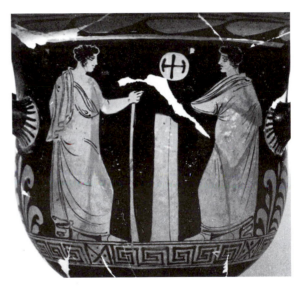

3–4. Once Frankfurt Market (9/122)

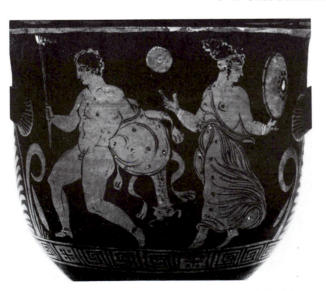
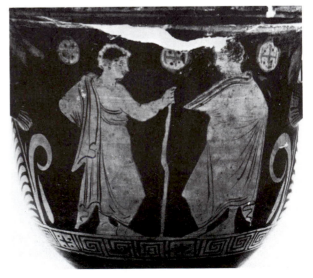

5–6. Matera 156619 (9/124)

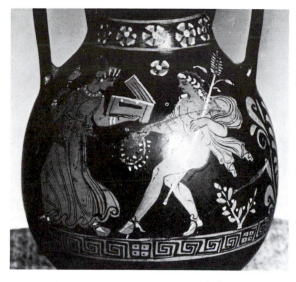
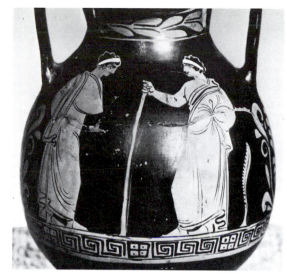

1–2. Neath, Dr. Elis Jenkins (9/129)

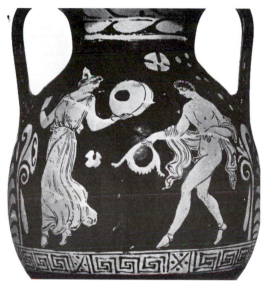
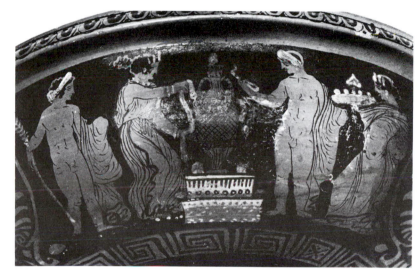

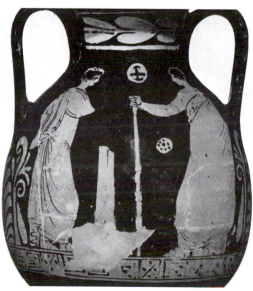
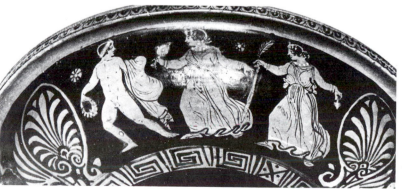

5–6. Bari 6455 (9/151)

3–4. Basel Market, MuM (9/131)

PLATE 80 The Schlaepfer Group

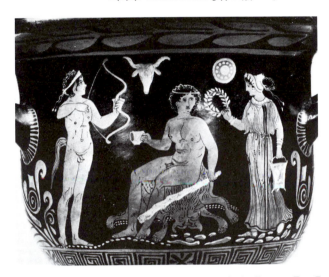

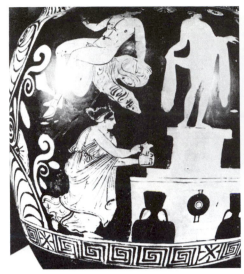

1(*a,b*). Amsterdam 3478 (9/160)

2. Harrow (9/162)

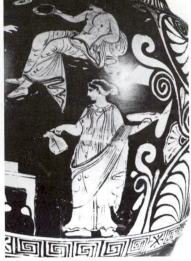

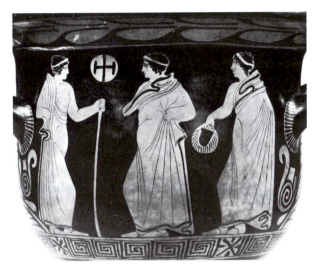

3–4. Berne, Dr. R. Schlaepfer (9/165)

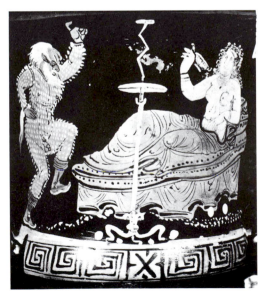

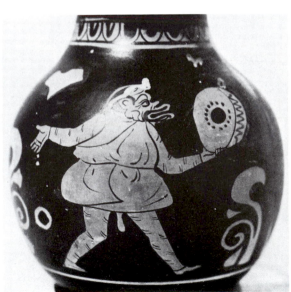

5. B.M. F 273 (9/171)

6. Taranto, Ragusa coll. 123 (9/174)

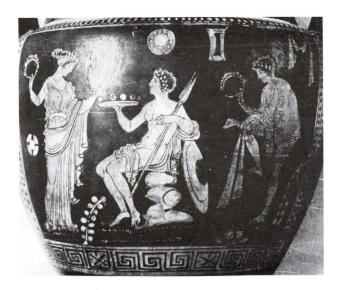
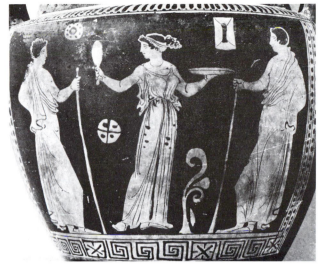

1–2. Montpellier 837-1-1116 (9/178)

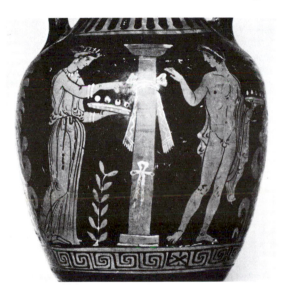
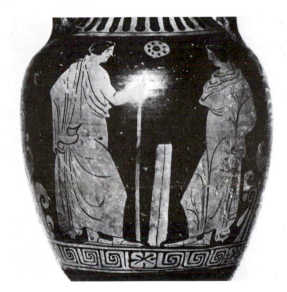

3–4. Ruvo 886 (9/181)

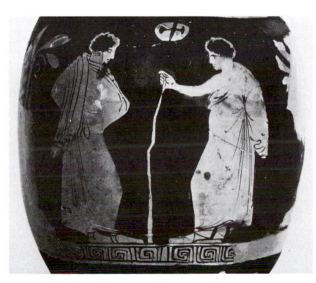
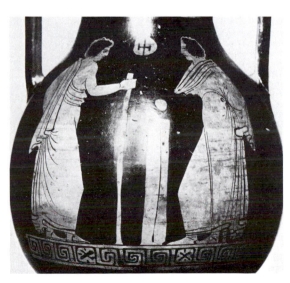

5. Taranto, Baisi coll. 40 (9/184) 6. Leningrad 529 (9/186)

PLATE 82 The Maplewood Painter

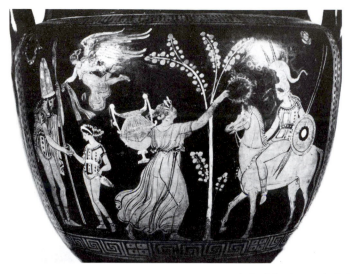
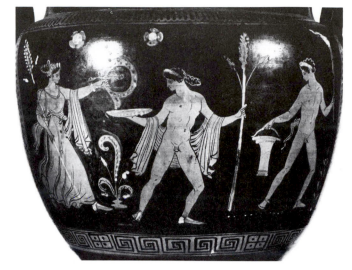

1–2. Maplewood, J. V. Noble coll. (9/187)

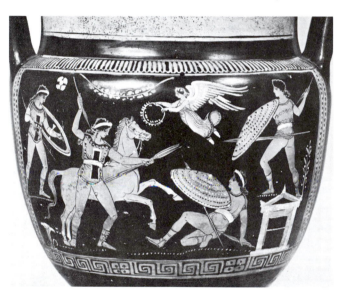
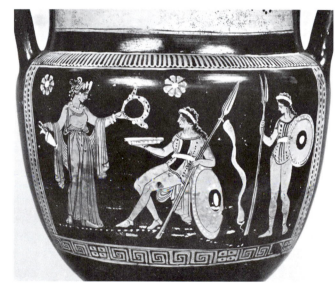

3–4. Once Milan Market, Finarte (9/188)

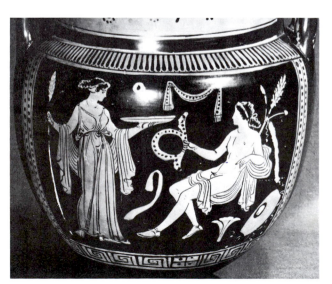
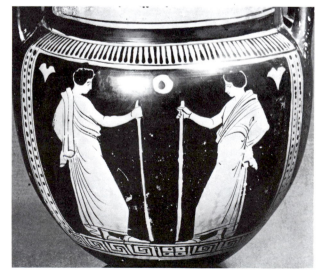

5–6. Edinburgh 1956.461 (9/194)

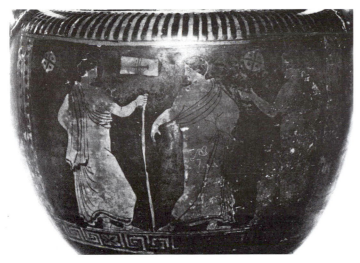

1. Bari 1366 (9/205)

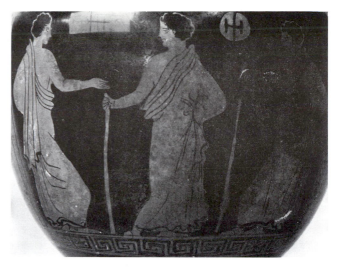

2. New York 96.18.42 (9/206)

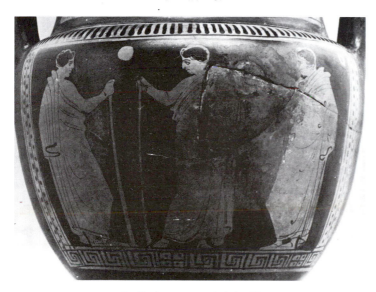

3. Budapest 57.5A (9/208)

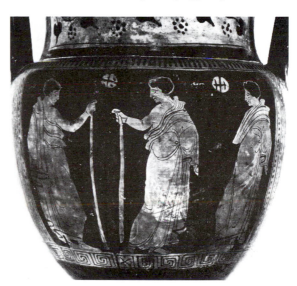

4. Louvre N 2623 (9/209)

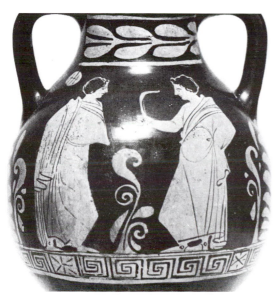

5. Bari, Lagioia coll. (9/211)

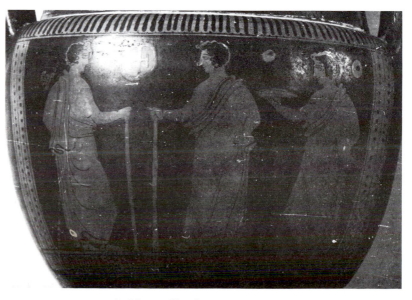

6. Montpellier 837-1-1117 (9/213)

PLATE 84 The Verona Painter

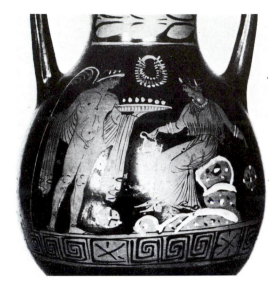
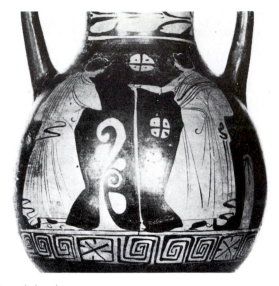

1–2. Bari 6274 (9/222)

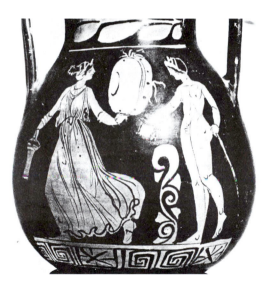
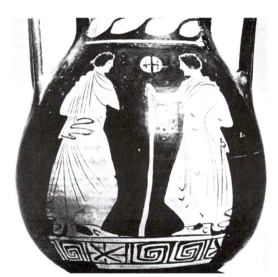

3–4. Bari, Lagioia coll. (9/224)

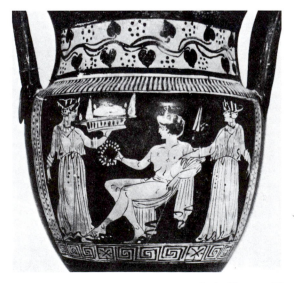
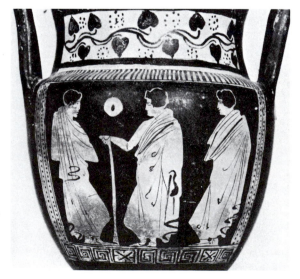

5–6. Nocera, Fienga coll. 565 (9/231)

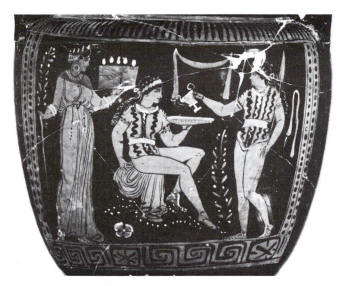
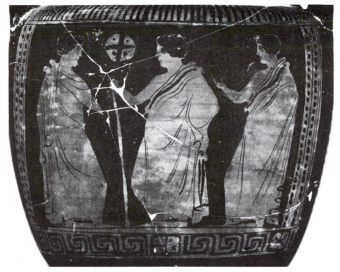

1–2. New York 1974.23 (Rockefeller Gift) (9/245)

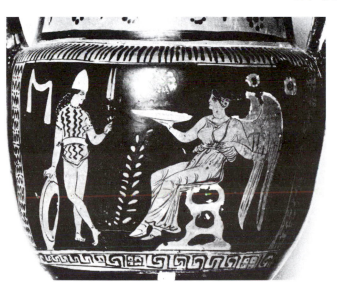
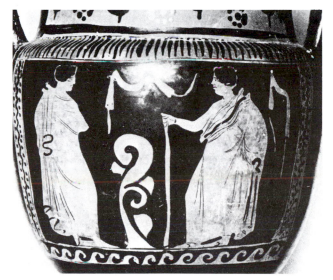

3–4. Naples 2323 (9/247)

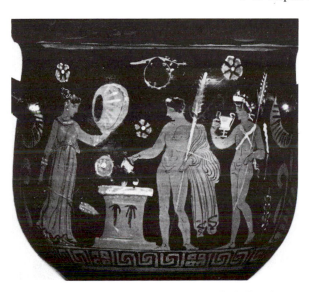
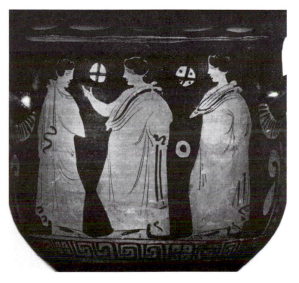

5–6. Basel Market, MuM (9/249)

PLATE 86 The Judgement Painter

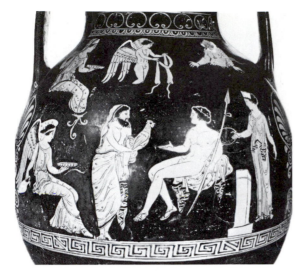
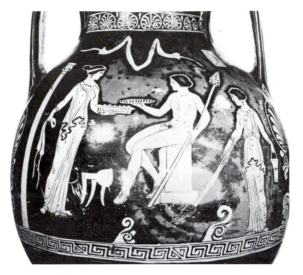

1–2. Taranto 117503 (10/18)

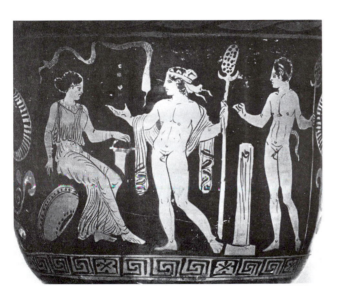
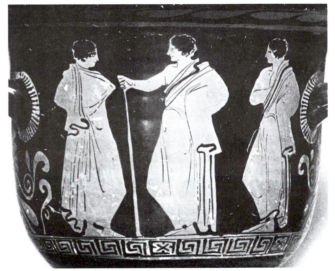

3–4. Ruvo 637 (10/22)

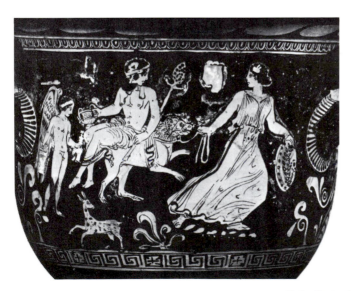
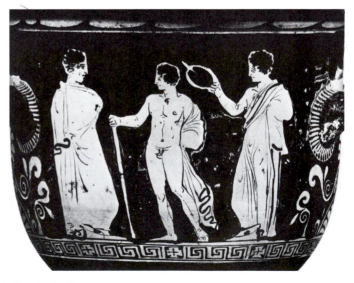

5–6. Swiss Market (10/23)

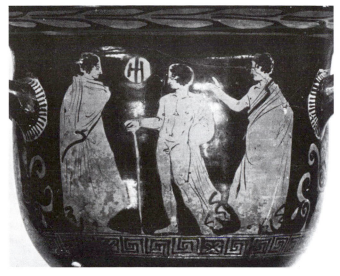

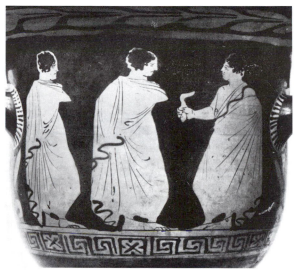

1. Bari 6332 (10/24)

2. Leningrad 1165 (10/25)

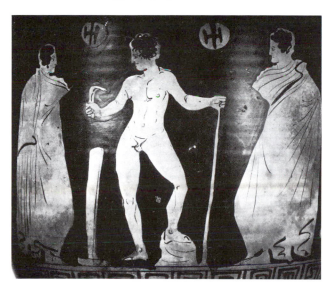

3. B.M. F 167 (10/26)

4. Bourges D 863.1.60 (10/29)

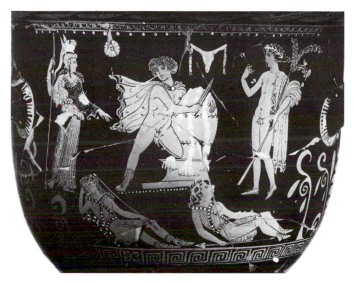

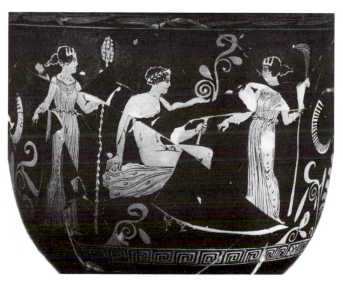

5–6. Boston 1976.144, Frederick L. Brown Fund (10/33)

PLATE 88 The Judgement Group

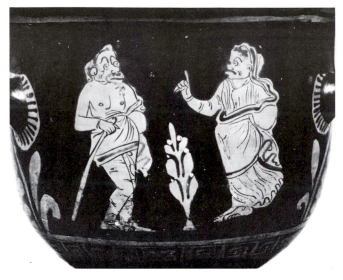

1–2. Vienna 466 (10/36)

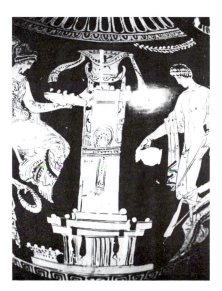
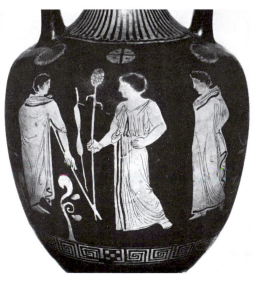

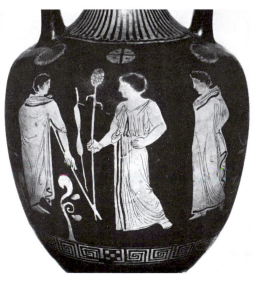
3. Naples 2289 (10/40)

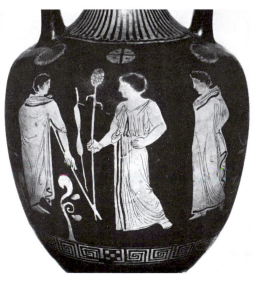
4. Copenhagen, Thorwaldsen 130 (10/41)

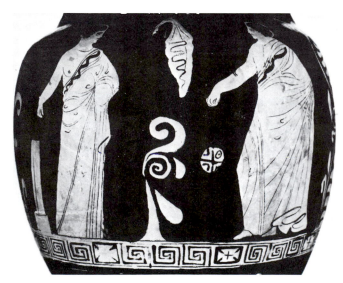
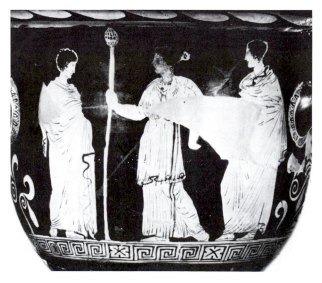

5. Andover 177 (10/42)

6. Barl 8014 (10/45)

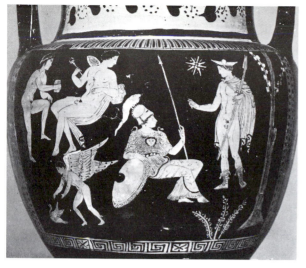

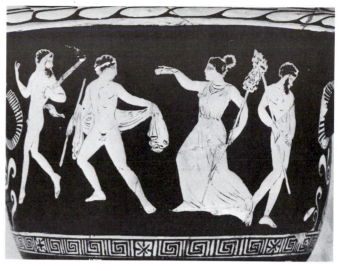

1. New York 50.11.4, Rogers Fund (10/47)

2. Boston 00.348 (10/48)

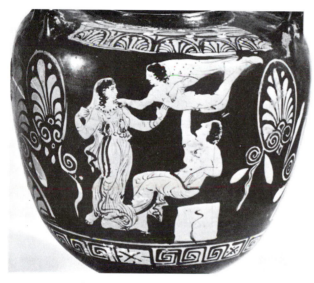

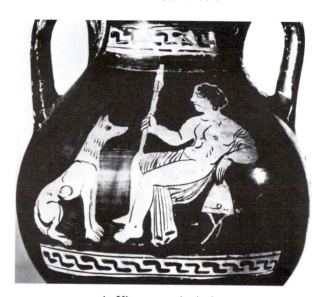

3. Once Signorelli 231 (10/52)

4. Vienna 903 (10/59)

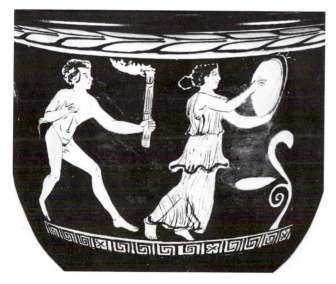

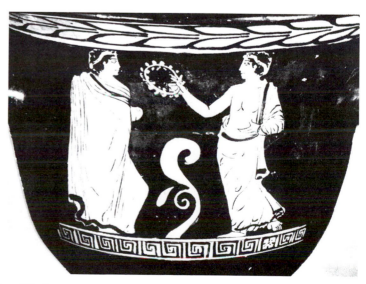

5–6. Amsterdam Market (10/61)

PLATE 90 The Dechter Group

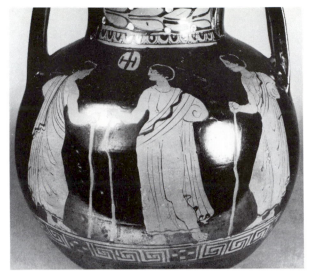

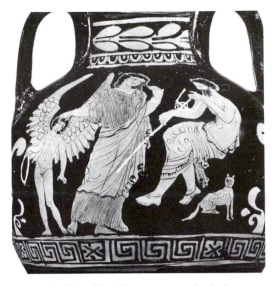

1. Los Angeles, Dechter coll. (10/70)

2. New York L. 1972.30.1 (10/72)

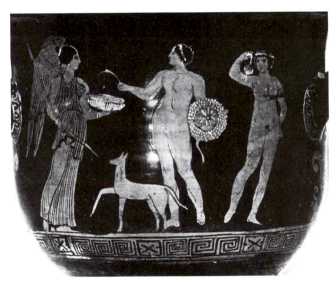

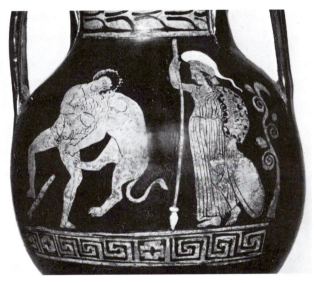

3. Ruvo 1050 (10/76)

4. Vienna 690 (10/81)

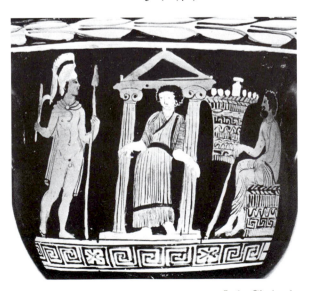

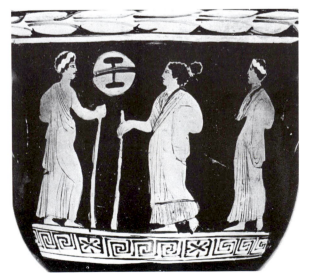

5–6. Christchurch 116/71 (10/83)

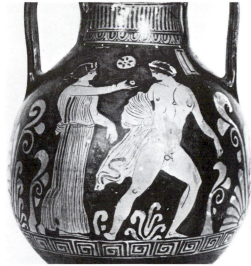

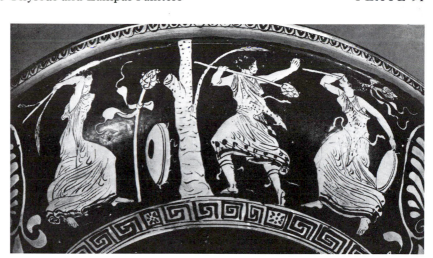

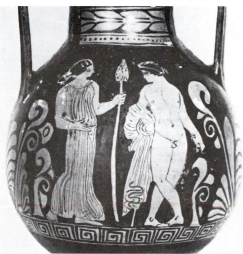

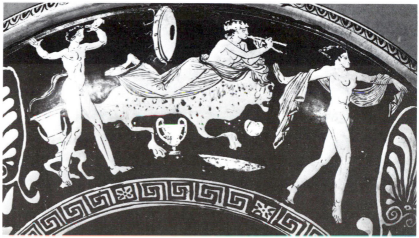

3–4. B.M. F 133 (10/190)

1–2. Taranto, Baisi coll. 43 = T. 18 (10/92)

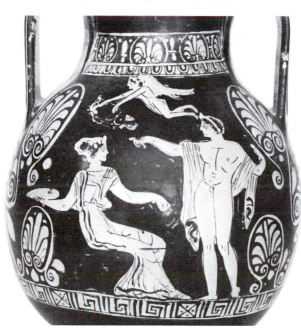

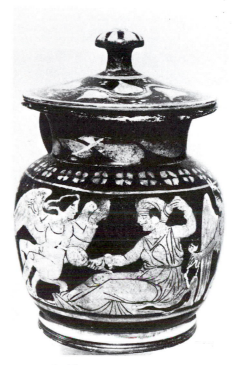

5. Once London Market (10/191) 6. Taranto 8883 (10/213)

PLATE 92 The Zaandam Group

1–2. Zaandam, private coll. (11/1)

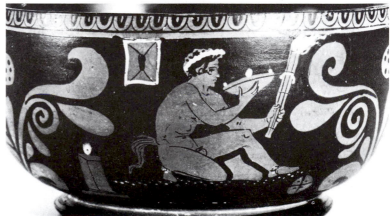

3–4. Zagreb 42 (11/11)

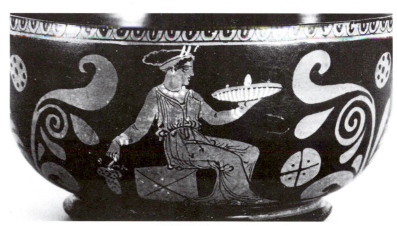

5–6. Once Milan Market (11/14) 7–8. North German private coll. (11/19)

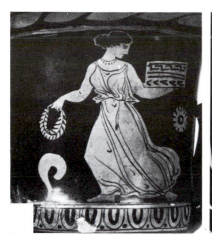
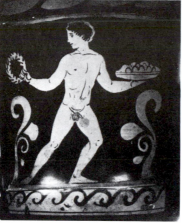
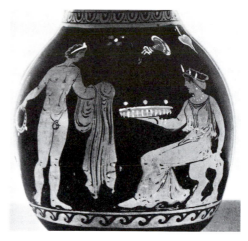

1–2. Melbourne, Monash University 127/69/73) (11/33) 3. Zurich Market (11/44)

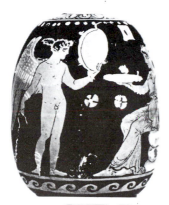
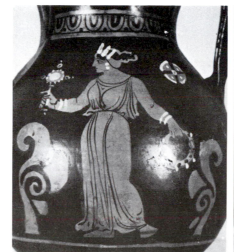
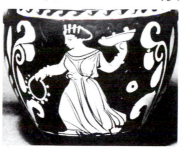
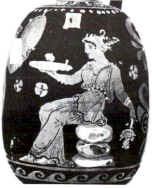

5–6. Cambridge, Mus. Class. Arch. 73 (11/53)

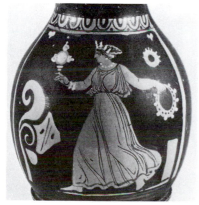

4(a,b). Palermo, Mormino 741 (11/45)

8. Edinburgh 1872.23.26 (11/69)

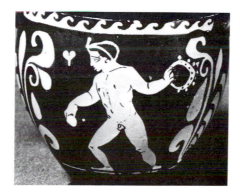

7. Malibu 71 AE 361 (11/56) 9. Edinburgh 1956.478 (11/70) 10. Lecce 727 (11/86)

PLATE 94 The Choes and Meer Groups; the Group of the Dresden Amphora

1. Zurich Market (11/101) 2. Monopoli, Meo-Evoli coll. 496 (11/116a) 3. Oxford G 1146 (11/117)

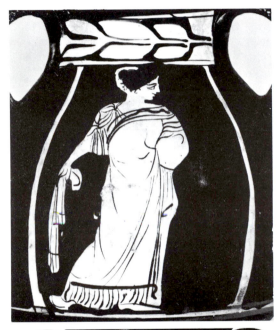

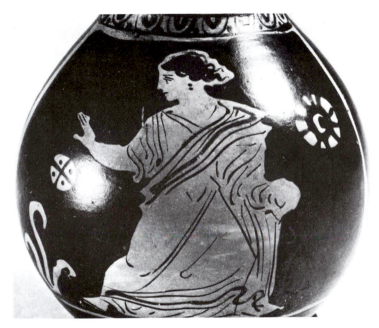

6. Zurich Market (11/136)

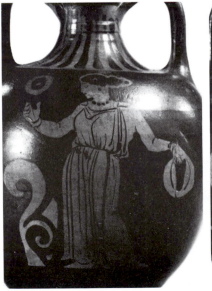

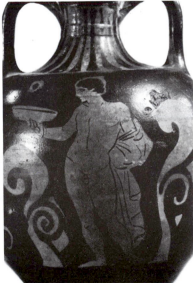

4–5. Geneva 13201 (11/130) 7–8. Dresden 525 (11/144)

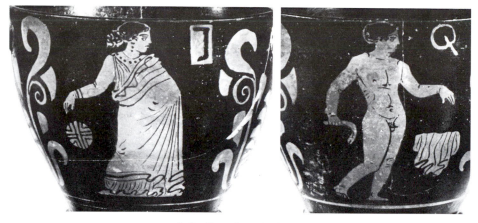

1–2. Zagreb 41 (11/155)

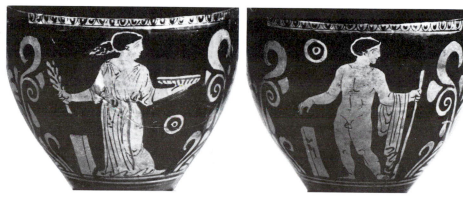

3–4. Zagreb 319 (11/159)

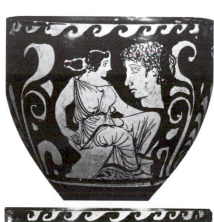

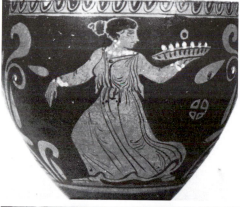

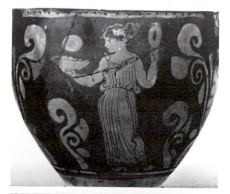

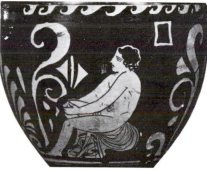

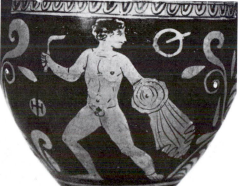

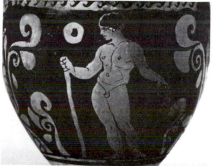

5–6. Basel Market, MuM (11/160) 7–8. Bari, Parmigiani coll. 3 (11/162) 9–10. Dresden ZV 855 (11/163)

PLATE 96 The Wellcome, Egg and Wave Groups, etc.

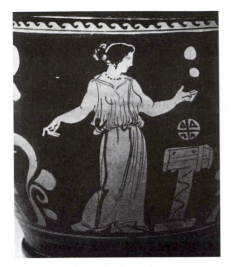

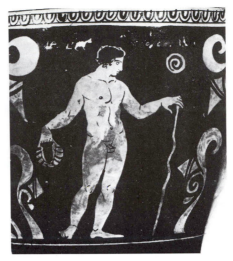

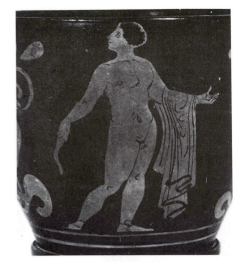

1. London, Wellcome Museum
R 394/1936 (11/174)

2. Sydney 49.11 (11/182)

3. Matera (11/184)

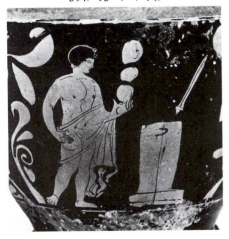

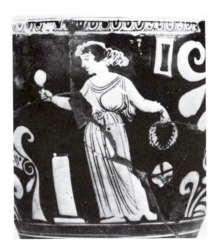

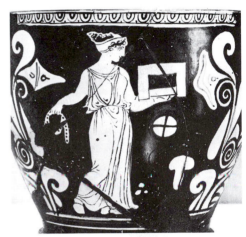

4. Hamburg 1917. 1089 (11/186)

5. Reggio Cal. 6980 (11/199)

6. Reggio Cal. 1160 (11/204)

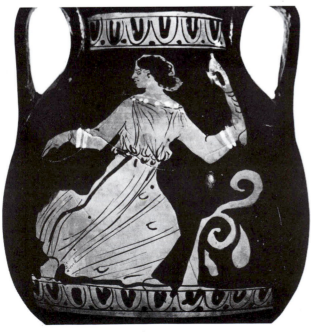

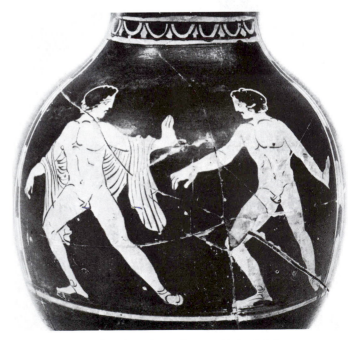

7. Boston 90.160 (11/239)

8. Los Angeles, private coll. (11/283)

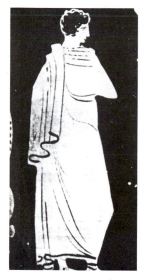

1. A (Lecce 609; 12/16)

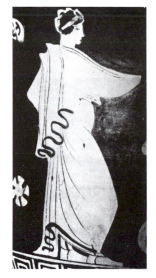

2. A1 (Milan 268; 14/182)

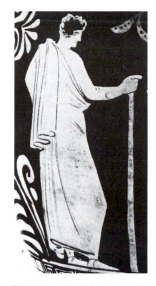

3. B (Milan 'H.A.' 364; 12/125)

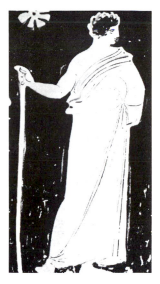

4. CR (Lecce 4811; 12/18)

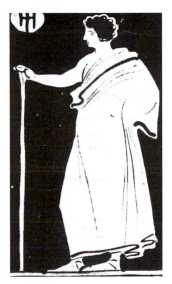

5. C (Lecce 609; 12/16)

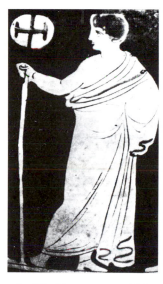

6. CL (Ruvo 529; 12/61)

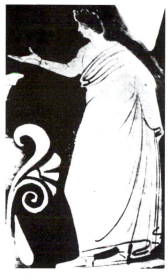

7. CX (Taranto 22556; 12/118)

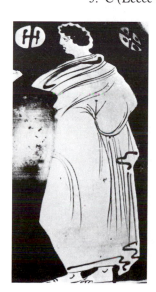

8. D (Vienna 1158; 13/101)

9. E (Trieste S 401; 12/26)

10. F (Lecce 4811; 12/18)

11. FX (Vatican V 38; 14/241)

PLATE 98 The Snub-Nose Painter

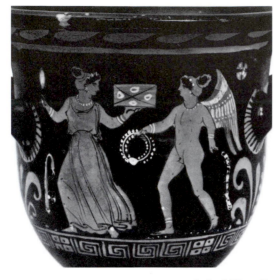

1–2. Milan, Soprintendenza. (12/6)

3–4. Milan, 'H.A.' coll. 428 (12/7)

5–6. Bari 932 (12/15)

1. Lecce 609 (12/16)

2. Lecce 4811 (12/18)

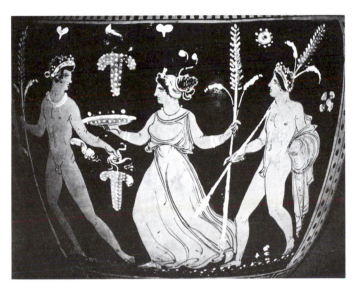

3. Vienna 663 (12/29)

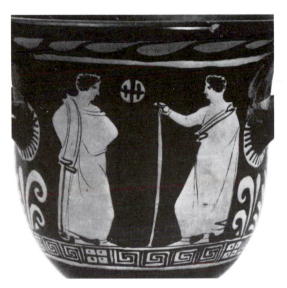

4. Milan, Soprintendenza (12/31)

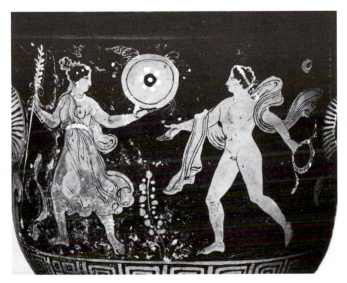

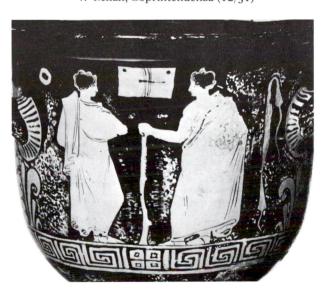

5–6. Vienna 919 (12/42)

PLATE 100 The Group of Lecce 660

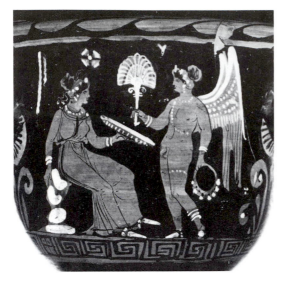
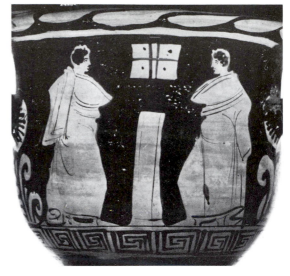

1–2. Louvre K 129 (12/43)

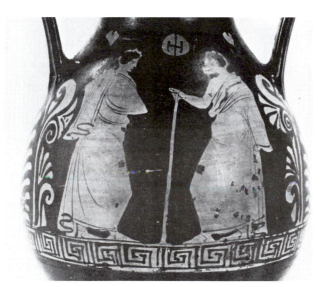

3. Matera 10208 (12/44)

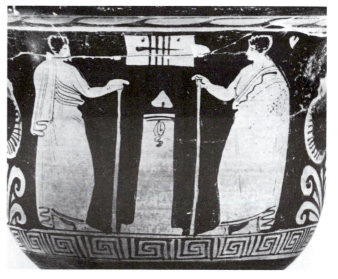

4. Frankfurt Market (12/48)

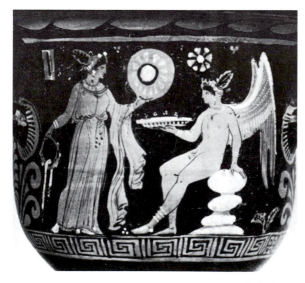
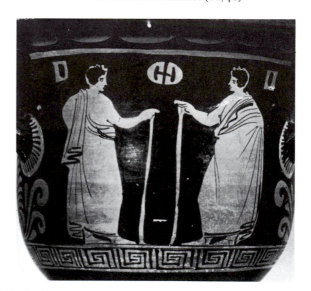

5–6. Lecce 660 (12/47)

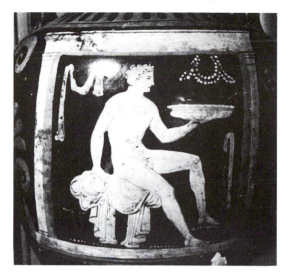
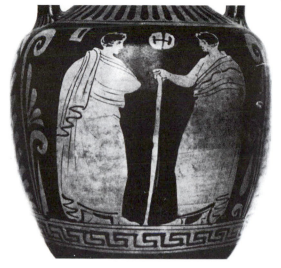

1–2. Naples 2029 (12/54)

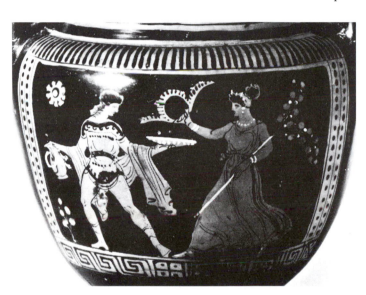
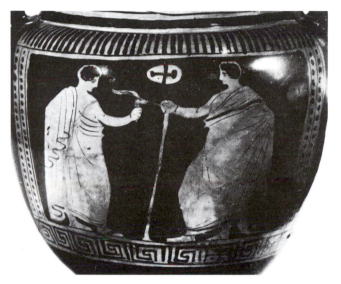

3–4. Stockholm, Medelhavsmuseet 1960.1 (12/59)

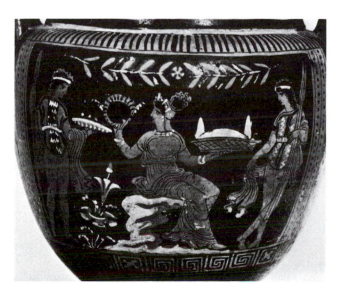
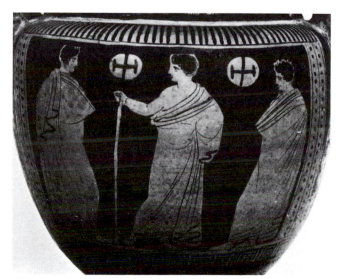

5–6. Ruvo 529 (12/61)

PLATE 102 The Woburn Abbey Group

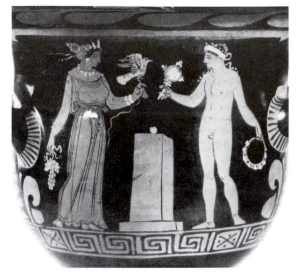

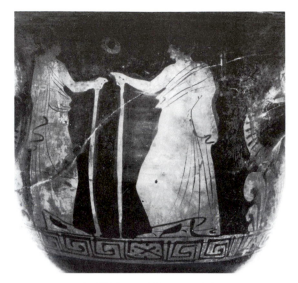

1. Leningrad 544 (12/67) 2. Woburn Abbey (12/68)

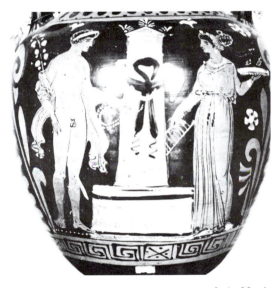

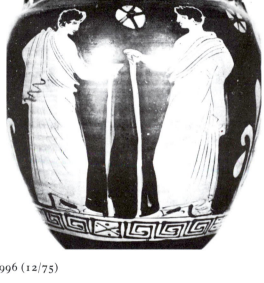

3–4. Naples 1996 (12/75)

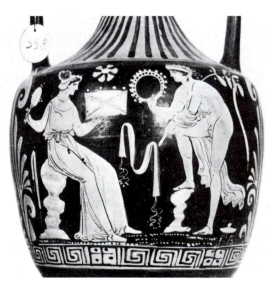

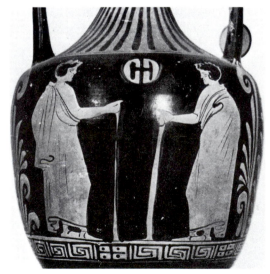

5–6. Nocera, Fienga coll. 558 (12/89)

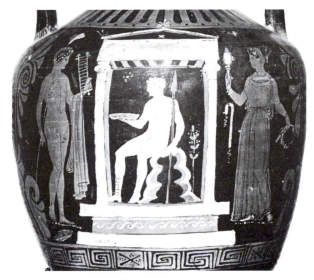
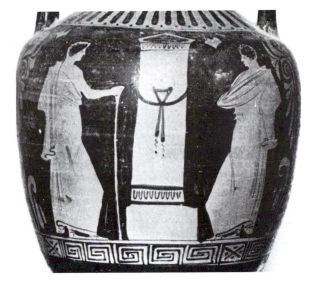

1–2. Ruvo 407 (12/90)

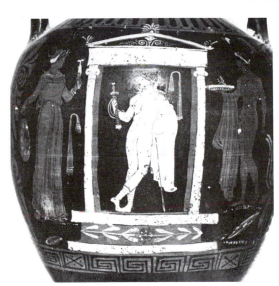
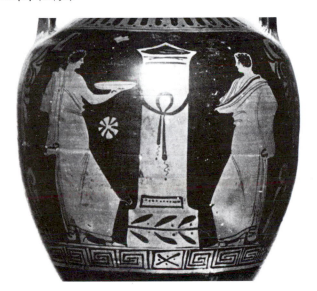

3–4. Ruvo 408 (12/91)

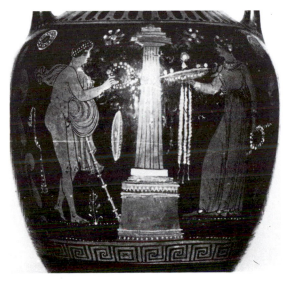
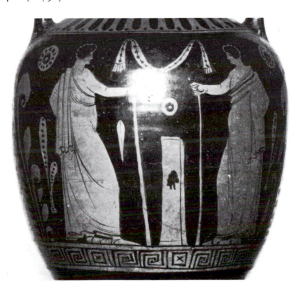

5–6. Bari 6377 (12/95)

PLATE 104 The Laterza Painter

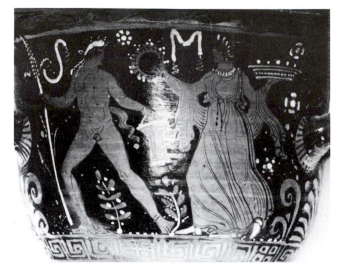
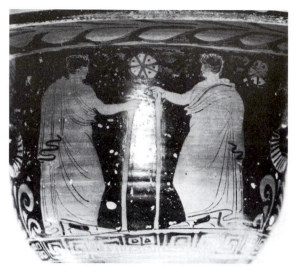

1–2. Foggia 132047 (12/106)

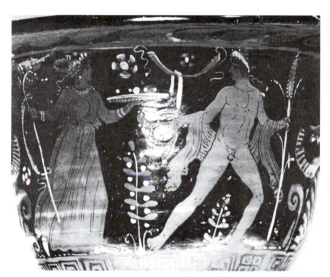
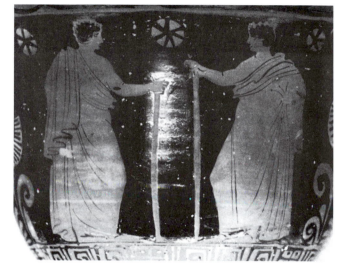

3–4. Foggia 132057 (12/107)

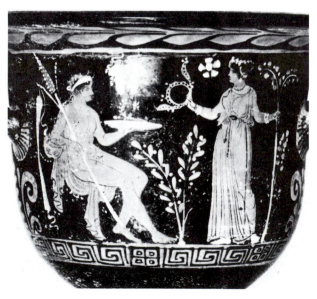

5–6. Taranto 22555 (12/113)

1–2. Taranto 22556 (12/118)

3–4. Boston 76.66 (12/122)

5–6. Milan, 'H.A.' coll. 364 (12/125)

PLATE 106 The 'H.A.' Group

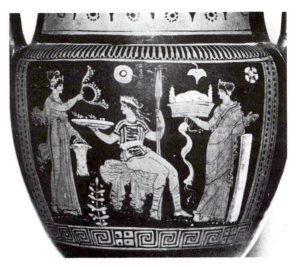

1. Altamura 1 (12/128)

2. Ruvo 793 (12/130)

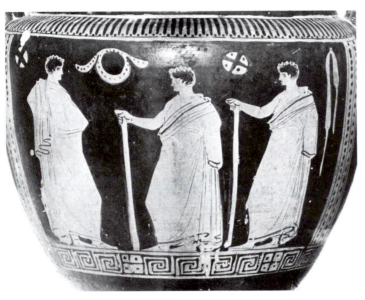

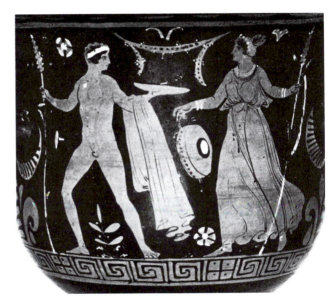

3. Ruvo 793 (12/130)

4. Matera 10207 (12/138)

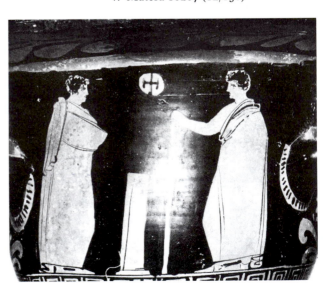

5. Udine 1665 (12/139)

6. Naples 1834 (12/149)

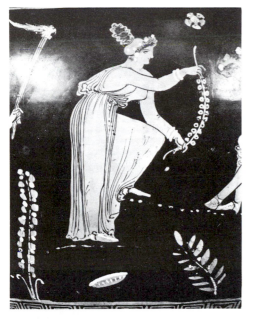

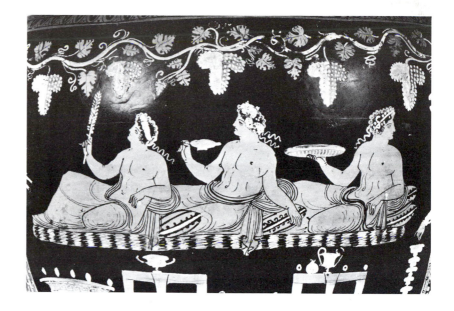

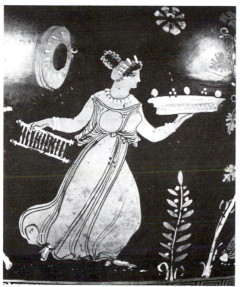

1–5. B.M. F 303 (12/151)

6. B.M. F 459 (12/153)

PLATE 108 The Varrese Painter

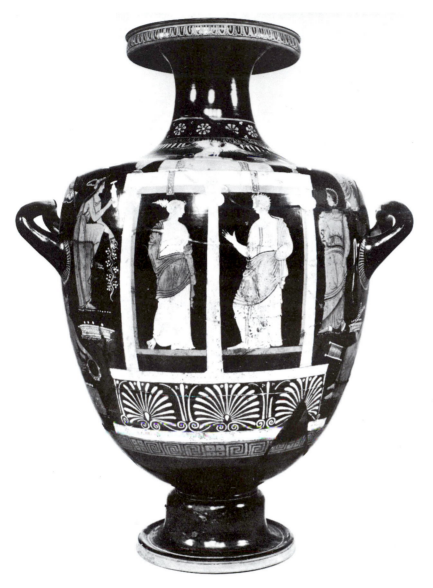

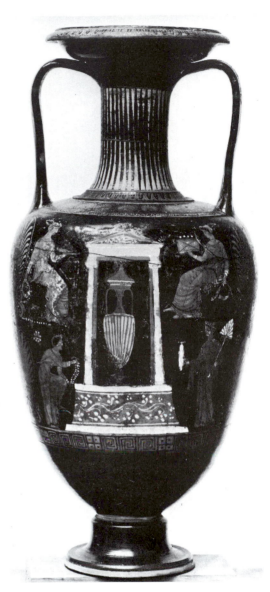

1. Taranto 8922 (13/1) 2. Bonn 99 (13/3)

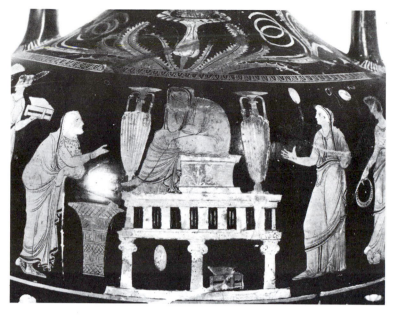

1. Taranto 8935 (13/4)

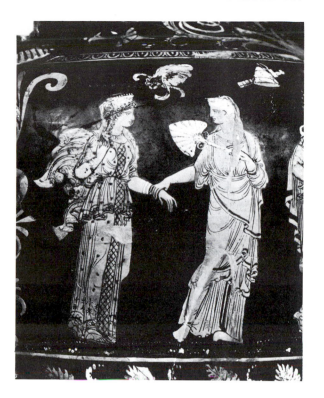

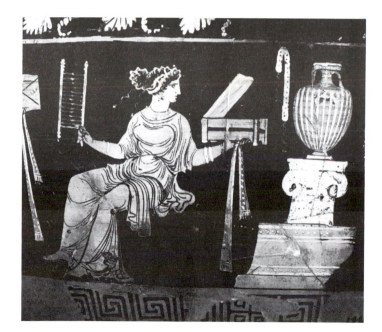

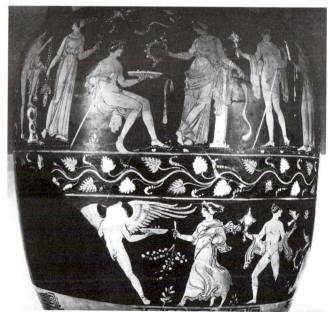

2–4. B.M. F 331 (13/5)

PLATE 110 The Varrese Painter

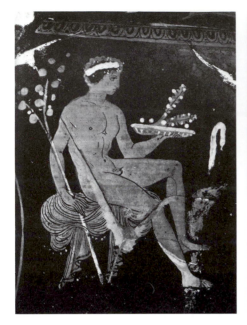
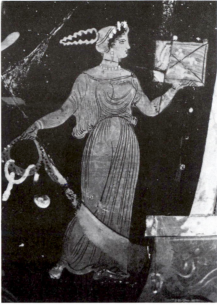
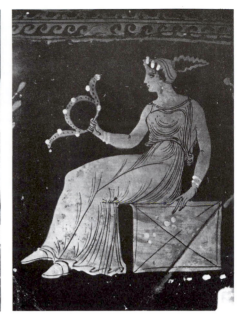

1–3. B.M. 1933.6–13.7 (13/9)

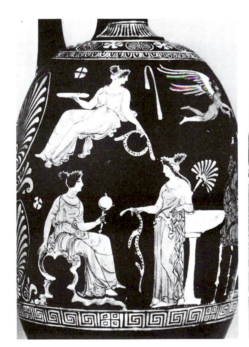
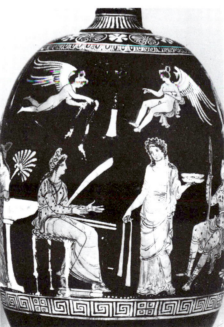
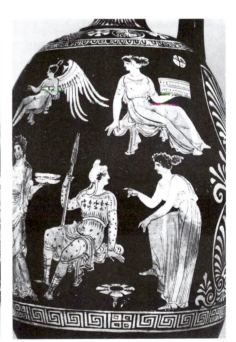

4–6. Paris, Cab. Méd. 1047 (13/25)

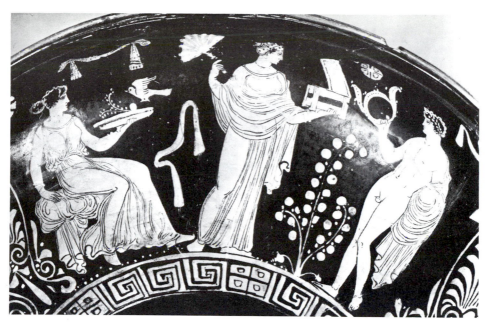

1. B.M. F 460 (13/33)

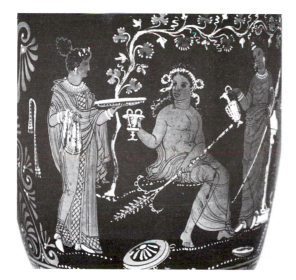

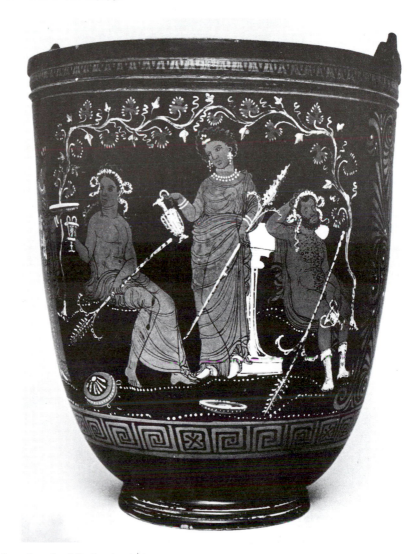

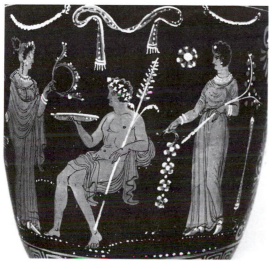

2–4. Los Angeles Market (13/35)

PLATE 112 The Varrese Painter

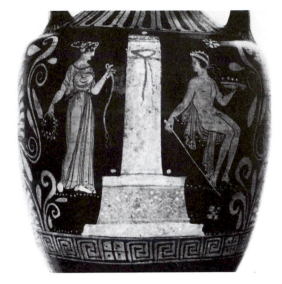

1–2. Bari 6109 (13/43)

3–4. Sarasota, Ringling Museum 1693 (13/52)

5–6. Basel Market, MuM (13/82)

1–2. Matera 9691 (13/100)

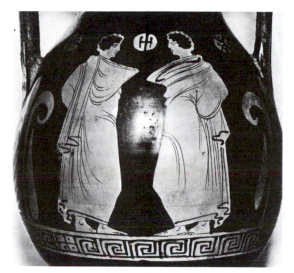

3–4. Vienna 1158 (13/101)

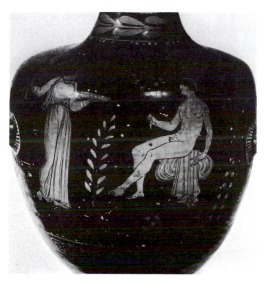

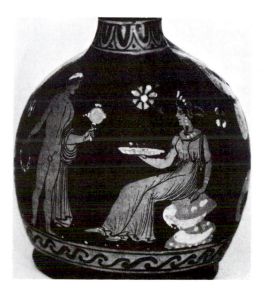

5. Once London Market (13/142) 6. Ruvo 860 (13/160)

PLATE 114 Associates of the Varrese Painter; the Wolfenbüttel Painter

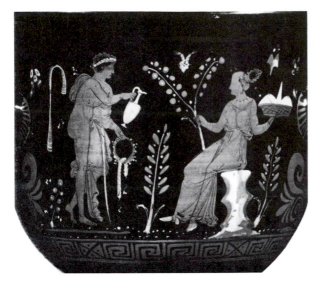
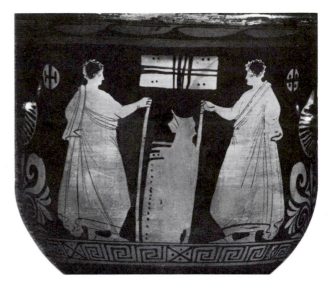

1–2. Basel Market, MuM (13/163)

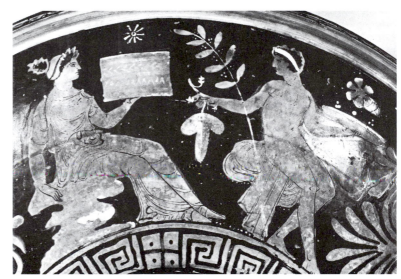

3–4. B.M. F 457 (13/164)

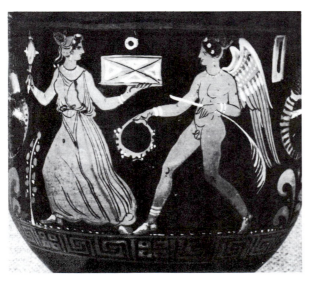

5–6. Hanover 1966.75 (13/188)

1–2. Taranto 54428 (13/191)

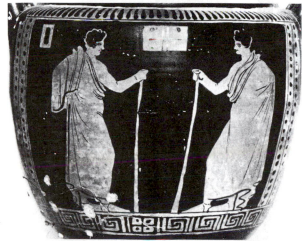

3–4. Naples Stg. 456 (13/196)

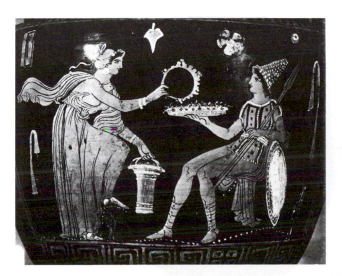

5–6. B.M. F 297 (13/197)

PLATE 116 The Painter of Vatican V 50

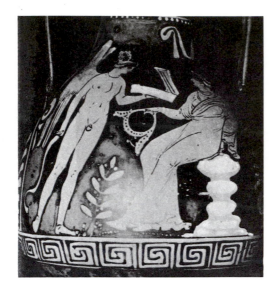
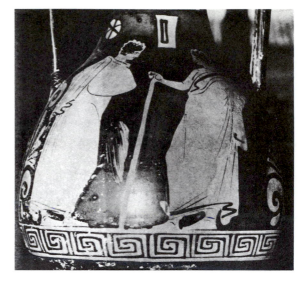

1–2. Catania MB 4359 (14/1)

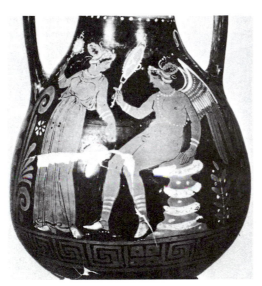
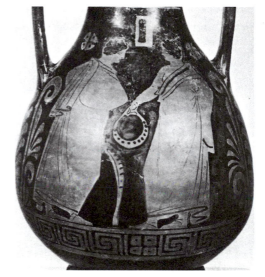

3–4. Taranto 110035 (14/2)

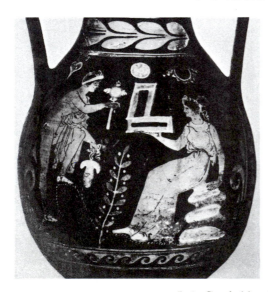
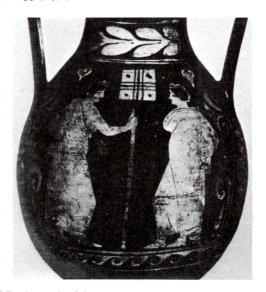

5–6. Cambridge GR 5/1912 (13/9)

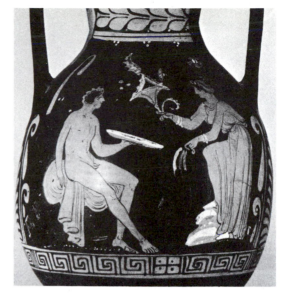

1. Bari 8010 (14/23)

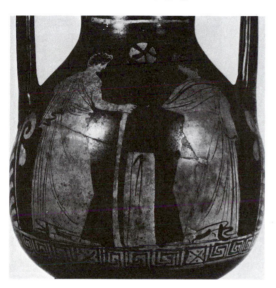

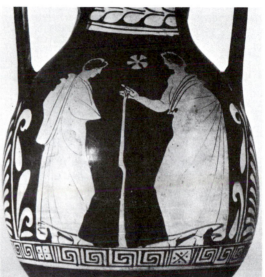

4. B.M. F 321 (14/26)

2–3. Once Zurich Market (14/25)

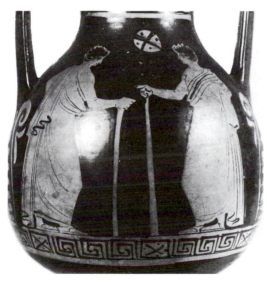

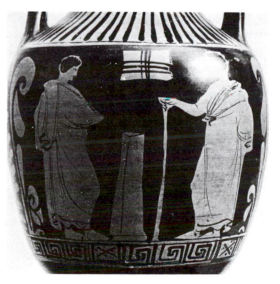

5. B.M. F 313 (14/27)

6. Nimes 891.25.41 (14/30)

PLATE 118 The Crossed Diptych Group

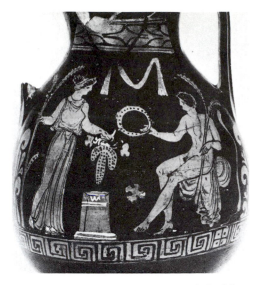
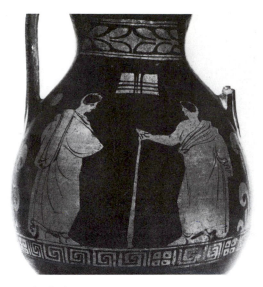

1–2. Matera 11279 (14/32)

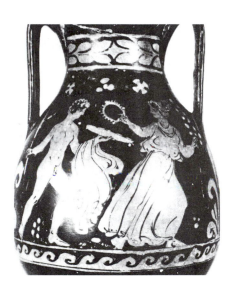
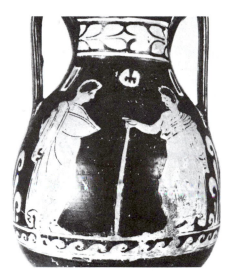

3–4. Monopoli, Meo-Evoli coll. 968 (14/33)

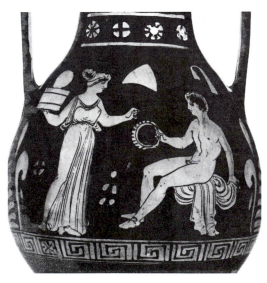
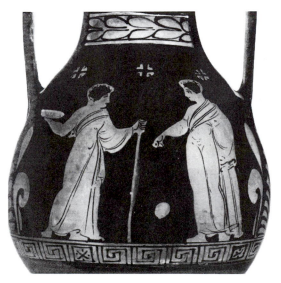

5–6. Geneva 18189 (14/43)

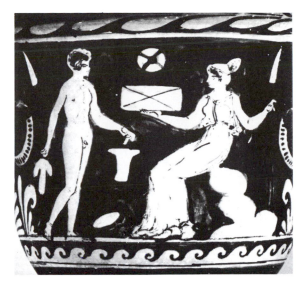
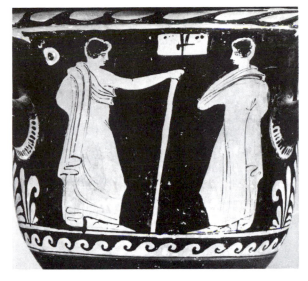

1–2. Paris, Cab. Méd. 934 (14/50)

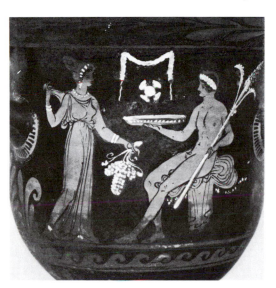
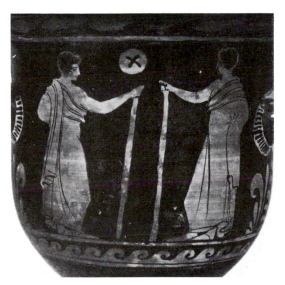

3–4. Bari 12034 (14/51)

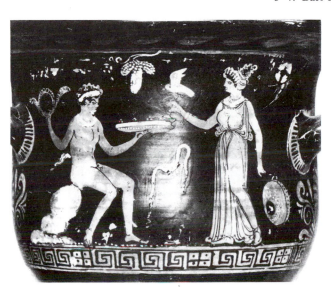
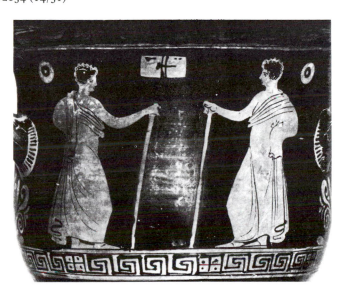

5–6. Naples 1934 (14/52)

PLATE 120　　　　　　　　The Painter of Ruvo 512

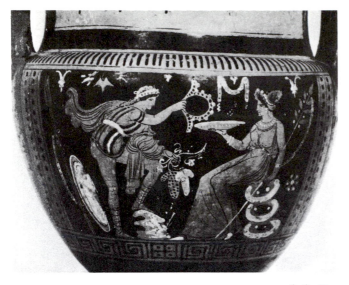

1–2. Ruvo 512 (14/58)

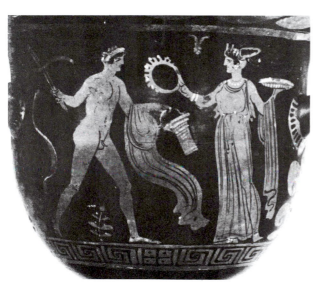

3–4. Frankfurt X 2629 (14/60)

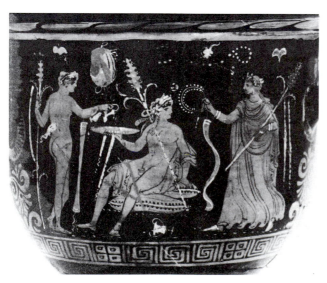

5–6. Matera 11036 (14/63)

1. Philadelphia L. 64.230 (14/67)

2. Bochum S 12 (14/71)

3. Milan, 'H.A.' coll. 369 (14/73)

4. Nocera, Fienga coll. 564 (14/74)

5–6. Geneva MF 290 (14/76)

PLATE 122 The Group of Vatican X 1

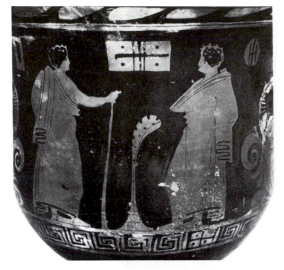

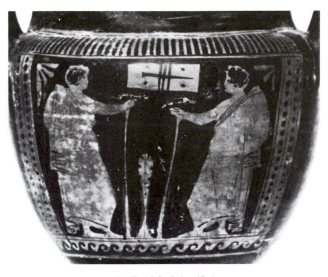

1. Bari, Sette Cirillo 3 (14/82) 2. Bari 898 (14/83)

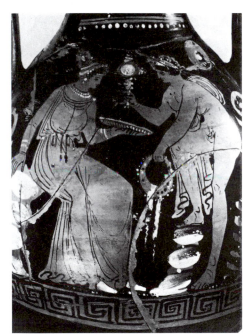

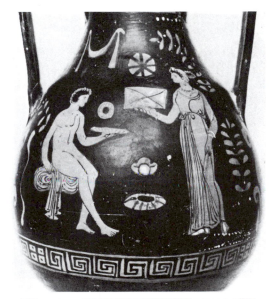

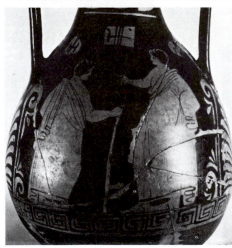

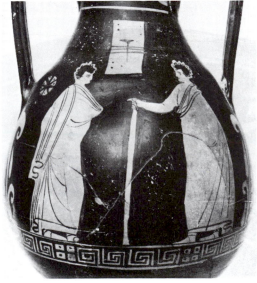

3–4. Vienna 1051 (14/97) 5–6. Benevento 359 (14/100)

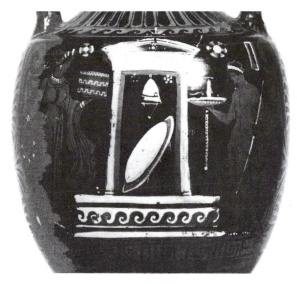
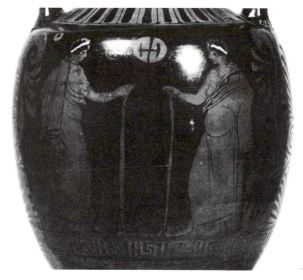

1–2. Philadelphia L. 64.26 (14/104)

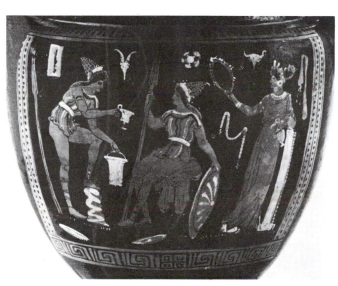
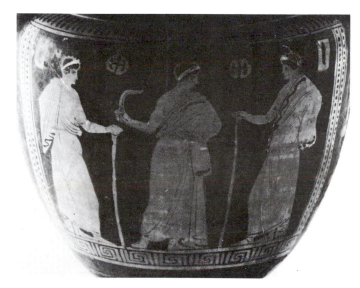

3–4. Milan, 'H.A.' coll. 335 (14/105)

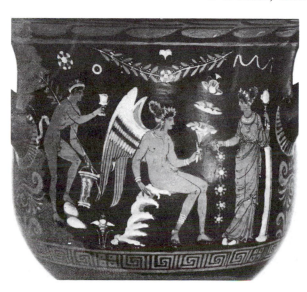
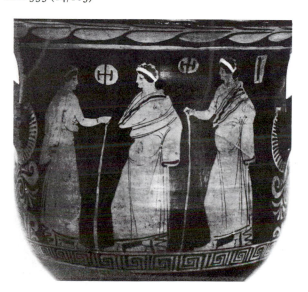

5–6. Milan, 'H.A.' coll. 418 (14/108)

PLATE 124 The Group of the Sotheby Amphorae

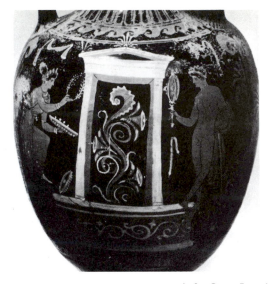
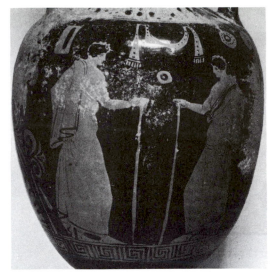

1–2. Once London Market (14/112)

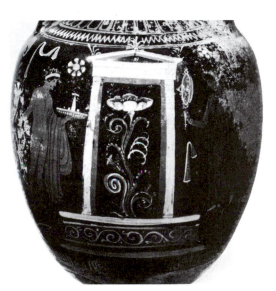
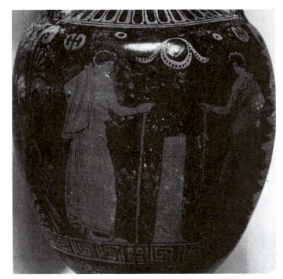

3–4. Once London Market (14/113)

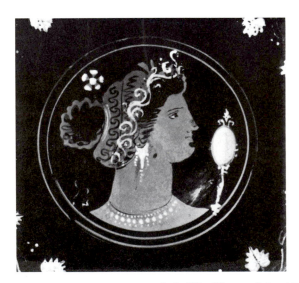
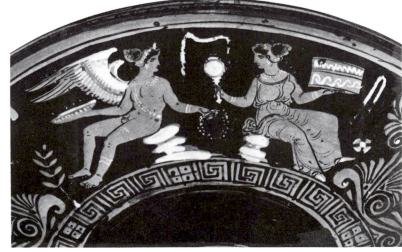

5–6. The Hague, Schneider-Herrmann coll. 184 (14/118)

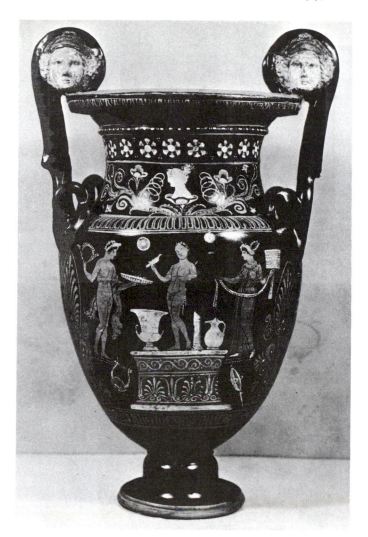

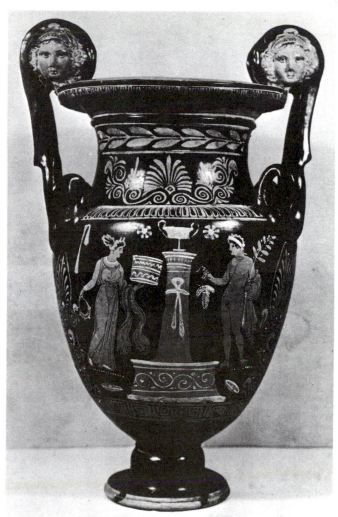

1–2. Louvre K 74 (14/120)

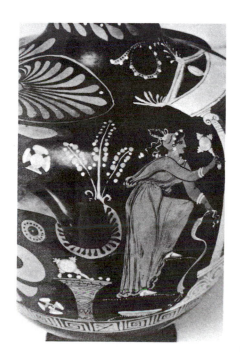

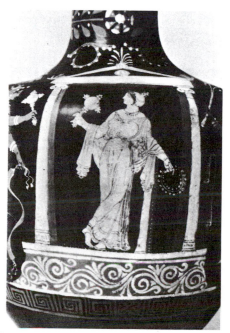

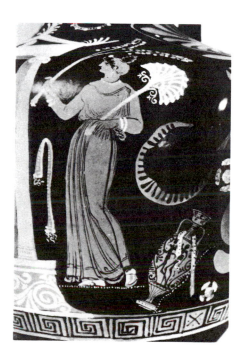

3(a,b,c). Los Angeles, Dechter coll. (14/121)

PLATE 126 The Painters of B.M. F 336 and of Bari 12061

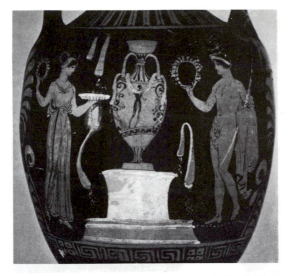

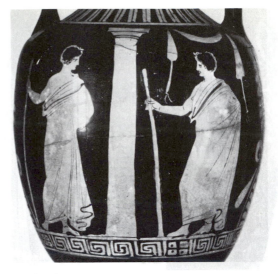

1–2. B.M. F 336 (14/122)

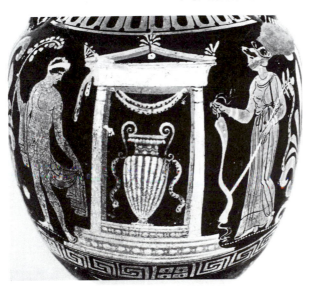

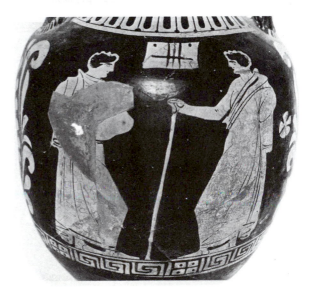

3–4. Bari 12061 (14/126)

5. Bari 20027 (14/123) 6. Once Roman Market (14/129)

1–2. Nimes 891.25.40 (14/138)

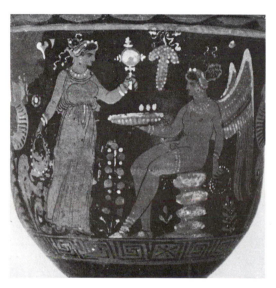
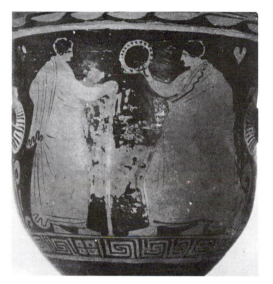

3–4. Nocera, Fienga coll. 562 (14/140)

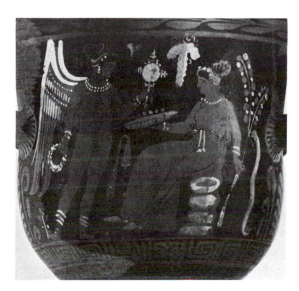

5–6. Milan, 'H.A.' coll. 396 (14/141)

PLATE 128 The Chiesa Group

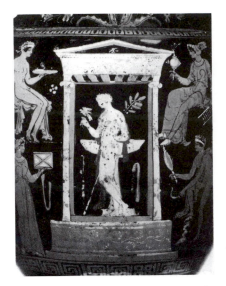

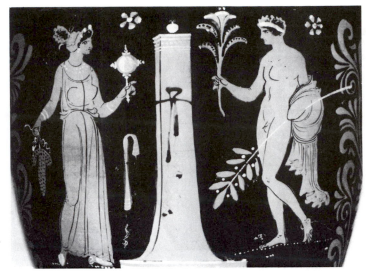

1–2. Basel, on loan from Dr. F. Chiesa (14/142)

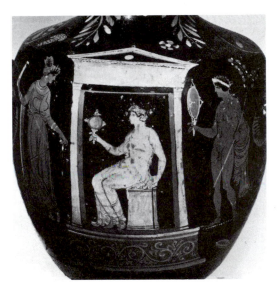

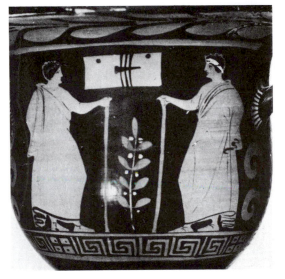

3. Once London Market (14/143) 4. Lecce 667 (14/146)

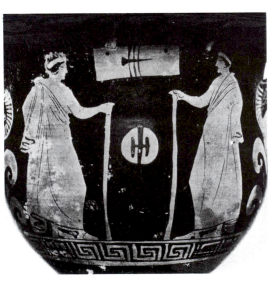

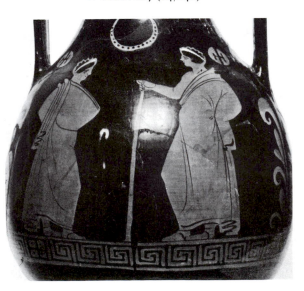

5. Lecce 767 (14/147) 6. Policoro 32755 (14/154)

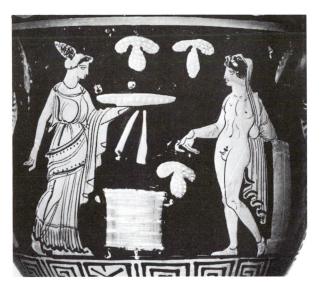
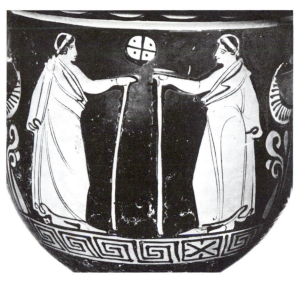

1–2. Vienna 1072 (14/157)

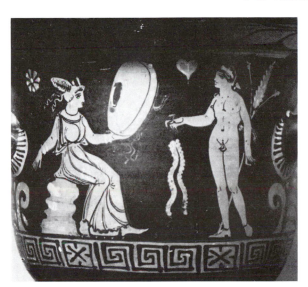
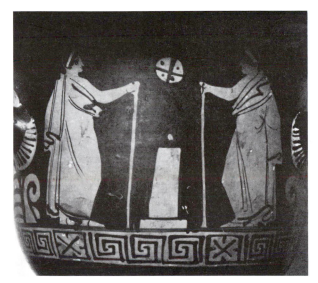

3–4. Once Milan Market (14/158)

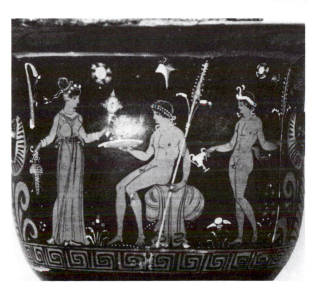
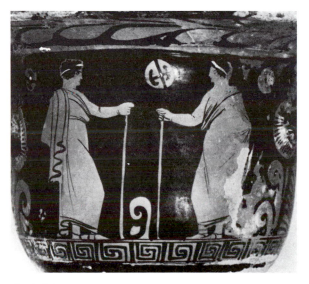

5–6. Lecce 751 (14/163)

PLATE 130 The Schulman Group

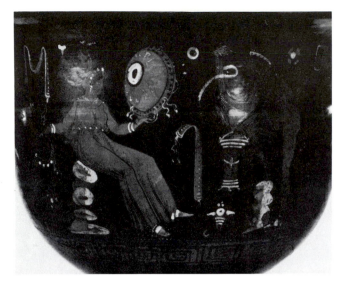
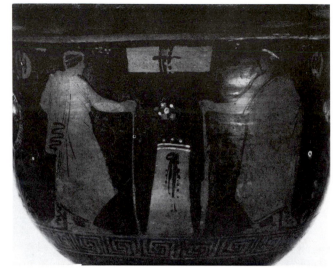

1–2. Once London Market (14/168)

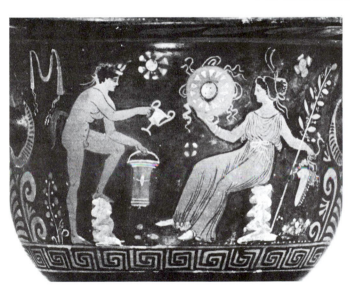
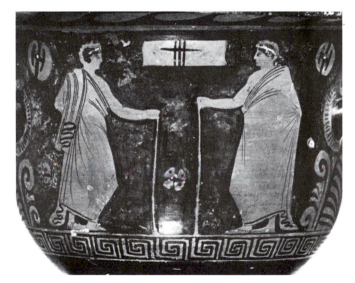

3–4. Sydney 69 (14/169)

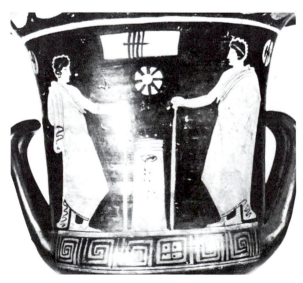
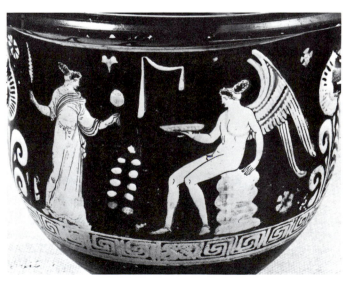

5. Boston, Mrs. Schulman (14–172) 6. York 24 (14/197)

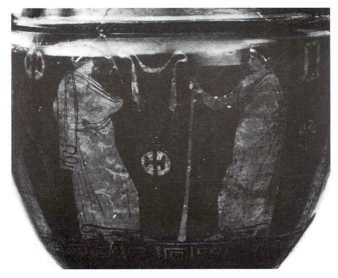

1. Bochum S 576 (14/204)

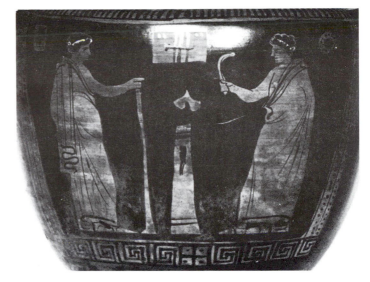

2. Philadelphia L. 64.229 (14/205)

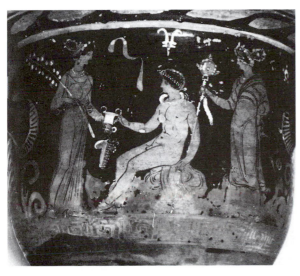

3. Hanover 1906.159 (14/208)

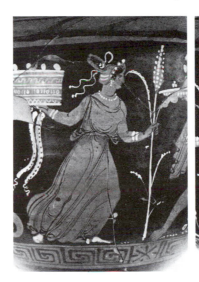

5(a,b). Liège, private coll. (14/210a)

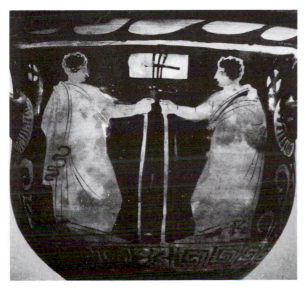

4. Paris, Cab. Méd. 929 (14/209)

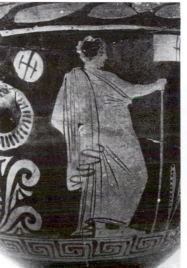

6(a,b). Liège private coll. (14/210a)

PLATE 132 The Helbig-Grape Vine and Pittsburgh Groups

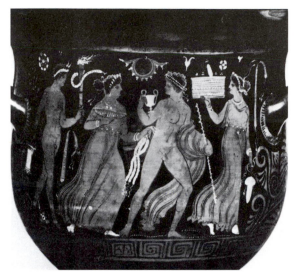
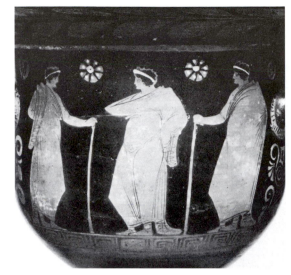

1–2. Copenhagen, Ny Carlsberg H 46 (14/212)

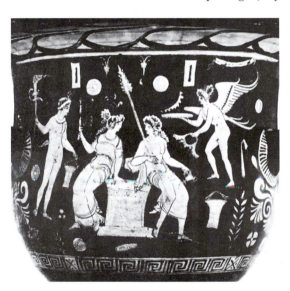
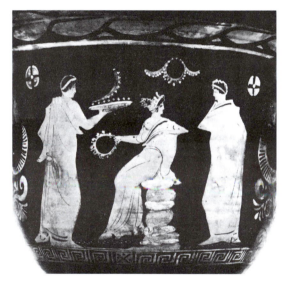

3–4. Louvre S 4049 (14/214)

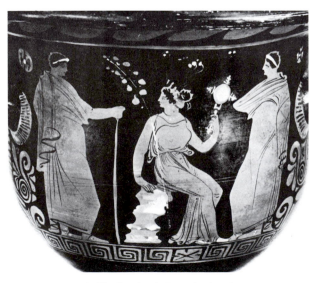
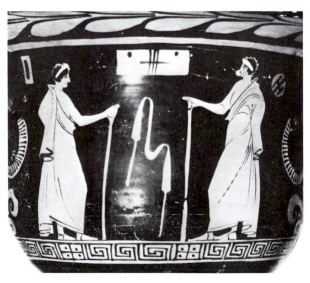

5. Karlsruhe 65/100 (14/215) 6. Lecce 655 (14/218)

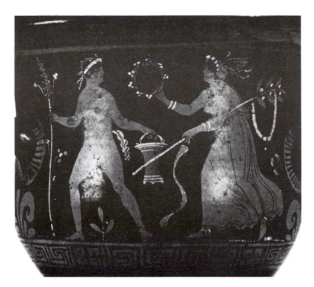

1–2. Matera 10064 (14/219)

3. Louvre K 109 (14/221)

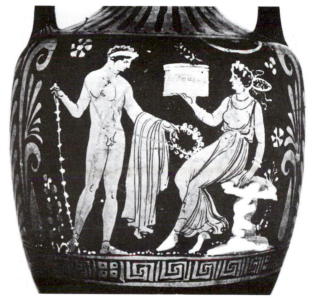

4. Once Zurich Market (14/223)

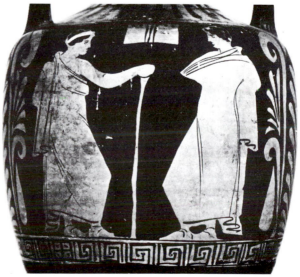

5–6. Louvre K 84 (14/225)

PLATE 134 The Barletta Group

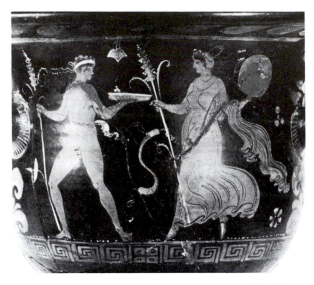

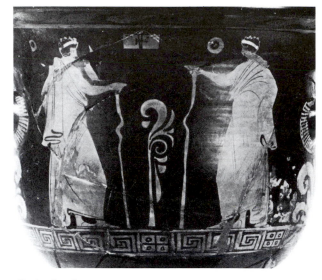

1–2. Matera 10481 (14/227)

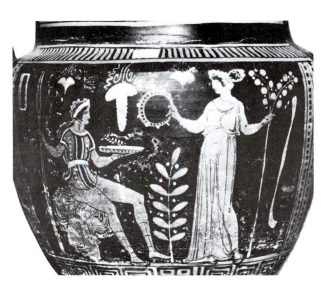

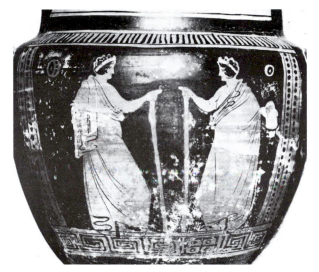

3–4. Naples 2036 (14/230)

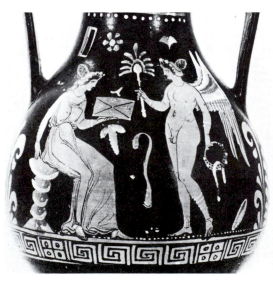

5–6. Matera 10278 (14/232)

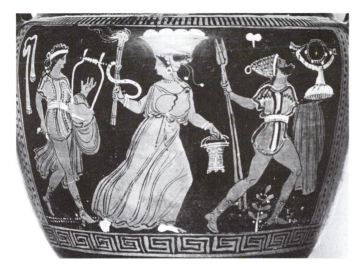

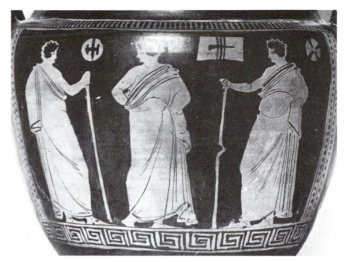

1–2. Altamura 2 (14/236)

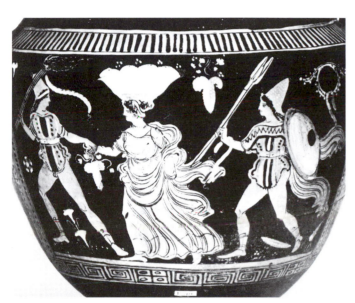

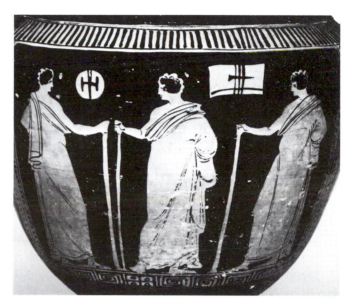

3–4. B.M. F 301 (14/237)

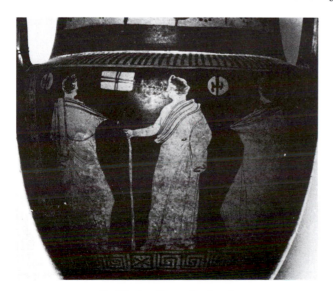

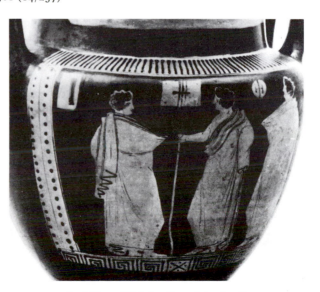

5. Naples Stg. 4 (14/245) 6. Milan, 'H.A.' coll. 448 (14/246)

PLATE 136 The Bearded Oscans Group; the Latiano Painter

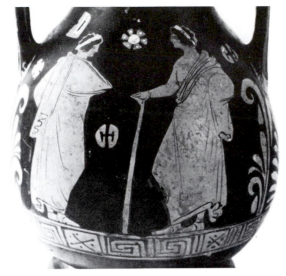

1. Milan, 'H.A.' coll. (14/254)

2. Catania MC 4365 (14/256)

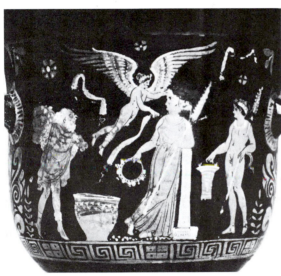

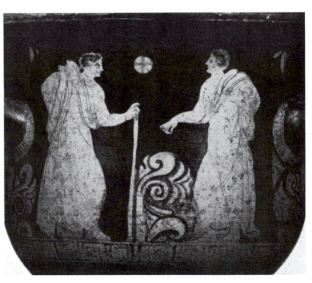

3–4. Taranto 135755 (14/257)

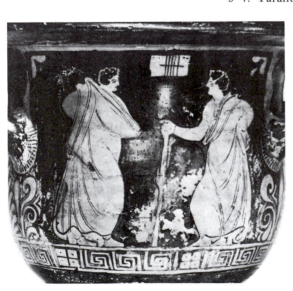

5. Hanover W.M. V2 (14/258)

6. Kiel B 513 (14/259)

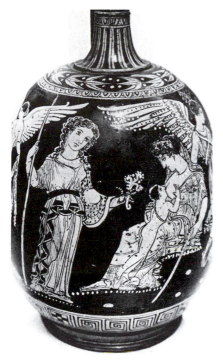

1. B.M. F 107 (15/1)

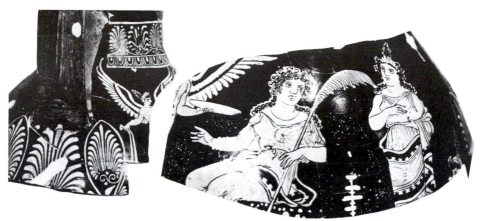

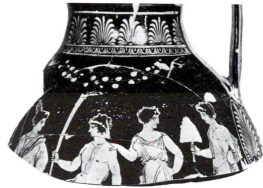

2–4. Taranto, Baisi
coll. 89 and Zurich
Market (15/5)

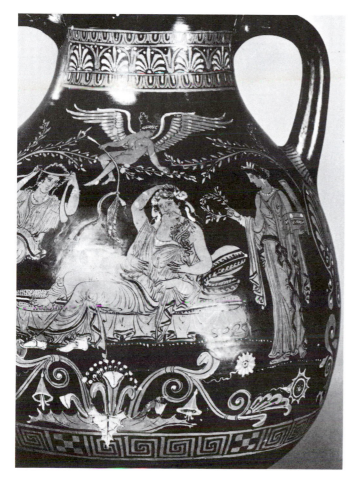

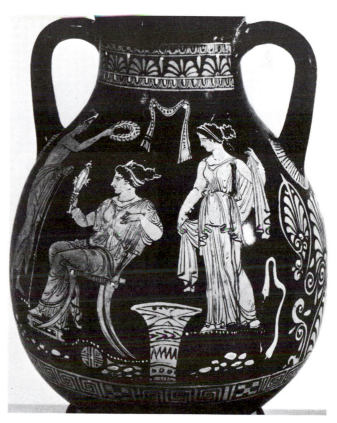

5–6. London, V. and A. 2493.1910 (15/6)

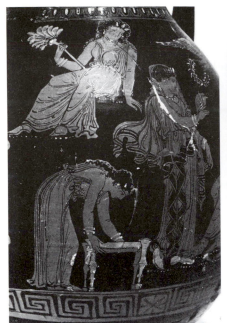
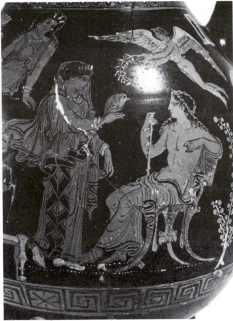
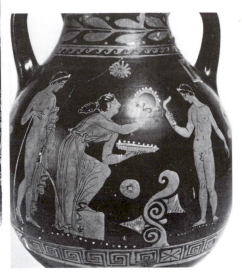

1(a,b). Once London Market (15/7)

2. Once London Market (15/7)

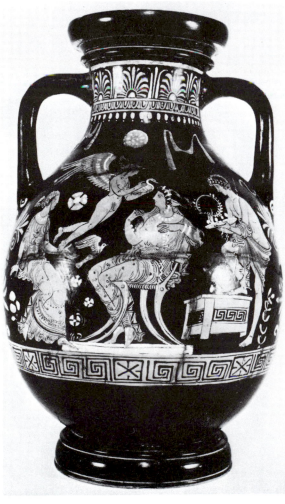
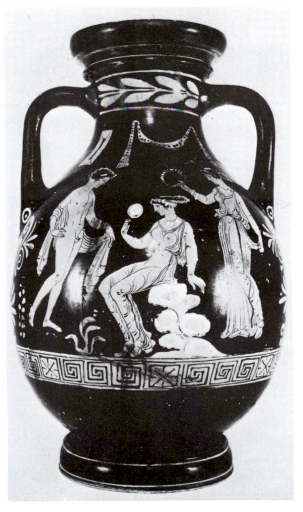

3–4. Bari 915 (15/9)

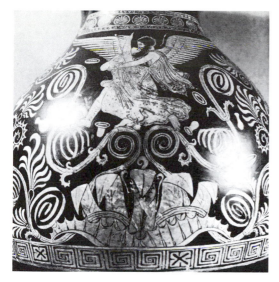

1. Louvre K 35 (15/11)

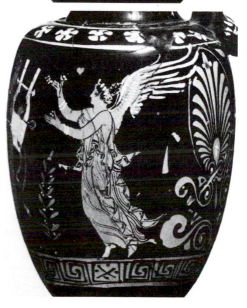

2. Ruvo 1619 (15/13)

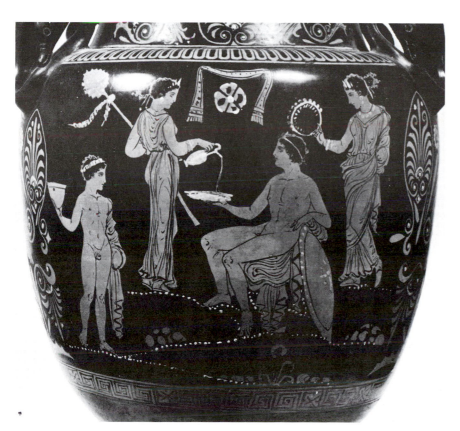

3. Ruvo 1094 (15/14)

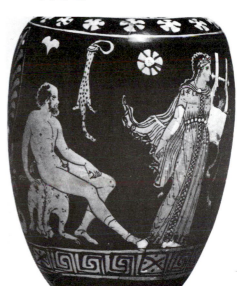

4(a,b). Naples Stg. 574 (15/18)

PLATE 140 The Suckling-Salting Group

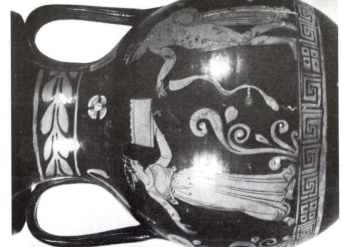

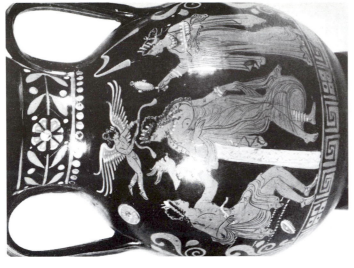

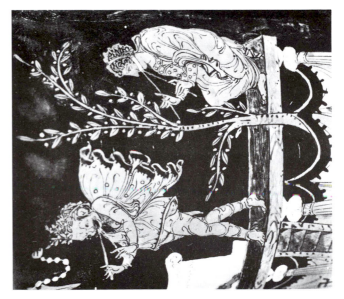

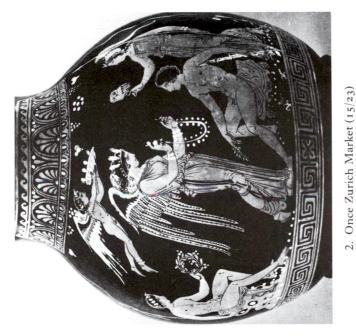

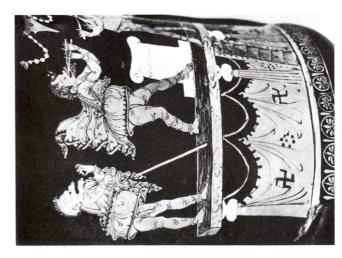

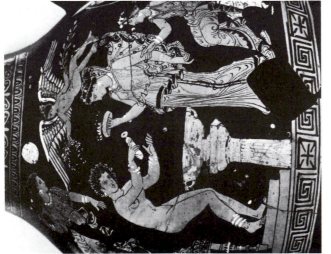

3–4. San Simeon 5535 (15/26)

2. Once Zurich Market (15/23)

5(a,b). Bari, Malaguzzi-Valeri coll. 52 (15/28)

1. Oxford G 269 (15/22)

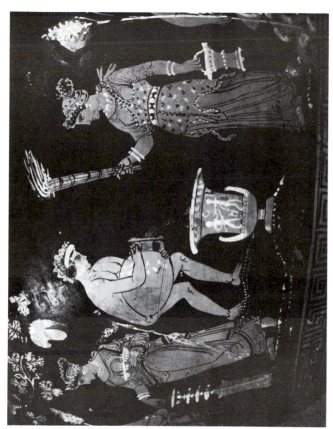

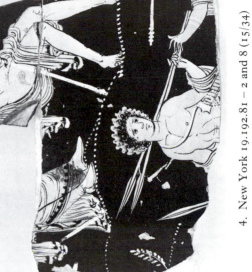

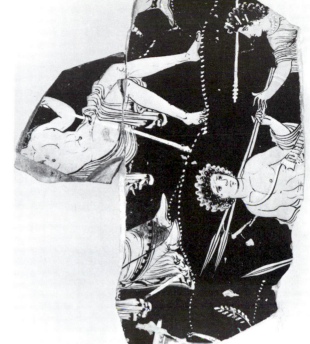

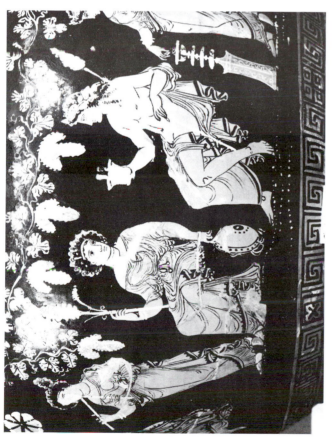

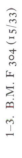

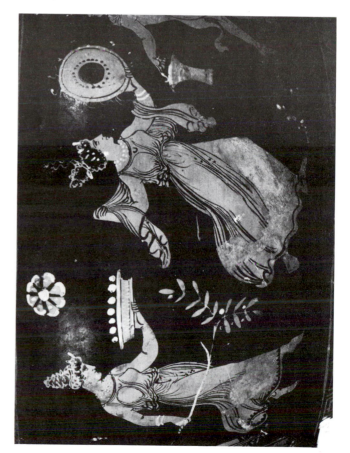

1–3. B.M. F 304 (15/33)

4. New York 19.192.81 – 2 and 8 (15/34)

PLATE 142 The Group of the Dublin Situlae

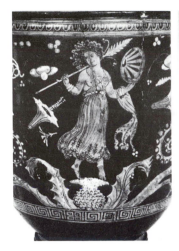
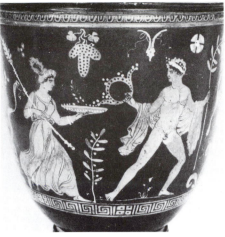
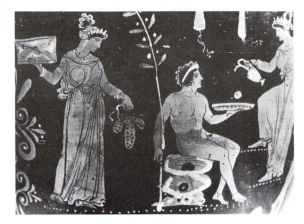

1–2. Dublin 1106.1880 (15/37) 3. Kassel T 749 (15/40)

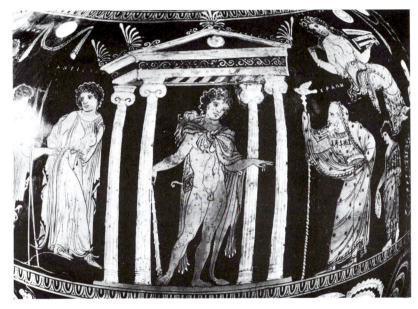

4. Ruvo 423 (15/41)

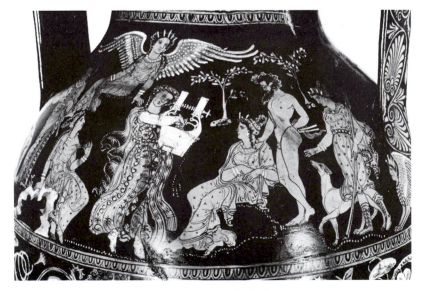

5. Ruvo 1500 (15/43)

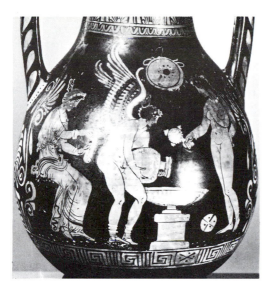
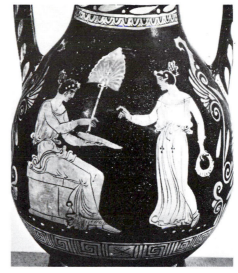

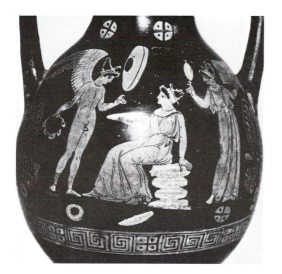
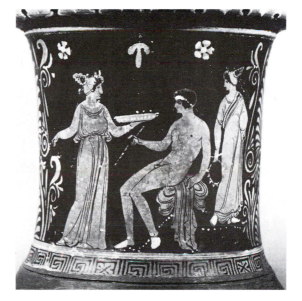

1–2. London, V. and A. 4799.1901 (15/45)

3. Madrid 11199 (15/47)

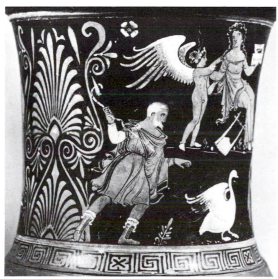
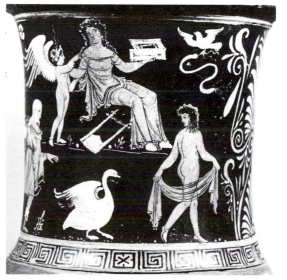

4–6. Maplewood, J. V. Noble coll. (15/51)

PLATE 144 The Group of Vatican W 4

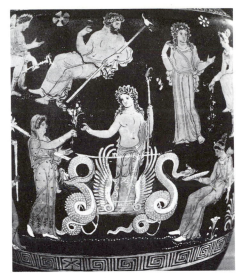

1–2. Vatican W 4 (15/60)

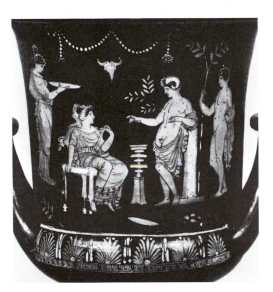
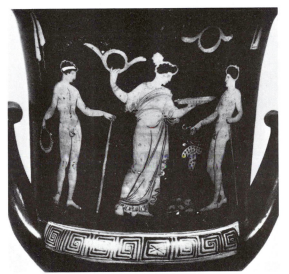

3–4. Leningrad 312 (15/61)

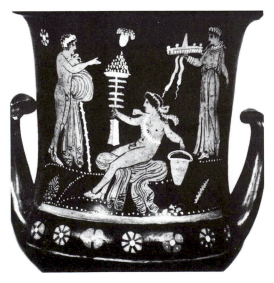
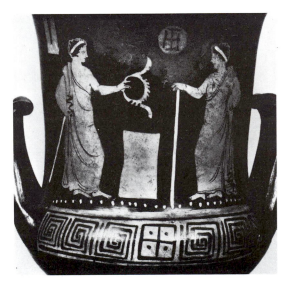

5–6. Leningrad 311 (15/62)

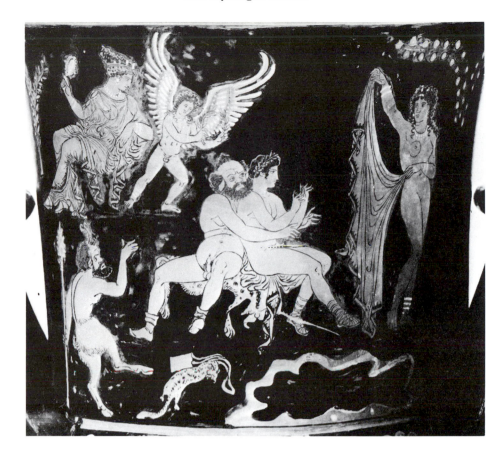

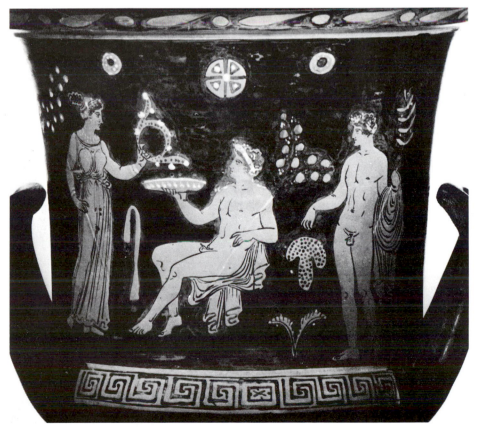

1–2. Basel, on loan from Ariel Hermann (16/1)

PLATE 146 The Lycurgus Painter

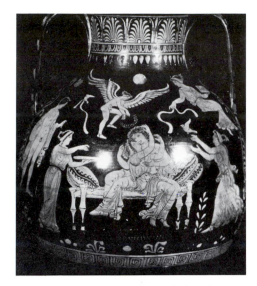
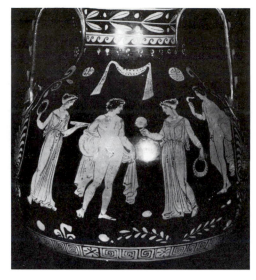

1–2. Milan, 'H.A.' coll. 236 (16/2)

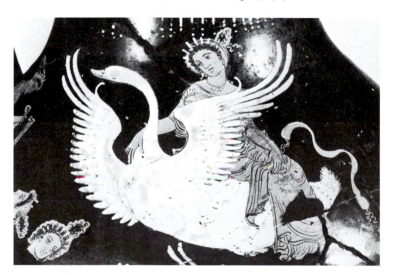

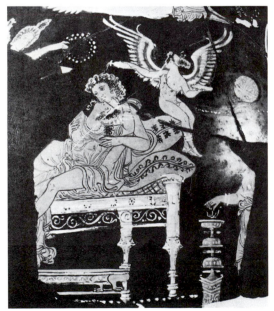
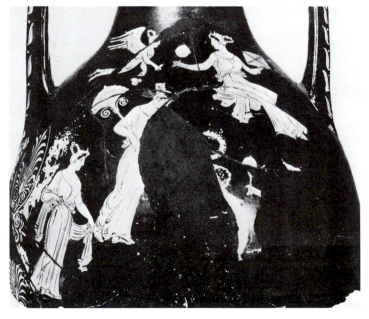

3–5. Taranto 4622 (16/4)

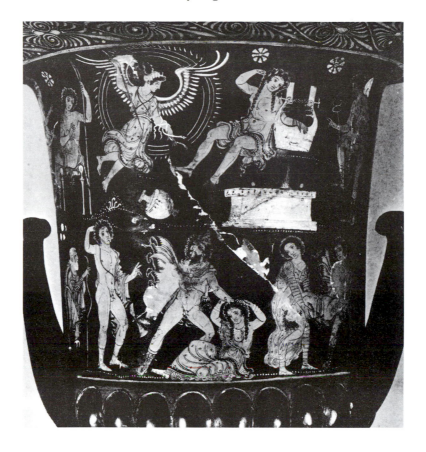

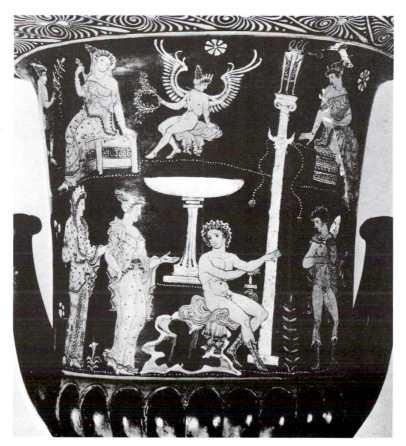

1–2. B.M. F 271 (16/5)

PLATE 148 The Lycurgus Painter

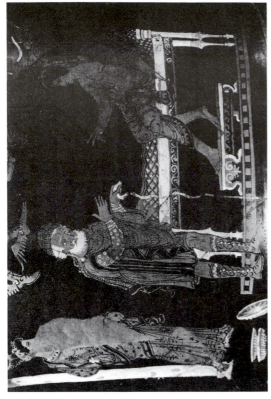

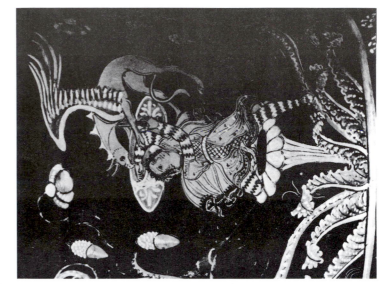

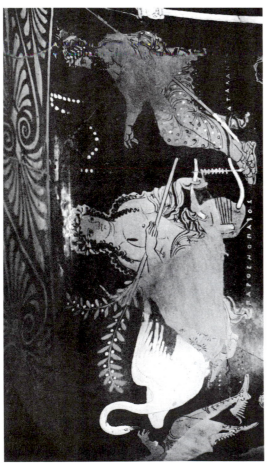

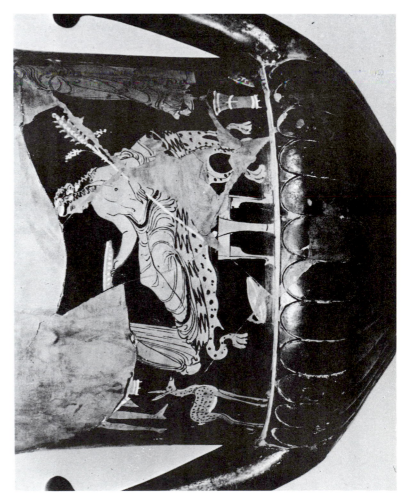

1–3. Milan ST. 6873 (16/6)

4. Naples, private coll. (16/7)

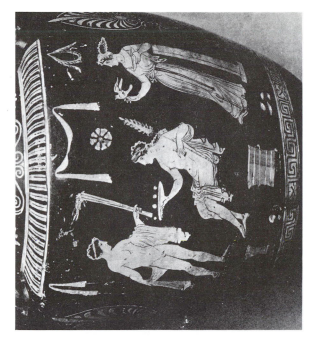

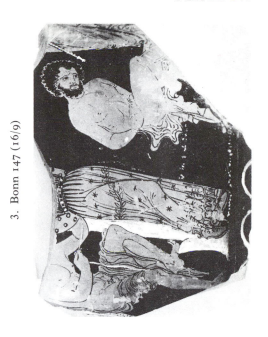

1–2. B.M. 1931.5–11.1 (16/10)

3. Bonn 147 (16/9)

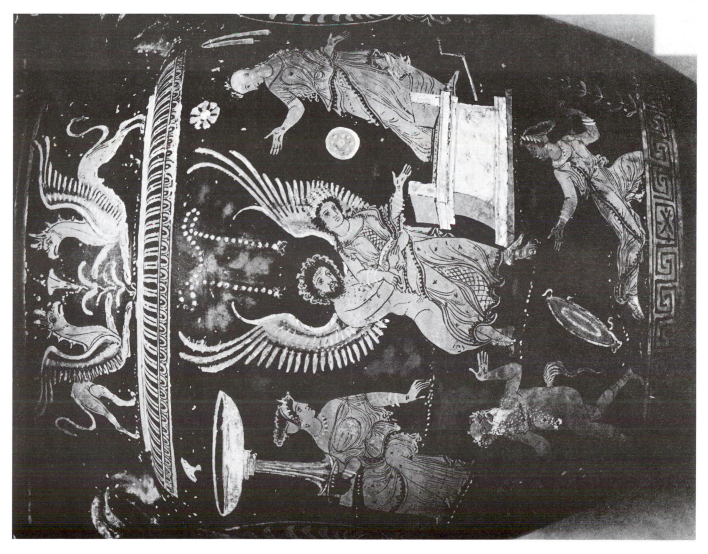

PLATE 150 The Lycurgus Painter

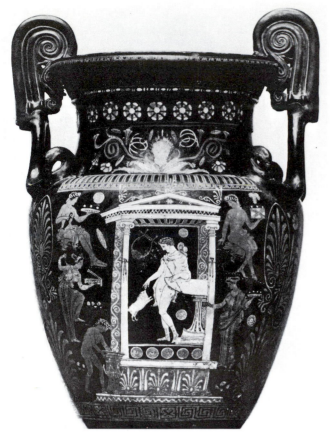
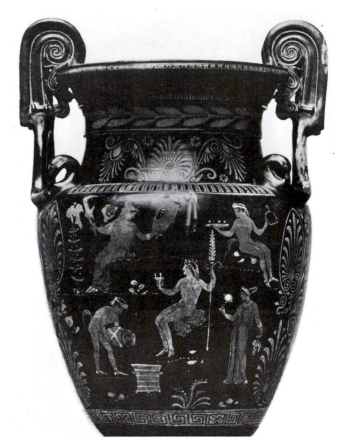

1–2. Bonn 100 (16/14)

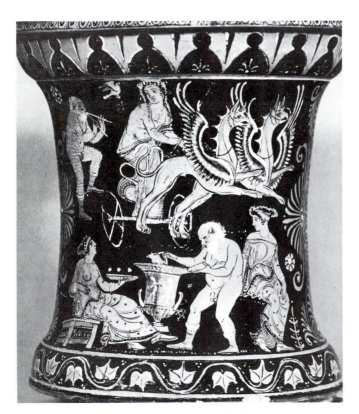
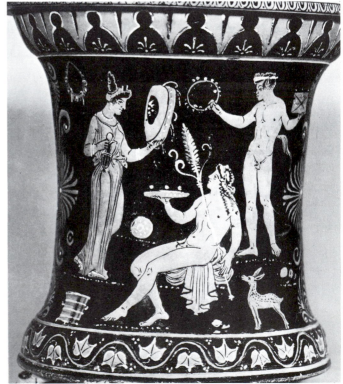

3–4. New York 56.171.64, Fletcher Fund (16/17)

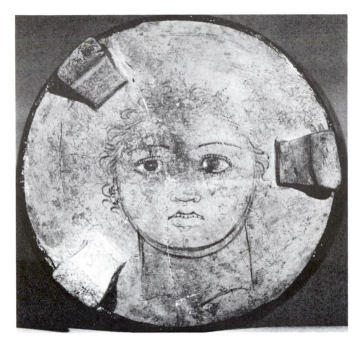

1. New York 56.171.64 (16/17)

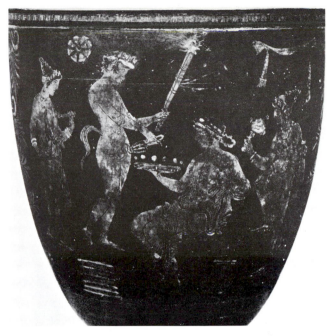

2. Naples 2910 (16/18)

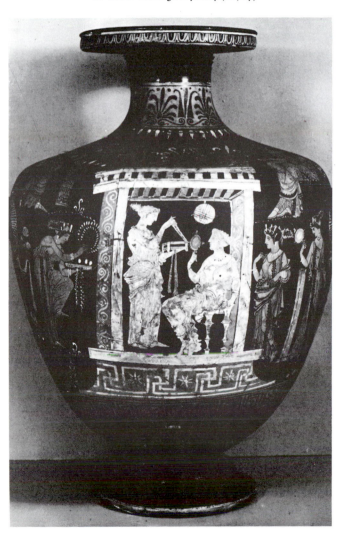

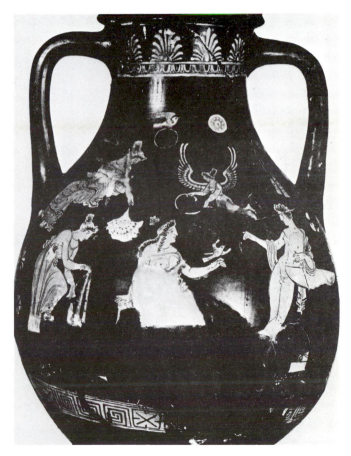

4. Taranto (16/21)

3. B.M. F 352 (16/20)

PLATE 152 The Lycurgus Painter

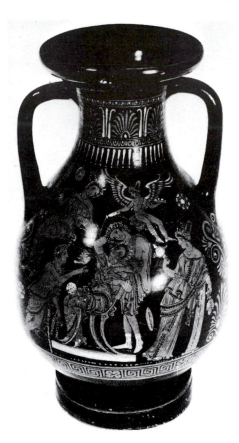
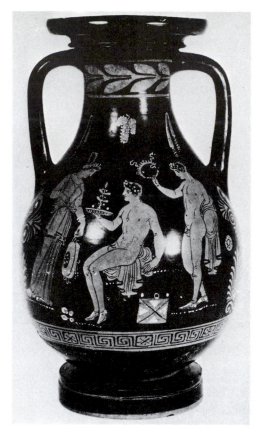

1–2. Matera 11671 (16/22)

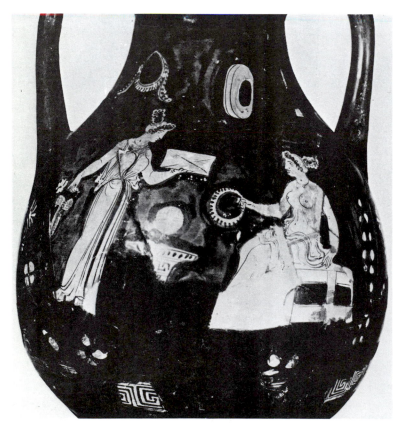

4. Cambridge, Mus. Class. Arch. 144 (16/23)

3. Taranto (16/21)

5. W. Berlin 30916 (16/28)

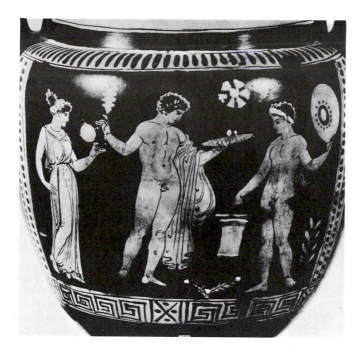

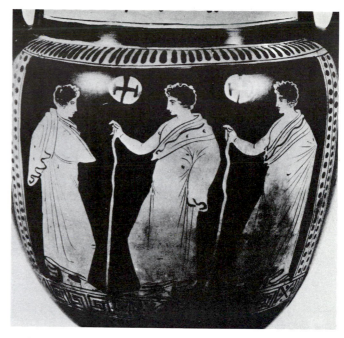

1–2. Boston 76.65 (16/32)

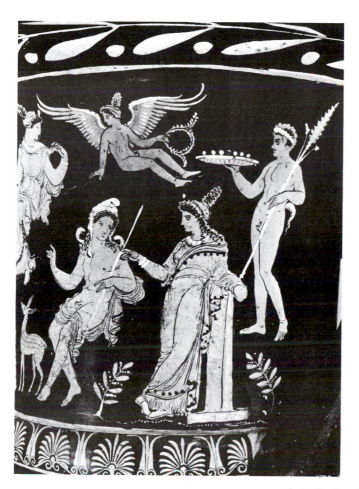

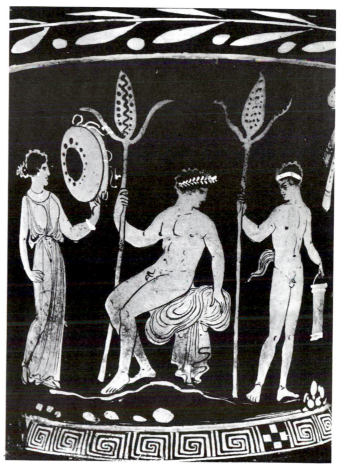

3–4. Vatican AA 3 (16/35)

PLATE 154 Lycurgan Associates

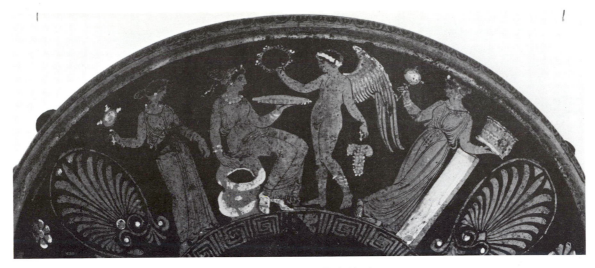

1. Kiel, private coll. (16/39)

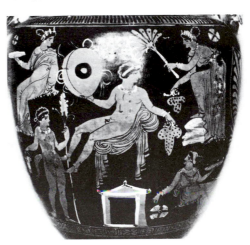

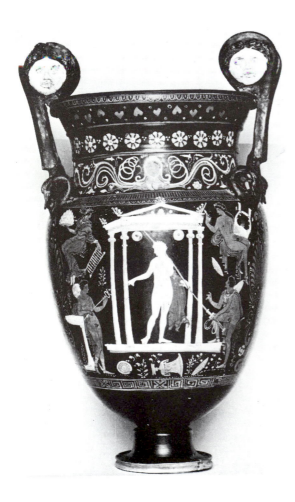

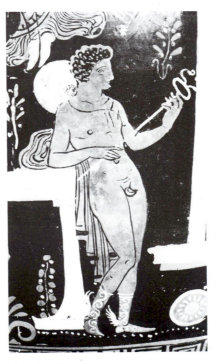

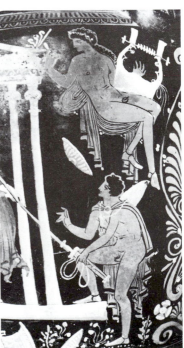

2–5. Bari 6270 (16/41)

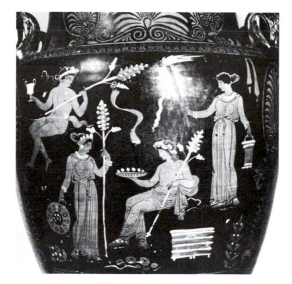

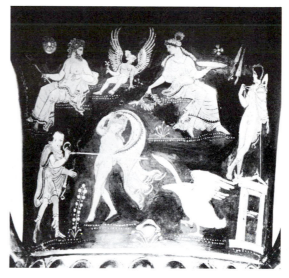

1. Naples 3230 (16/43)

2. Berlin F 3297 (16/49)

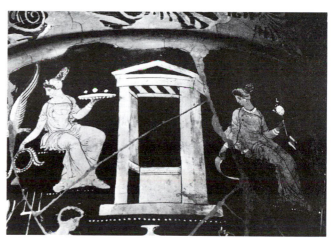

3. Copenhagen 13433 (16/50)

4. Naples 690 (16/51)

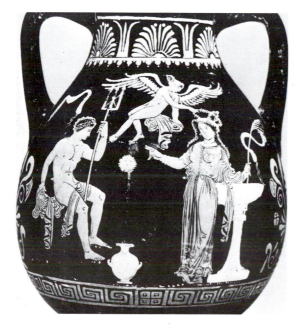

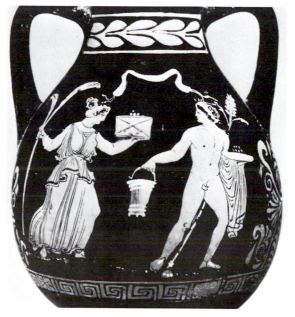

5–6. Taranto 124520 (16/52)

PLATE 156 The Chamay Painter

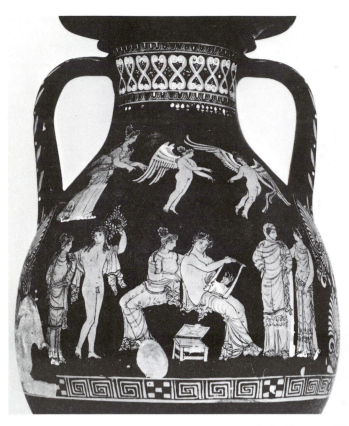

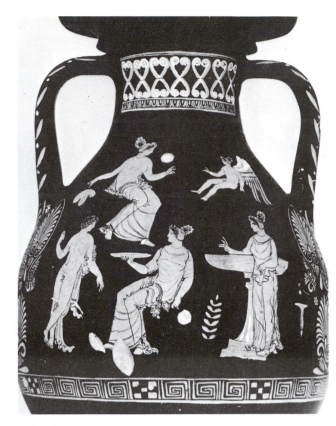

1–2. Geneva, Chamay coll. (16/57)

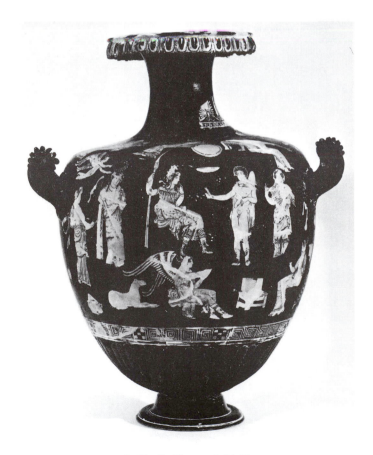

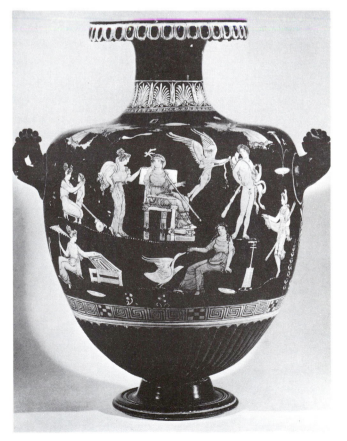

3. Berlin F 3290 (16/58) 4. Berlin F 3291 (16/60)

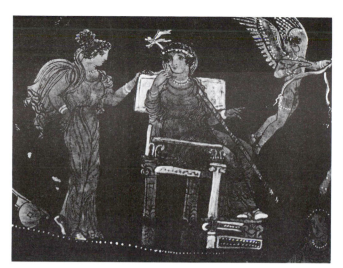
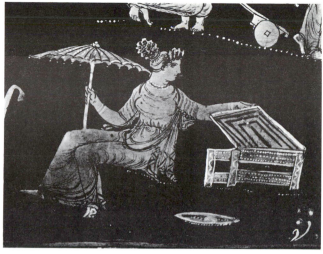

1–2. Berlin F 3291 (16/60)

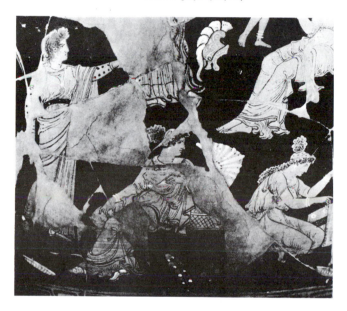

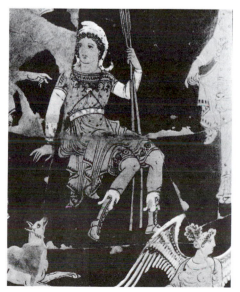
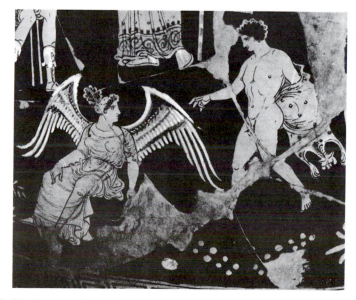

3–5. Naples 3244 (16/59)

PLATE 158 Lycurgan Followers

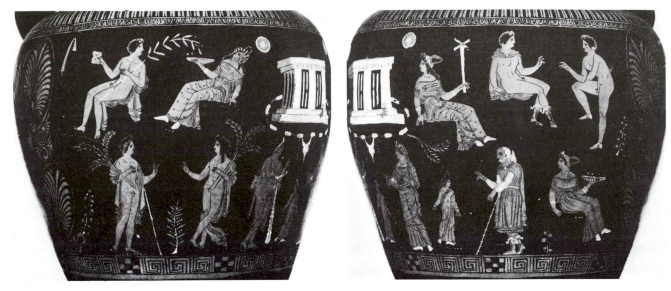

1–2. Florence, private coll. 116 (16/68)

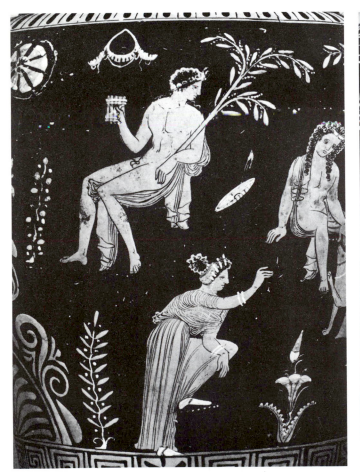
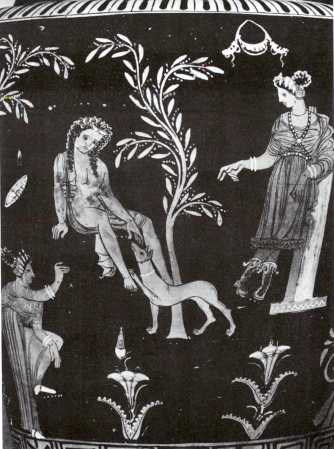

3–4. Paris, Cab. Méd. 949 (16/71)

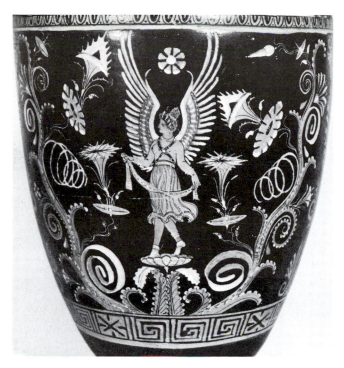

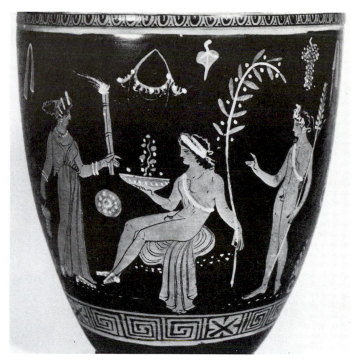

1–2. Bassano del Grappa, Chini coll. 86 (16/72)

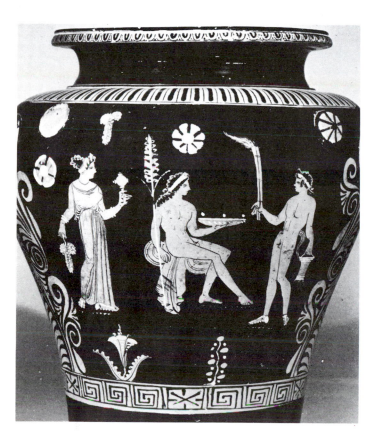

3. Paris, Cab. Méd. 949 (16/71)

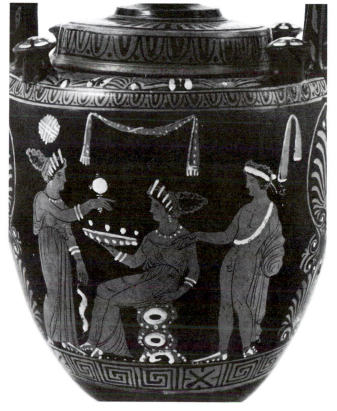

4. Once London Market (16/73)

PLATE 160 Two Underworld kraters

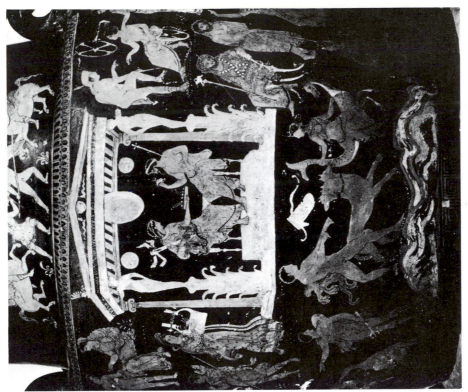

2. Naples 3222 (16/82)

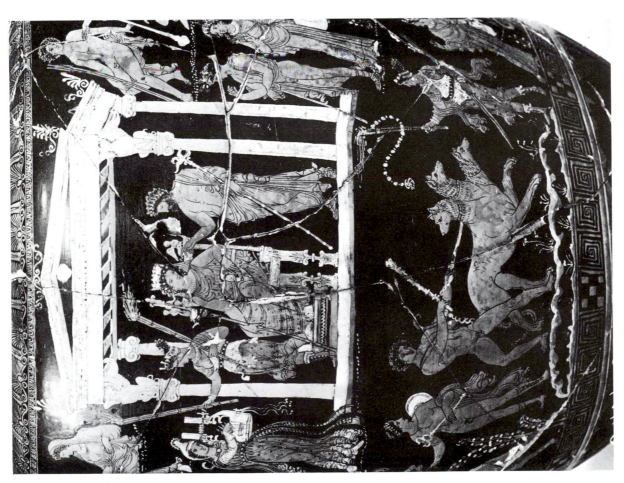

1. Kalrsruhe B 4 (16/81)